The
Woman Who
Knew
Everyone

The Woman Who Knew Everyone

THE POWER OF PERLE MESTA,
WASHINGTON'S MOST FAMOUS HOSTESS

MERYL GORDON

GRAND
CENTRAL

NEW YORK BOSTON

Grand Central Publishing
Hachette Book Group
1290 Avenue of the Americas, New York, NY 10104
grandcentralpublishing.com
@grandcentralpub

First Edition: January 2025

Grand Central Publishing is a division of Hachette Book Group, Inc. The Grand Central
Publishing name and logo is a registered trademark of Hachette Book Group, Inc.

The publisher is not responsible for websites (or their content) that are
not owned by the publisher.

The Hachette Speakers Bureau provides a wide range of authors for speaking events. To
find out more, go to hachettespeakersbureau.com or email HachetteSpeakers@hbgusa.com.

Grand Central Publishing books may be purchased in bulk for business, educational, or
promotional use. For information, please contact your local bookseller or the Hachette
Book Group Special Markets Department at special.markets@hbgusa.com.

Library of Congress Cataloging-in-Publication Data

Names: Gordon, Meryl, author.
Title: The woman who knew everyone : the power of Perle Mesta, Washington's most
famous hostess / Meryl Gordon.
Other titles: Power of Perle Mesta, Washington's most famous hostess
Description: First edition. | New York : Grand Central Publishing, 2024. | Includes
bibliographical references and index.
Identifiers: LCCN 2024025109 | ISBN 9781538751244 (hardcover) | ISBN 9781538751237 (ebook)
Subjects: LCSH: Mesta, Perle, 1882-1975. | Washington (D.C.)—Social life and customs—
20th century. | Ambassadors—United States—Biography. | Socialites—Washington (D.C.)—
Biography. | Socialites—Rhode Island—Newport—Biography. | Widows—Washington
(D.C.)—Biography. | Truman, Harry S., 1884-1972—Friends and associates. | Eisenhower,
Dwight D. (Dwight David), 1890-1969—Friends and associates. | Johnson, Lyndon B.
(Lyndon Baines), 1908-1973—Friends and associates. | Oklahoma—Biography.
Classification: LCC E840.8.4.M574 G67 2024 | DDC 973.9/092 [B]--dc23/eng/20240712
LC record available at https://lccn.loc.gov/2024025109

Interior book designed by Timothy Shaner, NightandDayDesign.biz

ISBNs: 9781538751244 (hardcover), 9781538751237 (ebook)

Printed in the United States of America

LSC-C

Printing 1, 2024

To Walter, with love

CONTENTS

Broadway Bound

Nestled high in the Rocky Mountains, with picture-postcard views and healing hot springs, the Hotel Colorado attracted a rich and famous clientele from the day it opened in 1893. More than a half-century later, when Broadway star Ethel Merman needed a break in July 1949 from belting "There's No Business Like Show Business" in the long-running show *Annie Get Your Gun*, she chose this isolated spot. Accompanied by newspaper executive husband Robert Levitt and their two young children, she convinced playwright Howard Lindsay and his actress wife Dorothy Stickney to join them.

Merman had starred in two musicals created by Lindsay and his writing partner Russel Crouse (*Anything Goes* in 1934 and *Red, Hot, and Blue* two years later). These members of Broadway royalty hoped to join forces again, but the Rocky Mountain sojourn wasn't meant to be a working vacation, just a chance to relax nearly two thousand miles from Manhattan's autograph seekers.

However, inspiration doesn't punch a time clock. Sitting by the pool that July, catching up on his reading, Lindsay picked up a several-months-old copy of *Time* magazine featuring a cover story about Perle Mesta, the Washington party giver who counted President Harry Truman among her closest friends. Anointing Perle Mesta

"the capital's No. 1 hostess," the March 14 *Time* solemnly stated, "Washington society persists chiefly because the capital is one of the world's most boring cities."

The article included gossipy tales chronicling Perle Mesta's unlikely rise from a Wild West Texas childhood with a "brash" father who dabbled in real estate, struck oil, and built the largest hotel in Oklahoma City, to her marriage to a self-made Italian Pittsburgh steel magnate, and, after his untimely death, her reinvention as a social-climbing widow who conquered stuffy Newport, Rhode Island, and set her sights on Washington. The nouveau riche hostess changed the spelling of her given name—from Pearl to Perle—because it sounded more sophisticated. She had a knack for ingratiating herself with up-and-coming politicians, befriending Truman when he was a Missouri senator and Dwight Eisenhower as an Army major.

By accumulating the "right" guests, a Washington hostess could invisibly pull the strings: whisper useful information into a senator's ear, help an underling gain a promotion through fortuitous seating, or put legislative opponents together in a congenial setting where, aided by copious champagne, they could forge compromises.

Perle Mesta was treated by *Time* with patronizing amusement, mocked for her weight ("her figure requires stern corseting") and sense of self-importance. "Not even her warmest admirers, who like her liveliness, would credit her with overwhelming charm or notable wit," the story declared.

By the time Howard Lindsay got around to reading the several-months-old magazine in July, Perle had become an even more controversial and polarizing figure. Just a few weeks earlier, Harry Truman had named her as the American envoy to Luxembourg, only the third woman to hold such a high State Department diplomatic post. With a population of 300,000 and situated on 998 square miles, Luxembourg was tiny, but since the country was bordered by Germany, France, and Belgium and with the Cold War reaching an alarming stage, it held tremendous strategic importance.

Truman was excoriated for picking a woman who didn't even have a college degree rather than a seasoned Ivy League–educated man. Naysayers jeered over Perle Mesta's lack of diplomatic experience, treated her as a punch line to a national joke, and cautioned that she would prove to be an embarrassment.

Small wonder that Howard Lindsay, leafing through that dated issue of *Time*, had a brainstorm. Perle's saga—from Western rube to European ambassador—had fabulous comic possibilities. Ethel Merman, with her booming voice, mischievous laugh, and brilliant comic timing, specialized in portraying larger-than-life characters. Lindsay put down *Time* magazine and told Merman, "I've got an idea for a show. A show about Perle Mesta. How would you like to play Perle Mesta?" The actress was game.

He sketched out the idea to his writing partner, Russel Crouse, who immediately grasped the potential. Crouse wrote in his journal on July 21: "A letter from L. with an idea for a new musical . . . Merman—Madam Ambassadress. Which cheers me and gives me new life."

The coauthors pitched the notion to Irving Berlin over a New York dinner, asking him to pen the music and lyrics. "We tell him our idea and he never has heard of P. Mesta . . . but he warms up later," Crouse wrote on August 22. "I. Berlin calls almost as soon as I'm awake—and now he has found out about Mesta and is very excited."

At that moment, Irving Berlin may have been one of the few Americans unaware of the rollicking life and times of Perle Mesta. A friend to presidents in both parties, a Republican turned Democrat, ardent feminist and supporter of the Equal Rights Amendment, this blue-eyed, brown-haired matron adorned in Paris couture was the darling of political and society columnists. During the first nine months of 1949, her name appeared in more than five thousand articles in American newspapers.

Even as Howard Lindsey, Russel Crouse, and Irving Berlin were plotting their theatrical spoof based on Perle Mesta, the real Perle Mesta had not started her new job yet. She was on the high seas,

traveling to France on the *America*, queen of the United States Lines. As Perle gazed at the Atlantic Ocean, she was trying to come to terms with the bewildering mixture of vicious vitriol and enthusiastic hurrahs showered upon her in recent weeks.

She was called "a political turncoat" and cruelly described in a newspaper as "a plain-appearing dumpty wren-like woman." When Perle took a friend to lunch at Washington's exclusive Sulgrave Club to celebrate her nomination, one diner insulted Perle to her face and other women jeered in tones that could be overheard, "payback" and "nauseating." When she was a young woman, Perle had trained as an opera singer and knew how to put on a performance. The hurtful blows landed even if Perle did not let her feelings show.

But in contrast, what to make of the lovefest when the Senate voted on her nomination, with only one dissenter? One senator after another, most of whom had been guests at her home, rose to sing her praises. In a sign of Perle's White House clout, First Lady Bess Truman took the train to Manhattan to see the new envoy off. At a shipboard farewell lunch, Supreme Court chief justice Fred Vinson toasted Perle as "a friend to many and a person with many friends."

What a confusing mix of life-affirming praise and mean-spirited scorn.

Before accepting the post, Perle had expressed doubts to confidants, who reassured her that she had the moxie and people skills to succeed. But now Perle feared letting Truman down and proving her critics right. Her wildcatting father had bluffed his way to success, carrying on even when his business empire was crumbling. She would have to follow his example. With so few women in high government jobs, she would inevitably be viewed as a role model. All eyes would be upon her.

PERLE WAS STUNNED to learn several months later about the Broadway show, after newspaper items appeared and a friend

mentioned it to her over a meal. "I was so upset by this news I could hardly go on with my lunch," Perle later recalled.

The creators were not being coy about their inspiration. Irving Berlin told the Associated Press, "It will portray the experiences of an American hostess in Washington who is appointed minister to a mythical duchy." Asked if Perle Mesta was aware of the musical, Berlin shrugged and laughed. "I don't know. She'll know soon enough."

His comments amped up Perle's anxiety. Would she be lampooned as a laughingstock? How closely would this fictionalized saga stick to her actual life, and what would be embellished? Would the musical hurt her standing as a diplomat and her ability to do her job?

A MERE FOURTEEN months after Perle Mesta arrived in Luxembourg as the new American envoy, *Call Me Madam* opened in Manhattan on October 12, 1950, to ecstatic reviews and $1 million in advance sales, the largest in theater history. To avoid claims of libel or defamation, the theater program disingenuously stated: "Neither the character of Mrs. Sally Adams, nor Miss Ethel Merman, resembles any other person, alive or dead."

Virtually all the reviews cited Perle as the show's inspiration. *New York Times* reviewer Brooks Atkinson wrote, "Since Miss Merman instinctively plays the part like a combination of a brass band and female wrestler, the semblance to Mrs. Mesta is not wholly exact. But there is no reason why Mrs. Mesta should feel piqued. For the character . . . is a winning one. She is frank, hospitable, generous and human and willing to learn."

State Department officials had discouraged Perle from seeing *Call Me Madam*, but now she felt compelled to attend. President Truman gave his permission and encouraged her to take his wife and daughter. On October 25, the three women slipped into fifth-row orchestra seats at the darkened Imperial Theatre for the matinee.

As the orchestra struck the opening chords, Perle was thrust back in time. Some of the events portrayed were real, and some were fictional, evoking a mélange of memories. The composers had a good laugh at her expense, riffing off her experiences.

Perle had carefully curated her public image, creating myths about her past and editing out unflattering details.

In truth, her life hadn't always been easy or as carefree as the effervescent Ethel Merman made it seem as she pranced across the stage.

A Texas/Oklahoma Upbringing

I was born on a thousand acres of Oklahoma land
Nothing grew on the thousand acres for it was gravel and sand
One day father starting digging in a field
Hoping to find some soil
He dug and he dug and what do you think?
Oil, oil, oil
The money rolled in and I rolled out with a fortune piled so high
Washington was my destination
And now who am I?

— "The Hostess With the Mostes' on the Ball"
by Irving Berlin

William Balser Skirvin did *not* strike oil while digging on an Oklahoma farm, and his heiress daughter did not roll directly to Washington. The true story was more convoluted. Skirvin was a likable schemer and dreamer who took big risks and was constantly searching for the next score. His firstborn, christened Pearl, idolized her father and his can-do spirit, often citing his motto: "Only busy people are happy."

Born in 1860 on a farm in Sturgis, Michigan, as a young man, the ambitious traveling salesman lived out the cliché—he married a pretty Kansas farmer's daughter. Harriet "Hattie" Reid, one of eleven children, played the piano and told intimates that she studied elocution at the University of Kansas. A devout Presbyterian, she was charmed by the loquacious five-foot-four farm implement salesman.

Hattie Skirvin gave birth to Pearl Reid Skirvin on October 12, 1882, while visiting her in-laws in Sturgis. In the Kansas State census in March 1885, Pearl was listed as two years old. (Throughout her life, she lied about her age, and it would be many decades before she renamed herself Perle.) William Skirvin started a real estate business in Kansas City, but then an irresistible opportunity lured him South: the Oklahoma land rush.

In a scandalous theft of land previously promised to Native American tribes, the federal government opened up two million Oklahoma acres for settlement by whites. After President Benjamin Harrison set the start date of April 22, 1889, for settlers to claim land, more than fifty thousand people gathered at Oklahoma's borders, patrolled by soldiers to keep the unruly mob from jumping the gun.

Skirvin and his brother-in-law Orrin Shepherd grabbed valuable acres in Guthrie. After filing claims with the Federal Land Office, they headed for the thriving Texas port city of Galveston. Cotton and grain warehouses lined the waterfront and the sophisticated island boasted a wealthy colony of shippers and merchants.

Skirvin and Shepherd's new real estate business thrived. Hattie and Pearl remained in Kansas City with relatives, but the family reunited in Galveston in early 1892. Daughter Marguerite Adelaide was born the following year.

Taking a look at his rapidly populating city—an island—Skirvin realized the surrounding areas were undervalued. He bought 320 rural acres about seventeen miles inland from Galveston with a $5,400 promissory note. Plagued by mosquitoes and nine-foot rattlesnakes, the location nonetheless had possibilities. The Santa Fe railroad

operated a depot so supplies could be shipped in and out. A newly drilled artesian well opened up agricultural possibilities.

Skirvin established the grandly named Alta Loma Investment and Improvement Company (*alta loma* in Spanish means "high ground"). He sent for his father and two half brothers, and they sold fifteen-acre lots, advertising the area in pamphlets as "located in the very heart of the Gulf Coast Magnificent Fruit Belt," where pears, oranges, and strawberries could be grown. Nellie Kitchel Skirvin, wife of William Skirvin's half brother Clifton, wrote in a memoir: "These pamphlets were bringing men from the far North as well as Kansas, Missouri and Northern Texas."

Skirvin built a two-story white Victorian home for his family in Alta Loma with a barn for horses, cows, and chickens. Son Orren William Skirvin was born in 1897. Pearl's life during that period was later conjured up by a *Time* correspondent who conducted interviews in Alta Loma in 1949 for the magazine's cover story. The reporter wrote of William Skirvin:

> He sold vast tracks of undrained and previously worthless land at eighty dollars an acre and became a wealthy man . . . Alta Loma became a gay small town, much favored by Galvestonians escaping smothering heat and haze of the gulf coast. There were many parties, a literary club, a small private school for young ladies run by Miss Clark Norris and a First Baptist Church just across from the Skirvin residence. Billy Skirvin, under the prompting of his wife (who is remembered as being very pretty but unwell) joined the Baptist Church.

Pearl grew up a tomboy, trailing her father as he taught her to ride and throw horseshoes. Her father encouraged her to speak her mind. "When his temper rose, the others were usually a little scared of him," she wrote in her autobiography. "But I always stood my ground . . . he spoiled me and made discipline very difficult for Mother. She

always said I was the worst child . . . I would use every trick to get what I wanted."

With a high forehead, blue eyes, and wavy dark hair, Pearl was an attractive girl who made friends easily, although she could be bossy. In the church choir, her lovely soprano voice made her a standout. Her little sister Marguerite was a beautiful sprite with delicate features and shiny blond hair. Eleven years younger, seemingly demure but with a rebellious streak, Marguerite looked up to her big sister. Pearl would spend a lifetime hearing people gush about Marguerite's exquisite appearance. The sisters were close, but there were inevitable undercurrents in their relationship.

The sociable Pearl gave her first party at age eleven, inviting friends over and serving bitter-tasting sandwiches that she concocted from nasturtium flowers, bread, and mayonnaise. Her menus would improve a great deal through the years.

She described her childhood as happy, but in truth her parents had a troubled marriage. The patriarch was often out of town or out on the town. There were rumors about the usual vices: alcohol and women. Hattie finally took the children and went to Michigan to live with her in-laws. In the 1900 census, seventeen-year-old Pearl and her siblings were listed as residing in Burr Oak, Michigan.

On September 8, 1900, a terrifying hurricane swept through Galveston and Alta Loma with winds of more than 140 miles an hour. An estimated ten thousand people died from being hit by debris or drowning in the fifteen-foot surge of water. Alta Loma was decimated. "People have no money and their property is destroyed," wrote the *New York Times*. "In the neighborhood 100 houses existed; forty are destroyed and about twenty are untenantable."

Skirvin heroically rode out the storm in the Galveston railroad depot. "His family was away at the time but he was there and assisted in the rescue work of people who, but for his efforts, might have been victims of that flood," according to *Chronicles of Oklahoma*. "On several

occasions in this effort he all but lost his life. The home in which he lived was washed off its foundations."

Hattie and the children returned to the area just as a plague of mosquitoes caused an outbreak of dengue fever. The seriously ill Hattie spent weeks in the local hospital and then went to the Battle Creek, Michigan, sanatorium run by cereal pioneer John Harvey Kellogg. She recovered, but her health remained fragile.

Faced with the devastation of his real estate empire, William Skirvin searched for a new source of income. When persistent drillers at the Spindletop field, near Beaumont, hit the jackpot on January 10, 1901, with an oil well that shuddered high into the sky, Skirvin raced to the rural area, a hundred miles away.

"Within twenty-four hours after that fact had set Texas wild with speculative fever, Skirvin was on the ground buying everything he could buy—on twenty four hours credit," according to the *Wichita Weekly Eagle*. "From a sleepy country village of five thousand people, Beaumont grew to a population of thirty thousand hustling, hurrying plungers in days: Skirvin got in and got in without a dollar. He hurried back to Galveston, got friends out from under their loads of grief and trouble and by sheer enthusiasm got the money to make good on his trades."

The money did indeed roll in for the Skirvin family, as Irving Berlin wrote in *Call Me Madam*. How much money William Skirvin was worth—at any point in his life—is impossible to ascertain since his dealings were private and complex. But he had enough to indulge in the finer things in life and was referred to as a millionaire at a time when a million dollars was serious money.

Eighteen years old at the time and fascinated by her father's tales of derring-do, Pearl might have been trained to run his business ventures had it been a different era. But her parents retained traditional values, and her younger brother O.W. was deputized for that role. Instead Pearl followed a timeworn female path—she was drawn to romantic involvements with men resembling her father.

"I was always fascinated by older men. They were doing things in the world while the young men my own age were still floundering around," she wrote in her autobiography. But aware of her father's infidelities, she was in no rush to tie the knot. Independent, with the kind of confidence that comes with family money, she was willing to chart her own course.

IN THE YEARS following the Oklahoma land rush, the state's population soared. In 1906, the Senate approved steps to allow Oklahoma to become the forty-sixth state. William Skirvin promptly relocated with his family to Oklahoma City, chasing new riches. He established the American Oil and Refining Company, selling shares to finance exploration on leased land, and began buying up city real estate.

The Skirvins moved into a redbrick home with eleven rooms, adorned with stained-glass windows and a wraparound porch, at 700 Northwest 16th Street. The upscale neighborhood had wide streets and ample lawns. The Skirvin property, on a large corner lot, included a stable. Pearl cared for her horse, Rex; brother O.W. tended to monkeys, hound dogs, and even raccoons; while Marguerite coddled her poodles. (The handsome house is still standing, and the neighborhood has been renamed Mesta Park, in honor of the most famous resident.)

"It was a little country town," Pearl reminisced years later to the Oklahoma Historical Society. "I used to ride horseback all over the city." She embraced Oklahoma as if she was a native daughter. For the rest of her life, she rarely mentioned her Texas upbringing and even told people she spent her childhood in Oklahoma, although she was twenty-four when she moved to the state. She felt her life truly began in the Sooner State. But she didn't initially stay long.

With aspirations for a career as an opera singer, she took the train to Chicago in 1907 to attend the Sherwood Music School. Founded in 1897 by pianist William Sherwood, the school offered

classes in music theory, piano, vocal technique and interpretation. The school catalog promised that graduates would be "fully capable of teaching others."

The mezzo-soprano realized that she didn't have the talent to be an opera singer but still hoped for a performing career. She auditioned for John Philip Sousa's traveling band as a vocalist and told friends she won the position but turned it down. Her mother's health was iffy, and her parents wanted her home. In 1907, the Oklahoma City directory listed Pearl R. Skirvin as a music teacher.

She was regularly featured in the *Oklahoma City Daily* society columns. "She was attractive, a splendid dresser," Oscar Dietz, the head of a wholesale grocery house, recalled. "She was dominating but definitely took the lead in activities." An accomplished bridge player, Pearl joined friends at the Mistletoe Dancing Club, the ten-cent silent movies, and the races at Delmar Gardens. Pearl often sang at friends' weddings with renditions of such songs as "I Love You Truly."

Oklahoma dressmaker Josephine Rue got to know her during this period. "Pearl is very emotional, tender hearted, and kind," the dressmaker recalled. "She is lavish with big things, close with small things. She loves parties and talking; she likes men better than women. She is a good bridge player but would rather talk to men than play bridge with women."

Beneath her cheerful façade, Pearl worried constantly about her mother. When Hattie Skirvin came down with the flu and pneumonia, Pearl stayed by her side. Her mother told her, "It doesn't look as I'm going to be here much longer, dear. When I go, I want you to look after Marguerite and William and your father." After a two-week illness, Hattie died on March 13, 1908. Pearl tried so hard to follow her mother's request that after a while, family members began to affectionately refer to her as "the general" for ordering them around.

William Skirvin distracted himself from grief by pouring his energies into work, focusing on his real estate ventures. A year later, a buyer offered to buy his property near the Rock Island Depot. After

learning that the purchasers planned to build a hotel there, Skirvin quashed the deal and seized on the idea as his own.

He had never built a major structure before, but he had big plans. Skirvin wanted his hotel to be the center of Oklahoma City's business and cultural life and to attract politicians, business travelers, and local couples for romantic evenings. The modest initial design turned into a towering ten stories with a convention ballroom and banquet hall, costing more than $500,000, roughly $13 million today.

With construction underway, he sent his youngest daughter Marguerite to an exclusive boarding school, the National Park Seminary in suburban Washington, DC. Unbeknownst to her father, Marguerite had set her sights on becoming an actress. "She was the leading spirit in all the playlets given at the school and penned a few vaudeville sketches," according to the *Washington Post*. Marguerite convinced her father to let her to transfer to Miss Gardner's School for Girls in New York City, under the ruse of stronger Greek and Latin departments. The real draw: taking drama classes at the American Academy of Dramatic Arts. The move to Manhattan proved to be a turning point, in many ways.

Skirvin hired a chaperone, Nan Wickersham, to keep an eye on his daughter. When Marguerite contracted a lingering case of pneumonia, Wickersham suggested an unconventional remedy. "The chaperone suggested why not go to a Christian Scientist practitioner and see if she could heal her," according to Marguerite's daughter Betty Ellis, in an unpublished memoir. "Mother did get well and was so impressed with Christian Science that she decided to become one."

Founded by New England widow and divorcée Mary Baker Eddy, by the time Eddy died in 1910, the Christian Science church was estimated to have more than 300,000 worshippers. The religion's central premise: with belief in God and one's own mental power, prayer can cure sickness and sin. Rather than consult a doctor, members are encouraged to bring in a Christian Science practitioner to lead them in prayer.

Pearl eventually embraced the religion, too. An optimist by nature, the positive-thinking aspects of Christian Science were a good fit with her personality. "It's very important to mention what a big role that Christian Science played in Aunt Pearl's life," says Linda Picasso, Pearl's great-niece. "She never drank any alcohol, even though she served it at all her parties. Whenever she was sick, she would always call a practitioner to pray for her, rather than go to a doctor."

AFTER GRADUATING FROM high school in June 1911, Marguerite turned up at the office of Manhattan theatrical producer Henry Savage. She was pretty and bold enough to land an interview. The producer inquired, "What experience have you had?" Her cheeky reply: "I played a maid's part in stock in Oklahoma City." Marguerite wasn't entirely lying—she had occasionally cleaned her room at home. Acing a follow-up audition, Marguerite landed the ingénue role in a long-running Broadway comedy, Rupert Hughes's *Excuse Me*.

Only after signing the contract did she tell her father. He sent her a telegram: "Cut it out." But after father and daughter met in New York, he agreed to let her pursue the bright lights, with one caveat. Skirvin told reporters that his daughter would require a chaperone, and he had just the right person in mind: "Miss Skirvin's sister should always travel with her, for the expense of which there is money from home."

This was not the future Pearl envisioned: watching from the wings as Marguerite took center stage. Her feelings about the situation can be intuited by the fact that Pearl never acknowledged the four years she spent as Marguerite's traveling aide. Her reward at that time was to be treated dismissively in newspaper items as her sister's also ran. In her 1960 autobiography, Pearl erased this entire experience as if it never happened.

Young Marguerite blazed a bright path. The story of the rebel-lious society girl–turned–actress made national headlines: "Success as Actress . . . Braves her Father's Wrath," wrote the *Washington Evening Star*. Marguerite performed in plays in Philadelphia; Bridgeport, Connecticut; Kansas City; and Memphis, with Pearl by her side.

In the meantime, their father completed his Oklahoma City edifice in September 1911. Leading with his ego, he named the 225-room hotel after himself: the Skirvin. Even a century later, the lobby is stunning, with high ceilings, Murano glass chandeliers, and nine Gothic-style wood-paneled pillars topped with carved gargoyle likenesses of Dionysus, the God of winemaking. That was Skirvin's personal joke, since Oklahoma was a dry state. The 1907 constitution banned the sale of alcohol for twenty-one years, unless it was sold for medicinal purposes. The accommodating owner and staff were happy to supply hotel guests with "medicine."

Skirvin hired a bookkeeper from Muskogee, Mabel Luty, who became his most trusted employee. *Harlow's Weekly* credited her with many of William Skirvin's successes: "Happily for him, Miss Luty has the inherent gift of handling details and of operating people. She is who executes his plans and dreams." Luty would work for him for three decades.

In between their travels for theater gigs, the Skirvin sisters joined their father and brother at the Skirvin Hotel in a five-room suite. For Pearl, people watching in the lobby became a source of education and entertainment. Her Republican father donated a suite as headquarters for the local GOP. Pearl recalled, "I got my first interest in politics from eavesdropping on the lobby conversations."

She was curious about how the hotel's operations worked. Native Americans were welcomed as guests. Black people were hired to work at the hotel, but by state law, they couldn't rent rooms. The Oklahoma legislature mandated segregation in housing, train wait-ing rooms, hospitals, restaurants, and cemeteries—even public pay phone booths.

Pearl chatted up the hotel staff about working conditions and tried to sweet-talk her father on their behalf. As she later recalled, "My father used to say, 'Sometimes I hate to see you coming, you're always stirring up the help.'"

LIKE MANY SELF-MADE wealthy men of the era, William Skirvin wanted to give his children cultural polish, so he sent his daughters to Paris in 1913. Marguerite took a break from acting while the sisters spent four months studying voice and French. This was the Belle Époque, the last gasp of the Art Nouveau movement: the stunning Galeries-Lafayette store had just opened, and the Paris Opera featured daring new work. Pearl and Marguerite became enamored of all things French—couture clothing, antique furniture, china, and silver. When it came time to decorate their own homes, only Louis XIV and pedigreed antiques would do.

When their boat, the *Mauretania*, docked in New York, Marguerite insisted to reporters that she had been hard at work. "I can assure you it was no holiday," Marguerite said. "I have been using every minute of my time from 8:30 in the morning until 9 or 10 every night in fitting myself for the most difficult roles in musical comedy."

With Pearl by her side, Marguerite toured the country in *The Fascinating Widow*, a controversial song-and-dance show with stops in Tulane, New Orleans, Kansas City, Memphis, Muskogee, Milwaukee, Oklahoma City, and San Francisco. The show starred female impersonator Julian Eltinge. ("Once over the initial unpleasantness of the idea of female impersonation . . . " the *New York Times* wrote, "He looks remarkably well in women's togs.") Marguerite played an ingénue whose mother dislikes her suitor—Eltinge—so he dresses in drag as a "widow" to secretly court her.

Marguerite made the leap into silent movies in 1914, playing the love of an American adventurer in *The Port of Missing Men*. Marguerite's assumption that acting in a movie would be easy was "rudely

shattered after my first scene," she told a reporter. "I was taken to Jay Gould's estate in Lakewood, N.J. and told to dress in an evening gown of light material. The scene was supposed to be in the summer and with a basket on my arm and a pair of shears I strolled out through a garden clipping flowers while a cold raging wind howled as only wind can howl in New Jersey and in the month of February."

Her next silent film—*Aristocracy*, with co-star Tyrone Power Sr.— turned Marguerite into a national star. Reviewers praised her as "a ravishing beauty and a clever actress," and fan magazines requested her beauty tips. Columnists quoted Marguerite's witty remarks, such as "The height of chivalry is the act of a man who remembers a girl's birthday but forgets her age."

Her hometown paper, the *Daily Oklahoman*, proudly noted that Marguerite, "who has enjoyed one of the most meteoric theatrical careers which ever startled Broadway, has risen in two years from an Unknown Oklahoma girl to leading lady in some of the biggest productions."

When Marguerite announced plans to return to Broadway in the play *Rolling Stone* in 1915, *Town and Country* ran a full-page photo. Dressed in an elaborate costume with a fur collar, she lowered her eyes demurely, giving a sweet but knowing smile.

Now that Marguerite was a twenty-two-year-old adult with a successful career, Pearl decided it was time to break up the sister act. After traveling all over the country, she rejected the idea of return-ing to provincial Oklahoma and informed her father that she planned to move to Manhattan. Grateful for her lengthy chaperone duty, he gave his blessing.

The Man of Steel: George Mesta

Arriving in Manhattan in 1915, Pearl moved into the sumptuous Park Avenue residence of her great-aunt, wealthy widow Florence Wellis. Her father promised to provide her with an ample allowance: Oklahoma gossip put it at $36,000 (nearly $1 million today) plus a Pierce-Arrow car. Now she could be a lady of leisure. And, at age thirty-three, perhaps find a husband.

She attended the opera, dated, and dabbled, and then one night, fate intervened. A family friend fixed Pearl up with Pittsburgh businessman George Mesta over a group dinner at the Waldorf Astoria Hotel. Clean-cut, well-dressed, and twenty years Pearl's senior, the attractive bachelor made a good impression.

After walking her home that night, he invited her out the very next evening, suggesting dinner at the Ritz Hotel followed by a nightclub. She came up with a less expensive outing, and they ate at the inexpensive Schrafft's and took a carriage ride in Central Park. "When we were introduced, he didn't know I had money and I didn't know he had," she later reminisced. The next day, Pearl was informed that George was worth more than $15 million (upward of $500 million today) and could afford a night on the town.

George Mesta had come from humble origins. "He was truly a self-made man," Pearl recalled with admiration. One of eight children, he was born on a Pennsylvania farm in 1862 to Italian immigrant parents; his father was a machinist. After excelling in engineering at the Western University of Pittsburgh, he landed a job designing engines and mill machinery. In 1886 he launched his own company and turned it into a manufacturing behemoth, Mesta Machine Company.

His sprawling factory, employing nearly three thousand people, produced everything from ship propeller shafts to power plant turbines. Mesta treated employees well enough to fend off unionization, avoiding the union-busting fights at Andrew Carnegie's nearby Pittsburgh Homestead Steel Works, where seven died in an 1892 battle.

"I remember he was a very peculiar sort of fellow," recalled Pittsburgh reporter Joe Arthur. "Didn't take much part in society, golf, or that sort of stuff. He was always tending to business." Mesta, a Republican, had an open checkbook when it came to Homestead, the suburb where his plant was located. "He always helped out on everything."

Despite his Italian background, he was invited to join Pittsburgh's elite establishments—the Duquesne Club, the University Club, the Oakmont Country Club, and the Pittsburgh Athletic Association. Never married, he was considered a prime catch.

But George Mesta went through a traumatic period right before he met Pearl. His eighty-one-year-old widowed mother Anna died in January 1915. In March, he faced a reputation-destroying scandal. He was having an affair with married socialite Elizabeth Kintner, and they were caught by her spouse, Westinghouse executive Samuel Kintner. As one newspaper described the scene, "The aggrieved husband, with a revolver in his hand, surprised his wife and her companion, both were garbed in much less than decorum demanded." In September 1915, Elizabeth Kintner committed suicide by swallowing poison.

Pearl eventually learned about the scandal and delicately acknowledged in her autobiography that George "left some smoldering

romantic trails behind him." But he had left those trails behind in Pittsburgh; New York City offered a clean slate.

Smart and worldly, George was a man of achievement—like Pearl's father—and appreciated her independent spirit. Financially secure, Pearl was opinionated and self-confident and did not see herself as a wilting flower awaiting a male savior. George knew nothing of Pearl's life in Oklahoma City, and she knew nothing about Pittsburgh.

With World War I raging in Europe, and American manufacturers getting rich filling foreign orders for weapons, George was transforming his plant to make war supplies. He called Pearl once or twice a week from Pittsburgh and, when in New York, took her to the opera, to the theater, and dancing. But the fifty-three-year-old lifelong bachelor wasn't in a rush to take this relationship to another level.

DURING THIS PERIOD Pearl frequently spent time with Marguerite, who had rented an apartment on Riverside Drive. The sisters made a new friend, Ann Snyder, a beautiful saleswoman at a Fifth Avenue jewelry store. The unmarried Snyder had two teenage children, David and Clare, from a relationship with traveling piano salesman William Boothe. When Ann lost her jewelry sales job, she was reduced to penury, and there were rumors that she temporarily became a call girl.

Marguerite visited her Upper West Side apartment and was appalled to see precocious thirteen-year-old Clare sleeping in a tiny room off the kitchen that was infested with mice and bugs. Ann Snyder's life improved dramatically after she married a successful physician.

Her daughter would grow up to be one of the most influential and controversial women of the twentieth century, admired and reviled—the talented and hungrily ambitious playwright-congresswoman-diplomat Clare Boothe Luce. She would become one of Pearl's lifelong friends.

Four decades later, syndicated columnist Westbrook Pegler interviewed the Skirvin sisters about Clare. He wrote: "Perle and Marguerite sketched a girlhood in conditions so unappetizing that Marguerite admitted, 'I can't ever blame Clare for anything she does.'"

GEORGE MESTA CONTINUED to shower Pearl with orchids while avoiding any hint of a commitment beyond paying his florist bills. Pearl was in love and wanted to spend the rest of her life by his side. After hearing rumors of George's impending marriage to a Pittsburgh woman, she confronted him. Mesta insisted he wanted to marry Pearl and to prove his commitment, gave her a fifteen-carat sparkler. Years later, she compared her jewelry with baubles worn by Elizabeth Taylor, bragging, "My engagement ring was as big as Mrs. Richard Burton's diamonds."

In Pearl's engagement photo in the *Daily Oklahoman*, her hair is piled stylishly high and she looks directly at the camera with a serene expression. The caption, apparently referring to her vocal talents, stated: "She is a young woman of many accomplishments and a charming personality, whose happy disposition has made for her a wide circle of friends."

None of these friends were invited to the wedding. Pearl had always dreamed of a church ceremony and big reception, but George, stung by his prior notoriety, insisted on a modest gathering. The wedding occurred at Marguerite's New York apartment on February 12, 1917. Reverend Malcolm McLeod, of the Presbyterian Church of Fifth Avenue, performed the ceremony to the tune of a single violinist. Marguerite was her sister's maid of honor, her younger brother O.W. served as best man, and Pearl's father and great-aunt Florence were witnesses. The newlyweds honeymooned in Havana, Palm Beach, and Oklahoma City.

All marriages require partners to adjust, but Pearl was unprepared for just how much she would need to adjust to West Homestead,

Pennsylvania, an industrial outpost nine miles from downtown Pittsburgh. Her husband owned a ten-thousand-square-foot 1880s mansion on the bank of the Monongahela River. But the view from the picture windows was hardly scenic: the Mesta Machine Company, with manufacturing buildings on twenty acres, spewed smoke and grit into the sky.

George Mesta employed a personal staff of dour German immigrants, including a dictatorial housekeeper who ignored Pearl's suggestions. Accustomed to VIP treatment at the Skirvin Hotel, Pearl was frustrated that she didn't control the menu or schedule in her own home.

She turned her attention to developing a social life, but George was still a pariah because of his earlier scandal. Her Texas-Oklahoma drawl and ignorance of the inbred rituals of the local aristocracy did not endear her to Pittsburgh's upper crust, and Pearl found herself shunned. The ostracism meant Pearl spent long hours at home playing the piano and practicing her singing while waiting for her husband, who put in ten-hour days. She found no solace in reading—it bored her—and bought a horse and took lonely rides. She gave family dinners for George's siblings, where shoptalk was unavoidable since his brothers, Frederick and Charles, worked at the company.

Pearl joined George on weekend visits to the Mesta plant, where she gazed at the flaming furnaces as he lectured her about his business. "From the very first days of our marriage my husband used to take me every Sunday on the tour of his steel mills," Pearl recalled. "We talked steel at breakfast, luncheon and dinner. He wanted me to know the subject from the ground up." This was the workaholic George's way of including Pearl in his life.

Aware that his new wife was struggling, after celebrating their first Christmas, George took Pearl to Manhattan, where he gave a surprise thirty-person New Year's Eve party. "My husband engaged a small orchestra to play show tunes, waltzes and fox-trots," she wrote years later in *McCall's* magazine. "I wore an ivory satin gown . . .

Outside, it was cold and blowy, as only New York can be. But in that room there were only warmth and beauty, for I was young, happy and indulged."

WITH AMERICA ON the verge of entering World War I, the Mesta Machine Company was gearing up to supply the government with naval gun barrels, engines, and war machinery. A month after the US declared war against Germany in 1917, George Mesta was summoned to Washington, DC, by President Woodrow Wilson to consult with the government's steel committee. Pearl joined him.

George Mesta received an unexpected request from Samuel Gompers, head of the American Federation of Labor, to serve on a labor-management committee. Mesta was anti-union, but Pearl convinced her husband to say yes. She made a patriotic pitch but likely had an ulterior motive—George would need to spend ample time in Washington.

Pearl reveled in their suite at one of the city's finest lodgings, the Willard Hotel. With marble pillars and an enormous lobby with gilded high ceilings, the Willard served as home away from home for senators, congressmen, and government officials. Top-floor rooms featured views of the Washington Monument and gleaming Capitol dome.

The outgoing Pearl, hungry for new friends, reached out to her hotel neighbors, Vice President Thomas Marshall and his wife Lois. The Mestas treated them to dinners; the Marshalls reciprocated with introductions to their social circle, including the fabulously wealthy Carrie Walsh, widow of Thomas Walsh, an Irish immigrant who struck gold in Colorado. Pearl and George were soon regulars at Mrs. Walsh's afternoon dances at her vast sixty-room Art Nouveau mansion. The widow's daughter Evalyn, married to *Washington Post* heir Edward "Ned" McLean, included these newcomers in her parties as well. The Mestas had entrée, but Pearl had much to learn.

Washington society operated on a distinct hierarchy. At the top rung were the "cave dwellers," the nickname for the old-line wealthy families who had resided in the city for several generations. Next came the fabulously wealthy robber barons along with the lesser nouveau riche like the Mestas, all capable of entertaining with aplomb. At the bottom were the influential insiders—elected politicians and government officials, newcomers who had power but struggled on federal paychecks.

More than virtually any other American city, Washington ran on a twenty-four-hour work cycle. Days might be spent at a government office, but nights were about jostling to get into the right rooms and meet the right people. Outsiders were not drawn to this sweltering swampy city for gracious living; they came to move up in the world or push for a favorite cause. Befriend an important politician or a lobbyist dangling lucrative deals, and a life's trajectory could change. If someone didn't return a call during 9-to-5 hours, there was an excellent chance that one could "accidentally" run into them at night, if one moved in the right circles. The word *networking* had not yet been invented, but that's what Washington has always been about.

There was a money-power imbalance within these social rankings. That was certainly true for Vice President Marshall and his wife Lois, who worried constantly about money. When Lois Marshall jealously admired the deluxe décor of the Mestas' Willard suite, Pearl had one of those wake-up moments, realizing that George Mesta's fortune could give them an edge in Washington.

She convinced George to take boxes at charity balls and concerts, inviting government officials who otherwise could not afford to attend. She threw debutante parties for the daughters of the city's powerful but underfunded government elite. She invited foreign attachés to add an exotic air to her gatherings.

In this era, women had minimal official sway in Washington. Suffragettes demonstrated regularly in front of the White House and were roughed up and arrested for their efforts to press for women's right to vote. Congress had a single female member, Montana's

Jeannette Rankin, a Republican suffragette and antiwar pacifist elected to the House in 1916. No woman had ever been appointed as a Cabinet member or ambassador. But women could weaponize the traditional hostess role in order to be quietly influential.

With an anthropologist's intensity, Pearl studied the rhythms of Washington social life, such as formal calling days. On Mondays, the wives of Supreme Court justices held open houses; on Tuesdays, congressional wives did the honors; Wednesdays were the designated day for Cabinet wives and the vice president's wife; on Thursdays, the Senate wives had their moment; and on Fridays, the diplomatic circle opened their homes. Pearl ordered her own engraved cards and made the rounds.

The Associated Press spelled out the pecking order in a tongue-in-cheek feature. "The busiest callers in the world are Washington society people right now," the AP stated. "There is little time left for the official or the 'professional' caller to do anything but call." It was considered charitable to call at the homes of the "has beens," those women whose husbands were now out of power.

There were rigid rules governing Washington dinners. Hostesses were obsessed with protocol, ranking guests by their importance and seating them accordingly. Should the British ambassador, a powerful senator, or a White House official be at the head of the table? The pecking order was unspoken; one was supposed to know. It wasn't until 1930 that the well-connected Helen Ray Hagner created the indispensable *Green Book*, a social bible that listed the city's elite by name and background and precisely spelled out who should sit where—with rankings changing yearly.

With a wealthy husband and the blessing of the vice president's wife, Pearl became what she called "a somebody." Supreme Court justice William Rufus Day and interstate commerce commissioner Charles McChord and their wives became regulars at the Mestas' events. The couple joined the Congressional Country Club, the Chevy Chase Club, and the Pennsylvania Society.

Pearl was not yet trying to compete with Washington's storied hostesses, such as Alice Roosevelt Longworth, daughter of President Theodore Roosevelt and wife of House Speaker Nicholas Longworth, known for her intellectual salon. Pearl didn't own a grand home staffed with servants, she didn't give big parties, and she wasn't trying to press a political agenda. But she liked being adjacent to power and useful to George by socializing with politicians.

Pearl learned from older and bolder women such as real estate developer Mary Henderson, widow of Missouri senator John Henderson. After moving to the capital in 1889, the couple accumulated large parcels of Washington land. Widowed in 1913, Mary Henderson built vast mansions that became Embassy Row. Pearl and George attended her frequent dinners.

"It was at these parties that I began to understand how a Washington hostess could be a factor in politics by having the right people at the right time," Pearl wrote in her autobiography. "To the eye she was just a dainty-blue-eyed white-haired completely feminine person, but back of all this gracious appearance was a dominating powerful woman."

As much as Pearl relished her new Washington life, she had other aspirations at the time—to become a mother. "Oh, how I wanted children, but I just couldn't," she sadly recalled. After Vice President Marshall and his wife adopted a son, the Mestas discussed following suit. But George demurred, thinking they might still conceive.

DURING FREQUENT TRIPS back to Pittsburgh, Pearl tried to get to know her husband's employees. After giving a Christmas party for the children and wives of foremen and subforemen, and hearing the women's concerns, she successfully pressed George to improve medical care on site and provide paid time off for teenage apprentices to finish school. "A wife should be a challenge—don't you think?" Pearl later said of her marriage. "A man could get bored."

Her husband eventually became fed up with her do-gooder efforts at his factory and asked her to step back, and she mostly deferred to his wishes. "George was older than I was and strictly an Italian husband," she reminisced. "He would give me jewels and lovely clothes and beautiful homes, but I was supposed to stay there and be there when he came home."

In the fall of 1918, influenza swept the nation. In Pittsburgh, the first case was diagnosed on October 1; by February more than twenty-five thousand people in the city had the flu. Smoke pollution produced by the steel mills—including the Mesta Machine Company—exacerbated the situation. Washington was hit hard, too, with more than 33,700 people ill and nearly 3,000 deaths; work and social life came to a standstill.

George and Pearl spent the worst of the pandemic in Pittsburgh, returning to Washington in February 1919. The city had become a different place in the wake of Germany's surrender several months earlier. With George's role as a wartime government adviser over, he no longer needed to be in the city on a regular basis.

Flush with war profits, he decided to build a new mansion in Pittsburgh, despite Pearl's entreaties to make Washington their home. In July 1919, George bought a large plot in the exclusive Squirrel Hill neighborhood and authorized a design for a massive white stone mansion with thirty-two rooms, fifteen bathrooms, and an elevator. But the builders did not start work for several years, and the couple remained on the move.

For George, the armistice opened up business opportunities in Europe. In his 1919 passport photo, he looked dashing in evening attire, with a black bowtie and stiff high-collared white shirt. Pearl's new passport listed her birth date as 1888, knocking off six years from the actual date. The couple sailed to England and spent months visiting France, Holland, Belgium, Italy, and Switzerland. Pearl would later recall this as one of the more blissful times of her marriage, dancing cheek-to-cheek on transatlantic voyages and exploring the great capitals together.

While Pearl was traveling the world, Marguerite's career continued to thrive. She starred in six silent movies, sharing billing with Lionel Barrymore in *The Upheaval*. But now that she was in her late twenties, she was contemplating her future, drawn to marriage and motherhood. In 1920, Marguerite became engaged to Robert Adams, scion of a wealthy Connecticut textile manufacturer.

The couple met at a dinner given by cereal heiress Marjorie Merriweather Post Hutton, also a Christian Scientist, at her Fifth Avenue triplex. "Fate took a real turn that night," wrote Marguerite's daughter Betty Ellis. "Mother captivated my father immediately with her lively, engaging personality and quick wit. Mother's career shortly went right out the window . . . and when he proposed to her over afternoon tea at the Plaza Hotel, she quickly said yes."

Robert Adams, who worked for his father, had recently gone through a bruising divorce. According to an article in the March 1919 *Reno Evening Gazette*, his soon-to-be ex-wife charged him with striking her, claiming he became so angry when she allowed the dog to sleep on their bed that he "threw the canine across the room with considerable force."

On March 15, 1920, Marguerite and Robert Adams were married in his parents' Park Avenue apartment. The sisters now had one more thing in common: Pearl had married a man with a tainted past; Marguerite had fallen for a husband accused of bad behavior. Mimicking Pearl's small wedding, only family members witnessed Marguerite's ceremony.

And that was the end of Marguerite's career as an actress. The toast of Broadway and Hollywood, she walked away from it all. Whether this is what she wanted—or what her husband demanded— Marguerite never complained or looked back. She embraced the role of wealthy wife (Fifth Avenue apartment, Greenwich weekend home) and eventually mother (of three children). She channeled her theatrical background—all those stage sets—into a passion for decorating. The sisters changed places on the seesaw of life: Marguerite became invisible just as Pearl was becoming prominent.

George Mesta traveled constantly to Europe, racking up twenty-two overseas trips, bringing along his wife. In France, people sometimes misspelled her name as Perle. The spelling seemed cosmopolitan, so on a whim she began to occasionally sign her correspondence that way, but mostly she retained her given name.

The Mestas celebrated the inauguration of President Warren Harding in 1921 by taking a box at the Charity Ball at the Willard. They kept their apartment at the hotel, and soon welcomed new neighbors, Vice President Calvin Coolidge and his wife Grace whose suite was right below theirs. Pearl made an effort to make them feel at home. She gave a lunch to introduce Grace Coolidge to spouses of Supreme Court justices and senators; the Mestas followed up with a formal dinner for the Coolidges.

Pearl thought her husband had much in common with the laconic Coolidge, later writing in *McCall's* that both men "spoke little unless pulled into the conversation by lively, spontaneous talk that really interested them . . . I got on famously with Calvin. And George found Grace fascinating. So did I."

After President Harding died of a heart attack in August 1923, the Mestas' Willard neighbor was sworn in as president. Once the Coolidges began entertaining at the White House, Pearl and George made the list.

Pearl was a Republican, but she was not locked into a particular ideology. In the 1920s—and, in fact, for most of her lifetime—both political parties were sprawling big-tent coalitions lacking the ideological cohesion of today's parties. The Democrats were an oddball mix of left-wing crusaders, big-city political machines, and Southern segregationists. The Republicans combined small-town conservatives with urban, often patrician, liberal reformers opposed to machine politics.

When George donated $100,000 to Coolidge for the 1924 election cycle, Pearl winced at the high sum, recalling that she "listened through the keyhole of small rooms" while he swapped cash and favors with Republican fundraisers. Pearl liked to challenge her conservative

husband by taking the side of the working class. "He named me 'Little Rebel' because I was so far out. Some of the worst fights we ever had were over politics," she recalled. "I'd get so mad I'd have to leave the dinner table." But she always returned.

In the summer of 1924, the couple spent several months in Europe. At the suggestion of George's doctor, who was concerned about his heart, they relaxed for several weeks at a spa in Germany.

Returning to Washington in March 1925, they celebrated Coolidge's inauguration by giving a series of teas and small dinners. George liked to show off his wealth; one night he took a look at floral arrangements his wife ordered and insisted on additional colorful bouquets. Their new Pittsburgh home was almost done, and in anticipation, George spent thousands of dollars on trees and shrubs.

On April 16, the couple traveled to New York, marking nearly a decade since their initial Manhattan rendezvous. At the last minute, George's work dinner on April 22 was canceled, and the couple celebrated with a romantic dinner at their hotel, the Ritz-Carlton, followed by a night at the theater.

At 3 a.m., Pearl woke up and saw George sitting up in bed, complaining he didn't feel well. He walked into the bathroom; a few minutes later, she heard a loud crash. Racing in, she found George on the floor, unconscious. By the time the doctor arrived, sixty-three-year-old George was dead from an apparent heart attack.

Starting Over

Pearl had anchored her life to George's priorities—his travels, his business, his needs—and now she was adrift. Upon returning Pittsburgh for his funeral, she was immediately faced with daunting life choices. Who was she without George? How would she spend her time? Where to live? And then there was the question of money. Pearl had never learned to balance a checkbook. Now she didn't know how much money she had.

In his will, George gave the bulk of his multimillion-dollar estate to Pearl and his brother Frederick Mesta. But when Pearl dug into the provisions, she discovered glaring problems. George had put 7,715 shares of Mesta stock in a trust for Pearl, making her the company's largest stockholder. But she could not sell any of it. She would receive the trust's income for as long as she lived. After her death, the stock would revert to his family members.

For Pearl, this situation was unacceptable. It would mean living on dribs and drabs of unpredictable interest income that depended on the company's fortunes. George had created a disconcerting scenario in which Pearl was worth more dead than alive to her husband's family.

In her first major decision as a widow, she defied George's wishes in order to take control of her financial destiny. Pearl told her lawyer

to insist on a different legal option, requesting half the estate immediately, equal to several million dollars' worth of stock. Pearl was giving up future riches for independence now. Under this ploy, George's relatives would receive their stock bequests immediately, so they didn't contest her request.

At age forty-two, Pearl nervously insisted on joining the Mesta board at a time when female board members were a rarity. "I inherited 90 percent of his investment in the company," she later explained, "and I wanted to know what was happening to my money. I did it with fear and trembling because I felt it was my duty."

Although George had tutored Pearl on the steel industry, she was unfamiliar with technical innovations and the intricacies of operating his plants. She attended board meetings in Pittsburgh for nearly a decade but left the decision-making up to company executives.

She put her newly built Pittsburgh home, where she had never lived, on the market. (It took two years to sell.) Washington was a place where she and George had been happy, so she decided to give it a try. Since the Willard Hotel held too many memories, she moved to the newly opened Mayflower Hotel on Connecticut Avenue.

She was lonely, discovering as so many new widows do that invitations have a way of drying up. She spent time with women friends and went horseback riding on local paths, but the hours were hard to fill. "I was like a ship without a rudder those first few years," she would later tell a reporter. Pearl distracted herself by splurging on $10,000 worth of clothes, along with a $20,000 chinchilla cape. All the money in the world wouldn't bring George back, but spending his riches gave her a lift.

In the fall of 1926, Pearl stumbled into a friendship that would pay dividends for nearly a half century. At the request of her uncle Orrin Shepherd, Pearl gave an engagement party for Helen Eakin, the daughter of a Kansas millionaire, and her fiancé, Milton Eisenhower. Yes, those Eisenhowers. Kansas State University professor Milton had just gone to work for the secretary of agriculture.

"We became great friends, and great friends of his brother, young Major Dwight Eisenhower, and his wife, Mamie, when the young major came to Washington for a tour of duty in the War Department," Pearl recalled. Ike and Mamie Eisenhower moved to Washington in 1929, spending six years in the city until the Army sent Ike to the Philippines. The couple would affectionately remember Pearl's warm welcome and dinner invitations, well before D-Day.

RETURNING TO THE passion of her youth, Pearl centered her life on the opera. In Washington, she became an early subscriber to a prestigious concert series at the Mayflower Hotel, "Musical Mornings." When famed New York Metropolitan Opera soprano Rosa Ponselle dazzled the group with her high C, Pearl was entranced, tracking the singer down in Manhattan.

Rosa was single and besieged by stage-door Johnnys; Pearl was single and rich and she wanted friendship. Pearl had given up her own opera dreams but she could live vicariously. When Rosa performed Vincenzo Bellini's challenging *Norma* in November 1927, Pearl gave her an after-party for one hundred guests at the Park Lane Hotel. This was Pearl's first spare-no-expense extravaganza. The room was decorated with orchids, the staff served caviar and champagne, and guests danced to the beat of society orchestra leader Meyer Davis. Topping off the evening, Pearl hired Broadway musical stars to perform, including Eddie Cantor of *Ziegfeld Follies*, Marjorie Moss and Georges Fontana from Club Lido, and Zelma O'Neal from *Good News*. The guests lingered until 6 a.m.

This party marked a radical shift in her entertaining. This was showbiz; this was fun; this was way over the top and very, very expensive. Pearl was going through money so quickly that she sold a chunk of Mesta stock back to the company in 1927 for $503,125 (more than $8.5 million today).

She began commuting to Manhattan so often that she finally rented a suite at the New York's Barclay Hotel, where yearly rates ranged up to $5,550. Pearl started to date again. She was attracted to Italian men, older men, artistic men, and politicians. With her wealth and effervescent personality, Pearl attracted suitors and became adept at turning down proposals and recognizing fortune hunters.

Pennsylvania congressman Stephen Porter, who had been George Mesta's friend, was the first to suggest nuptials, but she gently brushed him off. Pearl then caught the eye of General Augusto Villa, a military attaché at the Italian embassy. Walter Winchell, erring in his identification, chortled in a column: "Mrs. George Mesta and the Roumanian minister d'Avilla are making one shadow, both being free, white and more than 21." That didn't last, either.

Rosa Ponselle fixed up Pearl with Antonio Scotti, a handsome baritone with the Metropolitan Opera. Born in Naples, eighteen years Pearl's senior, Scotti was a critic's favorite, described in the *New York Times* as "one of the greatest baritones and artists that the current stage has known." He was also known as a ladies' man, or as the *Times* put it, "He was extremely interesting to femininity, and many were the tales told of sentimental relations and engagements broken."

For Pearl, dating Scotti, a flashy dresser with operatic emotions, was a revelation after the businesslike George Mesta. "Tony was tall, dark and very temperamental," she wrote in her autobiography. "We used to fight like cats and dogs over every little thing." Aware of their economic disparity, the opera singer took Pearl to romantic but inexpensive Italian restaurants. Imagine the incongruity of the widow, dripping in diamonds, seated in a joint in Little Italy with a red checked tablecloth and a candle in a Chianti bottle. The unlikely romance petered out. (The bachelor died alone, in poverty, in Naples in 1936.)

Rather than wait for the phone to ring, Pearl summoned guests for dinners and the opera. Like many wealthy widows, she was often escorted by single men euphemistically referred to as "confirmed

bachelors." Pearl never discussed her attitude toward homosexuality, but she was sophisticated enough to be aware that some men desired other men. Her religion, Christian Science, insisted that homosexuality was "a deviation from moral law," but she was willing to deviate from that dictum. Through the years, some of Pearl's male guests would either reveal they were gay or be outed as such. That did not bar them from being welcome by Pearl's side.

PEARL HAD A summer problem. The elite neighborhoods of Washington and Manhattan turned into ghost towns as wealthy residents fled the intolerable heat. Choosing among the playgrounds of the rich, Pearl rented a house in Saratoga Springs in August 1927, the height of racing season.

Ah, Saratoga, the home of healing hot mineral spas where Vanderbilts and Whitneys reigned. Through her opera connections, Pearl was friendly with socially prominent Manhattan banker Richard Wilson, a horse breeder and president of the Saratoga Racing Association, and his wife Marion. Wilson and his siblings were known as "The Marrying Wilsons" due to their Social Register nuptials. His sister Grace was married to Cornelius Vanderbilt III, his brother Orme had married (and divorced) Caroline Astor, and his sister Leila's husband was the former British ambassador to Washington. To be a friend of the Wilson family opened doors.

Invited to the Wilsons' Saratoga parties, Pearl enjoyed mingling with the horsey set. At the racetrack, she enthusiastically played the ponies, losing $17,000 (more than $260,000 today) in one year, choosing horses because the names amused her or she knew the owners.

Back in Manhattan that fall, Pearl and Marguerite spent time with Mrs. George Brokaw, the former Clare Boothe. The impoverished waif was now a blond beauty married to a prosperous (albeit alcoholic) lawyer, the inheritor of a family fortune. The couple lived in an enormous Fifth Avenue mansion with their young daughter. The

Skirvin sisters became so close to their friend that when Marguerite gave birth to her second child, Harriet Elizabeth Adams, in 1926, she named Clare as godmother.

Pearl and Marguerite joined Clare Brokaw on the New York social rounds—nightclubs, charity balls, beauty salons, and exclusive shops. The sisters would realize a decade later just how closely Clare was paying attention after she skewered society women in her hit Broadway play *The Women*. As Clare continued her ascent—divorcing Brokaw, marrying *Time* magazine founder Henry Luce, entering politics—her life would remain closely intertwined with Pearl's and Marguerite's lives.

Pearl's own rise in Manhattan society could be measured by the column inches devoted to her by *New York Daily News* society writer Nancy Randolph. "Nancy Randolph" was the pen name for the enterprising Inez Callaway Robb, who grew up on a cattle ranch near Boise. Armed with a University of Missouri journalism graduate degree, she began writing her popular *Daily News* column in 1928. "A society reporter has to be able to laugh or she'll go nuts over the gyrations of society's lunatic fringe, its playboys, its glamour girls," Inez Robb told journalism students. A necessity of the job? "A never-ending supply of clean, white gloves. A clean white glove is the cachet of responsibility in the Four Hundred."

Inez Robb and Pearl Mesta, two women of the West, recognized that they could help one another, developing a reporter-source relationship that lasted for decades. Robb eventually moved to Washington to write a five-day-a-week column under her own name, Assignment America for Scripps-Howard newspapers. She penned dozens of flattering stories featuring Pearl, stating at one point: "In 20 years of a beautiful friendship, I have never known Perle Mesta to give anything but a blunt answer, honestly arrived at, to any question."

PEARL HAD NOW spent enough time in Washington that the political had become personal. She knew two rivals seeking the 1928

Republican presidential nomination: Commerce secretary Herbert Hoover and Senate majority leader Charles Curtis of Kansas. Pearl's reaction to Hoover: "I thought he was a stuffed shirt. He was an engineer, they're all that way."

But she admired Curtis, who was so popular in his neighboring state that Oklahomans sometimes referred to him as their "third senator." The childhood jockey–turned–lawyer was one-quarter Indian, a member of the Kaw Nation through his mother. Curtis favored Prohibition, high protective tariffs, and isolation, but he was also an early champion of women's rights. The sixty-eight-year-old Curtis, a widower with three children, was a bridge- and poker-playing legislator who liked horse racing. Pearl, a teetotaler as a Christian Scientist, also appreciated bridge, poker, horse racing, and politics.

Tagging along with her father, she attended the 1928 Republican presidential convention in Kansas City. William Skirvin loved these occasions as a venue to ingratiate himself with politicians. "I got my love of politics from my father," Pearl later recalled. "There never was a campaign too big or too small for him."

Herbert Hoover won the nomination, choosing Curtis as his vice president. Pearl was flattered when Curtis asked her to court Oklahoma female voters. Organizing volunteers to speak at college campuses, she hosted Curtis and his half sister Dolly Gann when they came to Oklahoma City to campaign.

Hoover and Curtis won in a landslide. Pearl was fond of Charles Curtis, but she was unaware of just how much he liked her until he began to constantly invite her to be his date at official events. Newspapers speculated over whether wedding bells were in store. "No romance," Pearl later told a reporter when asked about their relationship. "The pitfalls of Washington I've always managed to avoid were manholes. But Charles and I were great friends and poker-playing pals."

Curtis loyally included Pearl at every event in his honor—White House receptions, birthday festivities, parties given for him by foreign dignitaries. He wasn't interested in remarrying (and never did), but

Pearl could be counted on as good company, a woman who wasn't pushing for more.

Pearl found common ground with First Lady Lou Hoover. "We shared one enthusiasm. I loved riding and she rode each morning with a young White House aide, who often accompanied me in the afternoon. I went to tea several times during the Hoover administration and Mrs. Hoover always fell into talking about horses."

AFTER SAMPLING THE charms of Saratoga Springs, Pearl decided to try Newport, the aristocratic colony on the Atlantic Ocean. Enormous marble and limestone châteaus perched on the famed Cliff Walk, handsome yachts anchored in the harbor, and elites socialized at the private Bailey's Beach and the Newport Casino. Summer residents quaintly referred to their spectacular homes as "cottages"; local newspapers referred to the owners as "cottagers" or "colonists."

With the stock market surging to new highs, the cottagers competed to outdo one another with lavish festivities. Pearl made her first visit to Newport as the guest of Harriet and Arthur Curtiss James, a railroad magnate and yachtsman who had been George Mesta's friend. Guests were cosseted with every imaginable luxury— the couple had vast flower and vegetable gardens plus their own dairy and smokehouse—but Pearl was bored. "Strangely enough, despite the imagination indicated by the Swiss village and the yacht, the home parties were quite dull," Pearl wrote later in *McCall's*. "Or maybe I simply hadn't sufficient appreciation for hours of Bach organ music."

Wondering if she might like the resort better if she wasn't a houseguest, Pearl convinced Marguerite to rent their own Newport cottage for the summer of 1929. Marguerite had three children by then—Robert, the mature oldest; pretty blond Betty; and family rascal Billy—and her husband commuted to Newport on weekends.

The sisters leased Fair Oak, an estate owned by Orme Wilson. His sister Mrs. Cornelius (Grace) Vanderbilt, Newport's social leader,

graciously issued invitations to the Skirvin sisters to her storied home, The Breakers. They were launched. "Back in Oklahoma and Texas, we always felt that when a newcomer came to town, she should wait until she is invited several places before she began entertaining," Pearl wrote in *McCall's*. "So that is the course I followed in Newport. When I did begin to give parties, I conformed to Newport's prides and prejudices."

When the stock market crashed in October 1929, many Newport grandees suffered massive financial losses. Pearl remained unscathed, at least judging by her continued ability to spend money at a breathtaking pace.

She had trusted her father with some of her Mesta millions to invest. At nearly seventy, William Skirvin was still chasing riches in real estate and Oklahoma oil wells. Optimistic even as the country slid into the Depression, he went ahead with plans to build a second hotel across the street from the Skirvin Hotel, the Skirvin Tower, a twenty-six-story, seven hundred-room structure, expected to cost up to $3 million. Pearl provided some of his financial backing.

At a time when many Americans were desperate for a roof over their heads, Pearl was obsessed with landing the right address in three different cities. In Washington, she leased an apartment at 1785 Massachusetts Avenue, a Beaux Arts–style building that housed multimillionaire Treasury secretary Andrew Mellon. In New York, she moved to the Pierre Hotel. In Newport, she joined Marguerite and her husband Robert Adams to rent The Rocks, a timber and granite 1870 Queen Anne mansion with ocean views.

For the nation, 1930 was the year when unemployment rose to record levels, starving people stood for hours in breadlines, and severe drought devastated Southern states, turning the West into the Dust Bowl. There was hardship all around.

For Pearl Mesta, 1930 was the year she became a figure of national prominence, with her name appearing in more than 324 newspaper stories from the *Chicago Tribune* to the *Sioux Falls Argus-Leader* to the *Knoxville News-Sentinel*. Society columnist Cholly Knickerbocker

parodied her busy life: "A phone call to Washington brings word that 'Mrs. Mesta has just departed for Pittsburgh,' and a telegram dispatched to her in the Western Pennsylvania city is undelivered due to the fact that the always-on-the-go hostess has started for Newport."

What was so alluring about Pearl? During the Depression, the country hungered for distraction, hence the Hollywood movies featuring plucky Park Avenue heiresses. The newspapers needed a rich, high-spirited party giver to offset life's daily sorrows, and Pearl fit the role. There was a fascination that a hick from the sticks could make it in America's most rarefied environments. In this pre-feminist era, she symbolized freedom, a style setter who could do what she wanted without the protection or support of a man. In the five years since George Mesta's death, she had become a very merry widow.

Everything she did made news. When she gave a dinner for Secretary of War Patrick Jay Hurley with a performance by Metropolitan Opera tenor Edward Johnson, Pearl was lionized for setting a new standard in entertaining. When she attended the Kentucky Derby, the *Louisville Courier-Journal* praised her fashionable clothes. She began dating Lieutenant Colonel Marco Pennaroli, an aide to the king of Italy and a military attaché at the Italian embassy.

In April, she gave a party at the Mayflower Hotel for Vice President Curtis and his half sister Dolly Gann. For Washington hostesses, these festive gatherings had become a social minefield due to the war between Dolly Gann and the formidable Alice Roosevelt Longworth. As *Time* described the feud, both women felt they should have the most prominent place at any dinner and became irate if one was favored over the other. This was such a sticky matter that Vice President Curtis brought it up with Secretary of State Henry Stimson, who talked it over with President Hoover. The decision was kicked to the diplomatic corps, which met at the British embassy and voted in favor of Dolly for the most prestigious seat.

In a bizarre way, this feud demonstrated the importance of hostesses in Washington society: the leader of the free world, in the midst

of the worst economic crisis in America's history, spent time on this vital issue.

The vice president accepted Pearl's invitation to visit her Rhode Island cottage. "I always thought he came to Newport to help break down the social barriers," she later reminisced. "They couldn't very well ignore the Vice President of the United States, even if he was part Indian."

Photographs from the weekend show the dapper vice president, with his bushy white mustache, in a jacket, white shirt, and striped tie, flanked by Marguerite, glowing in a fur-trimmed coat, and Pearl, wearing a large-brimmed hat and giving a satisfied smile. Arriving in Newport on August 15, Curtis attended a reception at city hall, was whisked to a tea, and served as guest of honor at Pearl's party for fifty people. Late that night, the two of them unwound by playing poker.

Pearl's next attention-getting effort was writing an essay for the magazine *The Spur*, urging government funding for the arts. She was ahead of her time; it wasn't until 1965 that President Lyndon Johnson created the National Endowment for the Arts. In "The Most Romantic of Arts," published on October 1, 1930, she described seeing the opera *Madame Butterfly* for the first time: "the ecstasy of superb orchestration, the visual response to the scenes, the sparkling glory."

She pointed out that foreign countries used tax dollars to support the opera and raised a provocative possibility. "How good it would be if the powers at Albany would make the bootleggers contribute to the upkeep of music and if possible bring them under its potent spell!" As an alternative, she suggested the baseball commissioner add a cent to admissions and donate the funds to underwrite concerts.

She wrote that opera "has state support in Vienna, gathered by special taxes which the poorest pay at no matter what sacrifice. To be deprived of good music is dreaded far more than to lack physical comforts."

That was tone-deaf given the horrors of the Depression. But Pearl had been immune from hardship for her entire life, and like many of her social class, she was oblivious to the wrenching upheavals.

Oklahoma, Revisited

Marguerite Skirvin Adams, former star of stage and screen, had established a comfortable life as a corporate wife. "Mother and Dad entertained a great deal of all of Father's important clients," gushed their daughter Betty Ellis. "Dad could not have had a lovelier or more competent hostess than my mother."

But her father, alas, fell for his new young secretary. Marguerite was distraught when she learned of their affair. The rift became public knowledge when Robert sought refuge at the Union League Club. Marguerite decamped with the children to the Skirvin Hotel. In her divorce papers, she charged her husband with cruelty and neglect, claiming he "applied vile and opprobrious epithets and nagged and criticized." As of March 1931, Adams refused to pay her bills.

Pearl began commuting to Oklahoma to support her sister. Her brother O.W., who studied agriculture at Cornell and earned a degree as a petroleum geologist at the University of Pittsburgh, was helping their father manage the family's businesses. The Skirvin family was together again.

In May 1931, Pearl sailed for Europe, taking Marguerite and her children along. This was no ordinary vacation: Vice President Curtis had arranged for Pearl to be presented at Buckingham Palace

to King George and Queen Mary. In this century-old British ritual, debutantes appeared at court to launch the social season and meet eligible men. Select foreigners were now welcome: Pearl would be presented with seventeen American women and four hundred British debutantes.

In a portrait taken to commemorate the occasion, Pearl wears a sleeveless white gown with a long lace train. Her flattering ear-length bob is adorned with white flowers, and she is sporting George Mesta's jewelry—a triple strand of pearls, diamond bracelet, and huge engagement ring. Pearl accented the outfit with a green feather fan. Although nearing fifty, her skin looks unlined, and she is quite attractive, giving a smoldering smile. That night, Pearl joined a small group to dine with the king and queen. The *Oklahoma News* gushed, "Mrs. Mesta has gone far—it is a long way from Oklahoma City in the middlewest to the scarlet and gold throne room of England's king!"

AND IT WAS a long way back, too. Returning to the Skirvin Hotel, Pearl learned that her father, the luckiest wildcatter, had finally run out of luck. He was forced to suspend construction on the Skirvin Tower due to a lack of funds. He went through an unpleasant court battle with his widowed sister-in-law Nellie Kitchel Skirvin, who sued him for $900,000 worth of stock. Nellie had been Pearl's childhood playmate, but Pearl loyally stood by her father's side in court. He won, but a few months later he was sued by a shareholder of his oil company, who charged that Skirvin illegally diverted money toward construction of the Skirvin Tower.

The lawsuits kept piling up. Yet Pearl continued to believe that her father was honest and that these plaintiffs were disgruntled people unjustly hounding him. He assured her that the money she had given him to invest would ultimately pay off.

In the summer of 1932, Pearl attended the gloomy Republican convention in Chicago, where delegates were in despair over

President Herbert Hoover's dire prospects. The unemployment rate was above 23 percent, homeless families were camping in parks known as Hoovervilles, and it was hard to see how Hoover could successfully woo voters.

Pearl was not a woman to allow her GOP party affiliation to get in the way of a good party. She returned to Chicago a week later to attend the Democratic convention. She had a bevy of Democratic friends, including New York political boss James Farley, campaign manager for New York governor Franklin Delano Roosevelt. Thanks to Farley and his wife Bess, Pearl was invited to the best parties as the Democrats celebrated FDR's nomination.

Pearl went directly from the convention to Newport to join her sister, who had received a generous divorce settlement of $500 per month in alimony (more than $10,000 today). Her ex-husband promptly remarried. Marguerite responded by giving a Newport party for three hundred people. In what she perceived as an amusing gesture, she billed her food as Depression fare, serving hot dogs, baked beans, and pretzels. Reflecting the out-of-touch worldview of Newport cottagers, her menu was seen as chic.

In the final months before the presidential election, Pearl organized GOP fundraisers in Oklahoma and attended a rally for Hoover at Madison Square Garden. But Hoover's election slogan—"We are turning the corner"—ran into a brick wall. FDR won in a landslide, taking forty-two out of forty-eight states. Pearl loyally attended Hoover and Curtis's farewell events and then, crossing party lines, turned up at the inaugural festivities for FDR.

But now that Democrats ruled Washington, the city had lost its appeal for her. Pearl's GOP allies would no longer be Cabinet secretaries; there would be no more invitations to White House dinners. Pearl gave up her Washington apartment and, for the next few years, only returned to the city occasionally.

Her ties to Pittsburgh were abruptly severed as well after George Mesta's nephew, company president Harry Wahr, committed suicide.

His successor at the steel company was Lorenz Iversen, an inventor and twenty-eight-year Mesta employee. As the first non–family member in charge of Mesta Machine, the Danish immigrant did not feel obligated to maintain a relationship with the founder's wife. He bought out Pearl's 10,565 shares of stock on October 30, 1934. Now she had no reason to return to Pittsburgh, ending another chapter of her life.

IN MANHATTAN, PEARL rented a suite at the Pierre Hotel, which turned into a family madhouse when Marguerite arrived from Oklahoma with her three children. Pearl lectured the children on the house rules. "She explained there would be no room service under any condition," according to Marguerite's daughter Betty Ellis, "and most of our meals would be cooked and served for us in the apartment kitchen by her cook." Betty's younger brother Billy, age seven, promptly ran up a hefty room service tab, infuriating his aunt.

In search of long-term larger quarters, in 1935 Pearl bought a five-story, 8,800-square-foot Beaux Art limestone town house at 44 East 74th Street, a block from Central Park. Built in 1870, the mansion had been updated with an elevator and an interroom telephone to communicate between floors. Marguerite handled the decor: black and white Chippendale furniture for the dining room and a Steinway piano and harp for the salon.

Pearl's third-floor bedroom was painted and wallpapered in shades of blue; Marguerite's adjoining room was pink. The children were housed on the fourth floor, and the staff were relegated to the fifth floor. For Pearl, sharing her Christian Science religion with Marguerite on a daily basis was a pleasure. The sisters developed a morning ritual, reading out loud to the children passages from *Science and Health* by Mary Baker Eddy.

The antics of the children eventually wore down the adults. The rambunctious Billy dressed up in war paint, pretending to be an

Indian, and jumped out of the dumbwaiter at one of Pearl's dinner parties. The sisters decided boarding school was the solution. Billy and his older brother Robert were packed off to American schools, while Pearl paid to send Betty to the Brillantmont School in Switzerland.

Once the children were gone, the sisters entertained constantly, inviting Broadway stars and Social Register habitués for cocktails, dinners, and games of bridge and poker.

Since Pearl had paid for the Manhattan town house, Marguerite did her part by buying a Newport cottage, Beachmound, a twenty-five-room, twenty-thousand-square-foot white mansion with a wrap-around porch. The cost: $29,000, equal to $680,000 today. The 1897 Greek Revival–style home featured ionic columns on the east and west façades. Even today, the home remains strikingly beautiful, with a vast lawn surrounded by large hedges. Set on a hill, the house faces the churning waves of Spouting Rock Beach. Pearl was so enamored of Newport that she switched her voter registration there.

DURING A TRIP to Oklahoma City to see her father, Pearl was surprised to receive a bouquet of yellow chrysanthemums from recently widowed Carl Magee, editor of the *Oklahoma News*. The flowers led to a date and a serious romance.

Magee, a teetotaler who taught Sunday school, had an impressive reputation as an investigative journalist. As the crusading owner of the *Albuquerque Morning Journal*, he exposed the Teapot Dome Scandal that rocked the Harding administration in the 1920s, revealing that secretary of the interior Albert Fall received payoffs. Magee was equally tough in writing about the judicial system. Sued for libel by a New Mexico judge, Magee was convicted and sentenced to jail but pardoned by the governor. A year later, the irate trial judge attacked Magee in a hotel lobby. Magee fired a gun in self-defense; a stray bullet killed a bystander. He was acquitted of all charges and left New Mexico for Oklahoma.

In 1935, Magee made American history. As a member of the
Oklahoma City Chamber of Commerce, he came up with an
innovative solution to deal with traffic congestion—creating the first
nickel-a-slot parking meter and then manufacturing it for other cities.

After dating romantic Italians who were great on the dance floor
but harbored old-fashioned ideas about women, Pearl was pleased
that Carl Magee treated her as an equal. He urged her to be better
informed about world affairs and sent her books and newspaper arti-
cles. She appreciated his concern, but because she didn't like to read,
she had her secretary type up summaries.

Pearl was a Republican and Carl Magee a Democrat, but their
interests aligned in the fall of 1936, since both supported GOP
Kansas governor Alf Landon for president. Magee opposed what
he viewed as Roosevelt's excessive spending. Pearl arranged for the
Landon-for-president headquarters to be stationed at the Skirvin
Hotel and was named vice president of the local organization. Her
efforts were for naught. Roosevelt won reelection by more than 10
million votes. Pearl later admitted that she was not upset by the
outcome. "I never voted for Roosevelt," she said. "But I was never
sorry to see him elected."

After Pearl returned to Manhattan, Magee wrote to her every day
and repeatedly suggested marriage. Pearl loved him, but was unsure
whether they had enough in common to build a lasting life together.
She put him off about making a commitment.

Her sister Marguerite, however, was ready to tie the knot again.
"Mother had been going out with several attractive suitors," recalled
Betty Ellis, "but the gentleman who finally won her heart was an
older bachelor who owned his own stock brokerage firm in Boston."

George Tyson Jr., twenty-five years older than Marguerite, hailed
from a distinguished New England family. His father had run a ship-
ping business in China and served as president of the Burlington
and Missouri River Railroad. George Tyson belonged to prestigious
clubs—the Somerset Club, the Harvard Club, and the Country Club

of Brookline—and owned a brick town house on Louisburg Square. Invited as an extra man to one of Marguerite's Newport dinners, the never-married stockbroker and the lively former actress clicked. For Marguerite, the kindly George represented safety and security.

The wedding took place in September 1937 at the bride's Newport home. William Skirvin gave his daughter away, and Pearl was the maid of honor. "The marriage pleasantly surprised society as no announcement of the engagement was made and the couple obtained their marriage license only this morning," noted the *New York Herald Tribune*. The newlyweds settled in at George Tyson's house in Boston.

For nearly three years, the Skirvin sisters had been inseparable. Now Pearl would be on her own again.

Acts of Rebellion

For a woman born in 1882, when opportunities were limited and hearth and home were the expected priority, Pearl had been a pioneer, serving on a corporate board and involving herself in presidential politics. But she had not yet embraced one of the most pivotal cultural movements of her time: feminism.

During the years when women were fighting for the right to vote—achieved in 1920—she had been married to George Mesta, a traditional husband who discouraged any activism. Keeping the peace at home was likely her priority at that point.

Pearl had missed that battle but now had a chance to join a new one. The National Woman's Party was pressing Congress to pass an Equal Rights Amendment, meant to end a wide variety of state laws discriminating against women. As drafted by suffragette leader Alice Paul, the ERA simply stated: "Men and women shall have equal rights throughout the United States and every place subject to its jurisdiction."

That sounded anodyne, yet it was extremely controversial since many prominent feminists thought the amendment was a bad idea. Thanks to the work of female reformers, states had passed "protective laws" to prevent women from being exploited, such as bans on night

work, hazardous jobs, and sweatshops with deplorable conditions. First Lady Eleanor Roosevelt, Secretary of Labor Frances Perkins, and the League of Women Voters feared the Equal Rights Amendment would negate these hard-won laws. The National Woman's Party disagreed, insisting that employers were using "protective laws" to pay women less or replace them with men, and these new laws left women worse off.

The arguments over the pros and cons of the ERA fractured normal alliances. "Factory workers have been pitted against factory workers; socialite has spoken against socialite," the *Christian Science Monitor* wrote, "and even the American Federation of Labor and the Roman Catholic Church have been dragged openly into the fray for the first time."

Pearl was dragged into the fray by her friend Sarah Pell, a Christian Scientist, Republican, opera lover, and early suffragette. A member of an aristocratic family—her grandfather was Rhode Island's governor, and her wealthy husband Stephen inherited the Revolutionary war site Fort Ticonderoga—Sarah was elected in 1937 as chair of the National Woman's Party.

When Pearl invited Sarah and her husband to dinner at her home in February 1938, the hostess's goal was to give her friends a chance to hear from former president Herbert Hoover, who just returned from meeting with foreign leaders, including King George at Buckingham Palace and Adolf Hitler in Berlin, to assess whether another world war was imminent.

That night was a turning point for Pearl, but she describes it in casual fashion in her autobiography. She goes on at great length about her guest list and entertainment (a piano player and Rosa Ponselle), never mentions Hoover's remarks about a possible war, and then adds in a brief aside: "During the party, Sarah Pell took me off to one side and asked me why I wasn't working for the National Women's Party. Little did I realize, when I offhandedly told Sarah I would be glad to help out, that I would soon become an ardent feminist." Pearl fell

into the welcoming embrace of a highly motivated group of women who were thrilled to have a new deep-pocketed convert who knew her way around Capitol Hill.

This was not Pearl's only leap that winter into a new identity and destiny. At the same time she made the commitment to stand up for women, she decided to stand up for herself—and challenge her father. Her decisions in that fateful winter of 1938 would have long-lasting repercussions on the remainder of her life.

Pearl's concerns about William Skirvin's freewheeling bookkeeping had been building up for years. In good times, he'd send her large checks, theoretically returns on an investment, but never explained the whys and wherefores. He routinely shifted money from one project to another without consulting investors. His attitude: better to beg forgiveness than ask permission. He didn't tell his children about his financial maneuvers.

Things came to a head when Pearl's brother O.W. discovered damning documents in their father's safe. William Skirvin had transferred his children's stock certificates in American Oil and Refining Company, his core firm, into his own name. O.W. alerted his siblings.

Around the same time, the IRS notified Pearl that she owed $50,000 in taxes for 1935–1936 on Skirvin-related assets. The debt caught her by surprise. Pearl asked her father to allow her auditors access to his books. He refused. Feeling betrayed and infuriated, she felt she had no choice but to take him on.

On March 26, 1938, Pearl filed five different lawsuits against her father, charging him with forging her name to $230,000 of checks and forging her name on stock certificates. She claimed he owed her $700,000 in oil, real estate, and hotel earnings. Pearl demanded that her father be removed as operator of the hotel. Marguerite and O.W. filed their own lawsuits. All three sued their father's bookkeeper, Mabel Luty, purportedly concerned that she was romantically involved with their father and might wind up as his beneficiary.

Sitting in the lobby of the Skirvin Hotel, William Skirvin irately insisted to the *Oklahoma News* that he had done nothing wrong. "He pictured himself as an indulgent and affectionate father who never remarried when his wife died and who had brought up his children from babyhood, giving them the best things in life. Trips to Europe, a Park Avenue apartment, New York fine education, social position, a chance for Marguerite to go on the stage." Skirvin complained that if his children won, "I would be left without a penny."

Fourteen stockholders in the American Oil and Refining Company filed their own $5.4 million lawsuit against Skirvin, charging fraud and demanding a financial investigation.

The towering concrete Oklahoma City Art Deco courthouse, with interior pink marble walls, is just two blocks away from the Skirvin Hotel. The Skirvin family spent many days making the sad trek.

In an early court hearing, the patriarch insisted this was a simple misunderstanding. He claimed that when he became seriously ill in 1926, he deeded property to his children but did not tell them. He explained that he later changed the stock back to his name in order to borrow money from a bank. Judge Alfred P. Murrah inquired, "What brought about the hard feeling between you and your children?" Skirvin replied, "I helped them make investments. Then they learned that the property once was in their names, so they are trying to get it now."

Annoyed by this self-serving whining, Murrah angrily admonished the Skirvins, saying, "This family has built a monument of accomplishment in this city. I don't intend to see a mass of testimony and litigation built up to wreck it." He concluded by shouting, "You should be ashamed of yourselves." According to the Associated Press, Skirvin "sat hunched in his chair, a portly man with heavy jowls, his expression one of deep concern, his hands folding and unfolding nervously. Never did he turn his eyes to his two daughters in the spectators' section, who appeared awe-stricken by Murrah's sudden blast from the bench."

At least Pearl had comforting company during this tense time. She was still seeing Carl Magee, and although he had moved to Texas to edit small Rio Grande newspapers, he came to Oklahoma City periodically and she made weekend trips to see him.

After a different judge urged the family to work things out, the exhausted Skirvins settled the case. In May 1938 the three children received shares in the American Oil and Refining Company, and their father agreed to allow an outside hotelier to run the Skirvin Hotel.

However, the fourteen independent stockholders denounced the settlement as a sham, demanded that no assets be transferred to the Skirvin children, and pressed on with their lawsuit. By starting this battle, Pearl had made her father's financial dealings public, and the related lawsuits dragged on for years.

She regretted her decision to challenge her father and did her best to patch things up. Her father put up a good front. But proud and stubborn, William Skirvin was determined to regain his standing.

He sat in the hotel lobby most nights with a drink in hand, shooting the breeze with cronies and taking off his shoes as if it was his own living room. At 9 p.m. loyal secretary Mabel Luty would pick up his shoes and lead him upstairs to his suite. Skirvin remained outraged that his children had taken away his control over the property.

WITH THE COURT case behind her, Pearl was free to become seriously involved in her new feminist cause. In October 1938, she joined Sarah Pell at the National Woman's Party's convention at Detroit's Hotel Book-Cadillac. Alice Paul, who had just returned from a trip overseas, made a rousing speech proposing a World Woman's Party. Concerned about Hitler's rise and restrictive international treaties that curtailed women's rights, she envisioned a Geneva-based group that would lobby on behalf of all women.

A December 1938 photograph shows Alice Paul, Sarah Pell, Pearl, and others signing a certificate incorporating the World Woman's

Party. Pearl volunteered to pay her way to Geneva to help publicize the opening of the new headquarters.

At a time when the majority of politicians and citizens were embracing isolationism, this feminist effort received a positive reception. "While governments hurl threats of war across the continents and seas, women, without regard to nationality, race or creed," the *Philadelphia Inquirer* wrote, "are banding together in a recently organized World Woman's Party to promote equal rights for women."

Now that her life was branching off in a new direction, she could no longer envision marriage to Carl Magee. In early 1939, he came to Manhattan and proposed again. When she asked for more time, he gave her a now-or-never ultimatum. Their goodbye scene took place at Penn Station, a bittersweet farewell. Only later, looking back at their time together, did Pearl realize that he had been the second great love of her life.

To symbolically mark the start of her next act, Pearl changed the spelling of her name to Perle in all communications. Commenting on her new moniker, one newspaper wrote that she "has no nickname but her given name is Perle, and if you want to displease her spell it Pearl." Aaron Fodiman, a lawyer who got to know her years later, explains, "Pearl sounded too corny. She wanted to be a sophisticated woman."

In keeping with her decision, for the remainder of this book she will be referred to as Perle.

ON JUNE 15, 1939, Perle headed overseas, stopping in London to meet members of thirty international women's organizations. Taking a leadership position, she told the group, "One of the causes of world unrest at the present time is the lack of the women's point of view."

In Geneva, Alice Paul arranged for the World Woman's Party to rent the Villa Bartholini, a spacious white 1825 neoclassical building overlooking a lake. Perle and the pioneering Alice—daughter of a Quaker businessman, Swarthmore graduate—had met before but

now they got to know one another well. For the opening ceremony, to be broadcast in the US on NBC radio, Perle paid an exorbitant $2,000 of her own money ($40,000 today) to American singer Grace Moore, star of Hollywood and Broadway, to perform.

While they prepared for the dedication, sad news came from back home. Sarah Pell had died on August 4 after a short illness, at the age of sixty-one. Perle would cite Sarah as her inspiration and role model for decades ahead, to keep her name alive.

More than three thousand people attended the gala opening, including feminists from England, China, Italy, South Africa, Germany, and other countries. But the colorful pageant was overshadowed by the threat of imminent war. German feminist Lida Gustava Heymann, who had protested Hitler's rise, warned, "We live in a time when deep darkness threatens the world. There is wide-spread fear that brutal forces may prevail and that reason and common sense may be eliminated." Since this gathering included delegates from nations about to go to war with one another, tensions spilled over. Perle argued with a German woman who insisted that Hitler would save the world.

On August 24, Perle left Europe from Cherbourg, France, sailing on the SS *George Washington*, arriving in New York on August 31. Her timing was fortuitous.

The next day, Hitler invaded Poland, sending fleets of aircraft to bomb airfields, train stations, communications lines, and munitions dumps. A massive ground force breached the border, and German troops killed hundreds of civilians as refugees desperately tried to flee. Britain and France declared war on Germany on September 3, 1939.

Concerned about how women would fare in these grim times, Perle wrote an impassioned essay for the *New York Journal American*, published on September 24. "Women are losing ground all over the world," she wrote. "Women should take their rightful place as co-workers with men, so that they can give their utmost to righting world affairs, instead of being slaves and subordinates, unable to help when they most ardently would." She added, "Women are the first

to suffer. They are thrown out of jobs right and left; married women are not allowed to work—they are told to get back to the kitchen and nursery."

That December, she attended the National Woman's Party convention in Washington. The group vowed—yet again—to pass the Equal Rights Amendment. Perle had befriended Republican and Democratic politicians but she had never asked for anything. That was about to change. Aware of her clout, National Woman's Party secretary Caroline Lexow Babcock wrote to Perle, suggesting she lobby legislators: "They would talk to you as they won't talk to me."

Perle replied: "I think one of the very important problems today is that we keep our Congress in session in Washington all summer. No doubt that will also help our amendment, as we can torment the life out of them while they are in session."

Passing a new constitutional amendment is a laborious process. Both the House and the Senate have to approve the amendment by a two-thirds majority within a two-year session, otherwise the bill is dead. If both bodies sign off, the amendment then goes to state legislatures, where three-quarters of the representatives have to vote in favor. It can take decades, if ever, to successfully run this gauntlet.

Perle set her sights on moving things forward at the June 1940 Republican convention in Philadelphia. Her seemingly unrealistic goal was to convince key legislators to include the Equal Rights Amendment in the GOP's platform, the party's statement of principle, which would be a major symbolic step forward.

During the previous eighteen months, twenty-six state legislatures had introduced bills to prevent married women from working in state government and private industry. Although those bills had not passed, their existence reflected a growing reactionary trend and underscored the need for a federal anti-discrimination law.

The fifty-three members of the Republican platform committee, all male, meeting at the Bellevue-Stratford Hotel, were besieged by interest groups arguing over every word in the document. The

National Federation of Business and Professional Women's Clubs opposed the Equal Rights Amendment and requested watered-down wording on women's rights.

Perle had close ties to politicians in Oklahoma, Kansas, Texas, Pennsylvania, Rhode Island, and New York. She knew the action occurred in the smoke-filled rooms controlled by men—and she knew those men. She tracked down former Oklahoma City district attorney Herbert Hyde, the platform committee's chairman, and he obligingly showed her the tentative wording. "They had put in a kind of plank which was, just vaguely for equal rights," recalled Alice Paul in an oral history, describing Perle's influential effort. Perle told Hyde, "That's all wrong. That is not what we want at all."

Perle persuaded Hyde to get the committee to substitute a simple endorsement of the Equal Rights Amendment. When the platform was presented to the convention, the last-minute switch provoked fury among GOP women, who felt hoodwinked. "Blitzkrieg struck the Republican women in Philadelphia today," wrote the *New York Times*. "The most extensive and portentous feminine controversy . . . with the adoption by the convention of the Equal Rights Amendment as a campaign plank."

In another historic development, the Republican Party used the platform to define itself as a principled alternative to the Democrats, who harbored Southern segregationists. The party of Lincoln adopted a plank urging that "American citizens of Negro descent" be given "a square deal," stating that "discrimination in the civil service, the Army and Navy and all other branches of government must cease" and legislation enacted to end "mob violence" against Black Americans.

The wrangling over the platform was immediately followed by a tumultuous fight over the choice of the GOP presidential candidate. Wendell Willkie, a charismatic lawyer and power company executive, won the GOP presidential nomination on the sixth hard-fought ballot. The exhausted delegates in the steamy hall erupted in an "ear-splitting pandemonium . . . a Niagara, a frightening torrent,"

according to *the Philadelphia Inquirer,* "the shrill acclamation from 10,000 human throats." Perle was one of those screaming for Willkie.

The choice of the Indiana-born Willkie was, in large part, a referendum on the war. France had fallen and newsreels showed French citizens weeping at the sight of victorious German soldiers goose-stepping into Paris. Bombed and beleaguered Britain was begging for help. Willkie, the favorite of Eastern elites, agreed with President Roosevelt that the US had to intervene to help America's allies. Willkie's GOP presidential rivals—racket-busting New York district attorney Thomas Dewey, Ohio senator Robert Taft, and former president Herbert Hoover—were all isolationists determined not to shed a drop of American blood.

Perle's friends urged her to back a seasoned politician, but she grasped the threat of Hitler and approved of Willkie's stance. "They rushed me in to see Dewey, but they couldn't budge me," she recalled. "I was 100 percent for Willkie."

As for her feminist role at the convention, Perle did not seek credit at the time for slipping the ERA into the party platform. Commentators professed to be mystified but insiders knew. In a July 2, 1940, letter to the National Woman's Party, Laura Berrien of the National Association of Women Lawyers wrote, "Mrs. Mesta was wonderful."

Two-Party Perle

After President Roosevelt won an unprecedented third term, Perle rethought her political loyalties. "I couldn't stand the shabby way the Old Guard wing of the GOP treated him [Willkie] when he began co-operating with Roosevelt for national unity," she recalled. She became a Democrat, explaining, "I had the courage of my convictions to leave the party because they weren't liberal enough for me."

Journalists nicknamed her "Two-Party Perle," a catchy moniker used in headlines for the rest of her life. She professed to appreciate the name, insisting, "But I love it. If you're in politics, you have to be a good sport. I love everything about politics."

In January 1941, she tackled a demeaning congressional tradition: female staffers were barred from the Senate floor. She found a sympathetic ally in Senator Theodore G. Bilbo of Mississippi, one of the most notorious racists of the twentieth century. Perhaps Perle caught Bilbo on a good day, since he professed to be open-minded when it came to women's rights.

After he sponsored legislation to allow women to not only go to the Senate but be elected as Senate committee clerks, Bilbo was photographed shaking hands with Perle. "Mrs. George Mesta is down on Administration Hill for every hearing and is a whirlwind

getting around to see the Senators and Representatives she wants to interest in the Equal Rights Amendment which she hopes Congress will pass this year," one newspaper wrote. "She has a rare genius for solving political and social problems."

She was spending ample time in the capital but had no fixed address. After selling her New York town house, she purchased a large brick 1890 home in Boston, to be near her sister. But Perle had scarcely unpacked when Marguerite decided to leave. Perle would describe her Boston home as a place "where I lived two weeks."

Her sister and brother-in-law embarked on a radical life change, buying a 2,735-head cattle ranch in Prescott, Arizona. Marguerite made the decision after her teenage son Robert had surgery for a tumor and a doctor suggested he might heal better in a warm and dry climate. After Perle joined Marguerite and George on a Hawaii vacation in August 1941, they convinced her to try Arizona, too.

Perle and her brother purchased a nearby 18,000-acre Arizona ranch with a herd of 1,800 Hereford cattle. Perle moved in with her sister and brother-in-law, in a home that Marguerite renovated in French provincial style. Prescott was a former Wild West town with a population of seven thousand. The annual July Fourth Frontier Day featured steer wrestling, bull riding, and barrel racing. The newcomers, with their fancy décor and East Coast airs, stood out.

Accustomed to swanning into the Metropolitan Opera in diamonds and furs, now Perle had to deal with rattlesnakes, lizards, and bugs. Out of step with her new milieu, she tried to discourage the ranch hands from drinking, which did not go over well. Her effort to learn to rope a calf was disastrous; her effort to learn to drive ended in damage to the foreman's car. She switched from Paris couture to a fringed skirt, blouse, and Western hat. But she couldn't bear to give up her ladylike impulses and never left the house without gloves. As much as she loved her sister, Perle quickly realized that she did not want to remain a full-time Arizona resident.

* * *

THE JAPANESE BOMBING of Pearl Harbor on December 7, 1941, and destruction of the US fleet deeply affected Perle, who had recently visited the island and could envision the destruction. Eager to be part of the war effort, she began making frequent trips to Washington to try to convince government leaders to employ women. She insisted to a reporter in April 1942, "Two million strong, members of the National Woman's Party stand ready to be drafted by our government for any war time jobs where we may best be of service."

The war transformed Washington as the government hired hundreds of thousands of new employees and dozens of temporary federal buildings sprouted all over, even by the Washington Mall. Newcomers grappled with a housing shortage, but Perle's wealth made her immune to wartime privations. She rented spacious rooms at the genteel Sulgrave Club, a private women's club housed in a converted Beaux Art mansion at Dupont Circle.

At night, the social scene was frantic as people gathered to share rumors, drink, and dance their cares away. Mary Borah, widow of Idaho senator William Borah, admitted to a reporter that nightlife had become like "trying to whistle in the dark—everyone feels kind of like he is living on the edge of a powder mill." Even with food rationing (minimal meat, lots of chicken) and gasoline rationing, long-time city habitués and lonely newcomers were eager for distraction.

Society carried on. "Soon after Pearl Harbor, a number of newspapers sounded the death knell of Washington society," noted *Town & Country*. "Old faces may give way to new ones, and stock figures may be replaced by stockier ones—but Washington parties go on forever. For Capital society is a deadly serious business: and almost any party may be almost anybody's road to a better mousetrap."

A generational shift in Washington entertaining had occurred during the years that Perle had been largely absent. The old-fashioned "calling days" had ended, and in deference to the war, President

Roosevelt canceled receptions and state dinners. Most private parties were smaller and started later, while hotels catered to the masses with jam-packed dance floors.

There had been turnover among the top hostesses of the city, which Perle discovered during her initial reentry as a guest. Some of her friends had died or left town. Perle found herself welcomed into the homes of some social arbiters and pointedly ignored by others. Perle's friend Carrie Walsh was dead, but her heiress daughter Evalyn Walsh McLean, who welcomed Perle, ruled the roost with lavish Sunday suppers for VIPs at her estate, Friendship.

Owner of the famous blue forty-four-carat Hope diamond, the divorced Walsh flaunted that bauble and was notorious for her extravagance and eccentric behavior, such as keeping a monkey in her bedroom, buying a yellow gown with diamonds to match a yellow Fiat, and giving $100,000 to a con man in hopes of rescuing the kidnapped Lindbergh baby. After witnessing starving World War I veterans camping in a Washington park, she impulsively ordered a restaurant to deliver a thousand sandwiches and cigarettes.

Her life had been marred by tragedy. As a teenager, her leg was mangled in a Newport car accident that took her brother's life. Her marriage to alcoholic philanderer Ned McLean was already troubled when their nine-year-old son eluded bodyguards, ran into traffic, and was killed.

Now even under wartime privations, she managed to give enormous parties for hundreds of people, with table settings featuring rare antique china on gold tablecloths. She usually showed first-run movies and hired orchestras for dancing.

Perle was a regular at those parties, but as far as Washington society went, she wasn't everyone's cup of tea. She was not invited to the salons hosted by Alice Roosevelt Longworth, the daughter of President Theodore Roosevelt and widow of Republican House Speaker Nicholas Longworth. Known for her caustic wit, she had decorated her home with animal skins dating to her father's hunting days. *Washington*

Post publisher Katharine Graham would later recall that she served "good, solid, American food" rather than putting on airs with French cuisine. The mischievous Alice Roosevelt Longworth had a favorite saying memorialized on a prominently displayed pillow: "If you can't say something good about someone, sit right here by me."

Perle tried to court Alice initially, to no avail. As the dowager would later say of Perle: "She's perfectly affable, of course, but persistent. She peppered me with telegrams when she first came here."

Social reformer Daisy Harriman, who had been FDR's minister to Norway until the Nazis invaded and she was forced to flee, was now back in the city, hosting White House officials and the old guard. The brilliant and imperious Harriman, who had lost most of her family money, entertained frugally in (and occasionally rented out) her historic home, Uplands. Born into New York aristocracy, Daisy Harriman disliked Perle and saw her as a social climber, later privately describing her to a reporter as "Mrs. Thing."

Perle would eventually win over Alice—who relented and accepted invitations to Perle's parties—plus get revenge over Daisy, who was forced to sell Uplands. But that was all yet to come.

A newcomer had burst into Washington society, Hungarian beauty Gwendolyn Detre de Surany Cafritz, who was married to prominent Jewish real estate developer Morris Cafritz, a Russian immigrant twenty-three years her senior. He parlayed a $1,400 loan from his grocer father into a massive empire of apartments and office buildings. The daughter of a famous immunologist, Gwen attended schools in Budapest, Rome, Paris, and Los Angeles, studied art history, and spoke several languages (mangling many, leading to phrases teasingly referred to as "Gwendolisms"). Following her 1929 marriage and the births of three sons, Gwen became active in Jewish philanthropic causes but yearned to conquer Washington's social heights.

At a time when Jews were banned from elite country clubs, the Cafritzes were up against timeworn prejudices. "She was not, as they say, invited anywhere at the beginning," novelist Gore Vidal later

recalled of Gwen. "Old Washington was very anti-Semitic . . . That's why her final victory rather delighted me."

Gwen's fortunes changed when Eleanor "Cissy" Patterson, scion of the Chicago Medill publishing family and owner of the *Washington Times-Herald*, decided to anoint a new society hostess in an effort to boost real estate advertising. "Cissy thought I was bright and eager and picked me up," Gwen told a reporter. "I always said she gave me my wings." The *Washington Times-Herald* featured Gwen as the "Beauty of the Week"; Morris Cafritz gratefully bought ads. The newspaper's society columnists fawned over the couple while Cissy Patterson, an ultra-conservative Republican isolationist, frowned on Perle's new allegiance as a Democrat and tried to limit mentions of Perle in her newspaper.

Gwen Cafritz typically gave dinners for twenty-two people and big cocktail parties on her terrace each fall to mark the beginning of the Supreme Court session. She exhorted her VIP guests to speak about the issues of the day. Since her husband was a Republican, her invitations tilted in that political direction.

Nearly thirty years younger than Perle, the slender and elegant Gwen was highly competitive and resented anyone who dared tread on her turf and invite the same high-and-mighty guests. She would come to loathe Perle, in a feud that spiraled in spectacular fashion.

Perle had previously entertained in Washington for pure pleasure or to help George Mesta with business, but now she viewed her parties as strategic endeavors to win converts for the ERA or press for other favored causes. She tried to acquire as many influential Republican and Democratic allies as possible.

Every hostess had a different style. Perle wanted her guests to unwind and enjoy themselves, to look forward to seeing new entertainers and surprise performers. Some old-fashioned hostesses still entertained sedately by candlelight and wouldn't dream of inviting society reporters to cover a party, much less make a guest list available to the press, which Perle was delighted to do.

If there was a glitch in Perle's plans, it was that, approaching sixty, she had become self-conscious about her appearance. Once she had been handsome; now, when she looked in the mirror, she saw her body and facial features had been reconfigured in matronly lines. She was constantly on a diet, worrying out loud about her weight. Her smile, her warmth, and her genuine interest in others would be the draw.

She launched her latest round of Washington entertaining with a party at the Sulgrave Club in May 1942 to celebrate the marriage of Democratic Texas senator Tom Connally, a widower, to Louise Sheppard, widow of another Texas senator. Connally chaired the powerful Senate Foreign Relations Committee, and his presence guaranteed a good turnout: seven other senators and spouses attended, along with an armada of admirals.

The Sulgrave Club, built in 1902 as a private mansion, featured a large two-story ballroom and a musicians' gallery. Perle decorated the place with white blossoms and wedding bells, hired a fortune-teller, and brought in Rosa Ponselle to sing and Sidney Seidenman's orchestra for dancing. In this early-to-rise, early-to-bed town, the guests lingered until midnight.

Perle courted the press, developing new allies such as *Washington Post* society editor Hope Ridings Miller, a Texas native who also wrote for *Town & Country*. The women were introduced by Arizona senator Henry Ashurst, who thought the reporter might be interested in Perle's feminism. Perle promptly took Hope out to dinner. "While I never got around to joining the National Woman's Party," Miller recalled, "I covered many of its activities at her behest and later, her crowded schedule in Washington, Newport and elsewhere for . . . decades."

Elise Morrow, who penned the well-sourced Capital Capers column for the *Philadelphia Inquirer*, was perpetually grateful for Perle's help. Her son, author and journalist Lance Morrow, recalls, "My mother was quite young then, born in 1922, so she was in her twenties. She had several surrogate older friends, like Alice Longworth. Perle Mesta was a big source for her; they'd occasionally have

lunch at the Cosmos Club and the Sulgrave Club. My mother spoke very fondly about Perle." The feeling was mutual—Elise became one of Perle's favorite confidants.

Babs Lincoln, the former *Washington Times-Herald* society editor turned freelance writer and publicist, became another ally. "She tipped off society editors on Mesta activities, got Perle into the Newspaper Women's club as an associate member advised her to entertain the news hens en masse and include them singly in higher level functions," according to *Time*. As Lincoln explained to the magazine, "That's the way it's done here. Say the right word to the right columnist at the right time. The press in this town is accustomed to being invited and fussed over."

Some society editors felt Perle was initially pushy, a little too eager for attention. "When she first came here, Mrs. Mesta used to come up to reporters at parties and tell them about herself," recalled Achsah Dorsey Smith, society editor of the *Washington Times-Herald*. "She used to send her guest lists." Perle eventually learned that she won more respect by being hard to get.

EVEN IN WARTIME, Perle trekked to the offices of congressmen and senators to win backers for the Equal Rights Amendment. The prospects were dim. As Senator James Hughes, a Maryland Democrat, told the National Woman's Party's annual convention: "In this disturbed time, you can't get things done as you could in previous years. Let me warn you that the opposition is just as bitter as it ever was."

As part of her charm offensive, she got to know powerful House Speaker Sam Rayburn. Short and balding with a ferocious temper, the Texan opposed the ERA but became fond of the energetic feminist, nicknaming her Perly-Whirly. The shy, divorced legislator rarely went out at night, but if summoned by Perle, he accepted.

Rayburn introduced Perle to his protégée, Texas congressman Lyndon Baines Johnson. Perle liked launching newcomers and as

she began to do more entertaining, she included the Johnsons As Luci Baines Johnson, the couple's daughter, recalled, "She thought my father was competent and worthy of her time and attention and tutelage." Her parents, she added, "had a great sense of respect and appreciation for the doors she had opened."

As Perle walked the halls of Congress in search of allies, she was gratified to receive a sympathetic reaction from Missouri senator Harry Truman, who told her he supported the ERA. "I walked right into his office and found he was for it," she later recalled. "He's always for women, he's a wonderful, wonderful man."

THE TWO OF them hit it off. Truman had grown up on a farm in precarious finances, served in the Army in World War I, and overcame daunting obstacles to make it to Congress. He was elected to the Senate in 1934. The highly respected Missouri senator and Perle were born two years apart—Perle in 1882, Harry in 1884—and both grew up in the heartland. Neither attended college, and both were often underestimated. Financially, they were worlds apart. Truman, his wife Bess, and their beloved daughter Margaret struggled on his government salary.

Perle was jubilant when Harry Truman agreed to write a letter supporting the ERA. So many male officials gave her the runaround, but Truman seemed genuinely interested and believed what she was doing was important. Perle championed Harry Truman from then on at every opportunity.

THE BROADWAY STAGE Door Canteen, launched in Manhattan in March 1942, now attracted hundreds of Army GIs and Navy sailors every night. Founded by the American Theatre Wing, the canteen provided free food, famous bands, and visiting celebrities from Bette Davis to a jitterbugging Lauren Bacall.

A Washington version was scheduled to open in September 1942 at the Belasco Theater, near the White House, but the organizers were short of funds. Perle was at her Arizona ranch when she received a call from Milton Shubert of the New York theatrical dynasty, asking for help.

Hustling back to Washington, she made herself indispensable. She organized a fundraising Blackout Ball for seven hundred people at the Mayflower Hotel and presided over a "Pound Party" for civilians prior to opening night, asking each person to donate $2 or two pounds of rationed sugar, meat, coffee, or juice. A crowd of twelve thousand turned up. The *Washington Star* featured a photo of Perle and canteen volunteers gazing with amazement at huge piles of donated supplies. On opening night, actress Helen Hayes thanked Perle for becoming an "expert panhandler."

For Perle, it was addictive to be needed. Night after night, month after month, Perle returned to organize volunteers, pitch in to make sandwiches, and talk to homesick soldiers. The canteen's patronesses were called "angels." "Perle Mesta was one of the most constant angels," wrote the *Washington Post*. "She was very popular, too, because she'd bring the heads of large corporations, who would, in turn, carry on the heavenly work"—by writing large checks. When Perle brought Evalyn Walsh McLean one night, the heiress entertained the GIs by passing around the Hope diamond.

At the canteen, Perle was reunited with Mamie Eisenhower, who had returned to Washington in early 1942. Her husband was now in London as Commander of US Armed Forces. "Mamie never missed a night waiting on tables at the Stage Door Canteen," Perle later reminisced. "The soldiers adored her. One of them told her that her husband was going to be President some day. She laughed."

IN MARCH 1943, Perle's father William Skirvin had a heart attack in his hotel room. By the next day, the newspapers reported he was

"much improved." A legendary figure, full of energy and big dreams, it was shocking for him to appear mortal.

Perle had tried to make amends with her father but William Skirvin remained furious over losing control of his hotel. It galled him that Dallas hotelier Fenton J. Baker was managing the Skirvin Hotel and Skirvin Tower under a receivership. William Skirvin had reluctantly signed off on the transfer of power, but his bout of ill health strengthened his determination to win back his properties.

In August 1943, the family's bitter fight resumed in the Oklahoma City federal courthouse, presided over by Judge Edgar Vaught. "Perspiring attorneys and members of the W.B. Skirvin Family nearly filled the courtroom," wrote the *Daily Oklahoman*, describing the five-day ordeal. Perle's father claimed he had been intoxicated and tricked when he agreed to allow the Dallas firm to run the Skirvin properties. He insisted his children committed fraud by forcing him to settle with them in 1938. Lawyers for the children countered that he had mismanaged the hotel and fleeced them out of hundreds of thousands of dollars.

Since Perle's younger brother O.W. had worked for their father for his entire career, he took the witness stand. Perle and Marguerite watched as their father's attorney, Harry Glasser, grilled O.W., asking about the father-son trip to Dallas to sign the contract with the Texas hotelier. Glasser stated, "You got your father drunk, didn't you?" O.W. Skirvin indignantly replied, "I did not."

In his testimony, William Skirvin raged against his children like King Lear, saying they snatched the hotel from him. "They took everything I had and left me penniless." Asked his age, Skirvin admitted that he was eighty-three but fiercely insisted that the number was irrelevant. "I'm a better man than a man of 60. Bring him on and I'll beat him."

But the hotel's accountant delivered the damning blow, stating that the new managers had achieved $104,000 in yearly profits, compared to $9,000 during William Skirvin's last year in charge.

The trial ended on August 20. A month later, Judge Vaught ruled in favor of Perle, Marguerite, and O.W. and continued the Dallas firm's contract to manage the Skirvin. Judge Vaught urged the litigants to make peace: "The most important step is to bring this family together so that the various members can work in harmony." That advice did not sit well with William Skirvin. Appealing Vaught's decision to the Tenth Federal Court of Appeals, he insisted the judge was prejudiced and erred in his rulings.

The family tried, at least superficially, to maintain the semblance of loving relatives. Perle spent Christmas that year in Oklahoma City with her father. There must have been some long silences and strained conversations. She was back in Washington when the fateful news arrived.

On March 9, 1944, the Tenth Circuit Court of Appeals issued a stunning ruling in favor of William Skirvin. The three-judge panel stated that Judge Vaught had committed "an abuse of discretion" and that Skirvin wasn't responsible for the hotel's financial problems, attributing the issues "to depressed economic trend." Striking a blow against age discrimination, the judges stated that the "advanced age alone of an owner or manager is not enough to warrant the appointment of a receiver." The court ruled there was no "sustainable basis" for Judge Vaught's conclusion that Skirvin committed "gross mismanagement" or was "incapacitated by age." The ruling gave him back control of the Skirvin Hotel.

William Skirvin went for a celebratory drive on March 13 with a younger friend, Earl Miles Saxon, the manager of a taproom. With Saxon at the wheel, they were driving on a highway when their car suddenly careened across the road, grazed a fence, and landed in a creek bed.

Skirvin was thrown into the windshield. At the hospital, he was diagnosed with a severe skull laceration, broken left ankle, and fractured right arm. Saxon had only minor injuries. Saxon told the police that he was forced off the road by a hit-and-run driver, but couldn't

describe the vehicle and the car was never found. In an era before breathalyzers, whether alcohol was involved is unknown.

By the time Perle and Marguerite joined their brother at their father's hospital bedside, the doctors believed he would not survive. William Skirvin was alert enough to hear his children's apologies. In Perle's version of events, her father forgave them, saying, "There's nothing but love in my heart for all three of you children, you're all I have."

A few days later, he went to sleep and never woke up, dying on March 25 from pneumonia and the injuries. Newspaper accounts pointed out the sad irony—that he was fatally injured right after vanquishing his children.

Within fifteen months, the Skirvin Hotel and Tower were sold to Dan James, an Oklahoma City hotelier, for $3 million, the equivalent of $48 million today. Some funds went to repay bank loans and investors, but the children, who remained William Skirvin's beneficiaries, came out ahead.

The Moon, the Stars, and All the Planets

In the summer of 1944, Perle attended the Democratic presidential convention in Chicago, hoping to replicate her victory at the 1940 GOP convention by convincing the Democrats to support the Equal Rights Amendment. Despite opposition from First Lady Eleanor Roosevelt, Perle and her National Woman's Party colleagues prevailed. By a narrow vote of 43 to 42, the platform committee recommended the ERA.

With that mission accomplished, Perle, an Arizona delegate, turned her persuasive skills to backing Harry Truman as Roosevelt's vice president. FDR's advisers had been pressing him to replace current vice president Henry Wallace, fearing the popular politician's quirky interests (astrology, vegetarian diet, references to Karl Marx) would drag down the Democratic ticket.

FDR gave conflicting signals, eventually stating he didn't want to dictate to the convention and nominally leaving the choice up to the delegates, even though he privately signaled his support for Truman. Henry Wallace was determined to keep his job.

An all-night fight ensued as supporters of Wallace and Truman wrangled for votes. Perle argued in favor of Truman, recalling, "I went

to the mat for him for vice president." Emotions ran hot as Henry Wallace won the first ballot by 429½ to Truman's 319½ votes. The winner needed 589 votes. Then big-city mayors and the party's political kingmakers coalesced behind Truman. On the second ballot, the Missouri senator won by a huge margin: 1,100 to 66 votes. Perle was elated that "my man for the job" won.

On November 7, Roosevelt and Truman defeated the GOP challengers, New York governor Thomas Dewey and his running mate, California governor Earl Warren, by nearly 3.6 million votes.

EAGER TO CELEBRATE Truman and his new job, Perle sent out ninety invitations for a party in his honor on March 8 at the Sulgrave Club. She fussed over every detail from the flowers (a rare shade of pink tulips) to the entertainment (New York ventriloquist Al Robinson with his dummy, Alkali Ike) to her guest list (which included ubiquitous House majority leader Sam Rayburn, Republican Senate minority leader Joe Martin, and Supreme Court justice William Douglas). Although she could have squeezed in more VIPs, she invited the college friends of Margaret Truman, Bess and Harry's daughter. Perle had a soft spot for the twenty-year-old aspiring opera singer and history major at George Washington University.

A week before Perle's party, the capital was rocked by stories implying the president was physically failing. On March 1, FDR looked frail when he spoke to Congress about his pivotal meeting in Yalta with Prime Minister Winston Churchill and Soviet premier Joseph Stalin. "I was not ill for a second until I arrived back in Washington and there heard the rumors about my health," Roosevelt quipped, trying to downplay concerns. But there was widespread fear his time was running out.

The morning of Perle's party, the newspapers delivered grim news. Soldiers injured overseas were arriving in the US at a rate of 1,200 per day. In Guam, Japanese forces were engaged in bloody

hand-to-hand combat with Americans. Official Washington needed a dose of good cheer, and Perle was ready to provide it.

Stationing herself at the top of the Sulgrave's second-floor staircase, with Harry and Bess Truman by her side, she welcomed guests. Up they trooped, the notables and quotables, witnessing Perle's biggest social triumph. After Sidney's orchestra performed, after the ventriloquist made fun of Rayburn's balding pate, after sincere and humorous champagne toasts, no one wanted the night to end. So the guests began to perform. Kentucky senator Happy Chandler sang "My Old Kentucky Home"; Oklahoma-born diplomat Patrick Hurley, raised on an Indian reservation, gave Indian war whoops; and Rosa Ponselle sang Franz Schubert's "Ave Maria."

Rosa convinced Harry Truman to be her accompanist. Once he sat down at the piano, she climbed up on it and assumed a seductive torch-singer pose, to the *ooh*s and *aah*s of the guests. The cheerful vice president went on to play a solo of Ignacy Jan Paderewski's Minuet in G.

Perle had been giving parties in Washington since 1917, but this evening put her on the map. The newspapers went wild. "It was a shindig to rival any given this season. Celebrities, fun, food and liquor were unrationed," wrote the Associated Press in an emblematic story. "Mrs. George Mesta, the Oklahoma oil heiress has a wardrobe of diamonds, of beautiful furs, a sense of humor and a superb knack for entertaining."

The following day, Perle took starstruck Margaret Truman to lunch with Rosa Ponselle at the Mayflower. The Metropolitan Opera star graciously then hosted Margaret and Perle at her Baltimore estate and brought her vocal coach to listen to Margaret sing. The Truman parents were very, very grateful. Still adjusting to their new status, the vice president and his wife were being feted in capital homes almost every night. They were still living in a two-bedroom apartment with Bess Truman's mother, with a listed phone number. They had a pleasant day-to day life until everything abruptly changed.

On April 12, President Roosevelt was at his favorite retreat in Warm Springs, Georgia, when he suddenly complained that he had

a terrible headache. Those were his final words. He died within two hours from a cerebral hemorrhage at age sixty-three.

Harry Truman was sworn in at 7 p.m. as the thirty-third president. Truman had never met Winston Churchill or Joseph Stalin and was unaware the US was secretly building an atomic bomb. The next day, the new president told reporters, "Boys, if you ever pray, pray for me now. I don't know if you fellows ever had a load of hay fall on you, but when they told me yesterday what had happened, I felt like the moon, the stars, and all the planets had fallen on me."

FDR's funeral was held on April 15. Two days later, Truman spoke to Congress, promising to fulfill Roosevelt's promises to win the war and uphold the New Deal, stressing "there will be no relaxation in our efforts to improve the lot of the common man." Perle sent Truman a supportive telegram. "I had a group of people with me in my apartment to hear you and everyone was most enthusiastic and greatly impressed with the sincerity and wisdom you expressed."

The Trumans moved into Blair House, the temporary government home across the street from the White House, while Eleanor Roosevelt prepared to leave. On April 27, Perle was surprised to be invited to a lunch at Blair House with the new president and his family along with Lewis Schwellenbach, a district judge about to be named labor secretary.

This was a pinch-me moment for Perle. In this national time of mourning, she was honored the Trumans wanted her company.

TRUMAN WENT AHEAD with the scheduled April conference in San Francisco to establish the United Nations. In the belief that World War II would end soon, delegates from nearly fifty nations worked out a charter establishing principles for peace, security, and human rights. The timing was prescient: Germany unconditionally surrendered to the Allies on May 7.

With only one official female American delegate (Barnard dean Virginia Gildersleeve), Perle and members of the National Woman's Party attended as observers to lobby for women's rights. The final UN charter contained a sentence affirming "the equal rights of men and women and of nations large and small." It was a small step, but the feminists felt they had made a difference.

Los Angeles Times columnist Lucille Leimert, covering Perle's UN efforts, wrote that the hostess "is always to be found anywhere in the United States where things are happening." Perle did want to be "where things are happening," and with Harry Truman in the White House, that place would definitely not be Arizona. She sold her ranch and began scouting Washington rentals.

She spent the summer in Newport, as usual. After spending so many years as her sister's houseguest, Perle bought her own Newport home, an 1886 Victorian-style stone and shingle cottage, Mid-cliffe, on a two-acre plot on prestigious Cliff Walk. Directly above the Atlantic Ocean, the graceful mansion featured twelve bedrooms and a large carriage house.

On August 16, when word came that the Japanese had surrendered, she was in Newport. People took to the streets to joyously celebrate. "One of the happiest in the city's history," wrote the *Newport Mercury*. "More than once the expression on a woman's lips was: 'Thank God, my boy is safe.'" Perle was relieved that Marguerite's twenty-two-year-old son Robert, about to finish Army training, would not see combat.

Returning to Washington after Labor Day, Perle renewed her push for the Equal Rights Amendment, buttonholing government officials. On September 22, President Truman met with the National Woman's Party to reaffirm his support. He wrote a letter saying he approved of the amendment "because I think it will improve the standard of living by setting a level on wages equal for both sexes."

The Capitol was aglow with postwar celebrations, and Perle made the rounds, attending a French embassy reception for General Charles de Gaulle and Evalyn Walsh McLean's party for General Omar Bradley.

And then a personal tragedy struck: Marguerite's son Robert was hospitalized with an infected appendix. He delayed seeking treatment in the hope that Christian Science prayers would pull him through. Marguerite flew to Kentucky and was by her son's side at the Army hospital when he died. He was buried at St. Mary's Cemetery in Portsmouth, Rhode Island.

Marguerite's three children had been a constant in Perle's life. Heartbroken, she remained with her sister in Newport for several weeks. President Truman sent a condolence note:

My dear Mrs. Mesta:
I have heard of the sorrow which came to you with such sudden and tragic force and want you to know that I am thinking of you as you mourn a loss so overwhelming. My heart goes out to you in deepest sympathy in which Mrs. Truman joins.

It took a full month before Perle felt capable of replying:

Your thoughtfulness in remembering us in this sad hour is deeply appreciated and has meant a great deal to all of Bob's family.

The Entertainer-in-Chief

E ach fall, hostesses in the capital anxiously awaited the October publication of the *Green Book*, which listed prominent Washingtonians and ranked their place in the pecking order. Carolyn "Callie" Hagner Shaw had taken over the society bible after the death of her mother, the guide's founder. As the former social secretary to Evalyn Walsh McLean and *Washington Times-Herald* publisher Cissy Patterson, Callie Shaw knew her subject well.

The list included traditional Washington society (cave dwellers), wealthy newcomers, and top government officials. As sole arbiter, Shaw insisted she was immune to bribes—flowers, candy, liquor— sent by ambitious climbers hoping to make her list, which included 5,500 names. A divorce or personal scandal could knock people off; a major government promotion was a plus. Hostesses often called her for seating guidance. In her private note cards, she wrote abbreviations for notorious guests such as B.D. (bad drunk) and O.F. (old fool, who pinched young women's bottoms).

The White House turnover from Roosevelt to Truman caused havoc with the October 1945 *Green Book*. So many people were up for new jobs that everything was in flux. "I was changing right up to the last minute," Shaw told a reporter. After adding seven hundred

new names—and cutting six hundred people—she was braced for protests.

"There are more social climbers per square foot in Washington than in any other city in the U.S.A.," she said. "I guess because there are more opportunities here. In New York, for example, it's hard to crack the 400; but people can become social successes almost overnight in Washington—if they play their cards right."

Wealthy developer Morris Cafritz and his wife Gwen desperately wanted to entertain the Trumans, but they had erred by previously ignoring the couple. "I used to see him at parties when he was in the Senate and he was dull, dull, dull," Gwen later admitted. "So naturally I never invited him or Mrs. Truman to my parties because I was sure they wouldn't be interesting guests. Who would have thought he'd ever get to be President?"

Perle was holding all aces. Thanks to her party for Vice President Truman, everyone knew how close she was to the First Family. When Bess Truman gave a small lunch at the White House in January 1946 for wives of officials, diplomats, and a few friends, Perle was included. The shy First Lady appreciated Perle's loyalty to Harry, her affection for the Trumans' daughter Margaret and Perle's discretion in keeping confidences.

Washington was now Perle's full-time residence. She rented Herbert Hoover's former Washington home at 2300 S Street NW, an enormous 12,000-square-foot mansion. With a music room, library, large dining room, and outdoor porches perfect for cocktails in warm weather, Perle planned to turn what had been a Republican refuge into a Democratic hot spot.

A good hostess needs a reliable staff. Perle imported a trusted Oklahoma couple to Washington—Garner Camper, a Black waiter at the Skirvin Hotel, as her butler and his wife Edna, a talented cook, seamstress, and housekeeper. The handsome and gregarious Camper, born in Jackson, Mississippi, in 1909, moved to Tulsa as a child, living through the city's horrendous 1921 race riots. The six-foot Camper

held jobs as a Pullman railroad porter and country club waiter before going to work at the Skirvin. One of Perle's guests would admiringly describe him as having "a million-dollar personality."

Perle viewed the couple, who moved into her house in Washington, as invaluable; they would be by her side for nearly three decades. Using the vernacular of the era, she described them as "practically members of the family." In her autobiography, she spelled out her butler's virtues.

Garner comes in like a steamroller, hires the extra help, buys the supplies and organizes the household down to the smallest detail. And although he has sometimes been called bossy, he has such a likeable manner that nobody takes offense . . . When he talks to Democrats, Garner is a Democrat; when he talks to Republicans, he is a Republican. What a born diplomat!

Perle's admiration and affection for the Campers may have contributed to her liberal attitude toward race relations. Although Perle was never a civil rights activist, she led by example, integrating her own gatherings and following the same policy when she began to orchestrate Democratic political events. She believed opinions could be changed via one-on-one interactions. Imagine the reaction of a rampant segregationist when he was seated next to singer Pearl Bailey at a Perle Mesta dinner—and had a good time. Using the language of the times, Perle would often say, "I'm for the Negro."

As a hostess, she was credited with uttering the following advice about wooing VIPs: "Hang a lamb chop in the window and they'll come." (The originator may have been columnist Inez Robb, who wrote, "It has been my cynical belief that any Washington hostess who merely hangs a ham out the window is in grave danger of being killed in the rush of free loaders.") Thanks to Perle's reputation for putting on an elaborate spread—platters of Virginia ham, roast turkey, Italian

meatballs, and pasta, and her signature drink, pink champagne—plus providing imaginative entertainment, the VIPs did indeed come.

In early 1946 Perle began sending out a raft of invitations for small dinners and larger galas, with an underlying rationale. For the first time, both the Senate and House Judiciary Committees had approved the Equal Rights Amendment, which meant the bill could come up for a full vote in both the Senate and the House. Democratic Arizona senator Ernest McFarland pointed out that with President Truman and both committees backing it, "Certainly final victory for the amendment can't be far away." The next stage was getting both houses to actually schedule a vote—no easy task. Perle hoped that by inviting Democratic and Republican legislators to her home, she could put a good word in their ear and put the ERA over the top.

Her evenings followed a strict timetable. Cocktails at 8 p.m., dinner at 8:30 p.m. After dinner, following Washington protocol, men adjourned to one room with cigars and after-dinner drinks, the women to another. Within an hour, they would reunite to see a performer or dance to the orchestra.

Gliding through these evenings appearing calm and self-possessed, Perle was constantly taking the temperature of the room. "With my back turned, I know everything that's going on," she told a reporter. "Wherever I am I can sense immediately if the gaiety's dropping off or in danger of going too far." She would race to the orchestra and whisper, "Pep it up, make it lively, don't let it die."

Marie Ridder, now ninety-nine, began working as a Washington journalist in 1944, and met Perle early on. "When I was a young reporter in town, I became aware of her," recalls Ridder, who attended several of Perle's parties. "She was making a big splash socially. God, she was such an obvious social climber but she was not an unkind human being. She just used her entrée and her money to do what she wanted to do. She did some very worthwhile things along the way."

Aware of the power of the press, Perle hit the daily double in early 1946 by giving two three-hundred-person parties for the city's rival

female press associations: the American Newspaper Women's Club and the Women's National Press Club. Pushing for passage of the ERA, she hoped that wooing the press would help.

Margaret Truman came to both of Perle's press parties, without her parents. Now a senior at George Washington University, Margaret was struggling with her role as first daughter. Uncomfortable with the newfound attention, Margaret worried that her friends would abandon her. An only child, she was concerned that her mother missed her Missouri friends and that she appeared unhappy as First Lady. *Life* wrote of Margaret: "She regards her Pennsylvania Avenue address less as a stepping stone to social glitter than as an uncomfortable and strictly temporary residence."

Eager to perk up Margaret's spirits, Perle took her to see the opera *Carmen* and offered to give a party for her twenty-second birthday. Since Perle's niece Betty Tyson was nearly the same age, Perle billed the party as a joint celebration for the two young women, who knew one another. Hoping to follow her mother's acting footsteps, Betty was studying at the American Academy of Dramatic Arts. The hostess told *Life* the publication could send a photographer and writer to cover the party.

Perle couldn't resist bragging about her plans, informing the *Washington Post* that she was flying in the Emil Coleman Orchestra from California. News of this upcoming lavish celebration irked eighty-year-old Democratic Illinois congressman Adolph Sabath, chairman of the Rules Committee. With strikes breaking out in multiple industries (steel, automakers, municipal employees) as union workers pushed for higher wages, he thought the president should not permit such an expensive spectacle for his daughter and believed it sent the wrong message about the president's priorities to Democrats. Sabath sent a letter to Truman saying so and made it public. Many newspapers wrote about his concerns, but Perle and the Trumans ignored his complaints.

On February 15, forty out-of-town guests gathered for Perle's pre-party dinner at the Sulgrave Club. An eighteen-year-old Harvard

junior described the evening in the *Los Angeles Examiner* under the name Sebastian Flyte (a pseudonym taken from Evelyn Waugh's new novel *Brideshead Revisited*). He was impressed at the sight of Perle asserting herself. "The first time I ever saw Mrs. Mesta, she was standing in a phone booth using some strong words with a nationally known singer . . . It seems the singer was refusing to come to the dinner because the piano wasn't right. Mrs. Mesta was telling the singer: 'I've been giving good parties for twenty years. Things have gone wrong but nothing's ever ruined my parties. You can decide for yourself if you're coming.'" The singer turned up.

By the time the 250 partygoers gathered at 10:30 p.m. at Perle's home, Margaret was ready to take her bows. Wearing a blue crepe dress with purple orchids pinned to her shoulder, and sporting a new pageboy bob and pearls, she looked girlishly happy as she greeted guests. Standing beside her, Perle wore a jade-green sequined gown, while the angelic Betty was in a white net gown trimmed with blue ribbons. They made for a colorful trio, all with elbow-length white gloves. Margaret wrote in her journal, "I danced every dance with a minimum of six different partners! My feet! There was a huge cake flown in from New York! It had my name on it."

But Perle's decision to allow *Look* to cover the party backfired. The magazine's four-page April 30 feature took vicious potshots, portraying Perle as a self-promoter unworthy of hosting the president's daughter. The text implied that the city's old-line arbiters had complained, albeit not for attribution, that Perle was not of the proper social class.

"Washington society has called the Trumans ill-advised for letting their daughter make her social debut at Mrs. Mesta's," *Life* declared. The critical caption on a photo of Margaret dancing: "Looking like social butterfly, which she is not." *Look* stated, in a tone of horror, that "Mrs. Mesta employs a press agent."

The magazine provided no evidence, but that accusation spread. Four years later, a memo prepared for the exhaustively reported cover

story on Perle for *Time* stated: "Perle Mesta has never, to our knowledge, hired a public relations woman, and rumors that she had a press agent have been denied by most of our sources."

She didn't need one. Reporters loved discovering and promoting a new Washington hostess. Taking the position that all publicity is good publicity, Perle accepted interview requests as an opportunity to talk up the ERA and add plugs for President Truman's latest initiative, cutting back on American food waste to export food to starving Europeans.

"The mysterious 'Mrs. Mesta' has Washington society standing on its ear," wrote Tony Smith of Gannett News Service. "For the first time in many years, a society matron; entertainer of presidents, vice presidents, diplomats, movie stars and Congressmen has risen to challenge the position of Mrs. Evalyn Walsh McLean." Asked about rumors of a social rivalry, Perle replied, "That's silly. There's nothing at all to them. You know how people like to talk."

Perle stressed that her parties had a purpose. "There's always a cause behind my entertaining," she insisted, adding that she was devoting "practically every minute of my days right now" to working for the ERA and Truman's food initiative. She was sufficiently effective in conveying her message that the reporter wrote: "She runs her campaigns for legislation like a social field general. When the support of a particular Senator or House member is needed, she builds a tea or dinner party so that he will be the major objective."

With *New York Post* reporter Mary Braggiotti, Perle begged to be taken seriously: "Please don't have the idea that I'm a social butterfly. I'm not anti-social, mind you, but I like people who DO things."

On April 29, Perle and members of the National Woman's Party met with Senate majority leader Alben Barkley, a Kentucky Democrat who Truman would tap as his vice presidential running mate in 1948. Barkley pledged his support for the ERA and promised to schedule a vote on the amendment by the full Senate, something that had never happened before.

* * *

PERLE BUILT HER travel schedule around the Trumans' plans. She went to Newport to ready her new cottage for the season, but returned to Washington for Margaret Truman's college graduation on May 29 at Constitution Hall, where the president gave the graduation speech.

The Trumans treated Perle like an extended member of the family. Reading through correspondence at the Truman Presidential Library, it's evident that Perle put a lot of thought into her relationship with the family—sending frequent notes and telegrams to the president, gifts for major holidays, and constant invitations. Bess and Margaret, when away from one another, frequently referred fondly to Perle in their letters. Bess plaintively wrote to her daughter, "I wanted to have a luncheon for Mrs. Mesta but what can I do if she is staying [in DC] just for the one day?"

In the summer of 1946, after spending a year renovating her Newport "cottage," Perle was ready to open the doors. Marguerite, who supervised the décor, proved she still had a knack for setting a scene. The downstairs rooms featured sparkling chandeliers, plush beige carpeting and hand-painted wallpaper with pastel floral designs. The sunroom overlooking the bay was perfectly situated for cocktails at sunset.

Perle hung a large portrait of George Mesta in a place of honor above the living room fireplace. Her husband had been dead for more than two decades. The prominent location sent the message: no one can replace the great love of my life. While Perle always had an extra man by her side, she no longer seemed interested in romance.

At her new home, Perle saved the best room for herself. Her second-floor bedroom, measuring a huge thirty by fifty feet, was decorated in soft green and beige, with an antique mahogany bed covered with a red and white candy-striped spread. When she woke in solitary splendor at 8 a.m., her first sight was a glorious view of the ocean. She read her Christian Science Bible in bed and had the staff deliver black coffee and a half grapefruit.

The talk of Newport that summer was the upcoming wedding of Marguerite's daughter Betty to John Mortimer Richardson "Richie"

Lyeth Jr. The Harvard graduate, who spent two years in the Navy, worked for his family's Detroit button company. Introduced by Betty's mother Marguerite, he was also a Christian Scientist. Marguerite and Perle invited 750 guests to the early September wedding.

Preoccupied with bridal arrangements, Perle did not go to Washington in July when the Equal Rights Amendment came up for a vote in the Senate. By then, she had done everything she could do to move things forward. The July timing of the vote was unfortunate: eighteen senators who backed the bill were out of town. Senator George Radcliffe of Maryland, the sponsor, requested a delay but was turned down. The Senate voted 38 in favor of the amendment, 35 against—eleven votes short of the two-thirds majority needed to pass a new constitutional amendment.

While it was a step forward to even get a vote by the Senate, the weary women would have to start all over again the next year.

WASHINGTON SOCIAL LIFE was quiet that fall. Evalyn Walsh McLean's twenty-five-year-old daughter Evalyn McLean Reynolds died of a drug overdose in September. The lights went dark at Friendship as Evalyn went into seclusion. Perle was partied out. She no longer needed to give dinners to boost the ERA; that was over for now. She gave up her lease at the Hoover mansion and returned to lodgings at the Sulgrave Club.

The country was so unhappy with Truman and the Democrats that the unthinkable occurred on Election Day—the Republicans won control of both the House and the Senate. All through the Roosevelt years, the Democrats controlled both chambers, often by ludicrously lopsided margins. But the Republicans won the House by a margin of 246 to 188 seats and the Senate with a 51 to 45 advantage.

The new legislators included three men who would have an outsize influence on American politics: Massachusetts congressman John F. Kennedy (who would soon receive invites to Perle's parties)

plus two Republicans, California congressman Richard Nixon and Wisconsin's new senator, Joseph McCarthy (who would both remain off her guest lists).

Perle found herself in unexpected company right after the election. On the way to her room at the Sulgrave Club, she ran into partying Republican friends, who invited her to join them. She never could resist a good party, and knew she would need Republican friends down the line.

"Mrs. Mesta is more democratic than the donkey himself and nothing seemed more astonishing than that she would come to gloat happily with the resurgent elephants," wrote the *Philadelphia Inquirer*'s Elise Morrow. "Several of her Republican friends—Joe Martin, who will be Speaker of the new House and Dolly Gann—spied her and insisted she stay awhile."

Perle reassured the columnist that she was just being polite and had not changed her loyalties. Morrow concluded, "So the Democrats who were worried can relax; Aunt Perle hasn't gone over to the enemy."

Democratic Party Stalwart

In the postwar 1940s, feminism was on the march—but backward. It wasn't just that victorious soldiers came home and displaced Rosie the Riveter. Harry Truman's full-throated backing of the Equal Rights Amendment had not translated into hiring women. FDR named the first female Cabinet member in 1933 (Secretary of Labor Frances Perkins) and appointed two female diplomats. All three had left office, and under Truman, the Cabinet and the State Department might as well have had signs saying "Only men need apply."

Women were losing ground in Congress as well. After the November 1946 election, there were no female senators and there were only seven women in the House, compared to ten the previous year. (Two-term GOP congresswoman Clare Boothe Luce chose not to run again.)

The National Woman's Party was in disarray, riven by an internal leadership fight that descended into lengthy litigation over whether a vote-by-mail result was legitimate. During this descent into factionalism, minimal effort went toward the passage of the Equal Rights Amendment. Perle retreated to the sidelines and put her energy toward supporting Truman and the Democratic Party.

The Washington social whirl continued but without one of its most memorable characters. Evalyn Walsh McLean died on April 26 at age sixty. Her death was treated as the solemn passing of an era. "Pneumonia Ends Fabulous Career of Woman Who Knew Poverty and Entertained Royalty" was the *Los Angeles Times* headline. The *Washington Post* noted that her home was "the scene of entertainment more lavish perhaps than this capital of the world will ever see again." These obituaries were followed by a wave of stories pronouncing Perle the capital's reigning hostess, praising her as a refreshing presence who "is no snob, socially or intellectually." The silver chafing dish had been passed to a new table.

Perle used the renewed attention to give interviews focusing on Truman's priorities. Now that the World War II draft was over and the armed forces had shrunk to civilian size, the president was unsuccessfully pressing Congress to mandate universal military training for male civilians. Perle talked up Truman's doomed cause, telling a United Press reporter, "If we don't adopt universal training, we'll be letting down the men who fought in this war."

Perle took her hostess act on the road that summer to Newport. She tried to lure the commander-in-chief and his family for a visit, but Truman preferred less snooty vacation spots. On August 7, Bess Truman wrote to his daughter Margaret, who had made her singing debut and was on a concert tour: "Mrs. Mesta just called from N . . . She wants Dad + me to come up for a weekend but you know darn well he's not going."

Perle doted on Margaret well beyond a desire to please her powerful parents. She was vicariously involved in Margaret's singing career. That October Perle was chauffeured to Pittsburgh to hear Margaret sing before four thousand people. The president's daughter won nine curtain calls, but critics panned her performance. The *Pittsburgh Post-Gazette*'s Donald Steinfirst bluntly stated she "is not a great singer and in fact, is not at this stage of her career, even a good singer."

Reathel Odum, Bess Truman's private secretary, provided a portrait of life on the road with Perle. Describing the trip back home

to Washington, Odum recalled in an oral history, "Mrs. Mesta had a car and chauffeur and we stopped at a fast food place for lunch. Mrs. Mesta had all of her jewels down in her bosom and I thought that was so funny! But she was a very down-to-earth, very friendly woman."

Playing camp follower, Perle went to Oklahoma City in November to hear Margaret perform, staying, of course, at the Skirvin Hotel. Trying to bolster the first daughter, Perle told the *Daily Oklahoman*, "She has a beautiful voice and above all, she doesn't want to be known as the President's daughter. She's right down to earth." Perle showed her fealty to the Truman family by underwriting a trip to Oklahoma City for Bess Truman's ten-member Missouri bridge club, putting them up at the Skirvin so they could see Margaret sing.

When the president went to Capitol Hill on November 17 to address Congress about his plans to battle raging postwar inflation, the grateful Bess brought Perle with her to the front row. The contrast in their personalities was demonstrated by their clothing: press-shy Bess wore a plain black suit and white gloves, while the ebullient Perle was clad in eye-catching purple.

The Democratic Party sought to take advantage of Perle's glittering profile and even more glittering bank account. The person designated to work out the specifics was India Edwards, head of the party's Women's Bureau and a former *Chicago Tribune* society writer who had been a speechwriter for FDR's 1944 campaign. Twice divorced and now married to State Department official Herbert Edwards, she was knowledgeable about everything from international affairs to kitchen-table issues like inflation. Her job was to deliver the women's vote to Democrats, but she took it a step further, pressing the White House to appoint more women to government jobs. Perle admired India Edwards's know-how and dedication, and the women became close friends.

India Edwards suggested the hostess give a party for female reporters, as an effort to win them over to the Democrats in advance of the 1948 election. Perle billed her event as a "tea party," but not

only was there plenty of bourbon, scotch, and champagne; she told the women to bring their beaus and invited male newsmakers—new House Speaker Joe Martin, ubiquitous former House Speaker Sam Rayburn, the treasury secretary, and a raft of senators—that the news hens were eager to see. An orchestra kept the dance floor full, and the loyal Margaret Truman appeared on behalf of the White House. As one scribe quipped, "The ladies of the press kept their pencils and notebooks out of sight but their minds alert."

From India Edwards's perspective, the event was a big success. "All the big shots came to the party and the women commentators were impressed," recalled Edwards. "The good impression lasted on them all through the campaign. They were invaluable to us." She realized that while Perle did not donate money directly to politicians, the hostess could be counted on to underwrite events. Estimating that Perle spent $5,000 on the party, Edwards theorized, "I strongly suspect that what she bought with that money did us as much good as a straight $5,000 contribution." The Democratic Party would come to rely on Perle, again and again, to put the *P* in *party*.

The *Washington Post* printed Perle's menu from that night as if it were a state dinner. It conjures up Washington's austere style in the late 1940s: fish balls, hot beets, cheese and tuna fish sandwiches, cheese and potato wafers, stuffed celery, raw cauliflower, carrots, and olives. In deference to the president's food conservation plan, Perle proudly announced that potato flour, rather than wheat flour, was used to make the sandwich bread.

Perle, however, was no longer filling her own plate. Following a stringent diet, she had lost twenty pounds. Asked about her new figure, she honestly replied, "I got tired of reading about 'the plump Mrs. Mesta.'"

Rewarded for her slimmed-down efforts, on December 26, she was named to America's Best-Dressed List, along with the Duchess of Windsor and Babe Paley. Since Perle still secretly had her Oklahoma

City dressmaker rework Paris gowns, she was flattered. She said of the honor, "It amused me."

THANKS TO HER loyalty to the Trumans and experience as an adroit pledge collector for the Stage Door Canteen, Perle was an obvious choice to co-chair the Democratic Party's February 1948 annual fundraising gala, the Thomas Jefferson–Andrew Jackson Dinner, named to honor the past presidents. What made this exceptional was that the Democrats had never asked a woman to do the job before.

Perle could have viewed it as an honorary title, leaving the real work to her co-chair, former Louisville mayor Wilson Wyatt. But Perle was highly competitive. She confidently told reporters that she aimed to pull off the most successful dinner in Democratic Party history. And she did.

The money desperately mattered. With the president's approval rating plummeting, inflation running at nearly 10 percent, and talk of dumping the unpopular Truman from the Democratic ticket, the situation was dire. With an arduous election campaign ahead against a deep-pocketed Republican (Thomas Dewey, the 1944 GOP presidential nominee, was favored), every dollar the Democrats could bank mattered.

Watching Perle in action impressed India Edwards. "No job was too big or small for her personal attention," she recalled. "We had lost the '46 elections, our prospects in '48 were bleak and nearly everybody was predicting that the Jackson Day dinners would be nothing but wakes. They might have been, except for Perle Mesta's work."

Perle raised more than $250,000 (more than $3 million today) by selling $100 tickets to everyone she could sweet-talk into writing a check. The turnout was so large that the committee booked two separate hotel ballrooms—at the Statler and the Mayflower—to accommodate ticket holders.

But there were ugly protocol issues. Truman had recently proposed sweeping civil rights legislation, including federal protection against lynching and ending segregation in the military. Southern Democrats were enraged and continued to use the Senate filibuster to uphold segregation.

These tensions surfaced at the Jefferson-Jackson Dinner. South Carolina senator Olin Johnston and wife Gladys, who had been selling tickets, announced they were boycotting since the Democratic Party refused to guarantee there would be no Black people at their table. South Carolina governor Strom Thurmond, laying the groundwork for a possible Dixiecrat presidential campaign, said he wouldn't come either. Democratic Party chair Howard McGrath, likely with the strong support of event co-chairs Perle and Wilson Wyatt, rejected the demand that Black people be shunted to separate segregated tables.

As FDR speechwriter Clark Clifford wrote in his memoir, *Counsel to the President*, when he and his wife Marny arrived, "we found a crude but cleverly executed rebuke of the President . . . Unbeknownst by anyone at the White House, Johnston had bought an entire table directly in front of the Presidential dais, which he left vacant in silent and ostentatious censure of the President." Photos of empty table 23 made it into newspapers, dramatizing the party's rupture over civil rights.

Rumors spread that Perle was under consideration for a top job in the Democratic Party as a reward for the successful ticket sales. "That's perfectly ridiculous," Perle replied when asked about the possibility. Astute observers at the dinner raised another intriguing prospect: wondering whether Perle had embarked on a romance with newly widowed Kentucky senator Alben Barkley, the former Senate majority leader. As toastmaster at the Jefferson-Jackson Dinner, Barkley gushed over Perle for her hard work and urged her to stand up and take a bow.

A strong advocate for the Equal Rights Amendment, he had been a frequent guest at Perle's parties. Asked whether they were involved, Perle was exceedingly coy, simply stating that he was her "old and dear

friend." Perle had a rotating range of single men as escorts, including former Arizona senator Henry Ashurst and Philadelphia diabetes doctor Anthony Sindoni. When India Edwards asked Perle why she had not remarried, the hostess replied, "I don't want to marry. I'm not lonely. I've got my family, my sister and her husband and my niece. For me, a husband would be so much excess baggage."

PERLE MADE NEWS that spring when she conspicuously walked out of a fundraising lunch at the Mayflower Hotel, offended by remarks delivered by the headliner, Nancy Langhorne Astor, the former Virginia belle transformed by her marriage to British viscount William Astor. The first woman to serve in the British Parliament (1919–1945), Lady Astor's speech had been highly anticipated. As one newspaper proclaimed: "Washington society is bracing itself for another invasion by Lady Astor, whose sharp tongue and tee totaling habits are regarded by Washington's Philistines on the Potomac with something close to awe."

Lady Astor's speech had a bland title—"Women as Peace Builders"—but instead she harshly criticized American women for being frivolous and only interested in "women, clothes, liquor and brassiere ads in newspapers" and worrying about their own "uplift." As the fabulously wealthy British peer insisted, American women should instead be thinking about a world "faced with famine."

Perle was so insulted that she stood up midway through the speech and left. Afterward, she furiously explained to a journalist that she was "just tired of hearing that woman criticizing American women." Then Perle added heatedly, in words that conveyed the underlying commitment that had shaped her recent life, "Furthermore, I don't consider her a feminist and I am."

Lady Astor could not resist a good fight. Asked about Perle's remarks, she retorted, "Why, she's just a social climber using me to get more publicity."

The "Battle over the Brassieres," as it was actually called in head-lines, only added to Perle's celebrity. The day after the Astor brou-haha, Perle opened up her house for a fundraiser for the Washington Home for Incurables, a charity that provided free lodging for people with chronic health problems. Thanks to the racy headlines, four thousand people lined up for hours as Perle, Bess Truman, and Edith Wilson (widow of the late president) offered homemade cookies. In the annals of Washington, this was a twenty-thousand-cookie event.

Capping off a hyperactive week, Perle summoned reporters to her home, stating that she would be revealing a big story. Given the headlines of late, anything seemed possible. "The rumors gathered like storm clouds and by noon they had her marrying Senate Major-ity Leader Alben Barkley," wrote the *Philadelphia Inquirer*'s Elise Morrow. "By cocktail time she was on the Democratic ticket for Vice President."

It turned out that Perle was taking advantage of her notoriety to promote another charitable cause. As Morrow wrote, "It was proba-bly the worst shock Washington had in months when the 'interest-ing story' turned out to be a coy way of announcing a benefit for the National Symphony Orchestra."

Dewey Beats Truman?

As a Truman loyalist, Perle joked that she was playing Mata Hari at the June 1948 Republican convention in Philadelphia, three weeks before the Democrats met in the same city. As she held court in a suite at the Barclay Hotel, Perle airily explained, "I am a leader of the Truman underground here . . . He is my candidate and I shall vote for him."

Perle had a substantive reason for being in Philadelphia, surrounded by Thomas Dewey and Robert Taft supporters. She was nurturing GOP alliances, and this event was potentially useful, although there wasn't much hope at the time for the Equal Rights Amendment, stalled again in Congress. But Perle believed in playing the long game. She gave a lunch for bachelor House Speaker Joseph Martin, chair of the convention.

For the first time, television was broadcasting both conventions for the roughly 350,000 Americans who owned an early TV set. Leading up to the nomination of New York governor Dewey as the GOP's presidential candidate, there were memorable moments of partisan invective. Perle watched her friend Clare Boothe Luce excoriate the Democratic incumbent: "Mr. Truman's time is short, his situation is hopeless. Frankly, he is a gone goose."

Perle disagreed but she was one of the few Americans in either party who believed the man from Missouri would prevail. She returned to Philadelphia in mid-July as a full-fledged Rhode Island delegate to the Democratic convention. For the Michigan-born, Texas-raised hostess who always claimed to be from Oklahoma, that honor made her Four-State Perle.

The convention was shrouded in gloom, as evidenced by campaign buttons donned by some delegates that read "I'm Just Mild About Harry" and "To Err is Truman." On the eve of the convention, FDR's eldest son James Roosevelt launched a desperate "Draft Eisenhower" campaign. He sent telegrams to all 1,592 delegates, unsuccessfully urging them to plead with Ike to declare for the presidency as a Democrat, even though the war hero had not declared an affiliation with either party.

The innovative India Edwards created a one-day "campaign school" to train female convention-goers to publicly express support for Truman, designating Perle to discuss why she became a Democrat. The day before the speech, Perle was in her suite with friends— Louis Bromfield, a hard-drinking novelist turned Ohio gentleman farmer; humor columnist George Dixon; and Brigadier General Joseph Battley—and admitted she feared her speech wasn't eloquent enough. "It reads kind of stilted," she said. "I wish you would help me brighten it up, Louie." The novelist, known for his pranks, took her only copy of the speech and the next day refused to return it. "I won't have you reciting that gibberish," he told Perle. With a short time to spare, Perle called on the indefatigable Edwards to help reconstruct the speech.

In her talk, Perle stated that the Republican Party had become more conservative, forcing her to part ways. "So I went to the Democratic party where they appreciate liberals. We have one now in President Truman. I admire him both as a man and a national leader."

No one thought there would be much to celebrate at this convention but Perle decided a pick-me-up was in order. She had planned a

small party for Rhode Island delegates but decided to go big instead, renting a ballroom, ordering large quantities of prewar 1937 Bollinger champagne, and inviting more than three hundred people.

The evening got off to a late start, thanks to Perle's rumored beau, seventy-year-old Kentucky senator Alben Barkley. He delivered a rousing keynote speech with cornpone lines, such as claiming that under Herbert Hoover, "spiders were so weak from starvation that they could not weave a web." A twenty-eight-minute cheering demonstration ensued, boosting Barkley for the vacant post as vice president. Barkley's prospects were the talk of Perle's party, which started after midnight.

Attired in a blue accordion-pleated lace dress and a campaign button saying "Don't Tarry—Vote for Harry," Perle declared, "This is no wake. I'm tired of that kind of talk . . . This is a victory party."

NBC sent a camera crew; Perle demanded and won a quid pro quo for her niece Betty, now divorced with a young daughter and trying to launch a television career. Perle convinced NBC to let Betty interview guests on camera. The scorching TV lights prompted partygoers to beg for mercy.

Bodyguards were stationed at the door to keep away interlopers. Perle banned Clare Boothe Luce, who was covering the convention as a newspaper feature writer, because of her rough attack on the president at the GOP convention. Florida's liberal senator Claude Pepper was also on Perle's naughty list for his attempt to dump Truman from the ticket.

But the security staff waved through a Rhode Island delegate who stood out from the rest of the crowd—Army veteran Paul Grandy, who was Black. With the Democratic Party bitterly at odds over civil rights and segregationist Southerners threatening a walkout, the sight of Grandy was startling to reporters, who sought him out. "Grandy sat with quiet dignity in the corner," noted the *Philadelphia Inquirer.* As far as Perle was concerned, he was a Democrat, he was a delegate, and he was welcome.

Late in the evening, cut-up Louis Bromfield and irreverent columnist George Dixon tried to liven up the waning minutes of the party. They went into an adjoining room, took off most of their clothes, and, clad only in their shorts and socks, opened up the door to the ballroom and called out, "It's time to go bed, Perle. Come along now." Perle howled with laughter, although some guests appeared shocked. At 3 a.m. Perle finally had to tell the hotel staff to turn out the lights so the laggards would leave.

THE STEAMY CONVENTION saved its best for Wednesday, the last night. Liberal Minneapolis mayor Hubert Humphrey gave an eight-minute oration that permanently transformed the Democratic Party. Speaking on behalf of a seemingly doomed effort to strengthen the platform language on civil rights, Humphrey declared, "The time has arrived in America for the Democratic party to get out of the shadow of states' rights and to walk forthrightly into the bright sunshine of human rights."

When the civil rights forces, emboldened by Humphrey's passionate oratory, narrowly prevailed, the Southerners erupted in rage. The entire Mississippi delegation walked out, joined by half of the Alabama delegates. Almost all remaining delegates from the thirteen states of the Confederacy abandoned Truman to vote on the first ballot for Georgia's segregationist senator Richard Russell as a protest.

As a result of the furor, Truman, joined by running mate Alben Barkley, did not give his acceptance speech until two in the morning. For nearly five hours, Perle sat with Bess and Margaret Truman in a sweltering small office at the convention center, waiting for the president to accept the nomination of the disunited Democratic Party.

With his party collapsing around him and the Republicans riding high with Dewey, Truman was considered a dead duck. Pollster Elmo Roper wrote on September 9 that he was suspending polling for the duration of the campaign, announcing, "Thomas E. Dewey is almost

as good as elected to the Presidency of the United States." The Gallup Poll was unequivocal, showing Dewey walloping Truman by a 47 to 39 percent margin, with other candidates—former vice president Henry Wallace and South Carolina governor Strom Thurmond—picking up the remaining votes.

PERLE, WHO HAD given up her Washington rental, retreated to Newport to wait out the election. In this Republican enclave, Perle was ridiculed for wearing a "Truman for President" button by her brother-in-law George Tyson.

In September, the president set off on a cross-country train trip in his bulletproof Pullman car, the Ferdinand Magellan, on what appeared to be a hopeless bid to win a full term in the White House. Despite the enthusiastic crowds who came out to see Truman, political money gravitates to winners, and Truman looked like a loser. His campaign was reduced to the equivalent of searching for stray nickels under seat cushions to keep the Ferdinand Magellan chugging.

"The Democratic party was down to almost its last cent," recalled International News Service reporter Robert G. Nixon. "Word got around that we were going to have to call off the campaign trip. The train would be broken up and we would have to make our way back to Washington on our own."

Those fears triggered one of the most important phone calls of Perle's life. She was at a Newport dinner when she received an urgent call from Louis Johnson, the president's campaign finance director. He confirmed to Perle that the campaign was on the brink of insolvency. Remembering Perle's ardor as a fundraiser, Truman told Johnson to call Perle and ask for her help.

Perle did not need convincing. She caught a flight from New York and joined the Truman campaign on September 29 in Gainesville, Texas, just south of the Oklahoma border. She boarded the seventeen-car train with about fifty Oklahoma Democratic Party leaders. Given

space at the end of Truman's private car, she sent telegraphs to friends, inviting them to hop on the train to meet the president. She begged, coaxed, and even teared up as she urged them to reach for their wallets.

In Marietta, Oklahoma, two thousand residents greeted Truman; in Ardmore, forty thousand people clogged the streets to see the president speak. The campaign rumbled through six Oklahoma towns as it headed for Oklahoma City, where Truman was scheduled to give a national radio broadcast. Meanwhile, Perle rattled the tin (or probably silver) cup for Truman.

India Edwards, onboard the train, recalled seeing Perle make a convincing pitch to Oklahoma friends, telling them, "I have just been back with the President. Isn't he a wonderful man? Nobody could have done this but him. He is going to win, you know. I've come down from Rhode Island and there is a prairie fire raging for him up there."

Finance chair Johnson recalled Perle's optimism. "Almost nobody thought Truman could win except Truman and Mesta. When our crowd got discouraged . . . Perle Mesta would raise hell," he said. "She called us men of little faith. She was a tonic for us—our little pepper-upper. No matter who we asked her to see, she always saw him and usually she brought back the bacon."

In those anxious weeks before the election, Perle allowed herself to participate in a celebration for another friend who bore the title of president. Dwight Eisenhower, whom Perle had known since the 1920s, was installed as president of Columbia University on October 12. Nearly twenty thousand people turned up to see Ike inaugurated on the grounds of Low Library. Perle was seated right behind Mamie Eisenhower. A photograph of the two women looking admiringly at Ike hangs in at the Eisenhower Presidential Library.

That trip was a rare exception amid Perle's single-minded fixation on the 1948 presidential race. On October 28 Perle joined the Trumans on their train in Providence as it headed whistle stop by whistle stop to New York. She came along to cheer up Bess Truman,

who had little of her husband's confidence about the result on November 2.

Things looked bleak. After Truman returned to Missouri to await the returns, the *New York Times* reported, "The rosy prospect of victory for the Truman ticket on election day has no credence beyond Mr. Truman's own kitchen cabinet."

Anticipating an easy Dewey victory, news organizations didn't wait for the final results. The *Chicago Tribune*, jumping the gun with fragmentary early returns, printed 150,000 copies of its first edition with the infamous headline "Dewey Beats Truman." The *Washington Post* published glowing articles about presumed president-to-be Dewey in an early edition.

Perle spent election night in Newport. Surrounded at a dinner by Republicans who were sure their man would win, she excused herself early and went home to listen to the radio. She called Bess Truman, at home in Independence, Missouri, every two hours to check in.

In an election night shocker, Truman beat Dewey by two million votes. Voters rejected the Republican-run Congress, voting in large numbers for Democrats and flipping control of both the Senate and the House. One of the newly elected senators: Texas congressman Lyndon Baines Johnson.

When Truman's victory became apparent, Perle called Bess to ask what the president had to say. Bess laughed and told her friend, "Oh, I haven't talked to him. He went to bed hours ago. He'll be up early, I suppose, and he'll get the news then."

A glowing Perle sent the president a victory telegram: "My heartfelt congratulations. You and Your family alone are responsible for this marvelous victory." The president replied, "I am particularly pleased to receive that fine message you sent me. I know you need no assurance of my gratitude."

That other president—Columbia president Eisenhower—wrote to Perle, noting that she must be relieved by the election results. "Incidentally, I wonder whether you had your blood pressure taken

about noon on November 3rd—if you did it must have shown some remarkable figures!"

PERLE'S FIRST TASTE of victory came when the Democratic Party asked her to co-chair Truman's inauguration ball on January 20. Perle relished the power of the post, as she was largely in charge of deciding who could buy tickets to the 5,300-seat National Guard Armory. She was deluged with requests.

Senators and congressmen wrote to her with pleas for tickets for their constituents, the Missouri Society sent in ten names, White House officials and Cabinet members had to go through Perle for tickets. Even Bess and Margaret Truman requested Perle's help for their friends. Perle had the bright idea of charging Republicans a premium and gleefully showed Truman several checks for up to $3,000 per box. He told her to return the money since he didn't want to gouge anyone. He set the price at $250 per box (equivalent to $3,100 today).

Working out of the Inaugural Committee's offices at the Tariff Building on F Street, Perle was so busy that she began bringing a monogrammed lunchbox containing a sandwich, an apple, and a slice of cake so she could work through lunch. She put a sign on her door reading "Knock. If urgent."

An urgent problem materialized. *Chicago Defender* publisher John Sengstacke and Christine Ray Davis, a staffer for Black Chicago congressman William Dawson, uncovered an effort to keep Black people from attending the inaugural ball. A staffer was covertly omitting reply cards from invitations to Black guests. Perle spent five hours in her office with Sengstacke and Davis, working together to ensure the inauguration ball would be integrated.

Well-connected Republicans took to the newspapers to complain they couldn't get tickets. United Press sent out a story on January 13 claiming that Perle was snubbing Republican hostesses, including

Alice Roosevelt Longworth and Mrs. Edward "Dolly" Gann, sister of former vice president Charles Curtis. One GOP hostess railed: "You have to be a friend of Perle's before you can get an invitation."

Perle disingenuously insisted to United Press that she had no sway, claiming a "secret committee of 20" people screened all requests. This was nonsense, as Lyndon Johnson quickly learned. As Robert Caro recounts in *Master of the Senate*, the third volume of his LBJ biography, the newly elected senator dispatched junior aide Warren Woodward to get extra inaugural ball seats. He met with a woman whose name—he thought—was "Miss Masters." Thrilled at receiving tickets from this minor volunteer, Woodward gushed to her, "I know Senator Johnson will be very grateful, and I wouldn't be surprised if he wants to have a dance with you."

When Woodward reported back to his boss, Johnson broke in to say, "Her name wouldn't be Mesta, would it? You were talking to Perle Mesta."

EVEN AS SHE was toiling away on the inauguration, Perle made time to rent a different residence, Uplands, a spacious redbrick Georgian mansion on a five-acre property at 1800 Foxhall Road. There was a delicious pleasure in taking over this mansion, previously owned by Daisy Harriman, the diplomat-hostess who had never given Perle the time of day. Harriman had been forced to sell the house due to deteriorating finances, and the new owner, a retired diplomat, rented to Perle.

Uplands was a historic preservationist's dream. Built in the 1770s from raspberry-colored bricks imported from England, Harriman had installed antique wood paneling and parquet floors from France and added such American touches as marble tiles from a Capitol Hill hotel where Andrew Jackson and Daniel Webster once lived.

Although Perle's sister Marguerite and brother-in-law George Tyson were devout Republicans, they were hungry for conversation after

the tedium of Arizona ranch life. The couple moved in with Perle for an indefinite stay, along with Marguerite's daughter Betty and grand-child. Marguerite made herself useful by stage-managing Perle's parties.

Perle was setting up her personal headquarters just a few blocks from Gwen Cafritz, who lived in a hilltop marble and mirrored modern house, built by her developer husband. In the cloistered environment of Washington, the two women had often been in many of the same rooms. Gwen was frequently described as an elegant beauty in contrast to Perle, whose yo-yo dieting efforts were chronicled instead.

The already chilly relationship between the two women went into deep freeze when Gwen asked Perle for inauguration ball tick-ets. Perle turned her down for reasons that were likely more political than personal. In her eyes, Gwen and her husband were Republicans who enthusiastically backed Dewey. Aware that Perle would soon be living nearby, Gwen tried to make nice by saying, "Now that you're a neighbor, I suppose I'll be seeing more of you." Perle's tart reply, "I suppose not."

Gwen was furious. Thus began a bitter rivalry that would last a decade, with Gwen making nasty comments about Perle at every opportunity and newspapers gleefully printing them.

FOR HIS NEW term in office, Truman was certain to revamp his Cabinet plus appoint a flock of new diplomats, but there was no indi-cation he would break with his unwritten policy of only choosing men. Globetrotting columnist Dorothy Thompson reported from Wash-ington: "Women here are glum over the chances any of them have to get important policy-making posts in the Truman Administration." India Edwards compiled a list of twenty women with leadership capacity, but she wasn't optimistic that Truman would take her advice.

The rumors swirling about Perle at that time had nothing to do with higher office—unless one counted the possibility of marry-ing into it. Syndicated columnist Cholly Knickerbocker breathlessly

announced: "The hottest rumor from Washington is that Mrs. George (Perle) Mesta, Washington's first hostess and President Truman's best pal, may marry Vice President Alben Barkley. Both of them are unattached and have been friends for years."

Perle enjoyed the column item, making coy references to "my beau" but declining to confirm or deny the story. The *Philadelphia Inquirer*'s Elise Morrow, who knew Perle well, wrote, "The Vice President is a thoroughly sweet, warm-hearted, universally beloved man . . . It is not the opinion of those close to either one that they are involved romantically." However, Morrow hedged her bets, adding that it was impossible to know what was going on "so it is just possible they might run off to a justice of the peace tomorrow." They didn't.

THOUSANDS OF PEOPLE poured into Washington for Truman's inauguration. Trains into the city were jammed, and hotels and restaurants were fully booked since even those without ball tickets wanted to be there for impromptu celebrations.

In his inaugural address on January 20, the always underestimated president reiterated campaign themes, denouncing communism as the enemy of world peace and vowing to support the United Nations.

Wearing jaunty top hats, Truman and Vice President Barkley rode together in an open car down Pennsylvania Avenue to the White House, followed by a two-hour parade of marching bands and state floats. An old-time circus calliope played "I'm Just Wild About Harry." Police estimated the crowd at one million people.

That evening, as the Marine Corps band played "Hail to the Chief," Perle made a grand entrance at the ball on the arm of President Truman. Photographers captured Perle beaming with joy, wearing an elegant ivory satin gown with gold brocade, diamond clips, and elbow-length white gloves.

Listening to bands headlined by Guy Lombardo, Benny Goodman, and Xavier Cugat, Perle sat with friends in her VIP box. Perle

loved to dance, but that night she was too tired from the preparations to even claim her whirl around the floor with Lyndon Johnson. She was content to watch others revel in the ball she had worked so hard to perfect.

Perle had much to be proud of. In a historical sense, almost nothing was as important as the story in the *Chicago Defender*, one of the nation's leading Black newspapers. "Breaking a long-standing national precedent, Negroes participated on a completely integrated basis in all activities—invitational and otherwise—attending President Truman's inauguration as the 33rd President of the United States. More than one hundred Negroes were present at the Inauguration Ball where they danced without racial segregation and enjoyed all the courtesies extended ball guests." Perle played only a small role, but she helped make it an integrated celebration.

Just Reward, or Government by Crony?

Harry Truman wanted to give Perle a tangible reward, but the president's first effort was insulting—he named Perle to a useless body, the Assay Commission, which monitored the metal content of coins. This twelve-person group met yearly to ostensibly assess the legitimacy of coins made at federal mints. Commission members were given a box filled with dimes, quarters, and half dollars and watched as the Bureau of Standards director weighed a selection to measure silver content. As a perk of power, this was on par with being allowed to go to the front of the line for a White House tour.

She accepted the appointment gracefully, but it scarcely occupied much time. Accustomed to a workaholic life on behalf of the Democratic Party, Perle agreed to chair the Democrats' major fundraising event again, the Jefferson Jackson Dinner on February 24. Perle was also helping plan the National Woman's Party's spring Washington convention. With a new Congress about to be sworn in, the group could try—again!—to pass the ERA.

In recognition of Perle's organizational skills, the *Washington Post* asked her to write a guest essay, which was published with an understated headline: "And Still the Wonder Grows That Amazing Mrs. Mesta Can Handle Such Big Shows."

The revealing article offered a rare window into her motivations. Perle confessed that she deliberately structured her life to have no free time. "The conviction that 'only the busy person is happy' is part of my inheritance, for it was part of my father's philosophy," she wrote. "I have found that a busy woman in Washington never has time to bother about whether she is happy . . . Personal problems are forgotten in the welter of plans, pressure and politics attendant on bringing any event, any project, to a credible conclusion."

It was an intriguing public confession: Was Perle happy? Or was she assuaging her middle-age loneliness by staying so busy that she had no time to brood? Convinced that no one would love her the way that George Mesta had, she constructed a life in which people surrounded her from dawn to dusk. Juggling mile-long to-do lists, she could take satisfaction in useful work.

Perle defended her handling of the inaugural ball tickets. In her essay she insisted that she was not on the secret committee that ruled on ticket requests, but admitted that she had the power to make wishes come true. "Pressure for tickets continued unabated until the late afternoon of Inauguration Day," she recalled. "The last invitation I managed to wangle was for a stranger from Nevada who haunted my office for hours."

To avoid the identity that had started to feel like an epithet—party giver—she ardently discussed the Equal Rights Amendment, describing her efforts "trying to persuade members of Congress that women were people and that working women should have equal pay, equal consideration and equal—not specialized—protection with working men." She went out of her way to thank Sarah Pell for recruiting her to the cause. She had not forgotten her friend.

Embedded in the article was a sentence that seemed designed to be read at 1600 Pennsylvania Avenue. "Never have I had a desire to hold political office," Perle claimed, "but I regard it as a high privilege to work with, and for, some of those who do."

There were intimations that Perle might have more interesting opportunities than the arduous and vital work of the Assay Commission. On February 14, *New York Daily News* columnist Danton Walker ran this well-sourced item: "Mrs. Perle Mesta, Washington's Democratic fundraising hostess, has been sounded out on the prospect of accepting a diplomatic post."

A plugged-in reader might have detected the artful hand of India Edwards, who was pressuring Harry Truman to appoint women. India had already approached Perle to determine her interest in an ambassadorship. Perle's immediate reaction: "That's ridiculous. Why, I don't know the first thing about diplomacy."

But incredulity soon gave way to a sense of possibility. "She thought of a diplomatic appointment as being a sort of prize, a reward for political work," Edwards recalled. "She didn't want a prize and thought it wasn't necessary to give her a prize or a reward. But after she thought it over, she said that if it was felt there was a job she could do, she ought to consider it."

As the embassy rumors persisted, Perle was offered an honor that she could not decline. She was asked to make the opening remarks at the Jefferson-Jackson Dinner. Perle had spoken at women's events, but this would be her first appearance before every powerful figure in the Democratic Party. She plunged into research at the Library of Congress about the lives of Thomas Jefferson and Andrew Jackson.

All of this work during the day did not stop Perle from entertaining constantly at Uplands. With the help of Marguerite and a staff of nine, Perle honored Ike and Mamie Eisenhower at one dinner and, a few days later, built an evening around inseparable friends Supreme Court chief justice Fred Vinson and his wife Roberta. Perle was planning three more dinners after the Jefferson-Jackson fundraiser, celebrating House Speaker Sam Rayburn, new vice president Alben Barkley, and Oklahoma musical producer Lawrence Langer.

In an attempt to play matchmaker, Perle put Margaret Truman together with a handsome, rich Massachusetts congressman with a promising future—John Fitzgerald Kennedy. "I thought it would be very nice if they got married," Perle told a reporter years later. "Margaret even sang for him and we went to concerts together."

Perle arranged an outing for Margaret, Jack Kennedy, Perle's brother O.W. Skirvin, and Margaret's friend Marvin Braverman. After a buffet dinner at the home of a Vanderbilt, they attended a benefit performance of the Ice Capades. Margaret described the gathering in her journal as "lovely." Kennedy kept accepting Perle's invitations.

On the night of the Jefferson-Jackson Dinner, Perle, in a red satin dress, was seated in the honored spot at President Truman's right in the Mayflower Hotel's Crystal Ballroom. The president was overheard kidding Perle about her rumored romances with both Alben Barkley and House Republican leader Joe Martin. The sixty-six-year-old blushed and laughed before diverting the conversation to gossip about the Democratic Party.

When it came time to give her speech, she refreshed her lipstick, powdered her face, and stood up. As she uttered her first words, the amplifiers in the public address system conked out. Perle stopped midsentence and awkwardly waited during a failed search for a handyman. Finally realizing that she would not be rescued by technology, she gamely pressed on with her unamplified speech. The jovial, tipsy crowd ignored her and chattered away, drowning out her remarks.

President Truman immediately understood the blow to Perle's ego. He was on his feet as soon as she finished. "I was most highly pleased with the speech of Mrs. Mesta," he told the crowd. "If that is her first effort at a political speech, I wonder what she will do ten years from now. My first effort at a political speech would not be printable—or quotable."

The next day, Perle returned to the Mayflower Hotel for a lunch with board members of the National Symphony Association. At 2:30 p.m., she met with members of another charitable board. A little after

3 p.m., Perle indulged her true passion—sitting down with members of the National Woman's Party to discuss the upcoming convention.

Then she raced home to Uplands to change clothes and join President Truman at the Statler Hotel reception for seven hundred out-of-towners who had attended the Jefferson-Jackson Dinner. With Bess Truman shunning the spotlight, so many people mistakenly greeted Perle as "Mrs. Truman" that she and the president began to wink at each other in jest.

PERLE'S PROXIMITY TO power brought perks and pitfalls. *Time* magazine—at the height of its influence and power—decided to do a cover story on Washington entertaining, centered on Perle. This was flattering, but when Perle initially agreed to cooperate, she didn't realize that swarms of *Time* reporters would be investigating her entire life.

Two days after the Jefferson-Jackson Dinner, Perle returned in the late afternoon to the Mayflower Hotel for a preliminary meeting with *Time* reporters Jim Bell and Alyce Moran. This was not an ideal moment to present herself to the world's leading newsmagazine, since Perle was exhausted. She had just come from a formal lunch and tried to refresh herself by having chauffeur Frank Toomey take her for a quick ride in her Packard limousine around the Tidal Basin. She told the reporters, "I have to get out away and lay back in the car. I need the fresh air. I'm terribly tired."

Perle was already having second thoughts about the potential *Time* article and balked at the reporters' questions. She refused to reveal her age, discuss how she met her husband, provide information on her finances, or answer other personal questions. This was not the kind of friendly treatment she was accustomed to from society columnists. She told the *Time* writers she didn't understand why they wanted her on the cover anyway. "Because you are an important person," the writers replied, wheedling for her cooperation.

Perle's mood brightened when she was asked about her role in the Democratic Party. She made it clear that she viewed herself as influential, saying, "I am a politician first. After that I am a hostess and a diplomat. You have to be a little of each. The entertaining I do is my way of serving the president and the party."

She couldn't resist bragging that people were aware she could pick up the phone on a whim to chat with the president. "They all know that I can get to the White House anytime I need to. Lots of them try to pump me to find out who's going to get fired and who's going to get hired." She leaned over and winked at the reporters. "Probably I know who's going to get the job. But I don't tell. I just act dumb."

Perle explained that the president knew she had helped save his 1948 campaign. "When things were the very darkest, I went out on a moment's notice and went through Oklahoma and Texas raising money. No train was going to stop and no broadcast was going to be called off while I was around."

Her role as the president's "unofficial hostess" was complicated. "I have to know exactly what's on his mind and what he thinks of people all the time," she said, and winked yet again. "I know, too. I don't have to call and ask."

The reporters admired her diamond ring, and she obligingly handed over the fifteen-carat bauble so they could take a closer look. After sipping her Coke, she announced that she had to leave. But she grudgingly agreed to a follow-up interview.

After the meeting, *Time* reporter Jim Bell wrote a detailed memo to his editors in New York, describing the conversation. With withering words, Bell made clear his scorn for the woman considered Washington's number one hostess.

"Perle Mesta is a dumpy little woman who looks like the wife of the President of the Chamber of Commerce in some small Midwestern City. She looks like she's had four children and now they are gone from home and she is free. She is 5 feet 5 inches tall, keeps 140 pounds

of flesh tightly laced up in a corset. Her eyes are a pastel blue, seem vacant. The flesh in her face sags, particularly around the lower jaws."

Paragraph after paragraph, Bell piled it on, hoping to impress his editors with his venom. "Her voice, while not actually coarse, is by no means appealing," he wrote. "She tends to drawl in the Southwestern manner. Her use of language is jerky. She salts the conversation with 'they was' and 'I'm agoin'." Responding to the romantic rumors that swirled around Perle in her midsixties, Bell sniffed, "Linking Mrs. Mesta with anyone and a bed seems highly improbable."

Time prided itself on the intensive research that went into cover stories. Reporters were dispatched to Perle's haunts (Oklahoma, Texas, Pittsburgh, Newport, Michigan, and even London). Time correspondents spoke to rival Washington hostesses, who sharpened their claws at the chance to take Perle down, although they insisted their names not be used, just their critical quotes. These reporters filed memos, which served as grist for the cover story to be written by a desk-bound New York writer who would never meet Perle.

The material paints a vivid portrait of the envy and ridicule that accompanied Washington society. Pioneering diplomat Daisy Harriman, who used to own Uplands, labeled the Truman confidant a climber. "She's a little like that woman in *Vanity Fair*," said Harriman. "But no, Becky Sharp had intelligence. This woman hasn't. But she's a schemer." She added that Perle had "a hide like an elephant."

Alice Roosevelt Longworth professed to be amused by Perle's ambition. "She's so full of deportment. She's almost a Helen Hokinson character," she said, referring to the *New Yorker* cartoonist known for mocking matronly New York society women. She acknowledged that Perle was considered the city's top hostess, but added, "I don't know why."

Lady Astor, given the opportunity to weigh in from London, did so with a vengeance and told the reporter to use her name. "She's excessively, excessively vulgar and gives enormous parties that nobody who's anybody really ought to go to, and that she's frightfully second rate."

Perle's allies went to bat, describing her as warm, generous, and energetic. Novelist Louis Bromfield came through with sincere praise. "She's really a frontier gal with a lot of money," he said. "She gets the damndest mixture of people at her parties. Most American hostesses don't have that sparkle. They all have to have money, in order to entertain you. Perle doesn't need the money, she could give you a good time if she only had a five-cent beer."

India Edwards spoke admiringly of Perle's prowess as a Democratic fundraiser. "She uses a psychological approach," Edwards explained. "She will start a conversation about what a great man President Truman is, how he is doing a fine job for the country. She'll point out how prosperous everybody is, and the first thing you know she will have the victim agreeing with her that he never made so much money in his life. When agreement is reached, she makes the touch. The prospective donor . . . is too embarrassed to turn Perle away. So he takes out his check book."

Time's efforts to fill in Perle's pre-Washington background often hit a dry hole. A reporter sent to Galveston wrote, "Practically no one remembers Pearl." An Oklahoma dispatch described Perle's father as a colorful character "who didn't go in for any of this fancy society stuff."

In Pittsburgh, a reporter researching Perle's relationship with George Mesta wrote cruelly and probably inaccurately "there is innuendo that theirs was not the perfect marriage . . . George furthermore is rumored to have a very tenacious mistress in Pittsburgh, who refused to be dropped when he married Perle. George's carrying on was too old worldly for the Pittsburghers, say the gossips, so the Mestas were never quite 'accepted.'"

Time never acknowledged a glaring contradiction in the portrayal of Perle by its reporters as an uncouth hick. If Perle was Annie Oakley without a gun, how did this woman with her parvenu background conquer Newport, which was far more aristocratic and snobby than Washington?

The reporting from Newport cast her in a glowing light. *Time*'s James Edward discovered that Perle had done an admirable job of breaking into society. "She moved in quietly, winning her way gradually to the top through her very fine personality, her very prominent guests and her large but not showy parties . . . All doors have swung open for her in the last two years."

Dr. Anthony Sindoni, the dapper Philadelphia diabetes specialist who was Perle's frequent escort, told Time that he met her roughly eight years earlier through a mutual friend, former Arizona senator Ashurst. "I liked her from the start. She was plain and simple and friendly." Well, maybe not so simple. He added, "If you're her friend she'll do anything for you but don't cross her path. She'll never forget it." Often seen on Perle's arm, he didn't believe she had a romantic companion: "I don't think there's a man in her life."

WEARING A STYLISH black dress, black coat, and black hat, Perle was feeling and looking perkier when she met *Time* reporter Alyce Moran at the restaurant La Salle du Bois. As Moran, a rare woman at *Time* in those days, wrote to her editors, "She looked good—a little less tired. Her eyes were bright, she looked freshly made-up, and her newly permanented hair curled softly out from under the brim of the hat."

Perle arrived with a strategy, hoping to convey that she had clout with the magazine. She heavy-handedly mentioned her long friendship with Clare Boothe Luce, wife of *Time* founder and editor Henry Luce. But when Moran asked follow-up questions, Perle bristled. "I tell you, I'll never go through this again," she said emphatically. "It's too grueling—all these questions! I don't want this story, I don't need it, and I would rather not have you do it. I DON'T GIVE A DAMN ABOUT THE STORY."

Irritated by the questions about her social life, she was frustrated that no one asked about her work for the National Woman's Party

and how she boldly inserted the ERA into the Republican platform in 1940. Perle insisted, "My life is not just party, party, all the time."

ARRIVING IN THE mailboxes of more than one million *Time* subscribers during the week of March 7, 1949, the headline on the red-bordered magazine read: "Washington Hostess Perle Mesta." The flattering cover illustration depicted Perle with a knowing smile, eyes gazing into the distance. She was wearing an elegant gown set off by diamond earrings, large diamond clips, and a triple strand of pearls. In the backdrop, the Washington monument had been turned into a candelabra to symbolize her party-giving persona, while a tiny oil rig was inserted on the lawn to hark back to the original source of her wealth.

The article inside—"Widow from Oklahoma"—began with a chatty description of Perle's recent dinner at Uplands for Vice President Barkley, noting that her guests provided the entertainment by singing "My Old Kentucky Home."

And then the knives came out. After anointing Perle "the capital's No. 1 hostess," the four-and-half-page story portrayed her as a "hearty good fellow type of woman" lacking wit or charm. After detouring to a lengthy history of Washington hostesses, the magazine returned the focus to Perle in a very personal way. "Her figure requires strict corseting; she carries a diet book in her purse, consults it before ordering. Except for her parties, she hates to spend money."

The article called her out for lying about her past, noting that Perle liked to describe her quaint Oklahoma childhood but she "did not come to Oklahoma until 1906, when she was a full-blown dark-haired woman." Her father was described as "a brash stubby, little cockerel" and "scoundrel" who took advantage of the "poor suckers" who bought real estate from him in Alta Loma, Texas.

Discussing her marriage to George Mesta, the story said she affectionately referred to him as "the wop"—an insulting moniker

that no one in her milieu had ever mentioned. The magazine detailed her financial feud with her father, estimating that Perle received a $400,000 inheritance (nearly $7 million) two weeks after her father's 1944 death.

Perle was depicted as a woman who craved acceptance in Washington society, with lines such as "Perle Mesta began her final assault on Washington in 1941 . . . Either with rare good luck or uncanny generalship, she ingratiated herself early with Harry Truman." She was credited as "a money-raising extraordinary" and her "tireless" lobbying for the Equal Rights Amendment got a brief mention. The story mocked her self-image as an important political player. "Perle's conception of herself as a combination Machiavelli and Madame de Stael makes White House aides smile quietly."

Ending on a positive note, *Time* wrote: "Rich, gusty, vigorous Perle Mesta obviously served Harry Truman well as Washington's No.1 hostess and Truman was obviously grateful. It seemed a very satisfactory arrangement for both."

The cover story was the talk of Washington. Perle never commented publicly but friends did so on her behalf. King Features columnist George Dixon wrote, "Mrs. Mesta did not make any loud complaints but she was pretty hurt. The thing was malicious, filled with inaccuracies, half-truths and slick innuendo."

Advise and Consent

Harry Truman had finally realized there could be a political plus in naming a female diplomat. But Perle was not on his list. On March 24, 1949, while *Time*'s Perle cover story was still on coffee tables all over America, Secretary of State Dean Acheson wrote in a memo, "The President would like us to consider with either Denmark or Luxembourg the appointment of some outstanding woman. He suggested that we give careful consideration to the appointment of Mrs. Eleanor McAdoo."

The daughter of President Woodrow Wilson, the divorced McAdoo gave frequent speeches promoting her father, still a revered figure in the Democratic Party. But despite the initial flurry of interest, McAdoo's name did not move forward.

Meanwhile, India Edwards kept pressing for Perle. Harry and Bess Truman "had been astonished when I had suggested in 1949 that he appoint Perle as minister to Luxembourg," Edwards wrote in her autobiography, *Memoirs of a Woman in Politics*. "She was their friend, they liked her, but they never would have thought of her as fitted for a diplomatic career, nor would they have supposed that she would be willing to be a diplomat in one of the smallest countries in the world."

Aware her future was being debated offstage, Perle kept going at her usual breakneck pace. When the National Woman's Party held

its three-day convention in Washington in early April, Perle loyally attended the meetings. After attorney general Tom Clark enthusiastically told the group that he supported the ERA, National Woman's Party chair Anita Pollitzer announced, "Victory for the Equal Rights Amendment is in sight."

But the opposition remained strong. The *Washington Post* editorialized against the bill, listing prominent organizations (the League of Women Voters, the National Council of Catholic Women, the National Council of Jewish Women, and the National Council of Negro Women) that feared the ERA would eradicate protective laws and was "a threat to women rather than a benefit."

By the end of April, the rumors about Perle's future reached fever pitch. Drew Pearson, America's most widely read syndicated columnist, delivered a beat-the-competition scoop: "Wealthy oil heiress Perle Mesta, social arbiter for the Trumans, will shortly be rewarded by an appointment as First Lady ambassador to either Denmark or Luxembourg."

Truman gave no public hints about his diplomatic plans for Perle, but he did signal her full membership in his inner circle. On April 30, Perle gave her annual dinner for the Truman family, attended by the entire all-male Cabinet and their wives. She seated herself between the president and vice president. Still trying to spark a romance between Margaret Truman and Jack Kennedy, Perle put them next to one another. The president played the piano and lingered until 1 a.m.

Days later, India Edwards asked Perle point blank: Would you take the job as minister to Luxembourg? President Truman had decided to offer Perle the post but didn't want to ask her directly for fear of a turndown. He asked India to play intermediary.

Perle was normally decisive, but she felt conflicted. Her sister Marguerite urged her to go for the challenge and the adventure; her brother O.W. tried to convince her to remain in Washington, concerned her outspoken persona would get her into trouble. Perle

worried that she didn't speak any of the country's languages (German, French, Luxembourgish) and lacked diplomatic experience.

The Grand Duchy of Luxembourg is smaller than Rhode Island, but the American envoy would face daunting challenges. With the political stability of Western Europe in doubt due to the Communist threat, Luxembourg occupied a strategic location bordering Germany, France, and Belgium. The country had been devastated by four years of Nazi occupation, with more than ten thousand Luxembourg men conscripted into the German armed forces, executions of striking workers, and the decimation of the duchy's Jewish community.

The six-week Battle of the Bulge, the final Nazi offensive of the war in which nineteen thousand Americans died, began in December 1944 in the freezing Ardennes forest that spans Luxembourg, France, and Belgium. Many Luxembourg villages were destroyed. The postwar period in Luxembourg brought with it hunger, uncertainty, and the prosecution of German collaborators. In 1949, US legation was still trying to weed out local employees who had been Nazis or collaborators.

Up until then, the American ambassador to Belgium had supervised Luxembourg diplomatic matters. Truman decided the duchy was important enough to warrant its own American envoy, although the US emissary would be a minister rather than an ambassador, with a lower rank and salary.

Perle recognized her limitations. An envoy would need to be knowledgeable about foreign policy, but Perle had never been much of a reader and was not about to start consuming detailed policy memos. But she grasped that there would be veteran career diplomats to handle that sort of thing. She was people smart, not book smart. If President Truman thought she could be the face of America in Luxembourg, a warm and welcoming presence, this was a role she could comfortably take on. She said yes.

Perle gave up her lease on Uplands and moved into the Sulgrave Club to wait things out. Still, the president dragged his heels on making an official announcement. On June 6, Truman made his first

nomination of a woman for a high-level federal post: Democratic activist Georgia Neese Clark, president of Richland State Bank, her family's bank in Kansas, was chosen as the United States treasurer. Since she was a college graduate and bank executive, her qualifications were not questioned.

As Perle waited to be officially appointed, she could not publicly acknowledge that she was duchy-bound. When columnist Inez Robb ran into Perle at a Manhattan wedding, the journalist tried to get Perle to confirm the rumors. "When do I start addressing you as Madame Ambassadress?" Robb asked. Perle's reply: "Oh, come now, you know I can't answer such questions." Robb pressed on, asking, "If I get to Europe this summer, will you put me up at the embassy?" Perle's pretend-innocent reply: "Are you going to Europe, too? Why, isn't that a coincidence. You too!"

Finally, on June 21, President Truman announced that Perle was his choice as minister to Luxembourg. Sensitive that the appointment would be perceived as a political payoff, Perle told the *New York Times*, "I didn't expect anything, one single thing. I worked in the campaign because I believed in the President and his principles."

American journalist Marie Ridder recalled the reaction to Perle's appointment. She was living in Paris then with her husband Walter Ridder, who was working for the Marshall Fund, dispersing US dollars to war-torn Europe. She told me, "The regular foreign service people were stunned. Their remark was—Luxembourg is very small. Everyone correctly said, she'll hostess a lot of people and they'll love that. They'll love that she puts on a party."

Perle gave a heartfelt interview to Oklahoma journalist Malvina Stephenson, explaining why she was abandoning Washington for a postage-stamp-sized duchy that most Americans couldn't find on a map. "How could I be anything but serious with the world in the condition it is today?" Perle said, adding a feminist twist. "Women all over the country want to be represented by a woman in the diplomatic field. That's the main reason I want to go."

Perle expressed exasperation that people saw her as one-dimensional. Fingering a stack of newspaper clips, she complained, "I don't want to be known as a 'fabulous hostess.'" That prompted Stevenson to end her article: "So, warning to foreign affairs: Don't discount Mrs. Mesta as a flighty socialite—you might lose your shirt."

But a widely syndicated editorial with the headline "Government by Crony" insisted that "in sending Perle Mesta to Luxembourg the U.S. is sending a social butterfly butter-upper to do a job that a trained diplomatic mind, appreciative of a people's ethnic heritage and culture, requires."

A powerful and oft-quoted endorsement of Perle came from Maine Republican senator Owen Brewster, whose political pedigree gave it more clout than if a Democrat uttered the same words. "She was rich 25 years ago and she's still rich today," said Brewster. "Any man or woman who can stay rich through two wars and all these taxes has something more on the ball than social grace. She is neither senile nor a dipsomaniac, which is more than you can say for some of the members of the diplomatic corps."

During the next few weeks, Perle made daily trips to the State Department for briefings about Luxembourg's history and economy plus a crash course on the basics of her diplomatic responsibilities. She would be meeting with Luxembourg's top leaders to represent America's interests, assess the European country's needs, and report back to the State Department. Perle had never supervised government employees before, but her new job required managing the legation's employees, a mix of career diplomats and local hires.

Perle's nomination sailed through the Senate Foreign Relations committee, chaired by her frequent party guest, Texas senator Tom Connally. Her official biography submitted to the committee listed her birth year as 1891—nine years after she actually entered the world. Perle took Elise Morrow to lunch at the Sulgrave Club to celebrate. To her dismay, Perle was greeted with hostile, jealous jibes. "Mrs. Mesta's entrance into the fashionable, light turquoise dining room

was the signal for a cats' field day," wrote Morrow. "It was an historic entrance like a scene from 'The Women.'"

That was a perfect pitch reference to the 1936 stiletto-wielding society play by Perle's sometime friend Clare Boothe Luce. The women at the Sulgrave Club purred "Congratulations" to Perle and then badmouthed her when she was scarcely out of earshot. Perle did her best to appear unaffected. She told Morrow she wasn't worried about Senate confirmation: "Of course they'll criticize me, but, after all, what can they say? The worst they can is 'rich dame who likes parties.'"

Perle accurately pegged the July 5 discussion on the Senate floor. Missouri Republican senator Forrest C. Donnell went after Perle in long-winded fashion. "So far as I can observe, no proof whatsoever has been brought before the Senate to show that Mrs. Mesta is qualified to perform the duties of the particular office to which she is chosen," he told his colleagues. Laying it on thick in defense of the nominee, Rhode Island Democratic senator Theodore Green replied that steel was an important industry in Luxembourg, and Perle was an expert as a former board member of the Mesta Machine Company.

The final word on the Senate floor belonged to Perle's friend Tom Connally. Mocking Donnell's pomposity, Connally said, "The Senator from Missouri wants a man with striped breeches, and a silk hat . . . Mrs. Mesta is a woman of high character and possesses a great deal of business experience, grace, and the ability to get along with people." On the confirmation vote, Donnell was the lone no.

The night of the Senate vote, Perle joined the Trumans for a quiet family evening. Margaret Truman noted in her journal, "We ate downstairs and came back up and visited until quite late." Following standard custom, the president wrote to Luxembourg's grand duchess Charlotte, singing Perle's praises.

She is well informed of the relative interests of the two countries and of the sincere desire of this Government to cultivate to the

fullest extent the friendship which has so long subsisted between them. My knowledge of her high character and ability gives me entire confidence that she will constantly endeavor to advance the interests of both Governments and so render herself acceptable to Your Royal Highness . . .

<div style="text-align: center">

Your good friend,

Harry S. Truman

</div>

Perle's confirmation sparked jokes speculating about who would be the next woman given an embassy. When actress Tallulah Bankhead, daughter of late Speaker of the House John Bankhead, attended a reception for Perle, a reporter asked, "Where would you like to go as ambassador?" Bankhead knowingly responded, "I wouldn't have the money."

That is the fact of life in the foreign service, both then and now. Ambassadors receive a government salary augmented by a minuscule entertainment budget, although they are expected to regularly host local officials for lunches, cocktails, and dinners. Appointees have to pay for everything else—food, wine, and entertainment for embassy parties, and salaries for any additional staff they wish to hire. Career State Department ambassadors are typically sent to poor countries, while political appointees—wealthy friends and supporters of the president—head to glamorous European embassies, since they can afford to subsidize the living costs.

Perle would receive a $17,500 yearly salary (roughly $219,000 today) and a mere $3,000 entertainment budget for an entire year. For a woman who spent up to $5,000 for a single Washington party, the government subsidy was a pittance. She was planning to bring her own retinue—chauffeur Frank Toomey, butler Garner Camper and his wife Edna, her maid, her secretary, and other employees. Perle's sister Marguerite had agreed to join her in Luxembourg to run the residence so Perle could focus on work. Marguerite's husband, daughter, and granddaughter were coming, too. Perle would have a full house.

Perle was sworn in at the State Department on July 9 before 250 people, including Vice President Barkley and several Cabinet members. Wearing a new Hattie Carnegie white shantung suit, a white felt hat trimmed with black, black satin gloves, and her signature three strands of pearls, Perle turned to the photographers and quipped in the manner of an aging celebrity, "You know what to do about my chin!"

Her appointment inspired a question on the Gallup Poll. In early July, the polling organization asked Americans: "A woman has been named by President Truman to be United States Ambassador to the European country of Luxembourg. Do you approve or disapprove of having a woman as ambassador or minister?" In a modest endorsement of feminism, 55 percent approved, while a troglodyte 43 percent disapproved.

WITH PERLE'S DEPARTURE imminent, *Time* magazine decided to prepare a feature on her likely successor as top Washington hostess, Gwen Cafritz. Reflecting the prejudices of the era, writer Jim Truitt advised the New York editors, "The drawbacks to Mrs. Cafritz are numerous in the social sense . . . She is Jewish and Nouveau Riche. These two facts alone preclude any genuine social position in snobby Washington." Perle's ally Elise Morrow told *Time*: "Mrs. Cafritz replace Mrs. Mesta? Why, she's an absolute moron—a tramp dressed in Dior and Elizabeth Arden."

Interviewed at her home, Gwen Cafritz had venomous things to say about Perle. "Why, she came to Washington with a telephone book and a cookbook . . . She never paid taxes or owned real estate here. She just came flying out of the outhouse, where she'd found an oil can. If you said intellectual integrity, I doubt if she'd know what you meant. I don't think she matters."

Time ran a four-paragraph item, "Life among the Party-Givers." Gwen's "outhouse" and "intellectual integrity" comments were excised

but the rest of her vitriolic comments toward Perle made it into *Time*. The magazine's sister publication, *Life*, ran a five-page party photo story in the August 1 issue, "Gwendolyn Cafritz Makes Her Bid." In a gratuitous put-down of a certain newly named US envoy, *Life* stated: "Mrs. Cafritz in her 40's looks more like an attractive charming hostess than Perle Mesta ever did."

PERLE SQUEEZED IN a final trip to Newport. Failing in her annual attempt to lure Harry and Bess, she did hook their daughter Margaret, who accompanied Perle via train and chauffeured car. "I have a lovely room with two bay windows, overlooking the ocean," Margaret wrote in her journal. The next day, she wrote, "Went wading in the ocean, got some sun. We went to lunch at Mr. Frederick Prince's home, Marble House. It is huge and magnificent and all the marble inside looks like a palace. Also saw Vanderbilt estate, the Breakers, which is so ornate that you don't believe it when you see it."

To give twenty-five-year-old Margaret a taste of her own generation, Perle took her to a Saturday night ball, where the president's daughter danced the night away. The next morning, Margaret was treated to breakfast in bed, followed by lunch at the Clambake Club and more visits to grand mansions. As Margaret wrote in her diary, "I've seen so many homes, I'm house happy."

Perle couldn't leave America without one last round of Washington going-away parties. Lady Bird Johnson would fondly recall a reception for Perle on the presidential yacht, the *Sequoia*, which she described as "one of the glittering events of that year."

India Edwards gave a reception for Perle and new treasurer Georgia Neese Clark at the Carlton Hotel with Bess Truman in attendance. Alerted that three Black women would be among the guests, the hotel cited its policy forbidding interracial events and tried to get the three uninvited. The hosts threatened to move the party elsewhere. At this

fraught time of transition in Washington, the Carlton Hotel caved and the party went off as planned.

The National Woman's Party gave a reception for Perle on the large lawn of its Capitol Hill headquarters, the Alva Belmont House. More than 150 members of Congress attended the feminist send-off. She had a final meeting with President Truman, returned to Newport for a few more days of ocean breezes, and finally—yes, finally—it was time to go.

On August 16, Perle stepped onto the steamer *America*, the queen of the United States lines. In addition to fifteen pieces of luggage, she brought dozens of cases of her favorite beverage, Coca-Cola, plus her Packard. The First Lady, the chief justice of the Supreme Court, and a large Washington delegation came to New York to see her off. The Eisenhowers sent Perle a telegram, and Ike followed with a note: "Mamie and I were sorry that we could not have been in New York when you sailed to assume your new duties, although I am certain friends were not lacking in number." Indeed, there were eighty guests at the farewell luncheon. When Bess Truman arrived at the stateroom and saw the crowd, she exclaimed, "Is there anyone left in Washington?"

Photographed standing between Bess and Margaret Truman, holding their hands, Perle gave a radiant smile. The guests disembarked, and the ship left the mooring. When no one could see her, Perle stood at the rail with America receding in the distance and burst into tears.

Lost and Found in Luxembourg

After Perle's boat docked in Le Havre on August 23, she was
chauffeured the three hours to Paris. Checking into the Ritz
Hotel at 4 p.m., she discovered the State Department had invited
reporters to meet with her for a 1 p.m. press conference. Cranky over
the long wait, the journalists pounced on the flustered Perle.

The questions, mostly from Paris-based reporters for American
newspaper and wire services, were midway between patronizing and
vicious. In an opening salvo, a reporter asked, "Is this your first job of
work or have you ever done any work before?" Following up in a nasty
tone, he added, "You know what a job is, Mrs. Mesta; you go to work
in the morning, work all day and get paid at the end of the week."

Perle responded sweetly: "Why, I worked all the time. I am just
about the hardest-working girl that ever came out of Washington."

The reporter pressed on: "What kind of work was that?"

Perle: "All my life I have been working hard for charity balls and
political parties."

Quizzed about her qualifications, she insisted that she had been
fully briefed about her diplomatic post. "I went to the State Depart-
ment every day, except weekends, for three weeks to study about
Luxembourg and the problems that might come up."

Reporters asked about the Washington party scene. "Washington society can be very, very useful if you want it to be," Perle replied in measured tones. "You get people together around a table and before you know it, all problems have been worked out." This is the point where Perle began to get into trouble as she added, blithely, "I hope to do the same sort of thing in Europe through social functions that I performed in Washington."

Her response prompted follow-up questions about Cold War tensions between East and West. Perle blundered through a combination of naïveté and overconfidence. Her fateful words included saying "I will try to help iron out the Cold War by social functions. It might indeed be tried."

Her comments were ridiculed. The Associated Press archly reported: "A few dinner parties, of the kind for which she is famous, might ease the East-West cold war, Mrs. Perle Mesta, new United States Minister to Luxembourg, said today." A Scottish publication quipped: "If Stalin catches on to the approach, the whole thing may be ironed out between cocktails and close harmony duets." Perle's press secretary was forced to issue a clarification: "Mrs. Mesta doesn't expect to solve world problems by giving parties in Luxembourg."

Things were about to get worse. Much worse. The next morning, Perle set off on the 230-mile trip to Luxembourg, with her trusted Irish chauffeur Frank Toomey at the wheel of her Packard. Toomey was following a French driver named Marcel, who worked in a garage near the Ritz and presumably knew the way to Luxembourg. Several autos crammed with reporters followed this two-car caravan. Everyone was expecting a ceremony at the French-Luxembourg border, where Perle would be met by State Department officials.

Luxembourg is the smallest country in NATO, but it was a nation of 300,000 people—it couldn't just vanish like Brigadoon. But Perle and her entourage seemingly pulled it off. Nothing symbolized incompetence more than a fledging diplomat unable to find the country

where she had been posted. And there was the traveling press pack to chronicle every discomfiting moment.

Driving through the countryside, the Parisian driver Marcel took a wrong turn and led the group to the border of Belgium, rather than Luxembourg. No one immediately grasped the error since there were no signs. There was no delegation to greet Perle and the customs officer refused to let them cross the border, since Perle's car had Rhode Island license plates instead of necessary documentation.

The customs officer didn't speak English, Perle's chauffeur didn't speak French, and Marcel's contribution was cursing in French. The situation quickly deteriorated into a shouting match. Perle sat quietly in her Packard, waiting for a resolution of her first diplomatic impasse.

Finally the travelers realized their mistake. The Belgian officials sent the group toward Luxembourg, but Marcel managed to get repeatedly lost. The cars eventually made it to Rodange, the correct Luxembourg border crossing. But the chagrinned border officer explained that State Department emissary Paul West Jr. had returned to the American Legation. With no one to point the way, the group meandered around the city. A policeman helpfully sent them to the Luxembourg foreign office, which was closed. A small boy noticed the seemingly lost cars, called out that he could help, and led them to Perle's new home.

The new minister was mortified. Nonetheless, Perle pulled herself together to give another press conference, this time to a friendlier crowd. When a Luxembourg reporter noted that the duchy was very small, Perle replied, "President Truman is a very warm-hearted man and he thinks Luxembourg is very important. Maybe it's small but we have a saying, pearls come in small packages." That quote received a warm response.

Life magazine reporter John Stanton, who had been part of the caravan, concluded, "For a woman who has just gone to the wrong country, been six times lost in Logwy and twice in Luxembourg and missed her welcoming committee, that was not at all bad."

The next day, Stanton shadowed the new minister. "Mrs. Mesta was up early, spent a couple of hours dictating letters, toured the residence again and discovered there was no piano, sent off a wire to Washington have one shipped to her." She didn't play but wanted the musical instrument for parties. In the afternoon, she visited Luxembourg's agricultural fair and as Perle walked past a hundred pigs, a passerby quipped, "The Americans have cast Perle before swine."

She made a pilgrimage to the American military cemetery at Hamm, paying homage to the grave of General George Patton. Perle understood the symbolic importance of her posting just four years after VE Day marked the Nazi surrender. Although Patton died in December 1945 in Germany from injuries sustained in a car accident, his wife buried him in Luxembourg to be near the graves of the thousands of American soldiers who died during the Battle of the Bulge.

Perle was photographed placing an enormous bouquet of flowers on Patton's grave. She told onlookers, "General Patton was a very dear friend and I saw Mrs. Patton just a few days before I left Washington." From then on, whenever American VIPs visited Luxembourg, Perle took them to the cemetery to bear witness to their country's sacrifice.

Since Grand Duchess Charlotte was in Scotland on a hunting trip, Perle was unable to immediately present her credentials. So she made get-acquainted calls, meeting with Luxembourg foreign minister Joseph Bech, who would be her regular contact. Knowledgeable about steel, coal, trade, and diplomacy, Bech had previously been prime minister for nine years. When the Germans annexed Luxembourg, he fled to London and led the government in exile. In April 1949, Bech went to Washington to sign the treaty establishing NATO on behalf of Luxembourg.

Bech and his family welcomed Perle to their home for dinner. His daughter Betty later told reporters that the American minister's fame was a boon to the duchy, saying, "Nobody knows where Luxembourg is, but everybody knows where Mme. Mesta is."

* * *

PERLE'S BIGGEST CHALLENGE in those early days in Luxembourg was dealing with the enemy within—her adversaries in the legation and the State Department. The clash was inevitable. The State Department's career diplomats were primarily Ivy League graduates who fought in World War II or served during the war at State in Washington, DC. Virtually none of them had ever reported to a woman before, much less an appointed official who had not attended college and was famed for her parties and friendship with the president.

The scornful attitude toward Perle was typified by the reaction of Eric Kocher, labor attaché in the US embassy in Brussels, whose responsibilities included Luxembourg. A World War II Army veteran with degrees from Harvard, Yale, and Princeton, Kocher was appalled by the thought of merely briefing Perle about labor issues.

"First, I tried to deal with the fact that the future Madame Minister was not noted for her intelligence," he wrote in a memoir, *Foreign Intrigue: The Making and Unmaking of a Foreign Service Officer.* After studying her photos prior to meeting Perle, he concluded, "If anything, she looked mean and quite tough . . . I sensed ego, shrewdness, drive, perhaps even a twist of humor."

Perle's greatest adversary—Paul West Jr., the senior American diplomat in Luxembourg—begged for a transfer to avoid working for her. The Stanford graduate, who joined the Foreign Service in 1938, was posted to Sweden during the war to monitor German activities, and then sent to the State Department in Washington to work on Cold War issues. In 1948, he was promoted to Luxembourg as chargé d'affaires, which entitled him to live in the residence and carried serious policy responsibilities.

"I was brought intensively into all the preparations for NATO, for the western European union, the Western European army and sent to Luxembourg," West said in a 1990 oral history. "The headquarters for the European Army was established here . . . Here I was, a junior officer, at a very lovely residence." But suddenly his fairy-tale

existence in a fairy-tale European capital came to a shuddering halt. "President Truman, in his infinite wisdom and on the advice of his wife, sent Perle Mesta to Luxembourg . . . She was the most gauche person you can imagine."

West turned to everyone he knew in his desperation to escape, even contacting General Douglas MacArthur in Tokyo, recalling, "I was ready to get out in a hurry." He had to get out of the mansion in a hurry so painters and carpenters could spruce it up for Perle. In a self-pitying tone, West likened his plight to that of a war refugee, saying, "I was a DP," an acronym for *displaced person*. Adding to West's problems was a bureaucratic delay in finding his replacement. He remained in Luxembourg for more than six months, demoted to the title of "first secretary."

The tone of their dysfunctional relationship was set at their first meeting. West suggested to Perle that she confine her activities to giving dinner parties while he, an experienced diplomat, ran the legation. Stunned by his tone, Perle made clear this proposal was unacceptable. But she recognized it was premature to bring out the heavy artillery. She didn't want to begin her career as the first female diplomat in this administration by complaining to President Truman. Late in her tenure in Luxembourg, Perle did write a scorching ten-page letter to Truman, describing her toxic relationship with West.

In that letter, she gave a firsthand account of their early conflicts. "It was soon apparent that Mr. West did not approve of me nor of my actions," she recalled, seeing the matter in feminist terms. "It was obvious that his advice was colored by the fact that I was a woman and he felt I should stay in the Legation residence to entertain only, so I decided that it would be better for me to follow my own intuition and use my own judgment."

Perle went on to explain her strategy. "Mr. West showed great surprise when I went into the office every morning between 8:30 and 9 o'clock . . . He told me that this was not necessary and he could easily handle the office . . . he resented the fact that I showed an interest in

what went on the Legation and that I asked to be briefed on all official actions taken by the officers."

TWO EARLY NEWSPAPER stories about Perle left negative impressions that took months to undo. She gave an interview during her first week in the country to *Chicago Daily News* correspondent David Nichol, who wrote a rant calling her appointment "an example of ineptness" and declaring her ill-suited for the job. He recounted that while awaiting his interview in an anteroom, he overheard Perle as she "clawed up a terrified little Belgian interior decorator" about the length of the carpet. Fox added, "If she was doing it to impress me, she did, and badly." This berate-the-help behavior was out of character for the usually even-tempered Perle.

He asked whether Secretary of State Acheson had briefed her. Nichol wrote that her response was to give him "the look which is reserved, I imagine, for people who spill sticky liquors on the stuffed velour." Without providing evidence, Nichol concluded, "Mrs. Mesta's relationships with the Luxembourgers themselves will be delicate in the extreme, and I'm afraid she is off to a poor start."

Syndicated columnist Tristram Coffin went after Perle with an original, albeit nebulously sourced criticism: that she was spy bait. Coffin posited that her close relationship with President Truman was a potential problem, since foreign intelligence services thought she could be easily manipulated.

"British Intelligence agents are keeping close tabs on her comings and goings and flashing the reports to London," he wrote. "The shrewd and sophisticated agents don't give a tinker's damn about the kind of carefree parties she throws. They want to know who Perle Mesta is listening to at length."

Coffin's theory was that European right-wingers would try to use Perle as a conduit to Truman. But even Coffin was forced to admit that "the British intelligence analysis of Mrs. Mesta is a strong willed

and determined lady, a little frustrated at being in such a small pond as Luxembourg, might be moved by great attention and flattery."

Perle's allies were determined not to let these poison-pen stories derail her career. As New York gossip columnist Dorothy Kilgallen wrote, "Perle Mesta's pals in Washington are bitter over what they consider the 'unfair press' she has been given in Luxembourg. They point out that wire service men and special correspondents make the presidential favorite seem 'giddy and foolish,' which they claim she isn't."

THE NIGHT BEFORE her audience with the grand duchess, Perle practiced her curtsy and speech before Marguerite. Her sister reminded Perle that visitors were never supposed to turn their back on the duchess. As Perle rehearsed backing out of the room, she caught her heel on her gown and barely missed tumbling over. This was role reversal: Marguerite used to rehearse her lines with Perle.

On September 21, 1949, Perle went to the palace to present her credentials to Grand Duchess Charlotte. Born in 1896, the second of six daughters, Charlotte Adelgonde Elisabeth Marie Wilhelmine did not grow up expecting to rule her country. Upon their father's death in 1912, his eldest daughter Marie-Adelaide became grand duchess, but her support for Germany during World War I made her wildly unpopular and she was forced to abdicate in 1919. Charlotte, then twenty-three, was elevated in her stead. To signal her commitment to democracy, Charlotte called for a referendum, and her reign was overwhelmingly endorsed. Married to a cousin, Prince Felix of Bourbon-Parma, the couple had six children. When the Nazis invaded Luxembourg in 1940, the royal family fled, spending the war in England, the US, and Canada.

The Grand Duchess made an effort to put Perle at ease, asking about her own Washington acquaintances. "She was delighted to find that I knew General and Mrs. Eisenhower," Perle later recalled in *McCall's*. Perle reported back to her sister, "She stands up very erect

and is handsome rather than pretty. Her English is beautiful, almost without an accent . . . She has great natural dignity."

That evening, Paul West gave a cocktail party in Perle's honor at the Hotel Brasseur, an 1873 local landmark. Given West's hostility to Perle, it is easy to imagine her host's gritted teeth. The surface cordiality didn't last long. Perle accepted an invitation to visit the metal ore mines at Esch-Sur-Alzette and meet miners whose labor leaders were Socialists. As she later wrote to President Truman, "Mr. West immediately informed me that none of the Ministers would ever think of doing such an undignified thing." She went ahead with the trip, joined by Antoine Krier, a member of the Luxembourg house of deputies, and Eric Kocher, the American labor attaché in Brussels, who, like West, was miffed by her appointment.

After descending in a mine car for twenty minutes to reach the 120-foot-deep mine, Perle spent two hours touring the subterranean passages. In a surprise demonstration, the miners dynamited a nearby wall, and Perle ended up with ringing ears and covered in dirt. She found the subterranean experience terrifying but gamely went on to visit a steel mill. Perle was in her element thanks to her experience as a board member at Mesta Machine, and she lingered to ask detailed questions.

But describing that day in his memoirs, Eric Kocher belittles Perle, insisting she deliberately committed a gaffe during a press conference. In his recollection, she mistakenly stated she had just visited an "iron mill" and a "steel mine." Rather than a slip of tongue, Kocher insisted that Perle had transposed the words "steel" and "iron" on purpose. "It seemed she really didn't mind how much a fool she made of herself. In fact, the more the fool, the more publicity," he wrote. "She was clever enough to know she would probably never be acclaimed for her political wisdom. So why not make her reputation as an odd ball."

A photo of Perle in a tin hat, descending into the mine, appeared in a local labor newspaper, letting Luxembourgers know that she

was not a typical diplomat. "Mrs. Mesta made a big hit with the miners—and others among country's trade-union membership of about 36,000—who promptly dubbed her 'Our Perle,'" according to one publication.

Discussing that day, she told a reporter, "You can't always be bothering about protocol. And maybe things like that mine trip do upset certain people. But I'm here to represent the President and I know it's just the sort of thing that Harry Truman would do if he were here."

AS SHE EXPLORED the American-owned Luxembourg residence, Perle came face-to-face with the building's odious history. The mansion had been occupied by sadistic Nazi gauleiter Gustav Simon, who ruled the duchy for four unrelenting years. Simon deported 1,300 Jews to concentration camps (only sixty-nine survived), executed twenty-one striking steelworkers, and shipped thousands of men and women to work in Germany. Arrested in the British zone of Germany in December 1945, Simon was found hanging in his cell—his death was ruled a suicide—before he could be tried for war crimes.

The Americans confiscated the building as war reparations. To exorcise the ghosts, US diplomat George Platt Waller called upon a Roman Catholic bishop. "The bishop went through every room, sprinkled holy water and gave a special blessing," Waller explained to reporters. "I wanted to get the devil out—he'd been there so long."

But the premises had not been scrubbed of the remnants of the devil's work. Informed that the Nazis kept a torture chamber in the basement, Perle ventured into the nether realms to see the grimy padded cells. That made her yearn for a substantial renovation so that Luxembourg citizens could enter the legation without shuddering in horror. She asked for advice from American ambassador to Belgium Robert Murphy, who had previously supervised the Luxembourg legation. He told Perle to call Frederick Larkin, the State Department's director of foreign buildings.

Murphy was amused by how things played out. As he wrote in a 1964 memoir, *Diplomat among Warriors*, "Larkin replied rather casually that Luxembourg was low on the list and he could not possibly reach it for a couple of months. 'Oh,' said Mrs. Mesta, 'I hoped you would come tomorrow.' When Larkin politely said that was out of the question, Mrs. Mesta said, 'But I'm talking to President Truman on the phone this afternoon and I know he would want you to come right away!' Somehow the director arrived in two days and eventually the residence in Luxemburg was all plushed up by Jansen of Paris."

Perle was willing to drop Truman's name to get what she wanted—and would do so again and again, to the chagrin of her superiors at State. Dark green velvet drapes were hung in the windows at the legation, her cream-colored office included a green leather couch and matching chairs, and the basement was renovated.

Perle's strength—and her weakness—was a strong ego. It irked her that she was a minister rather than an ambassador. Her title envy flared up when President Truman nominated Minnesota Democratic activist Eugenie Anderson as ambassador to Denmark, a post recently upgraded from the ministerial rank. Now that Anderson had bragging rights as the first female ambassador, Perle felt like a second-class diplomat. The *Washington Post* reported in mid-October: "Perle Mesta, writing to friends at Newport, says that before the year is out, she will have the rank of ambassador. But she neglects to mention whether the promotion will come to her at her present post as Minister to Luxembourg or whether she is destined for a bigger job."

Perle's indiscreet lobbying was a serious misstep. This level of hubris after just two months in Luxembourg raised hackles at the State Department. There was a diplomatic reason that the American envoy to Luxembourg held the title of minister—this was a reciprocal decision between countries. Tiny Luxembourg did not have embassies in any foreign countries at the time, only legations. But this reality of diplomatic life did not prevent Perle from complaining. "Here is the most recent report from Luxembourg, brought back

by a traveler," wrote *Philadelphia Inquirer* columnist Elise Morrow in November. "Mrs. Mesta is disgusted, bored and wants to be an ambassador instead of just a minister."

American reporter Daniel Schorr, then working for the Netherlands news agency Aneta, wrote a scathing column about Perle. His words had the tone of a headmaster rebuking the school's worst student. "This stocky, domineering little woman, who arrived here full of energy and had no idea of her shortcomings, has succeeded in committing stupidities with imposing regularities. Impulsive, dictatorial, magnanimous, fussy and friendly, Mrs. Mesta regards her task as a prolonged tea party with a few troublesome foreigners. A serious interview is a painful failure . . . She showed no signs of knowing anything much about the facts of the Marshall Plan, Benelux or Western union."

Perle was guilty, as charged, with having a lack of foreign policy expertise. At times, she deliberately played the part of a rube, reflecting her insecurity. Better to cast the first stone herself. In his memoir, Ambassador Murphy recalled, "Mrs. Mesta herself jested about her unfamiliarity with European geography and economics."

Perle learned. She became conversant with international issues and could write knowledgeably about Benelux, the customs union promoting free trade between Belgium, the Netherlands, and Luxembourg. But it took time.

AMERICAN REPORTERS DESCENDED on Luxembourg as if the country had suddenly become a hotbed of news. "Several hundred yards of newspaper copy have been written about her since she became a diplomat, some of it good, much of it unfavorable and a lot of it just plain bunk," wrote William H. Stoneman in the *Chicago Daily News*. "Luxembourg citizens and most of her fellow diplomats describe her as 'spirited, friendly, kindly, generous and smart'—though slightly out of her depth on some matters."

Three more feature writers arrived in Luxembourg to profile Perle: Flora Lewis of the *New York Times*, David Perlman of the *Sunday Magazine*, and world-weary war correspondent Martha Gellhorn for the *Saturday Evening Post*. Perle spent ample time, independently, with all three. She obligingly discussed her routine: a light breakfast in bed at 8 a.m., arriving at the office by 9 for paperwork, then heading out to give speeches, visit factories and schools, and attend quaint local customs like the Procession of the Sheep. Perle described the leisurely weekend drives that she and Marguerite took through the countryside, meeting local mayors and farmers. Perle was trying to be a different, surprisingly modern, diplomat, engaging with average citizens rather than spending time only with government officials and business leaders.

Overtly friendly but careful with her words, Perle refused to discuss her contacts with Luxembourg officials or anything to do with the State Department. Instead, she made anodyne remarks about how much she loved her job. Asked by David Perlman if she ever got bored, Perle replied, "How could I be bored? Look at all the people I haven't met yet?"

Her banalities could be revealing. Perle insisted to Martha Gellhorn: "I never get lonely. I've got resources within myself. On off nights, I just dive into the pillows with a book and it's heaven. I just love it." After spending a long day with Perle—including a six-hour round-trip drive for tea at a countryside hotel—Gellhorn vented in frustration, "We talked and talked but it was like flying through a cloud. So dim. So vague."

Here were the adjectives the writers used to describe Perle: "imperious," "impulsive," yet "surprisingly efficient" (Lewis); "fussy" and "bossy" (Perlman); and possessing "unshakeable self-confidence" (Gellhorn).

Perle allowed the *Times'* Flora Lewis to attend her first big party on November 6 for seven senators on a European fact-finding trip. For American foreign diplomats, entertaining traveling legislators

was—and still is—a perennial responsibility. Perle imported violinist Isaac Stern from New York to perform at the black-tie dinner and included foreign minister Joseph Bech, Prime Minister Pierre Dupong, and the mayor of Luxembourg City. To enliven the evening in small-town American fashion, she ended with square dancing.

A photograph shows the jovial Perle, bedecked in a white lace gown, sharing a plate of food with Oklahoma senator Elmer Thomas. He enthusiastically told the *Times*, "Perle is putting Luxembourg on the map." Lewis ended her story by describing a Luxembourgian lady rushing up to Marguerite to say of Perle, "Your President couldn't have sent us a nicer present. We do love her."

There had been rumblings in Washington that to cut costs, the government should recombine the Luxembourg ministry with the American embassy in Belgium and eliminate Perle's position. But none of the traveling senators, all members of the appropriations committee, pushed for this move upon their return to Washington.

Her next party honored Matthew Woll, vice president of the American Federation of Labor and a Luxembourg native who emigrated to the US with his parents in the 1890s. Perle was shrewd enough to write to Truman aide Clark Clifford to ask permission to entertain Woll. Clifford replied, "Perfectly proper to invite Matthew Woll." After the party, Woll sent a note to the president praising his dinner hostess. On November 30, she received a gratifying letter. "I have been hearing of the grand job you are doing in Luxembourg," President Truman wrote, "and I am just as proud as I can be that everything is working out as we anticipated that it would."

Perle decided to counter the in-house hostility at the Luxembourg legation by bringing in a Newport friend, Army veteran Albert Hoffman, known as Bertie. The sixty-two-year-old, a former military attaché in Madrid, had subsequently worked for the International Telephone and Telegraph in Belgium. At Perle's personal request, the multilingual retiree agreed to return to active duty. The State Department obligingly sent Hoffman to Luxembourg as a legation attaché.

Now Perle had the perfect man to escort her to official events. As one newspaper noted, "He is a charming man, and an authority on fine wines and food. And he knows European society intimately."

But Perle's arrogant sense of entitlement collided with the government bureaucracy when she asked that Hoffman be promoted from lieutenant colonel to colonel. Secretary of State Dean Acheson, in a sternly worded letter, told her that Hoffman would be jumping the queue over 5,800 senior officers. "That would be considered unwise in view of the injustices to the senior officers and . . . would set an undesirable precedent."

DECLASSIFIED STATE DEPARTMENT memos provide details about Perle's diplomatic responsibilities. She conferred frequently with Bech and sent memos to the State Department describing their conversations. Their discussions often centered on how Luxembourg planned to vote in the United Nations on issues ranging from the choice of a new president of the General Assembly to the administration of Italy's former African colonies (Libya, Somalia, Eritrea, and Ethiopia).

Her memos could be opinionated, in contrast to her genial public persona. In a September 8 note to the State Department, Perle complained that Bech tried to stonewall her on the Italy matter. "Aside from appearing poorly informed on subject, he gave impressions of not wishing to make commitment prior to consultation with the French."

The diplomatic demands varied. The State Department requested information on Soviet propaganda in Luxembourg, and on January 6, 1950, she submitted a lengthy memo, presumably prepared by her staff, that she signed off on. "There is no Russian émigré group in Luxembourg and only a few members of the Orthodox church . . . Local targets against American capitalism have been the Goodyear Tire and Rubber Company, which is constructing a plant here; the

local subsidiary of Standard Oil, whose tank farm is allegedly a fire hazard and of course, Coca Cola."

PERLE VISITED OVERFLOWING orphanages populated by children whose parents died in the war. It made her heartsick. If there was ever a reason for a brighten-the-day party, this was it. On St. Nicholas Day, Perle hosted 350 war orphans, feeding them hot chocolate, sandwiches, and cookies. Perle imported a Paris puppet show and showered the children with dolls and toys. Describing her plans in a letter to Elise Morrow, Perle wrote, "Of course, I will get more fun out of this than the children will."

A photo of the party shows Perle raptly watching the puppet show with the children, a benign smile on her face, dolls covering her lap. Even though she was recovering from the flu, she gave a speech in mangled Luxembourgish. The giggling children, who responded in English, called her "auntie." Perle acted out of emotion rather than calculation, but this gesture—which she made into a yearly event— was a brilliant way to endear herself to Luxembourg citizens.

One young boy stood out: the child of a wartime fling between a Black American serviceman and a local woman, who died shortly after giving birth. Perle was contacted by a Washington couple who had heard about the boy and wanted to adopt him but couldn't untangle the red tape. Concerned that six-year-old Frank would feel like an outcast in overwhelmingly white Luxembourg, Perle finessed the paperwork on behalf of Army lieutenant colonel Bert Cumby and his wife. Before the Black couple met Frank, they asked Perle for her frank opinion of the youngster. "The cutest child you ever saw," she told them. "And I'll say this to you. If you don't take the child, I will."

Chance inspired Perle to take on the cause that became her most memorable innovation. Three off-duty American GIs showed up at the legation: one soldier bet the others a bottle of champagne they could meet the new minister without an official invitation. Perle not

only greeted them but invited them to dinner that night with the legation's employees. "Those three G.I.'s were the life of the party," she later wrote. "One of them played the piano and another sang."

After Marguerite mentioned that one soldier admitted to being homesick, Perle impulsively announced that she would hold an open house for American soldiers on the first Saturday of every month, starting on January 7, 1950. She chatted up the roughly thirty soldiers who attended the first weekend and then sent notes to their parents, telling them how much she enjoyed meeting their sons. As word spread, hundreds began to turn up from Germany and Belgium.

"I put as much thought and work into those parties as I do for a party for any senator," she told the Associated Press. "The boys get their pay at the first of the month. They don't have much to do. This gives them some place to go. The boys get all they want to eat, plus milk, soft drinks and champagne if they want it."

Paul Colbert, a serviceman from Somerville, Massachusetts, fondly remembered these parties. "Perle would entertain as many as 1,200 of us at one time. She'd also write hundreds of letters home, telling our mothers she'd seen us and that we were looking fine. She's really a wonderful person, take it from me."

A senator wrote to the State Department demanding to know who was financing this extravagance. It certainly wasn't the American taxpayer. Perle was underwriting it and finally had to rent a hall to accommodate the troops. She would later estimate that more than 25,000 GIs came to the Saturday night frolics. Perle delegated the details to Garner Camper, the butler she had brought over from Washington. Perle's niece Betty, then living in Luxembourg, recalled, "He absolutely shone at these parties and all the GI's loved him. He served steaks and barbequed ribs, cheeseburgers, and hot dogs. Garner set up a soda fountain bar and he made them ice cream sundaes and milk shakes. Perle always got a lively local band to supply the music."

In an era marked by bitter racial prejudice in America, Perle danced with any GI who asked, regardless of rank, ethnicity, or race.

Hearst columnist Westbrook Pegler, a pugnacious right-winger who visited her in Luxembourg, wrote approvingly, "Perle said she had danced with many GIs including Negroes, explaining that, although this had not been her custom in Oklahoma where she spent much of her girlhood, she thought she was representing all the people of the United States."

IN MARCH 1950, Perle visited war-ravaged Germany. Newspapers ran a haunting photograph of her at a displaced persons' camp near Frankfurt hugging two Polish children. Children in the background looked hollow-eyed and lost, unable to meet her gaze.

In Heidelberg, where Perle was the first senior American diplomat to visit the city since the end of World War II, she delivered a rousing feminist speech at a local university, offering the young women hope for careers and a life different from the ones their mothers had led. She claimed, disingenuously, that America had abolished the "petticoat line," which she defined as a societal restriction "which once kept America's women spending her day over a hot stove in a smoky kitchen while her husband basked in the sunshine of public life."

In a bout of optimism, she declared, "Unlike the members of her sex in some other lands, where women still plow the fields and carry heavy loads on their backs, the woman of America has achieved a place of her own in the public scene—right alongside the man."

Perle, at least, had done it, achieving her place in the public sphere whether the men in the American diplomatic corps liked it or not.

Call Me Madam

The travel plans of American envoys to minor European countries are never scrutinized for hidden meanings. But Perle Mesta was no ordinary diplomat. The news that she would be returning to Washington for meetings at the State Department sparked a fresh round of rumors. They were fed by an unnamed diplomatic source in Luxembourg—likely a Perle enemy—who told *United Press* that she "was anxious to obtain a transfer." *New York Daily News* columnist Danton Walker upped the ante and insisted Perle would "demand" a transfer.

This quickly became a big enough news story that reporters pressed Charlie Ross, Truman's press secretary, about Perle's fate. He professed to be unaware of any change in the works. While still in Luxembourg, Perle vehemently denied the suggestion that she wanted to leave. "There's not a word of truth in that," she insisted. "I love my job and the people here are wonderful. It's a beautiful country and anyone who hasn't seen it should."

Fog delayed the arrival of the *Queen Mary* to New York by six hours, but when Perle stepped off the boat on April 6, 1950, reporters and photographers were still waiting at the pier. Wearing a black suit and matching black gloves, Perle smiled for the cameras as she greeted her welcoming party, India Edwards.

When Perle gave a formal press conference at Park Avenue's Drake Hotel, she became so annoyed by the lightweight queries that she let her feelings show. "Can't we get away from that question about parties?" Perle asked. "I'm trying to do a job over there."

Reporters had no appetite for her updates on Luxembourg steel production so their questions turned to Perle's future. She insisted again, "I don't want a change of post."

The pack then turned to the hot-button issue of the day: GOP senator Joseph McCarthy's inflammatory and exaggerated charges about Communist influence in the State Department. Perle offered a safe response: "I feel we're in very good hands with the Secretary of State and the President. I have great confidence in their judgment and whatever decisions they make."

Reporters were not the only people clamoring for time with Perle. "Anxious see you can you visit us," Dwight and Mamie Eisenhower wrote in a telegram from the general's new Manhattan home as president of Columbia University. Eisenhower remained so popular that members of both political parties hoped he might become their presidential nominee. In 1950—and for years to come—there were few Americans who did not have time for the Eisenhowers. But Perle could not linger in New York since she needed to take a midnight train to Washington.

Upon arriving in the capital, Perle held another press conference at the State Department. Asked whether she expected to return to her role as number one party giver, Perle replied, with irritation dripping from her voice, "I am not thinking about parties now. I am thinking about the world situation and what we can do about it."

But the journalists were too smitten by the idea of a Washington social war, to be fought to the last canapé, to give it up. Perle's long-time friend and King Features columnist George Dixon predicted in print that the battle of the hostesses was about to resume. "Perle Mesta is re-invading our peaceful shores this week—and Gwendolyn Cafritz is buckling her diamond-studded cutlass to repel the invader,"

Dixon wrote. Gwen Cafritz obliged him with bitchy quotes: "When she left Washington, I couldn't have been more pleased . . . I thought Mrs. Mesta was out of my life for good, but it seems I just gave her up for Lent." The target of her venom did not respond.

As Perle unpacked at the Sulgrave Club, she was deluged with so many invitations that even the legendary hostess was overwhelmed. Newly married Vice President Alben Barkley, then seventy-two, and his three-decades-younger new wife Jane wanted to give her a cocktail party. Rhode Island senator Theodore Green offered lunch in the Senate dining room. Cornelius Vanderbilt Whitney asked her to save a date for dinner. One high-profile figure after another sought to fete her, including General Omar Bradley and friends Janet and Hugh Auchincloss (mother and stepfather of Jacqueline Bouvier).

The ambassadors of Norway, Brazil, and Belgium requested the honor of arranging for separate celebrations. As columnist Elise Morrow wrote, "Everyone but the corner grocer and the postman is giving parties for Perle Mesta."

Perle showed up to see the Trumans with armloads of European luxury goods. "It looked like Christmas," wrote Margaret Truman in her journal on April 15. "She brought me 2 sets of pearls, a gorgeous ruby + gold dinner ring. Six Meissen demitasse cups and a blue satin lace negligee with my name on it and shoes to match." Harry Truman wrote Perle a thank-you note for "the wonderful wine from Luxembourg and the beautiful ties from Paris."

Despite the social hurly-burly, Perle took her diplomatic job seriously. Arriving daily at the State Department at 8:30 a.m., she had a list of things she hoped to accomplish. State Department secretary Dean Acheson received a memo from a staffer preparing him to meet with Perle. "You might desire to ask Mrs. Mesta about Mr. Bech's view on the general European political situation and on the Cold War. Mrs. Mesta has recently been in Germany and seems eager to discuss this subject, the displaced persons problem in particular."

Top on Perle's agenda was Luxembourg's request to launch a transatlantic airline route to fly directly to New York. The Civil Aeronautics Board had rejected the idea because no American airline wanted reciprocity.

Meeting with the acting assistant secretary of state for European affairs Llewellyn Thompson, Perle pressed hard, albeit unsuccessfully, for a change in policy. According to Penn State Shenango history professor Philip Nash's book *Breaking Protocol*, about pioneering female diplomats, she even threatened to get the White House involved but backed off when cautioned that would be a mistake. Constantly invoking Truman to get her way, she didn't care if this tactic made her resented at State.

Taking a less combative approach on a different Luxembourg aviation issue, Perle was successful in encouraging nonscheduled American charter flights to the duchy. She lobbied former Oklahoma senator Josh Lee, now a Civil Aeronautics Board commissioner, on behalf of Youth Argosy, a nonprofit company that chartered planes to send American students to Europe at low prices. The group planned to send a large contingent to Luxembourg, but Pan American Airlines had intervened to block the charter flights.

"Minister Mesta agreed to do what she could to help the cause," according to Hope Ridings Miller of the *Washington Post*, in a later appraisal of Perle's career. "She conferred at length with Commissioner Lee . . . and he arranged for her to present her proposal to the entire Civil Aeronautics Board." The board granted a special exemption; the first plane with students took off for Luxembourg on June 1.

The State Department had chosen an experienced foreign service officer, Anthony Swezey, to replace Perle's current deputy, Paul West Jr. A New Jersey native with a master's degree in history from Princeton, Swezey served in the Navy in World War II. After spending a year at the US mission to the United Nations, he joined the Foreign Service in 1947, serving in Paris and the Belgian Congo.

When they met for the first time at the State Department, Perle took an instant dislike to Swezey. "After talking with him, I felt that he would not fit into the Legation very well," Perle wrote in her 1952 critique to Harry Truman. "He struck me as being not only an intellectual snob, but a social snob as well. I told the department that I did not care to have him as an officer at the Legation . . . The chief of Personnel assured me that he thought he would change his attitude once he got to Luxembourg."

Perle had become allergic to Ivy League career diplomats. But envoys typically do not have the power to block State Department transfers without a credible reason, so Perle was stuck with Swezey.

Perle's close relationship with the president was on full display during her time in Washington. The Trumans gave Perle a White House dinner for the usual social circle—House Speaker Sam Rayburn, Supreme Court chief justice Fred Vinson and his wife Roberta, treasury secretary John W. Snyder, and Cornelius Vanderbilt Whitney.

Given the intense interest in Perle, the *Washington Post* asked her to write three columns, which ran in Sunday issues. To counter critics who still perceived her as a party giver, she described the lengthy meetings about the economy and political situation, which made up her daily life.

She used the opportunity to boost American tourism in scenic Luxembourg ("a setting for a fairytale"), praise Grand Duchess Charlotte (a "capable and conscientious ruler"), and stress her feminist goal as a diplomat (to "prove woman's usefulness in a field rather newly opened to us").

CALL ME MADAM was not scheduled to open on Broadway until October, but the publicity buildup was going strong. The Radio Corporation of America and NBC confidently put up the entire $225,000 production cost. Producer Leland Hayward, who already had three plays running simultaneously on Broadway, was producing *Madam*, and the legendary George Abbott agreed to direct. The

brassy Ethel Merman told the press, "Washington can just calm down about the whole thing. I'll be a sweet, loveable sympathetic Perle."

It was time for Perle to face the music. She accepted a dinner invitation from *New York Post* columnist Leonard Lyons to meet the creators and cast. A beloved Broadway character, Lyons was famous for his nightly theater district crawls—seeing a show and then hitting the hot spots like Sardi's and 21 in search of column items, home to bed at 6 a.m.

Perle brought surrogate daughter Margaret Truman to Lyons's apartment at the Beresford. Ethel Merman and her husband, newspaper executive Robert Levitt, showed up an hour and forty minutes late, brimming with apologies, explaining they had been waiting for a doctor to make a house call since their son appeared to have measles.

"So I said to Mrs. Mesta, 'Have you had the measles?' It's a great opening line in the diplomatic trade! But gee! She's a good dame . . . She said she understood and couldn't have been nicer," Merman said, describing the evening to columnist Inez Robb. "We wound up with our arms around each other, yak-yaking to beat the band. A real swell dame. She's promised to fly back from Luxembourg for the Broadway opening and I'm going to make her come up on the stage and take a bow."

With Irving Berlin at the piano, the guests sang and gossiped until 4 a.m.

Interviewed days later at the Carlyle Hotel, Perle pronounced herself delighted by the prospect of the musical. "I can't imagine anyone I'd rather have 'do' me than Ethel Merman," Perle told Inez Robb. "I've always been crazy about her."

Ethel genuinely liked Perle, but she also knew it was great publicity for them to be seen together. Merman and Mesta, Mesta and Merman, it sounded like a vaudeville act. Ethel gave a send-off lunch for Perle on the SS *America*, which would be taking the minister back to Europe. Photographers captured a very happy Perle, holding hands with Ethel Merman on her right and Margaret Truman on her left.

* * *

ELEANOR ROOSEVELT, BY many measures the most respected woman in America, believed that Harry Truman had erred in making Perle a diplomat. The passionately liberal former First Lady perceived Perle as frivolous and unworthy. As India Edwards admitted to reporters, "Mrs. Roosevelt said she had not been keen about the appointment because all she knew about Mrs. Mesta was what she read in the newspapers."

But in the summer of 1950, when Eleanor Roosevelt took her son Elliott, a decorated World War II pilot, and his two children on a postwar tour of Europe, she scheduled a stop in Luxembourg. She wanted to see Grand Duchess Charlotte, whom she had met in 1940 in Washington when the duchess was in exile.

Perle was anxious about playing Eleanor Roosevelt's tour guide but viewed the trip as an opportunity to redeem herself. She arranged a busy schedule, including dinner at the palace with Grand Duchess Charlotte and foreign minister Joseph Bech. Large crowds stood outside in the rain, patiently waiting for the duchess and the former First Lady to come to the window to wave. That evening broke the ice.

"We discovered that we had so much to say to each other that we stayed up nearly every night until one or two in the morning, talking at a great rate," Perle later wrote in *McCall's*. "We would talk until we were tired and hungry, have a glass of milk and talk some more. We spoke of religion and of its importance to men and nations. We discussed the role of women in America, in Europe, in the Iron Curtain countries and in the new emerging nations of the world."

Perle took Mrs. Roosevelt and her family members to the American military cemetery, where they laid flowers at the grave of General Patton. "It was a most moving experience," Eleanor wrote in her newspaper column, My Day. They drove through the countryside to see the ancient castle in Clervaux once owned by FDR's ancestor Count Philippe Delanoy, who changed his name to Delano when he came to the United States. Along the way, mayors and councilmen came out to greet the group and give welcoming speeches.

"Everywhere we went I found that Mrs. Mesta is already known," Eleanor Roosevelt wrote in her column. "She has visited all the institutions, hospitals, homes, sanitariums, etc. She has been down in the mines. She goes out and talks to the people on the farms and everywhere she is greeted as a friend and complimented on the way she has won the hearts of the people since her arrival."

Mrs. Roosevelt also gushed about her new friend during a trip to Washington. Perle received a jubilant letter from Harry Truman a few weeks later.

> *Dear Madam Minister:*
> *How do you like that salutation?*
>
> *I've just had a most pleasant visit with Mrs. Roosevelt and she spent most of her time singing your praises.*
>
> *As you know, she was not enthusiastically for you when I appointed you to be Minister to Luxembourg but you certainly sold her a bill of goods, as you have everyone who has visited you since you have held the Post.*
>
> *I think you have done more to create good will for us in Occupied Germany, Luxembourg, Belgium and France than anyone who has been in any of those Posts since I have been President. Keep up the good work. It makes me feel very proud when people I appoint to office make good, as you have done.*

Perle was adroit in her efforts to connect with Luxembourg citizens. She jumped on President Truman's suggestion to arrange a scholarship for a Luxembourg student to study in the US. The duchy chose high school student Pierre Reiff, the oldest of six children, who wanted to study engineering. Perle convinced Purdue University to give him a tuition scholarship, while she underwrote his travel and living expenses. Her next scholarship went to Evalyn Schaus, a talented musician who had spent four years in a concentration camp. Evalyn went to Perle's alma mater, the Sherwood School of Music in Chicago. Perle,

who loved playing matchmaker, fixed these two students up, and they eventually married. Unable to have her own children, she took pleasure in helping young people and would go on to pay the bills for two dozen foreign students seeking an American education.

When Perle and Marguerite methodically visited every small town in the Luxembourg countryside, Perle discovered that most mayors had never met their neighboring counterparts. She invited all 126 mayors to the American legation for a reception. They talked, they ate, they drank, they danced, and the party got a warm reception in local newspapers. By popular request, Perle agreed to host it again—same time, next year. Luxembourg academic Paul Lesch, in his 2001 book, *Playing Her Part: Perle Mesta in Luxembourg,* wrote that Luxembourg newspapers praised the parties for giving local politicians a chance to exchange views and discuss mutual problems and solutions.

Perle's butler Garner Camper was especially helpful since he was adept at picking up languages—French, German, and even a smattering of Italian—which allowed him to communicate with non-English-speaking guests. The genial Black man was a distinctive presence in lily-white Luxembourg. It amused him to tell the story of attending a local masquerade ball where a local woman complimented him on his mask—his normal skin tone.

HOWARD LINDSAY, COAUTHOR of the book for *Call Me Madam,* sent word to Perle that he and his wife, actress Dorothy Stickney, planned to spend a few days in Luxembourg to pick up ideas for the musical. Perle's first reaction was to flee, but she then decided that the type of charm offensive that worked with Eleanor Roosevelt might help.

The Broadway couple turned down Perle's invitation to stay at the legation. Lindsay explained to columnist Earl Wilson, "I told her I thought I'd better stay at the hotel. I wasn't going to be charmed out of

some of my jokes." Perle showed them her diplomatic home, took them for a drive to the countryside, and introduced them to local officials.

There was one tense moment, when Perle asked Lindsay to describe the plot of *Call Me Madam*. He admitted, "I thought of Irving Berlin and Russel Crouse, my associates and my bank balance, and I didn't tell her."

ALL OF PERLE'S trepidations about her new deputy, Anthony Swezey, came true when he arrived in Luxembourg to replace the hated Paul West Jr. As Perle described Swezey in her memo to the president, "He was such a snob that anyone without a title did not appeal to him . . . He barely spoke to the clerks in the office if he happened to meet them socially . . . Although he was courteous most of the time to my face, behind my back he slowly and deliberately organized my staff against me."

Swezey, who died in 1983, never publicly commented on his time in Luxembourg, but the friction between them reflects an ongoing issue at the State Department. Career Foreign Service officials have worked their way up the ranks and are trained in international protocol and the intricacies of running an embassy. They often find it difficult to deal with political appointees, who typically have minimal foreign experience or diplomatic background. But Perle's ongoing problems with her deputies in Luxembourg probably went beyond the norm. As a feminist and self-confident woman put in charge, she was a challenge to the status quo.

Perle believed Swezey was the ringleader of a group of dissatisfied men. She thought he had turned the legation's economic officer, William Canup, against her. "Mr. Canup was a young man, intelligent, but very immature who at first seemed happy in Luxembourg and who tried to co-operate," she wrote in her memo to Truman. "But as his friendship with Mr. Swezey developed, you could see a change come

over Mr. Canup. He became rude, disrespectful, un-co-operative and thoroughly disagreeable in his actions."

Perle felt she was being shut out of the legation's work by Swezey and Canup. As she later complained to Truman, "It was difficult to be at a dinner party where some Luxembourg Government Official would begin to discuss with me actions that had been taken by the Legation."

Perle had minimal experience with office politics but she grasped one essential fact—female secretaries and staffers, who type up correspondence and send telegrams, can be invaluable sources of information. She asked the women for help, and they began to keep her up-to-date.

LIKE ALL AMERICAN ambassadors, Perle's normal responsibilities were upended by the start of the Korean War in late June 1950. After seventy-five thousand North Korean soldiers, with backing from the Soviet Union, crossed the 38th parallel, which divided the two Koreas, Truman sent American troops to defend the pro-American government of Syngman Rhee in Seoul. As the president explained to the American people, "The attack upon Korea makes it plain beyond all doubt that communism has passed beyond the use of subversion to conquer independent nations and will now use armed invasion and war." The war would rage for three years, with five million casualties on all sides.

The State Department asked Perle to assess Luxembourg's reaction to America's decision to take up arms. In a telegram on June 28, 1950, Perle discussed her meeting with foreign minister Joseph Bech. "Bech described firmness of US reaction to Korean crisis as comforting . . . although commenting that situation was very serious, expressed belief Soviets would themselves be surprised by vigor of US reaction and therefore Korea would not be fatal spark touching off world conflict."

She followed up with another telegram. "Prime Minister Dupong welcomed US action in Korean crisis, which he considers decisive

and courageous step . . . Local press reaction to US action continues to be unanimously enthusiastic, except for single dissenting voice of Communist Zeitung."

From now on, she would frequently be asked to pass along American updates on the war to the Luxembourg government and relay the responses back to Washington.

The sudden onset of the war caused ripple effects. With commercial planes diverted to fly American servicemen to Korea, nearly three hundred college students were stranded in Luxembourg after their flights home were canceled. Perle set up a food canteen at the legation, using her own money to feed students (ham sandwiches and apple pie were standard fare) for three weeks.

She bristled at complaints that the US government wasn't doing enough to help the students get home. "It was obvious that malcontents were deliberately planted among the students to keep them stirred up and discontented," she waxed conspiratorially in an interview. "There was only a handful of them but they did their best to make trouble for everyone."

IN THE LONG history of American diplomacy, there have been many idiosyncratic reasons why a US envoy might return for home leave. But Perle was unequivocally the first envoy to cross the Atlantic to see herself portrayed on Broadway in an Irving Berlin musical.

The opening night of *Call Me Madam* was scheduled for October 12, and Perle was in high spirits on the ocean liner *Liberte* en route to New York. A fellow first-class passenger, *Washington Post* owner Eugene Meyer, used a radio telephone to alert his staff that Perle was "easily the 'personage' of the voyage." He dictated an item: "The charm with which the capital long has been familiar enchanted those aboard the great French liner."

Then, in the middle of the Atlantic Ocean, the rigid striped pants set at the State Department got their revenge. Perle received a cable

stating that State Department officials did not want her to attend the show, with no explanation. Perle tried to make the best of it when she arrived in New York on October 3. She told reporters that she was skipping the opening: "All I can say is, I'm not my own boss, I'm a working gal."

At the Drake Hotel, Perle played coy in an interview with long-time confidant Inez Robb, cheerfully saying, "Everyone seems to believe that the musical is about me, but I have my doubts." She stressed that she had not been given an advance preview of the script or music, noting, "After all, I'm not a censor."

So many admirers sent Perle bouquets– chrysanthemums, roses, dahlias, gladioli, and orchids—that Robb wrote in her column that her drawing room had "the look of a high-class gangster funeral."

Hollywood columnist Louella Parsons eventually broke the story: "The State Department stepped in and refused to let Perle Mesta attend the opening of 'Call Me Madam' . . . Because of the gravity of world conditions the biggies in Washington felt her appearance would be open to criticism."

This was the opening of the fall season. The advance ticket sales for Broadway hit a history-making $1 million (nearly $13 million today). The clamor on opening night was so great that $7.20 tickets were scalped for $200.

Gawkers perched on fire escapes to watch the arrival of the bold-faced crowd, women in ermine coats and men in black tie. The show won rave notices, and reviewers treated Perle as an offstage member of the cast. Virtually every story mentioned her as the show's inspira-tion, with her life pillaged for gags. Critics made fun of the program note that read "Neither the character of Mrs. Sally Adams, nor Miss Ethel Merman, resembles any other person alive or dead."

As embodied by Ethel Merman, wealthy Oklahoma widow "Sally Adams" is a prominent Washington hostess appointed by President Truman as ambassador to the fictional country of Lichtenburg. (At least Perle was upgraded on Broadway to the title of ambassador.) This

singing and dancing Sally, ignorant of foreign policy and protocol, makes numerous gaffes before she finally adjusts.

With topical political references threaded through the production, all eyes turned to Ike Eisenhower when the cast sang a song about his political prospects, "They like Ike." The general–turned–university president smiled, then tried to hide behind his playbill. Theatergoers clapped so enthusiastically that the singers gave it a reprise. As Earl Wilson pointed out, "He's already got a campaign song, although he insisted to friends later that he still ain't runnin'."

Not all critics loved the show. *New York Daily News* columnist Danton Walker described it as "a witless, tasteless 'book' that sets musical comedy back 20 years. Mrs. Perle Mesta, whose career inspired the show—whatever the authors say to the contrary—was wise to remain in Washington."

But Perle wanted to go. She needed to go. President Truman urged her to see the show and take Bess and Margaret. At Perle's behest, Leonard Lyons arranged for matinee tickets. Lyons, who joined his guests, chronicled the afternoon in his *New York Post* column, including their whispered comments throughout the performance.

Perle was relieved when Ethel Merman, looking irresistible and irrepressible, sashayed onto the stage as Sally Adams, hosting a glamorous gala at her grand Washington home. "Good party," Perle quietly commented to Lyons. "Just like I used to give."

The opening song was an adroit summary of Perle's Oklahoma roots and her rise in the capital. Ethel Merman belted out the lyrics:

And in Washington I'm known by one and all
As the hostess, with the mostes' on the ball

In this fictionalized version of Perle's life, en route to her diplomatic post in Lichtenburg, Sally Adams gets lost, wandering around Italy and Switzerland for hours, unable to find her host country. Loyal Bess Truman whispered to Lyons, "Perle may have taken a wrong

road, but eventually it led to the stage at the Imperial Theater, with a million-dollar advance at the box office."

Once Sally Adams arrives at the embassy, she is introduced to an imperious Foreign Service officer who treats her with disdain and complains about her "enormous lack of experience." This dialogue echoed Perle's actual experience. She would later tell a reporter, "I thought the State Department man was just perfect."

But when "Sally Adams" presents her credentials to royalty at the palace, she trips on her gown's long train and takes a pratfall, landing backward on her behind. Then she accidentally insults the monarchs.

The plot meanders off to include romance. Sally falls in love with a principled Lichtenburg official (played by debonair Hungarian actor Paul Lukas), but her nefarious State Department attaché raises suspicions that the man is only courting her for money. In a subplot, the grand duchess's daughter is romanced by the American press attaché.

Real elements of Perle's life were threaded through the musical. She was wary of gold diggers. "Like all unattached women with money, I've had my experience with professional fortune hunters," she later wrote in her autobiography. "They would stare rapturously at your diamonds and tell you were the most beautiful creature in the world. Why, those playboys would even look up a woman's financial status before preparing their traps."

The love songs in the show were poignant, such as "It's a Lovely Day Today" and "The Best Thing for You (Would Be Me)." Perle was now nearing seventy and going through life alone.

Ambassador Sally Adams, Perle's doppelgänger, is recalled from her post by Truman for interfering in Lichtenburg's internal affairs. Perle had never been threatened with recall, but the writers may have been inspired by the articles speculating about her future. Would she demand a better title or quit if she didn't get it?

One of the running gags in the show consisted of Sally's ebullient phone calls to President Truman ("Hi, Harry!!"), in which she

constantly asks about his daughter Margaret's singing career while alluding to poor reviews.

In her orchestra seat, the real Margaret Truman was savvy enough to pretend to laugh. But she hated the musical. "It is a dreadful show," she wrote in her journal that night. "I say this not because I am the butt of most of the jokes but because it's bad theater. The music by Irving Berlin is undistinguished and no one in it can sing. Ethel Merman puts across her songs but oh my she's so common and vulgar."

At the intermission, audience members recognized the three women and applauded enthusiastically. At Bess Truman's urging, Perle stood up and waved.

Ethel Merman told reporters after the show, "We didn't change any of the lines. How could we, we didn't know they were here until intermission."

For Perle, *Call Me Madam* was a ratification of how far she had come from her Texas/Oklahoma roots. Now she was the inspiration for an Irving Berlin musical. And despite the reflexive hostility of State Department traditionalists, she was watching the show with the president's wife and daughter.

The show's theme song, "The Hostess with the Mostes'," would follow Perle around for the rest of her life. When she walked into almost any room, the band would strike up that number. *Call Me Madam* ran for 644 performances on Broadway, and both Ethel Merman and Irving Berlin won Tony Awards. A touring road company subsequently performed all over America. Merman would star in the 1953 movie version of the show, arousing yet more interest in Perle just as her diplomatic career was coming to an end.

Embarrassed by some of the musical's jokes, Perle nonetheless opted to be a good sport. She gave Lyons a carefully thought-out quote: "Ethel Merman has always been one of my favorite entertainers. I hope that some day I could be as successful in diplomacy as Mrs. Merman is in musical comedy."

I Like Ike

Perle emulated her father's life philosophy—"only the busy person is happy"—but she overcommitted herself during her final weeks in Washington. She discussed the Korean War at the Women's National Press Club, told the Maryland Garden Club about Luxembourg's picturesque countryside, and attended so many lunches and dinners in her honor (including a party given by President Truman) that newspapers ran stories about just how busy she was. Sighing with exhaustion, Perle told a friend, "To be a social butterfly, you must be made of iron."

In December, the iron woman won a prestigious award. Perle was named "Woman of the Year" by the Associated Press poll of American newspaper women's page editors. The AP stated that she "surprised critics by settling down to a serious job in her diplomatic post and winning the apparent respect and affection of the Luxembourgers."

Upon her return to Luxembourg, Perle's first task was dealing with a different kind of affection—planning a wedding for Marguerite's divorced daughter Betty to Major Lewis Ellis, a charming air attaché at the US embassy in London. A family friend dating back to 1945, the decorated World War II pilot had worked as a White House usher for Harry Truman and became one of Perle's extra men in Washington and Newport. He was now acquiring a ready-made family, including Betty's three-year-old daughter Marguerite Adams

(named after her grandmother). The newlyweds would be living in London, and Perle's sister and brother-in-law were planning to leave Luxembourg to join them. With her family gone, Perle's home life would be quieter.

IKE AND MAMIE Eisenhower had been in and out of Perle's life for more than two decades. But a new chapter in their relationship began when the war hero was chosen as NATO's first supreme Allied commander of Europe, based on the outskirts of Paris. Truman's selection of Ike was a masterstroke. Isolationists in Congress were trying to block Truman from sending US troops to defend Europe. The administration hoped that the popular and seemingly apolitical Eisenhower would soften the opposition.

"Rejoicing in your appointment," Perle wrote to Eisenhower in a telegram. "Do not forget your promise to visit me."

Although Luxembourg was the smallest country in his NATO portfolio, Eisenhower quickly redeemed his promise, arriving on January 19, toward the end of his first tour of European capitals. At the airport, where 1,500 people gathered to see his arrival, Ike boomed out, "Hello, Perlie."

Perle gave a steak and lobster dinner for Eisenhower and such guests as Prince Felix, husband of the Grand Duchess; Prime Minister Dupong; and foreign minister Joseph Bech. Due to the guests' prominence, fifteen security police guarded the entrance, keeping bystanders and journalists at bay. Perle crowed about the dinner a week later during an evening playing canasta with visiting *New York Post* reporter Bill Attwood and his wife. When the phone rang, she raced to pick it up and returned beaming, explaining, "Why that was Ike! You know—Gen. Eisenhower. He came to see me last week. Wasn't it sweet of him to call?"

She described Eisenhower's Luxembourg touchdown in a letter to President Truman. "I always enjoy seeing General Eisenhower even

though it was a brief visit." Perle couldn't resist turning this into an opportunity to flatter the president, gushing, "You always pick the right man for the right job."

Stories began circulating that Perle was angling for a promotion to another embassy, The Hague. In all likelihood, Perle was comfortable in Luxembourg and not obsessed with another embassy posting. But she was indiscreet enough that any stray comment provided fodder for news stories, especially given the hostility of career diplomats.

The State Department information officer in The Hague, George R. Copeland, dutifully translated accounts from local newspapers and sent them to Washington. In a typical example, the Amsterdam newspaper *De Tijd* wrote, "We do not know whether the rumor is true. We only hope it is not true."

The speculation about Perle's future was so widespread that President Truman was asked at a news conference whether he was considering giving her a new job. His noncommittal reply: "I haven't thought about it. If I decide to give her a promotion, I will do it."

A reporter followed up with "Do you think she will ask for it?"

Truman: "I don't think so. You don't ask for things like that. They come to you unsolicited. I have made a number of people ambassadors since I have been president and none of them ever asked for a job."

The president then chuckled, and added, "And those who have asked me for jobs, don't usually get them."

PERLE'S FUTURE AS a diplomat—whatever the posting— depended on who was president. But in the first half of 1951, the bottom dropped out of Truman's presidency. By early January, his approval rating in the Gallup Poll had dwindled to just 36 percent, which turned out to be the high-water mark for his final two years in office.

Most alarming for Truman, the American public had turned against the Korean War after 300,000 Chinese Communists stormed across the Yalu River in November 1950, sending the United Nations

forces under Douglas MacArthur into a headlong retreat. While the president kept hinting that he intended to run for reelection in 1952, the electorate—both Democrats and Republicans—believed it was time for a change. In a June 1951 Gallup survey, only 17 percent of Americans said they wanted Truman to run for another term.

Political appointees are expected to submit their resignations if and when a new president is elected. The clock was ticking loudly on how much time Perle had left in Luxembourg.

Both publicly and privately, Perle never said a word or wrote a sentence that questioned her loyalty to Harry Truman. But as a woman with a several-decade grounding in American politics, she undoubtedly sensed that her frequent houseguest might well be Truman's successor.

In April 1951, Ike and Mamie returned to Luxembourg in April for back-to-back weekends—trips that had little to do with Luxembourg's strategic importance. To underline how useful she could be to Ike, Perle asked another key American official to join them: John J. McCloy, former assistant secretary of war, now presiding over the daunting task of rebuilding West Germany. Eisenhower described the visit in a letter to his son John, on April 16, 1951: "I have just finished a week of inspection in the Allied Zones of Western Germany and ended up by spending the weekend at Luxembourg. Mrs. Mesta, our minister there, and Mr. and Mrs. McCloy as her guests . . . This gave me a valuable opportunity to discuss the affairs of state with our High Commissioner in Germany."

The NATO commander added, "Mamie is remaining at Luxembourg for the week, and I will run back and pick her up next weekend. It is a good thing for her to have this kind of change."

Truman often used the line "If you can't stand the heat, get out of the kitchen." But it was Eisenhower who reveled in Perle's kitchen. Ike had learned to cook while growing up in Kansas, but in Europe he rarely got the chance to put on an apron and wield pots and pans. Finding cooking relaxing, he took over Perle's kitchen during those weekends. "Ike bakes wonderful apple pie but he couldn't make a

cake. Neither could I," Perle told *Time*. "So we got out a cookbook and learned to bake cakes together."

In Luxembourg, Eisenhower spent his free days on the golf course. At nights, he played cards. Perle noted that the general deferred to his wife: "Ike likes bridge, Mamie likes canasta. So we play canasta." All in all, Perle and Mamie spent five days together, bracketed by the general's weekend visits.

Even though Perle had not repaired the rift with the career diplomats on her staff, she made the strategic choice to praise them in an opinion piece that ran in American newspapers in April, under the headline "Perle Mesta Doing Her Best to Prove Women Can Have Diplomatic Careers Too." To encourage women to enter the diplomatic corps, she painted a rosy picture. "The men in the Department of State have been exceedingly helpful and there has not been the least bit of prejudice shown me." That was totally at odds with her actual experience.

The strongest evidence that Perle was becoming restless was a hint of homesickness. What else explains her unusual request for a working diplomat: to return to America for a speaking tour. She was not due for home leave for another six months. But formal rules never deterred Perle, who had no intention of working through the State Department bureaucracy.

Instead, Perle took her request straight to the top—she wrote to the beleaguered president, asking if she could make speeches in Houston, San Francisco, and Washington. Truman obligingly wrote to Secretary of State Dean Acheson, telling him it would be a "good plan" to allow Perle to return on official business, which meant her travel expenses would be paid by the government.

Perle thanked Truman with a chatty letter, telling him she planned to fly home rather than travel by ship as usual. "I admit I am frightened beyond words at the thought of flying but I am going to make myself do it as it would take such a long time otherwise," she wrote, adding, "You are doing such a magnificent job under the most trying circumstances any President has ever had to meet."

Since Perle had wrangled a free ride home to give speeches, the State Department decided that she would be better employed as a guided missile than a loose cannon. State Department official W. K. Scott wrote to a department colleague: "Why don't we try to use her in selling some of the policies the Department is trying to put across . . . She could certainly explain in prepared speeches the whys and where-fores of our military aid to Europe, the necessity for sending American troops to Europe etcetera . . . She could emphasize the good work of the Department and the Foreign Service, which might be helpful in coun-teracting some of the attacks will probably be leveled at us this spring."

As she crisscrossed the country starting in mid-May, Perle alter-nated between giving speeches promoting feminism to following the State Department's line and lecturing about the Communist threat. Asked at a Houston press conference about Europeans' complaints that they were spending so much to counter the Soviets that their own schools were underfunded, Perle snapped: "That sounds like Commu-nist propaganda. They don't want us to be prepared."

Perle went out of her way to praise her frequent Luxembourg houseguest. At this point, this was not out of line since Truman was using Eisenhower to build political support for a massive American military presence in Europe. "Gen. Eisenhower's arrival in Europe has made the most profound impression on the Europeans," she told Mutual Radio. "He has supplied the will to fight." She bluntly stated to the *Los Angeles Times*, "I think it is a pity that General Eisenhower is not getting the support he needs at home. He needs more divisions. The House and Senate should give them to him."

When the reporter asked who she planned to vote for in the next presidential election, at first she refused to comment. But then real-izing that this coyness might send the wrong message, she relented, saying, "I'll vote next time for Harry Truman if he runs."

The most revealing word in her reply was "if." President Truman was still refusing to reveal his plans, but Perle knew how much Bess Truman disliked Washington and longed to return to Missouri.

Perle mentioned her admiration for Eisenhower at every oppor-
tunity. Appearing on movie columnist Louella Parsons's radio show,
Perle stressed, "General Eisenhower does the right thing at the right
time. So does Mrs. Eisenhower." Then, switching topics without a
prelude, Perle stated, "Miss Parsons, your entire career makes me
suspect you're a feminist."

Parsons's reply: "I admit it. I also suspect you're a feminist too."

Perle: "Of course I am."

Her enthusiasm for Eisenhower raised eyebrows among Demo-
crats who feared that "two-party Perle" might defect if Ike yielded to
the growing movement to draft him for the 1952 Republican nomi-
nation. According to columnist Drew Pearson, Perle informed Pres-
ident Truman that Democrats were complaining about her praise
of Ike. In Pearson's telling, the president thought for a minute and
then said, "You go right on making the speeches." (The columnist's
shrewd interpretation: Truman "regarded the peace and unity of
Europe as more important than any political help to be derived by
Eisenhower.")

Perle ended this trip by making a humiliating public blunder at
the State Department. Joseph De Filipps, an American soldier from
Chicago, had taken a Luxembourg flag as a souvenir during the war
but now wanted to return it. But at the formal State Department
ceremony to celebrate the handover, Perle blurted out, "That is not
the Luxembourg flag."

She insisted the Luxembourg flag included the color yellow, and
this one didn't. "It took four State department officials and a telephone
call to the Luxembourg Legation to convince her she was wrong,"
wrote the *Philadelphia Inquirer*. "The flag of the duchy is red, white
and blue. Mrs. Mesta's face is merely red." This gaffe, covered by TV
newsreels, gave ammunition to critics who claimed that a wealthy
party giver had no business as a diplomat.

* * *

THE STATE DEPARTMENT sends inspectors to check embassies around the world, with the mandate to write reports covering everything from the competence of the staff to the condition of the government-owned furniture. Normally, these visits are greeted with trepidation. But that September, when Perle was introduced to inspector James Moose Jr. in Paris, she urged him to come to Luxembourg as soon as possible. Tired of fighting with her antagonistic deputies, she was determined to insist on a personnel change.

"She told me that there had been trouble in her Legation, but did not specify what kind," Moose wrote to his Washington supervisor. "From other sources I heard two different versions of personality clashes in her mission."

When Moose arrived in Luxembourg in November, Perle and her staff (the loyal and the angry) complained to the inspector for five full days. To her credit, Perle had taken her job seriously, working hard to understand and supervise all aspects of the legation's responsibilities. In his lengthy (now declassified) memo, Moose's most serious critique of Perle was that she insisted on being involved in even picayune decisions. As Moose wrote, "It would appear that the Minister could delegate additional administrative duties to subordinate officers, with consequent saving of her own time."

But the most important section of the report detailed the bitter feuding that poisoned daily life in the legation. Moore bluntly detailed the raging war between Perle and two career diplomats, Anthony Swezcy and William Canup, "which adversely affected the entire substantive work of the office."

The inspector wrote that "the lack of sympathy on both sides is so complete and the cleavage so wide and so deep, that the only practical solution lies in a transfer elsewhere." He recommended that Swezey and Canup be promptly transferred to other embassies "without undue delay."

As a slow-moving bureaucracy, the State Department had its own interpretation of "without undue delay." Swezey remained in

Luxembourg for another three months until January 16, 1952, when he was sent to Saigon, and William Canup was there until May 3, 1952, when he transferred to Casablanca. Both men unhappily lingered in Luxembourg long enough to play the villains in an ugly racial incident.

On November 14, less than two weeks after the inspector's visit, barnstorming Illinois congressman Peter F. Mack touched down in Luxembourg. A Naval aviator during World War II, he was flying himself around the world in a Beechcraft Bonanza on a 33,000-mile peace mission to thirty countries.

At the same time, the Fisk University Jubilee Singers, from the historic Black Tennessee college, performed in Luxembourg as part of a thirty-three-nation tour. In appreciation of their talent and goodwill efforts, Perle gave the singers a party but explained that she had to leave early to see Mack. As she recalled in her 1952 memo to Truman, "The singers asked if they could come to the airport to see him off as they had written a special spiritual in his honor and wanted to sing it to him."

Swezey and William Canup went to the airport as part of their diplomatic duties. But nothing prepared Perle for their reaction to the serenading Fisk students. "Mr. Swezey and Mr. Canup stood by watching them and began to make fun of them," she wrote in her memo to Truman. "They said that in all their lives they had never seen such a ridiculous display by an American Minister with a group of Negroes. Their actions were so apparent that Colonel Hoffman, the Military Aide to the Legation, who was standing with them, walked away as he did not want to be a party to such rudeness."

Perle chastised the two American officials on the spot. The next day, an unapologetic Canup confronted her in her office. Recognizing the seriousness of the situation, Perle asked her secretary to take notes on the acrimonious conversation. "I am not impressed with anything going on here," Canup said. "Mr. Swezey and I are both wasted here." He launched into a diatribe, according to the secretary's notes of the

conversation. "I am not interested in Negro universities or Negros. I know nothing about Fisk University and I am not interested in it. I do not know where it is and I don't care."

For the next six months, until he left for Morocco, Canup refused to speak to Perle in the office or in public. But while he went cold, Swezey went hot.

When Swezey's transfer to South Vietnam came through, he stormed into Perle's office and, as she recounted in her memo, "went into such a tirade that he screamed and shouted and finally slammed the door as he left the office." He told her he hated Luxembourg, that he had never wanted to come, and he had been "wasted there."

Canup lingered outside Perle's office to eavesdrop, and when Swezey came out, Canup grabbed his hand and said, "You were magnificent."

There was a disturbing postscript to Swezey's time in Luxembourg. The State Department had been seized by a gay panic, partly spurred by Joe McCarthy and partly reflective of the witch-hunt politics of the 1950s. The search was on to purge homosexual Foreign Service officers under the dubious rationale that they posed a national security threat at the time of the Cold War.

Even before his dust-ups with Perle, career officials passed along rumors that the unmarried Swezey was gay. Swezey's predecessor in Luxembourg, Paul West Jr., recalled many years later in his 1990 oral history, "He lit up as a homosexual."

Perle apparently believed the rumor—how she heard it is unknown—and badly erred by mentioning these allegations to Moose. Moose obligingly passed on the rumors to Washington, where, fortunately, they were squelched. Edward Wailes, acting director of the Foreign Service Inspection Corps, explained the reasoning to Moose in a confidential letter. It is indicative of the era that Wailes's wording was very constrained, saying nothing more substantive than the euphemistic words "officer's tendencies."

Wailes said that he had spoken with an American diplomat in Paris who knew Swezey well. "He knows the individual in question

and said that while there have been numerous vague comments, such as the Minister's, nothing had ever come out of them. He personally feels that the individual is quite all right, but nevertheless, I will continue to have an eye kept on him just in case . . . I am sealing both letters in an envelope for our special files and, so far as I am concerned, I am putting the matter out of my mind."

By ratcheting up the rumors, Perle could have destroyed Swezey's career. Instead, he survived and thrived in the Foreign Service, serving in Vietnam and Cambodia, charged with managing the State Department's Malayan affairs and Thai affairs and serving as the first secretary in Paris before he retired in 1964.

Was Perle homophobic, or grabbing any weapon at hand to bludgeon Swezey? While there is no way to be certain, fragmentary evidence suggests that Perle's major motivation was anger. During her more than half-century in public life, Perle never made public comments denigrating homosexuals. She gave a central role to "confirmed bachelors" at her parties, and some of her regular escorts later came out as gay.

None of this exonerates Perle for acting vindictively. She tried to ruin Swezey. It was an ugly and revealing moment for a woman who desperately wanted to be perceived as a kind and vigorous champion of others.

WHILE TRUMAN WAS on vacation in Key West in mid-November, he confided to his closest staff members that he did not plan to run for office again. He wanted them to know early so they could start looking for other jobs. But according to David McCullough's Pulitzer Prize–winning biography, *Truman*, he urged them to keep his plans under wraps. The secret held for five long months.

Few Americans were as torn over the upcoming election as Perle, who was in the unique role of being close to the Trumans and the Eisenhowers. Perle was a Democrat, but she had Republican roots and her sobriquet as "two-party Perle" was not casually chosen. If Harry Truman

was going to step down as president—and it is almost certain she had an inkling from Bess—the "Hostess with the Mostes'" would need to decide what was most important to her: friendship or party loyalty.

She opted, privately, for friendship. She knew Ike, trusted him, and thought he'd be a good president. Even though Eisenhower had not confirmed that he was a Republican or acknowledged his White House ambitions, Perle signaled to him that she was on board. He would later write to his older brother Arthur that Perle had not only "urged me to run for the Presidency but frequently offered to help financially in a very substantial way."

Perle was not subtle in expressing her attitude. In late October 1951, a plane carrying American reporters touring European military installations was grounded in Luxembourg by fog. At an impromptu dinner at her residence, she regaled the journalists with her favorite stories—such as the weekend that General Eisenhower whipped up potato salad in her kitchen. That prompted the reporters to quiz Perle about a would-be Eisenhower campaign. Peter Edson, of the Newspaper Enterprise Association, recorded the dialogue:

QUESTION: Is he a Republican or a Democrat?
PERLE: What do you think?
QUESTION: Well, how can he possibly run as a Republican
 for an isolationist Republican party?
PERLE: What do you think?
REPORTER: Maybe Mrs. Mesta ought to try converting him?
PERLE: Maybe you think I haven't tried!

Then, clapping her hand to her mouth and turning away, she acted as if her comment was merely a faux pas, adding, "My goodness! What did I just say?"

Divided Loyalties

G wen Cafritz, the Hungarian-born wife of a real estate devel-
oper, had ascended the throne of Washington society in Perle's
absence. At her Foxhall Road mansion overlooking a sea of greenery,
she gave the most exciting parties, wore the most fabulous jewelry,
and attracted the most important guests. Except one.

Harry Truman, ever loyal to Perle, had never accepted invitations
from the Cafritz family. Longtime Perle friends like Vice President
Alben Barkley and Supreme Court chief justice Fred Vinson were
regulars at the Cafritz dinner table, but the First Family maintained
an unspoken boycott.

In January 1952, with the upcoming presidential election on her
mind, Gwen Cafritz told United Press that she was hedging her bets
by issuing an equal number of invitations to Democrats as Repub-
licans. With a tin ear for politics, Gwen incorrectly speculated that
the two presidential candidates would be "Taft and Truman." Ohio
Republican senator Robert Taft, the conservative isolationist, had
already run twice unsuccessfully.

Gwen had never gotten over her enmity toward Perle, whose
initial sin was refusing Gwen's request for 1949 Inaugural Ball tick-
ets. Threatened that her archrival might return to Washington and
reclaim her entertaining crown, Gwen grasped every opportunity to put

Perle down. The photo caption accompanying the United Press article showed Gwen quipping about Perle: "Who cares about her anymore?"

The Democratic Party cared.

An Associated Press story ("Women Take Star Roles in '52 Political Line Up") singled out Perle as a very influential woman expected to play an important role in the presidential election. India Edwards was counting on Perle to rev up support for the Democrats. For the first time in history, more women (49.4 million) were registered to vote than men (47.5 million).

But it was hard for Edwards and others to plan the upcoming campaign when they had no idea who the Democrats would nominate. Truman refused to reveal his own plans even as he auditioned presidential candidates to replace him. Fred Vinson rejected Truman's plea that he abandon the Supreme Court for the political hustings.

In December 1951, Truman met privately with Eisenhower to sound out the general's political plans. Ike was tight-lipped, not even revealing his party choice. Truman turned to Adlai Stevenson, the patrician first-term governor of Illinois, who had been a top aide to the Navy secretary during World War II and worked on establishing the United Nations. But during a White House meeting, Stevenson frustrated Truman with his indecisiveness about a possible candidacy.

The dynamic dramatically changed a few weeks later when Eisenhower revealed that he was a Republican and indicated that he would be willing to accept his party's nomination for president at the July convention in Chicago. As for the actual sordid business of running for president, Ike stated that he would stay out of the competition and leave it to others to draft him. Not only was he unwilling to campaign in the presidential primaries, but he intended to stay at his post as the NATO commander.

Despite Eisenhower's sudden Republican plumage, Perle had no compunction about socializing with Ike and Mamie, visiting them in mid-February at their home near Paris. Afterward she wrote the NATO commander, "You and Mamie are perfectly wonderful

people . . . I am looking forward to your promised visit to the Grand Duchy with great pleasure."

While the general was entertaining Perle, his supporters, led by blueblood Massachusetts senator Henry Cabot Lodge, were in the midst of orchestrating a sweeping victory for Ike over Taft in the March 11 New Hampshire primary. But the biggest upset occurred on the Democratic side. Crime-busting Yale-educated Tennessee senator Estes Kefauver defeated Truman by four thousand votes, a humiliating setback. The beleaguered president took eighteen days to respond. Finally, at the Jefferson-Jackson fundraising dinner on March 29, Truman gave his answer. "I shall not be a candidate for reelection."

Just two days after he bowed out of the race, Truman wrote Perle to urge her to demonstrate party loyalty, despite her friendship with the Eisenhowers. "I made an announcement Saturday night which will require all the efforts we can put forth to elect a Democratic President and I want your help in this."

Perle responded with a full-throated yes. "I am filled with mixed emotions about your decision to leave the White House," she wrote on April 10. "It is a decision that I am happy you made as you deserve a rest after such a struggle to keep peace in the world . . . On the other hand, I don't know how we will win the election without you, but I do want you to know that I am standing by at all times and am ready to do whatever you want me to do."

All the GOP political momentum was going in Eisenhower's direction. As *Life* magazine, which was unabashedly for Ike, enthused in late March, "The Eisenhower candidacy has changed from a potential to a kinetic force . . . New Headquarters are burgeoning all over the place and there are even signs of that highest of political tributes. A 'Stop Eisenhower' movement."

The fiction that Ike could keep his day job protecting Europe from a possible Soviet invasion while running for president was growing laughable. In early April, Eisenhower bowed to the inevitable and announced his resignation as NATO commander at the end of May.

That deadline allowed Ike and Mamie to make one more visit to their favorite American diplomat. Just before the trip, Eisenhower wrote to Texas oilman Sid Richardson: "This minute I am on the road to Luxembourg, where I have to lay a wreath, make a call on the Defense Minister and then Mamie and I will spend the night with her friend, Mrs. Mesta." It is worth noting that Eisenhower, writing to a male friend and contemporary, demoted Perle to Mamie's friend.

Nearly 150,000 people—roughly half the population of the duchy—lined up to see the war hero travel from the airport into the city. The architect of D-Day remained beloved as the American who saved Europe from the Nazis. Perle met the Eisenhowers on the tarmac, and that night the three of them shared a seven-course meal with Grand Duchess Charlotte at the palace. The following day, Ike enjoyed what was closer to his idea of haute cuisine, putting on a white chef's hat at the legation to grill steaks for lunch.

Time magazine correspondent Curt Prendergast wrote to his editors in New York that reporters "drifted out to see Perle at ministerial residence, French Provincial style building set in pretty garden with white painted tables and chairs out back, overlooking one of the city's spectacular wooded ravines." The reporters noted that Perle had decked out her two drawing rooms with autographed photos—one room devoted to the Trumans and the other with photos of Ike and Mamie.

Asked whether she would support the general for president, she replied, "I am a Democrat and I am a friend of the Trumans. As a diplomat, I don't think I should say anything at all about politics in the United States."

With so much happening in America politically, Perle felt she was on the wrong side of the Atlantic. Fortuitously, Fairleigh Dickinson University wanted to grant her an honorary doctorate, and she was also invited to give several high-profile speeches in the US. So she temporarily left for America several months earlier than planned.

On May 14, 1952, as Perle was heading for Le Havre to take the ocean liner *America* to New York, reporters pressed her again about

her preferred presidential candidate. Perle went with her oft-repeated answer: "Eisenhower is a personal friend of mine, but I am in the State Department and we are not in politics. What's more, he's not an official candidate."

The *New York Daily News* Paris correspondent Bernard Valery interpreted her words in this fashion. "The normally talkative Mme. Minister has been careful not to reveal where she stands in the coming Presidential election . . . If Truman doesn't run, diplomats are wondering whether she—a lifelong Democrat—will stick to the party no matter who the candidate is and give the campaign her valuable time and invaluable money. Or will she, as most observers believe, back her friend Eisenhower?"

The Perle primary consumed a forest of wood pulp as speculation about her political plans ate up hundreds of newspaper column inches. When the *America* docked in New York, reporters asked whether she would attend both conventions. "You know which party I belong to. I will go to the Democratic convention. Haven't missed one in many years." Her comments did nothing to tamp down the rumors. Syndicated columnist Ruth Montgomery theorized that Perle might benefit if Ike ran and won: "Perle may yet get her heart's desire—an ambassadorship."

In Washington, the Trumans, who had just moved back into the refurbished White House, held a dinner for Perle in the State Room on May 31. Most of the guests were Cabinet secretaries and State Department grandees, but there was one nongovernment face at the table: Marie Harriman, wife of W. Averell Harriman, the fabulously wealthy railroad heir who was a former secretary of commerce and ambassador to Moscow. Her inclusion added a political note since her husband was now actively running for the Democratic presidential nomination, vying for support with Estes Kefauver.

Even as the White House diners worked their way through the many courses—pea soup, shad roe, roast beef, buttered cauliflower, and strawberry shortcake—Dwight and Mamie Eisenhower were on

a plane en route to Washington. The five-star general was scheduled to meet with Truman the next day to officially resign from NATO so he could plunge into the presidential free-for-all.

WITH SEVERAL SPEECHES on her calendar, Perle was unsure about what she was allowed to say, as a government employee, about the presidential election. She sought guidance from Howland Sargeant, the State Department's assistant secretary of public affairs. He told her she could talk about American foreign policy but discouraged her from overtly working for a candidate. Sargeant explained his reasoning in a memo: "Although there was no statutory prohibition against such participation, I thought she would have to consider very carefully whether such activity would be compatible with the exercise of the important official position she held."

Carefully following Sargeant's advice, Perle made substantive remarks about international relations and referred only briefly to the presidential race. At the Overseas Press Club in Manhattan, Perle stressed that the US and Europe were mutually dependent, complaining, "It distresses me that it should be considered good campaign oratory to berate and belittle our friends. This haphazard throwing of verbal brickbats at the English—the French—the Italians—is dangerous."

She did not name names, but it was obvious she was referring to GOP contender Robert Taft's reputation as an isolationist. After the speech, she did some heavy-handed lobbying, telling reporters, "I'm willing to stay in my job no matter who is President. I hope they'll leave me there." When a reporter asked a follow-up question, "Even under a Republican president?" she replied, "I certainly would."

FOR THE FIRST time since the 1930s, Perle did not attend the Republican convention in Chicago, held the second week in July. "I wouldn't dare," she told columnist Earl Wilson. "It wouldn't be good

taste." He asked who she would support for president and she replied, "I accepted an appointment by the Democrats and I'm a Democrat." Nonetheless, she was thrilled when Dwight Eisenhower vanquished his opponents on the hard-fought first ballot at the GOP convention.

The Democratic convention was also held in Chicago, and when delegates arrived in the Windy City ten days later, the nomination was still up for grabs. The new favorite was Illinois governor Adlai Stevenson, who would have given Shakespeare's Hamlet a run for his money with his diffidence about whether to be a candidate. Averell Harriman and Estes Kefauver were still in the mix. Seventy-four-year-old vice president Alben Barkley coveted the nomination, but the VP's dreams died when labor leaders told him that he was too old. The segregationist South stuck with Georgia senator Richard Russell.

Perle gave a press conference on July 17 at the Blackstone Hotel wearing an artifact from the last election—a black-and-white Truman button. "This is the same Truman button I wore in 1948," she cheerfully announced. "He's still my candidate—I have no second choice." She admitted that she hadn't spoken to the president since May and had no inside information about a last-minute Truman candidacy. But Perle added, "I can hope, can't I?"

As waiters passed around martinis and Manhattans to the thirsty journalists, she said that Averell Harriman was a "fine man" and had nothing at all to say about Stevenson, the rare public figure she did not know. She issued an open invitation to her post-session cocktail party that Tuesday night at the Blackstone Hotel, announcing, "The press is welcome, and so are the candidates and those running for Vice President too."

But first, there was the convention to attend. Hoping to attract the women's vote, the Democrats dubbed the second day, July 22, as "Ladies Day," but the delegates, caught up in the drama of an open convention, ignored speeches given by Perle, treasurer Georgia Neese, and ambassador to Denmark Eugenie Anderson. "The babble was deafening, the applause at best perfunctory as Mesta swept along

the runway and took her bow," wrote *Time* magazine reporter Eldon Griffith. "She looked like a Metropolitan opera singer about to give them Tannhauser. She flashed with pearls: three strings around her neck, pearl earrings beneath her upswept brown-gray hair."

Perle issued a full-throated feminist call for change, urging men to give women a seat at the table. "In America today, women are a tremendous force," she declared from the podium over the din. "We have a lot to say about what goes on and how it shall go . . . We want only to be equal partners on the team. We want to use our knowledge, our talents, our thinking, put to work. We want to help our men shape society."

But as TV cameras panned the room, it was clear that almost no one was listening. "Rapt with inattention, the vast audience shuffled and gossiped," wrote *Time*'s Griffith in a memo. "The menfolk weren't interested, the womenfolk couldn't hear."

Later that day, Adlai Stevenson finally sent word that he would accept the nomination if chosen. That's all anyone could talk about when the delegates crowded into Perle's party at the Blackstone Hotel at 10:30 p.m. Picture the scene: Perle at the door, glad-handing four hundred guests, including Eleanor Roosevelt; Congressman John Kennedy, now running for the Senate; his sisters Eunice and Pat; the wives of two presidential contenders, Marie Harriman and Nancy Kefauver; and Perle's Broadway doppelgänger Ethel Merman. Stevenson did not attend.

"The guest list read like a 'Who's Who' of Washington, generously sprinkled with names starred on stage, and TV," wrote Eleanor Page in the *Chicago Daily Tribune*. "And most of the famed guests literally sang for their supper." Merman belted out "I Get a Kick Out of You," former Kentucky senator Happy Chandler broke into "When Irish Eyes Are Smiling," and Clark Clifford's wife Marny sang "Oh, Careless Love."

At the buffet table, guests gobbled lobster, caviar, and salmon, an upgrade from Perle's usual fare. Newspapers guessed the party cost

Perle $20,000 ($227,000 today). The raucous party lasted until 3:30 a.m., as the pols and press talked over the prospect of Stevenson as the likely presidential contender. But it took three ballots and Truman's endorsement for Stevenson to win the slot.

Rounding out her convention trip, Perle appeared on a special Chicago edition of the CBS television show *What's My Line?* Four blindfolded panelists—columnist Dorothy Kilgallen, author and publisher Bennett Cerf, actress Arlene Francis, and comedy writer Hal Block—asked questions of a mystery guest to discover their identity. The show's bow-tied moderator, journalist John Daly, sat next to Perle, who wore a strapless evening gown, her hair curled softly around her face. She was beaming as the show began.

Dorothy Kilgallen: "Are you in the entertainment business?"

Perle's reply: "No."

Bennett Cerf: "Are you in public life?"

Perle's Oklahoma twang resonated as she smiled and drawled: "Yes."

Bennett Cerf: "Has your name appeared on front pages of newspapers within the past year?"

"Yes."

Bennett Cerf: "Have you ever held or do you aspire to holding some public office?"

Perle looked at Daly, who added, "By that do you mean elected or nonelected?"

Cerf followed up with "Have you ever been elected to one or would you like to be elected to one?"

"No."

Arlene Francis: "Would you consider that you are part of the political scene in any way?"

Perle gave a big grin and enthusiastically answered, "Yes!"

Francis followed up: "Are you married to somebody who is very well-known politically?"

"Nooooo," Perle replied.

Hal Block: "Are you part of the Washington scene?"

"YESSS!"

He continued, "Have you ever been abroad in any capacity?"

"Yes."

The audience laughed with recognition.

Hal Block: "Was it some capacity within the last, say, five years?"

"Yes."

Dorothy Kilgallen solved the mystery: "Are you not only a great lady of great charm and diplomacy but known as the hostess as the mostest on the ball?"

Perle laughs. "Yes."

Dorothy Kilgallen: "Have you ever been to a delightful country called Luxembourg?"

"Yes."

Dorothy Kilgallen: "Are you Madame Perle Mesta?"

"Yes!"

SEVENTEEN

Goodbye, without Leaving

The clock was ticking down on Harry Truman's presidency, with the Democrats poised to lose the White House for the first time in twenty years. An early August Gallup Poll gave Eisenhower a hefty sixteen-point lead over Stevenson. Perle had been bottling up her frustrations with State's career diplomats, only hinting to Truman about her humiliations as minister. About to return to Luxembourg, Perle realized it was now or never. After writing an enraged ten-page report, she made an appointment to see Truman at the White House on August 9 at 1:30 p.m. to personally hand the president her memo.

In her cover letter, Perle wrote: "I have never mentioned this to you before as I knew you had enough troubles of your own and I did not want to bother you. However, I feel that the continuous disrespect shown towards me reflects a disregard to the office of President."

Her pent-up fury was evident as she described the patronizing way that Paul West, Anthony Swezey, and others behaved—ignoring her ideas, undercutting her, and making it hard to do her job. Many specific incidents that Perle laid out for the president have been highlighted in previous chapters. But her tone was indicated by passages like this one: "Foreign service officers seem to take the attitude that

they are career men above reproach and that they will be in the service long after political appointees come and go," she wrote, adding that they believe they are of a higher "class."

Truman took her words seriously. After reading her report, the president sent off two letters on August 11. The first went to Perle

I appreciate most highly your giving me the facts with regard to your treatment by the career men in the State Department. Yours is not the first case of the kind I have run across and I am going to do something about it before I get out of office.

On the same day Truman dispatched a letter to Secretary of State Dean Acheson. Truman claimed that he coaxed the information out of a reluctant Perle:

After much prodding I succeeded in getting Mrs. Mesta to give me a report on her experience with the career men which she found in the Embassy in Luxembourg. Had I known of this situation when it was taking place these birds would have been kicked out forthwith.

I imagine the same situation exists in the other embassies when the President makes appointments with which they are not in sympathy . . .

I've never said anything to you about it but it is coming to the end of the row now and I thought you ought to know personally what goes on down the line . . . If you will read this report which Mrs. Mesta gave me I am sure you will feel as I did that these people need a kick where it will do the most good.

IN RESPONSE TO numerous inquiries about her postelection plans, Perle wrote an essay for the American Sunday newspaper supplement *This Week*, stressing that she had been transformed by

her time in Luxembourg. The startling headline: "I'm through with PLUSH PARTIES!'"

Appearing in print just weeks after Perle's champagne-and-lobster bash at the Democratic Convention, the depth of her conversion to a life of austerity was subject to intense doubt. But there was a core of truth beneath her exaggerated pronouncement.

Perle wrote that she had been deeply affected by conditions in war-torn Europe. "If I ever give Washington parties again, they will be different in purpose and spirit," she declared. Perle insisted that Europeans were appalled by Americans' lavish spending. "Every time we in this country spend money recklessly on sumptuous parties or a bizarre opening night at the Met, we are doing ourselves great harm."

She highlighted her own worthwhile events, such as her Luxembourg parties for orphans and Saturday night festivities for American GIs. "In these serious times, we cannot give parties for parties' sakes," Perle wrote. "The bad party helps to strengthen barriers between classes, races or countries. A good party helps to break down the barriers— whether they are between nations or whether they are the barriers of snobbishness between neighborhoods and people in your town."

The article highlighted the contradictions in Perle's persona. On the one hand, it was rare for someone of Perle's wealth and social status to publicly suggest breaking down class—and particularly racial—barriers. At the same time, Perle always had her own agenda. She liked the role of gatekeeper, introducing influential people to one another and feeling she could shape events, at least at the margins. The idea that she would ever relinquish giving parties was akin to believing that Ike would give up his beloved golf game.

WINDING DOWN HER American stay, Perle was interviewed on the CBS television show *Longines Chronoscope*. Wearing a low-cut dress and a corsage, she managed to maintain a fixed smile when *American Mercury* editor William Bradford Huie's first question was about

entertaining in Luxembourg—hardly what he would have asked a male envoy. Huie obliviously followed up by asking, "Have you found being a woman a handicap in performing your ministerial duties?"

Responding to the inherent put-down embedded in the question, Perle replied, "To a certain extent it's a handicap because we have to prove ourselves and prove we can do the job. We have to work a little bit harder than men to let the world know we're interested and we can really do the job when we make up our mind to do the job."

A few days later, as she was boarding a ship to France on August 22, she made yet another plea to keep her job. "I hope I am still there in 1953," she told reporters. "I hope Stevenson will leave me there."

Back in Luxembourg, Perle found it hard to focus on work when she was obsessed with an election thousands of miles away. Perle diverted herself with a trip to Paris for lunch with Margaret Truman and popped over to London to see a production of *Call Me Madam*.

On October 16, she wrote to Mamie Eisenhower on official American Legation stationery. "Dear Mamie, whichever way this all turns out, I know it will be for the best and that you will be happy."

DESPERATE TO RETURN to America for the final days before the election, Perle accepted speaking engagements in Oklahoma, Kansas, and Connecticut and once again wangled authorization from the State Department to return, thanks to President Truman's intervention. At her party in Luxembourg for American GIs before she flew home, one man shouted out "Perly? The guys down here want to ask you how you want us to vote?"

She replied, "Vote as United States citizens. Vote as you please. I do."

When she arrived at the State Department, the reception was frigid enough for a polar explorer. Undersecretary David Bruce was furious, with ample justification, that Perle used clout to arrange her return with the government paying her transportation. Bruce wrote on October 20, in his journal:

Perle Mesta came to see me. She has come home to make political speeches, against my strong objection, since her permission from the President to be here "on consultation" will cancel out home leave for at least one deserving foreign service officer. She has no appreciation whatever of the requirements and obligations of diplomacy or of civil service, governmental customs and observances and seems to me, in her pursuit of personal publicity, lacking in all commendable qualities.

This diatribe by the patrician Bruce, who had an Ivy League background and impressive war record, may have reflected the career State Department's standard line on Perle but there was truth in his criticism. Perle had never been interested in the intricacies of the civil service. She consistently bypassed State Department protocol with personal appeals to President Truman. And she certainly liked personal publicity. But in big-picture terms, she had accomplished what Truman had asked her to do—burnish America's reputation and create goodwill in the duchy.

Although Bruce bitterly characterized Perle's speeches as "political," she did not make campaign speeches. Her only overt political activity was attending a fundraising lunch for Stevenson in Washington. Instead, talking to Oklahoma City teachers, she relied on State Department–approved rhetoric to emphasize the Communist threat and urge educators to encourage free speech. "The masters of the Kremlin have very clearly recognized that this is basically a war for the minds of men," she said. "They are backing up that war militarily and economically, but fundamentally the victory will be won or lost on the ideological front."

On Election Day, November 4, she went to Newport to vote, then retreated to a suite at the Drake Hotel in New York City to watch the election returns with friends. It was a dismal night for the Democrats, with Stevenson conceding in the early hours of the morning. Dwight

Eisenhower and running mate Richard Nixon romped home in the biggest Republican victory since the 1920s, carrying thirty-nine states. The Republicans pulled off a full sweep, narrowly taking over the Senate and winning control of the House. This marked the first time since 1929 that the GOP controlled all three branches of government.

For Perle, this Democratic defeat had compensations. Instead of trying to ingratiate herself with the cerebral Stevenson, Perle was blessed with a president—albeit a Republican—whom she had known for more than two decades. The morning after the election, Perle sent a victory telegram to the Eisenhowers. "Congratulations the whole country will back you . . . Will Telephone you when you have had a rest and before I fly Luxembourg. Warmest regards."

Even though he was besieged with well-wishers, the president-elect made time to quickly reply to Perle. Writing on November 9 from Augusta, Georgia, where he and Mamie were vacationing, Ike wrote:

Dear Perle:

How nice to hear from you and many thanks for your good wishes. It is good to know my old friends are behind me.

Mamie and I are trying to get a much needed rest down here. I've been playing a bit of bad golf every day and we have indulged in some bridge as well . . .

Mamie joins in sending our best and again my thanks for your thoughtful wire.

Perle made time for an unusual interviewer, Jacqueline Bouvier, the twenty-three-year-old "Inquiring Camera Girl" for the *Washington Times-Herald*. Jackie's mother and stepfather, Janet and Hugh Auchincloss, were part of Perle's social orbit in Newport and Washington.

When the inquiring camera girl asked Perle about her future, the envoy dodged the question. "I don't know what I'll be doing,"

Perle admitted. "I love Luxembourg though. I've had lots of offers. But right now, all I can think about are my duties in Luxembourg."

TO THE VICTOR belong the spoils. Now that Republicans controlled the White House, they had the right to fill the thousands of government jobs not covered by civil service rules with party loyalists, including all non–career diplomats. Discussing the upcoming shake-up at the State Department, the *Los Angeles Times* singled out Perle as one of the diplomats most likely to lose her perch.

But Perle was convinced that she had a secret weapon: her friendship with the new president. In fact she felt so sure of her position that—unlike all her Democratic peers in embassies around the globe—she saw no need to resign, and said so. Belatedly realizing her comments might be considered presumptuous, she backtracked a few days later, telling reporters that she would follow protocol and submit her resignation when Truman left office on January 20. But in the same breath, she kept repeating, "I just love Luxembourg."

In Paris, she met with convivial *New York Herald Tribune* columnist Art Buchwald, who asked whether she thought Eisenhower would appoint women to top jobs. Perle's reply was blunt. "He should. It was the women who elected him. And I would like to add the Republicans have some very capable women." She stressed that she was a feminist first, with party loyalty her second priority. "Although I have been on one side of the political fence," Perle said, "the big battle that I have been fighting for the last twenty years has been the rights of women—all women. The more women in government, regardless of party, the better off we'll all be."

Buchwald, who would later become one of America's leading humor columnists, asked Perle if she planned to live in the capital. "I really don't know," she told him. "I've never owned a home in Washington for the simple reason that if I didn't like the Administration I

could move out. Of course, if I keep working for the rights of women, I may have to live there."

With the inauguration of a new president approaching, the question was, what side was Perle on? Like a juggler spinning plates in the air, Perle was trying hard to maintain her relationships with the outgoing and the incoming presidents, who were scarcely speaking to one another. She had genuine affection for the Trumans and the Eisenhowers. But there was another factor: Perle enjoyed having access to the corridors of power and being welcome at the White House. The elixir of power is a difficult drug to give up.

Perle continued her tradition of sending a Thanksgiving telegram to the Eisenhowers. Mamie responded on December 8 with a warm letter anticipating her coming life in the White House.

> *Gosh, it would be so nice to see you again, for plenty of water has gone over the dam since our last visit.*
>
> *As you can imagine, I am in the throes of preparations for the big move on January 20th. Between that, and tackling the mountain of correspondence that floods in here every day, I don't have a minute to myself. The Army was never like this, but it really is a lot of fun—though a little peace and quiet would be welcome, too.*
>
> *Made the grand tour of the White House on Monday and was much impressed by the results of the renovation . . . Ike joins me in sending you our best love!*

FRIENDLY LETTERS FROM Mamie and Ike were gratifying, but Perle craved a tangible sign that she could remain in Luxembourg. Broad hints in newspapers were not doing the trick. So Perle made a direct pitch, writing to Eisenhower on January 12, asking to keep her job. Since Ike was still nominally president of Columbia University, Perle sent her appeal to his Morningside Heights address in New

York. That was a mistake, since Perle's beseeching letter did not reach Eisenhower in the White House for several weeks.

She admitted to reporters on January 15 that she had submitted her resignation but insisted, "It's just a technicality for all us ambassadors and ministers but it doesn't mean a thing."

Perle remained confident that she would get her way. Her agent George T. Bye wrote to the *New York Herald Tribune*, inquiring whether there would be interest in hiring Perle as a columnist. "Madam Perle Mesta tells us that she is going to be retained in Luxembourg by President Eisenhower, with whom she is as friendly as she was with President Truman." The newspaper syndicate turned down the proposal for a regular Perle column.

On their final night in the White House, January 19, Harry and Bess Truman hosted an intimate dinner for *New York Post* columnist Leonard Lyons and his wife Sylvia. The president described his final tasks that day, which included accepting the resignations of all noncareer diplomats. When Lyons asked about Perle Mesta's fate, Truman replied, "She submitted it, but I refused to accept it. Let the general fire her, if he wants to."

Truman's refusal to sign Perle's resignation letter was his last official gift to the loyal fundraiser and party giver who had proven surprisingly effective in Luxembourg. In his column, Lyons explained Truman's reasoning: "He knows of her long friendship with the Eisenhowers, which predates her friendship with the Trumans, and it's now up to the new president."

Keeping up her regular correspondence with the new First Lady, Perle acted as if her own future was not in question. "Mamie Darling . . . I followed you every step of the way during the inauguration and your pictures are simply beautiful," she wrote, laying it on thick. "I am going to write Ike and tell him how much I enjoyed his inauguration address. It was excellent."

With the war grinding on in Korea and the Republicans ascendant in Washington, newspaper editorial writers still found time to

argue over who should be minister to the smallest nation in NATO. *Newsday* voted for Perle the diplomat. "She is good friends with the Luxembourgers, throws big blowouts for GIs who pass through the country, and always makes lively copy. Mrs. Morris Cafritz has replaced her as the ruler of Washington society. Mrs. Mesta is too colorful to go back to the quiet of Oklahoma oil fields. Obviously, the best course is to leave her where she is the Hostess with the Mostest on the Ball."

Perle's detractors had their own editorial page real estate. A canned editorial that ran in newspapers from Florida (*Palm Beach Post*) to Montana (*Helena Independent Record*) claimed that Republican women were demanding she be replaced with a GOP loyalist. "The women's division of the GOP National Committee has been swamped with protests against Mrs. Mesta's retention, coming from distraught ladies who campaigned hard in the general's behalf. Unless the president underestimates the power of women in politics, Perle will have to be content with the title of 'ex-Madam.'"

The always plugged-in Leonard Lyons summarized the state of play in his column: "The top Republican officials expect to disappoint Perle Mesta in Luxembourg."

WHEN PRESIDENT EISENHOWER belatedly received Perle's letter, he forwarded it to the State Department for guidance on a tactful way to let her down. She was a family friend, he was new to the job, and attention would be paid. Perle's bitter foe David Bruce, about to depart as undersecretary of state, scornfully wrote in his journal that Perle's plea to keep her job was "the most shaming letter of this type I've ever read." Bruce passed the job of drafting a suitable reply to his staff.

"As she is almost universally detested in the Department as an ignoramus and a pretentious bore, the drafting officers had a field day," Bruce wrote.

James Bonbright, a career Foreign Service officer, was given the job of writing the response. As he later acknowledged in an oral history, he attacked the task "with glee, because I had absolutely no admiration for the lady." But then he had misgivings. "When I got through with my drafting job, I looked at it and said, 'Oh, God, this is all terribly negative. I ought to lighten this up somehow . . . '

"So I stuck on a little paragraph saying that he [Eisenhower] recalled with pleasure the visit to Luxembourg, when she'd been kind enough to have him for dinner . . . I thought, with that, maybe the pill would be swallowed. The word came back from the White House that that had been accepted up to the last paragraph, which was deleted in toto. Not a kind word in it."

The editors of *The Papers of Dwight David Eisenhower* noted, "Eisenhower made a number of changes on Secretary of State Dulles' draft of the letter. He apparently considered making this letter warmer and more personal in nature, but he finally decided to send the relatively impersonal version."

But like a plot twist in a Victorian novel, the stiff letter from Eisenhower took a while to reach Perle.

JOHN FOSTER DULLES, the new secretary of state, came to Luxembourg on February 8 for a NATO meeting. At the airfield, when reporters asked about Perle's status, he hedged, saying, "That is something we will have to see about later." Perle took heart from a private conversation with Dulles, interpreting his careful words as an implicit promise that Ike wanted her to remain indefinitely.

However, in Washington the next day, Eisenhower signed the staff-written letter that sealed Perle's fate.

With regard to you staying on in Luxembourg, I am sure you will be the first to understand that this is not a matter which I can decide on the basis of my personal feelings . . . The State Depart-

ment believes and I agree, that . . . the wisest course is to accept the resignations of those who were appointed by the previous Administration. This, I believe, is what foreigners understand at the outset that there is to be a fresh approach to our foreign problems . . .

Needless to say, I sincerely appreciate your willingness to continue to serve, but I am sure you will understand and agree with the reasons which have impelled me to adopt my present policy.

On the same day that Eisenhower signed the letter ending Perle's diplomatic career, he named Clare Boothe Luce as ambassador to Italy. It was the political version of the old Hollywood joke: "Get me Perle Mesta. She's a Democrat? Then get me someone like Perle Mesta."

In truth, Clare Boothe Luce had a far more serious resume. The two-term GOP Connecticut congresswoman, a Catholic convert with a strong anti-Soviet record, was knowledgeable about foreign policy. She would be the emissary to a major, if troubled, European nation facing political pressures from a large internal Communist Party.

Friends for nearly four decades, Clare's star was rising while Perle's was falling. Clare was keenly aware of the pressures she would face in the Foreign Service, stressing in an interview, "Because I am a woman, I must make unusual efforts to succeed. If I fail, no one will say, 'She doesn't have what it takes.' They will say, 'Women don't have what it takes.'"

EXASPERATED BY PERLE'S seemingly oblivious approach to staying in Luxembourg, Eisenhower administration officials leaked the news. On February 20, Martha Kearney of the International News Service, stating that her information was based on high-level sources, broke a story that ran with the headline "Ike to Relieve Perle Mesta of Luxembourg Post."

Describing Perle as a "political casualty," Kearney wrote that Perle would return to civilian status as soon as she was replaced. (Her replacement, Texas businessman Wiley Buchanan, was not named until September.)

No one had given Perle a specific date to clear out, but she finally acknowledged that her days were numbered. David Bruce, dispatched to Luxembourg for a meeting, wrote in his diary on March 3: "I went to call this afternoon on Perle Mesta. She told me she expected to relinquish her post in May. She accompanied me while I visited my old friend Mr. Bech, the almost perpetual Foreign Minister . . . Perle Mesta is often referred to as 'shrewd.' If she is, it does not appear in many of her actions."

Perle kept irrationally hoping for a last-minute reprieve. Interviewed by NBC on March 11, Perle said, "I know that he could not keep me here if he wanted to, which I think he does. The President and Mrs. Eisenhower and I are good friends and whatever decision he makes will not make a bit of difference as far as this friendship is concerned."

THE INVITATION WAS presented casually, but it was obviously the fruit of elaborate deliberations in a major world capital. Perle received a puzzling diplomatic request from the new Russian ambassador to Belgium, Viktor Ivanovich Avilov, who asked for a meeting. Chatting at the Luxembourg legation, Perle inquired whether Avilov had ever visited the United States. It was an expected conversational gambit—and it set up Avilov's purpose.

Regretfully explaining that he had never been to the United States, he, in turn, asked Perle if she had ever visited Russia. In 1953, that was the equivalent of wondering if Perle had ever flown to the moon. When she gave the expected answer, Avilov eagerly invited her to visit the Soviet Union.

This was unheard of. Aside from diplomats and a small group of carefully monitored journalists, no Americans were permitted in Russia. There were no guided sightseeing tours of the Hermitage Museum in Leningrad or visits to Red Square in Moscow. But timing was everything in Perle's life.

Avilov's offer was the fruit of an unexpected—and very brief—thaw in the Cold War. The increasingly paranoid and always bellicose Joseph Stalin had died on March 5. An unsteady troika was now ruling the Soviet Union with Lavrentiy Beria, the head of the fearsome police, as the dominant figure. For all his well-deserved reputation for brutality, Beria was also a pragmatist who recognized the Soviet Union needed to strengthen itself internally before it could fully confront the West. Georgy Malenkov, the new premier, echoed these sentiments in a speech in March.

"At the present time there is no dispute or unresolved question that cannot be settled peacefully," he said. "That applies to our relations with all states including the United States of America." As a tangible sign of change, political prisoners were abruptly freed from Russian jails and false charges against a group of Jewish doctors were dropped.

A thaw in Moscow was one thing, but an olive branch to Perle personally was quite different. Given her outspoken criticism of communism, the Russians should have had no expectation that she would be a guileless fellow traveler who would end up burbling about the Soviet miracle. Most likely, the Russians were intrigued by Perle's friendship with Eisenhower and recognized that a visit by Perle would create headlines in the United States. Perhaps they hoped the party giver would play the role of useful idiot.

Perle was stunned by Avilov's unexpected overture. In an odd twist, this mission to Moscow had been presaged in Irving Berlin's lyrics for "Call Me Madam:" "What they really need behind the iron wall / Is the hostess with the mostes' on the ball."

On the same day she met Avilov, Perle received a cable from Secretary of State Dulles, stating that her resignation had been accepted effective April 13, giving her less than three weeks to pack up and leave. Stung by the way the blow was delivered, Perle told United Press on March 27 that Dulles had previously assured her that she could stay "indefinitely." "I thought that meant at least till this summer," she said. "I was expecting to be fired only about June. It was a great shock, being so sudden. For the time being, this is the end of my diplomatic career."

Perle sent her usual Easter telegram to the Eisenhowers. This set off a round robin of correspondence notable for its willful obliviousness. Mamie replied on April 9 and actually gushed, "Spring in Luxembourg must be very lovely—quite like a fairyland and I hope that all of you are having gay times . . . Perle, we do miss you like everything and hope that we will see you in person before too long."

Replying to Mamie, Perle mentioned her imminent departure. "You know I am leaving Luxembourg on April 13th. It saddens me somewhat but I carry with me many happy memories including the times you and Ike visited me." Perle then leavened her palpable disappointment with heavy-handed flattery. "As I get some of the Washington newspapers, I have been following your activities with great interest. Your photographs are just lovely you are getting younger looking every day. I really mean this. I admire you greatly."

FACING THE LOOMING prospect of unemployment, Perle found the idea of visiting Russia to be alluring. Here was the opportunity of a lifetime to see a forbidden world, stay in the news, and perhaps pursue diplomacy. Publicity-savvy Pittsburgh congressman James Fulton, who was staying with Perle in Luxembourg as one of her final visitors, urged her to go. He even tried to get Soviet permission to tag along, but his request and that of another congressman were denied. Perle, it seems, was a very special case.

Perle informed the State Department about the unprecedented Russia invitation. One can imagine the consternation in Washington: Perle would have scarcely been the State Department's first choice as an American visitor to a sworn enemy at a time of stark transition. Nonetheless, State nervously gave her the green light. What mattered to the bureaucrats was making clear that Perle was not—in any way—traveling on official business. Press officer Michael McDermott issued a statement saying that Perle would be in Russia as "a private citizen."

During her final days in Luxembourg, Perle was treated like a heroine. US brigadier general W. W. Ford gave her a tour of the military base at Verdun, where she reviewed the troops and stayed for lunch. On the morning of April 9, the day of the wedding of the Grand Duchess Charlotte's son, Perle was invited to the royal leader's private sitting room at the palace. The duchess presented her with the Grand Cross of the Crown of the Oak, the country's highest honor. The only other American who had received the medal was Dwight Eisenhower.

Perle was lionized in Luxembourg newspapers. "We sincerely regret that Mrs. Perle Mesta is leaving us," wrote the *Letzeburger Journal*. "This woman, from the very first moment, knew how to win the hearts of the ordinarily very reserved Luxembourgers." The *Luxemburger Wort* wrote, "When Christmas comes around again the children of our orphanages will think with much longing of the distinguished lady who year after year sent Santa Claus to them richly loaded with presents."

She received a different kind of compliment from her friend, syndicated columnist Inez Robb, who wrote, "Mrs. Mesta not only leaves Luxembourg with a genuine bona-fide decoration, but she leaves the State Department with a virtually unparalleled record: No one, not even the crack-pots and the lunatic fringe, has ever accused Perle of being a Commie or a poor security risk."

Her desk in Luxembourg had been cleared when she gave a final interview to Alfred Cheval of the Associated Press. The journalist

noted that Perle appeared sad and wrote, "It is evident, she is leaving her heart here." He pointed out that she had been a huge boon to Luxembourg tourism, attracting American vacation dollars to the small country struggling to get back on its feet.

Perle insisted that Luxembourg had done more for her than she had done for the country. "I learned to listen," she told him. "Rather than talk every time I think I have something to say, I've learned to keep my mouth shut. I listened, and I learned a lot that way."

On her final night in the country, she was serenaded by the state band. On the afternoon of her departure, a large group of orphans gathered on the front lawn of her residence to wave goodbye.

Perle sent a farewell letter to President Eisenhower, stressing that she did not have hard feelings.

Dear Mr. President

As I take leave of Luxembourg, I carry with me many happy memories—none of which I remember with more pleasure than the weekends you and Mamie spent with me at the Legation. We did have such fun and I am never in the kitchen without thinking of all that cooking we did . . . I well realize the political pressure you have been getting to remove me. I understand politics thoroughly and I know exactly how such things go . . . You are doing a magnificent job and I have heard many other Democrats say the same thing.

The people of the United States are very fortunate to have such a firm and steady hand at the wheel during these turbulent times.

EIGHTEEN

From Royalty to Russia

The news of Perle's upcoming trip to Russia was treated as a bombshell, with many people wondering about the hidden meaning of the invitation. An April 16 article by John Martin, the International News Service's foreign director, typified the reaction. "Everyone will look for a 'secret weapon' in this but it will be difficult to tell who is using it—Perle Mesta or the Kremlin leaders. The reason for the invitation is a mystery."

Upon arriving in Paris, a mink-coat-clad Perle told reporters, "I am going as a tourist but for a constructive purpose. I have some definite plans in mind concerning whom I want to see, and what I want to emphasize is that my purpose in going is to accomplish something constructive." She had just met with another Soviet envoy, adding, "He was extremely friendly and gallant and led me to believe I could visit not only Moscow but travel around Russia if I wished. I want to see everything."

Her fame was such that a routine trip to be photographed for a Soviet visa became a media event. Accompanied by *New York Herald Tribune* correspondent Art Buchwald, Perle reveled in this humdrum task, telling the photographer, "Now you take a good picture of me. I want to look good to those old Russians."

But before heading to Moscow, she had another stop to make. Perle was giving a gala in London in honor of the coronation of Queen Elizabeth II, whose father King George VI died the previous year. For the party, she rented Londonderry House, a vast three-story 1853 brick mansion with a grand ballroom, rococo chandeliers, frescoed ceilings, antiques and oil portraits of the Londonderry family. In London, Perle moved in with her sister and brother-in-law at their Grosvenor Street home; ordered a couture gown from Norman Hartnell, Queen Elizabeth's favorite dressmaker; and began issuing invitations.

Even though she had just denounced "plush parties," this event would assuage her hurt feelings about losing Luxembourg plus remind the world—as if there were any real doubts—that she remained relevant. While London was shaking off postwar austerity with dozens of plush parties, Perle's would be the only one thrown by a red-white-and-blue American free spender.

Everyone with a pulse, and probably some elderly British lords without one, begged for an invitation. Marie Ridder, an American journalist living in Europe with her newspaper executive husband Walter Ridder, was one of the supplicants. As she told me, "We had been invited to one or two of her parties when we were young. I wanted to go to this fabulous dance that Perle was giving. So I wrote her a note, hand delivered it. And she did ask us."

Jackie Bouvier, en route to London on an ocean liner to cover the coronation for the *Washington Times-Herald*, described eavesdropping on her fellow passengers. "One hears a lot on the promenade deck," she wrote. "Such as, 'I have hotel rooms and seats for the coronation, but I still haven't been asked to Perle Mesta's party.'"

She made her own request in person. "A striking young girl, hatless, swinging her camera, chattering enthusiastically to her companion, rapped on the door of my apartment in Grosvenor Square," Perle wrote years later in *McCall's*. "I did not know, of course, that this was her last story, for an attractive young Senator

from Massachusetts had been squiring her around and was even now sending her cables from Washington." (Jacqueline Bouvier and John Kennedy announced their engagement three weeks later, on June 24, and married in Newport that September.)

The *New York Herald Tribune*'s editors, who had previously rejected a proposal that Perle write columns, suddenly thought this was a terrific idea. Editor-in-chief Whitelaw Reid sent Perle a telegram. "Wondering if you would be interested in doing three pieces for *Herald Tribune* on people attending Coronation ceremonies." Perle agreed to write three articles for $1,000, the equivalent of more than $11,000 today.

As one of the lucky Americans to snag an invitation to the queen's garden party at Buckingham Palace, Perle described the scene in starstruck prose in her *Herald Tribune* column. "Just how beautiful Queen Elizabeth is can only be appreciated by those who see her, as I did, receiving her guests on the velvety turf of the palace gardens."

But Perle's status as a private American citizen rather than a diplomat was evident when her invitation arrived for the June 2 coronation. Instead of being seated in Westminster Abbey with the dignitaries, she was relegated to sitting outside as the ceremony was broadcast to the crowd. Still, Perle the newspaper columnist made sitting with the masses sound like fun. "I see the Queen first through the glass at the front of the stage coach. She sits there upright and serene. The glittering crown is on her head, in her hands the orb and sceptre . . . Never shall I forget this moment."

That night, Perle instructed her chauffeur to drive her around London so she could soak up the mood. She got out of the vehicle to mingle with the celebrating throngs. "This Love for the Queen shone out from above those narrow streets and courts," she wrote. "It shone from the windows of temporary little square boxes put up on bombed sites after the war to house the homeless."

Invited into a chimney sweep's parlor, Perle stayed for a cup of tea with the family. Writing it up, she didn't miss a cliché. "My night

'down Lambeth way' certainly made me feel close to all the cockney folk who let themselves go in their rich cockney English when they speak of their love for their queen."

THERE WAS NOTHING Lambeth-like about Perle's party. London police blocked off the street in front of Londonderry House as hundreds gathered to watch the arrivals of men in white tie and couture-clad women wearing enough diamond tiaras and emerald bracelets to stock Tiffany's for a year.

In a sequin-embroidered green tulle crinoline gown, Perle stood regally with Marguerite at the top of a grand staircase as a British butler announced the guests. Her seated dinner for 118 would be followed by a late-night party for seven hundred. The queen was giving a formal dinner for 250 people at Buckingham Palace. Perle scheduled her dance for 11 p.m. so the royal guests could also attend her festivities.

What passed as American royalty showed up to wave the stars and stripes. Movie stars (Lauren Bacall, Humphrey Bogart, Douglas Fairbanks Jr., Jennifer Jones, movie producer David Selznick); Social Register regulars (Marjorie Merriweather Post Davies, Mrs. Cornelius Vanderbilt); political royalty (American ambassador to Britain Winthrop Aldrich, California governor Earl Warren, World War II generals George Marshall and Omar Bradley, Pat Kennedy and her sister Eunice, accompanied by Eunice's new husband Sargent Shriver).

European royals graced Londonderry House: the Duke of Edinburgh, the Earl of Warwick, Prince Jean of Luxembourg and his bride Princess Josephine Charlotte of Belgium, Prince Bernhard of Holland, Crown Prince Olav and Crown Princess Martha of Norway. And of course a large press contingent attended.

"It was a beautiful party," Marie Ridder recalled. "Too many people but it was in London, where there was a need for over-the-top

festivity. She had imported food from the USA. I have a sense of hams, maybe Texas barbecue, something very American."

Perle's niece Betty was agog watching one of the British royals dance with Lauren Bacall. "He seemed to really enjoy her company," she wrote in her memoir. "Young Jacqueline Bouvier, who was covering the coronation, came to the ball and was cut in by many attractive men."

Perle reveled in her eclectic guests: "Crowned heads rubbed shoulders with GIs. Dignitaries from Elizabeth's far-flung empire hobnobbed with housewives. It was an odd mixture." At 3 a.m. the staff served an early breakfast. At 5 a.m., Perle told the orchestra to go home. As the crowd dispersed, a few people called out a heartfelt compliment: "God save our Perle. May our Perle live forever."

Glowing tributes to Perle appeared in the American press. Columnist Cholly Knickerbocker announced: "Perle Mesta really set London on fire." Jackie Bouvier wrote in the *Washington Times-Herald*, "The Mesta Fiesta—second only to the coronation—was the show to see in London last week."

NOW THAT PERLE'S trip to Moscow was imminent, the State Department was having conniptions over what she would actually do once she got there. What set off alarm bells was Perle's earnest request to Charles "Chip" Bohlen, the American ambassador to Russia, to arrange meetings for her with Communist Party leaders.

"Her visit here will present very real problems," Bohlen wrote to the State Department on June 6. "She apparently conceives her visit as a 'mission' which she takes very seriously and is insistent in her desire to see Malenkov immediately and through him to meet other Soviet leaders . . . and afterward to lecture and write on her experience."

A veteran Russian-speaking diplomat, Bohlen was on his third posting to Moscow, having first arrived in 1933, the year America

established diplomatic relations with the Soviet Union. Aware of Perle's friendship with the Eisenhowers, Bohlen feared her sense of self-importance combined with her naïveté would lead to diplomatic blunders, and as the American ambassador, he would be held responsible. Bohlen told the State Department that he would facilitate the usual Moscow visits (museums, schools) but drew the line there. "As a private person we do not (repeat not) intend to arrange any calls on Foreign Office officials."

The timing of her visit was problematic, since the US was poised to sign an armistice with North Korea, which was, in effect, a Soviet proxy state. "With the real possibility that her visit will fall on heels of armistice in Korea," Bohlen wrote, "activities of the kind she proposes, especially in light of publicity she has given to her acquaintanceship with the President would be in the highest degree undesirable." He worried her actions "would be misunderstood by the Soviet Government or at best offer them an opportunity for propaganda exploitation." He urged the State Department to stress to Perle "the clear delicacy of the situation and need for discretion."

Bohlen's telegram prompted the State Department to revoke Perle's diplomatic passport. American ambassador Winthrop Aldrich swapped it for an ordinary version.

Whatever the color of her passport, Perle was a privileged visitor to post-Stalin Russia. During the first eight months of 1953, the only other Americans (aside from diplomats and journalists posted to Moscow) were ten visiting newspaper editors. Even though Perle was now seventy and not especially fit—she said she was allergic to exercise—she wanted to put together a grueling itinerary. When she picked up her visa at the Soviet embassy in London, Perle told a Russian official that she wanted to visit a Ukraine steel mill. The Mesta Machine Co. had equipped the plant in the 1930s, but it had been off-limits to Westerners since World War II.

"I start my journey with the greatest anticipation of a friendly reception," Perle told reporters, noting that she was packing

uncharacteristically light for the trip—three suits, three evening dresses, and a mink wrap. She promised the *New York Herald Tribune* to write a series upon her return.

After flying from London to Helsinki, she changed planes. A newsreel on Warner Pathe News captured a smiling Perle walking to the Soviet plane as the dulcet-voiced announcer stated she had "obtained a difficult-to-get Iron Curtain visa." Wearing a brown felt hat, coat, and worsted suit, she smiled and waved to the camera. But her smile turned to dismay once she was onboard.

"That plane was terrible," she later recalled. "They don't fly by instruments. There was no warm up and we had no seat belts. They just took right off barely missing the trees."

As the last person off the plane at Moscow's Vnukovo Airport, she was greeted with a good omen—a huge rainbow. A customs official dourly asked, "What is your profession?" Perle replied, with a laugh. "I have no profession." An English- and Russian-speaking passenger managed to explain, with difficulty, her unusual status. Asked by *New York Times* correspondent Harrison Salisbury how long she would be in Moscow, she replied, "My visa is good for three months. Maybe you'll be tired of me before I leave." Now that she was no longer a minister, another reporter asked what her title should be. "Just call me Mrs.," Perle replied. "I'm just a plain private citizen of the United States, here on a trip."

When Perle later described this eventful trip—in a newspaper series, her autobiography, and speeches—what comes through is her pure excitement and pure terror at being plunked down in a repressive environment. Accustomed to freely exploring Luxembourg, she was shocked by the restrictions on her movements and the constant scrutiny. She kept trying to talk to ordinary people in parks, who fled in fear of being arrested for even speaking to a Westerner.

Chip Bohlen and his Russian-speaking American wife Avis picked Perle up at the airport and brought her to their official residence, Spaso House, a Neoclassical Revival mansion built in 1913.

For the next two weeks, the Bohlens served as her adult babysitters. Bohlen politely ignored her requests to visit the foreign office or meet Cabinet members and instead gave her a cocktail party and took her sightseeing. Sir Alvary Gascoigne, the retiring British ambassador, gave a luncheon for Perle and reported back to Bohlen that she appeared totally confused about key Russian leaders. Perle insisted she knew Soviet leader Georgy Malenkov "well," and "he's been to my house several times, he's a bit brusque." She had confused Malenkov with Foreign Minister Vyacheslav Molotov, who had been based in Washington.

Accompanied by Bohlen, Perle traveled to Yasnaya Polyana, the shrine-like home of novelist Leo Tolstoy, who wrote *War and Peace* and *Anna Karenina* there. At the museum on the premises, Perle was startled to see an anti-American propaganda exhibit featuring a picture of a Black man tied to a tree, being whipped by a white man. Recognizing that holding her tongue was prudent, Perle gave the United Press a safe quote, saying, "The peasants were wonderful. It's good to get away from Moscow and have contact with real people."

Foreigners were normally not allowed to travel more than twenty-five miles outside of Moscow. But the Russians decided to use Perle's request to get out of the city as a propaganda opportunity to convey the Soviet Union's post-Stalin openness. In mid-June, Perle received permission to take a more than five-hundred-mile trip to visit the steel mill equipped by her late husband's plant. A few days before she left for the Ukraine, the Russians sent a note to all diplomatic missions stating that they were relaxing travel restrictions for foreigners. As the Russians expected, the policy change received positive American coverage. The *St. Louis Post-Dispatch* headline: "Reds Open Wide Area of Russia to Uncurbed Travel by Visitors. Mrs. Perle Mesta Will Be First to Benefit—Key Siberian and Border Areas Still Barred."

Thus Perle became the first American since World War II to visit industrial sites in the Ukraine, and—even more surprisingly—take

photographs. Bohlen assigned David Klein, a consular officer at the US embassy, and his wife Ann as Perle's traveling companions. She didn't speak the language, few Russians spoke English, and the State Department felt responsible for her safety, so traveling alone was a nonstarter.

Perle and her escorts spent twenty-four exhausting hours in a first-class compartment on a train to Zaporozhe. Arriving close to midnight, they were greeted at the makeshift train station by a policeman, the deputy director of the steel mill, and a local town official. The Americans were driven—in a car that kept breaking down—to a dacha owned by the steel mill. The Russians had prepared a late-night banquet; Perle finally begged off to go to sleep at 3 a.m.

Early the next day, they toured the steel plant, a twenty-four-hour operation that employed ten thousand workers. Perle was impressed by the modern equipment but troubled to see women doing the worst jobs, such as lifting heavy pieces of equipment. Wherever Perle and her American escorts went, they were shadowed by Russian minders, watching who they spoke to and everything they did.

While Perle was touring such previously off-limits places as a power plant, Moscow was the scene of a brutal struggle for control in the void left by Stalin. Georgy Malenkov had Lavrentiy Beria arrested for being a supposed foreign agent. (After a Soviet show trial, Beria was executed in December.) The *New York Times* analyzed the move on July 12: "The feeling has been that when power slipped from Stalin's dying hands the surface unity among his heirs would inevitably explode in a fierce struggle."

Perle was in Kiev when Beria was purged. "I was awakened about 6 a.m. on July 10 by a loudspeaker in the square facing the hotel . . . shrieking more loudly and incessantly," Perle wrote in her *Herald Tribune* series after returning to America. Informed by her Intourist guide that Beria had been denounced as a spy, Perle tried to discuss this turn of events with local citizens, inadvertently putting them in peril. "Most were too frightened to say anything," she later admitted.

"This was far too dangerous a subject to discuss, especially with some-one they did not know."

Upon her return to Moscow, she gave careful public statements. "We've seen everything we wanted," she told reporters. "The Russians did all they could for us. The steel plant we saw was very well run."

Perle felt confined by staying at Spaso House and was annoyed that Bohlen was not making the requested introductions to Soviet officials. In the stubborn belief that she might do better on her own, Perle moved into a luxurious suite at the National Hotel. But Perle was now fully in the clutches of the paranoid Soviet state. When Perle returned to her room, she saw the maids going through her posses-sions, even checking the clothing pockets. Her room was bugged. As Perle later recalled, "The place was so completely wired that when I walked on the floor I could hear the wires squeak."

But despite the standard harassment, Perle was allowed to travel more widely in the Soviet Union than virtually any American in decades. With her State Department escorts, she flew to Stalin-grad, where they toured battlefields. At every stop, Perle tried to talk to ordinary people—shopkeepers, a shoeshine woman—but almost all were understandably wary, and the language barrier was insurmountable.

During her nearly three-month tour of the country, Perle covered twelve thousand miles, with overnight train rides and a boat trip down the Volga River. Much to Bohlen's relief, her repeated requests to meet Russian leaders were ignored. She was allowed to watch Soviet premier Georgy Malenkov's two-hour speech in August to the Presid-ium of the Supreme Soviet. Sitting in the diplomatic gallery, Perle later described the scene in her newspaper column. "He looked like a big fat baby boy . . . He went on for about two hours, reading his prepared speech in a monotonous voice . . . He dismissed Beria with a brief denunciation . . . and he made a violent attack on the United States." When the Russian delegates rose to applaud the speech, Perle joined Ambassador Bohlen and other Americans in walking out.

Perle's final stop was Leningrad. Preparing to go through customs to depart on the Soviet ship *Belo Ostrov*, she worried the Russians would discover her handwritten notes. "I stuffed them in the front of my dress!" she later confided to columnist Inez Robb. "I'd spent a lot of time taking those notes and I certainly didn't want them confiscated when I left. I was scared to death they'd turn on one of those x-ray machines on me at the last moment, discover where the notes were, and make me give them up."

Arriving in London on August 24, Perle looked relieved as she strode down the gangplank, wearing a hat with a veil and a dark suit, her mink wrap tossed insouciantly over one shoulder. "I am just back from a strange, strange world in which people are cut off from the rest of humanity and live in fear of each other and of their rules," she told reporters. "Did I talk to the Russian people? Sure I did. But I still think the West is the only place you can really talk without being afraid of what'll happen to you."

Perle sent a telegram to Mamie Eisenhower on August 28. "Just returned had most informative and interesting trip more convinced than ever free world must stand together miss you greatly."

IN LONDON, PERLE moved in temporarily with Marguerite and George and wrote her Russia series in their house. Now that Marguerite's daughter Betty and son-in-law Lewis Ellis had moved back to Washington, DC, there was scant reason for the family to linger in London. Betty was deputized to scout Washington properties for the threesome, recalling, "They wanted a large estate with a garden, a place for all of them to entertain in with a large living room."

Perle's ten-part series for the *New York Herald Tribune* syndicate, published in mid-October, was a sensation. In well-written, chatty prose, Perle provided an unusual glimpse into Soviet daily life, accompanied by her photos. If the Soviets hoped to be rewarded with an upbeat travelogue, they had badly misjudged Perle.

She described the wrenching sight of injured war veterans, missing limbs and eyes, and the omnipresent poverty. "Large number of peasants and other poor people were often scattered all over the place, sleeping on the stone or dirt floor throughout the night while awaiting their trains."

Perle was unimpressed by the Soviet attitude toward equality in the workforce. Her photos showed babushka-clad women hauling heavy rails and repairing a roadbed. "The result of the demands made on Soviet women can be seen in their hands and their races, which are toughened, tired and prematurely old," Perle wrote. "Even more strenuous than the working seems to be the waiting—waiting in long queues for bread, meat, clothes, movies and buses, which incidentally are driven usually by women."

In words that seem remarkably prescient some seventy years later, she described her visit to Ukraine, and the response when she asked residents whether they considered themselves Russian. "I learned that there is hardly a greater offense than to mistake a Ukrainian for a Russian . . . Their reaction sheds some light on why the Kremlin continues to be troubled about the Ukraine, the second largest republic in the Soviet Union and the source of much of its food, coal and iron ore."

Perle was not gulled by the Soviet rhetoric boasting of a classless society. As she wrote, "I was amazed to see how Russia was divided into two broad classes—the rich who had so much and the poor who had little. Everything in Moscow seemed to contradict the Communist stories of the classless society."

Perle's stories appeared in thirty-three American newspapers, and foreign rights were sold in sixteen countries. She earned more than $17,000, donating the sum to her scholarship fund for foreign students to attend American colleges. She agreed to go on the American lecture circuit to discuss her firsthand impressions of Soviet Russia.

Perle had traveled thousands of miles in the Soviet Union without flagging, but during a Paris stopover before heading home, she tripped and landed badly. She wrote to Mamie Eisenhower on November 9:

"Please forgive the typewriting but I had a severe fall and broke three ribs and am not yet feeling able to write by hand . . . I was delighted to hear that you liked the Russian articles. It was a most enlightening but difficult and hazardous trip."

Mamie replied with a welcoming note: "I can't tell you how delighted we are to think you will soon be with us here in Washington! . . . Ike said he 'sure would be glad to see Perle.' There is a kitchen, as you know, on the third floor here at the White House, and while it is small, it is large enough for you, . . . Do take care of yourself, Perle, as we want you to be fit as a fiddle when you come home!"

There's No Place Like Home

W hen the luxury SS *United States* docked at Pier 86 in Manhattan on December 1, the disembarking passengers faced an annoying situation. With longshoremen on strike, there were no porters—a daunting problem for Perle, who was returning with five trunks of clothes and souvenirs. Fortunately, Margaret Truman met the boat. Both clad in furs to ward off the chill, the women posed with bright smiles for photographers. "Don't worry, I'll help you," Margaret could be overheard telling Perle about the luggage. "We'll get off all right."

Perle had been away from the United States for an entire year, and much had changed. The nation was even more polarized by Joe McCarthy's unchecked reign of terror. Perle's two favorite presidents, Harry Truman and Ike Eisenhower, were at war with one another.

With Eisenhower's tacit permission, his attorney general Herbert Brownell had recently claimed that Truman, while president, retained a Treasury aide whom the FBI claimed was a Soviet spy. Fiercely denying the accusation, Truman lashed out at Eisenhower in a mid-November radio address: "It is now evident that the present administration has fully embraced for political advantage, McCarthyism."

Perle knew where her loyalties lay. Within forty-eight hours of her arrival in New York, Perle had lunch with the former president and Margaret at his Waldorf Astoria Towers suite. She was able to get a firsthand update on the political infighting plus fill in Truman on her Russia experiences.

Perle's ten weeks in the Soviet Union had been transformative. She had earned a new career as a Soviet expert. "I shall get in touch with the State Department as soon as I get to Washington and offer to tell it what I know," Perle told Inez Robb in a Manhattan interview. "I hope Mr. Dulles will want to hear it."

Eisenhower's secretary of state did want to hear it and met with Perle on December 11. As she was leaving the State Department, female elevator operators, almost all Black, gathered in the lobby to shake her hand. They recalled her warmth and kindness, unlike the chilly treatment by many State employees. "I didn't think you'd remember me," Perle told one of the women. "Remember you?" the woman replied. "Why as soon as I saw you go up to the Secretary's office, I alerted all the other girls and was so excited that I didn't know whether my car was going up or down."

But no one in the capital was happier to see Perle than *Washington Star* columnist Betty Beale. The Smith College graduate, a Christian Scientist, had written about Perle in the past, but now she glommed onto her like there was no tomorrow, sensing there would be many scoops ahead. A single woman whose grandfather was a congressman and who had grown up among the elites in the city, Beale had a reputation as ferociously smart and competitive. "Betty Beale is nosy, pushy and blunt. She snoops. She pries," declared *Time*. "She behaves like a police reporter, thinks like an editorial writer, and as a perfectly natural result, she is easily the best society reporter in town—and in the country."

Perle treated Beale as a confidant, and the columnist rewarded her with glowing mentions. Hyping Perle's return to the capital, Beale

informed her audience, "People who think Perle is out as leading host-ess because the Republicans are in don't know Washington or Perle."

The Washington social scene had become dreary following Eisen-hower's election. The president and his Cabinet officers (mocked as "nine millionaires and a plumber," a reference to Secretary of Labor Martin Durkin, a former union official) had minimal interest in the social ramble. Ike was a loner who liked masculine activities such as fishing and golfing and preferred the company of military men, while Mamie's need for social interaction appeared to be satisfied by playing canasta.

Perle's return was considered a hopeful sign the game might be afoot again. But first, she needed a place to live. In early January 1954, Marguerite and George Tyson bought a large French château–style white brick home in the Spring Valley neighborhood. Headlines stated that Perle was the purchaser, but in her autobiography Perle stated the place belonged to her sister and brother-in-law, although the three of them lived together.

With a thirty-six-foot drawing room, oval breakfast room seat-ing twenty, sunroom, small summer house, and formal gardens, the mansion was ideal for entertaining. Gwen Cafritz, always looking for opportunities to attack Perle, told the *New York Herald Tribune*, "She bought a hideous house." Perle quietly vowed to friends that Gwen would never see the home's inside.

Spring Valley was exclusive. Vice President Richard Nixon lived just down the block. The area's developers included a deed restriction forbidding home owners from renting or selling to Jews, Negroes, Asians, or Latin Americans. Perle would subvert the discriminatory intent by inviting guests of all backgrounds to her home.

Marguerite hired the Paris interior designer Stéphane Boudin of the storied firm Maison Jansen to work his magic and Harvard-trained landscape architect Perry Wheeler to redo the grounds. (Both men would be hired by Jackie Kennedy when she became First Lady, Boudin to decorate the White House and Wheeler to help Bunny Mellon create the Rose Garden.)

With a month to prepare for the lecture circuit, Perle hired a speech teacher, Lester Pridgen, for daily lessons. In an effort to achieve verisimilitude, they rehearsed in the empty ballroom of a New York hotel. Perle announced that she would donate the lecture proceeds ($2,500 per appearance) to her scholarship fund for European students. She had quirky criteria for choosing the winners, based on their goals and personalities. "They don't have to be top of their class," she explained to a reporter. "I never was a brilliant student, but I guess I did all right when I got out into the world."

Upon arriving in Texas for her first speech, Perle stressed her enmity toward the Soviets, telling the *El Paso Herald-Post*, "I hated them before I went there and I hated them just as much after I left." Perle dramatically insisted that she feared for her safety while in Russia. "You never could tell when they might come to your door at night and say 'Come along, you're a spy.'"

Of all of the dates on her lecture tour, the most anxiety-making was a January event at Manhattan's Town Hall. This cavernous space with 1,500 seats, right off Times Square, had hosted Paul Robeson, Billie Holiday, violinist Isaac Stern, the Trapp Family Singers, and even Joe McCarthy. Perle drew a full house: union leaders; exiled Ukrainians; actress Eva Gabor; former Democratic kingmaker James Farley and his wife Bess; socialist Norman Thomas, who had run for president six times; plus dozens of Perle's Newport and Washington friends. Perle kept looking over at Marguerite, who was sitting in the audience and displaying a reassuring demeanor.

Perle went public for the first time with her complaints about the State Department's career employees, describing their intellectual snobbery and prejudice toward women. She also told tales about her Russia trip. *Daily News* columnist Danton Walker's review: "Perle Mesta's local debut as a lecturer reveals her as a dryly witty observer of goings-on in Soviet Russia."

Although Perle longed for respect as a diplomat, she was willing to play the hostess card to build an audience. In Boston, she

demonstrated her culinary skills at the WBZ television kitchen. Perle put on an apron and proved that she knew her way around a mixing bowl. "Will I be bragging if I say I'm an A-1 cook? My teacher, President Eisenhower, says that I am," she said, adding that he had given her a kitchen mixer as a Christmas gift. She managed to concoct such simple dishes as macaroni and cheese and baked haddock.

She continued her "I like Ike" narrative at a press conference at Boston's Women's City Club. "Don't misunderstand me, I'm a Democrat," she said. "But I love Eisenhower. He's doing a good job. He just hasn't had time, what with a lot of people pulling against him."

Perle was perplexed that she had not heard from Ike and Mamie since her return to America. She had anticipated a warm welcome at the White House, which had not materialized.

What prompted Perle's abrupt banishment? One likely reason: Ike received a letter in December 1953 from his older brother Arthur Eisenhower that questioned Perle's loyalty. Arthur claimed that in 1952, when Perle was in Kansas City during the presidential campaign, "she was about as nasty in her remarks as I have heard from any woman" and "she was not very complimentary about you."

The letter was puzzling since a year had passed since the election, and it was strange that Arthur waited so long to convey his concerns. Ike replied on December 15, 1953.

Dear Arthur,
Your report on Perle Mesta does amaze me. She has always, on the surface, been most devoted . . . However, nothing that occurs in politics any longer can astound me.

Arthur Eisenhower's claims about Perle's supposed anti-Ike invective were at odds with everything she said publicly and wrote privately during the campaign. The Kansas City newspapers did not cover Perle's October 1952 remarks, so there is no record.

Nonetheless, anything that Dwight Eisenhower heard from his brother carried weight, and the president was known as a man who could nurse a grudge.

Perle had no way of knowing about the letter, which only became public decades later, after her death, included in a published collection of Eisenhower correspondence. She continued to send presents and sycophantic notes to Ike and Mamie and received friendly responses. The First Lady wrote on April 22 from Augusta, Georgia: "You were a dear to remember the President and me at Easter. Your beautifully wrapped box was sent down to me and as you can well imagine— with our children and grandchildren around—our goodies were most welcome—and very delicious!"

But missing from Mamie's letter was a stated desire to see Perle, something she had stressed in many notes until now.

PERLE RENTED A fifth-floor suite at Washington's Sheraton Park Hotel while Marguerite's new home was being remodeled. She made a beeline for Capitol Hill to witness the explosive Army-McCarthy hearings. The Senate subcommittee was investigating whether Joe McCarthy threatened the Army, demanding preferential treatment for his staff member David Shine, who had been drafted. These were the hearings when lawyer Joseph Welch, who had been hired to represent the Army, said to the snarling McCarthy: "Have you no sense of decency?"

At the May 6 hearing, angry wrangling broke out over McCarthy's menacing threat to make public a confidential FBI report, despite the Eisenhower administration's insistence that he had no right to even possess the document. *Time*'s description of the infighting: "Perle Mesta, the fabulous Washington hostess and former minister to Luxembourg, hardly had settled her more than ample bulk in a chair a few rows behind the committee table when it [arguing over the document] broke out and Perle just beamed with enjoyment. She was

asked by one eager photographer, 'When are you going to give a party, Perle?' And she replied: 'Ha! And try to compete with this party?'"

Time took cruel pleasure in making demeaning cracks about her physical appearance—such as "more than ample bulk"—as if all women over seventy were svelte. In this fat-shaming era, her weight swings received an inordinate amount of press attention. The *New York Times* would later run the headline "Perle Mesta Is Now Down to a Size Ten but Her Party Style Is Still Ample." When the hostess took a second helping of coffee ice cream with fudge sauce and walnuts at a dinner party, this was treated as newsworthy enough to print. The relentless scrutiny took a toll.

Despite joking at the Senate hearing about giving a party, Perle was in actuality already planning a large bash for seven hundred at the Sheraton Park. Since Perle liked the idea of parties with a purpose and never wavered in her feminist commitment, the occasion was nominally celebrating Washington's female reporters—members of the Women's National Press Club and the American News Women's Club. There was no better way to guarantee that she would continue to receive positive press coverage.

On the night of May 29, two butlers and two secretaries carefully checked the guests' engraved invitations. Security was considered necessary after a newspaper item stated that a man offered to pay $500 for an admission card. Perle took her place promptly at 8 p.m. and spent ninety minutes greeting six members of the Supreme Court and nine senators (including such luminaries as Arizona Republican Barry Goldwater and Minnesota Democrat Hubert Humphrey). French ambassador Henri Bonnet was photographed kissing Perle's hand; other foreign dignitaries hailed from China, Italy, Norway, Sweden, and Switzerland.

There were no place cards since Perle wanted her guests to mingle. People scrambled to save seats en route to the buffet line, which included politically themed ice cream desserts shaped like donkeys and elephants. "As you know we have no protocol tonight," Perle

announced, "and I feel that the Chief Justice and the Ambassadors are enjoying it."

Inspired by the memory of strolling violinists at a Paris restaurant, she hired twenty-four violinists for a surprise performance. At 10 p.m., the lights dimmed and a spotlight lit up a doorway as the violinists filed in. The music inspired the Italian ambassador and his wife to harmonize in a duet. Washington-based singer Eleanor "Hank" Forte performed a clever song that she composed called "Protocol," spoofing the rivalry between Perle and Gwen Cafritz. Of course, Gwen had not been invited.

As midnight approached, the party turned into a Broadway-style cabaret. Celeste Holm, who had recently starred with Frank Sinatra in the film *High Society*, had spent the early part of the evening wearing a slinky short black sheath dress and waltzing with Chief Justice Warren, an energetic if clumsy dancer. Now she changed into a long white gown and headed to the bandstand to sing "Zip," the stripper's inner thoughts from the musical *Pal Joey*, followed by "Young at Heart," which she dedicated the woman of the hour. Billie Worth and Donald Burr, a British husband-wife duo who had appeared in the London production of *Call Me Madam*, inevitably sang "The Hostess with the Mostes'."

Washington parties were almost never this grand: first-class entertainment, endless bottles of 1947 Lanson Champagne (which ran out at midnight, but cocktails kept coming) and a Broadway cast. *Life* devoted a four-page photo spread to the party with the headline "Hostess Mesta Is Back in Business Again."

Maybe yes, and maybe no. The crowd was huge, but only one Cabinet member (Interior Secretary Douglas McKay) attended, whereas under Truman, a half dozen would have been there. The Eisenhowers did not stop by, although Mamie's sister Frances and her husband Gordon Moore were among the revelers.

For all of her public announcements about her close relationship with the Eisenhowers, Perle no longer had entrée. She was not

invited to White House state dinners and did not accompany Mamie to Washington functions, as she had done with Bess Truman. Her friends were avoiding her, and she didn't know why.

UNCERTAIN ABOUT HER status, Perle told a reporter, "I want to be useful. But at the moment, I don't know what I'll be interested in doing." The Equal Rights Amendment had stalled again in Congress. With nothing to be done for the ERA at the moment, Perle bought a new Cadillac and headed to Newport, reopening Mid-Cliffe for the first time in five years. The first Newport Jazz Festival was taking place that summer, and Perle was treated as part of the Old Guard, as if her support mattered. The organizers, tobacco heir Louis Livingston Lorillard and his wife Elaine, were pleased when Perle attended the opening night concert. As Elaine Lorillard gushed to *New Yorker* writer Lillian Ross, pointing out Perle in one of the $100 boxes, "How nice of Perle Mesta to come!"

The musical lineup included Ella Fitzgerald, Dizzy Gillespie, Count Basie, Charlie Parker, Oscar Peterson, Stan Kenton, and Dixieland bands. "The most photographed person other than the performers was Mrs. Perle Mesta," wrote the *Newport News*.

In August, Perle returned briefly to sweltering Washington for a compelling reason. Mamie Eisenhower had finally accepted Perle's lunch invitation. Mamie never explained why Perle had been cut off or whether the banishment was fully over. The First Lady had likely smoothed things over with her husband. The ever polite Mamie wrote Perle after the lunch: "It is fun being with you again . . . I look forward to seeing you in the fall."

But when the fall social season began in September, Perle did not receive a summons from the White House. Perle had treated herself to a white satin Norman Hartnell gown with pearl-embroidered gold lace medallions. When the gown arrived from London, she wondered why she had bothered. "The only place appropriate for this dress

would be some grand affair at the White House," she told a friend. "But, of course, I'll never get invited there now."

A thick white engraved envelope arrived a few days later: an invitation to a White House dinner for the Queen Mother of England. Protocol dictated a written RSVP, but Perle called Mamie to accept, burbling that she didn't expect to be included and had been wondering if she'd ever have the chance to wear her new dress.

On November 4, Perle joined the sixty-two dinner guests along with Vice President Richard Nixon and his wife Pat, Alice Roosevelt Longworth, FDR's son James Roosevelt, and Undersecretary of State Herbert Hoover Jr., son of the former president. The tables were a tableau of gold: 1817 gold-and-green-rimmed china; gold forks, knives and spoons; and a gold candelabra. Mamie took a full look at Perle's ensemble, accessorized with a gold handbag, gold stole, and gold shoes, and announced with a smile, "Yes, the occasion is entirely worthy of the dress!"

Despite Mamie's jovial reaction, the mood was somber. Two days earlier, voters had expressed their unhappiness with the Eisenhower regime by voting for Democrats in the midterm election, flipping both the House and the Senate from Republican to Democratic control. It would be harder for Eisenhower to move legislation through Congress.

That evening at the White House, the guests moved into the ballroom, adorned with large portraits of George and Martha Washington, for a musical performance. Perle could look around with satisfaction—she was back at the center of power as the lone Democrat in attendance. "I never fail to get a thrill out of going to the White House," Perle told Betty Beale a few days later. Stressing her bond with the Eisenhowers, she added, "They are marvelous people who never forget their old friends."

Perle didn't forget her friends, either. In honor of the First Lady's November 14 birthday, Perle sent her a pink silk robe, pink nightgown, and pink bed jacket. On Christmas Eve 1954, Perle was rewarded with

yet another invitation to the White House. Mamie had decked the halls with a twenty-foot cedar tree, red and white poinsettias, giant holly wreaths plus a silver Christmas tree trimmed in blue glass bells.

Ike, an amateur painter, gave Perle a lithograph of his oil painting inspired by the famous Gilbert Stuart painting of George Washington. "I just can't thank you and the President enough for the print," Perle wrote. "I prize it highly . . . You are both wonderful friends and I always love being with you."

Perle was no longer on the outside with her nose pressed to the glass. But at age seventy-two, she longed for a sense of purpose. She was feeling her way, trying to find her place in the shifting Washington firmament.

Have Passport, Will Travel

Perle was restless. Invited to the White House reception for diplomats in January 1955, it felt bittersweet to be included as a former envoy. She missed her job. Proudly pinning on her Oak Cross from the Grand Duchess, Perle joined guests garbed in saris and kimonos, greeting a swarm of ambassadors by name. Foreign diplomats kept urging Perle to visit their home countries, hoping she would attract tourists as she had done in Luxembourg.

That winter, Perle hit the embassy circuit, dipping into different cultures several times a week. The Portuguese ambassador asked her to go to Lisbon for a royal wedding; the Greek ambassador chided Perle for failing to visit Athens; the Brazilian ambassador twirled her around the dance floor and whispered sweet nothings about Rio. After nights at the Cuban, Egyptian, Mexican, and Japanese embassies, Perle became captivated by the possibilities.

She realistically recognized that President Eisenhower was never going to appoint her as an ambassador or dispatch her on a diplomatic mission. Why not send herself? Why not become a self-appointed ambassador from a country called Perle and take a goodwill tour? She could meet world leaders, visit American GIs stationed overseas, and learn about the lives of women in other countries.

Perle consulted Robert Murphy, who had been ambassador to Belgium and was now the State Department's deputy undersecretary for political affairs. Perle came away from the conversation convinced that she should visit hot spots in Asia. Murphy told her the State Department could notify American embassies to make arrangements for the world traveler with the mostes'.

Perle excitedly blurted out her news in early June to Associated Press reporter Jane Eads. "I'm going to 17 countries. I'm going to Honolulu, Tokyo, Seoul. I hope to talk to American soldiers. I'm going to India, Pakistan, Greece and Rome." Pausing for breath, Perle added, "I hope to see all the leaders in the countries. I'm talking a walkie-talkie, four cameras, a typewriter, a secretary and an assistant secretary."

Her itinerary would cover 35,000 miles. Every stop had been carefully choreographed: speaking engagements, meetings with heads of state, sightseeing, press interviews, receptions in her honor. The subtext of her trip: gauging the worldwide influence of communism. Perle planned to visit South Korea and South Vietnam, two nations ripped asunder by communism, and meet with the exiled Chiang Kai-shek in Taiwan as he brooded and plotted against Mao's rule of mainland China. Perle had added visits to two nonaligned countries, whose leaders were adeptly playing America off against the Soviet Union: India under Prime Minister Jawaharlal Nehru and Egypt under mercurial president Gamal Abdel Nasser.

Perle had never been to Asia. She didn't have time to learn the history of each country or the backgrounds of the leaders, Cold War tensions, and unresolved local conflicts. American embassy representatives at each stop would brief her, as they did for globetrotting congressional delegations. Foreign diplomats based in Washington arranged some overseas appointments. Thanks to Perle's reputation as a close friend of President Eisenhower and her reputed influence on Capitol Hill, many foreign leaders believed that meeting Perle might help pry loose more American aid.

As Perle was finalizing her plans, she had a disconcerting experience. She had agreed to be roasted at a fundraiser for the Circus Saints and Sinners Club, a male-only charitable group. While previous honorees (and targets for humor) included Richard Nixon and Joe McCarthy, Perle was the first woman chosen. In deference to her star turn, women were admitted to the luncheon for the first time, and oddly enough, the club canceled the usual dancing girls sideshow.

Perle expected gentle teasing, a roast where everyone pulled their punches. Instead, the skits and jokes were harsh, provoking more grimaces than laughter. *New York Daily News* reporter Les Kramer performed a skit titled "My Day with Perle Mesta" which had her rudely bawling out her chef for serving hot dogs.

In narrating Perle's life story, another club member mocked her lawsuit against her father, raised innuendos about William Skirvin's confidential secretary, and stated (incorrectly) that Perle had only been married to George Mesta for a short time before he died and she inherited his fortune. He suggested "personal loneliness" was the reason she gave so many parties. Marguerite wept, with tears pouring down her face. Perle tried to absorb the blows stoically.

"Some of it was in good clean fun with a lot of humor, but there were times . . . when the kidding of Mrs. Mesta dropped to a low point," wrote one newspaper. "She didn't react as if her feelings were injured—but they must have been." Given two minutes to respond, Perle merely said that many of these statements were false.

On Friday, June 10, the Admiral's Club at the airport was packed with well-wishers as Perle prepared to take off on the first leg of the trip to Los Angeles, followed by Hawaii and then Tokyo. Perle's family was there—even her brother had come from Oklahoma City—along with writers from the *Washington Star* and the Associated Press. Perle would be accompanied on the trip by two assistants, Jean Anderson of the Sulgrave Club and Marjorie Pridgen, the wife of Perle's speaking coach Lester Pridgen.

At the airport in Japan, two lieutenant colonels plus the secretary to American ambassador John Allison were waiting to greet Perle. This would be standard procedure: an official airport welcome by American embassy personnel plus local officials to ease her through customs. After checking into the Imperial Hotel in Tokyo, Perle got her first inkling of postwar Japanese life. "Could not get rice!" she wrote in her journal. "Learned it was rationed—staple food of Japan."

During this whirlwind visit, Perle met with Japanese Foreign Minister Mamoru Shigemitsu, toured a private Japanese Christian school, met injured GIs at the Tokyo Army Hospital, and attended services at a Christian Science church. As the first woman to address the nine-year-old Foreign Correspondents' Club of Japan, Perle proved to be sadly prescient in her remarks, telling the journalists, "The United States is not ready to have a woman president."

Bad weather nearly canceled her trip to Seoul, and she arrived a day late. Although the Korean War had ended two years earlier, the two countries remained bitterly divided at the 38th parallel. American ambassador William Lacy took her to meet controversial South Korean president Syngman Rhee, a militant Christian anticommunist who had assumed dictatorial powers.

Eager to court favor with the United States, Rhee pulled out the stops for Perle, arranging for the government to pay for her suite at Seoul's Bando Hotel. He plied her with gifts and gave a formal dinner in her honor. Perle was even awarded an honorary law degree from Ewha Womans University.

Rhee's charm offensive worked with Perle, leaving her seemingly oblivious to the Korean strongman's efforts to quash dissent. Perle sent a letter to International News Service columnist Bob Considine, which he printed, claiming that Rhee "is a very conscientious and humble man, doing everything in his power to overcome communism, build up Korea and promote peace with the freedom-loving nations."

Her next stop was Taiwan, where Perle had arranged to meet Chiang Kai-shek. Under Eisenhower, America had committed itself

to defending the island in case of a seemingly probable attack by mainland China. Upon arriving in the country, Perle made a courtesy phone call to the American embassy and reached William Cochran Jr., chargé d'affaires. She guilelessly wondered if there was anything he wanted her to ask the exiled Chinese leader. Cochran was enraged to learn of her freelance diplomacy. As Perle wrote in her journal: "He very bluntly and gruffly replied, "This is the first I have known about any of this" and added, "I do not want to be put on record as giving you any questions, especially over the phone."

Perle met Chiang Kai-shek and his Wellesley-educated wife Soon Mei-ling at their mountain home. "The place is beautiful, but surrounded by soldiers and military men," she recalled in her journal. "The President entered with his interpreter and welcomed me to Free China." Mrs. Chiang organized Perle's schedule, and her time in Taiwan was full of surreal contrasts: elaborate feasts at grand homes interspersed with dispiriting sights.

Perle described seeing a housing project for "displaced intellectuals from Communist China." "Visiting living quarters—a deplorable sight," Perle wrote. "The rooms were the size of a large bath cabana in Newport. The first one I saw was a man, his wife and 6 children— not too clean . . . saw many families with several children in these cubby holes. I was told that before US helped in this program, conditions were much worse!"

Arriving in the British colony of Hong Kong, Perle stayed at the Peninsula Hotel, with sweeping views of Victoria Harbor. She met with Associated Press reporter Forrest Edwards, who had just returned from Saigon. When Perle mentioned that Vietnam was on her itinerary, he said the situation was tumultuous but assured her that she would be safe.

The next stop was Manila, where she spent time with new American ambassador Homer Ferguson, the two-term GOP Michigan senator who had been defeated for reelection the previous fall. He urged Perle to skip South Vietnam, citing a recent bomb scare and

other unrest. But after surviving three months in the Soviet Union, Perle was not easily daunted. She placed more weight on the reassuring words by the AP reporter who had just returned from Vietnam.

The timing of Perle's trip to Vietnam was risky. A year earlier, after North Vietnamese Communist leader Ho Chi Minh's forces drove the French military out of their former colony, a fragile peace had been forged between North and South Vietnam. Under the Geneva Accords, signed on June 21, 1954, the country was partitioned, with elections and unification expected to follow in two years. But fighting continued as Communist Viet Minh troops attacked Southern targets. Filling the void left by the French, the United States had just agreed to send in military instructors to train South Vietnamese forces.

The day before Perle arrived, the *New York Times* ran an analysis stating that South Vietnamese prime minister Ngo Dinh Diem had "unstable" political backing and "is still in the process of suppressing two rebel groups . . . At present the North would win national elections if they were held and would also win a military conflict if the two Vietnams went to war unaided on either side by outside forces."

Perle and her two assistants arrived in Saigon on Monday, July 18, checking into the Majestic Hotel, a three-story French colonial gem and the preferred lodging for foreigners. The Indochina Armistice Commission, established to enforce the Geneva truce, had offices on the second floor, down the hall from Perle's room. In the lobby, she ran into Angier Biddle Duke, the tobacco heir who now headed the International Rescue Committee. He invited her to visit a refugee camp.

The next morning, Perle met with Prime Minister Diem, who was eager to impress her at a time when he was balking at unification and new elections. Diem had just denounced the Communists in a national broadcast, refusing to meet with North Vietnamese representatives to discuss an election until they "give up terrorism and totalitarian methods."

After explaining his reasoning to Perle, Diem alerted her there would be peaceful demonstrations the next day, the first anniversary of the Geneva Accords. As Perle recounted in her journal, Diem told her the activists would be young people "who were protesting the detention in North Vietnam of members of their families who want to come south and the Communists won't let them." In truth, behind the scenes Diem was encouraging the protests as a show of support for his regime.

Perle drove fifty miles out of Saigon with Angier Biddle Duke to the refugee camp, housing roughly a hundred young men, many of them teenagers. In her journal, she wrote that the students "have left their families, friends and homes to come here to the South to help in the building of a free and independent nation." She recorded interviews with two students and the group sang folk songs. She wrote, "The battle here is two-fold—to be free of Colonialism and Communism."

Back at the Majestic Hotel, she noticed police officers stationed in a protective cordon out front. As the headquarters of the Indochina Armistice Commission, the hotel was a potential protest target. On the evening of July 19, loudspeakers rolled through the streets, urging residents to throw tomatoes and rotten eggs at Communist officials tomorrow on the "day of national shame."

At eight the next morning, Perle went downstairs to pay her hotel bill, planning to leave for the airport at 10:30 a.m. The manager demanded she change her money into local currency. Concerned that she was being cheated, Perle returned to her room and tried unsuccessfully to reach the American embassy. Looking out her window, she saw crowds gathering, shouting, and throwing stones. Some thirty thousand people had assembled that morning at City Hall to protest, and roughly a thousand had marched to the Majestic.

The police stood by as the mob broke into the hotel, racing from floor to floor, beating down doors with axes and clubs, looting rooms, throwing furniture out the windows. Perle stepped into the hallway and

was sprayed with tear gas. She went back to her room and closed the door. She considered jumping out the window but feared being injured.

Rioters began battering on her door. Making a split-second decision, Perle opened it. Confronting a large group of demonstrators, she called out, "No, we are your friends, we're Americans." One young English-speaking man ran off and returned with a leader, who in the heat of the moment agreed to protect Perle and her assistants. He stationed student demonstrators to guard her room.

Hearing a woman's screams, Perle went out to the hallway and discovered a frightened Black woman with a baby in her arms. Her husband worked for the American embassy. "She looked awful with her dress torn and she was almost hysterical," Perle later recalled. "I said to the students, 'She's American, she's American like me but with black skin.' I was finally able to get her into my room."

But then another mob approached her room. Ignoring her sentries, they barged in. Amid the chaos, a young man recognized Perle from her visit to the refugee camp. He echoed her word "friend" and encouraged the looters to move on.

As rioting raged for several hours, smoke filtered down from a fire set on the third floor. An American embassy secretary frantically called the Vietnamese government seeking help for Perle. Finally, Vietnamese officers arrived at Perle's room, followed by Frank Meloy, chargé d'affaires at the American embassy, plus a group of Marines.

"I was never so happy to see anyone in my life," Perle recalled. "He told me he brought regrets from President Diem." Perle, her assistants, and the Black woman and child were bundled into embassy cars and told to keep their heads down. Perle could hear bullets whizzing past and explosions.

By 12:30 p.m., she was at the airport, reunited with her seventeen pieces of luggage, which the Marines had retrieved from the hotel. Of the 125 rooms at the Majestic, Perle's room was one of only ten that were not looted. No one was seriously hurt in the riot, although there was significant damage to the hotel.

In Singapore, checking into Raffles Hotel, Perle told reporters she was too upset to speak. A few hours later, after she changed out of her tear-gas-stained white dress, she visited the Associated Press bureau, asking them to send out a story so her friends would know she was safe. "My phone rang half the night," she wrote in her journal.

At 7 a.m., she received a cable from the European news manager of United Press requesting her first-person version of the events. A reporter arrived at 8 a.m. with his typewriter and took down her words. News circled the globe about Perle's brush with danger and her heroics. "Nervy Perle Mesta Outtalks Vietnam Mob until Rescued" was the headline in the *Orlando Sentinel*; the *Cincinnati Enquirer's* version: "Perle Mesta Heroine of Rioting at Saigon."

Associated Press reporter Forrest Edwards, who had encouraged her to make the trip, sent an apologetic telegram: "Told you it was hot Southeast news spot but unknew it would be that hot. Gratefullest Providence you escaped unharmed."

Perle sailed through the experience on adrenaline and relief. Only later would she acknowledge how terrifying it had been.

The World Traveler Recovers

Perle's next few stops went by in a blur. In Bangkok, she met the prime minister and was put up at a government palace ("perfectly beautiful, gardens lovely, many lily ponds"). In Karachi, Pakistan, the accommodations were poor ("linens very coarse and dingy, meals very bad"). In New Delhi, her assistant Jean Anderson, traumatized by the Saigon riot, left to head home.

Perle was looking forward to meeting Indian prime minister Jawaharlal Nehru, who had just returned from visiting Russia. But Nehru, who fancied himself a neutral bridge between East and West, scarcely uttered a word to Perle during a frustrating one-hour meeting. "I never had such an interview," she said later. "I talked, talked, talked and got nothing."

In Cairo, she was charmed by Egyptian strongman Gamal Abdel Nasser, who a year later would seize the Suez Canal and touch off a Middle East war. "I liked him," she wrote in her journal. "He seemed to have interest of his people at heart, is building many schools." Prospering by playing off the US and the Soviet Union for hundreds of millions in aid, Nasser insisted on subjecting Perle to a propaganda tour. His guide pointed out the evils of King Farouk's profligate regime and Nasser's gleaming new construction.

Next on Perle's schedule: long, dusty car trips through Israel and Syria. Arriving in Istanbul on August 16, she took to bed with exhaustion. "I collapsed," she acknowledged. Her remaining assistant Marjorie Pridgen decided enough was enough and booked a flight home. Perle had been layering on new sights and experiences, but now when she tried to sleep, she was haunted by her near escape in Vietnam. "Bad night," she wrote repeatedly in her journal.

In Athens, she joined a free two-week cruise to promote Greek tourism organized by international hostess Elsa Maxwell on a yacht loaned by Greek shipping tycoon Stavros Niarchos. The leisurely trip through the Greek islands was just what Perle needed. As Maxwell explained the schedule to reporters: "We will play a little bridge and do a little dancing—and Spyros Skouras has sent us 20 new movies to show. But everybody will have to be in bed by 12 and up at 8." An onboard archaeologist discoursed on Greek ruins, and there was festive dancing on the island of Santorini. The trip ended in Venice. The refreshed and rested Perle was now back in her comfort zone: Europe.

She invited herself to Luxembourg, where President Eisenhower had recently promoted the legation to an embassy and upgraded Perle's successor, Wiley Buchanan, from a minister to an ambassador. The wealthy Buchanans had discontinued Perle's traditions of parties for American GIs and Luxembourg orphans. Perle was gracious about the changes, although it must have been painful to feel that her presence had been erased. "There was a lot of consternation about replacing Perle Mesta," recalled Ruth Buchanan, Wiley's wife, in an oral history. "People wondered if we were terrified to come after Perle, who was such a well-known party giver. We were totally undaunted."

Bonnie Buchanan Matheson, the couple's daughter, was a teenager at the time of Perle's visit and recalled her parents' reaction. "I don't think my father had a favorable impression of her," she told me. "My mother didn't like how she decorated, and my father didn't like some of the things she'd done. But she came to visit us in Luxembourg, and that's when everything changed. She was a very nice

woman and, for her time, very independent. She was a force for good. My parents became friends with her."

The Buchanans gave a dinner for Perle, inviting the omnipresent Prime Minister Bech. The next day, she met with the grand duchess at the palace, and then it was off to lunch in the country followed by a reception at the newly named American embassy. Ruth Buchanan marveled, "The most remarkable thing about Perle was her fantastic energy. Someone called her the human fireball."

Her next stop was Paris, where she met Marguerite. When the sisters learned that President Eisenhower had suffered a massive heart attack on September 23 while on a Denver golfing vacation, they tried unsuccessfully to call Mamie. The First Lady took the time to write to them a week later: "One of the first messages I got after the initial shock was that you had called from Paris . . . To be so remembered by old friends means much to Ike and myself."

Perle's final festivities took place at the American embassy in Rome, the fifteenth-century Villa Taverna. Ambassador Clare Boothe Luce and her husband Henry Luce, the *Time* and *Life* publisher, celebrated Perle's visit with a large party. Perle was the center of attention, breathlessly telling and retelling her Saigon near-death experience to anyone who would listen.

PERLE'S NEXT CHAPTER began when her chauffeur took her up the long, sweeping driveway of her imposing new home in Washington. Built into a hillside, with a large lawn and trees providing privacy from the street, the white brick Norman home encompassed more than nine thousand square feet on a nearly two-acre lot. The front of the property featured a flagstone terrace and garden overlooking leafy Fifty-Second Street, while the back faced a wooded park.

Marguerite had turned the place into a French jewel box, naming it Les Ormes, French for The Elms. The eye-catching entry hall featured a stylish black-and-white marble floor and red-velvet-covered

antique chairs. In the drawing room, antique rose fabric from a French château covered the walls. An inlaid desk with Sevres porcelain plaques was said to have belonged to Marie Antoinette. The dining room showcased eighteenth-century Venetian wall murals of elegantly clad women and men cavorting at leisure; the mahogany Duncan Phyfe table seated twenty-four. Aubusson rugs covered the parquet floors. Perle's second-floor suite included a circular sitting room with gold-inlaid wooden chairs upholstered in gold fabric.

This was a home designed for grand entertaining, but the parties would have to wait. Marguerite's husband George Tyson was in the hospital, recovering from a serious illness, while Perle had agreed to cross-country speaking engagements.

In her first talk to the American News Women's Club on October 19, she summarized her seventeen-country trip, saying, "The Far East is sizzling but we have friends out there." Discussing her escape in Saigon, she embellished the story, adding dubious new details. She recalled confronting a man who came toward her "with a big knife . . . I thought I was a goner, but I wanted him to know who he was going to kill, so I shouted, 'I am Perle Mesta, your friend.'" Each time she repeated the story, she added new images. Emotionally, she couldn't let go.

On December 16, Perle and Marguerite drove the eighty-six miles to Gettysburg, Pennsylvania, for lunch with Mamie Eisenhower at the president's farm, where Ike was still convalescing from his heart attack. This was a rare and coveted invitation since doctors had severely limited the president's visitors. The president wrote Perle a thank-you note on December 19, saying how much he enjoyed seeing both of them and how much he appreciated their gift of candied fruit. "It was fine to see you and Marguerite, and again my thanks, however inadequately they are expressed."

With Ike and Mamie preparing to head to Key West for the Christmas holiday and return to Washington in mid-January, Perle and her sister had a clever idea: giving a "welcome home" lunch for

Mamie, which would allow them to show off Les Ormes. Perle invited Mamie's mother Mrs. John Doud along with the wives of powerful men, including Mrs. John Foster Dulles, Mrs. David Bruce, Mrs. Winthrop Aldrich, and Mrs. Earl Warren. Pink was Mamie Eisenhower's favorite color, so Perle customized the decorations—pink tablecloth, pink flowers, pink napkins.

The guest list had one surprising name: syndicated gossip columnist Hedda Hopper, whose column had more than 35 million readers. Hopper had been consistently kind in print to Perle, who likely thought the columnist's presence would be a plus for the First Lady. Eager to trumpet her scoop as the only journalist in the room, Hopper wrote on February 3: "Perle had sworn everyone to secrecy, but when I asked Mamie if I could mention the party in my column, she said, 'Why not? Perle and I have been friends for 25 years.'"

Mamie saved the gold-edged menu as a memento: egg timbale, breast of chicken Malaga, rice, green beans with water chestnuts, apricot soufflé. Although Perle was a teetotaler, she lifted a class of champagne in the president's honor, telling her guests, "Although I'm a Democrat, I'm a great admirer of President Eisenhower and so let's toast to his good health."

Simultaneously burnishing her Democratic credentials, Perle gave a cocktail party a week later for Adlai Stevenson's sister Mrs. Ernest (Elizabeth) Ives, a North Carolina resident who had just published her memoir, *My Brother Adlai*. Guests tried to pin Perle down on whether she would support Stevenson for president, but she evasively replied, "Anyone who gets the nomination on the Democratic side is my candidate."

Really? When President Eisenhower, despite his heart attack, announced a few weeks later that he was running for reelection, Perle and Marguerite sent Ike a telegram: "We are very grateful for your wonderful decision the country will be greatly blessed."

With only sixteen states holding primaries (most of them nonbinding), presidential nomination fights were often uncertain until

the delegates actually gathered for the convention. Adlai Stevenson was widely considered the likely 1956 Democratic presidential nominee. But the *New York Times* noted that six "favorite son" candidates had serious backing in their home states, including Senate majority leader Lyndon Johnson in Texas. Perle had never warmed up to Adlai Stevenson and was not planning to endorse anyone before the convention.

She liked Lyndon Johnson and the feeling was reciprocal. "My father thought she knew anybody and everybody and had a gift for putting people together," recalls Luci Baines Johnson, the couple's daughter. "I think she felt my father was a bright man, pretty self-made, and she wanted to do what she could to be part of that making."

REPORTERS WERE BEGGING to see Les Ormes, so Perle and Marguerite gave a press open house. The predictable outcome: puff pieces fawning over their taste. *Washington Star* columnist Betty Beale enthused that this was "a setting that might have been designed for Marie Antoinette . . . A museum of the best furnishings of the time." *Town & Country* ran an admiring four-page spread praising "the priceless collection of furniture . . . the handsome Louis XV marble mantel."

Marguerite had become a celebrity herself. While in England, she had begun breeding miniature poodles and now ran a kennel in Virginia. She was traveling to dog shows all over the country and had been profiled by the *New York Times* for her expertise. Her champion poodle, Blakeen van Aseltine, won twenty best-in-show rosettes.

Meanwhile, the phone kept ringing and the mail kept piling up with invitations for Perle. A movie studio asked her to host the Manhattan premiere of *Helen of Troy* (she accepted); she was honored at Philadelphia's Golden Slipper Ball and the star attraction at Manhattan's Eden Roc nightclub for a party given by Earl Blackwell, the society impresario whose company tracked the whereabouts

of celebrities. Perle agreed to give a three-hour workshop on "how to curtsy" to the Cherry Blossom princesses from forty-eight states. The National Council of Jewish Women in Philadelphia gave her an award for outstanding public service. She was invited to Oklahoma to crown the Farm Woman of the Year at the Tulsa State Fair. With so many commitments, Perle leased her Newport home for the season.

This activity was on top of her lecture schedule. Perle booked paying engagements (Florida, New York, Oklahoma, Pittsburgh, and onward) for speeches on the topic "A Global Look at Communism." At a time when only the wealthy could afford foreign travel, Perle remained a popular draw. And her audiences wanted to hear her impressions of communism, a hot-button topic.

The advantages of capitalism versus communism were on display in sunny Palm Beach, where Perle was the houseguest in March of Marjorie Merriweather Post. The cereal heiress had just reopened her twenty-acre oceanfront estate, Mar-a-Lago, a 37,000-square-foot home decorated with historic Spanish tiles, gold fixtures, and gold leaf.

In her sold-out speech at the Everglades Club, Perle framed America's ideological conflict with Russia as a religious battle, saying, "There's no doubt that we can win this battle of Christ over Communism."

Then came a detour that had nothing to do with the Cold War. Perle headed to the small town of Independence, Missouri, for the wedding of thirty-two-year-old Margaret Truman to Clifton Daniel, foreign editor of the *New York Times*, after a secret six-month courtship. The Trumans winnowed their guests to the bare minimum to leave room for Margaret's friends; Perle was one of the few Washingtonians to be included. Margaret was married in the same small Trinity Protestant Episcopal Church where her parents tied the knot. More than two thousand people lined up outside the church, and many ambled over to the Trumans' Victorian home. Arriving at the reception, Perle "stopped the show," according to the *St. Louis Globe and Mail*, as one of the most famous faces in attendance.

Back on the speaking circuit, Perle gave a rousing talk to the McLean Virginia Lions Club on May 7. But once again she invented stories, as if her own travels were not dramatic enough. She said that while in Russia, she introduced herself to a young mother, who miraculously spoke English, and was sitting with her infant on a park bench. "She didn't want her child to grow up into a Communist," Perle told the audience. "It all seemed so hopeless that we wept." Then Perle said that to her horror, a policewoman swooped out of the bushes and led the woman away. Perle had been in Russia three years earlier but now magically recalled this never-told story.

Perle had become an increasingly shrill anticommunist. But she went too far in Oklahoma City in May 1956. Perle made headlines by channeling her inner Joe McCarthy and declaring that communist agents had infiltrated the American clergy. "I can't name them exactly and I wouldn't if I could," she said, in answer to a question following a speech at the Skirvin Hotel. "They are in the Methodist church, the Presbyterians, in the Episcopalians, in all the churches." Asked for proof, she said, "I'm not going to get into a political or religious argument." Afterward, she told a pastor the infiltration was common knowledge in high government circles. She was likely repeating right-wing Washington dinner party assertions.

The following day, she doubled down on her remarks. Admitting that she had received critical phone calls, she told journalists that she would not back down. "They [communists] are in every church excluding my own and Catholic—I think the Catholic Church is the least Communistic."

It took Perle three weeks to recognize the folly of her words. Finally, on May 29, after a speech at the Mayflower Hotel, she disingenuously claimed to the *Washington Star*, "They have misquoted me all over the United States. I was asked if I thought there were any Communists in the church among the clergy or congregations. My answer was there are some in the church and in the clergy, as there are everywhere."

In June, Perle was named one of the ten most influential women in Washington. At seventy-three, an age when many people quietly fade into obscurity, her fame just kept mushrooming. During the first six months of 1956, more than two thousand stories about Perle appeared in US newspapers. Her name had become an adjective, used as a reference point—"New Mexico's answer to Perle Mesta" or "Chicago's equivalent of Perle Mesta."

Fame begot more fame. On a vacation in Los Angeles, staying at the Beverly Hills Hotel, Perle ran into Speed Lamkin, a twenty-eight-year-old Louisiana native who had been her nephew Bill's Harvard classmate. The author of two well-reviewed novels, Lamkin pitched her the idea of a television show about her life. Although the hit musical and 1953 movie *Call Me Madam* made a fortune spoofing her life, Perle had never earned a penny. This was her chance to cash in.

CBS bought the rights for *Playhouse 90*, a new, critically acclaimed ninety-minute weekly special. A press release said Perle would be depicted as an industrialist, financier, politician, envoy, and Washington hostess. An actress would portray Perle, but the diplomat herself would appear at the end of the show. At a Hollywood press lunch, Perle explained, "I didn't want anybody to peer into my life but CBS convinced me. This will be the real Perle Mesta story. I loved Ethel Merman, but after all, it wasn't the real me."

WHILE PERLE WAS in California, family events were occurring back in Washington that would disrupt her life for an entire year. Her twenty-eight-year-old nephew Bill Tyson, who had been a mischievous child, had become an impetuous adult, repeatedly changing careers and spouses and leaving ample wreckage in his wake. (He would go on to marry four times.)

When his first marriage to a German stewardess came apart, Perle was caught in the crossfire. In the summer of 1956, when his wife Idel Tyson left their Washington home to visit her parents in

Frankfurt, he hopped a flight to Reno to get a divorce. While in Reno, he fell in love with a mother of three who was also getting a divorce, Elizabeth Merchant Leutz. On the day that Bill Tyson's divorce from his first wife Idel came through, he immediately married Leutz, who was from a prominent Washington family and whose father was the American ambassador to Canada.

His ex-wife Idel Tyson, furious upon learning of her husband's new marriage, sought revenge against his family. Claiming that valuable items had been taken from her apartment while she was in Germany, she sued Perle, Marguerite, and George Tyson in US District Court. She stated that the threesome had walked off with $8,700 (the equivalent of $100,000 today) worth of sterling silver, crystal chandeliers, antique tables, French chairs, prints, and Belgian taffeta drapes.

Process servers were unable to deliver the legal papers to Perle, Marguerite, and George because they were all out of town when the lawsuit was filed in July 1956. All three stayed out of Washington for a full year to avoid the legal fracas.

TWENTY-TWO

Windy City Blues: The Party Must Go On

Another opening, another show. Flying to Chicago for the Democratic Convention, Perle experienced déjà vu. She had played different parts at political conventions—dutiful daughter, feminist activist, delegate from Eastern and Western states, official speaker, and extravagant party giver. This time, her sole role would be as gatekeeper for a wildly popular evening.

Wearing a zebra-patterned cotton suit and a white tulle hat, perched on a chair at the Blackstone Hotel, she told a crowded news conference that she was shrinking her guest list from the seven hundred who crammed into her party four years earlier, explaining, "They were hanging from the rafters and I didn't have room for some of my own friends."

Then she made an announcement that guaranteed her event would be an even bigger draw: she was inviting all potential presidential candidates—Adlai Stevenson, Estes Kefauver, Averell Harriman, Hubert Humphrey, John Kennedy, Lyndon Johnson, Albert Gore, and others.

Her party was slated to start around 10:30 p.m. on August 14, immediately after the second night of the convention, and end at 1

a.m. She admitted, "Of course it will last much longer than that but I said one o'clock because it sounds so respectable."

Her party held the promise of being a bright spot amid the gloom hanging over the Democratic Party. Despite the party's midterm gains in Congress, the Oval Office appeared unattainable. Eisenhower remained extraordinarily popular. In a Gallup voter poll released on August 1, Eisenhower held an overwhelming advantage, 61 percent to Stevenson's 37 percent.

But Stevenson did not have a lock on the convention. Harry Truman was miffed at the former Illinois governor, who had not been deferential to him. Shortly after arriving in Chicago—where he was met at the train station by Perle—Truman decided to try to influence the outcome. He announced on August 11 that he backed New York governor Averell Harriman: "I know him and you can depend on him." He described Stevenson as a defeatist and insisted: "I just don't believe he can be elected."

That sent off a chain reaction. Lyndon Johnson had been quietly pursuing the nomination for himself, according to his biographer Robert A. Caro. After Truman endorsed the liberal Harriman, Johnson hoped the convention would deadlock and that he might have a chance as a compromise candidate. Johnson, who had suffered a major heart attack a year earlier, gave a press conference on August 12, announcing that he was in good health and wanted the presidency, stating, "The best candidate at the moment is Lyndon Johnson."

Perle agreed. Hours after Johnson's statement, in an exclusive interview with Texas reporter Liz Carpenter, Perle jumped on the Johnson bandwagon. Even though Truman had endorsed Harriman and her friend India Edwards was helping run Harriman's campaign, Perle declared her independence. "I'm all for Lyndon Johnson if he is really running," she said. "I KNOW he is my favorite. He has done a GREAT job in the Senate." Asked what made him attractive, Perle explained, "He has a spiritual quality. I think that's something nice to say about someone, don't you?"

The scene in Chicago morphed into electrifying chaos as delegates were besieged for votes. On the convention's opening day, August 13, the *Wall Street Journal* ran this headline: "Truman's Harriman Souffle Goes Awry as Convention Opens: Few Northern Delegates Are Turned from Stevenson; Southerners Rage Anew. Heat from Texas' Johnson." The gist of the story: Truman had less influence than he and others believed, and Stevenson still appeared the likely winner.

With so much up in the air, Perle's party took on renewed importance as a place to see and be seen. She fussed over the small touches: pink rosebuds tied around champagne glasses, matching pink coats for the waiters, an upscale menu (glazed salmon, Westphalia ham, lobster, tenderloin stroganoff). She instructed the orchestra to pair music to the guests, such as playing "The Missouri Waltz" when the Trumans arrived. But she could have made minimal effort and the party would have been a roaring success. Every major player came except for Averell Harriman, who sent his wife Marie.

The crowds in front of the Blackstone Hotel tried every ploy to get in. "It took us fifteen minutes and eighteen hundred 'excuse me's' to get to the bottom of the stairway," wrote novelist John Steinbeck, on assignment for the *Boston Globe*. "Flash bulbs were going off like anti-aircraft fire."

Several secretaries and policemen were carefully checking invitations. "I'm telling the doorman to be strict about enforcing this—I don't want anyone to suffocate," Perle had pronounced in advance. But what could the gatekeepers do when a senator or VIP brought along a gaggle of cronies? Wave them all in. Two enterprising Harvard students slipped into the kitchen, grabbed waiter's jackets, and began circulating with trays. Rhode Island senator Theodore Green stood by a plaque stating that occupancy of more than 350 people was unlawful, merrily pointing out that Perle was breaking the law.

When Lyndon Johnson and his wife Lady Bird arrived, Perle jubilantly announced, "You're my candidate!" Johnson would remember

this moment of validation, although 1956 was not to be his year. Flashing magnetic smiles, Jack Kennedy and his pregnant wife Jackie paid homage to Perle, making her erupt into laughter. An exhausted Adlai Stevenson turned up with his sister and an entourage, leaving after forty-five minutes. Harry Truman made a jubilant entry and received a standing ovation.

Reporters described the swirling crowd. "Where else could you have . . . heard Harry Truman demanded at the keyboard with shouts of 'Piano, piano'?" wrote the *Washington Star*'s Betty Beale. "Watched Lyndon Johnson embrace Perle because she came out two days ago for Lyndon if he was really running? Observed rival second place candidates Hubert Humphrey and Jack Kennedy getting palsy-walsy?"

The party shut down at 4 a.m. Perle vowed that she would never give another party like this. No one believed her, since she had made the same vow four years earlier.

Her role at the convention was over, but she remained to watch the action. By the next day, both Lyndon Johnson and Averell Harriman accepted the reality that Stevenson had the votes to win. Assured of victory, Stevenson made the startling announcement at 11 p.m. on August 15 that he would leave it up to the delegates to choose a vice president.

That opened up a spirited competition for second place. Estes Kefauver, Jack Kennedy, Hubert Humphrey, and Albert Gore launched marathon all-night efforts. With 687 votes needed to clinch the nomination, on the first ballot Kefauver came first with 483½ to Kennedy's 304. As voting began on the second ballot, Kennedy appeared to be surging toward the lead—until Gore withdrew and urged his delegates to back Kefauver. Once it became clear that Kennedy would lose, he graciously urged the delegates to vote unanimously for Kefauver.

As the Democrats prepared to leave Chicago, Perle was asked if she knew that Ethel Merman was performing at the upcoming

Republican convention in San Francisco. Her reply: "Yes. And she used to be a Democrat, too. But she married a Republican. That shows you what a man will do to you."

PERLE AND MARGUERITE'S exquisitely decorated Washington home, Les Ormes, was dark that fall. There were no limousines idling out front, no florists and caterers bustling about, no jangling phones, no miniature white poodles frolicking on the lawn. The phone had been disconnected and mail was forwarded out of town. Perle had relocated to a hotel apartment in Manhattan, while Marguerite and her husband George were in Nevada.

They were staying away due to the lawsuit filed against them by Marguerite's former daughter-in-law Idel Tyson over the missing antiques. The lawsuit was gathering dust since the out-of-town trio had not been served with legal papers and thus had not responded to the charges. Perle declined to answer questions about the matter.

Her datebook in New York City filled up: attending the Metropolitan Opera, taking notes on United Nations sessions, going to parties accompanied by diabetes doctor Tony Sindoni. Perle ventured to Philadelphia for the opening of Ethel Merman's new play, *Happy Hunting*, and saw Judy Garland perform at the Palace. Promoting a benefit for the Actors Studio, she posed for photographs with Marilyn Monroe ("She's a sweet little thing, charming and so pretty," Perle told a reporter).

Perle was not a dog lover, but she couldn't turn down Marguerite's gift of a miniature white poodle, Fifi. Now she had a constant, annoying companion who nipped, barked, and chewed the hotel furniture. But Marguerite knew her sister well; Perle became emotionally attached to the dog.

Perle treated the presidential campaign as a distant enterprise. She scarcely knew Stevenson, and she remained attached to the Eisenhowers, so she thought it best to keep quiet. A week before the election,

Perle gave a lecture in Des Moines to a bankers' conference. Asked for her prediction on the election, she replied. "I'm no prophet. All I can say is may the best man win. Who do you think will win? You bet I'm going to vote but I'm not saying for whom. That's my business."

It was telling that Perle did *not* repeat her usual line that she was a Democrat and would vote for a Democrat.

Since her legal residence remained Newport, Perle swooped into that city for twenty-four hours to cast her ballot in the November 6 election and then returned to Manhattan. Her dear friend Ike won again by a large margin.

Perle spent Christmas at an unlikely spot—a cattle ranch near Lake Tahoe, forty-five miles south of Reno. Her sister Marguerite had indulged her son Bill Tyson, buying him the 2,350-acre James Canyon Ranch from family friends Janet and Hugh Auchincloss. Tyson and his new wife Jerry planned to buy Guernsey cows and build a dairy to produce and sell milk, butter, and ice cream.

As trustee for Marguerite's finances, Perle signed off on her sister's $66,000 ranch purchase and contributed her own money to help her nephew. The charming Harvard grad had been selling Washington real estate but convinced his family he was serious about this new career. "To help Bill get started, mother and Father Tyson invested a great deal of money," wrote his sister Betty Ellis, in her memoir. "Dad just poured money in." She was baffled by her brother's self-confidence, noting that he insisted on running the operation rather than hiring a manager even though he "never had any experience in the dairy business."

AMBASSADOR TO ITALY Clare Boothe Luce had resigned on November 19, shortly after Ike's reelection, citing poor health. In a bizarre incident, she had become deathly ill in Rome. It took medical sleuthing to determine the source of the problem. In the aging Italian palazzo that served as the ambassador's residence, arsenic-laden paint

dust had drifted down from the ceiling in Clare's bedroom, poisoning her and leaving her rail-thin and weak.

Clare and Perle remained in close touch. Now Clare needed a place in America to convalesce. Perle wanted to "get beautiful" for her upcoming CBS television appearance. The friends both checked into Elizabeth Arden's Maine Chance spa near Phoenix for a two-week stay.

Located at the base of Camelback Mountain, the desert resort featured white stucco adobe buildings, marble floors, modern art, a vegetable garden, and daily flower arrangements, for up to $700 a week (equivalent to $8,000 today). The daily schedule: breakfast in bed (black coffee and chilled grapefruit); 9 a.m. calisthenics in the pool; a steam bath or an Ardena bath, in which guests were rubbed with melted paraffin wax and wrapped in paraffin sheets; followed by a massage.

After a healthy lunch (no sugar, salt, butter, or flour), guests rested in their rooms, and then received scalp manipulation, a facial masque, manicures, and pedicures. No alcohol was served. To accommodate women who needed to gain weight (Clare) or lose weight (Perle), the buffet dinner offered a "gaining table" and a "reducing table" of delicacies. A butler came by with hot herbal tea at 9:30 p.m. There were no TVs or radios in the rooms. Bedtime was at 10 p.m.

Imagine Clare and Perle lounging around the Arizona spa pool, gossiping about fellow guests and Washington friends and enemies, comparing notes about their overseas postings. Clare had a wicked sense of humor; Perle was an appreciative audience.

A refreshed Clare left for Washington to attend Ike's January 20 inauguration. But Perle turned down Mamie Eisenhower's invitation to be the First Lady's "personal guest" at the best celebrations, explaining that she would be on vacation. In truth, she was still staying out of Washington to avoid being served with legal papers by Idel Tyson, her nephew Bill's ex-wife. Instead, she joined her sister in San Francisco to see a dog show, then headed to Los Angeles to work with screenwriter Speed Lamkin on the *Playhouse 90* script.

Even though Perle was in California during the inauguration, she figured prominently in the *New York Times* feature written by reporter Allen Drury, "Politics Is the Be-All and End-All of Society in the Nation's Capital." Discussing the history of Washington society, he wrote about prominent hostesses and explained why politicians accept their invitations. "Hardly anyone goes to a Washington party just to be going to a party," he stressed. "At nearly every social gathering there is a certain alertness in the hinted secret, the half-disclosed truth or the outright indiscretion. Many a policy is originated over someone's scotch."

Not only was Perle described as a major player in the wheels of Washington life, but a large photo of her with a Supreme Court justice accompanied the story. She was gone for now, but hardly forgotten.

AS A SOUGHT-AFTER celebrity, Perle agreed to host the opening of the new $15 million Philadelphia Sheraton Hotel, on the condition that it be used as a fundraiser for Hungarian refugees who fled their country after the brutal Soviet invasion in the fall of 1956. The hotel hired Hungarian waiters, created a specialty menu, and agreed to match the $50 per person ticket price. Perle's job was to corral celebrities. She reeled in Eddie Fisher, Debbie Reynolds, Gypsy Rose Lee, Will Rogers Jr., Ginger Rogers, Zsa Zsa Gabor, and George Jessel.

The advance publicity proved too successful: eight hundred people bought tickets for the party but 1,187 turned up. With so many famous people in attendance and such a chaotic scene, reporters had ample material to work with. But here's what made the headlines in the City of Brotherly Love: Perle's encounter with rival Gwen Cafritz.

Journalists had been cackling over their feud and fanning the flames for a decade. Gwen obliged by regularly offering up nasty cracks about Perle for publication, such as "I was once quoted as saying that 'Mrs. Mesta came to town with only a cookbook and a telephone directory.' That is absolutely incorrect. I said those are the only books

she has ever read." Perle never stooped to respond to these remarks. She simply cut Gwen dead whenever their paths overlapped.

Gwen had been invited to Philadelphia by Sheraton executives, who were courting her real estate developer husband Morris. Perle was not informed that Gwen, a Hungarian native, would be there.

That night, standing in the hotel's receiving line, Perle was adorned with a new $200,000 diamond necklace and an emerald-green rhinestone-studded satin gown. Suddenly she was boldly approached by Gwen, a vision in a pink satin strapless dress and arm-length white gloves. Texas journalist Leslie Carpenter, dragooned at the last minute into making guest introductions to Perle, nervously blurted out, "Mrs. Cafritz, Mrs. Mesta."

Photographers captured the moment as Perle, whose hand was already out to greet the next guest, touched Gwen's hand, turned, and fled. "I was furious," Perle recalled. Gwen was so flustered that she dropped her purse and the contents went flying—lipstick, lace handkerchief, nickels, dimes, and a compact hit the floor. "Isn't this what happens when I come to a Perle Mesta party," Gwen muttered as she bent over to retrieve her belongings. "She walks away and I drop everything." Realizing her faux pas, Perle returned, claiming that she had walked away because someone called her name. She shook Gwen's hand and pretended to make nice.

"Perle Mesta's Latest Party Evokes Blue Ribbon Meows" blared one emblematic headline. *Washington Post* columnist George Dixon wrote, "It was truly heartwarming the way they ignored each other . . . If Mrs. Mesta and Mrs. Cafritz really have quit feuding they're no good to me anymore . . . I helped create that feud. I nurtured it. It was my dull day salvation."

WITH THE *PLAYHOUSE 90* show scheduled to air March 21, Perle gave advance interviews describing the high points of her life. Discussing her marriage to George Mesta, she told the *Washington*

Post, "I've never married again because I have never found anyone who could measure up to him."

In an interview with the *Los Angeles Times*, Perle stressed that her fee would go to scholarships for foreign students. "At present, I have 18 students studying in five universities in the country." She worried out loud about her own appearance on the program. "I don't know why, but the producers think it might add to the authenticity. I hope I look all right on television."

Perle's willingness to be vulnerable in public was endearing, making people root for her. But most reviews of the TV show were scathing. *New York Times* critic Jack Gould called it "the worstes'," "a bewildering bouillabaisse of cliché and corn." *New York Herald Tribune* critic John Crosby complained that CBS "had perpetrated the life story of Perle Mesta on the defenseless." The show's producer, Martin Manulis, later conceded the show was a "flop."

Perle professed to be happy with the broadcast. Watching the show in her suite at the Beverly Hills Hotel, she was joined by most of the cast. Perle wept at the scenes involving her deceased husband George. The drama included a mysterious new male character with the pseudonym of Philip Caldwell. The dastardly Caldwell was portrayed as using his friendship with Perle to promote business deals and trying to dissuade her from becoming a diplomat.

Perle refused to offer more details, telling a reporter, "I'll never tell his name. He was in and out of Washington and he's the most attractive man you ever saw."

Was he real? No one ever figured out the answer, and it seems likely that he was a fictional invention.

ON HER JOURNEY east, Perle stopped in Chicago and found herself in the middle of a police raid. The setting: a ladies lunch at the home of *Chicago Daily News* society editor Athlyn Deshais, with forty guests, including Eunice Shriver, Jack Kennedy's sister. Much

to the shock of these pampered women, three policemen pushed their way into the place, yelling. "This is a raid! We've had a complaint that you're running a private slot machine club here. Nobody's leaving." The cops realized within minutes that they were responding to a prank call. Perle burst out laughing, calling out to her friends, "I want them to frisk me."

The remainder of Perle's summer was spent at the summer playgrounds of the rich, from Southampton to Newport to the Adirondacks. Perle roughed it with Marjorie Merriweather Post at Camp Topridge, the heiress's 207-acre rural retreat featuring sixty-eight buildings. Guests were flown by private plane to Saranac Airport and then chauffeured by limo to a lake, where a boat would take them the last leg. Perle stayed two weeks, riding horseback, swimming, and playing what her friends called "a mean game of canasta."

In the midst of her summer travels, Perle made a surprise appearance in Washington. Perle, Marguerite, and George had finally settled the lawsuit by Bill Tyson's ex-wife Idel Tyson. In the wake of her divorce, she had charged her ex-husband's family members with stealing antiques and furnishings from her apartment. Idel was now engaged to a Washington lawyer; perhaps her upcoming August wedding date made her ready to resolve the incident. The terms of the settlement were not made public other than that Perle, her sister, and her brother-in-law made a cash payment to Idel.

Perle had come to the capital to reopen her house for the fall. When word got out that she was in town, a *Time* reporter tracked her down to ask about her plans. "A breeze is just floating through the house and there's a terrace for entertaining. With all of my old help back, I'll certainly have some of my old friends in." The reporter described her voice as being full of "girlish gusto." Perle was enjoying feeling impulsive and footloose, saying, "I'm a minute woman—I live by the minute, by the hour, by the day."

But she did want to make one thing clear: "I am back for good."

Fly Me to the Moon

G rowing up in Alta Loma, Texas, Perle had yearned for a larger
life. Now at age seventy-five—a number she never revealed or
acknowledged—she had become the woman who knew everyone. She
had wined and dined and posed for photographs with an astonishing
number of famous people, from Marilyn Monroe to Chiang Kai-shek
to every American president dating back to Woodrow Wilson.

In 1957, Perle added four world-renowned names to her roster:
Queen Elizabeth II and Soviet leader Nikita Khrushchev courtesy
of Ike, and rocket scientist Wernher von Braun and Judy Garland by
her own initiative.

After flinging open the doors to Les Ormes that fall, she went
on an entertaining spree. No occasion was too small (or too large) to
celebrate with Sunday lunches, cocktail parties, and formal dinners.
Loyal butler Garner Camper and his wife Edna returned from Tulsa
to run the show.

Perle partied as if it was 1948 again, spending prodigious amounts
of money on upscale caterers and New York musicians. For high-
ranking government officials (Supreme Court justices, senators) on
middle-class salaries, an invitation to Perle's home promised a taste
of the high life. She joked that being known as the hostess with the
mostes' was "like running a soup kitchen for the over-privileged."

But her initial return to entertaining had the whiff of poten-
tial disaster. On September 16, 1957, the opening of Judy Garland's
six-night run at the Capitol Theatre, Perle invited two hundred guests
to her home after the performance to meet the singer. But the guest
of honor did not turn up for several hours, and people began to leave.

When Judy Garland finally arrived at Perle's home, she made up
for her tardiness by breaking into "Over the Rainbow" and performing
until 3 a.m. Those guests of little faith who had left earlier regretted
their decision once word spread about the tuneful gathering.

Sensitive to changing trends, Perle updated her entertaining
style. Her friend Marjorie Merriweather Post was giving Western
square-dancing parties with lumberjack beef stew. Perle introduced
the conga line and served pheasant and tongue. She convinced a staid
group of female embassy social secretaries to riotously weave around
her home in a conga line, hands on one another's hips. That went so
well that she got their bosses—male ambassadors and their wives—
to do the same at a dinner dance.

A regular fixture at the White House again, Perle was included
in the exclusive ninety-person state dinner for Queen Elizabeth II
and Prince Philip on October 17. White House press secretary James
Hagerty, when asked how guests were chosen, explained they were
"the president's personal friends." A reporter promptly called Gwen
Cafritz to ask if she was going. "No! No! No!" she replied. Told that
Perle would be there, she exclaimed. "I don't believe it," and then
added, "It's true? Well . . . how nice for her!"

Mamie Eisenhower had barely tolerated the press during her
husband's first term, and now she opted out of cooperating. The
society columnists had to write about someone, and once again,
Perle filled the void. In a reprise of her Truman heyday, new profiles
appeared with headlines such as "When Perle Gives a Party, Bigwigs
Flock to Her Door." Her recipe for cream puffs with peppermint fill-
ing ran in dozens of newspapers. She was willing to dish personal
details, revealing that she had lost twenty-six pounds and splurged

on thirty-five new outfits by the California designer Marusia, and was wearing a bronze wig to cover her gray hair. ("Some people don't recognize me, which I love.") Perle felt she had nothing to hide, and other women could relate to her struggles with her appearance.

She came across as irrepressible. "At 2 a.m., she might be found leading a conga line around an embassy ballroom, her blue eyes and her pounds of diamonds sparkling in time with the Latin Rhythm," wrote Bonnie Angelo in *Newsday*, "and at 10 o'clock the next morning she might be occupying a front-row seat at whatever is the liveliest congressional hearing on Capitol Hill."

The *Washington Star*'s Betty Beale, who wrote three weekly columns plus a national column that ran in more than seventy newspapers, mentioned Perle at least once a week. Beale marveled at the hostess's "zest for life." "Perle Mesta feels that something interesting is going to happen every day and because of her enthusiasm it usually happens—and around her," Beale wrote. "She would rather embark on a brand new career tomorrow than fold her hands in luxury."

Selwa "Lucky" Roosevelt, who covered Perle's parties in the 1950s for the *Washington Star* and went on to become Ronald Reagan's chief of White House protocol, stressed to me that Perle's gatherings mattered. "Washington parties were very, very important. It gave you a chance to connect with people you want to meet."

Perle added her influential voice to the chorus of civic activists pressing for a cultural center in Washington. She joined Marjorie Merriweather Post in testifying before Congress. Perle insisted that Washington was "far, far behind all the capitals in the world as far as culture is concerned. I say it with humiliation." That year, Eisenhower signed the act that eventually resulted in the Kennedy Center for the Performing Arts.

During the first four years of the Eisenhower administration, Perle and Richard Nixon acted as if they wanted nothing to do with one another. The vice president even demanded a newspaper correction stating that he had never been to a party at Perle's home (or

Gwen Cafritz's, either). But now their paths crossed frequently, and the deep freeze melted.

When Nixon led a panel discussing foreign aid at the Statler Hotel, Perle stood up for twenty minutes, waiting to ask a question. He finally looked over and said, "State your name please." When she uttered "Perle Mesta," the audience laughed at his failure to recognize her. Nixon fixed the gaffe by praising her as a spokeswoman for her sex and experienced diplomat.

Perle's question: Why, if foreign aid was such a priority, did he approve of spending $10 million to tear down the East front of the Capitol to enlarge the building. (She favored historic preservation.) He gave a gentle smile and replied, "If by relieving the congestion that now prevails, we can improve the tempers of the House and Senate members with this program, let's go ahead and do it."

Perle's Democratic political alliances remained strong. Lyndon Johnson and Sam Rayburn were photographed kissing Perle so often at parties that it became a gossip column joke. "Johnson could be very charming, you know, very lovable, and very quiet when he wanted to be," she recalled in an oral history. "I adore him. I didn't always agree with him. I've had some fights with him but we always made up and kissed."

Lady Bird Johnson felt affection for Perle. "I liked her very much," Lady Bird said in her own oral history. "She's interesting, assertive, with her own and very positive sense of values and a great many of them were social. She was also quite capable of true friendships."

Even though Perle claimed Oklahoma as her home state, she was welcomed at Texas-centric events thrown by Texas lobbyist Dale Miller and his wife Virginia, known as Scooter. The Millers gave annual birthday parties for Rayburn (January 6) and Johnson (August 27), and Perle was a regular. Perle played the role of unofficial welcomer for Lyndon Johnson's burgeoning staff.

Texas law graduate Lloyd Hand joined Johnson's Washington Senate office in 1957. He and his wife Ann, now a prominent jewelry

designer, told me (in a joint interview in Georgetown) that Perle went out of her way for them. "We always felt we were welcomed by her because we came under LBJ's umbrella. I felt like she was taking me under her wing. I was thirty-one, and she knew I was trying to find my way into the city," says Ann. "She was wonderful. She'd come out to my house sometimes; she was fascinated by my five children. She would invite us to these glamorous parties."

Her husband adds, "I remember going to her homes and salons. What was unique about it is that she'd have both Republicans and Democrats, and you'd sit around and eat and drink, and afterwards, the ladies would go in one room, men in another, smoke cigars. Perle had a unique ability to put people together so they would have useful, substantive discussions."

But her friendly relationship with Massachusetts senator Jack Kennedy had become a relic of times gone by. Perle did not invite Jack and Jackie to her parties, and they didn't seek her out. The three of them were occasionally at the same events, but the Kennedys moved with a younger, hipper crowd, who perceived Perle as old news, not someone to be courted.

And she really, really liked being courted. Every time someone asked Perle to lend her name to a charity or host an event, it was a validation of her place in the universe. She flew to Los Angeles at the request of *Gentlemen Prefer Blondes* actress Jane Russell to chair a ball for the Women's Adoption International Fund. Russell attracted so much star power to the Beverly Hilton gala—Mickey Rooney, Van Johnson, Burt Lancaster, Lucille Ball, Desi Arnaz, George Burns, Gracie Allen, Jayne Mansfield—that it was hard to understand why she needed Perle Mesta. Yet Perle received as much attention in news stories as the Hollywood stars.

But in her desire to be relevant, she allowed herself to be used by others for political gain. Her frightening experience in Saigon had turned her into even more of a fervent anticommunist. Her fame was perceived as useful to the South Vietnamese government.

In January 1958, Perle cohosted the benefit for a new movie about Vietnam, based on Graham Greene's novel *The Quiet American*. Much to Greene's fury, his plot had been radically rewritten to give a positive spin to Prime Minister Ngo Dinh Diem's regime. Money raised by the benefit would go to the South Vietnamese government.

Perle's name was on the invitation along with those of Vietnamese ambassador Tran Van Chuong, the father of Diem's powerful sister-in-law, Madame Nhu, and Perle's friend Angier Biddle Duke, founder of the American Friends of Vietnam, a lobbying group backing Diem. At the party at her home, Perle added legitimacy to the effort to boost Diem by including such liberals as Supreme Court justice William Douglas and Senator Mike Mansfield.

Yet even as she was trying to help fund anticommunist forces in Vietnam, Perle accepted an invitation from card-carrying Communist Mikhail Menshikov, the new Russian ambassador to the US, for a musical performance at the Russian embassy. (Hungarian native Gwen Cafritz had a chilly reaction to the invitation, telling the press, "I do not go to Russian receptions.")

The ambassador's wife made a special effort to win over Perle—found her a seat, brought her food, gave her a special tour—but when reporters asked Perle if she planned to entertain the Soviets, she grimaced and declined to answer. Later that year, when Perle ran into Menshikov at Laurel Park Race Course in Maryland, she teased him into sharing a bet on a horse in the fifth race—and the horse, Bombeau, won.

WHEN THE SOVIETS launched the first satellite, Sputnik, into space on October 4, 1957, America was desperate to duplicate the feat. Wernher von Braun, the German rocket scientist now working for the US Army, promised the Pentagon that he could make that happen. On January 31, 1958, at Cape Canaveral, Florida, Explorer I thrust off into the sky, making history.

Von Braun watched the launch on TV from the Pentagon in Washington, and then went to the National Academy of Sciences for a press conference. Afterward, as he was about to leave, someone shouted to him that Perle Mesta was on the phone. Von Braun had no idea who she was, according to *Time*. "Should I talk?" he asked an Army general, who replied, "Sure, she's a good Democrat." Von Braun snapped, "Okay, we may need them again." Perle congratulated him and offered to do what she did best—give him a Washington party, where he could meet senators involved in funding the space programs. He accepted.

This was a coup for Perle. Von Braun was the face of the American space program. Treated as a heroic figure, this was a radical transformation for a man who had been Germany's leading rocket scientist during World War II, responsible for thousands of deaths.

In the 1930s von Braun led the German team that created Hitler's V-2 ballistic missile, the powerful war weapon that decimated London and targets in Western Europe. He claimed to be unaware that concentration camp prisoners were forced to build the V-2 missiles— more than twenty thousand died in the wretched conditions. After surrendering to the Americans in May 1945, von Braun went to work for the US Army, developing rockets and outer space launch vehicles.

The American government decided his technical brilliance trumped all other considerations and chose to largely hide his SS background until his death in 1977. Instead, he was heralded as the genius who propelled the country into space. Most Americans— including Perle—knew little about his past.

Now an American citizen, handsome and charismatic, von Braun mesmerized the guests at Perle's party, describing his dream of landing a man on the moon. Perle delivered a roomful of powerful men: Secretary of Defense Neil McElroy, presidential science adviser James Killian, three senators, and a host of administration officials. The tables were decorated with miniature satellites.

Von Braun was direct in his toast, saying, "I am grateful to the Secretary of Defense for letting us get into this race and grateful to

Congress for giving the money for it." When Perle toasted von Braun, she made a half-serious plea: "I want you to promise to let me go to the moon sometime. I want to go first."

Von Braun, who brought his wife that night, made numerous return appearances to Perle's home. Even some fifteen years later, he would still RSVP yes to her invitations.

Perle included a new Republican friend at that party, Bob Gray, who held the title of secretary to President Eisenhower. The thirty-five-year-old Nebraska native and Harvard graduate had recently become her frequent evening escort. For Perle, it was a pleasure to have a good-looking and solicitous young man by her side, an excellent dancer and conversationalist. For Gray, who later in life would become one of the city's premier lobbyists, Perle provided entrée to the right people.

Perle often stressed that she was no longer interested in romance, an attitude that worked well for her companions. Gray never came out as gay, but his 2014 Washington Post obituary listed a partner of twenty years, Efrain Machado. Gray had a sense of humor that proved useful in deflecting raised eyebrows in the 1950s about his sexuality. When Perle brought him as her date to a benefit for the Florence Crittenton Home, he quipped to a reporter, "I am not sure a bachelor should be at a party for unwed mothers."

Columnists picked up on Perle's new friendship. Describing the International Horse Show Ball, the Washington Post wrote, "Perle Mesta was another early arrival and had the orchestra breaking into songs from Call Me Madam as she swept around the floor with Bob Gray of the White House."

Gray was intrigued by Perle's relationships with journalists. "She invites working members of the corps to all her parties, including formal events, where they attempt to hide their note pads under their napkins," he later wrote in McCall's. "She can keep track of every cameraman in a crowded room and consciously assists in composing the pictures in which she appears."

He recalled attending the Horse Show Ball with Perle and walking past two merry-go-round horses placed in a bower of flowers. "'Let's stand here a minute,' she said. 'Some photographers are bound to come along and take a picture that will make all the papers.' She did, they did, and it did."

WITH HER SISTER Marguerite living far away in Nevada, Perle yearned for family connections and spent ample time with Marguerite's daughter Betty and her husband Lewis Ellis and their four children. The Ellis family lived near Perle's home and got together regularly for Sunday lunch.

Betty's daughters, Elizabeth (Ellis) Christian, now a sales account manager in health services and motivational speaker on Christian topics, and younger sister Linda (Ellis) Picasso, who sold real estate for many years, reminisced fondly about Perle in an interview with me at Linda's Maryland home. Perle splurged on them and hosted parties for the young women and their friends.

"We lived walking distance away. The house looked like it could be an embassy," recalls Linda. "Edna [Camper] would make the most delicious roasted chicken, there were glass salad dishes, we had finger bowls afterwards. Perle was relaxed." Her older sister Elizabeth adds, "I remember going into this lovely little circular room, all these shelves with beautiful Meissen china birds."

The girls realized that Perle was famous because people deferred to her whenever she took them places. "She did attract a lot of attention wherever we went," recalls Linda. Elizabeth adds, "Riding in a limousine with her, we did that a lot, it was fun." They loved going shopping with Perle. "We'd pull up to Saks Fifth Avenue, and I loved the fact that the whole store would be closed," Linda says. "Nobody was allowed to shop in the whole store but her and me, and I thought that was cool."

Perle doted on the children. Raised as Christian Scientists, they were aware that the religion played an important role in Perle's life.

"It gave her a sense of peace," Elizabeth says. "She read the Bible and the Christian Science that went with it every day." Linda, who as a teenager moved in with Perle for a time, recalls, "She had a sense of humor. She liked to laugh. You could tell from her face, she liked to have fun."

NEWPORT WAS THE launching pad for Perle's entrée into the American aristocracy in the 1920s, but it had served its purpose and she scarcely visited anymore, so she sold Mid-Cliffe. Given her excessive spending, the sale provided a welcome cash infusion and eliminated the cost of caretakers and gardeners. Rather than spend leaf-peeping season in Newport, she went to Europe with Marguerite.

Perle's sister had mixed news about her son Bill Tyson's dairy business. His Guernsey milk won a gold medal award at the California State Fair, but he had been hit with a $372,500 lawsuit charging him with hiring employees from a rival business and stealing trade secrets. Determined to help him, when Perle and Marguerite visited the World's Fair in Brussels in September, they brought milk packed in dry ice to exhibit at the pavilion.

Perle was back in Washington in time for the yearly Circus Saints and Sinners roast—that year's honoree was Gwen Cafritz—but did not attend. Nonetheless, the columnists treated Perle as if she was there. "In Washington, where entertaining one's enemies is legal, the Mesta-Cafritz social rivalry has had box office since the beginning," wrote Houston reporter Les Carpenter. "Both rivals know it and play to it."

The skits made fun of Gwen's meager food at her parties: one man joked that he would have settled for a hot dog but instead met Justice Frankfurter. Reporter Walter Kiernan had worked on his lines: "She weighs 110 pounds without her money belt. She is a charitable lady. After every party, she sends her old crepes suzettes to the Salvation Army. Her Morris has everything a woman could want in

a husband. He is rich, kind, rich, alive and rich." Gwen beamed her way through the lunch.

NOW THAT CLARE Boothe Luce had made a full return to health, Ike nominated her in the spring of 1959 to become ambassador to Brazil. Six years earlier, her nomination as ambassador to Rome sailed through the Republican-controlled Senate, but now the Democrats were in charge, and they were determined to block her confirmation, using her own words at a weapon.

Renowned for her sharp tongue, in the past Clare had charged that Franklin Delano Roosevelt "lied" the country into entering World War II and questioned the patriotism of Democrats. Oregon senator Wayne Morse, leading the opposition, insisted she was unqualified to be a diplomat: "The role for which I believe she is well qualified is that of political hatchetman."

Perle sent her a telegram: "Can I be of any assistance?" Clare took her up on the offer. On April 24, four days before the Senate vote on her friend's confirmation, Perle put together a bipartisan dinner for Clare with useful guests, including Lyndon Johnson, Republican senator Bourke Hickenlooper, former GOP House minority leader Joe Martin, Perle's ubiquitous escort Bob Gray, plus Clare's friends Alice Roosevelt Longworth and *Vogue* editor Margaret Case. Often described as an ice queen, Clare relaxed enough that night to dance the rumba.

The Senate confirmed Clare's nomination by a 79 to 11 vote. However, Clare managed to snatch defeat from the jaws of victory. Furious over how she had been treated, she issued an angry statement after the vote in her favor. "My difficulties, of course, go some years back and began when Senator Wayne Morse was kicked in the head by a horse."

Attacking a sitting senator was a breach of protocol; other senators immediately expressed remorse for voting to confirm her. Henry

Luce urged his wife to withdraw, saying the "smears and suspicions" would make it difficult for her to do the job. President Eisenhower acknowledged her comments were "ill advised" but "perfectly human" and insisted he supported her. But on May 1, the day she was slated to be sworn in, Clare Boothe Luce met with Eisenhower and resigned.

PRIVY TO WASHINGTON secrets, Perle occasionally bragged about her insider knowledge. In his diary on April 23, 1959, syndicated columnist Drew Pearson wrote in frustration: "Went to one of Marjorie Post Davies May's square dances. Sat beside Mrs. Perle Mesta. She said she had some dynamite-laden information which I would love to have but refused to give it to me. I did not press the old bag of wind."

While Perle may have represented an "old bag of wind" to Pearson, to others she remained a valuable commodity. Even though her life story had been lampooned in *Call Me Madam* and given the television treatment on *Playhouse 90*, there were new mediums to conquer. *Saturday Evening Post* contributor Robert Cahn urged Perle to write her autobiography with his help. "I liked him, so we went right to work," Perle recalled. The publishing firm McGraw Hill snapped up the rights to the book, to be published in April 1960.

Cahn, who would go on to win the Pulitzer Prize for a newspaper series about the National Parks, had a low-key and engaging style. "He is mild appearing, talks easily with all, and makes friends instantly; he has a ready smile and quick quip," wrote the *Christian Science Monitor* in a profile of Cahn.

Perle and her amanuensis spent months together as Cahn drew her out in conversation and taped the answers. "He would come to my house at 9:30 in the morning and we would work until 12:30 p.m.," Perle explained to a reporter. "Then he would go home and return in the early afternoon and sometimes we would work until late at

night." Reflecting on her life, Perle put a positive spin on her experiences, other than her husband's death. When a reporter asked about the book's content, she breezily replied, "It'll be nothing like 'Call Me Madam.' I like music, but my life wasn't a musical."

THE EQUAL RIGHTS Amendment was languishing in Congress despite the valiant efforts of the National Woman's Party. Democratic New York congressman Emanuel Celler, who controlled the powerful Judiciary Committee, vowed the ERA would never come to a vote in the House.

Perle had stepped aside from the ERA battle for several years because it seemed hopeless and she had other priorities. But now she pitched in again, telling a *Daily News* reporter that she was "lobbying like mad" and doing everything "but knocking some Senators on the head" to move the legislation forward. Sounding a bit grandiose, she insisted, "The work I do is not for pay. What I do is for progress of the female of the species."

To win supporters, she gave a party in July 1959 for legislators and ERA activists at the National Woman's Party headquarters, the Alva Belmont house. A strolling orchestra wandered the historic mansion's large garden, which was lit with Japanese lanterns. Perle stood with legendary suffragette Alice Paul in the receiving line, welcoming Sam Rayburn and a dozen other congressmen and senators. New York congresswoman Katharine St. George tried to rally the guests by chanting, "Equal Rights for men and nothing more! Equal Rights for women and nothing less!"

Perle put on an optimistic front, saying philosophically, "I know Celler is against it and I think he's terribly wrong but I still like him."

The *Star*'s Betty Beale lingered afterward. "When all the guests had gone, Mrs. Mesta and her co-workers of the NWP sat in a circle and compared notes on the reactions of the gentlemen from Capitol Hill to their amendment. And the more they compared the more

determined they became to open up a truly high-powered campaign."
But once again, they failed in their efforts to get the bill passed.

WHILE PERLE WAS mining her life for authentic stories for her
autobiography, another writer in the city was working on a fictional
tale about the capital's political machinations. In August 1959, veteran
New York Times reporter Allen Drury published *Advise and Consent*,
an immediate number one bestseller, which became the basis of a
play and hit movie.

"The guessing game has already begun as to which Senators,
ambassadors, hostesses and other persons are, in whole or in part or
in composite, really the characters who move through Mr. Drury's
book," wrote Minnesota Democratic senator Eugene McCarthy in
his favorable review for the *Washington Post*.

Perle inspired a character in the most famous Washington
novel of the era. The plot revolved around an aging and ill president
(resembling FDR) and a Senate fight over the confirmation of his
left-leaning choice for secretary of state, with a subplot about the ugly
blackmail of a closeted male senator. *New York Times* reviewer Rich-
ard Neuberger, an Oregon senator, praised Drury's verisimilitude in
describing Washington's denizens. "He neither protects the private
lives of Ambassadors who poke and pry into American politics nor
of the widows who set snares of sex and wealth for lonely members
of the Senate."

Early in the novel, an important scene takes place at the tree-
shaded home of wealthy hostess Dolly Harrison, who is having an
affair with widowed Senate majority leader Bob Munson (shades of
the rumors about Perle and Alben Barkley). Describing Dolly Harri-
son, Drury wrote: "She had always had a lively interest in politics and
world affairs, had fortunately been blessed with the native intelligence
and shrewdness to give it point . . . 'I'm going to live in Washington,'
she had told everybody, and everybody had exclaimed; but not half so

much as they did when they subsequently learned from press, radio, television and newsreel just how overwhelmingly successful the move had proved itself to be."

Several reviewers noted the similarities between Dolly and the hostess with the mostes'. The perception that Perle was the inspiration for Dolly remains part of the novel's legacy. In 2009, when novelist Thomas Mallon wrote an appreciation titled "'Advise and Consent' at 50," in the *New York Times*, he referred to Dolly Harrison as "a more genteel version of Perle Mesta."

Thrilled and flattered, Perle promptly befriended Allen Drury. He became a guest, and guest of honor, at her parties, joining her other new conquest, Wernher von Braun.

IN THE FALL of 1959, Soviet Premier Nikita Khrushchev arrived in Washington with his wife, son, two daughters, and son-in-law on September 15 for a historic twelve-day trip. The Soviet premier and his family were guests at a White House state dinner, serenaded by the Fred Waring Band.

With only a hundred people on the guest list, Perle was surprised to be invited, given her critical comments about Russia. She was seated next to FBI director J. Edgar Hoover, who admitted that he didn't expect to be there either. If only the candelabra had ears—they were quite the pair, the popular hostess and the feared lawman who kept secret files on "subversive" Americans and investigated thousands for Communist leanings. Hoover was overheard telling Perle that he thought Eisenhower had included the two of them to send a message: "I think we're here just to show the Russians that the Administration approves of our opinions."

Khrushchev's itinerary included Manhattan (where he spoke to the United Nations), Los Angeles (the Soviet leader was furious that his visit to Disneyland was canceled over security concerns), San Francisco, Des Moines (to visit a farm), and Pittsburgh (where he

toured the Mesta Machine Company; Perle no longer had a stake in the corporation).

Perle did not have the opportunity to speak with Khrushchev at the White House dinner, but she had a second chance at a reception at the Soviet embassy toward the end of his trip. Photographers captured Perle shaking hands with the smiling Khrushchev, as his wife and Soviet ambassador Mikhail Menshikov, interpreting the conversation, looked on.

Perle was eager to tell Khrushchev about George Mesta's background as a man from an immigrant family who flourished under the free enterprise system. As she told the press afterward, "I wanted Khrushchev to know that my husband had to borrow money to start that plant he visited in Pittsburgh today." Unaware that Perle was no longer involved with the company, Khrushchev told her that he would like to buy machinery from her. Perle's reply, "I said, I am not a saleswoman. I am not selling any."

Aware of Perle's friendship with President Eisenhower, Menshikov continued to court Perle, deluging her with holiday tins of Russian caviar and champagne. She remained vehemently opposed to communism. But she didn't send the gifts back.

All the Way (or Not at All) with LBJ

P erle flew to Los Angeles in October 1959 to search for a party
venue for the July 1960 Democratic Convention. "I've always
said I'd never give another party and I always come up with one,"
she told the *New York Herald Tribune*. "And I said I'd never write my
life's story but now I'm doing it."

The Democratic convention had the potential for high drama,
with Jack Kennedy, Lyndon Johnson, Hubert Humphrey, and Adlai
Stevenson expected to compete for the presidential nomination. Perle
knew all of them, but her closest relationship was with Johnson.

The charismatic Jack Kennedy had been actively campaigning
for the presidency for several years, building a far-flung network of
allies. His mega-wealthy father Joseph Kennedy, former ambassador
to Great Britain, was willing to spend whatever it took, and the sena-
tor's persuasive younger brother Bobby served as his political emis-
sary to Democratic powerbrokers. But Kennedy was by no means a
shoo-in, since concerns remained about whether Americans would
vote for the first Catholic president.

Lyndon Johnson was hungry for the job but conflicted about
pursuing it. Haunted by the fear of defeat, he didn't want to appear

to be giving his all. A graduate of Southwest Texas Teachers College and eight years older than Kennedy, Johnson derogatively referred to the Massachusetts senator, a Harvard graduate, as a spoiled rich kid.

Johnson's political paralysis drove his supporters nuts since while he dithered, his rival was lining up allegiances. "I was very, very anxious for him to run," Perle later recalled. Asked why Johnson held back, she said, "Nature, that was his nature. Reluctant to give word to the public what was in his mind."

On October 17, 1959, House Speaker Sam Rayburn tried to move things forward, announcing in a Dallas press conference that he was launching a Lyndon-for-president drive in Texas in the hope of staging an upset at the convention. When an Associated Press reporter informed Perle about Rayburn's move, she pledged her support for LBJ. "He's my boy," she exclaimed. "I've just been waiting for the word."

TO INJECT FEMINISM into the national dialogue, the National Woman's Party sent questionnaires to politicians asking whether they supported the Equal Rights Amendment. When the group held its first convention in seven years in Washington on January 5, 1960, select answers were read aloud at the opening night banquet.

President Eisenhower, Vice President Nixon, and Hubert Humphrey all sent in replies supporting women's rights. And then there was Jack Kennedy, who dodged the issue with patronizing blather. "I am sure your discussions and activities will stimulate among your members and in the country at large a program of responsible action."

At the Woman's Party convention, Perle was elected first vice president and the group's representative to the US mission to the United Nations. When she called a press conference a month later to discuss women's rights, reporters pelted her with questions about the presidential race. She pledged her loyalty again to LBJ.

"Of course I think he'll win. I'm campaigning for him right now," she said. "I said four years ago when he came to my party in 1956 that he was my candidate for President. Oh dear, I hope Jack Kennedy won't be mad at me." She insisted that Johnson would do well. "Yes, I think he'll get the women's votes." But there wasn't much campaigning to do yet, since the Texas senator had not officially declared his candidacy.

Perle was free to concentrate on launching her autobiography, *Perle: My Story.* The grateful Lyndon Johnson joined the Perle book bandwagon with a blurb. "It is a very revealing story of a warmhearted woman with a witty mind and a perceptive eye who has been surveying the Washington scene for many years," Johnson wrote. Clare Boothe Luce also wrote a supportive sentence: "Perle Mesta is a warm, gay, generous-hearted woman who has enjoyed the friendship and confidence of the great, regardless of political party."

In a prepublication interview with the *Washington Post*, Perle stressed her hope for a wide audience, but her comments had a condescending tone. "I didn't write this book for Mamie Eisenhower or for any of my Washington friends. I wrote it for housewives. You notice there are no big words in it. I don't use big words when I talk."

She threw a high-end book party on April 19, 1960, at the rooftop ballroom of the St. Regis Hotel, decorated with red and pink carnations and scarcely a housewife in sight. The big names included Ethel Merman, currently starring in *Gypsy*, and actresses Celeste Holm and Helen Hayes, along with Washington politicians, ambassadors, New York socialites, and journalists. The Lester Lanin Orchestra played "Baubles, Bangles and Beads" as Perle, in a blue sequined Marusia dress, was swept around the dance floor by Cabinet secretary Bob Gray.

Perle defied expectations again—her autobiography became a national bestseller. It was filled with amusing anecdotes, uplifting moments, self-deprecating humor, and a pinch of self-aggrandizement. Perle romanticized her childhood and treaded lightly over the fight

with her father. She described her mostly happy marriage to George Mesta, her desperate loneliness after his death, her social triumphs in Washington and Newport, and her close friendship with the Trumans.

Her ghostwriter, Robert Cahn, captured her voice so well that it felt like Perle was speaking directly to the reader. She raised intriguing questions but did not answer them.

"People often ask me why I give so many parties. Am I lonely and do I crave company? Is my party-giving the outlet for some suppressed desire? Am I making up for a deep scar left on me as a little child when no one showed up for my first party—as was once portrayed in a television version of my life? Or do I give parties for some Machiavellian purpose, secretly trying to sway the course of history?"

Rather than provide insight, she wrote, "I have never been a great one for stopping to figure out such matters. I would discount most of these points, although I do like to have people around me and it is certainly true that most parties have a purpose."

Reviewers praised the book's tone with adjectives like "disarming," "full of Oklahoma zest," and "beguiling candor." Assessing Perle's style, *New York Times* reviewer Bess Furman described her as all "gusto. In an up-and-at-'em, let-the-phrases-fall-where-they-may spirit, she out-madams Ethel Merman, out-antics Auntie Mame, out-impresarios Elsa Maxwell and out-wits all and sundry."

Some reviewers were unimpressed. The *New Jersey Record*'s Russell Thacher depicted her as "a gregarious, cheerfully meddlesome, domineering, impervious, insensitive extrovert." The Jackson, Mississippi, *Clarion-Ledger* reviewer Jean Culbertson actively disliked the book: "Her self-righteous self-esteem can cause the reader to downright gag at times."

McGraw Hill mounted an expensive publicity campaign, buying newspaper ads and sending Perle on a lengthy book tour. The publisher sold newspaper serial rights in addition to *Saturday Evening Post* excerpts. Perle was here, there, and everywhere,

appearing on radio and television shows and bookstore signings. She used her fame to talk politics. During a brief return to the capital, she told the *Washington Post*, "Every place I was supposed to talk about my book, I plugged LBJ . . . I just can't resist speaking up for Lyndon every place I go."

Johnson was now belatedly maneuvering to set up a convention showdown. As the power controlling the purse strings of the Senatorial Campaign Committee, he sent word that senators who supported Kennedy might be deprived of campaign funds. He made the case that Southern states were more likely to support him than a liberal Northerner. As the *Wall Street Journal* put it in an analysis: "Key Theme of Johnson Presidential Campaigning: 'Kennedy Can't Win.'"

But Kennedy had quieted fears about his religion and won a devastating primary victory over Hubert Humphrey in the West Virginia primary, a heavily Protestant state. He appeared to have a lock on the nomination.

Perle remained stalwart in her support for LBJ. She gave a brunch at Les Ormes in mid-June for eighty-three congressional wives who supported the Senate majority leader. "The interest is so great that I have hardly had to call anybody myself," she insisted. "They all call me." Lady Bird Johnson told reporters, "Perle has watched this town for years and with her stamp of approval and you all thinking Lyndon is the man, that's enough accolade for me."

The couple's older daughter Lynda Bird Johnson Robb told me that the hostess's support was meaningful. "In 1960, we did not have a lot of fancy folks supporting us. We didn't have a lot of actors and high society people. To have Perle Mesta be supportive was absolutely wonderful, a name some people would have heard of."

But a few weeks later, appearing at Philadelphia's Wanamaker's department store on June 30, Perle made a startling statement that indicated she was thinking the unthinkable—what if Johnson did not win the nomination or the presidency? Perle said that she was backing LBJ but that she was comfortable with the GOP's candidate, Richard

Nixon: "If he makes it as president. Mr. Nixon is a fine person. He has a good grasp of the international scene."

Perle had gotten to know and like the vice president, and her friend Bob Gray was one of Nixon's biggest boosters, already calling him "President Nixon."

Harry Truman jumped into the political fray at a press conference on July 2 at the Truman Library in Missouri, questioning whether Kennedy was "quite ready" to be president and stating that he had withdrawn as a delegate since "I don't like a fixed convention." Perle seized on his remarks at her own press conference the next day at the Beverly Hills Hotel. "It was a wonderful speech. We don't want Joe Kennedy buying the Presidency for his son." She took a dig at the Massachusetts senator. "I have nothing against him but he does look a little like a teen-ager."

Perle had another priority at the Democratic convention, making sure the party kept the Equal Rights Amendment in the platform. She joined National Woman's Party president Emma Guffey Miller in testifying before the platform committee. Their powers of persuasion failed to convince the delegates. The final Democratic platform did not specifically mention the Equal Rights Amendment. Perle was angry and disappointed.

THE COCOANUT GROVE nightclub at the Ambassador Hotel in Los Angeles, famous for its glamorous clientele and Moroccan-themed décor, opened in 1921, hosted the Oscars for several years, and remained a magnet for big-name entertainers. Nat King Cole, the Kingston Trio, and Lena Horne all performed there in 1960. On the morning of July 12, at 9 a.m., hundreds of people lined up outside, waiting to get into Perle Mesta's largest party ever.

Perle had sent out five thousand invitations for a brunch in support of LBJ to delegates, journalists, and political hangers-on. Newspaper estimates of the final turnout reached 7,500 people. Perle brought in

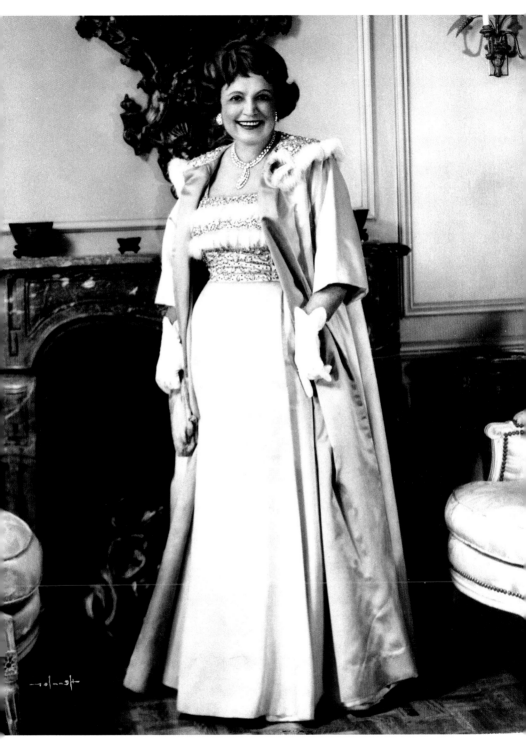

Perle Mesta, Washington's most popular hostess, in her glamour years. (Photo by Johnny Melton, Oklahoma Historical Society)

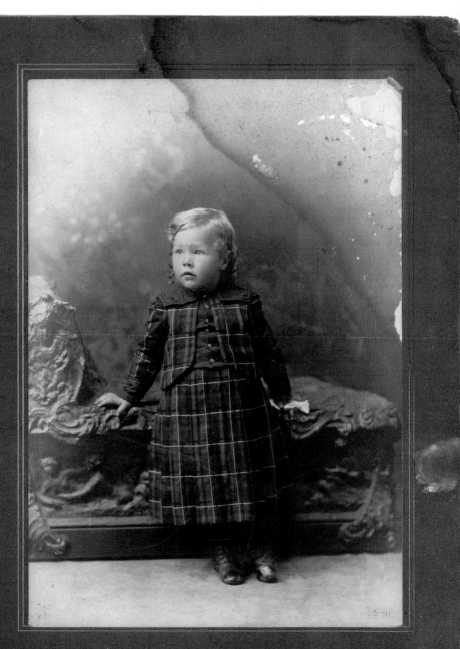

MORRIS
GALVESTON
TEXAS

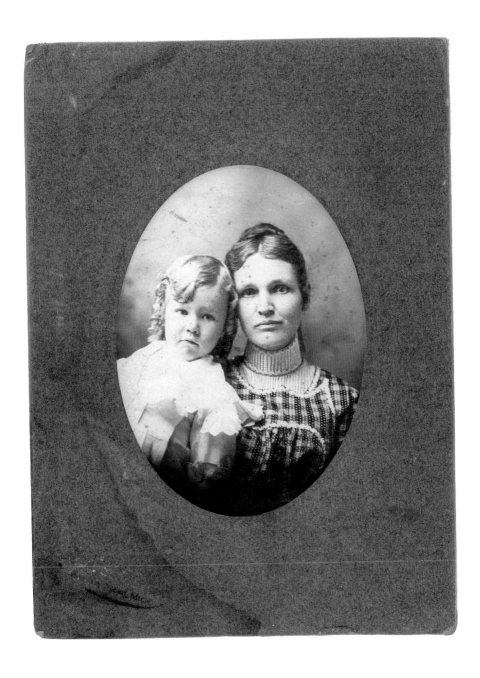

OPPOSITE: Born Pearl Skirvin on October 13, 1892, Perle was the oldest of three. (Oklahoma Historical Society)

ABOVE: Hattie Skirvin and her daughter Pearl, whose formative years were spent in Texas. (Oklahoma Historical Society)

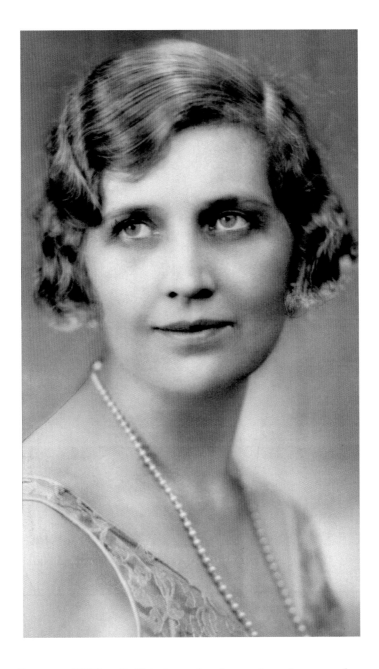

OPPOSITE: William B. Skirvin made a fortune in real estate and oil and then built the largest hotel in Oklahoma City, the Skirvin. (Oklahoma Historical Society)

ABOVE: Marguerite Skirvin, Perle's younger sister, was a hit actress on Broadway and in silent movies. (Oklahoma Historical Society)

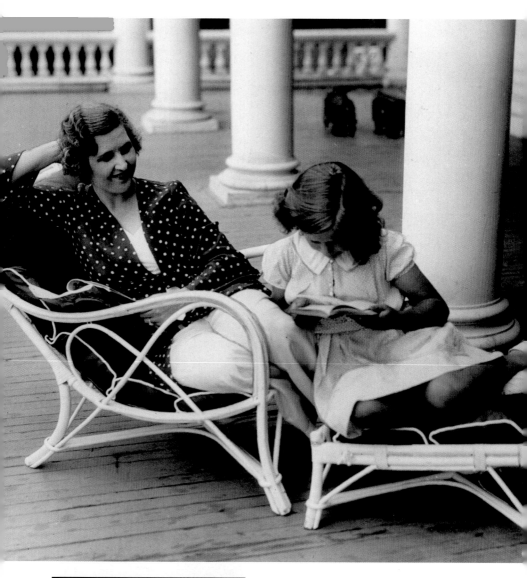

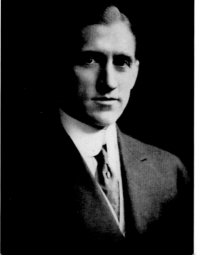

ABOVE: Marguerite Skirvin Adams and her daughter Betty spent summers in Newport with Perle. (Oklahoma Historical Society)

LEFT: Pittsburgh steel magnate George Mesta was nearly twenty years older than his bride. (Collection of Elizabeth Christian and Linda Picasso, Perle's great-nieces)

OPPOSITE: Perle wore her best jewelry when presented to King George and Queen Mary at Buckingham Palace in 1931. (Collection of Elizabeth Christian and Linda Picasso, Perle's great-nieces)

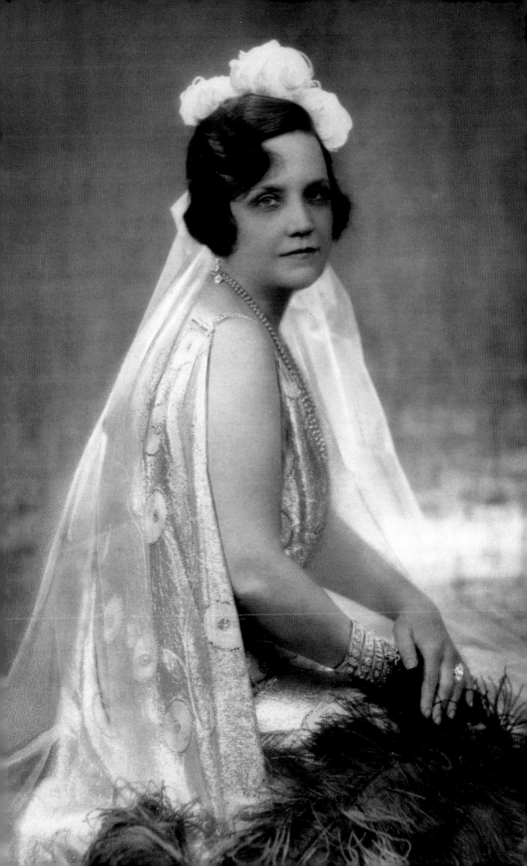

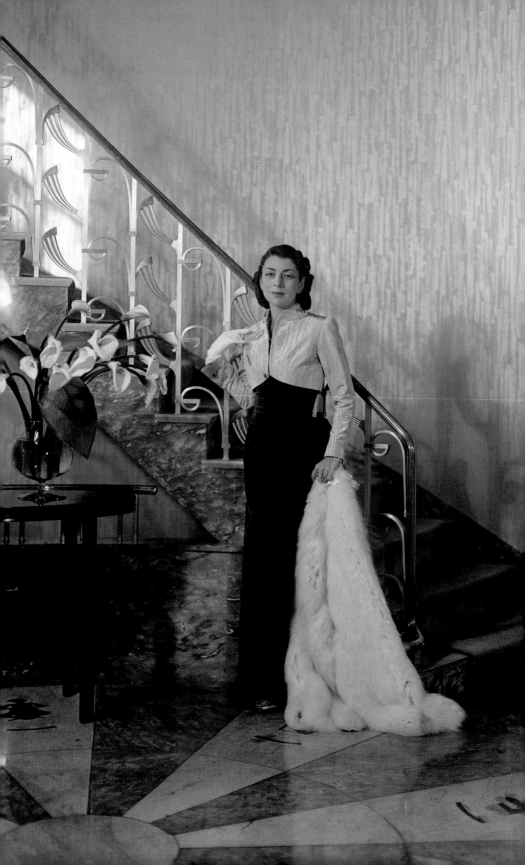

OPPOSITE: Gwen Cafritz, Perle's rival, cut a glamorous figure at her Foxhill Road home. (Library of Congress)

ABOVE: From left, Perle Mesta, First Lady Bess Truman, US treasurer Georgia Neese Clark, and Democratic activists India Edwards and Gladys Tillett. India Edwards pressed Truman to appoint women to top jobs. (Harry S. Truman Presidential Library)

RIGHT: Perle dancing with Supreme Court justice William O. Douglas in 1954. (Lisa Larsen/The LIFE Picture Collection/Shutterstock)

Opposite above: Perle spent every weekend driving around and exploring Luxembourg. (Dmitri Kessel/The LIFE Picture Collection/Shutterstock)

Opposite below: President Harry Truman, co-chairman Wilson Wyatt, and Perle Mesta at the February 24, 1949, Jefferson-Jackson Dinner. Perle raised a record-breaking amount of money. (AP Photo)

Above: Perle doted on Harry Truman's daughter Margaret, showering her with gifts and invitations. Margaret visited Perle in Luxembourg. (Harry S. Truman Presidential Library.)

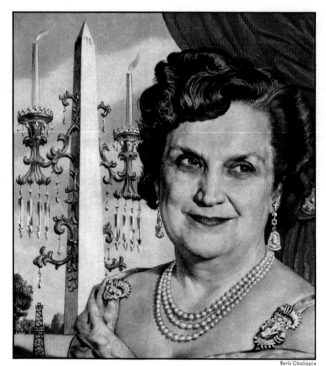

ABOVE: *Time* featured Perle Mesta on the cover of the March 14, 1949, issue. (TIME. © TIME USA LLC. All rights reserved. Used under License)

OPPOSITE: President Eisenhower, arriving at Andrews Air Force base on May 20, 1960, received a hearty greeting from Perle, a friend since the late 1920s. (Courtesy of the Associated Press)

ABOVE: Perle gave a brunch for Lyndon Johnson that attracted five thousand people at the July 1960 Democratic National Convention in Los Angeles. (Thomas D. McAvoy/The Life Picture Collection/Shutterstock)

BELOW: Perle was so upset when LBJ agreed to be JFK's vice president that she backed Richard Nixon in the 1960 presidential election instead. (Hank Walker/The LIFE Picture Collection/Shutterstock)

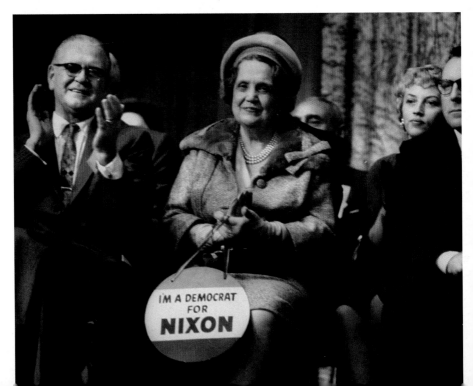

I'M A DEMOCRAT FOR NIXON

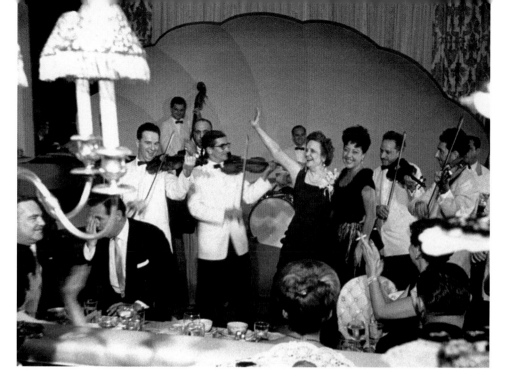

ABOVE: Broadway star and Perle doppelganger Ethel Merman sang at Perle's famous party at the 1952 Chicago Democratic Convention. (Cornell Capa/The Life Picture Collection/Shutterstock)

BELOW: Perle and Mamie Eisenhower, December 19, 1974. (Oklahoma Historical Society)

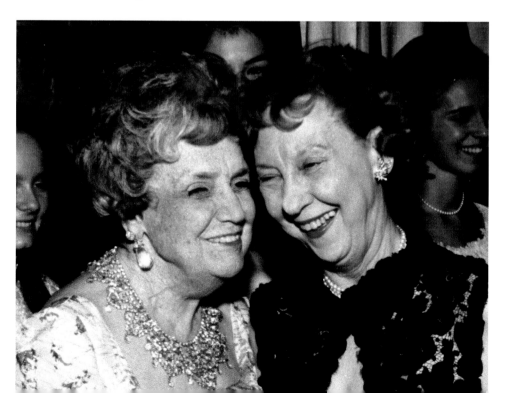

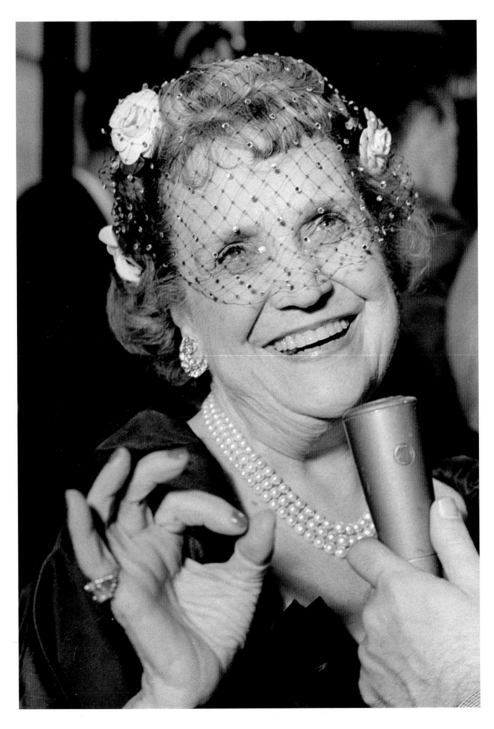

Perle cheerfully gives an interview at a party for Soviet leader Nikita
Khrushchev at the Russian embassy in 1959. (Library of Congress, Prints &
Photographs Division, U.S. News & World Report Magazine Collection)

a pro to work the door: legendary take-no-nonsense William "Fish-bait" Miller, doorkeeper for the House of Representatives, stood with her to greet guests.

Jack Kennedy and his entourage were conspicuously not invited, but delegates supporting Kennedy were welcome since Perle hoped they might change their minds. The dance floor was covered in red carpet, and the décor featured ice sculptures of a kicking donkey. When Lyndon and Lady Bird Johnson arrived with their sixteen-year-old daughter Lynda, the Barney Sorkin orchestra broke into a medley of Texas songs "The Eyes of Texas" and "The Yellow Rose of Texas."

Lady Bird, starved and exhausted from an early-morning start, told a reporter that she was not used to events this big and elegant in Texas: "We go in more for barbecues and fish fries." Her husband added, "I think so much of Perle, I'd like to stay here and visit all day but I have other fish to fry."

Even after the Johnsons left, the crowds kept coming. The hotel staff kept a tally of the kitchen output: 273 gallons of chicken à la king, 13,200 eggs, 750 pounds of bacon, 700 gallons of coffee, 1,400 gallons of fruit juice, and at least 22 cases of whiskey. The party cost Perle more than $35,000, equivalent to $250,000 today. She joked about the expense, saying, "For me, hard times are just around the corner."

Hard times had already arrived for her candidate.

Just that morning, the *Washington Post* had run a story stating the race was over: "Kennedy Victory Seen on First Ballot as Pennsylvanians Spark Stampede." The following night, July 13, Johnson watched the convention proceedings on television in his Biltmore Hotel suite. Kennedy won a smashing victory on the first ballot. He needed 761 votes to win, but wound up with 806 votes, while Johnson got only 411½.

Kennedy and Johnson profoundly disliked each other. As majority leader, Johnson cared deeply about the Senate and felt that Kennedy, who had missed numerous votes, was lazy and too much of a young man in a hurry. Kennedy thought Johnson was getting in the way of

his ambitions. Johnson repeatedly insisted that he wasn't interested in the number two slot, telling journalists a few days earlier that Kennedy should be *his* vice presidential running mate. "The vice presidency is a good place for a young man who needs experience," Johnson said, in a voice dripping with sarcasm.

But in the early morning of July 14, the phone rang in the Johnson suite, and Lady Bird answered. Senator Kennedy asked to talk to her husband. "He's asleep," she replied, but Johnson overheard and got on the phone. Kennedy wanted to discuss the vice presidency and came down to talk.

Both men consulted allies, who argued the pros and the cons of the potential match. "The whole thing is such a crescendo of comings and goings and telephone calls and emotions," Lady Bird recalled in her oral history. "Some of the conferences took place in the bathroom." On the Kennedy side, the hardest sell was Bobby Kennedy, who hated Johnson. But the consensus was that Kennedy-Johnson could be a winning electoral ticket.

Perle was appalled. She was in Johnson's seventh-floor suite when the Texan told his inner circle that he planned to accept Kennedy's offer. Baptist pastor Luther Holcomb witnessed her reaction. "Mrs. Perle Mesta was in there, and I saw her actually walk over and reach and grab Senator Johnson's tie and say, 'Lyndon, you've betrayed me. You've betrayed everything,' and she'd jerk on it. I'm sure that Mrs. Johnson was of great help in that. I remember that she put her arm around her and said, 'Oh, Perle, everything will be alright.' But Mrs. Mesta was pulling that tie and saying, 'You've betrayed everything you've ever stood for.'"

Reporters were waiting outside when Perle left Johnson's suite, and she made no attempt to hide her feelings. "Kennedy isn't good enough to be Johnson's vice president," she bitterly told the *Miami Herald*. Perle wailed to the *San Francisco Examiner*, "I told Lyndon he was doing wrong. I am heartsick about it. I wanted him to be first choice or nothing."

Perle left the building in tears.

Lyndon Johnson's youngest daughter Luci believes that Perle's reaction—grabbing Johnson's tie—was understandable given their relationship. "It doesn't surprise me that she felt she had the liberty to do that," she told me. "They'd been that vulnerable and open to each other. She'd earned that right to feel, 'I invested in you and how can you make this decision?' Of course, a lot of people felt that way and were unhappy with my father."

WHEN THE REPUBLICAN Convention began in Chicago on July 25, Perle was conspicuously in attendance. NBC had hired her to do radio commentaries. "They like to have me because I know so many people and can find them for interviews," she explained. She showed her inexperience by holding a microphone upside down when she tried to interview Bob Hope.

On the eve of the convention, she wrote a feminist opinion essay, aimed at both political parties, that ran in numerous newspapers, with lines such as "Why does the United States lag behind when other countries with brand-new constitutions give women equal rights as a matter of course?"

She added that politicians "would be wise to put on their glasses to discover that women as a whole today want to participate in much more than the floss, fluff and trivia of political gatherings."

In Chicago, Perle lobbied the Republican platform committee to include the Equal Rights Amendment. Unlike her experience at the Democratic convention, this audience was receptive and she won. The GOP platform stated: "Congress should submit a constitutional amendment providing equal rights for women."

Nonetheless, she kept insisting that she remained a Democrat. Her sister Marguerite joined her in Chicago along with Marguerite's dairy farmer son Bill Tyson, who was running as a Republican for a Nevada congressional seat (he lost the primary). Perle told

longtime chronicler Inez Robb, "He is a darling boy but politically misinformed."

Perle was impressed by Nixon's foreign policy credentials. She thought the vice president handled himself well during his 1958 trip to Russia, where he conducted a spontaneous "kitchen cabinet" debate with Nikita Khrushchev while the two toured a display of new American products at a Moscow cultural exchange. Berated by the Soviet leader, Nixon held his own.

In Chicago, Nixon won an almost uncontested first ballot victory to become his party's nominee. He gave a rousing anticommunist speech. "If Mr. Khrushchev says that our grandchildren will live under Communism, I say that his grandchildren will live in freedom."

PERLE COULD HAVE patched up her relationship with Jack and Jackie Kennedy. In terms of her anti-Kennedy rhetoric, she had primarily echoed Lyndon Johnson's criticisms of the senator's youth and his father's wealth. Since LBJ had been forgiven, she would likely have been forgiven too as long as she enthusiastically supported the Kennedy-Johnson ticket. But then she blundered badly.

While she was in Chicago, she gave a disastrous interview to the Associated Press. Using uncharacteristically harsh language, Perle attacked Jackie Kennedy and the Kennedys' friends. Given her friendship with Jackie's mother Janet Auchincloss and her earlier good relationship with Jack Kennedy, her comments came across as bizarre and self-destructive.

What apparently triggered Perle's ire was seeing glowing photographs of Jackie and Jack Kennedy at Cape Cod, dressed in casual summer attire and looking relaxed. The AP reporter wrote that Perle was "in a tizzy."

"Perle is not sold on the ticket. Her problem is that she does not see eye to eye on several matters with Jacqueline Kennedy . . . For example, Mrs. Mesta cites stockings. 'Do you know,' she fumes

indignantly, 'half the time Jacqueline doesn't even wear stockings.' Perle shivers at the prospect of a White House managed by a First Lady from Hyannis Port wearing no stockings and a bandanna on her head.

"Why, do you know, they run around with all sorts of people and they'd invite Joey Bishop, Frank Sinatra and Sammy Davis Jr. to the White House. They're all part of that 'clan.' I don't know what I'm going to do." An accompanying photo showed a radiant Jackie Kennedy in casual slacks and Perle in her finest couture.

At nearly seventy-eight, Perle's words appeared to reflect her deep fear of becoming irrelevant. A woman born in the previous century, a White House visitor since the 1920s, she was used to First Ladies who wouldn't think of being photographed without white gloves. The world was changing at the dawn of the sixties, and Perle was having trouble changing with it.

By attacking Jackie, Perle was committing social suicide. If Jack Kennedy won the election, Perle would be persona non grata at 1600 Pennsylvania Avenue. When Jackie Kennedy was asked about Perle's rude comments, she deftly deferred to Harry Truman's reaction, repeating his statement: "I don't think it is nice or polite to attack the wife of a candidate." With even Truman siding against Perle, the Democratic consensus was that her behavior was inexcusable.

BY LATE AUGUST, Perle appeared to be at war with herself. At a lawn party at American University for female judges, she criticized her favorite candidate. "On the day that the Equal Rights Amendment . . . was called on the floor of the Senate, Senator Johnson was strangely called out" of the room and thus did not vote, Perle announced. Asked why she was criticizing the Democratic vice presidential nominee, she primly replied, "I felt that the women should know about this."

"Are you no longer behind Senator Johnson?" a reporter asked.

"I was," Perle replied.

"Does that mean . . . ?"

"I was when he was running for President. I do not wish to say any more at this time."

The following day, she defiantly turned up at a birthday party for Johnson at the Mayflower Hotel. Johnson was known for his temper and could swear a blue moon but rather than upbraid Perle, he graciously accepted her for who she was, calling out, "Hello, darling, God bless you" and giving her a big kiss.

Perle was already feeling estranged from the Democratic Party, but the tipping point likely came on September 3, when Nixon announced that he was in favor of the Equal Rights Amendment. "This is wonderful," said a startled Alice Paul.

Newspapers ran items predicting two-party Perle's defection, but she remained mum. She scheduled fall events guaranteed to produce a tsunami of RSVPs from Washington's social and political eminences—the last gasp of the Eisenhower era.

First came a party at the Sulgrave Club for the Debutante of the Year, Bonnie Buchanan, daughter of White House protocol chief Wiley Buchanan, who had succeeded Perle in Luxembourg. "I have a memory of standing in the receiving line with Perle," recalls Bonnie Buchanan Matheson. Perle loved the romantic ritual of celebrating young women starting off in life.

Perle's next party honored Wernher von Braun, celebrating the movie based on his life, *I Am at the Stars*. That evening von Braun addressed his history albeit in a lighthearted manner. He said a fellow told him: "You are controversial. The British are sore at you because your V-2s fell on them. The Germans are sore at you, because you left to come to America. And the Americans are sore at you, also the British and the French, and the Germans because you didn't beat the Russians getting a satellite into orbit." In a photo, Perle gazes adoringly at him.

Bob Gray appreciated Perle's mischievous pleasure in putting unlikely people together. "For the wife of Wernher von Braun, she selected as escort the Pentagon official who had been in the news as

the missile scientist's antagonist," he wrote in *McCall's*. "She does her matchmaking with such apparent innocence that it is impossible to avoid the contagion of her enthusiasm." Perle wasn't innocent; she knew exactly what she was doing, trying to facilitate conversations.

WITH LESS THAN three weeks before the presidential election, Perle made her move. On October 18, she announced, via a press release issued by the Republican National Committee, that she supported Richard Nixon. She stressed that her decision came "after much prayerful reflection because I have many affectionate ties with the Democratic Party—but, of course, my country comes first."

She said she had known Nixon since he came to Washington in 1946 as a congressman and her "opportunity to observe him at close hand" made her believe Nixon was the one.

Perle's party switch was sufficiently head-spinning that more than 140 newspapers ran stories about her change of heart. "She is an important political influence," wrote syndicated newspaper columnist Ray Tucker, stating that "her declaration may mean votes for Nixon." Others humorously questioned her future social standing. Fletcher Knebel quipped in his column Potomac Fever: "If Kennedy's elected, the hostess with the mostest will become the ghostest hostess."

Perle had previously agreed to give a party for Allen Drury, tied to the opening of the play based on his novel *Advise and Consent*. On the same day that she endorsed Nixon, she turned her get-together for Drury into a pro-Nixon campaign event, which came as a surprise to the 250 guests. As a party favor, she had postcards printed up with Nixon's picture on one side and, on the other, the words: "I'm for Dick Nixon. How about you?"

Standing with Drury in her drawing room, she handed her Nixon postcard to guests as Nixon campaign manager Leonard Hall beamed nearby. Her butler passed trays of champagne to Democratic senators Albert Gore, Mike Mansfield, and William Fulbright, along with

Supreme Court justice William Douglas, CIA director Allen Dulles, a raft of ambassadors, and the play's cast. The *Washington Post* wrote that Perle's choice of Nixon "has guests buzzing." A very merry Perle was seen at 2 a.m. doing a Spanish dance to the tune of "The Rain in Spain."

Journalist Marie Ridder, who was friendly with the Kennedys, was not surprised that the three of them didn't get along but found it astonishing that Perle jumped ship. "Jack and Perle would not have been on the same page," Ridder told me. "Imagine her supporting Nixon; I can't believe it. She was so not the kind of person Jack and Jackie would have enjoyed. She was frumpy; she was self-serving. I never heard people say she brought interesting conversation to the table. Her style of entertaining was not theirs—they did small groups, not large groups and mediocre food."

Perle made a campaign speaking swing on behalf of Nixon, starting in Texas and heading to California, underwriting her own expenses. "I am still a Democrat—but for Nixon," she insisted, and had buttons made with the phrase. While she was on the road, Jack Kennedy came out in favor of the Equal Rights Amendment. Republicans jumped on the belated gesture, calling it a "masterpiece of hindsight." For Perle, it was too little, too late.

Perle had always been an accentuate-the-positive-eliminate-the-negative kind of person. But she ripped into Kennedy at every opportunity, mocking him as an immature "boy" and saying he wasn't strong enough to stand up to the Soviets. Taking cues from Nixon's attacks, Perle tried catchy lines, riffing off stories about the photogenic Kennedy family: "I want a man, not a clan, in the White House."

Speaking at a shopping mall in Palo Alto on November 1, she claimed Joe Kennedy was trying to use his $300 million fortune to buy the election. "Joe Kennedy can't buy America," she said, adding that he "would rather have his boy be president than anything else in the world. He is spending any amount on it." In Sacramento, she told a group of GOP women that she feared for the country's future. "I really and sincerely feel that if the American people put Jack Kennedy

in the White House, inside of a year we'll be at war. I think Khrushchev would love to see Senator Kennedy in the White House because he knows he can handle Senator Kennedy."

Richard Nixon welcomed Perle's help, embracing her gratefully at a large rally in Los Angeles.

Perle's support for Nixon caused agita among her friends. Columnist Drew Pearson noted: "Harry Truman used some of his famous four letter words in telling friends what he thought of Perle Mesta, the lady whom he made famous by making her minister to Luxembourg, who has now deserted to the Republicans."

On election day, November 8, Perle bought an ad in the *New York Daily News* with the headline "Why Democratic Women Vote for Nixon-Lodge." In weirdly capitalized copy, she made two points: "We Don't Want War!" and "We Don't Want Money to Buy Less." The copy: "Candidate Kennedy declared 'We'll go on the move' and that he favors actively supporting armed revolt against Cuba's Castro. This ill-tempered zeal could draw us all Into War, perhaps a Big War . . . Do you realize who will pay the bills for all the increased spending threatened by Kennedy? We, the people, that's who! THE COMMUNISTS CAN WIN without firing a shot, IF we allow the Government to spend us all into Bankruptcy."

Trying to convert fellow Democrats, Perle's ad stated that they need not worry about becoming outcasts if they cast a ballot for Nixon. "In America Your Vote is Still Secret. No One Knows How You Vote."

Perle spent election night at Nixon's headquarters at the Ambassador Hotel in Los Angeles. An exhausted Nixon flew in early that morning after a grueling final thirty-six hours of campaigning. He watched the vote tallies on television in his suite. Perle and his supporters grew grim as the numbers were posted on a tote board in the ballroom. Perle got a laugh when she told people, "I've left the Democratic Party. What can I do now? Will you take me in?"

At 12:23 a.m. West Coast time—3:23 a.m. on the East Coast—Nixon came down and spoke to supporters. "Words are really

inadequate at times like this . . . We've never had a more wonderful group of people in all of the 50 states than have been in our campaign . . . As I look at the board here, while there are still some results still to come in, if the present trend continues, Senator Kennedy will be the next President of the United States."

The final tally was exceptionally close: Kennedy won 49.7 percent to Nixon's 49.5 percent of the popular vote. But the breakdown looked different when it came to electoral votes: Kennedy accumulated more than 300, 31 more than needed, while Nixon had 219.

Perle flew to Washington to attend the International Ball on November 10, a fundraiser for Children's Hospital. Janet Auchincloss, Jackie Kennedy's mother, spent the night accepting congratulations, and repeating, "It's rather awe-inspiring." Perle tried to pretend that she was okay with being on the losing side, telling Betty Beale, "It's not going to get me down."

She wasn't ready to throw in the towel. She flew to San Francisco to join a group of GOP women pushing for a recount. Perle told the *San Francisco Examiner* that she had telephoned at least two hundred friends in Texas, urging them to press for a recount because of "irregularities."

The recount effort ended on December 19 when the Electoral College certified Kennedy as the thirty-fifth president of the United States.

The year ended for Perle on a final indignity. Social chronicler Cleveland Amory published a book titled *Who Killed Society?* that listed Perle as a culprit, under the category "manslaughter in the second degree." In Amory's eyes, her sin was being a self-promoter: "Probably the most relentless Publi-cietest on the Washington scene is the famed Perle Mesta." He concluded that Perle was "anathema" to true aristocratic society.

And now, she had become anathema to many of her Democratic friends.

A House Is Not a Home

DON'T LET THE door hit you on the way out. A few weeks after the election, Perle was asked whether she planned to sell her house and leave Washington. The implication was that with the Kennedys in the White House, no one would want to go to her home—so she might as well just disappear.

"That's the most ridiculous statement I have ever heard," Perle responded in late November to the first reporter who inquired when she was calling the moving van. In early February, Hedda Hopper wrote that Perle was putting Les Ormes on the market, and a few days later ran Perle's response. "Hedda, you done me wrong—it's not for sale. I love my home."

Still, the rumors persisted. Perle reiterated again in late February that she was staying put, telling Hollywood columnist Louella Parsons, "I never had any intention of selling my house. I didn't vote for President Kennedy but he's our President now and I'd feel very unpatriotic if I didn't back him."

Upon Perle's return to Washington in mid-March, Texas native Hope Ridings Miller, former editor of *Diplomat* magazine, gave a party for her at the Sulgrave Club and invited prominent Texans.

Proving he did not hold a grudge against Perle for endorsing Richard Nixon, Vice President Lyndon Johnson turned up and twirled Perle around the dance floor.

Lynda Johnson Robb believes her mother Lady Bird Johnson convinced her husband to get over his annoyance that Perle backed Nixon. "Mother was the social glue," she says, adding that Lady Bird likely told LBJ to go easy on Perle since she had pushed so hard for his presidential nomination. "Perle was for you when other people weren't for you, she did that."

Years later, in an oral history for the LBJ Library, Perle said, "Although I didn't work for him, I loved him. He will sputter at you. But you know he'll forgive you." She believed Johnson appreciated her honesty. "I don't think anybody likes anyone that's very subservient and always agrees with you . . . I'm sure Johnson doesn't like it."

Sam Rayburn was initially unwilling to let bygones be bygones. "Speaker Sam Rayburn bumped into party giver Perle Mesta, the Democratic renegade, at a social function the other day," wrote columnist Drew Pearson, repeating Rayburn's words: "I didn't expect to speak to you again, but now I find myself in a position where I have to." Rayburn eventually decided that friendship trumped politics. Seeing her at another party, he told her, "I ought to be mad at you— but I'm not" and gave her a kiss.

THAT SPRING, DESPITE Perle's fervent denials, Les Ormes was put up for sale. Perle never publicly revealed what changed, allowing people to think what they liked. The real reason? Serious money trouble. Her nephew Bill Tyson's Nevada dairy farm had been a disastrous failure with repercussions for his entire family. A dreamer and gambler, he could not pay suppliers and was forced to file for bankruptcy. Marguerite and George Tyson lost their life savings.

As executor of Marguerite's trust, Perle signed promissory notes guaranteeing credit for Bill Tyson's expenses. Now she was being sued

for more than $428,000 (nearly $4.4 million today) in unpaid bills for everything from milk cartons to truck rentals.

"I will never forget the day when I called my mother and was told that the phone was shut off," recalled Betty Ellis in her memoir. "I called my Uncle William in Oklahoma City and he told me that the James Canyon Ranch had gone bankrupt and everything had to be sold on the ranch quickly." Although Les Ormes was virtually always identified in the newspapers as Perle's home, her sister and brother-in-law owned the property.

For Perle, it was wrenching to contemplate leaving. She loved the terraced gardens, a blue and white paradise with camellias, periwinkle creepers, and blue hyacinths. It made her happy to wake up and look out her second-floor window at the trees. The rooms were alive with memories of famous faces and whispered conversations and 3 a.m. merriment.

Could she have bought the place? Although journalists frequently guessed at her net worth—$50 million was the latest number—no sources for estimates were ever listed. Years of excessive spending had eaten into Perle's principal.

She didn't want the cherished home to go to just anyone. Perle came up with perfect potential buyers: a family of four currently squashed in a small two-story brick house who needed more room to entertain in keeping with the husband's new government job.

She called Lyndon Johnson.

"I got a hold of him and told him how he needed it and sold it to him," Perle recalled in an oral history. "He needed it for his girls. He needed it for himself, and he should have a house like that." The purchase price was estimated to be roughly $200,000. Given how much money Marguerite had put into decorating, the Johnsons likely got a good deal.

Although the Johnsons had assets, their money was tied up in their Texas ranch and a radio station. "For the first time, we decided we would just spend everything we could afford and more," Lady

Bird Johnson recalled in her oral history, "because we had lived quite frugally, because it was always one more tractor we needed to buy or we needed to put up a tower for a radio station, or we needed a few more acres of land. But this time we decided we would spend it on living and so we bought a beautiful house. When Lyndon did anything, he went whole hog, so he was all for it and wanted me to get good furniture, good everything."

Luci Baines Johnson, thirteen at the time, remembers her parents' conversations about the purchase. "We came from a very humble dwelling in Washington," she told me. "They were trying to stretch to buy it because they knew the one thing they could do for President and Mrs. Kennedy was maybe take some of the entertainment load off. Mrs. Kennedy had just had a baby in November."

To downsize, Perle and Marguerite sold antique furniture and possessions. Accompanying her mother to look at the cast-offs, Luci fell in love with the Steinway piano. "I thought it was a magnificent piece and it sparked my attention and I was hopeful," she said, adding, "I was taking five years of music and was without a doubt the worst piano student my teacher ever had." Perle was sympathetic to the teenager's longing and offered a low price. "She didn't have a place to take this and wanted it to have a home that was worthy of it, to be loved and used. She was trying so much to convince my mother." Lady Bird Johnson turned Perle down. "My mother said, 'Mrs. Mesta you are so gracious and I wish I could afford it but I can't and nobody in my family plays the piano except for Luci and she doesn't play that well.'"

On the day the Johnsons moved in, Luci recalls, "I was giddy, running from room to room. I ran into the salon and there was a piano with a big red bow on it." Perle had left a note on it for Lady Bird: 'You and Luci win.'" Luci and her mother were delighted. "When she saw my look and that bow, a little tear came to her eye and we had a big hug."

The Johnsons changed the name of the house from Les Ormes to its English equivalent, The Elms. "Every time it's called a château in

print, I lose 50,000 votes," Johnson joked. The couple put in a swimming pool, piped Muzak through the house, and hung paintings by Texas artists. Marie Ridder, who worked as a liaison for Lady Bird, recalls, "It was neo-French, it was a little gaudy when Mrs. Mesta was there—the chandeliers and the gold—toned down considerably by Lady Bird."

Once the sale was announced in late May 1961, Perle needed a new place to live, along with her sister and brother-in-law. She would be supporting them from now on. "Aunt Perle took care of her sister," says Elizabeth Christian, Perle's great-niece. "She made it seem like the most natural thing in the world."

New York developer Robert Dowling was building a new luxury apartment building at 3900 Watson Place NW, just north of Georgetown. He thought Perle could add prestige and offered her reduced rent. Perle asked to combine four apartments on the eighth floor. It took six months of construction and decorating before the trio could move in.

AFTER BACKING A losing presidential candidate plus losing her house, Perle needed an emotional lift. She got it in the form of an honor from a nonsectarian group, Religious Heritage of America, which named her Church Woman of the Year in June 1961. She was the first Christian Scientist to receive the award.

In mentioning the award, *Newsweek* noted that Perle was currently leading a party-free life and focusing on religion. "Away from Washington's social whirl, celebrated hostess Perle Mesta spends much of time reading Bible verses, meditating, and otherwise following the recommendations of the late Mary Baker Eddy," *Newsweek* wrote. "She attends services regularly at Washington's Sixth Church of Christ Scientist (which meets over a drugstore on Wisconsin Avenue)."

For Perle and her family members, Christian Science and the healing power of prayer were fundamental beliefs. But that summer,

prayer—plus medical intervention—was not enough to conquer a serious illness. Her nephew Bill Tyson's second wife, Elizabeth "Jerry" Merchant Tyson, was diagnosed with advanced breast cancer at the age of thirty-one and died at the end of the summer.

Her survivors included three children from her first marriage and a three-year-old from her marriage to Bill Tyson. The three older children were taken in by her family members, and Tyson was left as the single parent of toddler Elizabeth "Lizzie" Skirvin Tyson. Perle was emotionally attached to Lizzie, and a few years later, when her irresponsible nephew asked for help, Perle became involved with her upbringing.

IN THE FALL of 1961, waiting for her new apartment to be ready, Perle headed to New York, staying at the Gotham Hotel for several months. She sat in on meetings of the United Nations General Assembly, an education in Cold War tensions in the wake of the Soviet erection of the Berlin Wall to stop refugees from fleeing East Germany.

Her time in New York was interrupted by sad news—Sam Rayburn was diagnosed with pancreatic cancer. Perle flew to Dallas in October to say goodbye, bringing along a bouquet that was so enormous the airline gave her an extra seat. She tried to be upbeat, telling people, "He'll be around a long time."

But on November 16, Rayburn died in his sleep at the age of seventy-nine. Elected to Congress in 1912, he had been one of Perle's closest political friends for decades. She had helped alleviate his loneliness with her frequent invitations; he beamed whenever he saw her. At least they had made up their political differences before the end.

EARL WILSON BROKE the news in a December column: "Perle Mesta plotting a big comeback as Washington's hostess with the mostest."

Determined to prove that she could do just fine in the capital without the Kennedys' imprimatur, Perle was orchestrating a splashy return. Marguerite had taken the new apartment's raw space and, with the help of a New York decorator and an architect, created a seven-bedroom aerie. The walls had been painted soft pastel colors, and the pale green dining room could seat thirty-two people. The large outdoor terrace off the living room featured views of the Washington Monument and Potomac River.

Perle's bedroom sported pale silver, gray, and blue tones, with a brocade chaise lounge and six closets for her enormous collection of Marusia gowns. Her bedroom view: the handsome stone Neo-Gothic Washington Cathedral. The apartment included quarters for butler Garner Camper, his multitalented wife Edna, and chauffeur Terry Akinaga.

To get ready for her return to Washington, Perle spent eight days at the Elizabeth Arden Maine Chance salon in Phoenix as the guest of the owner. Arriving at her new abode in January, Perle issued invitations to one thousand of the city's movers and shakers for three consecutive February nights. By doing it this way, floral arrangements would last for all three nights, and if guests were unavailable on a specific evening, they could come a different night. She invited reporters to cover her comeback. The *Washington Post* ran a feature about her apartment, and the *Washington Star* published several party stories.

Festive music greeted the guests on opening night—the band was instructed to play Chubby Checker's "The Twist" as well as waltzes. Perle's favorite dance partner Bob Gray came, as well as India Edwards and Democratic national chair John Bailey. "On Friday, there was the fun of seeing the lovely new apartment with its magnificent views of the city and welcoming the hostess back," wrote Lee Walsh in the *Star*. The most photographed guest: Arizona Republican senator Barry Goldwater, considered a likely potential 1964 GOP presidential candidate. Given Perle's reputation as a Democrat, she joked with

him about being seen together, saying, "This will ruin you, won't it?" Goldwater politely replied, "No, indeed, it will get me votes."

The next night, Perle arranged a surprise cameo: her sworn rival, Gwen Cafritz, along with her husband Morris, made a grand entrance. There was an audible gasp from the crowd; flashbulbs popped. The women enjoyed the fuss. Neither explained how their rapprochement had come about, given how long they had professed to loathe one another. "I hate ferocious fighting," Gwen said sweetly. "This is serene. I love serenity, in my clothes, in my dinners, in paintings and in literature." Perle, who made the peace overture with her invitation, simply stated, "I'm not going to have feuds, it's silly." The peace held.

For the final party on Sunday, the special guest of honor was— drum roll—Lyndon and Lady Bird Johnson. He was photographed giving Perle a big Texas hello, holding her hand with a smile on his face. Describing Perle's back-to-back-to-back evenings, Betty Beale wrote, "Perle Mesta returned to Washington with her best foot forward."

Not quite. There were only a few faces from the Kennedy White House: Dr. Janet Travell, the president's personal physician, Secretary of the Army Elvis Stahr, and Postmaster General Edward Day. Eight top employees of *McCall's* magazine, including editor John Carter and publisher Edward Miller, had been included. The magazine, with a huge eight million circulation, had signed Eleanor Roosevelt and Clare Boothe Luce as contributors. Perle had just joined as a monthly columnist. This was lucrative: fees ran up to $3,000 per column, equal to more than $30,000 today. On top of the fee, *McCall's* agreed to help underwrite the costs of many of Perle's parties.

Her first column, Perle Mesta's Party Notebook, ran in April 1962. She listed her favorite guests: the top entry was Mrs. Hugh Auchincloss, aka the mother of the First Lady. "Because she is a beautifully dressed, lovely-looking woman with elegant manners and a ready sense of humor—a delight to look at as well as to talk to," Perle wrote. "Now, with her daughter Jacqueline serving as First Lady,

Mrs. Auchincloss has the added glamour of one connected with the White House and its attractive occupants."

If Perle thought such obvious flattery would open the gates to the White House, she badly misjudged the Kennedy family. Her friend Angier Biddle Duke was now chief of protocol, but even he couldn't end her banishment. Perle seethed, even though she had done this to herself with her nasty remarks.

Unwelcome at the White House, she threw herself into charitable enterprises, such as raising money for the Newspaper Women's Club. Television personality Mike Wallace (later of CBS's *60 Minutes*) praised Perle for selling out the Capitol Theater's 3,426 seats for a movie premiere. "She may well have fed more people in the United States than anyone else except the United States Army only her food is better. She is just about the best fundraiser in the city . . . A warm and gracious lady—Mrs. Perle Mesta!"

The accolades and applause were gratifying after a year in social Siberia. Emboldened, Perle offered to give a dinner for Democratic Senate majority leader Mike Mansfield, and he accepted. It was a typical evening at Perle's with five senators, prominent journalists, plus wives. The most amusing moment: seventy-three-year-old columnist Walter Lippmann's request to learn the twist. "To appropriate piano music, two ladies at once started to teach him, the first showing him how to move his hips in one direction while the second showed him how to move his shoulders in the other direction," Perle wrote in *McCall's*. "It was the best show of the evening, but soon over, Walter decided he would stick to straightening out the news."

Marguerite cohosted Perle's parties but kept a low profile. "You could always be sure that if you went to a party given by Mrs. Mesta . . . that blonde blue-eyed Mrs. Tyson would be somewhere in the background, welcoming guests, making them feel at home or enjoying their sallies," the *Washington Star* noted. "Mrs. Tyson was indispensable to Mrs. Mesta, arranging the details of the endless social whirl."

Perle liked adding new people to the mix, especially extra men. Shortly after young lawyer Aaron Fodiman moved from New York to Washington in 1961 to work at the Federal Trade Commission, he joined the roster. "Once Perle met me, I automatically went on her guest list because I was single, I was available, I was what they wanted to have around. I'm a wealthy well-educated Jewish boy who knows art, opera, music—six foot seven, considered good-looking," recalls Fodiman, now editor and publisher of *Tampa Bay Magazine*. "She was lovely, she reminded me of one of my aunts. She loved dance contests and I was a great dancer, and that's one of the reasons I was invited a lot."

Fodiman was a mere twenty-two, having sped through private schools and NYU law school. Perle would occasionally sit with him at parties and reminisce. "Perle would talk about her upbringing, how her life as a teenager was strange because she didn't live in a house, she lived in her father's hotel. She always talked about being from Oklahoma." He added, "People used to talk about Perle as being a feminist but it seemed to me that Perle was the same as any younger woman who married a wealthy older man and thought she should be running things. Gwen Cafritz was the same."

He looked forward to Perle's invitations. "All the big names turned up. Nobody turned down a party."

To keep up with the younger generation, Perle welcomed the children—and grandchildren—of her friends to her home. And more than a half-century later, several attendees still have fond memories of the experiences. Susan Eisenhower told me that she accompanied her grandmother Mamie to Perle's parties. "Perle was one of the grand dames," she recalled. "These were quite powerful women; they wielded power through their connections and with big entertaining flair. The power comes in who they know and what they know about that person. Perle was a convener, part of the social glue."

Journalist Sandra McElwaine, whose folks knew the hostess, says, "I met her as a teenager and I really liked her. She loved to invite

young people. I remember being in a conga line at one of her parties. She was engaging, so kind. She was always cheerful, she made you laugh."

PERLE'S MONTHLY COLUMNS included tidbits about famous people (First Ladies she had known), travelogues about other cities (*McCall's* sent her to Atlanta and Denver), plus advice on entertaining. She wrote about using her parties to brighten the lives of orphans (a National Zoo day) and children with disabilities (a party at New York's Rusk Institute).

When a *McCall's* reader complimented Perle, saying her columns sounded just like her conversation, she explained that she dictated her columns to a secretary, who transcribed and edited the material, and she approved the final version. *McCall's* editor Lenore Hershey later admitted in her memoir that she was Perle's "ghostwriter," polishing the columns.

Perle hit a sweet spot with readers thanks to her self-deprecating humor and tales of Washington's inner workings. In one amusing column, she tackled the question of how to handle a heavy drinker or overly amorous guests. She insisted her goal was "helping the guest avoid making a fool of himself in the same way I'd wish someone would stop me from folly." If she knew in advance that a guest had a drinking problem, she instructed her staff to keep away with the drinks tray and hand over a cup of coffee.

As for guests on the hunt for a sexual partner, she wrote, "I don't mind a bit of harmless flirting; but I do think people who choose other people's homes as arenas for their extra-marital prowling are being tasteless, not to mention indiscreet." She urged hostesses, if aware of this predilection, to "seat him or her next to someone safe and dull. He or she may not stay there, but at least you tried."

Thanks to her political friendships, Perle had unusual access as a women's magazine columnist. Pennsylvania GOP congressman James

Fulton, a member of the Manned Flight Subcommittee, brought her along to see the Cape Canaveral Space Station in Florida. For a woman born in 1882, this was a phenomenal experience. "I cannot completely describe my emotions as I stood on the open elevator and soared up the rocket's side to the point when I could peer inside," Perle wrote in *McCall's*. "This was so awesome, so undreamed of, that I had to hold on tight against the wind and against the sweeping impact of what I was viewing."

PERLE KEPT TRYING to make amends with the Kennedys, but her repeated efforts fell flat. Perle praised Jackie Kennedy in an April interview with the Associated Press, but her remarks came across as patronizing. AP reporter Jean Sprain Wilson reminded Perle of her provocative campaign criticism of Jackie and asked what she thought now. Here's what the AP wrote:

> "Yes, I was worried," candidly admits the expensively dressed matron with iron gray hair and lively blue eyes. "I've known Jackie ever since she was a little girl and she seemed to me at the time to be so very young, much too young to handle such a tremendous job. But she's matured. She's grown up practically overnight," Mrs. Mesta adds, with a tone of amazement. "Being a First Lady is a great responsibility and I think she's doing a magnificent job. I'm really very pleased."

The Kennedys didn't need Perle. They were reportedly offended, rather than pleased, by her remarks.

Alone Again

The year 1963 started off on a happy note for Perle, with more—yes, more—parties. In January, she gave a belated birthday lunch for Lady Bird Johnson with fifty-five guests. Even the most loyal Kennedy administration acolytes could not turn down a social event honoring the vice president's wife.

The attendees included the wives of four cabinet secretaries (Interior, Agriculture, Commerce, Labor) and of the chairman of the Joint Chiefs of Staff, the undersecretary of state, the postmaster general, and a half dozen congressmen and senators. The icing on the orange birthday cake was the presence of Joan Kennedy, bride of newly elected Senator Ted Kennedy.

A *McCall's* photographer captured the attractive twenty-six-year-old in animated conversation with Perle and Lady Bird. Perle described Joan Kennedy in the magazine: "Somehow, despite the tremendous attention . . . she seems so simple and unassuming that, except for her beautiful manners and feminine poise, she could be any shy young wife, a bit overwhelmed by the Washington pace."

Perle included old friends in the gathering—Marjorie Merriweather Post, Supreme Court justice Fred Vinson's widow Roberta, and former rival Gwen Cafritz. The hostess went with a Texas theme,

decking her apartment with yellow roses and arranging for Lady Bird's friend Scooter Miller to fly tamales and hot sauce up from Texas.

Perle was slowly making inroads with the Kennedy crowd. Her next effort was a February dinner dance for popular columnist and Kennedy intimate Art Buchwald, who had chronicled Perle's life for a decade. "Perle Mesta had so many New Frontier types at her dinner and dance for the Art Buchwalds, she can no longer be said to be OUT," pronounced Betty Beale. The throng included *Chattanooga Times* reporter Charlie Bartlett and his wife Martha, who had introduced Jack Kennedy to Jackie Bouvier, plus the First Lady's press secretary, twenty-four-year-old Pamela Turnure. *Los Angeles Times* columnist Bill Henry announced: "Perle Mesta has emerged as Washington's No. 2 political hostess. Jackie Kennedy, of course, rates No. 1."

That was a social triumph; next came a heartwarming one. On February 13, Perle appeared at the US courthouse in the company of a Black family of four. Frank Cumby, the Luxembourg orphan whose adoption she had finessed, was becoming a naturalized citizen. Now a seventeen-year-old sophomore at Dunbar High School who played the saxophone, Frank told Perle he hoped to become an Army officer like his father, a decorated military intelligence officer about to join the Foreign Service. "I really don't know how I ever overcame all that restrictive red tape," Perle said. "Actually, I do. But I don't think it would be diplomatic to tell."

His parents, Esther and Lieutenant Colonel Bert Cumby Sr., and younger brother Bert Jr. beamed with pride. Perle told the *Baltimore Afro-American*, "He's turned out to be a wonderful boy. Naturally, this is very gratifying and very emotional. He has such terrific parents, they're very fine people."

WITH SONGS LIKE "Blowin' in the Wind" playing on the radio, eighty-year-old Perle was curious about sixties music and asked a friend, publicist Tania Grossinger, to take her to hear folk singers.

"Mrs. Mesta loved that I lived in Greenwich Village and used to enlist me to show her the 'scene,'" wrote Grossinger in her autobiography, *Memoir of an Independent Woman.* "She so enjoyed the folk singers she met on Bleecker Street that she recruited me to put together a hootenanny for her in Washington, DC, which she hosted and arranged for *McCall's* to sponsor."

The audience? Perle decided to introduce student leaders to political leaders. Per her request, the presidents of six local universities, including historically Black Howard, brought top students to Georgetown's 1989 Club. Senators Frank Church, Claiborne Pell, George McGovern, and Maurine Neuberger turned up along with a smattering of congressmen and ambassadors, NASA director James Webb, Civil Rights Commission director Berl Bernhard, and Bill Moyers of the Peace Corps. Perle imported New York City folk singers Bob Gibson, a banjo player who hosted ABC's *Hootenanny*, and Mike Settle, an Oklahoma native who wrote songs for the Kingston Trio.

Joining together to sing songs like "Walk Right In" and "Marching to Pretoria" broke the ice between the two generations. With 120 singing and clapping guests, the restaurant was so crowded that students perched on the floor. "I wish I could get a blood transfusion from Perle," Missouri congressman Bill Hull commented. "Look at her, she's the youngest one here." Perle's "hootenanny" received nationwide attention as columnists quipped that Perle was "joining the youth movement."

In the years ahead, this happy evening would shimmer in Perle's memory with an edge of sadness. This was the last time she entertained with her sister.

Marguerite developed stomach pains a few weeks later. A devoted adherent to Christian Science, she never consulted doctors. Convinced of the power of prayer, she called Christian Science practitioners and asked them to pray with her. The Skirvin sisters were planning to go to Los Angeles, and Perle hopefully told columnist Hedda Hopper that prayer was working and Marguerite appeared to be on the mend.

Instead, she suddenly died at home on March 26, at age sixty-seven. Family members believe her death might have been avoided if she had seen a doctor. "She had an ulcer," recalls her granddaughter Elizabeth (Ellis) Christian. "It was a ridiculous way to die; it didn't have to happen."

Marguerite's life was abbreviated in obituaries. Even the leading Oklahoma newspaper, the *Daily Oklahoman*, failed to mention her successful career as an actress in silent movies and Broadway plays. Described in 1917 as "a young woman of much talent and rare beauty," headlines now referred to her as "Perle Mesta Kin."

The *Washington Star*'s Lee Walsh wrote, "Publicity surrounded her more famous sister, the ebullient outgoing Perle, but it was Mrs. Tyson who always backed up plans for the dinners, luncheons and balls which Mrs. Mesta gave . . . Those who knew Mrs. Tyson remember her as a beautiful quiet-voiced woman who loved nothing better than watching her sister preside at a party but who also was a personality in her own right."

Perle was devastated. Condolence letters and telegrams poured in from near and far. So much of Perle's life had been shared with Marguerite—their childhood, their travels during Marguerite's acting career, sharing homes in New York City, Newport, Luxembourg, and Washington. They were the keepers of each other's memories and secrets. Now, Marguerite was gone and her husband George Tyson was in failing health; he would die six months later in a New Jersey hospital.

When Lyndon and Lady Bird Johnson learned of Marguerite's death, they invited Perle to a barbecue for diplomats on April 30 at their Texas ranch, hoping to buck up her spirits. "He called and said, 'Perle, you get down to the ranch right now,'" she recalled. "He knew how close I was to her. And during dinner, he reached over and touched my arm, ever so often. Never said a word about it. Just touched my arm." Telling this story to a reporter, she stressed, "I can't stand it when people say he's tough. He's really so very tender."

The barbecue was a colorful scene with an unusual mixture of guests—foreign diplomats, Washingtonians, and Texans. LBJ had included his eccentric older cousin Oriole Bailey. "There were Paris frocks and Levi's, you heard Texas twang and clipped British," recalled Richard "Cactus" Pryor, one of Johnson's employees, in an oral history. He remembered hearing Oriole Bailey ask, "What do you do, Mrs. Mesta?"

"Well, I give parties," Mesta said.

"You mean that's all you do?" Mrs. Bailey inquired.

"Yes, that's about all I do," Mesta replied.

"My, that's a funny way to carry on," Cousin Oriole remarked.

THAT SPRING, THE White House and the State Department were wrestling over a sticky protocol issue—involving Perle—for the upcoming state dinner for Luxembourg Grand Duchess Charlotte. The four previous American ambassadors to Luxembourg would normally be invited, but Perle was on Jackie Kennedy's personal boycott list. The First Lady, according to press reports, was angry over Perle's campaign comments and thought Perle had been presumptuous in her *McCall's* column about First Ladies. With no good option, White House and State Department officials decided to ban all four former ambassadors from the White House dinner and invite them instead to a State Department lunch with the duchess.

Offended, Perle turned down the invitation. Her Luxembourg successor under Eisenhower, Wiley Buchanan, refused to attend as well. He told a reporter that he declined the invitation "because of the way the White House treated Perle Mesta. She and I were of different political parties, but she is the one who put Luxembourg on the map for Americans and I reaped a lot of the goodwill that she generated, when I succeeded her there."

* * *

LONELY WITHOUT MARGUERITE, Perle compensated by making sure she scarcely had a free moment. She gave a dinner for houseguest Clare Boothe Luce, organized a *Swan Lake*–inspired benefit for the Washington Ballet Guild, accompanied segregationist South Carolina senator Strom Thurmond to a benefit showing of the Elizabeth Taylor–Richard Burton movie extravaganza *Cleopatra*, and dropped by a farewell party for the Pakistani ambassador.

When Perle ran into reporter Esther Van Wagoner Tufty at a Kingston Trio concert in July, the hostess confessed that she was filling her days "with more and more people to keep from missing Marguerite too much" and the loss had made "going home to the apartment a sad ending to each day."

She got out of town to avoid the pain, traveling for column material. In Manhattan, she gave a party for the wives of the hapless New York Mets at the Regency Hotel, and attended an eleven-inning game (the Mets won). This was one of Perle's rare forays into the sports world, and she was unfamiliar with the characters. Informed that she was about to be introduced to the Mets' infamous manager, she asked, "Who is Casey Stengel?" Stengel was equally unimpressed, referring to her moments after their meeting as "Mrs. What's-Her-Name."

She flew to Puerto Rico on November 21 to host a reception for 1,500 at the new four-hundred-room Americana Hotel, traveling with *McCall's* editor John Mack Carter, magazine writer Lenore Hershey, and their spouses. Perle brought a new black and gold brocade gown trimmed in black fox. "We were all in a festive mood and the red carpet treatment started at the airport," recalled Hershey in her memoir.

The next day, the group went to the Casa Blanca, the home of the head of the Puerto Rican military, where they abruptly heard shocking news. As Perle recalled, "As we went in, they said, 'Kennedy has been shot!'"

Hershey described the scene. "The soldiers were down in the courtyard listening to a portable radio, and we finally heard the news

in Spanish. I will never forget the scene as we stood in the dark mahogany dining room, overlooking the Morro Castle entrance to San Juan Bay, with a bleak shipwreck symbolically foundering in the distance."

Perle, immediately aware of the repercussions, blurted out, "I always knew it. I always said Johnson would be President some day."

Hershey's reaction: "It was not exactly tasteful and I could have throttled her. But that was Perle."

The group immediately left Puerto Rico. Perle recalled, "I flew right to New York and I went to bed, I was there the whole time because I had a terrible cold." Perle watched the sad proceedings on television in a hotel room.

In Washington, crowds gathered in front of her old house to see the newly sworn-in president, who was remaining at The Elms until Jackie Kennedy could move out of the White House. Luci Baines Johnson recalls those painful days. "When you have flashbacks of memories, you remember the nitty-gritty details even if you can't remember what you had for lunch," she says. She overheard her parents arguing about picking a moving date. LBJ insisted on December 7; his wife did not want to leave on the anniversary of another traumatic day in America, the bombing of Pearl Harbor.

"This was a disagreement with raised voices . . . I put my ear to the door . . . we weren't going to be in that house anymore, it now had a date and it now had a time, and that had cornered a large part of my mother's heart for devastating reasons," she recalls. "The beginning of our tenure in the presidency was just too much to bear when my mother seemed to be able to bear everything. She loved The Elms . . . and that was gone."

THE NATION WAS in mourning. The sight of little John Kennedy saluting his father's casket was seared into memory. Journalists needed something forward thinking to write about—an easy topic was predicting Washington life under President Johnson.

A mere six days after President Kennedy's funeral, the first newspaper items appeared about Perle's social status. "Everybody keep their sights on Mrs. Mesta," wrote syndicated columnist Suzy Knickerbocker on December 1. "She is a great friend of our new president and her social star, which had been dimmed, is about to take on new luster." Betty Beale, on the same day, wrote: "Perle Mesta, who didn't set her foot in the White House in three years, will probably do so now."

Perle received so many requests for comment that she finally spoke with syndicated political columnist Robert Boyd. She diplomatically refused to discuss the Kennedys and used the opportunity to praise the new president. "I'm one of Lyndon's real true admirers. He has been so marvelous all his life—I just think he can do no wrong. I was very cross when he took the Vice presidency. But he was right and I was wrong." The article ran in dozens of newspapers with headlines such as "Years of Exile Over: Perle Mesta Back in Action."

On January 8, 1964, President Johnson asked the White House operator to place a call to Perle, according to the logs in the LBJ Presidential Library. When the Johnsons gave their first state dinner for Italian president Antonio Segni on January 14, Perle made her triumphant return to the White House. As Lady Bird Johnson wrote in her diary, "It gave me a lot of pleasure to see Perle Mesta, looking stunning, coming down the line with my friends Scooter and Dale Miller."

The Johnsons used the guest list to reward old friends and strengthen relationships with political allies. Perle was singled out for special attention. *Washington Post* columnist Arthur Hoppe weighed in: "Ah, there's nothing that brings a lump to your throat like seeing a forgotten has-been, game to the last, stage a smashing comeback. I mean, of course, Perle Mesta."

PERLE'S HOME HAD been quiet in the wake of Marguerite's death, but suddenly there was childish laughter in the large apartment. Her five-year-old great-niece Lizzie Tyson had moved in.

The little girl had been through a difficult time in the two years since her mother's death. Perle's nephew Bill Tyson had raced into a third marriage a mere seven months after his second wife's funeral. His new bride, divorced San Francisco socialite Nanette Holmes Osgood, had two children from her previous marriage and did not welcome Lizzie to the mix.

Her cousin Elizabeth Christian heard stories from Lizzie about her difficult childhood. "She was shuffled around; I felt sorry for her," Christian says. "One of Nanette's children was very mean to her, locked her into the attic for hours. Nanette wasn't very nice to her either." Lizzie was temporarily shipped off to live with another relative, and finally Perle stepped in and said, "Send her over here, I'll take care of her."

As much as she loved the little girl, Perle was not equipped, in her eighties, to take on a parental role. She handed child-rearing responsibilities to her staff. "Aunt Perle really didn't do anything like being a mother to her," Elizabeth Christian says. "I doubt whether Aunt Perle ever attended any events at her school. Lizzie didn't have any friends that came over when she lived there. Her best friends were Edna and Garner, who worked for Perle."

Lizzie Tyson was ill with cancer when I wrote to request an interview in the summer of 2019, and she suggested that I send her questions since she was too tired to talk by phone. I did, and on July 12, she replied by email, saying my note had brought back fond memories. She confirmed her cousin's comments, writing about sharing Perle's household with "Edna and Garner Camper and Terry Akinaga (household engineer, butler and chauffeur respectively); my best friends."

"Pleasantly reliving memories of Aunt Perle, living with her . . . has been a precious investment of time. Getting completed answers back to you will take more time than I anticipated because a few sentences here and there doesn't capture life and the wonderful dynamics of it while living with my precious aunt. This is a wonderful travel back in time with me for one of the best times of my life."

Alas, the former pediatric nurse had less time left to live than she expected. Her cancer accelerated and she died at age sixty-one, on August 19, 2019, in Denison, Texas.

Elizabeth Christian passed along Lizzie's stories. "She thought Aunt Perle's apartment was very fancy, very elegant; it looked like Marie Antoinette's living room. Lizzie remembers Aunt Perle doing her Christian Science reading every morning. She said that Perle never dwelled on the negative, she was always planning the next event, it was exciting for her to put people together."

When the *Daily Oklahoman* published a profile of Perle on February 16, 1964, the hostess affectionately mentioned that six-year-old "Billy's child" was living with her. When the girl expressed an interest in art, Perle hired an artist to come to the house to give her lessons. The ne'er-do-well Bill Tyson's third marriage did not last. Even after that divorce, when he could have brought his daughter to live with him, Lizzie remained with Perle in the interest of stability.

Perle's friend Hope Ridings Miller introduced Bill Tyson to the woman who would become his fourth wife, Patti Birge, a Texan then working as a press secretary to Texas congressman Joe Poole. "Bill was an adorable fellow but you couldn't anticipate what he would do next," Birge told me. She married Tyson in 1965 and eventually divorced him. "Perle was very, very fond of him. He had a great sense of humor and she did too, and they always had a wonderful time together. Perle loved Lizzie very dearly, she was an important part of her life. Lizzie would visit us on weekends, she had a governess."

She adds, "Perle was very active, very busy, it took a lot of time and energy to live that socially active life. Both Bill and Lizzie had this very positive and outlook on life. I think Perle always had that feeling. I admired her."

Perle indulged her nephew, picking up expenses. "One night we were at dinner at a restaurant," Birge recalled. "I guess he was getting a handkerchief out of his pocket and Perle [thinking he was

reaching for his wallet] said, "No, no, I'll take care of it." And he said, "Have no fear."

GWEN AND MORRIS Cafritz were at the Homestead resort in Hot Springs, Virginia, in July when Morris complained of feeling ill and left the dance floor. He was found a few minutes later in an adjoining room, dying of a heart attack at age seventy-seven. Praised in obituaries as a developer who changed the face of Washington and built a $23 million empire, he had given millions to charity. A low-key man who doted on his beautiful wife, he bankrolled her social ascent in Washington. With their three sons now long grown, she would be alone in her large estate, other than the help.

Gwen was not the only Washington hostess now on her own. That spring, the city was alive with gossip about another change in the local hierarchy. Marjorie Merriweather Post divorced her fourth husband, Pittsburgh businessman Herbert May. The reason did not become public for many years; blackmailers had sent photos of him cavorting with naked men at Mar-a-Lago.

Both Gwen Cafritz and Marjorie Merriweather Post led quiet lives for several months but then reemerged doing what they enjoyed the most: giving parties. Perle turned up at both of their homes to show her support. Like Gwen, she too had lost her husband to a sudden heart attack, and she had been living an independent life for many years—she knew it could be done.

WITH THE AUGUST Democratic presidential convention scheduled at down-on-its-heels Atlantic City, Perle asked her frequent escort, Philadelphia diabetes doctor Tony Sindoni, to help find a suitable rental property. As he was driving with her down Atlantic Avenue in the suburb of Ventnor, she spotted a spacious and gracious white

wedding cake of a house on a corner lot. "That's the kind of place I would like," Perle announced. The three-story stone house was not for rent, but Sindoni explained that he could make that happen. The fifteen-room house belonged to his stockbroker brother Frank, who had just spent two years renovating the 1923 abode.

Only a ten-minute drive from Convention Hall, this mansion with seven bathrooms and an outdoor patio could accommodate the two hundred guests that Perle planned to invite each night. She booked the ballroom at the Claridge Hotel for a 750-person blowout on the last night of the convention. She was going all the way with LBJ, outdoing her previous convention parties.

Unlike the suspense of the 1960 Democratic convention, there was no doubt about the party's presidential nominee. Johnson would be up against Arizona senator Barry Goldwater, an archconservative, isolationist, and fervent anticommunist, chosen as the GOP presidential contender at his party's San Francisco convention. He had voted against Lyndon Johnson's landmark civil rights bill, which outlawed segregation in schools, restaurants, hotels, and theaters and banned job discrimination, which became the law on July 2, 1964. Reverend Martin Luther King Jr.'s reaction to Goldwater's selection as the GOP nominee: "While not himself a racist, Mr. Goldwater gives aid and comfort to racists."

That August, as Perle prepared to open up her Atlantic City rental for parties, neighbors across the street erected a large Goldwater sign in protest. Goldwater had been a guest at Perle's parties, but she opposed him now.

"Personally, Senator Goldwater's a very charming man," she told longtime chronicler Inez Robb in an interview in Atlantic City. "But we can't go back to the horse-and-buggy days, can we? I simply don't believe in what Senator Goldwater stands for. For example, President Johnson is dedicated to the cause of civil rights. And I am dedicated to them too, although you may think this sounds strange from someone who grew up in Oklahoma."

Perle continued, pouring out her thoughts. "If the Negroes had been justly and generously treated in the past, there wouldn't be any trouble today. God loves us all—black, white, red and yellow." Robb asked whether Perle's parties would be integrated—would civil rights leaders attend? "Of course," says Perle. "I've invited all of them."

Civil rights remained an omnipresent topic. James Chaney, Andrew Goodman, and Michael Schwerner, three civil rights activists who had volunteered in Mississippi's Freedom Summer to register Black voters, were abducted and murdered; their bodies were discovered on August 4. The segregated state of Mississippi had chosen an all-white delegation to attend the Democratic convention. The Black Mississippi Freedom Democrats, led by activists Fannie Lou Hamer and Aaron Henry, arrived in Atlantic City demanding to be seated instead of the official lily-white group.

Perle's Black butler, Garner Camper, was startled when he opened the door of her rented mansion to several men who asked whether Perle employed Negroes. He explained that there were three others in addition to him, and inquired, "Why do you ask?" The men identified themselves as members of the Congress for Racial Equality (CORE), a civil rights group that was pressing for more jobs for Blacks.

Perle had already hired Black musicians for her parties. *New Pittsburgh Courier* columnist Major Flock announced that Pearl Bailey was being paid a whopping $5,000 to perform at Perle Mesta's Claridge Hotel party. Perle had also signed up society orchestra leader Lester Lanin and crooner Eddie Fisher.

The scene at Perle's mansion resembled a red carpet Hollywood opening on the three nights when she held court. She had added a rock garden, waterfall, and orchids creeping up the house. TV crews set up cameras and microphones outside and inside to capture the pandemonium. "It was hard to tell at the Mesta hoedown who had the best time, the hostess, the guests or the neighbors," wrote *New York Post* reporter Lael Scott. "Perle didn't disappoint them either. She came out on her own front steps, wearing a baby-blue sequined

dress, to wave and smile, at the hundreds who jammed the sidewalk and the street."

Perle hired minibuses, labeled "Perle's Party Line," to take guests to and from the convention center. Scores of famous visitors dropped by including *Hello, Dolly!* Broadway star Carol Channing, scheduled to sing a version with new lyrics, "Hello Lyndon," at the convention.

"As usual, I worked for the entire week behind the scenes," wrote Lenore Hershey in her memoir. "There were 200 guests a night, press, politicos, celebrity volunteers. Muriel Humphrey, wife of the man Johnson was to select as his Vice President, was cohost on one of the evenings." Given Hershey's involvement, *McCall's* likely paid for Perle's parties.

In the Atlantic City convention hall, the action was heavy on emotion. When a memorial film honoring John Kennedy played, Bobby Kennedy stood speechless on the podium for sixteen minutes as wave after wave of applause filled the hall. The emotion also came from Fannie Lou Hamer's speech, describing being beaten as she tried to register to vote. Only two Black members of the Mississippi Freedom Democrats were seated as delegates. But the Democrats agreed from now on to bar states from using racial discrimination in selecting convention delegates, a fundamental change.

For her Claridge Hotel party, Perle decked the ballroom with five thousand red carnations; Eddie Fisher sang such songs as "How Can We Wait until November." The convention ran until midnight, and there were rival events afterward. "So one finally tore over to Perle's party at the Claridge and wished one had gotten there much sooner," wrote Betty Beale. "It was cheerful, it was gay, it had tables surrounding the dance floor and on the prettily lighted terraces overlooking the ocean, and delectable food and spirits."

An exhausted Perle could have written off political conventions for the foreseeable future. But on September 1, she appeared at the New York State Democratic Convention at Manhattan's 71st Armory,

applauding as Bobby Kennedy was nominated to run for the Senate. Perle was seated in the VIP section with Eunice Shriver, Kennedy's sister. "Robert will make a fine senator," Perle told *New York Times* reporter Martin Arnold. He mischievously asked whether she was there to reconcile with the Kennedy family. Perle went into full denial, insisting, "We never were anything but friendly."

That fall, Perle made campaign appearances on behalf of Lyndon Johnson in Dallas, Arkansas, Pennsylvania, Michigan, and Oklahoma. In Allentown, she made a feminist pitch to Democratic women. "The country isn't ready for a woman president. But President Johnson has done more for women than any other president. He has appointed 50 women to major offices. No other president has ever done a thing like that."

On election night, November 3, Johnson won a decisive victory over Barry Goldwater, with the highest popular vote total ever, more than 43 million votes. Johnson and his family watched the results at the Driskill Hotel in Austin. At 9:06 p.m., when victory was evident, LBJ made the time to call Perle. A few minutes later, Lady Bird called Perle, too. That call was taped and one can listen to the emotional comments on the LBJ Presidential Library website.

PERLE: Isn't it marvelous!

LADY BIRD: Listen, I ran into your footsteps everywhere . . . When I was in Oklahoma, they told me about your being there . . . Weren't you in Arkansas, too?

PERLE: Yes, I was in fifty-two counties.

LADY BIRD: I kept on hearing how you had enthralled everybody and what a hit you had been, and they'd all just been charmed by you, and I can't say thank you enough!

[. . .]

PERLE: Lots of love.

LADY BIRD: Well, lots of love to you, and lots and lots of

thanks. And here's Lynda Bird; she wants to say a word to you.

LYNDA BIRD JOHNSON: Hello!

PERLE: Hello, darling.

LYNDA BIRD: I hope you're as excited about tonight as we are.

PERLE: Oh, I tell you, it's marvelous.

The president put Texas lobbyist Dale Miller in charge of the inaugural arrangements; Miller asked Perle to be the event's protocol adviser. After Johnson made it known that he did not want to wear a tuxedo, Perle insisted that whatever he wanted to do was fine. "He's my boy and I'm for him even if he decides to be sworn in wearing pajamas."

Blame It on the Frug

The Swinging Sixties were a bewildering time for Perle, now an octogenarian. Desperate to appear au courant, she wore wildly inappropriate clothes: a miniskirt, lace tent dresses with fishnet stockings, beaded knee-length slit harem pajamas. Some women of a certain age might have been able to pull it off, but she was not among them. Her fashion-forward efforts were chronicled by *Women's Wear Daily* and other publications with amusement. But she did draw a line. At a charity fashion show, when a reporter teasingly asked whether she would wear the see-through blouses on display, Perle replied, "I'm too old and too fat and besides, I don't approve of them."

She wanted to be relevant and say the right thing, but she was increasingly coming across as out of touch with the times. In May 1965, President Johnson named Howard University constitutional law professor Patricia Harris as the first Black ambassador, sending her to Luxembourg. Perle's reaction was tone-deaf. "I am sure people will like her," Perle said. "When I went to Luxembourg I took my butler and maid, who are colored, and people adored it."

Using the word *colored* and comparing her household help to a distinguished attorney were jaw-dropping gaffes. Harris chose to be gracious. "While shudders ran up and down the State Department,

Mrs. Harris remained unfazed," reported the *International Herald Tribune*. Harris issued a statement: "I'm sure Mrs. Mesta didn't mean anything by it." Perle made amends by giving Harris a going-away tea, inviting the professor's Howard University colleagues.

There were story lines that Washington reporters could not get enough of—such as the enmity between Perle and the Kennedy family. So when Perle and Teddy Kennedy inadvertently scheduled parties on the same June night—with overlapping guest lists—the press covered the brouhaha with glee.

Senate majority leader Mike Mansfield caused the snafu. After Perle sent out invites for her annual dinner in his honor for June 24, he asked to change the date. Perle moved the party to the following night. But Mansfield neglected to check his calendar. If he had done so, he would have realized that he had already been invited to Teddy and Joan Kennedy's party celebrating the wedding anniversary of Bobby and Ethel Kennedy. Two Kennedy brothers versus Perle? The fight was on.

"The society editors, who hadn't had anything to write about in six months, rushed to their typewriters and began filing thousands of words on the confrontation," wrote columnist Art Buchwald, in his satirical sum-up. "The town started choosing sides and the cry heard along Pennsylvania Avenue was Kennedy–Mesta, or fight!"

Reporters lurked, collecting quotes. The Associated Press noted that Wyoming senator Dale McKee looked at the arriving guests at the Kennedys' house and quipped, "Who's ahead, Perle or . . . ?" Minnesota senator Eugene McCarthy, who started the evening at Perle's apartment, joked that he and his wife were going to practice "bi-partyship" and attend both events.

Perle insisted, "The whole thing is most ridiculous. I didn't even know about the Kennedy dance until the day before our parties. I like and admire Joan Kennedy, and Teddy too, and the farthest thing from my mind would be to interfere with a party they were having." The Kennedys did not respond.

The headlines: "New Frontier vs Great Society: Kennedys Outdraw Mesta Fiesta" (*Philadelphia Inquirer*); "Champagne Corks at Twenty Paces" (*Los Angeles Times*).

Perle's fraught relationship with the Kennedy family was too good a story to let drop. When a journalist visited her apartment, he admired her collection of autographed photos of politicians and noted there wasn't a single picture of President Kennedy. "My star went down in Washington when Jack Kennedy's went up," Perle replied. "They never invited me to the White House and I've been invited by every President since Wilson." She insisted, "But I'm not bitter about it."

Yet her rage continued to surface in unpredictable ways and times. She had a standard paid speech about First Ladies, but Perle abruptly veered way off message in a luncheon talk in Saint Joseph, Missouri. "When people get into the White House, it makes a different woman out of them," she said. "They change."

Then she pointedly referred to a recent occupant of 1600 Pennsylvania Avenue, a First Lady she declined to name. Perle's startling comment: "Nobody ever said she was beautiful before she got to the White House. She just had big feet. Now she's a raving beauty." To emphasize her message, she added, "I'm not talking about Mrs. Johnson."

As *Saint Joseph News-Press* reporter Robert Slater wrote, "It's unlikely anyone in the audience failed to assume Mrs. Mesta was talking about Jackie Kennedy."

THE HOSTESS REMAINED so busy—giving a dinner for Vice President Hubert Humphrey and a gala for the American Newspaper Women's Club—that she hired a social secretary. Sophia Fleischer, who had previously worked for Supreme Court justice Arthur Goldberg's wife Dorothy, relished the job, staying on the payroll for a decade. "They were the most exciting, interesting, enlightening years

that anyone could wish for," recalled the graduate of Mary Washington College, who was married with two sons. In an oral history, Fleischer explained, "When I used to go to work, I didn't know if I was going to stay there, work on paying bills or on whatever party she was giving, planning the menu or the guest lists or the seating arrangements."

Perle was of an age when she found it reassuring to have a constant companion and brought her secretary to lunches and out-of-town trips. "I traveled with her to Europe and all over the United States. I went with her wherever she went. I'd get to work and she'd say, 'Come, we're going down to the Capitol to have lunch in the Senate dining room.'" Fleischer recalled, "All the Capitol Police knew her and loved her and treated her like royalty. I never knew when I got to work what we would be doing."

THE SEEMINGLY AGELESS Perle still embodied the idea of the ultimate Washington hostess. In the fall of 1965, the two-year-old ABC television show *The Farmer's Daughter* was in danger of being canceled, so producer John Mitchell concocted a stunt to try to save it. The main characters—Congressman Glenn Morley (actor William Windom) and his housekeeper, Katy Holstrum (Inger Stevens)— would marry, with the wedding reception staged at Perle's apartment. Perle's role was to play herself and invite her famous friends.

More than four hundred people crammed into 3900 Watson Place, jostling with TV crews filming the episode. The show's sponsor, Clairol, paid for the party, including the pink champagne and three-tiered wedding cake. Kuwaiti ambassador Talat al-Ghoussein told reporters, "I don't know why I'm here, but I'll go anywhere where it's fun, and Perle's is always fun." Viewers tuned in, but the ratings boost did not last and ABC ended the show.

A frequent guest on TV talk shows, Perle was excited when Seven Arts Productions, in conjunction with *McCall's*, signed her to host a

five-day-a-week show, *Perle Mesta's Washington*, with a thirteen-week commitment. The producers promised to build a studio that replicated her Louis XV living room. Actor Gary Merrill signed on as cohost.

"Everyone should work," Perle insisted to UPI. "It gives happiness and a sense of achievement." The show's premise: Perle would give parties, take a camera crew to other people's parties, plus interview major Washington figures. In an article plugging this venture, her longtime Oklahoma chronicler Malvina Stephenson asked Perle, "Why do it for money, you don't need it."

Perle candidly replied, "Yes I do. There are a lot of people I help. Some I have known for a long time who may have come into hard times. I may give them $50 or $100 a month, enough to make ends meet." Her once hefty resources were becoming stretched, and she was constantly on tap for her nephew Bill Tyson and his daughter Lizzie.

By January 1966 she had taped three episodes, interviewing Hubert Humphrey, astrologer Jeane Dixon, and reporter Ruth Montgomery. But the airdate kept being pushed back, and ultimately the show never ran. It was a comedown for the hostess with the mostes', trying to hold her place in the Washington hierarchy.

She was in a reflective mood when *Los Angeles Times* columnist Paul Coates interviewed her in mid-May 1966, meeting initially at her home and then continuing to a restaurant. He just let her talk, rarely interrupting. She mentioned that she had just attended "one of those insufferable parties, where the host asks you not to mention anything because it's a private affair and they don't want it to get into the society columns." Showing her intense love for publicity, she added, "Isn't that ridiculous? Why have a party if you don't want it mentioned in the press?"

When they arrived at The Club, Perle pointed out that there wasn't a single senator or ambassador in the restaurant. "This was always a popular place for important politicians. You know what's changed in this town?" Coates said he didn't know. "The frug," she whispered. "People began doing those silly dances and now everybody

goes to discotheques instead of the really good old restaurants. It's sad. Don't you think it's sad?"

Coates asked whether she thought *Call Me Madam* ridiculed her. "Ridiculed me?" Perle replied, insisting that she liked the show and wished she could have invested in it. She confided, "I like money, you know."

Coates raised the obvious question: "You don't need money, do you?"

Perle's telling reply: "Everybody does. But for different reasons. When you earn money, it can buy you the things you want. Or it can be a way of measuring your importance. I need to earn money, to find out how much I'm really worth to people."

AFTER TWO DECADES in Perle's employ, butler Garner Camper and housekeeper wife Edna were a smoothly functioning team. They had been by her side in Luxembourg, Newport, and various Washington households, taking care of the great and near great. As live-in staff, they were with Perle from morning until night. They knew her needs and her whims; she knew she could count on them for pretty much everything. The butler even groomed her poodles.

The impeccable Camper cut such a distinctive figure that he often garnered complimentary mentions in the press. He was warm, he was unflappable, and he always knew the right thing to say to put people at ease.

So his sudden illness in the spring of 1966 threw the household into a tizzy. After battling a brief unspecified ailment, Camper died in early June 1966 at Perle's home, a month before he would have turned fifty-seven.

For Perle, this loss was almost as crushing as the death of her sister. Day and night, night and day, she was used to his calming presence, and now the apartment echoed with loss. Clare Boothe Luce came to stay with Perle for a few days after his death. The women

carried on with previous plans to attend the Ballet Ball together but sat at a table by themselves, in a small room adjoining the festivities, so Perle did not have to put on a smiling face.

Perle did not hire a replacement. As far as she was concerned, Camper was irreplaceable; his wife Edna agreed to remain by Perle's side. When Malvina Stephenson interviewed Perle a few weeks later, the hostess admitted she was so "dispirited" by Camper's death that she couldn't bring herself to make calls to raise money for Oklahoma candidates. Patti Birge, married at the time to Perle's nephew Bill Tyson, told me, "She had this wonderful butler. He was just wonderful. You could be comfortable knowing he was a very important cog in her party activity. You could see the difference when he died."

CALL ME MADAM remained a popular show in regional theater. Perle was intrigued to hear that singer Pearl Bailey had been cast as the lead in an upcoming production at the Melodyland Theatre in Berkeley, California—the first Black actress to play a version of Perle.

Since Bailey happened to be performing her nightclub act that summer at Washington's Shoreham Hotel, Perle cheered herself up seeing the show, and then invited the singer to her home. The two women, thirty-six years apart in age, had nothing in common, yet it was a laughter-filled afternoon. The sultry singer, daughter of a minister, won her first song-and-dance contest at age fifteen and then leaped from vaudeville to Broadway to the movies.

Perle and Pearl, both pros at publicity, told the press about their instant rapport. "Guess who's most delighted she's being portrayed on-stage by a sepia star?" wrote syndicated columnist Mike Connolly. "The Hostess with the Mostes' herself, Madam Perle Mesta." Not to be outdone, Pearl Bailey spread the news of their get-together. "From the mutual admiration emanating from the meeting," wrote Alan Ward in the *Oakland Tribune*, "Miss Bailey was given assurance that Mrs. Mesta would attend one of the Melodyland performances." That

did not happen—the theater filed for bankruptcy during the run and shut down—but Pearl and Perle remained in close touch.

Perle relished her friendships with talented Broadway divas. Whenever Ethel Merman came to the capital, she stayed with Perle, who gave dinners or luncheons in her honor. Word spread about Perle's affection for and generosity to performers. Angela Lansbury, appearing in *Mame* on Broadway to rapturous reviews, sent a note to Perle introducing herself. Perle was so flattered that she gave Lansbury and the *Mame* cast a party at New York's chic Voisin restaurant. Reporters noted that restaurants often comped Perle's events for the favorable publicity. Lansbury became yet another regular in Perle's orbit.

A LADY NEVER discusses her bank account. But Perle was beginning to have genuine concern about her finances. "She wasted a lot of money; she had no concept of money," her great-niece Linda (Ellis) Picasso told me. "I'm sure she didn't know how to balance a checkbook. She had no business sense; it was just live for the moment." And now it was catching up with her.

McCall's new editor-in-chief Robert Stein ended her column, ditching Perle's party advice in order to hire young journalists like Gloria Steinem to write about feminism. When Perle ran into the editor at a Washington event, she came straight to the point. "You naughty boy," she exclaimed. "You fired me." Worse than the loss of the monthly stipend was the end of the magazine's financial support for her parties.

At the same time, she was in danger of losing her discounted rental apartment. The building's developer had sold most of the units at 3900 Watson Place as co-ops and was pressuring her to buy. Perle's apartment was reported to have a sale price of $225,000. She didn't want to purchase the unit—or couldn't afford to—yet dreaded starting over somewhere else.

Joseph Higgins, vice president of the real estate firm, contacted her to discuss the situation, according to a book by his son Peter T. Higgins. Perle hoped her fame would protect her. When Joseph Higgins asked Perle about her plans, she replied loftily, "Do you know who I am?" His response: "Yes, you are the lady who refuses to pay her rent." On September 17, 1966, she sent him a letter agreeing to leave but didn't specify a date. Perle was in no rush.

Tumultuous Times

The March 1967 headline suggested a startling drop in status: "Mrs. Perle Mesta Facing Eviction." Texas reporter Sarah McClendon, of the Women's News Service, had gotten the scoop on Perle's real estate problems.

The owners of 3900 Watson Place NW had lost patience after six months. They went public, telling McClendon their famous tenant was refusing to pay up and they wanted her out. A humiliated Perle, caught off guard, initially denied to McClendon that she was moving, saying, "Not now." But then she admitted she was having trouble finding a place that would accept her poodles. She dragged out her departure for several more months.

Accustomed to flattering stories, Perle abruptly became fair game. New reporters on the society beat, eager to make their mark, found her easy to ridicule. *New York Daily News* reporter Judith Axler wrote, "Since her butler died she hasn't been able to do anything well. He ran her parties. Garner Camper spoke French, Italian, and German and knew everyone by name . . . Mrs. Mesta confesses that it's difficult to get along without him."

Washington Post columnist Maxine Cheshire took a shot at Perle, underscoring how often she was living on freebies. "For her, the best

things in life are often free," Cheshire wrote. "There is always someone eager to shower her with gratis goods or pick up the tab for one of her parties in exchange for the promotional talents of Perle herself."

Anxious about her status, the sound of her ringing telephone was music to Perle's ears. Although she had a secretary and a maid, Perle admitted that she answered her own phone "whenever I can, because I'm always afraid I'll miss something."

Frantic to bring in money, Perle signed with a booking agent and hit the lecture circuit, hopscotching from Virginia to Los Angeles to Ohio to Florida. Everywhere she went, people pressed her about Vietnam. Perle consistently backed Lyndon Johnson's war with comments such as "We have the most marvelous president, and that war in Vietnam is going to stop Communism."

She told Oklahoma chronicler Malvina Stephenson that expensive parties should be put on hold. "The country is very sobered," Perle acknowledged, describing what she heard on the lecture tour. "In almost every audience, there were people with sons and nephews in Vietnam. The women are especially upset and aroused . . . I think the rest of the country would be less resentful about Vietnam if official Washington had a more sober image."

The White House continued to include Perle on guest lists. "I played for President Johnson and she was definitely around," society bandleader Peter Duchin told me. "She was the kind of person who people perceived with interest and a sense of reverence."

IN JULY, PERLE finally moved to the Sheraton Park Hotel, a stately 1928 redbrick building in the leafy Cleveland Park neighborhood, two miles from the White House. The hotel's managers gave Perle and other VIPs cut-rate deals, ranging from one-third off to completely free rent, depending on the person's clout. The Sheraton Hotel chain was part of the sprawling conglomerate ITT, which had

frequent business dealings before Congress and the White House, so it was in the company's interest to cultivate the city's elite.

While Perle's new seventh-floor place was smaller, it was still spacious: four bedrooms plus a library, drawing room, two balconies, and a pantry large enough for her silver trays, Meissen porcelain service, and antique Baccarat stemware. Perle estimated that she could give a cocktail party for two hundred and a dinner for seventy in the place.

She tried to spin this move as a positive development, telling Betty Beale, "The easiest thing in the world is hotel living. If your maid isn't feeling well, you can always get help, good food, and get your clothes pressed. It also has a post office, hairdresser and swimming pool." Perle said she might even get into a bathing suit "early in the morning when nobody sees me."

Perle christened her new apartment with a party for Pearl Bailey, who was performing in *Hello, Dolly!* with Cab Calloway, the jazz singer and bandleader, the first major production featuring an entirely Black cast. At Perle's cast party, a photo showed Pearl Bailey sitting on the floor, nibbling on a plate of food. Even at this apolitical event, the conversation turned to Vietnam.

Like her hostess, Pearl Bailey backed President Johnson, and she made her feelings emphatically clear at the party in a conversation with Senator Vance Hartke, who opposed the war. Stressing her admiration for the president and lecturing the senator, Bailey said that she had recently been inspired at 4 a.m. to write the president a supportive letter "with a religious theme," and he responded.

The actors ended the evening by bursting into song. Cab Calloway led off with "It Ain't Necessarily So," and soon Bailey was on her feet singing "Put on Your Sunday Clothes" from *Hello, Dolly!*

When President Johnson learned the singer had criticized Hartke, he was so pleased that he and Lady Bird made a surprise visit to a matinee of *Hello, Dolly!*, joining the star onstage for a curtain call.

* * *

WEEKS AFTER THIS triumphant gathering, Perle received upsetting news. Her brother O.W. Skirvin flew in from Oklahoma on November 27 to inform her that someone had forged $25,000 (equivalent to roughly $227,000 today) worth of checks on her account at the Newport National Bank. The villain was believed to be her chauffeur Terry Akinaga.

She regularly made out checks to cash and sent Akinaga to local banks to cash them. Since Perle never balanced her checkbook, she did not notice checks were missing. The forgeries were believed to have begun in 1965 and involved forty checks. The bank red-flagged a November 20 check for $5,576; her brother stopped payment.

The forgeries were inept. Perle always put a period after her middle initial—Perle S. Mesta—but the forger skipped the period. She used 00/100 for dollars and cents and the forger used xxx/100. When Perle's brother showed her the checks, she sadly acknowledged that she didn't write them. She trusted and liked Terry Akinaga, who ferried her great-niece Lizzie Tyson to school and was kind to the girl.

O.W. contacted trust and estate lawyer Daniel J. Andersen. "Mr. Skirvin was very much concerned about security," Andersen wrote in a detailed account. "It was definitely decided that Terry did this and took the money. He was an expert in karate and always carried a switchblade and had frequently threatened to kill people." The lawyer hired a two-armed ex-policeman from the National Detective Agency. The group met at the flower shop of the Sheraton Park before proceeding to Perle's apartment to confront the live-in chauffeur.

The lawyer showed Akinaga a photocopy of the stopped check with the bank's notation, "signature unsatisfactory." The chauffeur's lips started to quiver. Then Akinaga broke down and confessed. "My mind is not right. I don't know why I did it, Mrs. Mesta has been so good to me, I am like one of the family, I wish I could commit suicide." He admitted he had a gambling addiction. He would sneak

out of the apartment late at night and go to Baltimore to gamble, returning before Perle woke up in the morning.

Waiting in a separate room, Perle had already decided that she didn't want to prosecute. She felt betrayed but didn't want to ruin the life of someone whose company she had cherished. But he had to go, and he had to go now. Since Akinaga's family lived in Los Angeles, the lawyer bought the chauffeur a TWA ticket for the next flight, on Perle's dime. Akinaga signed a statement admitting to the forgeries. Perle even had her lawyer give him money so he wouldn't arrive penniless. The guards watched him pack his possessions—six bags and parcels—and took him to the airport.

PERLE RETURNED TO the lecture circuit a week later, speaking in Port Huron, Michigan. She still had a knack for charming the press, although her age showed. "Perle Mesta is a lady who is capable of laughing at herself while carrying the whole thing off with great dignity," wrote the *Port Huron Times-Herald*, adding, "Mrs. Mesta, in the autumn of her life, is not a great speaker. She had some trouble with the microphone. But what came through was the personal warmth of a great lady."

The questions came, as always, about Vietnam. Perle said, "Let's don't criticize Johnson because of the war. Let's just pray for him."

Given Perle's unconditional support for the president, her invitation to the December 9 White House wedding of Lynda Bird Johnson to Marine captain Charles (Chuck) Robb was never in doubt, although Perle's former rival did not make the list. "Gwen Cafritz never forgave me because she wasn't invited to my wedding," Lynda Johnson Robb told me. "She had a party, so she said, when Daddy was running for office. I guess she would have thought that I had gotten too big for my boots."

Rather than suffer in dignified silence, Gwen Cafritz called the White House social secretary to say that there had been a mistake. As Lynda Johnson Robb recalls, "I do know that Bess Abell got a call

from Gwen Cafritz saying, 'My wedding invitation hasn't arrived.' And Bess had the hard job of telling her she wasn't invited."

WHEN PEARL BAILEY was chosen by *Cue* magazine as entertainer of the year, she deputized Perle to present the award at the Pierre Hotel in early January 1968. Bailey quipped to the audience, "You got a bargain tonight. Two pearls for the price of one." Aware that Perle was spry for her age, Bailey brought her friend up on the stage, and the two women did an impromptu buck and wing, to raucous cheers. Then Cab Calloway pulled Perle onto the dance floor to do the Watusi, the latest dance craze.

The Perle and Pearl act resumed a month later when the two women appeared at a twelve-hour New York telethon for United Cerebral Palsy. At the end of the evening, Pearl Bailey sang "Hello, Dolly!" and summoned Perle to the stage again. Perle lifted her skirt and did a kick and step.

Perle's party for Pearl Bailey in Washington, a week later, was supposed to feature LBJ. But at the last minute, President Johnson decided to leave town, and the White House was represented by newlyweds Lynda and husband Chuck Robb. Chuck was about to be posted to Vietnam.

Perle made mischief with her seating chart, putting her guest of honor next to Louisiana senator Allen Ellender, a staunch segregationist who voted against every civil rights measure. Pearl Bailey turned her klieg-like charm on him. "Miss Bailey told the senator that there was no color connected with love and if love could control the world there would be no wars, no hard feelings," wrote Betty Beale. "The senator was so charmed by her philosophy he danced with her later, something that his segregated constituents never would have dreamed he would do."

* * *

PERLE ACCEPTED AN inordinate number of speaking engagements that winter—twenty-two during a six-week period. She packed her wigs and Adele Simpson outfits and headed to California. A *Newsweek* item had recently unkindly referred to her as "hefty." Trying to slim down, she put herself on the grapefruit diet.

At each city, there were cocktail parties and interviews for Perle with local reporters. She proudly let slip that she was being paid $1,500 a speech, even while insisting that she didn't need the money. In her speeches, she talked about Washington protocol, repeated her greatest hits about her 1955 trip to Russia, and constantly praised Lyndon Johnson. "He is trying so hard and working so hard night and day," she told a group in Palo Alto on February 28. "The party should stand behind him . . . There is nothing dove about me."

But doves had taken over the Democratic Party. On March 12, antiwar presidential candidate Eugene McCarthy, the Minnesota senator, almost beat LBJ in the New Hampshire primary. Four days later, Bobby Kennedy announced that he too was running for the presidency.

When the weary and depressed president announced on March 31 that he would not run again, Perle was stunned. She thought she knew LBJ and didn't see it coming. The next day, she spoke with Lynda Johnson Robb, who confided that her father feared his candidacy would split the Democratic Party.

The first Gallup Poll taken in April, in the wake of Johnson's withdrawal, showed Bobby Kennedy in first place with the support of 35 percent of Democrats. Hubert Humphrey, who had not yet announced his candidacy, won 31 percent of the vote, while Eugene McCarthy, the only candidate who had actually run in the Democratic primaries, trailing with 23 percent of the vote.

At Perle's next stop in Iowa, over breakfast at the Hotel Blackhawk with a *Quad City Times* reporter, the hostess admitted, "He took me by complete surprise. But I know why he did it. Lyndon is a party member first and a politician second. He is determined not

to have the party split down the middle. I also know he doesn't want to be drafted. He is definitely out of the race. If the wrong man is nominated I'll go to Switzerland."

Hubert Humphrey had been a frequent guest in her home; Eugene McCarthy had dined at her table, too. Perle wouldn't say whom she was supporting, other than stating definitively, "You can be sure it isn't Bobby Kennedy."

TWENTY-NINE

A World Turned Upside Down

Perle had just returned to Washington when the dreadful news arrived that Martin Luther King Jr. had been assassinated in Memphis. Within twenty-four hours, riots broke out in the capital. Entire blocks went up in flames, store windows were shattered, and looters carried away armloads of goods. Enraged crowds stoned firefighters and policemen.

The chaos lasted for four days and left eight people dead, 987 injured, and more than 7,600 facing criminal charges. Some seven hundred dwellings were destroyed, leaving thousands of people homeless. Perle huddled at the Sheraton Park, glued to the television. The epicenter of the riot was at 14th and U Streets, a mere mile and a half from her apartment. She was shocked by the simmering rage that exploded so suddenly.

For upper-class Washington residents, life quickly returned to normal. Just two weeks later, Perle joined an aristocratic group—including Laurance Rockefeller and Brooke Astor—on one of Lady Bird Johnson's bus trips around the city to highlight her beautification campaign. The president gave his annual spring reception for foreign diplomats in late April, and Perle joined 124 foreign envoys in the East Room. Hubert Humphrey, about to officially announce

his presidential bid, was vibrating with energy about his plans. Perle told everyone that she planned to work hard to elect him.

Speaking at the Des Moines Women's Club in May, Perle admitted to being deeply shaken by the riots. Asked her opinion about Chicago mayor Richard J. Daley's order telling the police to shoot arsonists and looters on sight, Perle approved of the harsh measures. "Daley is doing what he thinks is right. I think it's time we tell these people where to get off. They should abide by the law."

Perle had spent a decade warning about the communist threat and reacted to the riots by indulging in a conspiracy theory. She told the *Des Moines Register*, "I think some of the recent trouble in Washington was caused by Communists. I think the Communists were telling them where to set fires. I'd almost rather die than live under a Communist regime."

THE TERRIBLE JOLTS just kept coming. Bobby Kennedy, who had just given a victory speech celebrating his California primary win, was assassinated on June 5 at the Ambassador Hotel in Los Angeles.

With the Democratic Party in disarray, pressure mounted to rally around Hubert Humphrey, who appeared to have the best chance to beat Richard Nixon. Nixon was campaigning on the promise that he would return law and order to America. He won every Republican primary he entered.

Perle did her bit for Humphrey in a visible way on Johnny Carson's *Tonight Show*, the hugely popular NBC nightly staple with nine million viewers. The show's bookers came up with wildly disparate guests on June 26: Aretha Franklin, mod hairdresser Vidal Sassoon, Democratic presidential contender Eugene McCarthy, and the hostess with the mostes'. "Perle Mesta was irrepressible on the Johnny Carson show last week," wrote *Washington Star* columnist Ymelda Dixon, "She followed Senator McCarthy onstage and gleefully shook hands with him wearing a large HHH button."

To show her support for the president in his waning days, Perle invited him and Lady Bird to a small dinner for recently retired Supreme Court justice Tom Clark, one of the president's close friends. Johnson promised to attend. Perle had an insatiable need for publicity and alerted the press. Lady Bird changed into a beige lace dress to go to Perle's party, but as she wrote in her journal, "When I stopped by Lyndon's office he had a stack of work and didn't see how he could possibly leave until 9:00 which would be too late. So I went alone. Then as I walked into the Sheraton Park there, private or no, was a photographer and [*Washington Post* reporter] Dorothy McCardle. My heart sank."

The Secret Service escorted her into Perle's apartment. As Lady Bird continued in her diary, "I circled the room, had a drink, some light and pleasant talk and then left before I thought it was time for them to go into dinner." To her dismay, McCardle and the photographer were still waiting outside when she left.

Perle just loved the press, and for female reporters newly assigned to cover Washington, meeting the hostess had become a rite of passage. The fashionable and outgoing *Women's Wear Daily* reporter Kandy Shuman, now Kandie Stroud, who moved from Manhattan to the capital in 1968, told me she was thrilled to be invited to one of Perle's parties. "I was bedazzled because I was this kid and all these important people were there, heads of agencies. I met people like John Chancellor, the NBC anchor, I was like—wow! She had sparkling blue eyes, a little heavyset; she was not my generation. There was something very vulnerable about her. She was really quite a nice person."

LARGE PARTS OF Washington resembled a war zone, with blocks decimated by the fires. In an effort to do something positive for the downtrodden area, the National Park Service organized a free summer outdoor concert in a mostly Black neighborhood, a few blocks from where the worst of the rioting occurred. The Park Service needed help

to book free entertainment. As a white society woman in her eighties, Perle was an unlikely choice to host an inner-city concert, but her name was synonymous with good-time parties and she was friendly with Black entertainers. Happy to help, Perle recruited Pearl Bailey and Cab Calloway to perform at Meridian Hill Park on July 14. Their names won over Gene Donati's orchestra, the singer Hildegarde, the Soul King and the Invaders, and Howard University's Afro-American dance troupe.

Meridian Hill Park, the jewel of the city's green spaces with Italian-style gardens and twenty elaborate fountains, had recently been refurbished with new lighting and plantings. More than fifteen thousand people were expected, but the audience surged to twenty thousand on the day of event. White helium balloons floated gaily around the park, with fireworks scheduled after the concert. Perle was accompanied by her new favorite reporter. "I went with Perle to Pearl Bailey's concert, down this big street, outdoors," Kandie Stroud told me. "That's where I met Pearl Bailey."

Perle had vowed to shake every hand, but as she surveyed the crowd, she admitted that there were just too many people. Standing onstage, wearing a long white lace summer dress, she asked the audience to raise their hands. Thousands of arms reached into the air and people cheered.

But as Hildegarde began to perform, the singer was interrupted by fifty Black youths, protesting a recent police shooting. They loudly chanted "No more murders" and pushed their way toward the front. Things were starting to get ugly, but Pearl Bailey saved the day. Coming onstage to urge calm, she chastised the protestors, saying, "This is a fun place, we don't need this." She recalled that she had played in the park as a child and her father had been the minister of a nearby church. "This is home to me . . . Out of the 20,000 people, I think I know 19,000."

The show went on. The *Washington Post* reported, "An attempt by demonstrators to exploit the occasion was smothered peacefully

by the poise of the performers and the good sense of the audience." Stroud wrote in *WWD* (as Kandy Shuman): "Most of the VIP's were ushered out quickly but Perle stuck it out until the bitter end."

PERLE'S FRIEND BOB Gray, the former Eisenhower aide turned PR man, asked her to speak about Hubert Humphrey at the Georgetown Club. He wanted to dazzle a client, Richard Baker, head of the accounting firm Ernst and Ernst, by having VIPs discuss the presidential race. To make the case for Richard Nixon, he brought in Anna Chennault, the Chinese-born vice chairman of the Republican National Finance Committee.

The widow of US major general Claire Chennault, she had moved to Washington following her husband's death in 1958, carving out a lucrative niche consulting for aerospace companies and military leaders in the US and Asia. As Nixon's leading fundraiser, she had mastered the art of wooing big contributors at her Watergate penthouse. Although Anna Chennault and Perle were on opposing political sides, both liked collecting new people. After that evening at the Georgetown Club, they put one another on guest lists.

Two-party Perle still loved political conventions—whatever the party—and flew to Miami in early August to see Richard Nixon coronated as the GOP nominee. When she turned up at Pat Nixon's press breakfast, Perle was asked what she was doing there and she replied, with a smile, "I'm a spy."

Mary Brooks, assistant national chairman of the Republican Party, insisted to reporters that she wasn't responsible for giving Perle convention access, even though she was being blamed. "She has tickets but certainly not a box, and I certainly had nothing to do with getting them for her. Everyone was mad at me when they read that."

Perle attended a press conference given by Judy Agnew, wife of Nixon's newly chosen running mate, Maryland governor Spiro Agnew. Sitting prominently in the second row, Perle, when asked for

her opinion of Nixon's VP selection, mischievously replied, "I think it is marvelous—for the Democratic party."

Back in Washington, Perle took Kandy Shuman, now Kandie Stroud, to lunch at the Sulgrave Club, granting an interview for a full-page *WWD* profile. Perle explained why she was not planning a big bash at the Democratic convention: "It's the world situation . . . boys dying in Vietnam, the hungry march in Chicago."

Analyzing the grand dame's decision, Stroud praised Perle's approach to life. "It's sad to see the decline of the Gatsbyesque extravaganza, but Perle knows it's all part of the contemporary life process. And that's what makes her tick. She's eternally young . . . She absorbs change even though a lot of people don't like the way she goes about absorbing it. Perle Mesta is growing older . . . but only in years. Her hearing is not as sharp. Her memory has faded somewhat. Her hair is a little grayer . . .

"One would think PGP [Party Girl Perle] would fade quietly into obscurity with the passing of her moment of glory and the coming of the Pepsi generation. But this is not the case. Perle is just as much on the scene as ever."

ONCE PERLE ARRIVED in Chicago for the Democratic convention, she immediately announced she was giving a party after all. In a suite at the Ambassador East Hotel, Perle told the *Chicago Tribune* that she hoped to give a Wednesday night gathering for three hundred people at the hotel's Pump Room. But logistics were a problem, given everything from a transit strike to overwhelmed hotel phone operators. "I've been on the phone for one solid hour trying to reach the Hilton Hotel . . . It's hard to get anything done here now and the transportation is ridiculous. Such confusion."

Despite her fervent support for the Vietnam War, Perle was sympathetic to the thousands of antiwar demonstrators descending on Chicago and their desire to be heard. "I'm for the youth. The

hippies, the yippies. Remember when everyone thought the jitterbug was awful. We have to understand them. We shouldn't throw youth out the window. We were young once, it isn't so hard to remember."

Perle was in fine form as a featured speaker at a "food for thought" lunch for female delegates, organized by India Edwards. Perle was interviewed by *Star* columnist Ymelda Dixon, who had just published a book titled *How to Get Married in Washington*. Their dialogue went as follows:

> YMELDA DIXON: How DO you get married in Washington and are there attractive men in Washington?
>
> PERLE: I've been trying for 20 years to get married in Washington without success. Yes, there are attractive men in Washington but they aren't marriageable.
>
> DIXON: Will the Humphreys change the entertainment at the White House?
>
> PERLE: Yes, they will, because each administration changes White House entertainment for the better. But I do hope the guest list will be the same because I want to be invited.
>
> DIXON: [Have] you ever been in love with a Republican?
>
> PERLE: Worse than that—I married one.
>
> DIXON: Will you campaign in the election?
>
> PERLE: I intend to campaign and I want to campaign among Negroes—because I like them.

ON MONDAY AUGUST 26, the first night of the convention, Perle watched the action from a box with Oklahoma delegates and then joined power couple Liz and Les Carpenter to visit risqué *Playboy* founder Hugh Hefner's mansion. At the pleasure palace, she had a long conversation with *Bonnie and Clyde* star Warren Beatty about his mother, and mingled with guests including cartoonist Jules Feiffer, director Elia Kazan, and folksingers Paul Stookey and Mary Travers.

Hefner graciously referred to Perle as "the other big party-giver of our time." Perle admired his Picasso painting and told friends he was charming.

But while they were enjoying genteel conversation, the city was exploding. Chicago mayor Richard Daley ordered the police to show no mercy to protestors at Lincoln Park and Grant Park. Night after night, the cops beat up anyone in the vicinity, threw people through restaurant and store windows, and doused the crowd with tear gas.

Traveling around Chicago in her chauffeured limousine, Perle was able to escape the violence. But when Hugh Hefner left his own party to see the action, a policeman clobbered him. On the evening of August 27, the police overreacted to any threat to their authority inside and outside the convention. CBS reporter Dan Rather was roughed up as he tried to interview a delegate inside the convention hall, a frightening interaction shown on television.

At the convention hall, sitting high in the gallery with the Oklahoma delegation, Perle was asked—yet again—about her party plans. She sounded uncertain. "I want to do what I can," she said. "It's strange to have a convention in a barbed wire camp. The only thing I feel cheerful about is that my candidate is going to win."

More than fifteen thousand protestors gathered at Grant Park on the night of August 28. Although they had a legal permit to hold a demonstration, the police and National Guardsmen swept in, injuring and arresting hundreds of people.

That evening, Betty Beale spotted Perle at the Ambassador East's Pump Room. As tear gas drifted in, the guests fled. Perle announced she was canceling her party to protest the police "beating up of the kids." She no longer approved of Mayor Daley's law-and-order policy, saying, "It's all Daley's fault. He insisted on having the convention here."

THAT FALL, PERLE resumed her packed schedule. She attended a Washington lunch for Ed Sullivan and went to Manhattan for the

premiere of Barbra Streisand's movie *Funny Girl*. *Esquire* magazine, celebrating its thirty-fifth birthday with a Washington party, asked Perle to host the event. For a magazine that prided itself on being au courant, she was a surprising choice. Maybe she was so retro that she was hip. The editors agreed to donate $3,500 to her new favorite cause, the Wiltwyck School for Boys, a center for emotionally disturbed youth founded by Eleanor Roosevelt. Perle stood in the receiving line with publisher Arnold Gingrich, and as one account put it, the party "rocked and roll and attracted Washington's best."

With Election Day, November 5, rapidly approaching, every event in Washington had political overtones. On October 31, Perle gave a cocktail party and included Anna Chennault, who brought along wheeler-dealer lawyer Thomas Corcoran. Perle had no way of knowing that the FBI was tailing Chennault, investigating her ties to Nixon and the South Vietnamese government. FBI logs from that evening show agents following Chennault from her Watergate home to Perle's apartment.

The Johnson administration had been tipped off that the Nixon campaign was using Chennault as an intermediary to urge the South Vietnamese to torpedo negotiations for a peace deal with North Vietnam. The Nixon team hoped to prevent the Democrats from claiming victory. Nixon wanted to send word: if he became president, he would give the South Vietnamese a better deal.

During Perle's party on October 31, Anna Chennault received a call from Nixon's former law partner and current campaign manager John Mitchell. He asked Chennault to call him back from a private spot. After leaving Perle's place—followed by the FBI—Chennault and Corcoran made a stop at Corcoran's home.

The Chinese widow asked Corcoran to listen to her call to Mitchell, since she wanted a witness. John Mitchell reportedly told Chennault, "I'm speaking on behalf of Mr. Nixon. It's very important that our Vietnamese friends understand our Republican position and I hope you have made it clear to them."

On November 2, Anna Chennault called the South Vietnamese ambassador at the embassy and told him, "Hold on, we are gonna win." Her phone call was taped by the FBI. After listening to that tape, an enraged President Johnson called several Democratic senators and insisted her action was "treason."

Yet despite his fury, the combative Johnson decided not to go public. Doing so would have forced him to reveal that the US government was taping calls to the Vietnamese embassy. Johnson was reluctant to make a bombshell accusation on the eve of the election.

On November 5, Richard Nixon squeaked out a win over Hubert Humphrey; the popular vote margin was thin: 31,783,783 versus 31,271,839. Two months later, *St. Louis Post-Dispatch* reporter Thomas Ottenad broke the story—"Pre-Election Contacts of GOP and Saigon"—describing Nixon's efforts to use Chennault to block the peace talks. Chennault played coy, telling the reporter, "You're going to get me into a lot of trouble . . . I know so much and I can say so little." When Ottenad told her the Nixon campaign disclaimed any responsibility for her actions, she replied, "You've covered politics. What would you expect?"

There were no repercussions for Nixon or Chennault from the outrageous Vietnam ploy. In fact, shortly after the bombshell story ran, Anna Chennault was featured in a *Washington Post* story marveling at her connections, with the headline "Next Perle Mesta?" Perle was in the opening graph, listed among the one hundred notables scheduled to attend a party that night at Chennault's apartment.

With the Nixons moving into the White House, reporters assessed the eighty-six-year-old Perle's social status. "Perle Is In," crowed the *Washington Star.* Syndicated columnist Suzy wrote: "Come What May, Perle Prevails. Administrations Come and Administrations Go, but Dear Perle Mesta Flourishes, Come Rain, Shine or Republicans to Our Nation's Capital."

Celebrating Nixon's inauguration, Perle took an eight-person, $1,000 box at the event. Eyebrows were raised when word got out

that the formerly profligate hostess asked her guests to chip in $125 per seat.

Perle cheerfully announced to Betty Beale that she hoped the country would enter a period of unity. "What I want is a political moratorium for one year. I think we Democrats should stick by Nixon without criticizing him for one whole year. I'll try my best to keep my mouth shut and be charitable. Along with that, I want gaiety. I don't want to get stale. I want the Republicans to be as gay as Democrats."

Never Give Up:
A Feminist in Her Eighties

Mamie Eisenhower wrote a poignant letter to Perle in early January 1969 about Ike's failing health. Ever since April 1968, he had been at Walter Reed Hospital, suffering from repeated heart attacks. "We spent a rather unhappy Christmas with Ike in the hospital and with my illness which started out with acute asthma and ended with the flu," Mamie wrote. "However, we are thankful to have Ike with us."

A few weeks later, Ike had surgery for an intestinal blockage and then developed pneumonia. On March 17, Perle wrote to Mamie: "I hope that Ike will continue to improve and that he will soon be well enough so that I can come to see him." Mamie came for lunch a few days later at Perle's apartment, but Perle never saw the general again. Eisenhower died on March 28, at age seventy-eight.

Perle attended the solemn service at the National Cathedral. Interviewed repeatedly about her friendship with the Eisenhowers, she reminisced to the *Washington Star* about Ike taking over the kitchen in Luxembourg. "He cooked the best soup and the best steak I ever tasted. He was always telling jokes and we laughed all the time. You could hear us all through the embassy."

* * *

PERLE HAD CHAMPIONED Richard Nixon for president in 1960 and was pleased back then when he supported the Equal Rights Amendment. But now that he was in the White House, Nixon showed his true chauvinist colors by appointing an all-male Cabinet and giving only a few government jobs to women.

Patricia Hitt, his campaign co-chair, was one of the lucky few, named as assistant secretary of health, education, and welfare. But she balked when asked to give Nixon a list of potential female nominees for government posts, responding by belittling women's abilities. "These cabinet departments are so big and all-encompassing," she told a luncheon group. "Very few men are capable of administering them, and, frankly, I couldn't give you a single, solitary woman who has the training, background and ability to fill one of these cabinet posts."

That statement infuriated the former envoy to Luxembourg. "I like Pat Hitt but she is going to lose a lot of women's votes with that statement," Perle declared. "It is going to hurt Nixon. The best way for Nixon to offset Mrs. Hitt's statement is to appoint women in some top jobs. I think he should have named one woman in the Cabinet but it is not too late to put some women in as Ambassadors and other top spots."

Perle got the chance to personally lobby the president at a May 4 lunch at the Virginia apple orchard of Senator Harry Byrd Jr. There were sixty guests, but Perle deftly snagged a prime seat next to Nixon. But whatever she told him that day was ineffective. Perle continued to be disappointed in how his White House treated women.

When the Nixon administration announced plans for a national volunteer program to combat crime and poverty, White House officials urged women's organizations such as the YWCA, the National Council of Jewish Women, and Women in Community Service to donate ideas and time. Perle attacked the plan. "They're the richest people in the world—Republicans," Perle said. "Why do they want women to do all this volunteer work, for free?"

Even though she was unhappy about Nixon's direction, she didn't want to be exiled to Siberia with a repeat of the Kennedy White

House years. So Perle made a point of befriending his appointees. His personal secretary Rose Mary Woods became a fixture at Perle's parties. Perle gave a lunch for new US Mint director Mary Brooks, the same Mary Brooks who disavowed her at the GOP convention in Miami and had recently moved into Perle's building.

Just as proximity helped her develop relationships with vice presidents in the past, Perle had the good fortune, again, of a new apartment neighbor. Vice President Spiro Agnew and wife Judy took an eight-room suite at the Sheraton Park, also at a reduced rate. "We've got Secret Service men coming out of our ears," Perle marveled to a reporter. "The whole place is jumping." Judy Agnew, new to Washington and the city's social mores, was happy to find an experienced and generous guide in Perle. Nearly a half century ago, Perle had introduced Grace Coolidge to Washington's social set; now she did the same for Judy Agnew. The hostess agreed to co-chair, with Spiro Agnew, a benefit for a new USO, the military's entertainment and support center, to be built at Union Station.

The well-connected Bob Gray wanted to make sure Perle got to know Nixon insiders, so he included her at a party at the exclusive 1925 F Street Club, with new attorney general John Mitchell and his outspoken wife Martha. One party invitation led to another. When the Mitchells chaired a benefit at the Washington Hilton's new Racquet Club, they included Perle.

The controversial Martha, the infamous Mouth of the South known for her stiletto heels and stiletto tongue, behaved outrageously in her efforts to assist the Nixon administration. She called senators' wives to demand they convince their husbands to confirm Supreme Court nominee Clement Haynsworth, and she threatened to hurt the careers of legislators who didn't come through. (He lost the confirmation fight.)

Perle liked feisty women who broke the rules. Perle gave Martha a Washington lunch. John Mitchell gave a joking toast, asking Perle how she got to know "a shy, retiring girl like my wife." In the coming months, Perle brought Martha to Manhattan several times to

introduce the Arkansas native to high society. The fact that Martha was anathema to Washington's grande dames made her even more appealing to Perle, thirty-six years her senior. "I love her," Perle said of Martha. "She speaks out just like Harry Truman used to."

PERLE KNEW IT was easy to send a targeted message via the press. She missed her White House entrée. Interviewed for a July 1969 *Parade* feature about the Nixons' social life, Perle made strategically complimentary comments about the First Lady. "Pat Nixon will be a perfectly divine national hostess," Perle told him. When the reporter mentioned comments that Pat Nixon is from Dullsville, Perle bristled. "They come from sore losers and don't reflect the truth."

Perle's words had weight. She was rewarded with a prime invitation to the White House, an October 21 state dinner for the Shah of Iran. The formal white-tie event with 106 guests included Henry Kissinger, Billy Graham, and Nixon campaign contributors, with music by the Marine Orchestra and the Modern Jazz Quartet.

For Perle, wearing a glitter-trimmed white dress and sporting false eyelashes, the White House dinner was a chance to show off her new figure. She had lost twenty pounds on a radical diet—fasting every other day and sticking to a 1,000 calorie count—and was now a size 10. "It was no fun. In fact, it was perfectly horrible," she told people. "I felt as if I was starving to death."

An AP reporter wrote a sympathetic profile, describing her as "prettier than the Perle Mesta of earlier years . . . Her once dark hair is short, curled in a soft grey halo about her face, illuminating her peach-toned skin and azure eyes. Once considered plump, she is no more."

NOW IN HER late eighties, Perle was experiencing waves of nostalgia. To publicize a benefit for a new USO, she visited the current crumbling Washington headquarters, located in the former home of the Stage

Door Canteen, the dilapidated Belasco Theater. The soldiers playing pool didn't know who she was but politely listened to Perle describe her time there during World War II. "I used to peel potatoes," she recalled. "I used to sell tables at $100 a seat. The food didn't amount to much for the $100 a seat people. But for the boys, it was marvelous."

That summer, she took a sentimental trip to Luxembourg, an emotionally satisfying return. "I spent in this country the five happiest years of my life," she told the Associated Press, tearing up. She stayed at the legation with current ambassador Kingdon Gould, great-grandson of notorious financier Jay Gould. She was moved by ceremonies commemorating the Battle of the Bulge. When she walked down the street, people did double-takes and applauded. Someone called out, "Perle is back!"

Rounding out her nostalgia trifecta, she gave a Washington party in January 1970 centered on a showing of the 1953 movie *Call Me Madam*. Everything came together. Jack Valenti, a former LBJ aide now serving as president of the Motion Picture Association, gave a cocktail party and black-tie screening for seventy people. Columbia Pictures paid for the after-party at the Sheraton Carlton Hotel.

Even now, more than a half century later, Lynda Johnson Robb remembers what a glamorous evening it was. "I remember going to see the movie of *Call Me Madam* and dancing afterwards," she recalls. "I remember how famous it was. That was very exciting to meet Ethel Merman."

Ethel burst into "There's No Business Like Show Business" for an audience including John and Martha Mitchell, Rose Mary Woods, Nixon social secretary Lucy Winchester, Cabinet secretaries, and a half dozen foreign ambassadors. To get the buttoned-up crowd on their feet, Perle staged a dance contest complete with judges and the prize of a weekend in Manhattan. Winston Lord, an aide to Henry Kissinger, and his wife Betty wowed the crowd with their racy version of the Charleston.

Even the *New York Times* acknowledged that she still had clout. "Mrs. Mesta has made an unexpected comeback as a Washington

society hostess," wrote reporter Thomas Meehan, although he sniffed that "she isn't really close to President Nixon—as she was, for example, to President Truman."

Rather than always include the same cast of characters, she expanded her guest list to include interesting newer names. "I don't know why I was invited but she reached in all directions," legal scholar Peter Edelman told me, recalling a January 1970 dinner at her home, in which the guests included a Black militant activist, a senator, and journalists. A former aide to Bobby Kennedy and married to Children's Defense Fund founder Marian Wright Edelman, he recalls that Perle "lived up" to her reputation as an engaging hostess.

Things were going well for Perle. Yet whenever she was asked about the Kennedys, she still rose to the bait. At a speech in Fort Worth, Texas, a reporter brought up Jackie Kennedy's marriage to Greek ship owner Aristotle Onassis. Perle's description of the groom: "the ugliest man I've ever met. If Jackie wants to live on that island, let her live there—it's probably a good thing." Newspapers ran her comments, with this typical headline: "Perle Mesta Lets Out Her Claws: Ari Is Ugly."

FOR MORE THAN thirty years, Perle had been pressing for the passage in the House of the Equal Rights Amendment, losing count of how many legislators she had lobbied. New York Democratic congressman Emanuel Celler, the eighty-two-year-old chair of the House Judiciary Committee, refused to hold hearings on the bill to let it move forward. The last time the vital committee heard testimony on the ERA was in 1948, when Republicans controlled the House.

But in August 1970, Michigan Democratic congresswoman Martha Griffiths came up with a ploy to bring the bill before the entire House of Representatives. She convinced 270 House members to agree to "discharge" Celler's committee from further considering the legislation, thus allowing the House to vote.

Excited and hopeful, Perle stopped off at the beauty parlor before heading to Capitol Hill on August 10. Sitting in the House gallery, tears of joy running down her face, she watched as members voted 346 to 15 to pass the amendment. "I couldn't stop crying," she told Betty Beale. "I have worked for this . . . I have put a lot of money into it." Perle was so happy that she couldn't sleep that night.

She met with pioneering suffragette leader Alice Paul to celebrate. But now it was up to the Senate to act. While eighty-one senators cosponsored the ERA, many were suddenly having second thoughts. Perle promptly called on four senators at their offices, and her houseguest Clare Boothe Luce sent telegrams to legislators. Perle convened an all-female emergency strategy meeting at her home on September 3. She included Democrats and Republicans, female business leaders, senators' wives, and journalists from the *Washington Post*, the *Washington Star*, the Associated Press, and United Press International.

The usually ladylike Perle was in a take-no-prisoners mood. She insisted that if senators refused to back the bill, women should vote them out of office. "If they're not for us, put them out. If we're going to be wishy-washy and support them anyway, where are we?" she declared. "If we don't lay it on the line, we won't win."

Dividing up the list of senators believed to be neutral or opposed, the women vowed to pressure them. Two senators' wives giddily vowed to insist their spouses support the measure—or else. "He will lose his beddin' and boardin' rights if he doesn't," declared Maryon Allen, wife of Alabama senator James Allen.

At the end of the gathering, AP reporter Peggy Simpson asked the group whether they also agreed on the women's lib movement. Two years earlier at the Miss America pageant, women tossed bras on the Atlantic City boardwalk, protesting the treatment of women as sex objects. In August 1970, thirty thousand women marched down Fifth Avenue demonstrating for equal rights, legalized abortion, and better childcare. Asked their reaction to women's lib, the ERA enthusiasts

gave a joking response. "We want to keep our bras," quipped Democratic fundraiser Esther Coopersmith. Perle replied, "Absolutely!"

Perle and her allies were stymied yet again. Two senators added amendments to the ERA that they knew would kill it: a rider to allow "nonpartisan" prayers in schools (an effort to roll back the Supreme Court's 1962 decision that school prayer was unconstitutional) plus a rider stating the Armed Forces could only draft men. Senator Birch Bayh tried to come up with compromise language, but women's groups found his wording inadequate.

Since the bill had not passed both the House and Senate during the two-year congressional cycle, the clock went to zero and the supporters would need to start all over.

DURING A TRIP to Newport, Perle was invited to watch the America's Cup race from the USS *John F. Kennedy* aircraft carrier. Her companions on the boat: Jacqueline Kennedy Onassis, her children John and Caroline, and several Kennedy cousins.

After spending the afternoon together, Perle finally had kind words for the former First Lady. "I think Jackie loves children. I have never seen her look better in her life," Perle told Betty Beale. "She looked happy and cordial. She seemed different somehow."

The difference was in Perle. She had raged at Jackie from afar for years. But being in the company of the loving mother made it hard to hold on to what had always been an absurd grudge. Perle stopped badmouthing Jackie and, from then on, acted as if nothing had ever been amiss.

The Octogenarian Jetsetter

Perle was competitive about her relationships with reporters. When she met Associated Press's Ann Blackman, newly relocated to the capital from the New York bureau, at a party given by Anna Chennault, Perle didn't waste time wooing the writer. "She told me to call her, and I did, and she had me over Saturday afternoon for tea," Blackman wrote in her journal on October 3, 1970. "She was dressed in a blue mini-dress with white calf-length boots. She invited me to all sorts of functions and could not have been nicer, or wanted to be more helpful."

Recalling that afternoon a half-century later, Blackman told me, "She just craved having people around all the time. This was a Saturday afternoon, who invites a reporter for tea on a Saturday afternoon unless you're lonely? I was a young reporter in my early twenties. She wanted to fix me up, she wanted to impress me with everyone she knew. She was smart enough to know that the AP really got you known around the country, these little stories got into hundreds of papers."

A week after her original visit, Blackman was summoned back to Perle's apartment. "As I didn't realize I had been invited for lunch, I had two hot dogs before I went so as not to feel faint," Blackman wrote in her journal. That was a mistake since Perle served an elaborate

menu: eggs cymbale, filet of sole, creamed cucumbers, and apricot soufflé, with two wines and champagne.

The reason for the invitation: Princess Julia Cantacuzène, the ninety-four-year-old former Julia Grant, granddaughter of President Ulysses S. Grant, was Perle's guest, and the hostess thought her friend would enjoy media attention. Married in 1899, the princess had escaped the Russian Revolution in 1917 with her husband, Prince Michael Cantacuzène, and their children, settling in Washington.

Looking for a conversational topic, Blackman asked about women's liberation, which the princess was happy to discuss, declaring it "a lot of nonsense." Blackman filed a story on the encounter, writing that the princess displayed "wit and charm." Her article ran in more than a hundred newspapers.

PERLE AND MAMIE Eisenhower attended a White House lunch for Imelda Marcos, the shoe-loving wife of Philippines president Ferdinand Marcos. The talk of the lunch was the outfit worn by Joan Kennedy—a see-through blouse over a blue brassiere, with a skirt and black boots. The women literally gasped as Kennedy walked down the receiving line.

Mamie, whose primary residence was her Gettysburg farm, was staying with Perle, whose Sheraton Park guest room had become a rotating base for her friends. Pearl Bailey spent the night there when she performed at the White House; Ethel Merman and Clare Boothe Luce were regulars. Edna Camper still kept the place shipshape and knew what everyone wanted for breakfast. A new chauffeur transported the hostess and her guests around. For Perle, it was comforting to be with old friends.

Perle had been profiled innumerable times, but she never said no to an interview request. In an October 1970 profile by the *Washington Star*, Perle talked up causes dear to her heart—civil rights and women's rights—although some of her language was antiquated.

"There are certain things I've always been for," she said. "I was always for the Negro. I felt they were downtrodden and never given the right kind of chance. And I have always been for women's rights. I believe in a certain amount of liberation, or at least some aspects of it. For instance, abortion. I think every woman should have control over her own body, certainly Congress shouldn't."

She stressed the importance of Christian Science in her life, noting that she attended church every Sunday and believed in the power of prayer. "Just this week I was having trouble with a tooth and I called my practitioner and we worked on it together and the pain is gone."

Adroit in using the press, Perle had discovered that virtually every time she publicly said something nice about Richard Nixon, another invitation would materialize from the White House. So she praised him yet again. "I know him very, very well. I like him and I think he's doing a good job . . . as good as possible."

Taking a break from Washington, Perle took Martha Mitchell to New York on November 30, 1970, accompanied on the train by FBI agent Frank Illig, Martha's assigned bodyguard. That same day, *Time* published a critical cover story on Perle's companion: "Martha Mitchell's View from the Top." The magazine described Martha as "scatterbrained, overstimulated and insecure," charging that she had a "virulent case of Potomac Fever." Perle, who had experienced the *Time* treatment two decades earlier, could relate to Martha's discomfort. But she had reason to be pleased by *Time's* tip of the hat to her in a section about the capital's social life. "Perle Mesta, eightyish, the hostess who is a household word, is back on Washington's social barricades again after an eclipse during the Kennedy years brought on by her support of Nixon in 1960."

In Manhattan, Perle brought Martha to a dinner with celebrity maven Earl Blackwell, followed by a costume party at the St. Regis Hotel honoring eighty-year-old Russian aristocrat Serge Obolensky. The setting was meant to mimic the Winter Palace in St. Petersburg

in 1910—the kind of party where women wore tiaras. Perle told Aileen Mehle, the gossip columnist who wrote under the name Suzy, that her diamond tiara was too heavy to wear, so she had it copied with fake stones.

That was a good public explanation. Family members later discovered that she had sold George Mesta's diamonds to subsidize her lifestyle.

PERLE STILL LOVED debutante parties, especially when a family member was involved. She gave her great-niece Elizabeth Ellis a December party at the Sulgrave Club and then brought her to Manhattan for the International Debutante Ball at the Waldorf Astoria. "It was fabulous," Elizabeth, now Elizabeth Christian, recalls. "I was seventeen, a senior at Holton-Arms. It was not only a fabulous party; she bought me every one of my debutante gowns. We went to Georgetown; she picked them out. This is how generous she was."

Perle did one odd thing during a trip with her great-niece to New York. "When we got to the hotel room, the first thing she did, and this took me by surprise, she opened every closet door, she looked under the bed. I didn't realize at the time being the celebrity she was, she had to be cautious all the time. She didn't have a bodyguard. We were at one of the top hotels. I remember her doing that, and I thought it was different."

Gwen Cafritz had been robbed twice in her Washington home, tied up for hours but left uninjured. Perle did not want to take any chances.

AT NEARLY NINETY, the indefatigable Perle spent 1971 as a jetsetter—three trips to Los Angeles, an overseas sojourn to London and Luxembourg, two separate trips to Oklahoma, a plane ride to Dallas and another to Chicago, and three visits to Manhattan. Slow

down? Never. She remained in demand for speaking gigs, charity events, TV appearances, and press interviews. She basked in displaying her connections.

Invited to appear on *The Mike Douglas Show*, filmed in Philadelphia, she told the talk show host, "I'll come if I can bring a man with me." The man she had in mind: Wernher von Braun. As the limousine made its way to Philly on January 4 in rain and fog, Perle got a crash course from von Braun in the latest doings at NASA. Her secretary Sophia Fleischer, along for the ride, was starstruck, describing the German in her datebook as "charming, kisses your hand. And so smart!"

A week later, Perle touched down in Oklahoma to give speeches. Her protective younger brother O.W. kept her company. She appealed to audiences by playing the hometown girl made good, telling the Skiatook Chamber of Commerce that two things never failed to thrill her: "When I enter the White House and when I step off the plane in Oklahoma."

Back in Washington, she went to Capitol Hill to watch Richard Nixon give his 1971 State of the Union address, sitting with neighbor Judy Agnew. A lifetime ago, she had joined Bess Truman for her husband's State of the Union address.

Perle represented living history. AP reporter Ann Blackman interviewed the hostess and wrote an affectionate story describing her as "the essence of mod, like Auntie Mame come to life. The same throaty laugh, the feigned naughtiness, the passion for secrets, the unshakeable aplomb . . . From the moment you see her, it's clear that at 80 or thereabouts, Perle Mesta is still kicking up her fashionable booted heels." Blackman added that Perle displays "the energy of a woman half her age." Perle told her, "I used to give 30 speeches a year. Now I limit myself to six because of all these TV appearances."

A few days later, she left for Los Angeles to appear on Pearl Bailey's ABC variety show, which had launched in January to ecstatic notices. For this short stay, Perle brought nine suitcases plus her

secretary. Excerpts from Sophia Fleischer's datebook give a glimpse of Perle's frenetic schedule.

> Feb. 14. To California. TWA #99. TWA pr took care of us. We were the only 2 in first class section . . . Beverly Wilshire, 2 bedroom and living room suite. Felt 2 earthquakes and aftershocks.
>
> Feb. 15. Took cab to Hollywood Palace. Conference, Pearl Bailey, Sarah Vaughn. Polo Lounge at the Beverly Hills hotel for lunch.
>
> Feb. 16. Carroll Righter [celebrity astrologist] picked us up and took us to Perino's for lunch with Mrs. Norman (Dorothy) Chandler, wife of the Los Angeles Times publisher. Dropped us at Elizabeth Arden's, Mrs. Mesta had hair done and facial. Picked up to go to 20th Century Fox preview of memorabilia to go to auction.
>
> Feb. 18. Brown Derby for lunch. Rehearsal at Hollywood Palace. Mrs. Mesta took dinner at Le Bistro with Carroll Righter.
>
> Feb. 19. We were there from 12:30 p.m. through taping and cast party afterwards. At taping sat with Allen Drury.

And on and on they went, going out day after day, night after night. Drury, living in Tiburon, California, sent Perle a thank-you note for including him in the festivities. "You're a true friend a great gal, and one of the world's really nice people. Long may you wave, Madame Ambassador!"

Perle was summoned back to Los Angeles in April to be a guest on the TV show *This Is Your Life*, which was honoring Ethel Merman. Each week, host Ralph Edwards wangled a celebrity into a TV studio, and then surprised them by bringing out friends and family.

On April 28, Perle and Sophia Fleischer repeated their journey— TWA flight 99 again, same suite in the Beverly Wilshire—and the

next day attended four practice run-throughs of the show. "Ethel Merman in studio across hall," Fleischer wrote in her notes, "so they locked us in all day. She was really surprised."

"All those memories came rushing back," Ethel Merman wrote in her autobiography. "I dissolved. I cried so hard it took them eight minutes to get me pulled together . . . For me, it was an emotional bath that left me cleansed and raring to get on with the rest of my life."

PERLE THOUGHT SHE had made inroads with the Nixons, but she was pointedly excluded from the White House wedding of the president's daughter Tricia Nixon to lawyer Ed Cox on June 12. The president thought that Perle was useful, but First Lady Pat Nixon had never warmed up to her. Given a list of potential guests, the president's wife crossed off the names of Perle and Gwen Cafritz, without explanation. Perle found herself in the lobby of her building when guests arrived for Judy Agnew's wedding shower for Tricia. Asked whether she was attending the wedding, Perle gave a sad smile and said, "You don't go where you're not invited."

Leaving town lifted her spirits. Perle flew to London in late June, heading straight to a cocktail party. The globetrotter made an impression on gossip columnist Suzy. "One of the questions most often asked about Perle is how does she do it?" Suzy wrote. "Whereas most people step off a plane from the U.S. at London airport bent over double from jet lag and suffering everything from vision to the pip . . . Madam Mesta prances in like some young bright-eyed thing just sprung from the convent school and dying to make up for what she's missed."

No trip to Europe would be complete for Perle without a pilgrimage to Luxembourg. But her time as the American envoy felt like distant history. By the time she returned to Washington, she was feeling nostalgic about the past. Now there was no end in sight to the Vietnam War. American soldiers were dying in far-off hamlets; nationwide demonstrations constantly disrupted city life. Unlike

World War II, when the country had been united against the terri-
fying specter of Germany and Japan, the Vietnam War had come to
seem futile.

She wrote a touching letter on August 10 to Harry Truman:
"With world events as they are today, it makes me realize more than
ever what a marvelous president you were and I know, of course,
what a great help and inspiration Bess was to you during those years.
I just wish that you could be our president again today, or that we
had someone to come forward with your same qualities of leadership
and dedication."

Perle had always been aware that she had a front-row seat as
history was made. Still, it was an honor for her to be interviewed for
the LBJ Library in early October by Texas historian Joe Frantz. Perle
was usually loquacious, but she wanted to be careful with her words.
Frantz, who came to her home, asked whether she had worked behind
the scenes to help Johnson secure the vice presidency.

> PERLE: No, for him to be president. I never wanted him to
> be vice president. I thought he was due to be number one
> man, not number two man.
> FRANTZ: Did you have any idea he would accept the vice
> presidency?
> PERLE: No, no. I was very disappointed when he did.
> FRANTZ: Is that the main reason you supported Nixon in 1960?
> PERLE: Yes, absolutely, absolutely. He knew I was going to
> support Nixon.
> FRANTZ: Did that ever make a difference in your personal
> relationship?
> PERLE: Never did. Not a bit.

Asked whether she ever gave parties for LBJ when he was vice
president, she replied, "Sure."

FRANTZ: For any political purpose or just for friends?
PERLE: Everything I do is for a political purpose.

She described how much she relished her relationship with LBJ. "He'd kind of jump on me about something and then I'd jump back. Because I'm kind of a spitfire too, you know. I come from Oklahoma. But I never held it against him and I'm sure he didn't me."

The day after that interview, Perle attended a prayer breakfast with the Nixons in the East Room at the White House, along with Pearl Bailey and Supreme Court justice Warren Burger. Perle was hoping Nixon would relent and appoint women to high office.

Her sights were now set on the Supreme Court, which had two vacancies. Perle had scheduled a party at her home to celebrate Earl Wilson's new book, *The Show Business That Nobody Knows*, when word spread that President Nixon planned to reveal his Supreme Court picks that night.

She rented three televisions and turned it into a viewing party. When Nixon announced his choices—Virginia lawyer Lewis Powell and assistant attorney general William Rehnquist—a groan erupted in the room. A disappointed Perle blurted out, "Turn it off. Men won't give us anything."

"Perle, You're an Event in the Life of America"

Perle welcomed a new member of the household that winter: her seventeen-year-old great-niece Linda Ellis. "I just wanted to get out of the house," recalls Linda, who had been living nearby with her parents. "Perle and I had a very close relationship. She understood me, that I was a little headstrong, had my own way of thinking, a little feminist. She let me live there. I thought that was cool." Perle's great-niece Lizzie Tyson was off at boarding school, so there was a free room.

For Perle, there was always another party to plan or attend. In late January 1972, she gave a seventy-five-person lunch for Martha Mitchell. President Nixon, hoping that Perle would back him again, dangled a White House perk, an invitation to the state dinner for Turkish prime minister Nihat Erim. Perle attended, but when Nixon's secretary Rose Mary Woods followed up by requesting a contribution to the president's reelection campaign in the $50,000 to $100,000 range, Perle turned her down.

She had a different political investment in mind. Perle wanted to get in on the ground floor for Texan John Connally, a conservative Democrat turned Republican, who had just stepped down as Nixon's

treasury secretary. Nixon had quietly made it known that Connally was his preferred presidential successor in 1976, and Perle was willing to wait.

Perle had known Connally, a longtime Lyndon Johnson protégé, for decades. As the governor of Texas, Connally was in the limousine with President Kennedy in Dallas in November 1963 when the president was assassinated. Hit by a bullet, Connally was seriously wounded in and out of consciousness for days.

He had crossed party lines to serve in Nixon's Cabinet. Now Perle wanted to celebrate his political future. After inviting 150 people (Washington insiders, Texas oilmen, society) to a party for Connally and his wife Nellie at the Shoreham Hotel, Perle went into overdrive to make it special. She hired the All American Banjo Team plus the tap dancing Little Steps. Ethel Merman agreed to perform.

The news that Perle was giving a big bash launched a round of newspaper stories. *Boston Globe* reporter Marian Christy wrote an article that was simultaneously cruel and insightful. After interviewing the hostess at her apartment, Christy described Perle as "a bouncy-frank bewigged blond," mentioned her "not-so-slim tummy," and referred to her as "the dear old girl, oozing spirit-strength sturdiness."

Bristling at the reporter's confrontational approach, the still feisty Perle began to grill her, asking a series of rapid-fire questions that made Christy uncomfortable. "The amusing third degree, definitely a manipulative role reversal, is a game created by Mesta the Magnificent," Christy wrote. "She's an aggressive, still-ambitious, fame-hungry wisdom filled woman who purposely throws preposterous questions geared to force you to lose your equanimity. You score by keeping cool."

Christy baited Perle, asking why she threw expensive parties when the world was filled with hungry people. Didn't she feel pangs of conscience? "Why doesn't she use that mountain of money to accomplish some good."

Perle coolly replied, with a note of noblesse oblige, that she hired up to seventy people to work a party—the orchestra, florist, caterers,

entertainers, and so on. "They're well paid. This, in turn, enables them to feed their families."

The interview ended on a quarrelsome note. Pressed about her age, Perle replied in an angry tone that she tells people it's none of their "goddamned business."

AT PERLE'S PARTY for John Connally, the tablecloths were pink; the champagne was pink; the menu consisted of flaming duck, zucchini parmesan, tomatoes Provençal, endive salad, and sherbet; and the entertainment was, as always, lively.

"It was the most coveted invitation in town," wrote *WWD*'s Kandy Shuman, now Kandie Stroud. Circulating among such guests as Art Buchwald, Cornelius Vanderbilt Whitney, Commerce secretary Pete Peterson, and White House economic adviser Arthur Burns, Perle enjoyed the banter. John Connally, sporting a black velvet dinner jacket and matching bow tie, laughed out loud when informed by astrologer Carroll Righter that the stars were aligned in his favor.

Perle wore a new red and black floral Oscar de la Renta dress, and her smile was a mile wide as she listened to Connally's toast. Commenting on the fact that both of them had switched political affiliations, he said, "You have said that you and I are members of the same party, but if we define it in philosophical terms, we would be a party of two." He went on to exclaim, "You're a tradition, no, more than a tradition. You're an event in the life of America."

This celebration would turn out to be Perle's last major party.

Let's freeze the frame for a moment. Here was Ethel Merman, belting out songs in Perle's honor. Washington's influential players were laughing, talking, and dancing—who knows what connections were happening, what legislation might be passed, whose careers might get a lift, what liaisons might ensue, all because she had gathered this group together. This was an evening for Perle to savor. This power-centric world had not been handed to her, she didn't grow up

in it or marry into it, and yet she had made herself into the hub of the wheel, with important people revolving around her.

That spring, Perle was honored with so many awards—the Wilt-wyck School Merit Award, the Thomas Dooley Foundation's Splendid American Award, the Catholic Church's Francis Cardinal Spellman Award for loyal and distinctive service—that it was like attending her own wake.

By now, she was such a part of the national cultural firmament that her name regularly appeared in newspaper crossword puzzles. In just one month—June 1972—she was repeatedly cited as a metaphor:

- A promoter for the Rolling Stones American tour, describing the scramble for tickets, told the *Washington Post*: "I was the Perle Mesta of Houston during ticket sales."
- Movie star Burt Reynolds, discussing lady friend Dinah Shore, said, "She used to be the Perle Mesta of Beverly Hills—every night a party."
- A real estate advertisement in the *Los Angeles Times* read: "PAGING PERLE MESTA. The best party house West of the Capitol."

She was no longer in search of a party house in any city. The 1968 Democratic convention had been such a debacle that Perle decided to stay away from political gatherings. Two-party Perle was about to be no-party Perle. She wrote to Allen Drury on June 6, 1972: "At the moment, I do not plan to attend either of the conventions."

When the Democratic convention began, many newspapers ran this syndicated joke: "Perle Mesta, the veteran hostess, was not at Miami Beach and the rules committee is studying the question of whether the convention is legal in view of this unusual situation."

Perle had stopped discussing her party affiliation. She had nothing to say about the Democrats' selection of antiwar candidate George McGovern, a South Dakota senator, as the party's presidential

nominee. Instead, she signaled her feelings by giving a fancy GOP pre-convention Washington lunch for Judy Agnew.

THERE ARE MOMENTOUS events in life that creep up on us. Everything is fine—and then it's not. Decisions that seem minor become major turning points. For Perle Mesta, the next few years would turn on, of all things, a hat.

Her great-niece Linda was packing for a trip to California and realized she was missing her favorite accessory. "Oh, shoot, I forgot my hat," she told Perle. The teenager, still living with Perle, had left it in her second-floor bedroom at her parents' nearby home. Perle, who was about to head out for the day with her chauffeur, offered to pick it up. Since Perle had a key, she could just let herself in. Linda's parents were away on vacation.

Perle's chauffeur dropped her off and waited patiently outside the house. And waited. And waited. Perle seemed to be taking a very long time. Finally, he went to check and discovered that she had fallen down the stairs and was writhing in pain on the floor. She had been calling for help but too faintly to be heard. The chauffeur and a neighbor called for an ambulance: Perle was taken to Sibley Hospital, where she was diagnosed with a broken left hip.

Even now, a half century later, Perle's great-niece Linda becomes upset as she tells me this story. "I wasn't with her. I don't know why the chauffeur didn't go up with her. It was all because of my hat. She never really recovered from the accident. And it was because of me."

Of course it wasn't her fault. Things happen. If only we could roll back the clock and change the outcome. Therein lies the heartache: we can't.

PERLE'S INJURY COULD not be fixed with Christian Science prayer. What followed was major surgery and endless consultations

with doctors. Her most recent starvation diet had taken a toll, and she was severely anemic. Her brother O.W. Skirvin flew in from Oklahoma City to be by her side.

Betty Beale was the first to print the news of Perle's fall in the *Washington Star*, but the hostess convinced her to put a positive spin on the story. "The indefatigable Mrs. Mesta, who is due to appear in Oregon in two weeks on behalf of [Republican] Sen. Mark Hatfield, now campaigning for reelection, said, 'Don't worry. I'll be there. I want to make sure that good-looking man is re-elected.'"

She didn't go to Oregon. She wasn't going anywhere. The headline on a UPI story: "Mrs. Mesta Doing Well." But Sophia Fleischer's notes tell a different story. "Went to hospital at 10:30. Mrs. Mesta not as good as yesterday. Huge flowers from Pearl Bailey + lots of others. I went to apartment and wrote about 40-something thank you notes. Mrs. Mesta had to have blood transfusion in the afternoon."

Ethel Merman visited Perle at the hospital, and both Lyndon Johnson and Richard Nixon sent get-well notes. Perle was still there a month later and having a rough time. On September 6, Sophia Fleischer wrote, "Dr. Becker called me with not very good news. She was having blood transfusions."

Never a proponent of exercise, Perle refused to participate in the intense physical therapy necessary to walk again, despite the recommendation of her surgeon. "She informed Dr. Peterson that she would get out of bed when she was ready, and that was that," Betty Ellis wrote in her memoir. "She never really recovered properly the way she should have if she had listened to her surgeon." Perle was mostly confined to a wheelchair from then on.

After three months at Sibley Hospital, Perle was released on October 8 and returned to her Sheraton Park apartment with round-the-clock nurses. She turned ninety on October 12. Since she never acknowledged her birthday or her age, there was apparently no celebration.

Her friends checked in. Martha Mitchell and Mamie Eisenhower both called, and Pearl Bailey sent two dozen roses again. When Betty

Beale visited Perle in mid-November, the hostess was sitting in a wheelchair, expressing amusement at the latest gifts. "I don't know why it is, but every man who comes to see me brings me a pound of caviar," Perle told her. Beale wrote: "What else would you bring the hostess with the mostes?"

Wearing attractive robes—pink and silver, and one with her name spelled out in pearls—Perle appreciated an audience. Talking with *WWD* reporter Kathleen Brady on December 6, Perle expressed concern about Harry Truman, said to be critically ill. "He taught me everything I know," she said. "He told me never to be afraid to put people together who disagree. 'Get them together for a party, They'll be friends before you know it.'"

Perle respected him because he was true to his wife, unlike other presidents she had known. "I'll never forget picking up a picture he had given her," said Perle. "He had written on it, 'To Bess, the only woman I will ever love.'"

Harry Truman died on December 26, 1972. Perle was unable to attend his funeral. The next blow came a month later. Lyndon Johnson died on January 22, 1973. She couldn't go to that funeral, either.

Perle was in mourning when *Washington Star* reporter Clare Crawford came by. "I feel as though I've lost the two most important men in the past month . . . except, of course, Mr. Mesta," she said. Grief-stricken, she tried to think back on the good times. "I am grateful and humble that I knew them and was part of it. If I have any regrets, it's that I wasn't a little more flirt-y with Lyndon. He was marvelous with the women." She quickly made a point of adding, "Lady Bird made him. She gave him the money to get started and she was the brains. If he called her, she'd drop everything and go."

Perle felt well enough to attend an early February luncheon in her building, given for her by Charles Carey, executive director of the ITT-Sheraton Corp. But upon arriving she appeared anxious, constantly looking for reassurance from her nurse. One friend mentioned that it must be chic to break a hip, since both Perle and

the Duchess of Windsor had done so. Perle's reply: "I don't want to be chic."

Her health continued to deteriorate. On June 19, Perle was admitted to Doctor's Hospital. "She did not feel well at all," Sophia Fleischer worriedly wrote in her date book. On July 13, she noted, "Mr. Skirvin did not want me to go see Mrs. Mesta." On August 1, she wrote, "Went to hospital but only stayed a couple of minutes because Mrs. Mesta felt terrible."

Perle was released from the hospital on August 14, but visitors were not encouraged. *WWD*'s Kandie Stroud and her physician husband Frank Stroud were surprised to be summoned for lunch on November 7. "Out of blue I got this call, must have been from Sophia Fleischer, 'Perle would like you to come over,'" Stroud recalls. "I didn't know what to expect. We walked into that Sheraton Park apartment. I thought she was dying. I knew it was the bitter end. She said words to the effect, she wasn't 'going to be around much longer.' And I talked about the wonderful times we had had, and thanked her for being so good to me."

Perle wanted the journalist to have her something to remember her by and gave her a piece of Meissen porcelain.

The reporter gave Perle a gift as well—an affectionate *WWD* story that made minimal mention of her ailments. "Perle may be confined to a wheelchair but she's full of fight and opinions." Perle confided, "I sit here and pick up more gossip and scandal than you can imagine." She professed to be horrified by the Watergate scandal. "I never thought I'd live to see anything like this. I'm so sick of this. I wish it were over. There are so many more important things we all have to do and worry about before we die." With that sentence, she was acknowledging her mortality.

Perle's brother and niece made the difficult decision to uproot Perle and move her to Oklahoma City, where her brother could manage her care. "Aunty Perle was no more the vibrant and energetic hostess that she used to be," Betty Ellis wrote in her memoir.

"William discussed the situation with me. He and I were very close and we wanted what was best for Aunty Perle."

The *Washington Star* broke the news on January 1, 1974, of Perle's upcoming departure. "I feel fine," Perle gamely insisted, explaining that she was going to Oklahoma to make her brother's life easier, since he had flown to see her twenty times and missed his dogs. She was baffled that people still kept asking her age. "I told Harry [Truman] that I couldn't be ambassador to Luxembourg because I couldn't go before the Senate and say I'd never lied. I have been lying about my age and where I was born so long I'm not sure what the truth is."

Perle wanted to take a last drive around the city that she had loved for many years. Her brother took her out in a van on January 24. But she didn't last long—feeling weak, she asked to go home.

With just a few days left in town, she summoned Betty Beale over for a final goodbye. On February 7, wearing dark glasses, Perle was taken in her wheelchair through Dulles Airport, accompanied by two nurses. Listed on the manifest under the pseudonym A. Jones, she boarded a Braniff International jet to Oklahoma City. Her housekeeper Edna Camper would join her later. "We knew it would be an emotional wrench," Betty Ellis told reporters after the plane took off. "There were no tears. I've never heard her complain. She doesn't give up."

And with that, Perle slipped out of town, never to return. "Washington will miss the colorful hostess whose friendships with presidents and flair for turning a party into an extravaganza made her name a household word," wrote Betty Beale, with sadness. "For her friends, there is a vacuum in the city where before there was warmth."

SETTLING IN TEMPORARILY at Oklahoma's Windemere Nursing Home, Perle adorned her room with autographed photographs of Harry Truman, Dwight Eisenhower, and Lyndon Johnson. Martha Mitchell sent a plant to brighten the surroundings. Trying to remain

relevant, Perle gave an interview to the Associated Press. Stressing that Harry Truman was her favorite president—"He's my hero"—she was not as enthusiastic about Ike. "I did not think he was a great president. But I loved him. I still keep in close touch with Mamie."

She was politically aware enough to be distressed by the swirling scandals surrounding Richard Nixon, and the investigations into his White House staff and Republican friends. But Perle said she remained his admirer and wished people would "leave Mr. Nixon alone."

She was treated like a local heroine. The Oklahoma Senate passed a resolution lauding Perle's "successful efforts at acquainting people throughout the world with the attributes of native Oklahomans." She wasn't a native, but had certainly acted the part. Lieutenant Governor George Nigh personally came by to present the fancy paperwork. Perle credited the Sooner State for her success. "Without Oklahoma, I wouldn't be here. I've come back."

A surprise visitor came by—Ed Vaughn, one of the thousands of soldiers who attended Perle's parties for GIs in Luxembourg. To show how much her hospitality meant to him, he proudly brought along the cherished 1951 letter that Perle had written to his family.

Many friends sent notes and flowers, but Pearl Bailey outdid them all. She turned up in person. En route to Tulsa to tape a TV special, the singer made a hundred-mile detour to visit Perle out of "love for this wonderful creature here." Reporters were invited to witness the reunion. Pearl Bailey didn't just talk—she wanted to sing. As she launched into the spiritual "Never Alone," Perle began softly sobbing. Bailey reached over and took her hand, telling her friend, "If the love that filled the nursing home of Perle Mesta could be packaged and sent around the world, there would be no further wars or cross words."

The singer asked the nurses, her police escort, reporters, and cameramen to join her in the chorus of "In the Garden." She whispered to Perle, "Washington is lonelier without you." A UPI photographer captured Bailey solicitously engaging a frail but smiling Perle in conversation.

A few weeks later, Perle's brother moved her into a wheelchair-accessible house with four bedrooms and an elaborate flower and vegetable garden. Perle was joined by three nurses and Edna Camper.

Angela Lansbury, who was performing in Oklahoma City in the musical *Gypsy*, made time for her old friend. "Miss Lansbury and Aunt Perle had kept a mutual friendship going for years," Perle's great-niece Lizzie Tyson wrote to me in an email. "Even when Aunt Perle became frail, she came to visit her and was of comfort to her."

Perle was dressed in a pink lamé gown for Lansbury's visit, although she wore dark glasses and looked confused when they posed for local TV reporters. The actress, trying to make the best of an awkward moment, brightly told the press, "I've learned a lot about being photographed from Mrs. Mesta. She always told me to keep my head up and smile."

When Sophia Fleischer flew to Oklahoma to visit Perle, she was relieved to see her former boss. "Mrs. Mesta not as bad as expected," she wrote in her datebook. "Edna served a lovely lunch. We visited afterwards."

Perle was weary, but old habits die hard—she still followed Washington news. So she knew that Richard Nixon had been forced to resign on August 8 and was pardoned by his successor, President Gerald Ford. A local friend of Perle's, Hallie Ward, gave the press an update on her condition in October. "She is very alert, as charming as ever, and gets so carried away, it's like she was planning parties in the old days. She was very disturbed by Watergate and thought they were picking on Mr. Nixon. But now she's all for Mr. Ford."

When Washington's latest *Green Book* was published in October, Perle had been dropped from the list. She officially no longer had a role in the capital.

She lingered for a few more months, a public life quietly winding down. At 10:30 p.m. on March 16, 1975, Sophia Fleischer received the phone call she had been expecting and dreading, informing her

that Perle had died at Baptist Medical Center. Her brother was by her side, holding her hand at the end.

Perle spent fifty years praising Oklahoma but left instructions to be buried beside George Mesta at Homewood Cemetery in Pittsburgh, some 1,200 miles away. As much as she relished a big life and noteworthy friends, she requested a small private service.

Only seven family members and two friends attended. A Christian Scientist from a local church held a graveside reading. Patti Birge, ex-wife of Perle's nephew Bill Tyson, flew out from Washington. "I was invited," she recalls. "I remember standing out in the cemetery. I remember it being windy and noting how beautiful Pittsburgh was."

Perle's will was filed in Denton County, Texas. An inventory of her stocks, cash, and personal effects revealed that the woman once said to worth more than $50 million had run through almost all of it; the value of what remained was only $466,150 (equivalent to $2.7 million today). Her fabulous jewelry, valuable Aubusson rugs, and antiques had already been sold.

Her estate was divided among her brother, her niece Betty Ellis, her nephew Bill Tyson, Bill's daughter Lizzie Tyson, and the loyal Edna Camper, who died just three months after Perle's death. An attorney for Perle's brother told the *Washington Post* that Perle had previously left money in trusts to unknown beneficiaries, and added, "She also made some bad investments a few years ago and lost quite a bit."

More than 750 stories on Perle's death ran in American newspapers, from the *Greeley* (Colorado) *Daily Tribune* to the Fairbanks, Alaska, *Daily News-Miner* to North Carolina's *High Point Enterprise*. Every publication got her age wrong: she was actually ninety-two. Some writers riffed, quipping that Perle "has left us for that Great Dinner Party in the Sky" or was now "hiring Gabriel, with his trumpet, for her bashes," or imagining her last words as "The party's over."

Newspapers in cities where she lived claimed her as their own, such as the *Pittsburgh Post-Gazette* ("Perle Mesta as Pittsburghers

374 | THE WOMAN WHO KNEW EVERYONE

Knew Her") and the *Newport Mercury* ("Perle Mesta Dies at 85; Was Newport resident"). The *Daily Oklahoman* proudly reported that Perle's former neighborhood, a place she had last lived in prior to World War I, had been renamed Mesta Park. There was hometown pride in these stories—a sense that the fairy dust of Perle's life had scattered, casting a magical glow on every life she touched, every place she went.

She was gone. But some friends and advocates felt Perle had not received her due. In 1982, Oklahoma governor George Nigh and Oklahoma City television station manager Ben West asked the Postal Commission to honor Perle Mesta with her likeness on a stamp. With roles as a diplomat, feminist, philanthropist, beloved hostess, and friend of presidents, they thought she was worthy.

The Postal Commission turned them down on the grounds that a decade needed to pass after a subject's death before the person could be considered; Perle died only seven years prior in 1975. The group redoubled their efforts in 1986, recruiting House Speaker Carl Albert, an Oklahoma native, to persuade politicians to join the cause. The signatures on the petition were a who's who of Perle's life: Pearl Bailey; Bob Gray; journalists Art Buchwald, Malvina Stephenson, and Hope Ridings Miller; actor Ginger Rogers; diplomat Leonore Annenberg; TV hosts Merv Griffin and Art Linkletter; a half dozen congressmen; and three presidents.

Given Richard Nixon's standoffish reaction to Perle during her lifetime, he wrote a surprisingly appreciative letter of support.

> *Perle was well-known as a great Washington hostess and a great American lady. What is less well-known, however, is that she had a shrewd grasp of the great foreign policy and domestic issues of the post-war period.*
>
> *Her famous parties were not the usual sterile Washington affairs but rather carefully conceived combinations of leaders from the whole range of the political ad professional spectrum. Unless a*

party featured the proper mix of light food and weighty conversation, Perle considered it a failure.

Gerald Ford was not part of Perle's charmed circle but he knew her from afar and wrote from the perspective of a capital insider:

During most of my 28 plus years in Washington as a member of the Congress, as Vice President and President, Perle Mesta was highly respected and widely known for her broad and constructive interest in the American political scene.

Jimmy Carter had been a peanut farmer, state senator, and Georgia's governor during Perle's Washington reign. But he pressed for the honor in acknowledgment of her feminist achievements.

Ms. Mesta did much to aid the cause of women's rights throughout the world . . . She also was instrumental in getting a major political party's endorsement of an equal rights amendment for women for the first time.

Those famous names didn't carry enough weight to sway the US Postal Citizens Advisory Committee, which turned down the request in 1986 without an explanation. The next year, the group tried again. The *Washington Post* published an article ("For Perle Mesta, Postage Is Overdue") urging the commission to act. "Though she died in 1975, Mesta still lives on more than a scratchy 78 rpm record or a fading video or a cashed campaign check."

There was competition for these honors, and Perle lost to an impressive group. In 1986, stamps featured abolitionist activist Sojourner Truth, suffragette lawyer Belva Ann Lockwood, and *Gone with the Wind* author Margaret Mitchell. In 1987, Julia Ward Howe, author of "The Battle Hymn of the Republic," and Mary Lyon, the founder of Mount Holyoke, were honored. All of these women had

been dead for more than sixty years—the Post Office was playing catch-up.

Perle never got her stamp. She joined a long line of accomplished American women who operated successfully in a man's world, were often underestimated and belittled, and yet triumphed on their own terms. Harry Truman and Lyndon Johnson took Perle seriously, but few others did. She was mocked for her appearance ("plump," "dumpy") and rustic pedigree, but Perle possessed an uncanny ability to understand politicians—their egos, their needs—and knew how to artfully sway them into compromising and working together. Her ebullient personality drew people to her side.

A tireless advocate for the Equal Rights Amendment—which still has not passed nearly fifty years after her death—she was prescient, speculating that a Black man would reach the presidency before a woman.

Perle wanted to be known for her feminist achievements and feared, correctly, that she would be remembered for her parties—if she was remembered at all. Ask anyone under fifty today about Perle Mesta, and you get a blank stare. But in her day—and oh, what a day it was—she was one of the most admired and famous women in America. Frustrated by the obstacles put in her way, yet fundamentally happy, Perle loved her life and tried to do good. That would have to be enough.

Acknowledgments

I became fascinated as a teenager with newspaper society columns, which featured a glamorous world far from my hometown of Brighton, New York, a suburb of Rochester. Perle Mesta often played a starring role, identified as a friend of three presidents, former envoy to Luxembourg, Equal Rights Amendment crusader, and fabulous party giver. Unlike most grande dames, she didn't come across as intimidating or superior. She exuded fun, making her someone you'd want to meet.

By the time I moved to Washington as an editor for Gannett News Service in 1978, Perle had been dead for three years. Her name still came up in conversations as a memorable figure who had once held influence in the capital. But as the years went by, she faded into obscurity.

My curiosity reemerged in 2019 when New York City Center announced a revival of the 1950 Irving Berlin musical *Call Me Madam*, written by Howard Lindsay and Russel Crouse, inspired by Perle Mesta's life as a diplomat. My friend and NYU colleague Perri Klass and I both subscribe to the Encores! series. When I mentioned to Perri my search for a new book subject, she immediately replied, "How about Perle Mesta?"

Thank you, Perri. That offhand suggestion launched me into a fascinating five-year quest to learn about this human dynamo, a feminist force in the 1940s, '50s, '60s, and early '70s. Perle wrote a best-selling autobiography in 1960, but there has never been a fully reported account of her entire eventful life. As a biographer, it is a

DGMENTS

cover an iconic American figure and return her

n history.

Gail Hochman, who has handled all of my

...act with Grand Central editor Gretchen Young,

...no nas been an enthusiastic champion of my work and skillfully edited my biography of Bunny Mellon. After Gretchen left to start her own publishing imprint, the capable editor Suzanne O'Neill took over the project. I am grateful for her astute suggestions to shape the original doorstop of a book. I want to thank editorial assistant Morgan Spehar for shepherding it through publication and thorough copyeditor Lori Paximadis.

Sisters Elizabeth Christian and Linda Picasso, Perle's great-nieces, and Linda's husband Gino Picasso greeted me with a dining room table stacked high with Perle memorabilia and photographs. Linda lived with Perle in the early 1970s; Perle launched Elizabeth as a debutante in Washington and Manhattan. Both have been very generous with their time and patient with my endless questions.

Alyson Krueger, one of my former NYU journalism grad students, is a prodigious, talented contributor to the *New York Times* Style section. Nonetheless, she made the time to fact-check this book and my two previous biographies, saving me from numerous errors.

Sisters Luci Baines Johnson and Lynda Johnson Robb were invaluable sources of information. Perle Mesta was close to Lyndon and Lady Bird Johnson and knew the couple's daughters during their formative years. Lynda spoke with me at her Virginia home, pointing out antique French furniture that had once belonged to Perle, and Luci gave me a long phone interview from Texas.

Serendipity plays a role in landing interviews. When I shared the stage with architect Yann Weymouth at a book panel event in St. Petersburg, Florida, he asked what I was working on. The next day, he arranged for me to interview his friend Aaron Fodiman, publisher of *Tampa Bay Magazine*, who knew Perle Mesta in the 1960s. What a great first interview. At the Rancho Mirage Book Festival, director

Jamie Kabler made sure that I met author Susan Eisenhower, grand-daughter of Ike and Mamie, who attended Perle's parties with her grandmother, and she agreed to speak with me.

Several plugged-in Washington women shared their memories of the city's political-social world: journalist, JFK friend, and Lady Bird liaison Marie Ridder; *Washington Star* columnist turned Reagan White House chief of protocol Selwa "Lucky" Roosevelt, who covered Perle's events in the 1950s; and folk art expert Martha Bartlett, who famously introduced Jacqueline Bouvier to Jack Kennedy. Journalists Ann Blackman and Kandie Stroud discussed their experiences interviewing Perle.

Butch Fleischer, the son of Perle's secretary Sophia Fleischer, lent me his mother's datebooks with her handwritten commentary, which helped me reconstruct Perle's final years. Author Lance Morrow, the son of Perle's favorite reporter, *Philadelphia Inquirer* columnist Elise Morrow, gave me insight into her experiences. Bonnie Buchanan Matheson, who was given a debutante party by Perle and whose parents were the hostess's close friends, shared her memories.

Knowledgeable librarians are invaluable to authors. I am very grateful to Randy Sowell and Tammy Williams of the Harry S. Truman Presidential Library, Robert Bear of the Texas and Galveston History Center, Linda Smith and Ariel Turley at the Dwight D. Eisenhower Presidential Library, and the staff of the Library of Congress and the National Archives.

Steve Lackmeyer, a veteran reporter at *The Oklahoman* and coauthor of the book *Skirvin*, generously met with me and provided local knowledge. Ragan Butler of the Skirvin Hotel arranged a tour.

AND NOW I come to the difficult part: writing about my husband, Walter Shapiro, who died on July 21, 2024, at age seventy-seven from a combination of chemo for a newly diagnosed cancer plus COVID and pneumonia.

We were intimately involved with each other's work. Walter read and edited every draft of my four books, and I did the same for his two books. He thought this was a marvelous way to spend time together and was always striving to make the prose better, to add a nuanced historical detail or an inside joke. If you see a particularly well-written sentence in this book, or something that makes you smile, he likely had a hand in it.

We met in 1972 in Ann Arbor, when I was a senior at the University of Michigan and he was a graduate history student running for Congress. (He lost.) We ran into each other again in Washington in 1978: He was then a speechwriter for a Cabinet secretary and I was new to the city as a journalist. We married in 1980. During our four decades together, we had great adventures and took exotic trips. But the best part of our relationship was our nightly two-hour dinners. Over a bottle of wine, we talked about everything and marveled that we never ran out of things to say to one another.

As a political columnist, Walter wrote for numerous publications, including the *Washington Post*, *Newsweek*, *Time*, *USA Today*, *Esquire*, and *Politics Daily*. At the time of his death he was writing columns for the *New Republic* and *Roll Call*, plus teaching a popular course at Yale on presidential politics and the media. This wasn't work to him; covering politics was a calling. He relished his trips to New Hampshire, Iowa, and South Carolina, getting to know candidates and talking to voters, covering eleven presidential races.

Walter, who had a great sense of humor, performed stand-up comedy for several years. Our relationship wasn't perfect, but we could never stay mad for long, because he always made me laugh.

For my Perle Mesta biography, Walter came along enthusiastically to the Harry S. Truman Presidential Library in Independence, Missouri; the Dwight D. Eisenhower Presidential Library in Abilene, Kansas; Oklahoma City, where Perle's father William Skirvin built the city's grand hotel, the Skirvin; and to Newport, Rhode Island, the site of Perle's early social triumphs. He relished tracking down

regional James Beard restaurant nominees so we could eat well wherever we went.

As a political junkie, he collected thousands of books, which took over our apartment. As I plunged into relearning American history, nothing gave him more pleasure than pulling out just the right volume at the right time. I couldn't have written this book—or gotten through forty-plus years of a happy life—without his love and support.

MY MOTHER ADELLE Gordon, at nearly ninety-nine years old, is remarkable, reading the *New York Times* and the latest fiction bestseller daily, enjoying life. My nephews and their families bring great joy to us all: Jesse Gordon, his wife Meg Wolf, and their son Ozzy; and Nate Gordon, his partner Jenny Rakochy, and their daughter Sadie. Special thanks to Nate, a journalist and photo editor, who designed the photo layout and arranged the photos for my four books. I am grateful for many decades of love and friendship with my sisters-in-law, Sarah Cooper-Ellis and Amy Shapiro. My cousins have been consistently terrific: Debbie and Marty Greenberg, Mindy and Mark Sotsky, Andy and Suzanne Pinkes.

My father David Gordon died in 2021 at age ninety-eight, and his mischievous spirit remains with me. My brother Bart Gordon, who died in 1995, was a charismatic lawyer and blues radio DJ, gone way too soon.

I am lucky to have wonderful friends: Michelle Stoneburn; Mary Macy; Susan Birkenhead; Maralee Schwartz; Mandy Grunwald; Christine Doudna and Rick Grand-Jean; Rita Jacobs and Jim Wetzler; Jane Hartley and Ralph Schlosstein; Josh Gotbaum and Joyce Thornhill; Alexis Gelber and Mark Whitaker; Tom Curley; Nancy Leonard and Urban Lehner; David Ignatius and Eve Thornberg; Jim and Deb Fallows; David and Peggy Weisbrod; Jodie-Beth Galos and Michael Zwerling; Patricia Bauer and Ed Muller; Judy Miller; Kate Feiffer; Orin Kramer; Elaine Kamarck; Lindi Oberon;

Jill Lawrence and John Martin; Ben Cooper and Payton McCarty-Simas; Matt Cooper; Deborah Gurewich and Akos Svilvasi; Jeff Greenfield and Dena Sklar; Joe Klein and Victoria Kaunitz; Marian Carey; Connie Casey and Harold Varmus; Michael Shapiro and Susan Chira; Wendy Gordon and Larry Rockefeller; Amy Nathan; Diane Yu; Brooke Kroeger; Rachel Swarns; Carol Sternhell; Liz Loewy and Paul Giddens; Caroline Miller and Eric Himmel; Emily Yoffe and John Mintz; Richard, Pat, and Katharine Cavanagh; Nancy and Charlie Kantor; Regine Hollander; Nancy Hollander; Rosina Barker; Diane McWhorter; Louise Grunwald; Joseph Girven; Bryan Huffman; Thomas Lloyd; Jane MacLennan; Philip Marshall; Ben O'Connell; Gary Greengrass; Betsey and Stone Roberts; Geraldine Brooks; Mara Liason; Melinda Henneberger and Bill Turque; Linda Fairstein and Michael Goldberg; Swoosie Kurtz; Tamar Lewin and Robert Krulwich; Gail Gregg; Charlotte Moore; Garrett Epps; Jonathan Alter; Jean and Fergus Bordewich; James Hohmann and Annie Linskey; Christine Rosen; Amy Cunningham and Steven Waldman; Michael Waldman; Michael Tomasky; Karen Tumulty; Rick Ridder and Joanie Braden; Dan and Becky Okrent; Jonathan and Terry Miller; Carla Rapoport; Doug Brunt; Steven Levy and Teresa Carpenter; Bruce Buschel; Mark Starr; Michael and Kate Walsh.

Special thanks to the doctors and medical professionals involved in Walter's care through the years: Kanti Rai, Manish Vira, Mark Podwal, Joanna Rhodes, Iris Sherman, Jacqueline Barrientos, Markus Plate, Leslie Rudolph, Carl Crawford, and Elizabeth Harrington.

I can still see the smiles and hear the laughter of Stephen Stoneburn, Howard Fineman, Margo Lion, Michael Barker, Melvin Silverman, Neil Hollander, Charlie Peters, Tony Horwitz, Michael Delaney, Jere Couture, Jason Epstein, Dotty Lynch, Henry Hubschman, Hillary Ballon, Glenn Roberts, Gordon Stewart, Ron Silver, Ward Just, and Wendy Wasserstein. I miss them all.

Sources

Perle Mesta died in 1975 at the age of ninety-two, so her contemporaries are long gone. But from the 1920s until her death, she was one of the most famous women in America. Look her up in just one database—newspaperarchive.com—and Perle Mesta (or Pearl Skirvin or Mrs. George Mesta) is mentioned in more than 98,000 newspaper articles.

This biography is based on extensive archival research. I was also fortunate to be able to interview Perle Mesta's family members, along with spry eighty- and ninety-plus-year-old Washington insiders who knew her, as well as her friends' children and grandchildren, including LBJ's daughters Lynda Johnson Robb and Luci Baines Johnson and Dwight Eisenhower's grandchild Susan Eisenhower.

My research file, listing every newspaper and magazine article that I read for this book, runs more than 600 single-spaced pages. In the interest of making the chapter notes manageable, I am listing the most important and relevant stories. The quotes attributed to her come from Perle's letters, lectures, essays, innumerable interviews, and press conferences and her 1960 autobiography, as listed in specific chapters.

Perle Mesta had particularly close relationships with three presidents. At the Harry S. Truman Library in Independence, Missouri, it took four days to read through the large quantity of correspondence, journals, and material related to Perle. The Dwight Eisenhower Library in Abilene, Kansas, contains numerous letters between Perle and Mamie and Dwight Eisenhower. The Lyndon Baines Johnson

Library has a trove of oral histories, available online. The Richard Nixon Presidential Library also contains several mentions of Perle Mesta.

The National Archives in College Park, Maryland, home of the State Department's records, retains hefty boxes of declassified cables and memos chronicling Perle Mesta's time as US minister to Luxembourg. The Library of Congress houses the National Woman's Party records as well as material from Perle Mesta's friends, including Clare Boothe Luce and Hope Ridings Miller.

The Oklahoma Historical Society, in Oklahoma City, has family material including Perle's fifty-plus-page journal from her 1955 world tour and a lawyer's account of forgery by one of Perle's trusted employees.

The New-York Historical Society contains the reference archive of Time Inc., which includes extensive reporters' dispatches for a March 14, 1949, Perle Mesta cover story plus reporting for other features on Perle through the mid-1970s.

Perle Mesta's niece Betty Ellis wrote an unpublished memoir, "Years Remembered," made available by her daughters, Elizabeth Christian and Linda Picasso. Sophia Fleischer, Perle's secretary for a decade, kept detailed datebooks lent by her son Butch Fleischer. Timothy Crouse passed along information from the journals of his father Russel Crouse.

The New York Public Library has issues of *McCall's* with Perle Mesta's columns from 1962 to 1965. The 1957 CBS *Playhouse 90* docudrama about her life, "The Hostess with the Mostes'," is available on YouTube.

Perle Mesta's regular chroniclers included Betty Beale, the *Washington Star* society editor, and Hope Ridings Miller, the *Washington Post* society editor and *Town & Country* columnist. The *Washington Star* mentioned Perle in more than five hundred stories dating back to 1918; the *Washington Post* ran four hundred stories dating to 1941.

Inez Robb wrote her first article, under the pseudonym Nancy Randolph, about "Mrs. George Mesta" in 1928 for the *New York Daily News* and interviewed Perle frequently for her long-running column, Assignment: America, which appeared in 140 newspapers.

Oklahoma journalist Malvina Stephenson, who ran a Washington news bureau serving Oklahoma and Kansas newspapers, was a personal Perle favorite due to their home state connection. Perle doted on the *Philadelphia Inquirer*'s Elise Morrow. *WWD*'s Kandy Shuman (Kandie Stroud) only began writing about the hostess in 1968 but was one of the few summoned to visit the ailing Perle before she left Washington in 1974.

Perle appeared regularly in the works of humor columnists Art Buchwald and George Dixon, syndicated political columnists Drew Pearson and Westbrook Pegler, and society and gossip columns by Hedda Hopper, Suzy (Aileen Mehle), Ymelda Dixon, and Cholly Knickerbocker (Maury Paul, Igor Cassini).

Two authors have done an excellent job chronicling Perle Mesta's experience as a diplomat: Paul Lesch's 2001 volume, *Playing Her Part: Perle Mesta in Luxembourg*, and Philip Nash's detailed twenty-five-page chapter in his 2019 book, *Breaking Protocol: America's First Female Ambassadors, 1933–1964*. Their books showed me the way, and I have tried to build on their work.

Named Pearl at birth in 1882, she changed the spelling to Perle in 1939. In this book, she is referred to as Pearl until she takes on what she believed to be a more sophisticated and distinct moniker.

INTRODUCTION: BROADWAY BOUND
Books
Mary Ellin Barrett, *Irving Berlin: A Daughter's Memoir* (Simon & Schuster, 1994).
Ethel Merman with George Eells, *Merman: An Autobiography* (Simon & Schuster, 1978).
Perle Mesta with Robert Cahn, *Perle: My Story* (McGraw Hill, 1960).

Archives and Documents

New-York Historical Society. Courtesy of the New-York Historical Society
and Time USA LLC. © 1949 TIME USA, LLC. All rights reserved.
Used under license.

Russel Crouse's diary, courtesy of his son Timothy Crouse.

Articles

March 14, 1949, *Time*, "Washington Hostess Perle Mesta."

June 22, 1949, *New York Times*, "Mrs. Mesta Named Luxemburg Envoy," by
Bess Furman.

July 2, 1949, *Philadelphia Inquirer*, "Ethel Merman and Husband Bob off to
Colorado," by Ed Sullivan.

July 4, 1949, *Philadelphia Inquirer*, "Envoy Mesta Plans to Enjoy Overseas
Job," by Elise Morrow.

July 5, 1949, *Knickerbocker News*, "Perle Mesta to Be Third Woman Envoy,"
by Robbie Johnson.

July 9, 1949, *International Herald Tribune*, "A Washington Hostess Goes to
Luxembourg."

July 10, 1949, *Miami News-Record*, "From Duchy to Duchy."

July 21, 1949, *Tucson Daily Citizen*, "More Dignity Wanted," by Robert
Ruark.

Aug. 7, 1949, *Washington Evening Star*, "Exclusively Yours," by Betty Beale.

Aug. 17, 1949, *Christian Science Monitor*, "Vinson Praises Mrs. Mesta at
Sailing."

Aug. 26, 1949, *New York Herald Tribune*, "News of the Theatre," by Bert
McCord.

Sept. 3, 1949, *Washington Post*, "The New Lindsay & Crouse-Ethel Merman-
Irving Berlin Will Be Titled 'Call Me Madam,'" by Leonard Lyons.

Sept. 11, 1949, *Washington Star*, "Miss Merman to Play Perle Mesta Type in
Next Musical by Lindsay and Crouse," by Mark Barron.

Dec. 30, 1949, *New York Times*, "Berlin Writing Show on Mrs. Mesta's Life."

Sept. 20, 1950, *Boston Globe*, "Ethel Merman in the Crouse-Lindsay Berlin
Hit," by Cyrus Durgin.

Oct. 1950, *Cosmopolitan*, "Ethel Merman Hit Parade," by Maurice Zolotow.

Oct. 13, 1950, *New York Times*, "Night at the Theater: Ethel Merman as an
American Envoy in "Call Me Madam," by Brooks Atkinson.

Oct. 16, 1950, *Wall Street Journal*, "Dame Ethel."

Oct. 26, 1950, *New York Times*, "Mrs. Mesta Enjoys Merman Musical."

CHAPTER 1: A TEXAS/OKLAHOMA UPBRINGING

Interviews

Elizabeth Christian, Linda Picasso

Books

Eliot V. Banks and William Crew Webb, *Reports of Cases Argued and
Determined in the Supreme Court of Kansas* (1923).

Betty Ellis, "Years Remembered" (unpublished family memoir).

Judith Walker Linsley, Ellen Walker Rienstra, and Jo Ann Stile, *Giant under the Hill: A History of the Spindletop Oil Discovery* (Texas Historical Association, 2002).

Herbert Molloy Mason Jr., *Death from the Sea: The Galveston Hurricane of 1900* (Dial Press, 1972).

Perle Mesta with Robert Cahn, *Perle: My Story* (McGraw Hill, 1960).

Jack Money and Steve Lackmeyer, *Skirvin* (Full Circle Press, 2009).

Sylvia Jukes Morris, *Rage for Fame: The Ascent of Clare Boothe Luce* (Random House, 1997).

Nellie Kitchel Skirvin, *The Skirvin-Kitchel Families of Oklahoma* (Spindletop, 1902).

Jean Hurt Thomas, *Settlements on the Prairie: A History of the Alta Loma, Santa Fe, and Algoa Communities, 1830–1985* (Gary Thomas, 1998).

Archives and Documents

Lyrics from *Call Me Madam*: "The Hostess With The Mostes' On The Ball" from the Stage Production CALL ME MADAM Words and Music by Irving Berlin Copyright © 1950 BERLIN IRVING MUSIC CORP. Copyright Renewed All Rights Administered by UNIVERSAL MUSIC CORP. All Rights Reserved Used by Permission Reprinted by Permission of Hal Leonard LLC.

Kansas State Census Records (re: Pearl Skirvin's birthday).

LBJ Presidential Library: Perle Mesta oral history with Joe B. Frantz, Oct. 4, 1971.

New-York Historical Society. Courtesy of the New-York Historical Society and Time USA LLC. © 1949 TIME USA, LLC. All rights reserved. Used under license.

Oklahoma Historical Society: Perle Mesta interview with Pen Woods, Raymond Fields, Jan. 31, 1970.

Santa Fe Area Historical Foundation: Historical Sketches of the Communities along the Santa Fe, 1882–1974.

Social Security Index (re: Pearl Skirvin's birthday).

Texas Historical Association: History of Spindletop; History of Alta Loma.

Articles

April 28, 1895, *Galveston Daily News*, "Alta Loma."

Sept. 21, 1900, *New York Times*, "Conditions in Small Towns."

Nov. 16, 1903, *Galveston Daily News*, "Big Oil Land Deal."

March 28, 1906, *Galveston Daily News*, "Gulf, Colorado and Santa Fe Railroad."

Nov. 9, 1906, *Kansas City Globe*, "Miss Pearl Skirvin Will Study Music under Sherwood."

Jan. 12, 1908, *Daily Oklahoman*, "Social Notes."

Aug. 31, 1909, *Oklahoma City Daily Pointer*, "Skirvin and Daughter."

Nov. 11, 1909, *Oklahoma City Daily Pointer*, "Plans Finest Hotel."

June 11, 1911, *Daily Oklahoman*, "Oklahoma City Society Girl Will Go on Stage," by Edith C. Johnson.

Oct. 15, 1911, *Philadelphia Inquirer*, "Of Such Are Stars Made."

Dec. 31, 1911, *Washington Evening Star*, "Won Father Over."

March 12, 1912, *Washington Post*, "Success as an Actress."

July 10, 1912, *Daily Oklahoman*, "Add Five Stories to Skirvin Hotel."

March 30, 1913, *Daily Oklahoman*, "Oklahoma's Star Back in America."

Oct. 9, 1913, *Houston Post*, "Alta Loma Girl Is with Eltinge."

Dec. 29, 1913, *Daily Oklahoman*, "Society," by Edith C. Johnson.

March 31, 1914, *Variety*, "Movie Passers by."

May 31, 1914, *Daily Oklahoman*, "Empress."

June 1, 1914, *Daily Oklahoman*, "Marguerite Skirvin Is Here on Vacation."

Aug. 15, 1914, *Billboard*, "Plays and Players," by Dixie Hines.

Dec. 5, 1914, *Billboard*, "Feature Films Reviewed, Tyrone Power in Aristocracy."

Dec. 26, 1914, *Billboard*, "Marguerite Skirvin, Formerly of the Lyceum Players, Will Soon Enter Vaudeville."

Jan. 26, 1915, *Hartford Courant*, "Margaret Skirvin, the Juvenile Lead Woman of the Players Had a Fortunate Part in 'Baby Mine.'"

June 10, 1916, *Billboard*, "Local Color, Provided by Miss Skirvin, Metro's Western Girl."

June 24, 1916, *Muskogee Times–Democrat*, "The Quitter."

Sept. 10, 1916, *Syracuse Herald*, "Review of the Upheaval."

March 14, 1949, *Time*, "Washington Hostess Perle Mesta."

Sept. 19, 1955, *Greenville, S.C. News*, "Mrs. Perle Mesta Not Offended by 'Call Me Madam,'" by Westbrook Pegler.

Feb. 29, 1976, *Galveston Daily News*, "Clara Norris."

Feb. 29, 1976, *Galveston Daily News*, "Santa Fe School Has Very Rich History."

CHAPTER 2: THE MAN OF STEEL: GEORGE MESTA

Books

Cleveland Amory, *Who Killed Society?* (Harper & Brothers, 1960).

Bernadette Cahill, *Alice Paul, the National Woman's Party, and the Vote: The First Civil Rights Struggle of the 20th Century* (McFarland and Co, 2015).

Betty Ellis, "Years Remembered" (unpublished family memoir).

Perle Mesta with Robert Cahn, *Perle: My Story* (McGraw Hill, 1960).

Jack Money and Steve Lackmeyer, *Skirvin* (Full Circle Press, 2009).

J. D. Zahniser and Amelia R. Fry, *Alice Paul: Claiming Power* (Oxford University Press, 2014).

Archives and Documents

Library of Congress: National Woman's Party records.

New-York Historical Society. Courtesy of the New-York Historical Society and Time USA LLC. © 1949 TIME USA, LLC. All rights reserved. Used under license.

Oklahoma Historical Society: Perle Mesta.
University of Michigan Center for the History of Medicine: The American
 Influenza Epidemic of 1918–1919.

Articles

March 27, 1915, *Baltimore Sun*, "Forces Grant to Wife."
March 29, 1915, *Dixon Evening Telegraph*, "Injured Hubby Is Provident."
May 29, 1915, *Oklahoma News*, "Bankruptcy Case against W. B. Skirvin."
Sept. 14, 1915, *Pittsburgh Post-Gazette*, "Beautiful Pittsburgh Woman Who
 Ends Marital Troubles with Poison."
Sept. 20, 1915, *Town & Country*, "In Love with the Man Who Starts the
 Play."
Jan. 13, 1917, *Daily Oklahoman*, "Lure of Oil Pulls Oklahoman Back in the
 Game."
Feb. 13, 1917, *New York Times*, "George Mesta Marries."
Feb. 13, 1917, *Pittsburgh Post*, "Pittsburgher Married Yesterday in New York."
Feb. 17, 1917, *Wichita Weekly Eagle*, "Oil Wizard, Rugged Character of
 Oklahoma."
Nov. 19, 1917, *Daily Oklahoman*, "Society."
March 15, 1919, *Reno Evening Gazette*, "Scions of Wealth in Divorce Court."
May 27, 1919, *Washington Post*, "Society."
July 17, 1919, *Pittsburgh Post-Gazette*, "Squirrel Hill Home Bought for
 Home."
July 19, 1919, *Pittsburgh Post-Gazette*, "Plan European Trip."
Nov. 28, 1919, *Washington Times*, "Navy Relief Ball at the Willard."
March 17, 1920, *New York Daily News*, "Screen Star Bride of Divorced Oil
 Man."
March 17, 1920, *Washington Evening Star*, "Marriage of Marguerite A.
 Skirvin."
May 2, 1920, *Washington Post*, "DC Architect Plans 2 Homes."
March 8, 1921, *Pittsburgh Gazette*, "Entertainments in Capital in Honor of
 Pittsburghers."
Nov. 3, 1921, *Oklahoma City Times*, "Young Skirvin to Enter Oil Game in
 State."
April 22, 1922, *Washington Times*, "Coolidge Lunch."
Jan. 13, 1923, *Buffalo Times*, "Social Life in Washington" (AP).
April 22, 1925, *Pittsburgh Press*, "Mesta Machine Company Head Dies
 Suddenly."
April 23, 1925, *New York Times*, "George Mesta, Noted Engineer, Dies
 Here."
July 19, 1925, *New York Times*, "Mrs. John Henderson."
June 5, 1952, *Brooklyn Eagle*, "Perle Mesta Hits Political Critics of Our
 European Allies."
June 6, 1952, *Herald Tribune*, "Mrs. Mesta Advises against U.S. Criticism."
March 17, 1957, *Washington Post*, "Can 90 Minutes Make the Most of Mesta
 Saga?" by Marie McNair.

January 1965, *McCall's*, "Perle Mesta's Party Notebook: New Year's Eve
Parties—Somber and Gay," by Perle Mesta.
Spring 1965, *Oklahoma Today*, "Madam Mesta," by Madelaine Wilson.
March 19, 1972, *Boston Globe*, "Perle Mesta: Washington's Hostess with the
Mostest," by Marian Christy.
July 10, 1977, *New York Times*, "Alice Paul, a Leader for Suffrage and
Women's Rights, Dies at 92."
Jan. 9, 1984, *Pittsburgh Post-Gazette*, "History of Mesta Machine Co." (*Wall
Street Journal*).
June 19, 2021, *Pittsburgh Post-Gazette*, "Potential Buyers with Different
Goals Assess Bryce-Mesta Home," by Kevin Kirkland.

CHAPTER 3: STARTING OVER

Interview
Luci Baines Johnson

Books
Wayne Brown, *Reconstructing Historic Landmarks: Fabrication, Negotiation,
and the Past* (Routledge, 2018).
David Burner, *Herbert Hoover: A Public Life* (Alfred A. Knopf, 1979).
Deborah Davis, *Gilded: How Newport Became America's Richest Resort* (Wiley,
2009).
Perle Mesta with Robert Cahn, *Perle: My Story* (McGraw Hill, 1960).
Jack Money and Steve Lackmeyer, *Skirvin* (Full Circle Press, 2009).
Sylvia Jukes Morris, *Rage for Fame: The Ascent of Clare Boothe Luce* (Random
House, 1997).

Archives and Documents
New-York Historical Society. Courtesy of the New-York Historical Society
and Time USA LLC. © 1949 TIME USA, LLC. All rights reserved.
Used under license.
Oklahoma Historical Society: Perle Mesta file.
Senator John Heinz History Center: History of Mesta Co., Annual Reports
1934.

Articles
Feb. 21, 1924, *Christian Science Monitor*, "Women's Party Leader in Boston."
Aug. 17, 1924, *New York Times*, "Women Will Strive for a Congress Bloc."
April 23, 1925, *Pittsburgh Post-Gazette*, "Mesta Funeral to Be Held Here."
May 11, 1925, *Pittsburgh Press*, "George Mesta Leaves Millions."
July 19, 1925, *Pittsburgh Post-Gazette*, "Widow Rejects Will of George
Mesta to Get Half of Estate."
July 28, 1926, *Washington Evening Star*, "Mrs. Mesta to Europe."
Oct. 13, 1927, *Washington Evening Star*, "Wedding of Miss Helen Eakin to
Milton Eisenhower."
Nov. 17, 1927, *New York Times*, "Dance for Rosa Ponselle."

Dec. 9, 1927, *Washington Evening Star*, "President and Mrs. Coolidge Receive Social and Political Leaders."

March 17, 1928, *Oklahoma News*, "Member of National Music League."

April 20, 1928, *Washington Evening Star*, "Society."

June 16, 1928, *New York Times*, "Curtis Likes Racing and Indian History."

July 30, 1928, *New York Times*, "Saratoga Racing Season to Be Inaugurated Today."

Sept. 28, 1928, *Oklahoma News*, "Curtis Arrives for Fair Talk."

Oct. 22, 1928, *New York Daily News*, "Sparklers Set for Diamond Horseshoe," by Nancy Randolph.

March 5, 1929, *Washington Evening Star*, "Brilliant Throng at Inaugural Ball."

July 29, 1929, *Syracuse Herald*, "Races Bring Society Set to Newport."

Aug. 25, 1929, *New York Herald Tribune*, "Resort Seasons Largest Ball Given by Stuart Duncans."

March 13, 1930, *New York Herald Tribune*, "Mrs. George Mesta Will Occupy the Rocks."

April 23, 1930, *Oklahoma News*, "Skirvin Sued for $900,000."

July 5, 1930, *Washington Evening Star*, "Mrs. Mesta Hostess Last Night at Brilliant Party."

July 31, 1930, *New York Daily News*, "Social Jostling for Curtis Visit," by Nancy Randolph.

Aug. 16, 1930, *New York Herald Tribune*, "Newport Entertains at Social Affairs for Vice President."

Aug. 17, 1930, *New York Daily News*, "Ochre Court's New Hues Gleam for Society," by Nancy Randolph.

Aug. 23, 1930, *Daily Oklahoman*, "Skirvin to Erect Skyscraper Hotel."

Oct. 1, 1930, *The Spur*, "The Most Romantic of Arts," by Mrs. George Mesta.

Feb. 1, 1931, *Washington Evening Star*, "Society at Capital Hastens Its Pace."

Feb. 23, 1931, *New York Herald Tribune*, "Newport Homes Opened for Week End."

May 12, 1931, *Daily Oklahoman*, "Mrs. Mesta to Sail for European Tour."

June 1, 1931, *Washington Evening Star*, "Washington Woman Included among 17 Who Will Meet King."

June 10, 1931, *Daily Oklahoman*, "City Girl Received at Court."

June 10, 1931, *Oklahoma News*, "Tess' Tea Table Talk."

June 16, 1931, *Daily Oklahoman*, "Kin Sues Hotel Chief."

June 21, 1931, *Washington Evening Star*, "Presented at Court."

July 11, 1932, *Time*, "The Presidency: The Hoover Week."

Feb. 29, 1936, *New York Times*, "Antonio Scotti, 70, Noted Singer, Dies."

Aug. 5, 1939, *New York Times*, "Mrs. Stephen Pell, feminist leader."

Feb. 9, 1953, *Time*, "Historical Notes: The Head of the Table."

March 1963, *McCall's*, "First Ladies I Have Known," by Perle Mesta.

Sept. 1963, *McCall's*, "There Will Always Be Newport," by Perle Mesta.

Spring 1965, *Oklahoma Today*, "Madam Mesta," by Madelaine Wilson.

Aug. 23, 1968, *WWD*, "The Perle," by Kandy Shuman.

June 29, 1969, *Baltimore Sun*, "The Perle of Washington's Official Party Givers," by Kelly Smith Tunney.

March 19, 1972, *Boston Globe*, "Perle Mesta: Washington's Hostess with the Mostest," by Marian Christy.

May 5, 1981, *New York Times*, "Rosa Ponselle, Dramatic Soprano, Dies."

CHAPTER 4: OKLAHOMA, REVISITED

Books

Betty Ellis, "Years Remembered" (unpublished family memoir).

Perle Mesta with Robert Cahn, *Perle: My Story* (McGraw Hill, 1960).

Jack Money and Steve Lackmeyer, *Skirvin* (Full Circle Press, 2009).

Archives and Documents

Library of Congress: National Woman's Party records.

New-York Historical Society. Courtesy of the New-York Historical Society and Time USA LLC. © 1949 TIME USA, LLC. All rights reserved. Used under license.

Articles

Sept. 19, 1931, *Harlow's Weekly*.

Sept. 20, 1931, *Daily Oklahoman*, "Younger Set Members Pictured at School."

Feb. 11, 1932, *Daily Oklahoman*, "Society," by Dixie Payne.

March 17, 1932, *Oklahoma News*, "Society Leader Seeks Divorce."

March 21, 1932, *Miami Daily News Record*, "Skirvin Settlement Labeled Forgery."

May 1, 1932, *Alva Weekly Record*, "Mrs. Skirvin Loses Suit."

June 27, 1932, *New York Daily News*, "Two Big Openings Today in Chicago," by Nancy Randolph.

July 10, 1932, *New York Daily News*, "Oil Magnate's $25,000 Suit Bares Divorce."

Aug. 21, 1932, *New York Daily News*, "Newport Makes Hey-Hey While Season Shines," by Nancy Randolph.

Aug. 21, 1932, *New York Times*, "Tennis Week Ball Held at Newport."

Aug. 24, 1932, *Pittsburgh Press*, "Capital Capers."

Sept. 8, 1932, *Daily Oklahoman*, "Skirvin to Appeal."

Oct. 7, 1932, *Oklahoma News*, "Ask Receiver for Skirvin Oil Concern."

July 26, 1933, *Oklahoma News*, "Tess' Tea Table Talk."

Aug. 13, 1933, *New York Daily News*, "Like Old Times with Entertainments," by Nancy Randolph.

Nov. 21, 1933, *Miami News Record*, "W. B. Skirvin Victor."

April 29, 1934, *Oklahoma News*, "Mr. Skirvin's Case."

July 22, 1934, *Atlanta Constitution*, "Who and Why and Where in the Amazing New Deal Shuttle of New York Free-for-All Society," by Mary Crane Melish.

July 28, 1935, *Daily Oklahoman*, "Five Floors to Be Ready in November."

Aug. 15, 1935, *Oklahoma News*, "Tess' Tea Table Talk."

Aug. 18, 1935, *Pittsburgh Press*, "Former Pittsburgher Entertains at Newport," by Evelyn Burke.

March 16, 1936, *Washington Post*, "The Washington Scene," by the Poe sisters.

May 17, 1936, *Washington Post*, "The Washington Scene," by the Poe sisters.

Sept. 13, 1936, *Oklahoma News*, "Who's Who among the Democrats in the Landon-Knox Non-Partisan."

Dec. 14, 1936, *New York Daily News*, "Coup is Brought Off by Mrs. George Mesta," by Nancy Randolph.

Sept. 5, 1937, *New York Daily News*, "Mrs. Marguerite Skirvin Adams' Marriage to George Tyson Was the Biggest Surprise of All," by Nancy Randolph.

Sept. 5, 1937, *New York Times*, "Marguerite Skirvin Adams Remarries."

Feb. 1, 1946, *Miami Daily Herald*, "Death Claims Carl Magee, 73, Inventor and Ex-Editor."

Aug. 24, 1947, *Philadelphia Inquirer*, "Curdling Newport Cream," by Gwen Brewster.

Oct. 1, 1975, *New Mexico Historical Review*, "The Political Trials of Carl C. Magee," by Susan Ann Roberts.

CHAPTER 5: ACTS OF REBELLION

Interview

Aaron Fodiman

Books

Betty Ellis, "Years Remembered" (unpublished family memoir).

Perle Mesta with Robert Cahn, *Perle: My Story* (McGraw Hill, 1960).

Jack Money and Steve Lackmeyer, *Skirvin* (Full Circle, 2009).

Nancy Woloch, *A Class by Herself: Protective Laws for Women Workers, 1890s–1990s* (Princeton University Press, 2015).

Archives and Documents

Library of Congress: National Woman's Party records; Correspondence, Caroline Lexow Babcock and Perle Mesta.

New-York Historical Society. Courtesy of the New-York Historical Society and Time USA LLC. © 1949 TIME USA, LLC. All rights reserved. Used under license.

Articles

May 23, 1935, *Washington Post*, "Woman's Parley Marks the Arrival of Leader Alice Paul."

July 4, 1935, *Washington Post*, "Plight of Europe's Women a Warning to U.S. Sisters: Alice Paul," by Hope Ridings Miller.

Feb. 13, 1936, *New York Times*, "Alice Paul Sails for Geneva Fight."

Dec. 18, 1937, *New York Times*, "16 More Accept Program Posts."

March 19, 1938, *New York Times*, "Hoover Sees War Unlikely" (AP).

March 29, 1938, *Daily Oklahoman*, "Skirvin Denies All Charges of Daughter."

March 29, 1938, *Oklahoma News*, "77 Year Old Skirvin Sees More Suits from Children—and Victory for Self."

April 13, 1938, *Tulsa Tribune*, "Oklahoma's Squabbling Skirvins Are Told to Make Up—or Else."

April 15, 1938, *Miami News-Record*, "Skirvins Asked to End Strike."

April 16, 1938, *Tulsa World*, "Outsider Blamed for Skirvin Suit."

May 14, 1938, *Christian Science Monitor*, "Equal Rights Gain at Geneva."

May 15, 1938, *Daily Oklahoman*, "Skirvins Leave Attorneys Behind."

May 16, 1938, *Tulsa World*, "Skirvins Settle Estate Quarrel."

May 23, 1938, *Time*, "Press: Society Reporter, Inez Calloway."

June 6, 1938, *Daily Oklahoman*, "Good Morning."

June 7, 1938, *Oklahoma News*, "Tess' Tea Table Talk."

June 23, 1938, *Ada Weekly News*, "Skirvin Children Awarded Stock."

Oct. 9, 1938, *New York Herald Tribune*, "Women's Party Maps Drive for Equal Rights."

Oct. 28, 1938, *Daily Oklahoman*, "State Joins in Skirvin Case."

Nov. 5, 1938, *Oklahoma News*, "Tess' Tea Table Talk."

Dec. 28, 1938, *Christian Science Monitor*, "Promoting a World Crusade," by Mary Hornaday.

Feb. 1, 1939, *Daily Oklahoman*, "Society Chatter," by Dixie Payne.

April 23, 1939, *Philadelphia Inquirer*, "Women of World Uniting while States Talk of War."

June 14, 1939, *Daily Oklahoman*, "To Rescue of Women under Fascism," by Edith Johnson.

June 15, 1939, *New York Herald Tribune*, "Mrs. Mesta Is Sailing Today."

June 26, 1939, *Pittsburgh Press*, "Former Pittsburgher Takes Active Interest in Efforts for Peace."

July 2, 1939, *Washington Evening Star*, "Mrs. George Mesta arrives in Geneva."

July 29, 1939, *Pittsburgh Sun-Telegraph*, "Perle Mesta in Geneva," by Cholly Knickerbocker.

Aug. 2, 1939, *North Eastern Gazette*, "Feminist from New York."

Aug. 19, 1939, *New York Times*, "Geneva Building Opened by Women's Party."

Aug. 24, 1939, *New York Times*, "Germany and Russia Sign 10-Year Non-Aggression Pact."

Aug. 26, 1939, *Christian Science Monitor*, "Women's Organizations Join in Work for Genuine Equality."

Sept. 2, 1939, *New York Times*, "Roosevelt Pledge."

Sept. 10, 1939, *New York Herald Tribune*, "Europe's Status Likely to Prolong Newport Season."

Sept. 10, 1939, *Philadelphia Inquirer*, "Youngs Host at Dinner in Newport."

Sept. 24, 1939, *New York Journal American*, "Mrs. George Mesta."

Dec. 13, 1939, *Washington Evening Star*, "Speakers to Launch Drive for Women's Equal Rights."

Note: In Perle Mesta's autobiography, she says she returned "a few days after the start of World War II" (p. 79). But according to immigration records on Ancestry.com, she left France on August 24 and arrived in New York City on August 31, just before the war started.

CHAPTER 6: TWO-PARTY PERLE

Books

Carl Sferrazza Anthony, *First Ladies: The Saga of the Presidents' Wives and Their Power 1789–1961* (Quill William Morrow, 1990).

David Brinkley, *Washington Goes to War: The Extraordinary Story of the Transformation of a City and a Nation* (Knopf, 1988).

Robert Caro, *The Years of Lyndon Johnson: Master of the Senate* (Alfred A. Knopf, 2002).

Susan Eisenhower, *Mrs. Ike: Memories and Reflections on the Life of Mamie Eisenhower* (Farrar, Straus and Giroux, 1996).

Betty Ellis, "Years Remembered" (unpublished family memoir).

Jeffrey Frank, *The Trials of Harry S. Truman: The Extraordinary Presidency of an Ordinary Man, 1945–1953* (Simon & Schuster, 2022).

John A. Garraty and Mark C. Carnes, eds., *American National Biography* (Oxford University Press, 1999): vol. 2, "Theodore Bilbo," by J. William Harris; vol. 6, "Thomas Dewey," by Nicol C. Rae; vol. 7, "James Farley," by Eliot A. Rosen; vol. 21, "Robert Taft," by Nicol C. Rae; vol. 22, "Henry Wallace," by Richard Kirkendale; vol. 23, "Wendell Willkie," by James Madison.

Paul F. Healy, *Cissy: The Biography of Eleanor M. "Cissy" Patterson* (Doubleday & Co., 1966).

Alice Albright Hoge, *Cissy Patterson: The Life of Eleanor Medill Patterson, Publisher and Editor of the Washington Times-Herald* (Random House, 1966).

Ralph G. Martin, *Cissy: The Extraordinary Life of Eleanor Medill Patterson* (Simon & Schuster, 1979).

David McCullough, *Truman* (Simon & Schuster, 1992).

Perle Mesta with Robert Cahn, *Perle: My Story* (McGraw Hill, 1960).

Jack Money & Steven Lackmeyer, *Skirvin*, (Full Circle, 2009).

Charlie Peters, *Five Days in Philadelphia: The Amazing "We Want Willkie" Convention of 1940 and How It Freed FDR to Save the Western World* (Public Affairs, 2005).

Donald A. Ritchie, *The Columnist: Leaks, Lies, and Libel in Drew Pearson's Washington* (Oxford University Press, 2021).

Daniel Mark Scroop, *Mr. Democrat: Jim Farley, the New Deal, and the Making of Modern American Politics* (University of Michigan Press, 2009).

Amanda Smith, *Newspaper Titan: The Infamous Life and Monumental Times of Cissy Patterson* (Alfred A. Knopf, 2004).

Burt Solomon, *The Washington Century: Three Families and the Shaping of the Nation's Capital* (Harper Perennial, 2004).

Marjorie Williams, *The Woman at the Washington Zoo: Writings on Politics, Family, and Fate* (Public Affairs, 2006).

J. D. Zahniser and Amelia R. Fry, *Alice Paul: Claiming Power* (Oxford University Press, 2014).

Archives and Documents

Alice Paul Institute: Oral History Interview by Amelia R. Frye 1972–73.

Library of Congress: National Woman's Party records; Perle Mesta correspondence with Caroline Lexow Babcock and Laura Berrien; Hope Ridings Miller papers.

New-York Historical Society. Courtesy of the New-York Historical Society and Time USA LLC. © 1949 TIME USA, LLC. All rights reserved. Used under license.

University of California, Suffragists Oral History project: "Conversations with Alice Paul: Women's Suffrage and the Equal Rights Amendment," by Amelia R. Fry, 1975.

Articles and Documents

June 24, 1940, *New York Times*, "Candidates' Lives Sparkle in Print," by Sidney M. Shalett.

June 24, 1940, *New York Times*, "Willkie's Forces Seek Strategists," by Arthur Krock.

June 27, 1940, *Chicago Daily Tribune*, "Plan of Equal Rights Surprise to G.O.P. Women," by Marcia Wine.

June 27, 1940, *New York Times*, "Equal Job Rights for Women Backed," by Kathleen McLaughlin.

June 28, 1940, *Louisville Courier-Journal*, "U.S. Women Jubilant as Republicans Include Plank Calling for Equal Rights," by Inez Robb.

June 29, 1940, *Philadelphia Inquirer*, "Torrents of Acclaim from 10,000 Throats Greet Willkie at Hall."

Sept. 23, 1940, *Time*, "Ashurst Out."

Sept. 23, 1940, *Time*, "Wallace of Iowa."

Dec. 7, 1940, *Washington Star*, "Optimistic Report on Equal Rights Law Given by Mrs. Wiley."

Jan. 26, 1941, *Washington Post*, "Lend-Lease Bill Hearings Attract D.C. Hostesses to Capitol Hill," by Hope Ridings Miller.

Feb. 2, 1941, *Washington Evening Star*, "Women Thank Bilbo for Introducing Bill."

Feb. 6, 1941, *Vancouver Sun*, "Two Women Liven Washington Socially and Politically," by Helen Effinger.

Feb. 13, 1941, *Washington Post*, "Mrs. Mesta in New York."

April 5, 1941, *Washington Post*, "Miss Alice Paul to be Tea Guest of Woman's Party."

April 30, 1941, *Tucson Citizen*, "Former Banker Is Ranch Purchaser."

May 4, 1941, *Arizona Republic*, "Ranch House Will Be Built."

July 17, 1941, *Detroit News*, "Skirvin Sisters Snub Newport."

Aug. 7, 1941, *San Francisco Examiner*, "Getting Around with Cholly."

Sept. 6, 1941, *Christian Science Monitor*, "Daisy Harriman Attributes Her Success to Enthusiasm," by Inez Whitely Foster.

Oct. 20, 1941, *San Francisco Examiner*, "Metropolitan Smart Set," by Maury Paul.

Oct. 26, 1941, *New York Times*, "Women Get Report on Equal Rights."

March 23, 1942, *Chicago Tribune*, "Author Finds Washington Has Lost Its Lazy Southern Charm."

April 26, 1942, *Daily Oklahoman*, "Girl about Town," Miss Pickwick.

May 12, 1942, *New York Times*, "Equal Rights Bill Sent to the Senate."

May 24, 1942, *Daily Oklahoman*, "Former Sapulpan Takes Limelight at Capital Event."

May 30, 1942, *Washington Evening Star*, "Varied Entertainments Enliven Social Scene in Capital."

June 7, 1942, *Daily Oklahoman*, "Oklahoma Folk in Capital City Make Headlines."

June 30, 1942, *Washington Evening Star*, "Mrs. George Mesta Dinner Hostess."

Aug. 11, 1942, *Atlanta Constitution*, "My Day: Washington Opens Stage Door Canteen," by Eleanor Roosevelt.

Sept. 9, 1942, *Washington Post*, "Equal Pay Guarantee Needed."

Sept. 27, 1942, *Washington Evening Star*, "Mrs. George Mesta Returns to Assist in Canteen Work."

Sept. 28, 1942, *New York Herald Tribune*, "Asks Equal Pay for Women."

Sept. 28, 1942, *Tulsa World*, "Equality for Women Amendment is Asked."

Oct. 4, 1942, *Washington Evening Star*, "Stage Door Canteen Preview Attracts Crowd of 12,000."

Oct. 5, 1942, *Washington Times-Herald*, "Uniformed Men Throng Canteen on Its Opening."

Oct. 18, 1942, *New York Daily News*, "Women's Party to Seek Equal Pay."

Nov. 9, 1942, *Life*, "General Ike Eisenhower."

Nov. 14, 1942, *Washington Evening Star*, "Mrs. Mesta Hostess at Informal Party."

Nov. 19, 1942, *Washington Post*, "Mrs. Mesta Hosts Canteen Tea."

Dec. 1942, *Town & Country*, "Our Washington Letter," by Hope Ridings Miller.

Dec. 20, 1942, *Washington Post*, "Home Never Like This."

Jan. 10, 1943, *Daily Oklahoman*, "Girl about Town," by Miss Pickwick.

Jan. 25, 1943, *El Reno Daily Tribune*, "'Oklahoma' Is Their Password" (UPI).

March 22, 1943, *Daily Oklahoman*, "W. B. Skirvin Suffers Heart Attack Sunday."

April 11, 1943, *Washington Evening Star*, "Retired Woman Diplomat Devoting Time to Aid Less Fortunate of Allied Nations," by Katharine Brooks.

June 14, 1943, *Daily Oklahoman*, "Senator Harry Truman."

June 21, 1943, *Hugo Oklahoma Daily News*, "Echoes of Victory Dinner Still Being Heard in Ranks."

July 4, 1943, *Daily Oklahoman*, "Skirvin Feud Flares Again."

July 9, 1943, *Atlanta Constitution*, "Mrs. Ike Eisenhower Active in War Work on Home Front," by Malvina Stephenson.

Aug. 17, 1943, *Daily Oklahoman*, "Skirvin Hotel Suit Opened."

Aug. 18, 1943, *Daily Oklahoman*, "Under Pearl Mesta."

Aug. 20, 1943, *Daily Oklahoman*, "Baker Denies Skirvin Suit Liquor Charge."

Aug. 21, 1943, *Daily Oklahoman*, "Skirvin Hotel Suit Decision Reserved."

Sept. 20, 1943, *Bartlesville Examiner*, "Skirvin Hotel Plea Denied."

Oct. 19, 1943, *Washington Post*, "About Sooner Siege of Washington," by Hope Ridings Miller.

Dec. 2, 1943, *Washington Post*, "Brilliant Sulgrave Fete Draws Many Notables."

March 9, 1944, Decision on Skirvin Lawsuit, https://www.casemine.com/judgement/us/5914a24fadd7b049346964df.

March 12, 1944, *Daily Oklahoman*, "Skirvin Upheld in Receivership Fight by Court."

March 13, 1944, *Tulsa World*, "W. B. Skirvin Injured Seriously in Accident."

March 14, 1944, *East Reno Daily Tribune*, "W. B. Skirvin in Critical Condition."

March 17, 1944, *Daily Oklahoman*, "Skirvin Ruling Cites City Boom."

March 26, 1944, *Baltimore Sun*, "W. B. Skirvin, Oil Man, Dies."

March 26, 1944, *Daily Oklahoman*, "W. B. Skirvin, Pioneer Hotel Man, to Be Buried Here Monday."

April 26, 1944, *Daily Oklahoman*, "Skirvin Family Regains Hotel."

April 27, 1947, *New York Times*, "Mrs. Evalyn W. McLean, Owner of Hope Diamond, Dies in Capital."

Nov. 16, 1947, *Austin American*, "Wealthy Oklahoma Widow Now Washington's Top Party-Giver," by Liz Carpenter.

May 20, 1948, *Winona Daily News*, "Daisy Harriman, Ex-Envoy."

Dec. 9, 1977, *Washington Post*, "Sidney Seidenmann, Head of Orchestra 41 Years."

Jan. 20, 1980, *Washington Post*, Style: "Maryon Allen's Washington."

Sept. 27, 1981, *Philadelphia Daily News*, "Mamie Eisenhower Works for Ike's Ideals," by Helen Thomas (UPI).

Note: The dates of the meeting of Gwen Cafritz and Cissy Patterson vary in three biographies of Patterson: Alice Albright Hoge says they met in 1936; Ralph Martin says 1938; Amanda Smith states late 1930s.

CHAPTER 7: THE MOON, THE STARS, AND ALL THE PLANETS

Books

Robert A. Caro, *The Years of Lyndon Johnson: Master of the Senate* (Alfred A. Knopf, 2002).

John C. Culver and John Hyde, *American Dreamer: A Life of Henry A. Wallace* (W. W. Norton & Co., 2000).

Margaret Truman Daniel, *Bess W. Truman* (Macmillan, 1986).

James A. Farley, *Jim Farley's Story: The Roosevelt Years* (Whittlesey House, McGraw Hill, 1948).

Amanda Smith, *Newspaper Titan: The Infamous Life and Monumental Times of Cissy Patterson* (Alfred A. Knopf, 2004).

Burt Solomon, *The Washington Century: Three Families and the Shaping of the Nation's Capital* (Harper Perennial, 2004).

Margaret Truman, *Souvenir: Margaret Truman's Own Story* (McGraw Hill, 1956).

Archives and Documents

Harry S. Truman Presidential Library.

Library of Congress: National Woman's Party records, Hope Ridings Miller papers.

Articles

June 27, 1944, *Desert News*, "Women Play Big Part at Meet," by Jack Sinnett (AP).

June 28, 1944, *Rock Island Argus*, "A Woman's Prerogative."

June 30, 1944, *Los Angeles Times*, "Women Politicians Prove to Be Alluring," by Lucille Leimert.

July 13, 1944, *New York Times*, "Not a Candidate, Truman Says" (AP).

July 19, 1944, *Washington Post*, "7 out of 10 Democrats Favor Wallace for the Nomination," by George Gallup.

July 19, 1944, *New York Times*, "Contest Develops on Equal Rights."

July 19, 1944, *Tampa Morning Tribune*, "Mrs. Roosevelt against Women's Rights Bill."

July 20, 1944, *Camden Courier-Post*, "Women and What They Are Doing—Women Battle for and against Equal Rights Plank."

July 20, 1944, *Washington Post*, "Equal Rights."

July 21, 1944, *Christian Science Monitor*, "Equal Rights Amendment Approved by Democrats," by Mary Hornaday.

July 21, 1944, *New York Times*, "Democrats Yield on Equal Rights: Plank Calling for Amendment Goes into Platform after Two-Decade Resistance," by Kathleen McLaughlin.

July 21, 1944, *New York Times*, "President Favors Truman, Douglas," by James Hagerty.

July 22, 1944, *New York Times*, "Truman Is Chosen for Vice President."

July 26, 1944, *New York Times*, "Mrs. Farley Ready to Bolt Her Party. Won't Vote for Roosevelt but Sharing a Chicago Suite with Mrs. Mesta, New Democrat," by Kathleen McLaughlin.

Oct. 1, 1944, *Washington Post*, "Diplomatic Circling," by Carolyn Bell.

Jan. 28, 1945, *Philadelphia Inquirer*, "Capital Capers," by Hugh Morrow.

Feb. 5, 1945, *Time*, "The Vice Presidency."

Feb. 6, 1945, *Washington Post*, "Town Talk: Vice President Makes Hit with Hostesses," by Carolyn Bell.

March 1, 1945, *New York Times*, "Prophecy of Peace Roosevelt Hopeful for Future."

March 2, 1945, *New York Times*, "Senate Faces Crucial Choice," by Robert C. Albright.

March 10, 1945, *Washington Evening Star*, "Luncheons Given Yesterday."

March 10, 1945, *Washington Post*, "Notables Feted by Mrs. Mesta."

March 11, 1945, *Washington Post*, "Town Talk," by Carolyn Bell.

March 12, 1945, *Chicago Tribune*, "Capital Society Makes Truman Gay Butterfly."

March 12, 1945, *Philadelphia Inquirer*, "Parties Fail to Tire Truman," by Hugh Morrow.

March 23, 1945, *Dayton Herald*, "About Washington," by Hope Ridings Miller.

April 1, 1945, *St. Petersburg Times*, "Oil Heiress Gives a Slick Party," by Jane Eads (AP).

April 1, 1945, *Washington Post*, "War Shows Little Respect for Society's Blue Book," by Marie McNair.

April 22, 1945, *Washington Post*, "Washington Merry-Go-Round," by Drew Pearson.

May 1945, *Town & Country*, "Washington Letter," by Hope Ridings Miller.

May 10, 1945, *Philadelphia Inquirer*, "Conference Chit-Chat. Jap-Conscious West Delays Celebration," by Helen Rich.

May 12, 1945, *Philadelphia Inquirer*, "Conference Chit-Chat," by Helen Rich.

May 22, 1945, *Los Angeles Times*, "Confidentially," by Lucille Leimert.

Aug. 13, 1945, *Philadelphia Inquirer*, "Capital Capers," by Elise Morrow.

Aug. 17, 1945, *Newport Mercury*, "Victory Celebration Breaks All Records."

Aug. 26, 1945, *Washington Post*, "Betty Tyson Makes Bow to Society," by Marie McNair.

Sept. 22, 1945, *New York Times*, "Truman Reaffirms Equal Rights Backing."

Oct. 11, 1945, *Newport News*, "R. S. Tyson, 22, dies at Fort Knox Hospital."

Oct. 16, 1945, *New York Herald Tribune*, "Mrs. Mesta Buys Newport Villa."

CHAPTER 8: THE ENTERTAINER-IN-CHIEF

Interview

Lance Morrow

Books

Margaret Truman Daniel, *Bess W. Truman* (Macmillan, 1986).

Jeffrey Frank, *The Trials of Harry S. Truman: The Extraordinary Presidency of an Ordinary Man, 1945–1953* (Simon & Schuster, 2022).

David McCullough, *Truman* (Simon & Schuster, 1992).

Perle Mesta with Robert Cahn, *Perle: My Story* (McGraw Hill, 1960).

Margaret Truman, *Souvenir: Margaret Truman's Own Story* (McGraw Hill, 1956).

Archives and Documents

Library of Congress: National Woman's Party records.

Harry S. Truman Presidential Library.

Articles

Oct. 28, 1945, *Indianapolis Star*, "Capital Turnover Baffles Editor of Social Register," by Malvina Stephenson.

Dec. 17, 1945, *Philadelphia Inquirer*, "Capital Capers," by Elise Morrow.

Jan. 6, 1946, *Philadelphia Inquirer*, "Capital Capers," by Elise Morrow.

Jan. 12, 1946, *Washington Evening Star*, "President Attends First Affair Given Him."

Jan. 14, 1946, *Philadelphia Inquirer*, "Capital Capers," by Elise Morrow.

Jan. 21, 1946, *Newark Star Ledger*, "Director Captivates Capitalites," by Hope Ridings Miller.

Feb. 1946, *Town & Country*, "Our Washington Letter," by Hope Ridings Miller.

Feb. 3, 1946, *Washington Post*. "Mrs. Mesta's Parties Tops in Everything," by Marie McNair.

Feb. 10, 1946, *Boston Globe*, "Boston Debutante Guest of Honor at Washington Party."

Feb. 14, 1946, *St. Louis Post-Dispatch*, "Congressman Sabath: He Takes Dim View of Big Social Event," by Doris Fleeson.

Feb. 16, 1946, *Los Angeles Examiner*, by Sebastian Flyte.

Feb. 16, 1946, *New York Herald Tribune*, "Washington Fetes Given in Honor of Margaret Truman."

Feb. 16, 1946, *New York Times*, "Margaret Truman Honored at Ball."

Feb. 16, 1946, *Washington Evening Star*, "Mrs. Mesta's Dinner Dance Last Night Glamorous Affair," by Betty Beale.

Feb. 18, 1946, *Washington Post*, "Town Talk," by Eva Hinton.

Feb. 18, 1946, *Philadelphia Inquirer*, "Capital Capers," Elise Morrow.

Feb. 23, 1946, *New York Post*, "Capital's Lobbying Hostess," by Mary Braggiotti.

Feb. 25, 1946, *Newsweek*, "Parties for Margaret."

Feb. 25, 1946, *Plainfield Courier-News*, "Mystery Woman Intrigues Capital," by Tony Smith (Gannett News Service).

March 19, 1946, *St. Louis Post-Dispatch*, "She Loves to Give Parties," by Beth Campbell.

March 29, 1946, *Miami News*, "They Give Parties at All Hours," by Jane Eads (AP).

April 1946, *Town & Country*, "Our Washington Letter," by Hope Ridings Miller.

April 1, 1946, *Philadelphia Inquirer*, "Capital Capers," by Elise Morrow.

April 30, 1946, *Ithaca Journal*, "Mrs. Perle Mesta May Replace Mrs. McLean as 'Entertainer,'" by Tony Smith, Gannett News Service.

April 30, 1946, *Life*, "Margaret Truman: Guest of Honor."

May 1946, *Town & Country*, "Our Washington Letter," by Hope Ridings Miller.

May 23, 1946, *Oklahoma City Advertiser*, "Tea Table Talk," by Irene Bowers Sale.

May 27, 1946, *Philadelphia Inquirer*, "Capital Capers," by Elise Morrow.

July 1, 1946, *New York Daily News*, "Clever Betty: She Turns Tea into Champagne," by Nancy Randolph.

July 8, 1946, *Morning Herald*, "Meet Mrs. Mesta—Truman's Friend," by Malvina Stephenson.

July 14, 1946, *New York Herald Tribune*, "Young People's Dance to Open Series of Weekly Newport Fetes."

Aug. 2, 1946, *Kansas City Star*, "The Washington Angle," by Thomas Alford.

Aug. 2, 1946, *Kansas City Times*, "Politics at Her Meals."

Aug. 3, 1946, *Republican and Herald*, "Washington Scene," by George Dixon.

Sept. 2, 1946, *Boston Globe*, "Betty Tyson's Large Wedding to Set Newport Postwar Pace."

Sept. 5, 1946, *Oklahoma City Advertiser*, "Tea Table Talk," by Irene Bowers Sale.

Sept. 7, 1946, *New York Herald Tribune*, "Mrs. Mesta Newport Hostess."

Sept. 8, 1946, *Washington Post*, "Betty Tyson's Wedding Is Brilliant Social Event," by Marie McNair.

Nov. 1, 1946, *Washington Evening Star*, "Brilliant Party Is Given at Sulgrave by Mrs. Mesta."

Nov. 11, 1946, *Austin Statesman*, "How a Successful Hostess Entertains," by Jane Eads (AP).

Dec. 8, 1946, *Philadelphia Inquirer*, "Capital Capers," by Elise Morrow.

Dec. 16, 1946, *Waco-News Tribune*, "Capital Chatter," by Hope Ridings Miller.

Feb. 1, 1948, *Harper's Magazine*, "Newport: There She Sits," by Cleveland Amory.

Nov. 15, 1951, *Birmingham News*, "Editor Brings Messages from Far Away Places," by Charles Pell.

July 6, 1962, *Time*, "The Press: Social Snooping."

June 8, 2006, *Washington Post*, "Washington Star Society Columnist Betty Beale, 94," by Adam Bernstein.

CHAPTER 9: DEMOCRATIC PARTY STALWART

Books

A. J. Baime, *Dewey Defeats Truman: The 1948 Election and the Battle for America's Soul* (Houghton Mifflin, 2020).

Clark Clifford and Richard Holbrooke, *Counsel to the President: A Memoir* (Random House, 1991).

John C. Culver and John Hyde, *American Dreamer: A Life of Henry A. Wallace* (W. W. Norton & Co., 2000).

Margaret Truman Daniel, *Bess W. Truman* (Macmillan, 1986).

Jeffrey Frank, *The Trials of Harry S. Truman: The Extraordinary Presidency of an Ordinary Man, 1945–1953* (Simon & Schuster, 2022).

David McCullough, *Truman* (Simon & Schuster, 1992).

Perle Mesta with Robert Cahn, *Perle: My Story* (McGraw Hill, 1960).

Margaret Truman, *Souvenir: Margaret Truman's Own Story* (McGraw Hill, 1956).

Archives and Documents

Library of Congress: National Woman's Party records.

Dwight D. Eisenhower Presidential Library: Dwight Eisenhower correspondence with Perle Mesta.

Harry S. Truman Presidential Library: Correspondence between Bess and Margaret Truman; Reathel Odum oral history.

New-York Historical Society. Courtesy of the New-York Historical Society and Time USA LLC. © 1949 TIME USA, LLC. All rights reserved. Used under license.

Articles

Jan. 1, 1947, *Washington Evening Star*, "Young Folk and Their Elders Make Merry," by Betty Milliken.

Jan. 15, 1947, *Christian Science Monitor*, "Equal Rights 'Rebels' Ask Equal Rights."

Feb. 10, 1947, *Philadelphia Inquirer*, "Capital Capers," by Elise Morrow.

Feb. 11, 1947, *Baton Rouge Morning Advocate*, "Washington Merry-Go-Round," by Drew Pearson.

Feb. 16, 1947, *Los Angeles Times*, "Dinner of Capital No. 1 Hostess Told," by Lucille Leimert.

Feb. 23, 1947, *Pittsburgh Post*, "Capital's Wildest Social Whirl Slows Up as Lent Arrives," by Douglas Larsen.

Feb. 24, 1947, *Life*, "The Washington Social Scene."

Feb. 27, 1947, *New York Daily News*, "Capital Circus," by Ruth Montgomery.

March 9, 1947, *Philadelphia Inquirer*, "Miss Truman Faces Test in Air Debut."

March 17, 1947, *New York Times*, "Voice Is Praised, Called Sweet and Appealing," by Noel Straub.

March 24, 1947, *New York Times*, "Mr. Truman's Loyalty Order."

March 24, 1947, *Washington Evening Star*, "Prominent Officials at Party Given by Mrs. George Mesta," by Betty Beale.

March 26, 1947, *Philadelphia Inquirer*, "Capital Capers," by Elise Morrow.

April 14, 1947, *Pittsburgh Press*, "Late Pittsburgher's Wife—Capital's No. 1 Party Giver Always Lobbying for Cause."

April 15, 1947, *Washington Post*, "Matchmaker Busy as Ever at Resorts," by Marie McNair.

April 20, 1947, *Kansas City Times*, "Mrs. Mesta Looks Again to Newport as Washington Season Wanes," by Malvina Stephenson.

April 27, 1947, *Los Angeles Times*, "Evalyn W. McLean Dies; Owner of Hope Diamond."

April 30, 1947, *Ithaca Journal*, "Mrs. Perle Mesta May Replace Mrs. McLean as Entertainer," by Tony Smith, Gannett News Service.

May 24, 1947, *Washington Post*, "Washington Merry-Go-Round," by Drew Pearson.

Aug. 15, 1947, *Washington Post*, "Matchmakers Busy as Ever at Resorts."

Aug. 17, 1947, *Arizona Republic*, "The Party Season Isn't Far Away," by Doris Fleeson.

Aug. 17, 1947, *Pittsburgh Sun-Telegraph*, "Washington's Lady Dictator," by Pearl Gross.

Aug. 17, 1947, *San Francisco Chronicle*, "Newport Newsreel," by Nancy Randolph.

Aug. 24, 1947, *Philadelphia Inquirer*, "Curdling Newport Cream," by Gwen Brewster.

Aug. 31, 1947, *Philadelphia Inquirer*, "Washington's Top Hostess Takes Reins in Newport," by Gwen Brewster.

Sept. 3, 1947, *Philadelphia Inquirer*, "Capital Capers," by Elise Morrow.

Sept. 10, 1947, *Washington Post*, "Schellenbach Family Clan to Gather for Celebration," by Marie McNair.

Sept. 24, 1947, *Washington Post*, "Town Topics," by Marie McNair.

Oct. 16, 1947, *Washington Evening Star*, "White House Command Capital Society due to Dim Lights as State Dinners Are Cancelled," by Doris Fleeson.

Oct. 17, 1947, *Pittsburgh Sun-Telegraph*, "Mrs. Mesta Here for Margaret's Debut."

Oct. 17, 1947, *Washington Post*, "Friends to Hear Mrs. Truman Sing," by Marie McNair.

Oct. 18, 1947, *Chicago Tribune*, "4,000 Applaud Miss Truman; Critics Critical" (AP).

Oct. 18, 1947, *Pittsburgh Press*, "President's Daughter Bows to Applause Here."

Nov. 4, 1947, *Daily Oklahoman*, "Heiress Is Here to Play Hostess for Margaret."

Nov. 9, 1947, *Washington Post*, "Margaret Truman Gets 21 Curtain Calls in Oklahoma."

Nov. 10, 1947, *Kansas City Times*, "Cheers from Her Home" (AP).

Nov. 10, 1947, *Tulsa Tribune*, "Oklahoma Hostess Takes Lead in Streamlining Entertainment," by Malvina Stephenson.

Nov. 11, 1947, *New York Herald Tribune*, "Touring with Margaret Truman."

Nov. 18, 1947, *New York Times*, "Atmosphere Is Tense and Grave as President Reports on Crisis."

Nov. 18, 1947, *Washington Post*, "Opening as Congress as Simple, Unpretentious," by Mary Van Rensselaer Thayer.

Nov. 19, 1947, *The Saratogian*, "Dignity Marks House Visit by Mrs. Truman," Gannett News Service.

Nov. 22, 1947, *Washington Post*, "Nosegays, Not Protocol, Rule at Party Feting First Lady," by Genevieve Reynolds.

Nov. 25, 1947, *Washington Evening Star*, "Brilliant Assemblage at Tea by Mrs. Mesta for NewsWomen," by Katharine M. Brooks.

Nov. 25, 1947, *Washington Post*, "Mrs. Mesta Hostess at Press Party," by Genevieve Reynolds.

Nov. 30, 1947, *Philadelphia Inquirer*, "Capital Capers," by Elise Morrow.

Dec. 13, 1947, *Washington Post*, "Mrs. Geo Mesta Entertains for Chief Justice."

Dec. 17, 1947, *New York Daily News*, "Capital Circus," by Ruth Montgomery.

Dec. 19, 1947, *Cohoes American*, "Washington's New No. 1 Hostess," by Esther V. W. Tufty.

Dec. 21, 1947, *Kansas City Star*, "Party Loving Washington Keeps Up a Giddy Pace," by Jane Eads (AP).

Dec. 24, 1947, *Staten Island Advance*, "Washington Officialdom's New Number One Hostess Is Perle Mesta."

Dec. 27, 1947, *Pittsburgh Sun-Telegraph*, "World's 10 Worst Dressed Women," by Cholly Knickerbocker.

Dec. 28, 1947, *Washington Post*, "Holiday Brew," by Mary Van Rensselaer Thayer.

Dec. 31, 1947, *Christian Science Monitor*, "The World of Henry Wallace."

Dec. 31, 1947, *Hartford Courant*, "Wallace Announces Candidacy."

Jan. 2, 1948, *Austin American Statesman*, "Social Calendar Full as Ever in the Capital City," by Jane Eads (AP).

Jan. 1948, *Town & Country*, "Our Washington Letter," by Hope Ridings Miller.

Jan. 8, 1948, *Washington Evening Star*, "Society Fills Capitol Galleries to Hear President's Address," by Betty Milliken.

Jan. 8, 1948, *Washington Post*, "Official Families Gather to Hear President Speak," by Marie McNair.

Jan. 10, 1948, *Christian Science Monitor*, "Mrs. Wintergreen and the Women's Vote," by Josephine Ripley.

Jan. 25, 1948, *Philadelphia Inquirer*, "Capital Capers," by Elise Morrow.

Jan. 30, 1948, *Washington Evening Star*, "President and Mrs. Truman Feted by Feminine Scribes," by Betty Beale.

Feb. 1, 1948, *Philadelphia Inquirer*, "Eisenhower Lionized at Truman Fete."

Feb. 8, 1948, *Akron Beacon-Journal*, "Broadcasters Feted: Marshall Plan Is Theme for Mrs. Mesta's Party," by Elise Morrow.

Feb. 13, 1948, *Salpulpa Herald*, "About Malvina Stephenson."

Feb. 14, 1948, *Washington Post*, "A Century of Party Machinery," by Edward Folliard.

Feb. 15, 1948, *Seminole Producer*, "Women Who Figure in Capital Must Watch Figures."

Feb. 18, 1948, *Washington Post*, "Washington Merry-Go-Round," by Drew Pearson.

Feb. 19, 1948, *Washington Post*, "Jefferson-Jackson Anniversary Dinner."

Feb. 20, 1948, *Washington Evening Star*, "Washington Hostess Plays Part in Democratic Dinner."

Feb. 22, 1948, *Washington Evening Star*, "Party Given by Mrs. Mesta for Her Niece," by Margaret Hart Canby.

Feb. 22, 1948, *Washington Post*, "Two Big Parties in One Week Is Something of a Record," by Marie McNair.

Feb. 23, 1948, *Austin American Statesman*, "The Ladies Have a Say at Jackson Day Dinner," by Doris Fleeson.
Feb. 25, 1948, *Newsday*, "Dixie Rebels in Drive to Knock Out Truman."
Feb. 26, 1948, *Detroit Free Press*, "Skirvin Women Loom as Capital Influence," by Nancy Randolph.
Feb. 29, 1948, *Washington Post*, "Ladies of Congress Get Love Letters," by Genevieve Reynolds.
March 14, 1948, *Washington Post*, "Mrs. Mesta to Serve Tea on Home Tour."
March 28, 1948, *Philadelphia Inquirer*, "Capital Capers," by Elise Morrow.
March 28, 1948, *Washington Post*, "A Healthy Minority Would Be Nice, All Signs Point to a GOP Sweep," by Edward T. Folliard.
April 4, 1948, *Atlanta Constitution*, "Money Won't Buy Happiness," by Ann Chilton.
April 10, 1948, *New York Daily News*, "D.C. Socialites Walk Out on No-Lady Astor," by Ruth Montgomery.
April 10, 1948, *Philadelphia Inquirer*, "Capital Capers," by Elise Morrow.
April 10, 1948, *Philadelphia Inquirer*, "Capital Socialites Snub Lady Astor."
April 11, 1948, *Washington Evening Star*, "4,000 'Drop In' on Mrs. Mesta."
April 12, 1948, *Boston Globe*, "Lady Astor–Mrs. Mesta Tilt Enlivens Washington 'Battle of the Brassieres,'" by Malvina Stephenson.
April 15, 1948, *Tucson Daily Citizen*, "Washington Scene," by George Dixon.
April 26, 1948, *New York Daily News*, "Capitol Stuff," by John O'Donnell.
April 28, 1948, *Washington Evening Star*, "Exclusively Yours," by Betty Beale.
May 2, 1948, *Cedar Rapids Gazette*, "2 Conventions to Have Same Social Hostess," by Martha Kearney (INS).
May 3, 1948, *Washington Post*, "Topics in Our Town," by Marie McNair.
May 16, 1948, *Philadelphia Inquirer*, "Capital Capers," by Elise Morrow.
June 5, 1948, *Washington Post*, "Perle Mesta Entertains."
Dec. 25, 1949, *New York Times*, "Madame Minister to Luxembourg," by Flora Lewis.
April 16, 1956, *Newsday*, "So You Want To Give a party," by Bonnie Angelo.
May 3, 1964, *New York Times*, "Lady Astor Dies, Sat in Commons."

CHAPTER 10: DEWEY BEATS TRUMAN?
Books

Clark Clifford and Richard Holbrooke, *Counsel to the President: A Memoir* (Random House, 1991).
John C. Culver and John Hyde, *American Dreamer: A Life of Henry A. Wallace* (W. W. Norton & Co., 2000).
India Edwards, *Pulling No Punches: Memoirs of a Woman in Politics* (Putnam, 1977).
Dwight David Eisenhower, *The Papers of Dwight David Eisenhower* (Johns Hopkins University Press, 1970).
Jeffrey Frank, *The Trials of Harry S. Truman: The Extraordinary Presidency of an Ordinary Man, 1945–1953* (Simon & Schuster, 2022).

John A. Garraty and Mark C. Carnes, *American National Biography* (Oxford University Press, 1999): vol. 6, "Thomas Dewey," by Nicol C. Rae.
David McCullough, *Truman* (Simon & Schuster, 1992).
Perle Mesta with Robert Cahn, *Perle: My Story* (McGraw Hill, 1960).

Archives and Documents

Dwight D. Eisenhower Presidential Library: Dwight Eisenhower correspondence with Perle Mesta; Museum, photo display.
Harry S. Truman Presidential Library: Robert Nixon oral history; Margaret Truman journals; Harry Truman correspondence with Perle Mesta; 1948 inauguration memorabilia.
New-York Historical Society. Courtesy of the New-York Historical Society and Time USA LLC. © 1949 TIME USA, LLC. All rights reserved. Used under license.

Articles

May 19, 1948, *Journal News*, "Political Convention Still Weeks Away but Philadelphia Buzzes with Activity," by Esther V. W. Tufty.
May 26, 1948, *Ithaca Journal*, "Day Foreseen When Woman Is President," Gannett News Service.
June 5, 1948, *Philadelphia Inquirer*, "Capital Hostess Set for Philadelphia Invasion," by Elise Morrow.
June 21, 1948, *Philadelphia Inquirer*, "President's Fan Watches G.O.P.," by Inez Robb.
June 23, 1948, *Boston Globe*, "Politics Also Makes Strange Table Mates at GOP Convention," by Robert S. Allen.
June 30, 1948, *Morning Call*, "On the Line," by Bob Considine.
July 11, 1948, *Boston Globe*, "Back to School for Women Attending Democratic Convention," by Elizabeth Watts.
July 11, 1948, *Boston Globe*, "Will Truman Warm Up?" by Malvina Stephenson.
July 11, 1948, *New York Daily News*, "Donkeyshines by Dems with Carnivalize Philly," by Ruth Montgomery.
July 13, 1948, *Austin American Statesman*, "Flow of Cold Champagne Drowns Demos' Intra-party Strife," by Inez Robb.
July 13, 1948, *Daily Oklahoman*, "Perle Is First Again: Party on Television."
July 13, 1948, *Washington Evening Star*, "Democratic Bigwigs Perspire at Mrs. Mesta's Televised Party."
July 14, 1949, *Christian Science Monitor*, "Hostess Tells Women She Is 'Converted Democrat.'"
July 14, 1948, *Philadelphia Inquirer*, "Down with Doldrums," by Elise Morrow.
July 14, 1948, *St. Petersburg Times*, "Civil Rights Bow to Social Rights at Delegate's Party," by Inez Robb.
July 15, 1948, *Washington Post*, "Democrat Party's Party Moves around Crowded Bar, Buffet, and Dance Floor," by Mary Van Rensselaer Thayer.

July 15, 1948, *Washington Post*, "Washington Merry-Go-Round," by Drew Pearson.

July 15, 1948, *Fort Worth Star Telegram*, "Two Party Perle Explains Her Shift from GOP to Democrats in 1940," by Inez Robb.

Aug. 19, 1948, *Daily Oklahoman*, "Another Former Oklahoman Takes to a Career."

Aug. 25, 1948, *Philadelphia Inquirer*, "Capital Capers," Elise Morrow.

Sept. 5, 1948, *Philadelphia Inquirer*, "Spy Probe Breaks Dreary Social Season."

Sept. 9, 1948, *New York Herald Tribune*, "Dewey Is Almost Certain to Win, Roper Poll Finds," by Elmo Roper.

Sept. 19, 1948, *Miami Daily News Record*, "Social Upset If GOP Scores," by Douglas Larsen.

Sept. 29, 1948, *Daily Oklahoman*, "800 Sip Punch, See First Lady."

Sept. 29, 1948, *Clinton Daily News*, "Newsvues," by Charles Engleman.

Sept. 29, 1948, *Daily Oklahoman*, "Ardmore Really Turns 'Em Out for President."

Sept. 29, 1948, *Daily Oklahoman*, "Across Oklahoma with Mr. Truman," by Bill Van Dyke.

Oct. 13, 1948, *Philadelphia Inquirer*, "Capital Capers," by Elise Morrow.

Oct. 13, 1948, *New York Herald Tribune*, "Mrs. Tyson Newport Hostess."

Oct. 18, 1948, *Daily Oklahoman*, "The Lyons Den," by Leonard Lyons.

Nov. 1, 1948, *New York Times*, "Truman Confident of 'Groundswell,'" by Anthony Leviero.

Nov. 4, 1948, *Washington Post*, "Ballad for the GOP," by Mary Van Rensselaer Thayer.

Nov. 4, 1948, *New York Times*, "Election Prophets Ponder in Dismay," by Kenneth Campbell.

Nov. 5, 1948, *Wall Street Journal*, "Truman Miracle Affects Strike, Railroad Traffic, Movie Dialogue."

Nov. 11, 1948, *Washington Post*, "Ball Is Held at Shoreham," by Mary Van Rensselaer Thayer.

Nov. 24, 1948, *Philadelphia Inquirer*, "Capital Capers," by Elise Morrow.

Dec. 6, 1948, *Tucson Daily Citizen*, "Washington Scene," by George Dixon.

Dec. 12, 1948, *Washington Post*, "Mrs. Mesta to Entertain at Uplands Next Year," by Marie McNair.

Dec. 18, 1948, *Philadelphia Inquirer*, "Capital Capers," by Elise Morrow.

Dec. 23, 1948, *Pittsburgh Post-Gazette*, "The Lyons Den," by Leonard Lyons.

Dec. 26, 1948, *Pittsburgh Press*, "Mesta's Widow to Crown Social Career at Truman Inaugural Ball."

Dec. 27, 1948, *Los Angeles Times*, "CBS Chief's Wife Best Dressed in U.S."

Jan. 5, 1949, *Washington Post*, "Busy on Inaugural Ball: Lady behind the Initialed Tin Lunch Box Is None Other Than Perle Mesta," by Mary Van Rensselaer Thayer.

Jan. 12, 1949, *Pensacola News-Journal*, "The Washington Panorama," by George Dixon.

Jan. 12, 1949, *Pittsburgh Sun-Telegraph*, "Taft and Foes Neighbors."

Jan. 14, 1949, *Ashville Citizen*, "GOP Women Are Omitted from Inaugural Guest List," by Joan Marble (UP).

Jan. 16, 1949, *Boston Globe*, "Women See Best Chance for Recognition in Truman's Little Cabinet," by Dorothy Thompson.

Jan. 17, 1949, *Pittsburgh Sun-Telegraph*, "A Capital Question: Mrs. Mesta to Wed Vice-Pres. Barkley?" by Cholly Knickerbocker.

Jan. 19, 1949, *Philadelphia Inquirer*, "Capital Capers," by Elise Morrow.

Jan. 21, 1949, *Philadelphia Inquirer*, Danton Walker column.

Jan. 22, 1949, *Reno Gazette*, "Inaugural Grind 'Breaks' Truman."

Jan. 22, 1949, *Chicago Defender*, "Integration Feature of Inaugural."

Jan. 22, 1949, *Washington Evening Star*, "President Greets Thousands at Three Big Receptions," by Betty Beale.

Jan. 29, 1949, *Baltimore Afro-American*, "New Democratic Party Blooms at Inaugural."

Jan. 31, 1949, *Philadelphia Inquirer*, "Capital Capers," by Elise Morrow.

Feb. 3, 1949, *Pittsburgh Press*, "He Really Can Pick 'Em."

Feb. 6, 1949, *Wisconsin State Journal*, "Capital Capers," by Elise Morrow.

Feb. 7, 1949, *Tucson Daily Citizen*, "Washington Scene," by George Dixon.

CHAPTER 11: JUST REWARD, OR GOVERNMENT BY CRONY?

Books

India Edwards, *Pulling No Punches: Memoirs of a Woman in Politics* (Putnam, 1977).

Paul Lesch, *Playing Her Part: Perle Mesta in Luxembourg* (American Chamber of Commerce, 2001).

Perle Mesta with Robert Cahn, *Perle: My Story* (McGraw Hill, 1960).

Philip Nash, *Breaking Protocol: America's First Female Ambassadors, 1933–1964* (University Press of Kentucky, 2020).

Archives and Documents

Dwight D. Eisenhower Presidential Library: Dwight and Mamie Eisenhower correspondence with Perle Mesta.

Harry S. Truman Presidential Library: Harry Truman correspondence with Perle Mesta; Margaret Truman journals.

Library of Congress: National Woman's Party records; Hope Ridings Miller papers; Clare Boothe Luce papers.

National Archives: State Department records.

New-York Historical Society. Courtesy of the New-York Historical Society and Time USA LLC. © 1949 TIME USA, LLC. All rights reserved. Used under license.

Articles

Feb. 11, 1949, *Washington Post*, "And Still the Wonder Grows That the Amazing Mrs. Mesta Can Handle Such Big Shows," by Mary Van Rensselaer Thayer.

Feb. 14, 1949, *Newsweek*. "Madame Hostess."

Feb. 14, 1949, *Philadelphia Inquirer*, Danton Walker column.
Feb. 21, 1949, *New York Daily News*, "Mrs. Mesta to Make Debut as Political Speaker," by Nancy Randolph.
Feb. 21, 1948, *Philadelphia Inquirer*, "Capital Capers," by Elise Morrow.
Feb. 25, 1949, *New York Herald Tribune*, "Truman at Jefferson Jackson Day Speech."
Feb. 28, 1949, *Newsweek*, "Washington's Top Party Thrower."
March 1949, *Town & Country*, "Letter from Washington," by Pendleton Hogan.
March 2, 1949, *Philadelphia Inquirer*, "Capital Capers," Elise Morrow.
March 6, 1949, *Washington Post*, "Sec of Defense Johnson Values Art— Mainly of Defense," by Marie McNair.
March 13, 1949, *Daily Oklahoman*, "Washington Scene" by Elise Morrow.
March 14, 1949, *Time*, "Washington Hostess Perle Mesta: The Right Men Come to Dinner."
March 14, 1949, *Philadelphia Inquirer*, "Capital Capers," by Elise Morrow.
March 15, 1949, *Pittsburgh Sun-Telegraph*, "Washington Whirl," by Augustine.
March 30, 1956, *Daily Record*, "Washington Scene," by George Dixon.

CHAPTER 12: ADVISE AND CONSENT

Interviews
Marie Ridder; Selwa "Lucky" Roosevelt

Books
India Edwards, *Pulling No Punches: Memoirs of a Woman in Politics* (Putnam, 1977).
Dwight David Eisenhower, *The Papers of Dwight David Eisenhower* (Johns Hopkins University Press, 1970).
Paul Lesch, *Playing Her Part: Perle Mesta in Luxembourg* (American Chamber of Commerce, 2001).
Perle Mesta with Robert Cahn, *Perle: My Story* (McGraw Hill, 1960).
Philip Nash, *Breaking Protocol: America's First Female Ambassadors, 1933–1964* (University Press of Kentucky, 2020).

Archives and Documents
Harry S. Truman Presidential Library: Harry Truman correspondence with Perle Mesta; Margaret Truman journals
National Archives: State Department records.
New-York Historical Society. Courtesy of the New-York Historical Society and Time USA LLC. © 1949 TIME USA, LLC. All rights reserved. Used under license.

Articles
March 18, 1949, *Binghamton Press*, "Embattled Women See Triumph for Sex Equality," by Robbie Johnson.
March 20, 1949, *Daily Oklahoman*, "Washington Scene," by Elise Morrow.

March 20, 1949, *Pittsburgh Press*, "The Fabulous Mrs. Mesta," Part 1, by Andrew Tully.

March 21, 1949, *Pittsburgh Press*, "The Fabulous Mrs. Mesta," Part 2, by Andrew Tully.

March 21, 1949, *Pittsburgh Press*, "The Fabulous Mrs. Mesta," Part 3, by Andrew Tully.

March 28, 1949, *Tucson Daily Citizen*, "Washington Scene," by George Dixon.

March 31, 1949, *Parade*, "Washington Hostess: Mesta's Food Is Good, Guest Distinguished, and the Politics Lively," by Mary Van Rensselaer Thayer.

April 1, 1949, *Washington Evening Star*, "Delegates Here for Convention."

April 4, 1949, *New York Herald Tribune*, "Dr. Agnes Wells Heads National Woman's Party. Is Elected at Convention as Alice Paul Declines; Will Push Equal Rights," by Emma Bugbee.

April 9, 1949, *Baltimore Sun*, "President Urges Victory in '50."

April 17, 1949, *Pittsburgh Post-Gazette*, "The Lyons Den," by Leonard Lyons.

April 18, 1949, *Philadelphia Inquirer*, "Capital Capers," by Elise Morrow.

April 28, 1949, *Washington Post*, "Washington Merry-Go-Round," by Drew Pearson.

May 1, 1949, *Pittsburgh Post-Gazette*, "The Lyons Den," by Leonard Lyons.

May 4, 1949, *Philadelphia Inquirer*, "Margaret Quits Sickbed for Mrs. Mesta's Party," by Elise Morrow.

May 11, 1949, *Pittsburgh Sun-Telegraph*, "On the Scene in Washington," by George Dixon.

May 22, 1949, *Pittsburgh Post-Gazette*, "Capital Capers," by Elise Morrow.

May 22, 1949, *Washington Post*, "Capitol Has Own Heat Wave."

May 25, 1949, *Philadelphia Inquirer*, "Capital Capers," by Elise Morrow.

May 31, 1949, *Philadelphia Inquirer*, "Capital Capers," by Elise Morrow.

June 1, 1949, *Vogue*, "People Are Talking About."

June 4, 1949, *Washington Post*, "Truman May Name Woman Envoy, He Says."

June 6, 1949, *Washington Evening Star*, "Mrs. Mesta an Envoy," by Doris Fleeson.

June 8, 1949, *New York Herald Tribune*, "Two Democratic Women Headed for Envoy Posts."

June 9, 1949, *Washington Evening Star*, "Women's Clubs."

June 10, 1949, *Washington Evening Star*, "Cry Revived to Outlaw Political Contributions," by Raymond P. Brandt.

June 13, 1949, *Philadelphia Inquirer*, "Capital Capers," Elise Morrow.

June 15, 1949, *Albany Times-Union*, "Assignment America," by Inez Robb.

June 21, 1949, Associated Press, "Mrs. Perle Mesta . . . Nominated by President Truman Today as Minister to Luxembourg."

June 22, 1949, *Pittsburgh Press*, "Perle Is Okay."

June 23, 1949, *Arizona Daily Star*, "Don't Write Off Perle Mesta as Just Washington Hostess," by Malvina Stephenson.

June 23, 1949, *Washington Post*, "Perle's Oyster."

June 24, 1949, *Pittsburgh Sun-Telegraph*, "Seeing America," by Inez Robb (INS).

June 24, 1949, *Town & Country*, The Argonaut, "Washington," by Hope Ridings Miller.

June 24, 1949, *Washington Post*, "Washington Merry-Go-Round," by Drew Pearson.

June 26, 1949, *Battle Creek Enquirer*, "Mesta Appointment Generally Approved in Capital Circles," by Milt Dean Hill.

June 26, 1949, *Boston Globe*, "Perle Mesta Enjoys Seeing Other People Have a Good Time."

June 26, 1949, *Philadelphia Inquirer*, "What Will Capital Do Without Perle's Parties?" by John Cummings.

June 26, 1949, *Washington Post*, "No Place in Washington Like an Air-Conditioned Home," by Elizabeth Maguire.

June 28, 1949, *Arizona Daily Star*, "Luxembourg Ambassadress," by Frederick Othman.

June 29, 1949, *Washington Evening Star*, "Mrs. Mesta to Leave Late in August," by Betty Beale.

June 29, 1949, *Washington Post*, "Diplomatic Career of Mrs. Mesta Gets Double Boost."

July 3, 1949, *Washington Post*, "Mrs. Morris Cafritz Shrugs Off Mrs. Mesta's Party-Giving."

July 4, 1949, *Philadelphia Inquirer*, "Capital Capers," by Elise Morrow.

July 5, 1949, *Knickerbocker News*, "Perle Mesta to Be Third Woman Envoy," by Robbie Johnson.

July 6, 1949, *Tonawanda News*, "Women Diplomats."

July 6, 1949, *Washington Evening Star*, "Mrs. Perle Mesta Confirmed."

July 7, 1949, *Alexandria Daily*, "Town Talk," by Jane Eads (AP).

July 7, 1949, *Philadelphia Inquirer*, "Comedy in the Senate."

July 8, 1949, *Christian Science Monitor*, "Party Launches Mrs. Mesta on Luxembourg Assignment."

July 8, 1949, *Pittsburgh Post-Gazette*, "Mrs. Mesta Takes Oath, Honored by Celebrities" (AP).

July 9, 1949, *International Herald Tribune*, "A Washington Hostess Goes to Luxembourg," reprinted from *Louisville Courier-Journal*.

July 9, 1949, *New York Herald Tribune*, "Mrs. Mesta Gets Her Credentials as Envoy to Luxembourg" (AP).

July 9, 1949, *Washington Post*, "There Were Stars among the Standees to Felicitate Madame Minister Mesta," by Mary Van Rensselaer Thayer.

July 10, 1949, *Arizona Republic*, "Star Social Role Vacant in Capital City" (INS).

July 10, 1949, *Daily Oklahoman*, "Turmoil Reigns as Perle Mesta Vacates Throne as Entertainer," by Elise Morrow.

July 10, 1949, *Miami News-Record*, "From Duchy to Duchy."

July 11, 1949, *Pittsburgh Post-Gazette*, "Washington Job Open: Hostess to Capital," by Ingrid Jewell.

July 11, 1949, *Time*, "Life among the Party-Givers."
July 13, 1949, *Pittsburgh Sun-Telegraph*, "Perle Gets Job, Rival May Get Barkley," by Cholly Knickerbocker.
July 16, 1949, *Chicago Daily Tribune*, "Mrs. Mesta to Take Long List of 'Usual' Things to Luxemburg."
July 19, 1949, *Tucson Daily Citizen*, "More Dignity Wanted," by Robert Ruark.
July 23, 1949, *New York Herald Tribune*, "Envoys of Norway, South Africa, and Iceland in Newport."
July 24, 1949, *Pittsburgh Sun-Telegraph*, "Washington Whirl," by Austine.
July 24, 1949, *Washington Evening Star*, "Reward for Number One Hostess," by Winifred Van Duzer.
July 30, 1949, *New York Herald Tribune*, "Margaret Truman with Mrs. Mesta in Newport."
July 30, 1949, *Pittsburgh Press*, "The Gallup Poll: Women Envoys Approved by 54 Percent of U.S. Public."
Aug. 1, 1949, *Life*, "Gwendolyn Cafritz Makes Her Bid."
Aug. 5, 1949, *Arizona Republic*, "One Man's Opinion," by Walter Kiernan.
Aug. 9, 1949, *Washington Post*, "Perle Mesta Honored at Equal Righters Party," by Genevieve Reynolds.
Aug. 11, 1949, *New York Herald Tribune*, "Mrs. Mesta Sees Truman."
Aug. 13, 1949, *Chicago Defender*, "Three Negro Women, Prominent in Democratic Party, Attend Reception for Perle Mesta in Washington."
Aug. 17, 1949, *Christian Science Monitor*, "Vinson Praises Mrs. Mesta at Sailing."
Aug. 17, 1949, *Tulsa Tribune*, "Minister Mesta Toasted at Ship's Sailing," by Malvina Stephenson.
Aug. 17, 1949, *Washington Evening Star*, "Mrs. Truman and Margaret Attend Party Aboard America for Mrs. Perle Mesta," by Betty Beale.
Aug. 17, 1949, *Washington Post*, Mrs. Truman, Washingtonians Give Perle Mesta Gala Send-off as She Sails for New Post," by Marie McNair.
March 25, 1956, *New York Sunday News*, "DC Wash," by Ruth Montgomery.

CHAPTER 13: LOST AND FOUND IN LUXEMBOURG
Books

Dwight David Eisenhower, *The Papers of Dwight David Eisenhower* (Johns Hopkins University Press, 1970).
Betty Ellis, "Years Remembered" (unpublished family memoir).
Eric Kocher, *Foreign Intrigue: The Making and Unmaking of a Foreign Service Officer* (New Horizons Press, 1990).
Paul Lesch, *Playing Her Part: Perle Mesta in Luxembourg* (American Chamber of Commerce, 2001).
Perle Mesta with Robert Cahn, *Perle: My Story* (McGraw Hill, 1960).
George Murphy, *Diplomat among Warriors: The Unique World of a Foreign Service Expert* (Doubleday, 1964).

Philip Nash, *Breaking Protocol: America's First Female Ambassadors, 1933–1964* (University Press of Kentucky, 2020).

Archives and Documents

Association for Diplomatic Studies and Training Foreign Affairs Oral History Project: George West Jr., interviewed by Charles Stuart Kennedy, Feb. 9, 1990.

Dwight D. Eisenhower Presidential Library: Dwight and Mamie Eisenhower correspondence with Perle Mesta.

Harry S. Truman Presidential Library: Harry Truman correspondence with Perle Mesta and Matthew Woll.

National Archives: State Department records.

New-York Historical Society. Courtesy of the New-York Historical Society and Time USA LLC. © 1949 TIME USA, LLC. All rights reserved. Used under license.

Articles

Aug. 23, 1949, *Cushing Daily Citizen*, "Minister to Luxembourg Lands Today: 100 Cases of Coca-Cola and Perle Mesta," by Sally Swing (UP).

Aug. 23, 1949, *Pittsburgh Post-Gazette*, "Mrs. Mesta Prepares for Cold War" (AP).

Aug. 23, 1949, *Washington Post*, "Mrs. Mesta Plans No Parties—Not at Once, Anyway."

Aug. 24, 1949, *Aberdeen Journal*, "Europe's Lady Diplomat."

Aug. 24, 1949, *New York Times*, "Mrs. Mesta Says Dinners Might Ease the Cold War" (AP).

Aug. 25, 1949, *New York Times*, "Mrs. Mesta Is in Mix-Up. Goes to Wrong Border."

Aug. 25, 1949, *Philadelphia Inquirer*, "Dinner Table Diplomacy."

Aug. 26, 1949, *Pittsburgh Post-Gazette*, "Mrs. Mesta Visits Patton's Grave."

Aug. 28, 1949, *Boston Globe*, "New U.S. Envoy to Luxembourg Charms Natives," by Judy Barden (North American News Service).

Sept. 5, 1949, *Newsweek*, "Diplomatic Perle."

Sept. 12, 1949, *Daily Oklahoman*, "Ghosts among Her Guests Are Expected" (AP).

Sept. 13, 1949, *Chicago Daily News*, "Diplomacy on an Oyster Fork Produces Perle-Like Diplomacy," by David Nichol.

Sept. 13, 1949, *Camden Courier-Post*, "Hot Intrigues Center about Perle Mesta," by Tris Coffin.

Sept. 22, 1949, *Pittsburgh Post-Gazette*, "Mrs. Mesta Calls on Grand Duchess."

Sept. 23, 1949, *Chickasha Daily Express*, "Madame Minister Mesta Off to Fabulous Start," by Rosette Hargrove (Newspaper Enterprise Association; hereafter NEA).

Nov. 6, 1949, *Pittsburgh Post-Gazette*, "Perle Mesta Still Can Throw a Party."

Nov. 13, 1949, *Daily Oklahoman*, "Capital Capers," by Elise Morrow.

Nov. 21, 1949, *New York Herald Tribune*, "Mrs. Mesta Host to Woll."

Dec. 16, 1959, *New York Times*, "In the Nation," by Arthur Krock.

Dec. 16, 1949, *Pittsburgh Press*, "Perle's Parties Open to All GI's Luxembourg" (UP).

Dec. 25, 1949, *New York Times Magazine*, "Madame Minister to Luxembourg," by Flora Lewis.

Jan. 7, 1950, *Saturday Evening Post*, "Party Girl in Paradise," by Martha Gellhorn.

Jan. 20, 1950, *International Herald Tribune*, "Luxembourg to Fete Ruler on Birthday."

Jan. 29, 1950, *Los Angeles Times*, "Perle Mesta Makes Good," by David Perlman.

Feb. 5, 1950, *Boston Globe*, "Luxembourgers Vote Perle Mesta a Good Scout," by Omer Anderson (North American Newspaper Alliance; hereafter NANA).

Feb. 21, 1950, *International Herald Tribune*, "Mrs. Mesta Now Ready to Move in 'Big Leagues'" (UPI).

Feb. 22, 1950, *Washington Post*, "Matter of Fact," by Joseph and Stewart Alsop.

March 4, 1950, *Washington Post*, "Ministers Both Popular Gals," by Albert Cheval (AP).

March 7, 1950, *Newport News*, "Mrs. Perle Mesta Hails American Women. Tells Heidelberg Gathering Housewives Have Abolished 'Petticoat Line' for Jobs."

March 9, 1950, *Philadelphia Inquirer*, Danton Walker column.

March 16, 1950, *New York Herald Tribune*, "Perle Mesta Visits D.P. Camp in Germany."

Jan. 24, 1952, *Tucson Daily Citizen*, "Madam la Minister," by Westbrook Pegler.

Feb. 23, 1953, *Asbury Park Evening Press*, by Westbrook Pegler.

Feb. 13, 1963, *Washington Post*, "Perle Mesta Beams at Ceremonies Making Orphan She Aided a Citizen," by John Goshko.

Sept. 1964, *McCall's*, "Great Lady: Memories of First Family of Luxembourg," by Perle Mesta.

CHAPTER 14: CALL ME MADAM
Books
Jane Barkley, *I Married the Veep* (Vanguard Press, 1958).

India Edwards, *Pulling No Punches: Memoirs of a Woman in Politics* (Putnam, 1977).

Dwight David Eisenhower, *The Papers of Dwight David Eisenhower* (Johns Hopkins University Press, 1970).

Susan Eisenhower, *Mrs. Ike: Memories and Reflections on the Life of Mamie Eisenhower* (Farrar, Straus and Giroux, 1996).

Betty Ellis, "Years Remembered" (unpublished family memoir).

Marilyn Irvin Holt, *The General's First Lady: Mamie Doud Eisenhower* (University Press of Kansas, 2007).

Eric Kocher, *Foreign Intrigue: The Making and Unmaking of a Foreign Service Officer* (New Horizons Press, 1990).

Paul Lesch, *Playing Her Part: Perle Mesta in Luxembourg* (American Chamber of Commerce, 2001).

Ethel Merman with George Eells, *Merman: An Autobiography* (Simon & Schuster, 1978).

Perle Mesta with Robert Cahn, *Perle: My Story* (McGraw Hill, 1960).

George Murphy, *Diplomat among Warriors: The Unique World of a Foreign Service Expert* (Doubleday, 1964).

Philip Nash, *Breaking Protocol: America's First Female Ambassadors, 1933– 1964* (University Press of Kentucky, 2020).

Archives and Documents

Lyrics from *Call Me Madam*: "The Hostess With The Mostes' On The Ball" from the Stage Production CALL ME MADAM Words and Music by Irving Berlin Copyright © 1950 BERLIN IRVING MUSIC CORP. Copyright Renewed All Rights Administered by UNIVERSAL MUSIC CORP. All Rights Reserved Used by Permission Reprinted by Permission of Hal Leonard LLC.

Association for Diplomatic Studies and Training Foreign Affairs Oral History Project: George West Jr., interviewed by Charles Stuart Kennedy, Feb. 9, 1990.

Harry S. Truman Presidential Library: Harry Truman correspondence with Perle Mesta and Eleanor Roosevelt; Margaret Truman journals.

Library of Congress: Hope Ridings Miller papers.

National Archives: State Department records.

Articles

March 15, 1950, *Arizona Daily Star*, "Ethel Merman Prefers Stage to Hollywood Cutting Room," by Erskine Johnson (NEA).

March 18, 1950, *Los Angeles Times*, "Mrs. Perle Mesta Will Return to U.S.—'Just for a Visit'" (UP).

March 18, 1950, *New York Times*, "Mrs. Mesta to Return for Talks" (AP).

March 18, 1950, *Stockman's Journal*, "Perle Mesta Anxious to Receive Transfer" (UP).

March 19, 1950, *Chicago Tribune*, "Truman Scoffs at Snooping by Census Takers."

April 3, 1950, *Tucson Daily Citizen*, "Washington Scene," by George Dixon.

April 2, 1950, *Boston Globe*, "Mrs. Mesta Big Hit" (NANA).

April 7, 1950, *New York Herald Tribune*, "Mrs. Mesta Says Luxemburg Is Busy, Happy," by Herbert Kupferberg.

April 7, 1950, *Washington Post*, "Parties Secondary for Mrs. Mesta," by Marie McNair.

April 8, 1950, *New York Times*, "Mrs. Mesta Puts Diplomacy before Dinners Because She 'Loves' Her Role as U.S. Envoy."

April 13, 1950, *Daily Oklahoman*, "Perle Mesta Fills Quick Party Date with All Her Zest," by Alice Hughes.

April 15, 1950, *Vogue*, "People and Ideas: Luxembourg," by Perle Mesta.

April 18, 1950, *New York Times*, "Argosy to Plead for Youth Flights."

April 19, 1950, *Washington Post*, "Mrs. Mesta Piles Up Invitations."

April 23, 1950, *Binghamton Press*, "Parties for 'Aunt Perle' Keeping Capital Social Circles in Whirl," by Elise Morrow.

April 26, 1950, *Baltimore Sun*, "Perle Mesta Takes on New Role as Guest."

April 27, 1950, *Philadelphia Inquirer*, "The Lyons Den," by Leonard Lyons.

April 28, 1950, *Newport News*, "No Hostess, Hardworking," by Jane Eads (AP).

April 28, 1950, *Tucson Daily Citizen*, "Washington Scene," by George Dixon.

April 30, 1950, *Philadelphia Inquirer*, "Capital Capers," by Elise Morrow.

May 3, 1950, *Washington Evening Star*, "President and Mrs. Truman Hosts at Dinner in Honor of Mrs. Mesta."

May 4, 1950, *New York Times*, "Truman Greets Liaquat Ali as Pakistani's Tour Begins."

May 7, 1950, *Washington Post*, "Mme Minister Sees Job as Challenge to Work for Peace, Aid Women's Causes," by Perle Mesta.

May 14, 1950, *Washington Post*, "Mrs. Mesta's Viewpoint: GI's Abroad Like Parties," by Perle Mesta.

May 21, 1950, *Pittsburgh Press*, "Potomac Patter," by Andrew Tully.

May 21, 1950, *Washington Post*, "Luxembourg's Charm Delights Tourist," by Perle Mesta.

May 26, 1950, *New York Herald Tribune*, "Mrs. Mesta Honored at Luncheon Here."

May 26, 1950, *New York Times*, "Watson, Woll Hosts to Minister Mesta."

May 28, 1950, *Albany Times-Union*, "Perle Mesta Irate at Acheson Tactics," by Martha Kearney (INS).

May 31, 1950, *Austin American-Statesman*, "Assignment America," by Inez Robb.

June 2, 1950, *Newsday*, "Perle Beyond Price," by Hal Burton.

June 3, 1950, *Detroit Free Press*, "Good Morning," by Malcolm Bingay.

June 5, 1950, *Philadelphia Inquirer*, "The Lyons Den," by Leonard Lyons.

June 8, 1950, *New York Times*, "Came to See Envoy Sail."

June 20, 1950, *Newport News*, "Mrs. FDR Honors Patton" (AP).

June 23, 1950, *Pittsburgh Press*, "My Day," by Eleanor Roosevelt.

July 21, 1950, *Washington Evening Star*, "Finds Mrs. Mesta Liked in Luxembourg," by Harry McLemore.

Aug. 3, 1950, *Philadelphia Inquirer*, "The Lyons Den," by Leonard Lyons.

Aug. 11, 1950, *Washington Post*, "Pearl Loves It."

Aug. 15, 1950, *Philadelphia Inquirer*, "The Lyons Den," by Leonard Lyons.

Sept. 1950, *Vogue*, "Tip Sheet for Angels on the New Broadway Shows: 'Call Me Madam.'"

Sept. 2, 1950, *Hartford Courant*, "New Musical Presented at New Haven."

Sept. 2, 1950, *Washington Evening Star*, "300 Stranded U.S. Youths Eat Free at Mrs. Mesta's" (AP).

Sept. 3, 1950, *New York Times*, "Rehearsal Notes from 'Call Me Madam.'"

Sept. 5, 1950, *Buffalo News*, "Perle Mesta Wins the Full Affection of Luxembourgers," by Marie Brown (NANA).

Sept. 10, 1950, *Washington Evening Star*, "Broadway's Shortage Is Comics," by Mark Barron.

Sept. 13, 1950, *New York Herald Tribune*, "Call Me Madam Gets New Haven Raves," by Bert McCord.

Sept. 14, 1950, *Boston Globe*, "Perle 'Call Me Madam' Mesta Makes Diplomacy Work."

Sept. 15, 1950, *Vogue*, "Women Honored."

Sept. 25, 1950, *New York Times*, "Mrs. Mesta Is Praised."

Sept. 26, 1950, *Washington Evening Star*, "Democratic Chiefs Warn Women of Civic Duties."

Oct. 1950, *Cosmopolitan*, "Ethel Merman Hit Parade," by Maurice Zolotov.

Oct. 7, 1950, *Memphis Press-Scimitar*, "2nd Mesta Visit in Year; Guest of Taxpayers," by Roger Stuart.

Oct. 7, 1950, *Omaha World-Herald*, "'Call Me Madam?' No, Smiles Mrs. Mesta," by Inez Robb.

Oct. 8, 1950, *Arizona Daily Star*, "Envoy Will Be Orphan's Santa," by Cynthia Lowry.

Oct. 8, 1950, *Washington Evening Star*, "Mrs. Mesta Has No Plans to See New Show," by Betty Beale.

Oct. 10, 1950, *Tucson Daily Citizen*, "That's My Perle," by George Dixon.

Oct. 11, 1950, *Washington Evening Star*, "Hostess with Mostest Won't See Show," by James Cullinane.

Oct. 13, 1950, *New York Times*, "Ethel Merman as an American Envoy," by Brooks Atkinson.

Oct. 13, 1950, *Philadelphia Inquirer*, "Divorce Film to Use Nine Female Stars," by Louella Parsons.

Oct. 13, 1950, *Tucson Citizen*, "Call Me Madam Is Brilliant Show" (UPI).

Oct. 13, 1950, *Washington Evening Star*, "The Eisenhowers Join DC Couple for Opening."

Oct. 14, 1950, *Camden Courier-Post*, "It Happened Last Night," by Earl Wilson.

Oct. 14, 1950, *New York Daily News*, Danton Walker column.

Oct. 15, 1950, *Syracuse Journal*, "Ghost of Perle Mesta Haunts Reigning Hostess," by Elise Morrow.

Oct. 22, 1950, *Washington Evening Star*, "Exclusively Yours," by Betty Beale.

Oct. 23, 1950, *Newsweek*, "Periscope: Mostes' Hostess."

Oct. 23, 1950, *Newsweek*, "Rave Review for Madame."

Oct. 26, 1950, *Chicago Sun-Times*, "Perle Mesta Enjoys Stage Travesty of Self."

Oct. 26, 1950, *Washington Evening Star*, "Mrs. Mesta Sees Her Show with Mrs. Truman, Margaret" (AP).

Nov. 2, 1950, *San Francisco Chronicle*, "The Lyons Den," by Leonard Lyons.

Nov. 6, 1950, *Newsweek*, "Three on the Aisle."

Dec. 11, 1949, *Charlotte Observer*, "Capital Capers," by Elise Morrow.

March 1963, *McCall's*, "First Ladies I Have Known," by Perle Mesta.

Sept. 1964, *McCall's*, "Memories of the First Family of Luxembourg," by Perle Mesta.

Sept. 1983, *Foreign Service Journal*, "Foreign Service People: Deaths, Anthony Clinton Swezey."

CHAPTER 15: I LIKE IKE
Books

Carl Sferrazza Anthony, *First Ladies: The Saga of the Presidents' Wives and Their Power 1789–1961* (Quill William Morrow, 1990).

Dwight David Eisenhower, *The Papers of Dwight David Eisenhower* (Johns Hopkins University Press, 1970).

Susan Eisenhower, *Mrs. Ike: Memories and Reflections on the Life of Mamie Eisenhower* (Farrar, Straus and Giroux, 1996).

Betty Ellis, "Years Remembered" (unpublished family memoir).

Jeffrey Frank, *The Trials of Harry S. Truman: The Extraordinary Presidency of an Ordinary Man, 1945–1953* (Simon & Schuster, 2022).

Marilyn Irvin Holt, *The General's First Lady: Mamie Doud Eisenhower* (University Press of Kansas, 2007).

Paul Lesch, *Playing Her Part: Perle Mesta in Luxembourg* (American Chamber of Commerce, 2001).

Perle Mesta with Robert Cahn, *Perle: My Story* (McGraw Hill, 1960).

Philip Nash, *Breaking Protocol: America's First Female Ambassadors, 1933–1964* (University Press of Kentucky, 2020).

Archives and Documents

Association for Diplomatic Studies and Training Foreign Affairs Oral History Project: George West Jr., interviewed by Charles Stuart Kennedy, Feb. 9, 1990.

Dwight D. Eisenhower Presidential Library: Dwight and Mamie Eisenhower correspondence with Perle Mesta.

Harry S. Truman Presidential Library: Harry Truman correspondence with Perle Mesta.

Library of Congress: Hope Ridings Miller papers.

National Archives: State Department records.

New-York Historical Society. Courtesy of the New-York Historical Society and Time USA LLC. © 1949 TIME USA, LLC. All rights reserved. Used under license.

Articles

Nov. 14, 1950, *Washington Post*, "Crowded Days for Mme Minister," by Marie McNair and Elizabeth Maguire.

Nov. 19, 1950, *New York Times*, "Mrs. Mesta's Party Whirl."

Nov. 19, 1950, *Tulsa World*, "Capital Capers," by Elise Morrow.

Nov. 20, 1950, *Tucson Daily Citizen*, "Oslo Newspaper Can't See Perle as an Envoy" (UP).

Nov. 23, 1950, *Washington Evening Star*, "Press in Scandinavia Sounds Alarm against Mrs. Mesta as Norway Envoy," by Constantine Brown.

Nov. 25, 1950, *Washington Post*, "Washington Merry-Go-Round," by Drew Pearson.

Dec. 4, 1950, *Newport News*, "Mrs. Perle Mesta Selected Woman of Year by Associated Press Poll."

Dec. 18, 1950, *New York Herald Tribune*, "Mrs. Mesta Says Women Equal Men as Diplomats."

Dec. 26, 1950, *Washington Evening Star*, "Mrs. Mesta Gives Christmas Party for 600 Orphans" (AP).

Dec. 27, 1950, *Washington Evening Star*, "Engagement Announced" (AP).

Jan. 1951, *Good Housekeeping*, "Who Would You Like for Dinner?" by Betsy Barton.

Jan. 1951, *Stars and Stripes*, "7806 SCU Soldier is U.S. Legation Guest at Monthly Open House in Luxembourg," by Sargent Albert Spratley.

Jan. 20, 1951, *New York Times*, "Eisenhower Gratified by Efforts of Atlantic Pact Bloc in Defense."

Jan. 21, 1951, *Omaha World-Herald*, "The Capital's No. 1 Partygiver."

Jan. 29, 1951, *Philadelphia Inquirer*, "The Lyons Den," by Leonard Lyons.

Feb. 2, 1951, *Boston Globe*, "Perle Mesta Teaches Luxembourg Canasta," by Bill Attwood.

Feb. 13, 1951, *International Herald Tribune*, "U.S. Minister Says Free World Will Not Allow Enslavement by Russia."

Feb. 19, 1951, *Binghamton Press*, "Record of Perle Mesta: No Diplomatic Coups, but Lots of Good Will," by William H. Stoneman.

Feb. 20, 1951, *Tucson Daily Citizen*, "Mme Mesta Leaves Ladies of Press with Baffled Feeling" (AP).

March 23, 1951, *Christian Science Monitor*, "Truman Returns to Capital, Poll Bares Ebbing Prestige," by Robert Strout.

March 31, 1951, *Washington Evening Star*, "Dutch Paper Hits Report Mrs. Mesta Will Go There" (AP).

April 13, 1951, *New York Herald Tribune*, "Eisenhower Visits Commissioner McCloy" (UP).

April 17, 1951, *New York Daily News*, "Ike Bakes Pie for Perle."

April 21, 1951, *Washington Evening Star*, "Eisenhowers in Luxembourg."

April 28, 1951, *Daily Reporter*, "Perle Mesta Doing Her Best to Prove Women Can Have Diplomatic Careers Too," by Perle Mesta.

May 13, 1951, *New York Herald Tribune*, "Mrs. Mesta Here to Report and Make Speeches."

May 15, 1951, *Washington Evening Star*, "Mrs. Mesta Acclaims Eisenhower's Work."

May 19, 1951, *Christian Science Monitor*, "Mrs. Mesta Lauds Ike's Work."

May 21, 1951, *New York Herald Tribune*, "Mrs. Mesta Sees Europe Bolstered by Eisenhower."

May 22, 1951, *Washington Evening Star*, "Bess Truman Gives Lunch for Perle Mesta at Blair House."

May 25, 1951, *Washington Evening Star*, "National Woman's Party Opening Convention Here."

May 27, 1951, *New York Herald Tribune*, "Equal Rights 'Victory' Seen by Mrs. Mesta," by Dorothy Brandon.

May 27, 1951, *Washington Evening Star*, "Mrs. Mesta Stresses Foreign Policy Gains at Women's Session."

May 28, 1951, *Newport News*, "Mrs Mesta Lauds Women before Oklahoma Grads" (AP).

June 3, 1951, *Los Angeles Times*, "Ike Needs Men, Mrs. Mesta Says."

June 6, 1951, *New York Herald Tribune*, "Mrs. Mesta, Luxembourg Flag, Legion, Protocol, All Mixed Up" (UP).

June 7, 1951, *Philadelphia Inquirer*, "Madam Minister Flagged."

June 11, 1951, *Philadelphia Inquirer*, "The Lyons Den," by Leonard Lyons.

June 17, 1951, *Arizona Daily Star*, "HST's Daughter Dined by Envoy" (AP).

July 29, 1951, *Chicago Daily Tribune*, "Meet Washington's New Number 1 Party-Giver," by Norma Browning.

Oct. 17, 1951, *Christian Science Monitor*, "The Personal Equation: Mrs. Mesta's Gracious Touch," by Volney Hurd.

Oct. 26, 1951, *Binghamton Press*, "Perle Is the Girl for Me, Big Shots and GIs Agree," by Philip Reed.

Nov. 1, 1951, *Ithaca Journal*, "Mrs. Mesta Big Success as Ambassador," by Peter Edson.

Nov. 3, 1951, *Pittsburgh Press*, "My Day," by Eleanor Roosevelt.

Nov. 20, 1951, *New York Daily News*, Danton Walker column.

April 25, 1952, *Washington Post*, "Mrs. Mesta Explains Ike's Role," by Drew Pearson.

Sept. 1983, *Foreign Service Journal*, "Foreign Service People: Deaths, Anthony Clinton Swezey."

CHAPTER 16: DIVIDED LOYALTIES

Books

Stephen E. Ambrose, *Eisenhower: Soldier, General of the Army, President-Elect, 1890–1952* (Simon & Schuster, 1983).

Dwight David Eisenhower, *The Papers of Dwight David Eisenhower* (Johns Hopkins University Press, 1970).

Susan Eisenhower, *Mrs. Ike: Memories and Reflections on the Life of Mamie Eisenhower* (Farrar, Straus and Giroux, 1996).

Jeffrey Frank, *The Trials of Harry S. Truman: The Extraordinary Presidency of an Ordinary Man, 1945–1953* (Simon & Schuster, 2022).

William Leuchtenburg, *In the Shadow of FDR: From Harry Truman to Barack Obama* (Cornell University Press, 2011).

David McCullough, *Truman* (Simon & Schuster, 1992).

Perle Mesta with Robert Cahn, *Perle: My Story* (McGraw Hill, 1960).

Philip Nash, *Breaking Protocol: America's First Female Ambassadors, 1933–1964* (University Press of Kentucky, 2020).

Archives and Documents

Association for Diplomatic Studies and Training Foreign Affairs Oral History Project: George West Jr., interviewed by Charles Stuart Kennedy, Feb. 9, 1990.

Dwight D. Eisenhower Presidential Library: Dwight and Mamie Eisenhower correspondence with Perle Mesta.

Harry S. Truman Presidential Library: Margaret Truman's journals; Harry Truman correspondence with Perle Mesta; Harry Truman correspondence with Missouri governor Forrest Smith.

Library of Congress: Hope Ridings Miller papers.

National Archives: State Department records.

New-York Historical Society. Courtesy of the New-York Historical Society and Time USA LLC. © 1949 TIME USA, LLC. All rights reserved. Used under license.

Articles

Jan. 24, 1952, *Atlanta Constitution*, "David Bruce Named to Webb's Post."

Jan. 30, 1952, *Austin American Statesman*, "Women Take Star Roles in '52 Political Line Up," by Sigrid Arne.

Jan. 31, 1952, *Burlington Daily News*, "Politics Won't Interfere with Entertaining in Washington," by Ruth Gmeiner (UP).

March 31, 1952, *Life Magazine*, "The Ike Boom."

April 27, 1952, *New York Daily News*, "Luxembourg Yells Good-by to 'Gen. Eek.'"

April 27, 1952, *New York Herald Tribune*, "Eisenhower Visits Luxembourg on Farewell Tour of NATO Area," by Don Cook.

April 27, 1952, *Washington Evening Star*, "Eisenhower Dines with Duchess on Last Visit to Luxembourg" (AP).

May 14, 1952, *New York Daily News*, "Perle on Way Home Amidst Rumors," by Bernard Valery.

May 24, 1952, *New York Daily News*, "D.C. Wash," by Ruth Montgomery.

May 25, 1952, *Binghamton Sunday Press*, "Mrs. Mesta's Visit Sparks Interest in Political 'Parties,'" by Elise Morrow.

May 28, 1952, *New York Times*, "A Dinner Will Be Given Next Saturday Night by President and Mrs. Truman for the Minister to Luxembourg, Mrs. Perle Mesta."

May 30, 1952, *Washington Evening Star*, "Mrs. Mesta, Miss Merman Are Guests," by Ruth Dean.

June 5, 1952, *Brooklyn Eagle*, "Perle Mesta Hits Political Critics of Our European Allies."

June 6, 1952, *New York Herald Tribune*, "Mrs. Mesta Advises against U.S. Criticism."

June 24, 1952, *Washington Evening Star*, "Mrs. Mesta Receives Honorary Law Degree," by Betty Beale.

June 25, 1952, *Washington Evening Star*, "Exclusively Yours," by Betty Beale.

June 26, 1952, *Miami News*, "Gold Coast," by Suzy.

June 27, 1952, *Albuquerque Journal*, "Cold War Scales Are Tipping in Our Favor" (AP).

July 8, 1952, *Evening News World*, "GOP Convention Avoided by Diplomatic Perle Mesta," by Earl Wilson.

July 15, 1952, *New York Daily News*, "Madame Casts a Perle of a Slate," by Ruth Montgomery.

July 17, 1952, *St. Louis Post-Dispatch*, "Perle Mesta Arrives in Chicago Supporting Truman for President."

July 22, 1952, *Christian Science Monitor*, "Democrats Told by Women Eyes of World on Chicago," by Helen Henley.

July 24, 1952, *Washington Evening Star*, "Exclusively Yours," by Betty Beale.

July 24, 1952, *Washington Post*, "Perle Packs 'Em In," by Christine Sadler.

July 27, 1952, *Washington Evening Star*, "Perle with Ethel Merman."

July 29, 1952, *Christian Science Monitor*, "Television Spurs Political Reform," by Roscoe Drummond.

Aug. 13, 1952, *Washington Evening Star*, "Lady Democrats Flock to Meet Stevenson," by Isabelle Shelton.

Aug. 17, 1952, *Arizona Republic*, "Adlai's Visit to Capital Sets Women A'Flutter," by Martha Kearney (INS).

Aug. 17, 1952, CBS, *What's My Line?*

CHAPTER 17: GOODBYE, WITHOUT LEAVING

Books

Dwight David Eisenhower, *The Papers of Dwight David Eisenhower* (Johns Hopkins University Press, 1970).

Susan Eisenhower, *Mrs. Ike: Memories and Reflections on the Life of Mamie Eisenhower* (Farrar, Straus and Giroux, 1996).

Jeffrey Frank, *The Trials of Harry S. Truman: The Extraordinary Presidency of an Ordinary Man, 1945–1953* (Simon & Schuster, 2022).

David McCullough, *Truman* (Simon & Schuster, 1992).

Perle Mesta with Robert Cahn, *Perle: My Story* (McGraw Hill, 1960).

Sylvia Jukes Morris, *Price of Fame: The Honorable Clare Boothe Luce* (Random House, 1998).

Archives and Documents

Dwight D. Eisenhower Presidential Library: Dwight and Mamie Eisenhower correspondence with Perle Mesta; Dwight Eisenhower correspondence to State Department re: Perle Mesta.

Harry S. Truman Presidential Library: Harry S. Truman memo to Secretary of State Dean Acheson with attached report from Perle Mesta.

Library of Congress: Hope Ridings Miller papers; Whitelaw Reid papers; Clare Boothe Luce papers; James Bonbright interview by Peter Jessup, Feb. 26, 1986.

National Archives: State Department records.

New York Public Library: *McCall's* magazine collection.

Articles

Aug. 17, 1952, *This Week*, "I'm Done with Plush Parties," by Perle Mesta.

Aug. 23, 1952, *Arizona Republic*, "Perle Mesta Hopes to Keep Envoy Post" (UP).

Oct. 5, 1952, *American Weekly*, "Two Party Perle: Perle Likely to Keep Her Job No Matter Who Wins the Election," by Inez Robb.

Oct. 20, 1952, *Washington Evening Star*, "Exclusively Yours," by Betty Beale.

Oct. 22, 1952, *Washington Evening Star*, "Mrs. Truman Is Hostess."

Oct. 23, 1952, *Washington Post*, "Democrats Raise $54,000 for Adlai at $53 Luncheon."

Nov. 3, 1952, *Washington Evening Star*, "Exclusively Yours," by Betty Beale.

Nov. 4, 1952, *New York Herald Tribune*, "Election Parties in Newport."

Nov. 7, 1952, *Los Angeles Times*, "Shake-Up Seen in State Department."

Nov. 8, 1952, *Arizona Republic*, "Perle Mesta Won't Quit" (UP).

Nov. 24, 1952, *New York Herald Tribune*, "Paris and People," by Art Buchwald.

Jan. 16, 1953, *Arizona Republic*. "Mrs. Mesta Hopes Ike Will Reappoint Her" (UP).

Jan. 17, 1953, *Newsday*, "Two-Party Perle."

Jan. 24, 1953, *Philadelphia* Inquirer, "Broadway Medley," by Leonard Lyons.

Feb. 3, 1953, *Monroe News-Star*, "End of Engagement."

Feb. 10, 1953, *Birmingham News*, "Lady Ambassadors Not Wanted," by Drew Pearson.

Feb. 10, 1953, *Cincinnati Post*, "What Next, Perle? Mrs. Mesta in Dark about Her Future."

Feb. 12, 1953, *Brooklyn Eagle*, "Diplomatic Tip, Perle to Clare: Step Right Up, Take Command," by Robert Musel (UP).

Feb. 20, 1953, *Lubbock Evening Journal*, "Perle Mesta to Be Retired as Minister in Luxembourg," by Martha Kearney (INS).

Feb. 25, 1953, *Asbury Park Evening Press*, Westbrook Pegler column.

March 11, 1953, *Arizona Republic*, "Perle Mesta Says Ike's Wish Is Hers" (UP).

March 28, 1953, *Baltimore Sun*, "Mrs. Mesta Leaves Post Next Month" (AP).

April 12, 1953, *New York Daily News*, "Perle Mesta Sad on Leaving Envoy Post in Luxembourg," by Alfred Cheval (AP).

April 18, 1953, "Longine's Chronicle."

Sept. 1964, *McCall's*, "Memories of the First Family of Luxembourg," by Perle Mesta.

CHAPTER 18: FROM ROYALTY TO RUSSIA

Interview

Marie Ridder

Books

Dwight David Eisenhower, *The Papers of Dwight David Eisenhower* (Johns Hopkins University Press, 1970).

Susan Eisenhower, *Mrs. Ike: Memories and Reflections on the Life of Mamie Eisenhower* (Farrar, Straus and Giroux, 1996).

Betty Ellis, "Years Remembered" (unpublished family memoir).

Perle Mesta with Robert Cahn, *Perle: My Story* (McGraw Hill, 1960).

Sylvia Jukes Morris, *Price of Fame: The Honorable Clare Boothe Luce* (Random House, 1998).

Archives and Documents

Dwight D. Eisenhower Presidential Library: Mamie Eisenhower correspondence with Perle Mesta.

Library of Congress: Hope Ridings Miller papers; Whitelaw Reid papers; Clare Boothe Luce papers.

National Archives: State Department records.

New-York Historical Society. Courtesy of the New-York Historical Society and Time USA LLC. © 1949 TIME USA, LLC. All rights reserved. Used under license.

New York Public Library, *McCall's* magazine collection.

Articles

April 1953, *Washington Times-Herald*, "Inquiring Camera Girl," by Jackie Bouvier.

April 14, 1953, *Pittsburgh Post-Gazette*, "Mrs. Mesta and Fulton Plan Trip to Russia" (AP).

April 15, 1953, *Fort Worth Star-Telegram*, "History Making Trip? Madam Mesta Mission to Moscow Mysterious," by Kingsbury Smith (INS).

April 16, 1953, *Albany Times Union*, "Perle Mesta Mum on Plans for Moscow Trip," by John R. Martin.

April 21, 1953, *New York Herald Tribune*, "Europe's Lighter Side," by Art Buchwald.

May 2, 1955, *Washington Evening Star*, "Exclusively Yours," by Betty Beale.

June 2, 1953, *Boston Globe*, "Well Worth the Effort. How No. 1 U.S. Hostess Views London's Big Show," by Perle Mesta.

June 3, 1953, *New York Herald Tribune*, "Perle Mesta Describes Coronation Pageantry," by Perle Mesta.

June 3, 1953, *Times-Recorder*, "Perle Mesta with Her Camera," by Earl Wilson.

June 3, 1953, *Washington Post*, "Never Shall I Forget This Moment," by Perle Mesta.

June 4, 1953, *Arizona Republic*, "Party Magnificent: Mrs. Perle Mesta Admits Defeat; Lavish Hands of British Did it," by Gay Pauley.

June 4, 1953, *Austin American*, "A Texan Abroad. Perle Mesta Takes Off on Moscow," by Grace Halsell.

June 4, 1953, *Evening Standard of London*, "Mrs. Mesta Steps Out to the Tunes of Call Me Madam."

June 4, 1953, *Jersey Journal*, "Assignment America," by Inez Robb.

June 4, 1953, *Rock Island Argus*, "Queen and Perle Mesta Give Parties," by Nicholas King (UP).

June 4, 1953, *Washington Evening Star*, "Mrs. Mesta Gives Coronation Party for 500 Guests" (AP).

June 5, 1953, *New York Daily News*, "Party Coronates Perle Society's Undoubted Queen."

June 5, 1953, *New York Herald Tribune*, "Mrs. Mesta Describes Her Coronation Party," by Perle Mesta.

June 8, 1953, *Atlanta Constitution*, "Perle Mesta Did Excellent Work," by Bob Considine.

June 13, 1953, *New York Times*, "Mrs. Mesta Arrives for Visit to Soviet Union."

June 14, 1953, *Philadelphia Inquirer*, "Perle Mesta Feted in Moscow" (UPI).

June 15, 1953, *Arizona Star*, "Hostess with Mostes' Unhurt as Fire Hits House of U.S. Envoy" (AP).

June 15, 1953, *New York Times*, "Perle Mesta in Moscow Says, Just Call Me Mrs.," by Harrison Salisbury.

June 16, 1953, *Arizona Republic*, "Mesta Makes Russia Debut. Moscow" (UP).

June 23, 1953, *St. Louis Post-Dispatch*, "Reds Open Wide Area of Russia to Uncurbed Travel by Visitors," by Thomas P. Whitney (AP).

June 25, 1953, *New York Times*, "Mrs. Mesta to Ukraine," Reuters.

July 10, 1953, *New York Times*, "Beria Rose to Fame under Stalin as Chief of the Soviet Secret Police."

July 12, 1953, *New York Times*, "Beria's Fall."

July 21, 1953, *Vancouver News-Herald*, "Perle Mesta Moves Freely in Russia," Reuters.

July 25, 1953, *New York Times*, "Mrs. Mesta Sees Ukraine."

Aug. 12, 1953, *New York Herald Tribune*, "Mrs. Mesta Goes to Leningrad."

Aug. 14, 1953, *New York Times*, "Diplomats Extend Touring in Soviet Union," by Harrison Salisbury.

Aug. 25, 1953, *New York Herald Tribune*, "Perle Mesta Told the Reds She Doesn't Like Regime."

Aug. 25, 1953, *Philadelphia Inquirer*, "Soviet Living Conditions Prove Shock to Mrs. Mesta" (AP).

Sept. 24, 1953, *Newport News*, "Perle Mesta, Hostess with Mostest, Expected Back as Capital Leader," by Jane Eads.

Oct. 14, 1953, *New York Herald Tribune*, "Perle Mesta in Russia: An Unexpected Invitation Lifts the Iron Curtain," by Perle Mesta.

Oct. 15, 1953, *New York Herald Tribune*, "Perle Mesta in Russia: The Rich Have Much, the Poor Have Little in the Soviet's Vaunted Classless Society," by Perle Mesta.

Oct. 16, 1953, *New York Herald Tribune*, "Perle Mesta in Russia: Russia's New Women Do the Heaviest Labor," by Perle Mesta.

Oct. 18, 1953, *New York Herald Tribune*, "Perle Mesta in Russia: Surprising Visit to a Steel Mill in the Ukraine," by Perle Mesta.

Oct. 19, 1953, *New York Herald Tribune*, "Perle Mesta in Russia: Friendlier Ukrainians Mistake Being Mistaken for Russians," by Perle Mesta.

Oct. 20, 1953, *New York Herald Tribune*, "Mrs. Mesta in Russia" (editorial).
Oct. 20, 1953, *New York Herald Tribune*, "Perle Mesta in Russia: Beria's Picture Is Needled out of a Chinese Tapestry at Exhibit," by Perle Mesta.
Oct. 21, 1953, *New York Herald Tribune*, "Perle Mesta in Russia: No Sign of Beria Is Found in His Native Georgia," by Perle Mesta.
Oct. 22, 1953, *New York Herald Tribune*, "Perle Mesta in Russia: Travel Tips, Take Lots of Rubles," by Perle Mesta.
Oct. 23, 1953, *New York Herald Tribune*, "Perle Mesta in Russia: Foreigners Still Treated Like Spies," by Perle Mesta.
Oct. 25, 1953, *New York Herald Tribune*, "Perle Mesta in Russia: Supreme Soviet in Session," by Perle Mesta.
Nov. 25, 1957, *Buffalo Evening News*, "Her Moscow Room Was Wired during Visit, Perle Mesta Says."
March 1963, *McCall's*, "First Ladies I Have Known," by Perle Mesta.

CHAPTER 19: THERE'S NO PLACE LIKE HOME

Books

Dwight David Eisenhower, *The Papers of Dwight David Eisenhower* (Johns Hopkins University Press, 1970).
Susan Eisenhower, *Mrs. Ike: Memories and Reflections on the Life of Mamie Eisenhower* (Farrar, Straus and Giroux, 1996).
Perle Mesta with Robert Cahn, *Perle: My Story* (McGraw Hill, 1960).

Archives and Documents

Dwight D. Eisenhower Presidential Library: Mamie Eisenhower correspondence with Perle Mesta.
Harry S. Truman Presidential Library: Margaret Truman journals.
New-York Historical Society. Courtesy of the New-York Historical Society and Time USA LLC. © 1949 TIME USA, LLC. All rights reserved. Used under license.

Articles

Nov. 17, 1953, *Boston Globe*, "Truman Lambastes Brownell."
Nov. 17, 1953, *Christian Science Monitor*, "Truman's Remarks."
Dec. 1, 1953, *Logansport Pharos Tribune*, "Outlaw Dock Workers Set Picket" (UP).
Dec. 8, 1953, *Austin American-Statesman*, "Mme Pearl Mesta Hopes Dulles Will Listen," by Inez Robb.
Dec. 13, 1953, *Daily Oklahoman*, "Report from Washington," by Allan Cromley.
Dec. 15, 1953, *Arizona Daily Citizen*, "'Hostess with Mostest' Returns to Defend Title," by Ruth Cowan.
Dec. 20, 1953, *Star Press*, "War College Wives Cheer Lonely Troops," by Dorothy McCardle (NANA).
Dec. 20, 1953, *Tulsa World*, "Letter from Washington," by Betty Beale.

Jan. 4, 1954, *The Messenger*, "Mrs. George Tyson, Sister of Perle Mesta, Has Acquired a Kennel in Charlottesville, Va.," by Jane Eads (AP).

Jan. 15, 1954, *Washington Evening Star*, "New Home for Mrs. Mesta."

Jan. 19, 1954, *El Paso Herald-Post*, "Perle Mesta Hates Reds More after Trip to Russia."

Jan. 26, 1954, *Buffalo News*, Danton Walker column.

Jan. 31, 1954, *Pittsburgh Post-Gazette*, "Washington Calling."

Feb. 10, 1954, Pittsburgh Press, "My Day," by Eleanor Roosevelt.

March 2, 1954, *Boston Globe*. "I'm a Democrat . . . but I Love Ike," by Edward Driscoll.

March 2, 1954, *Christian Science Monitor*, "Diplomatic Roles Urged for Women," by Betty Driscoll.

March 6, 1954, *Boston Globe*, "Mme Mesta in Action."

March 7, 1954, *Boston Globe*, "Perle Mesta Tells How President Eisenhower Makes Famous Apple Pie," by Dorothy Crandall.

May 30, 1954, *Henrietta Daily Free-Lance*, "Perle Mesta Still the Hostess with the Mostest in Capital," by Ruth Gmeiner (UP).

May 30, 1954, *Minneapolis Star Tribune*, "Mrs. Mesta Retakes Capital Society," by Jack Wilson.

May 30, 1954, *Portsmouth Star*, "Perle Mesta Tosses Wing-Ding Party for Bigwigs of Capital," by Margaret Brewer (INS).

May 31, 1954, *Knoxville News-Sentinel*, "Admission to Perle's Shindig Was by Ticket, and None Was for Sale," by Peter Edson.

May 31, 1954, *Washington Evening Star*, "Exclusively Yours," by Betty Beale.

June 1, 1954, *Los Angeles Times*, Bill Henry column.

June 1, 1954, *Portsmouth Star*, "Echoes of Party Given the 'Women of the Press,'" by Lelia Triplett.

June 2, 1954, *New York Daily News*, "Perle Mesta Proves She's Still Got Old Touch on Return to Washington," by Isabel Kinnear Griffin.

June 2, 1954, *Variety*, "Perle Mesta Spoofs DC Protocol as Showbiz and Diplomacy Frolic," by Herman Lowe.

June 9, 1954, *Brooklyn Eagle*, "Perle Mesta Helps Tense Capital Relax," by Ray Tucker.

June 13, 1954, *Washington Post*, "Capital's Memory Long," by Marie McNair.

June 14, 1954, *Life*, "Life Goes to Perle's Homecoming Party."

July 4, 1954, *Washington Post*, "Have You Seen," by Marie McNair.

July 8, 1954, *Newport News*, "Hardy Jazz Fans Brave Downpour to Hear Their Favorites Go, Go, Go."

July 19, 1954, *New York Daily News*, "Newport Jazz Sends La Mesta Home."

Aug. 14, 1954, *The New Yorker*, "Newport Jazz Festival. How Nice of Perle Mesta to Come," by Lillian Ross.

Nov. 5, 1954, *New York Times*, "Eisenhower Host to Queen Mother."

Nov. 5, 1954, *WWD*, "Rich Satins Worn at White House Dinner Honoring Queen."

Nov. 21, 1954, *Washington Evening Star*, "Perle Mesta: Her First Prize Was Calvin Coolidge, V.P.," by Betty Beale.

Nov. 21, 1954, *Washington Post*, "VIP Parade Goes On," by Dorothy McCardle.

Nov. 28, 1954, *Washington Evening Star*, "Invited to White House? Here Is Your Primer," by Isabelle Shelton.

Nov. 29, 1954, *Washington Evening Star*, "Famous Capital Hostesses," by Betty Beale.

Jan. 5, 1957, *Tampa Times*, "Perle Mesta Is a Lady of Many and Varied Interests," by Margaret McManus.

CHAPTER 20: HAVE PASSPORT, WILL TRAVEL

Books

Perle Mesta with Robert Cahn, *Perle: My Story* (McGraw Hill, 1960).

Sylvia Jukes Morris, *Price of Fame: The Honorable Clare Boothe Luce* (Random House, 1998).

David A. Nichols, *Eisenhower 1956: The President's Year of Crisis* (Simon & Schuster, 2011).

Nancy Rubin, *American Empress: The Life and Times of Marjorie Merriweather Post* (iUniverse, 2004).

Archives and Documents

Dwight D. Eisenhower Presidential Library: Mamie Eisenhower correspondence with Perle Mesta.

Oklahoma Historical Society: Perle Mesta papers, world trip journal.

Articles

Feb. 23, 1955, *Washington Evening Star*, "Arts Patron Offers to Head Fund Drive for Cultural Center."

March 2, 1955, *Washington Evening Star*, "Exclusively Yours," by Betty Beale.

March 14, 1955, *Washington Evening Star*, "Mrs. Mesta, Rayburn, Party Circuit Stars," by Betty Beale.

March 17, 1955, *Family Weekly Magazine*, "Meet the Real Perle Mesta," by Jerry Klein.

March 21, 1955, *Washington Post*, "Dinner Time."

May 2, 1955, *Washington Post*, "Perle Will Join Elsa on Aegean Cruise," by Mary Van Rensselaer Thayer.

June 3, 1955, *Washington Evening Star*, "Perle Going for Four Month around the World Tour," by Betty Beale.

June 3, 1955, *Washington Post*, "Perle Is Packing," by Marie McNair.

June 4, 1955, *New York Daily News*, "Perle at Circus Saints and Sinners Club."

June 4, 1955, *Washington Post*, "Still the Mostes' Parties."

June 5, 1955, *Philadelphia Inquirer*, "Perle Mesta Awards."

June 7, 1955, *Tulsa Tribune*, "Skit Done, Perle, Too. They Can't Get the Besta Mesta."

June 12, 1955, *The Tennessean*, "Rough Ribs Bruise but Healing's Quick," by Betty Beale.

June 13, 1955, *Clarion Register*, "Hostess Mesta Takes Breather," by Jane Eads (AP).

June 22, 1955, *Buffalo Evening News*, "No Gal President Says Perle Mesta" (AP).
June 23, 1955, *North Star News*, "Perle Mesta Off on Single-Handed Good Will Trip."
June 29, 1955, *Berkshire Eagle*, "Perle Mesta Hits South Korea" (UP).
June 30, 1955, *Frederick Leader*, "Perle Mesta Tells of Chats with Servicemen" (AP).
July 1, 1955, *Pittsburgh Press*, "Perle Mesta Pays Call on Madame Chiang."
July 3, 1955, *New York Times*, "Mrs. Mesta Talks with Nehru."
July 8, 1955, *The Daily Independent*, Bob Considine column.
July 20, 1955, *Jamestown Post Journal*, "Perle Mesta Escapes Rioters in Saigon Hotel" (AP).
July 21, 1955, *New York Herald Tribune*, "Perle Mesta Talks Way Out of Riot" (AP).
July 22, 1955, *Washington Post*, "Riot Story Told by Mrs. Mesta."
Aug. 31, 1955, *Washington Post*, "Society as Usual Is in a Big Whirl," by Marie McNair.
Sept. 17, 1955, *Pittsburgh Press*, "Perle Mesta Going Back to Luxembourg."
Sept. 23, 1955, *International Herald Tribune*, "As Mrs. Mesta Saw Saigon," by Art Buchwald.

CHAPTER 21: THE WORLD TRAVELER RECOVERS

Interviews

Luci Baines Johnson; Bonnie Buchanan Matheson; Selwa "Lucky" Roosevelt

Books

Robert A. Caro, *The Years of Lyndon Johnson: Master of the Senate* (Alfred A. Knopf, 2002).
Frederick Logevall, *JFK: Coming of Age in the American Century, 1917–1956* (Random House, 2020).
Perle Mesta with Robert Cahn, *Perle: My Story* (McGraw Hill, 1960).
Sylvia Jukes Morris, *Price of Fame: The Honorable Clare Boothe Luce* (Random House, 1998).
David A. Nichols, *Eisenhower 1956: The President's Year of Crisis* (Simon & Schuster, 2011).

Archives and Documents

Dwight D. Eisenhower Presidential Library: Dwight and Mamie Eisenhower correspondence with Perle Mesta; Ruth Buchanan oral history.
Oklahoma Historical Society: Perle Mesta papers, world trip journal.
New-York Historical Society. Courtesy of the New-York Historical Society and Time USA LLC. © 1949 TIME USA, LLC. All rights reserved. Used under license.

Articles

Sept. 25, 1955, *Washington Post*, "Perle Earns a New Title. Human Fireball They Call Her," by Dorothy McCardle.

Oct. 6, 1955, *Washington Post*, "The Mesta Report," by Charles Docherty (Reuters).

Oct. 9, 1955, *Philadelphia Inquirer*, "Visits with Yanks in Madrid, Rome."

Oct. 21, 1955, *Christian Science Monitor*, "Mrs. Mesta Relates Asian Adventures," by Josephine Ripley.

Oct. 29, 1955, *Newport News*, "Far East 'Sizzling' but U.S. Has Friends Says Mrs. Perle Mesta."

Nov. 20, 1955, *Washington Post*, "What Is Society Today?" by Marie McNair.

Nov. 24, 1955, *Philadelphia Inquirer*, "By the Way with Bill Henry."

Feb. 3, 1956, *New York Daily News*, "Hollywood on Tour," by Hedda Hopper.

Feb. 5, 1956, *Asbury Park Press*, "Perle Mesta's Hostess Again" (AP).

Feb. 5, 1956, *New York Times*, "Sister of Stevenson Thinks He Can Win."

Feb. 5, 1956, *Washington Evening Star*, "Exclusively Yours," by Betty Beale.

Feb. 6, 1956, *Washington Post*, "Perle's Parties Will Skip Nobody," by Marie McNair.

Feb. 12, 1956, *Pittsburgh Press*, "Potomac Patter," by Andrew Tully.

Feb. 15, 1956, *New York Daily News*, Hedda Hopper column.

Feb. 18, 1956, *New York Daily News*, "DC Wash," by Gwen Gibson.

Feb. 22, 1956, *New York Times*, "Mrs. Tyson Became Poodle Fancier as Embassy Guest," by Gordon S. White Jr.

Feb. 28, 1956, *Evening Vanguard*, "Perle Mesta Boosts Her Rating as No. 1 Hostess," by Jane Eads (AP).

March 1, 1956, *New York Times*, "Eisenhower Announces for Re-election," by James Reston.

March 6, 1956, *Miami Herald*, "Perle Mesta Labels Holy Land Peril Spot," by Russ Marchner.

March 18, 1955, *Daily Press*, "Letter from Washington," by Betty Beale.

March 23, 1956, *The Tribune*, "Perle Charging $1,500 per Speech," NEA.

April 1, 1956, *Montgomery Advertiser*, "Washington Easter Dinner, 800 dignitaries," by Ruth Cowan.

April 15, 1956, *Wichita Eagle*, "Letter from Washington," by Betty Beale.

April 16, 1956, *Newsday*, "So You Want to Give a Party," by Bonnie Angelo.

April 22, 1956, *New York Times*, "Miss Truman Wed to Clifton Daniel," by Edith Evans Asbury.

April 22, 1956, *St. Louis Globe and Mail*, "Margaret Truman's Wedding."

April 28, 1956, *Washington Post*, "Spring Partygoers Step up the Pace," by Marie McNair.

April 30, 1956, *New York Times*, "Stevenson Leads Delegate Survey. No Democrat Is Likely to Win on First Ballot at Party Convention," by W. H. Lawrence.

May 7, 1956, *El Paso Herald Tribune*, "Lion's Club Brings Forth Mrs. Mesta," by Frederick Othman.

May 11, 1956, *Cushing Daily Citizen*, "Perle Mesta Says Women Not Treated Fairly in Politics."

May 11, 1956, *Daily Oklahoman*, "Perle Mesta Says A Lot of Clergy Are Red," by Wes Leathercock.

May 12, 1956, *Tulsa World*, "Perle Mesta Says Truman Will Determine Nominee," by Phil Dessauer.

May 30, 1956, *Washington Evening Star*, "Red Clergy Remark Is Denied."

June 3, 1956, *Nashville Tennessean*, "10 Most Influential Women in Washington," by Patricia Wiggins (AP).

June 11, 1956, *Washington Evening Star*, "Here's Why Mesta Dance Was a Wow," by Betty Beale.

June 17, 1956, *Tampa Bay Times*, "'Hostess with the Mostest' Loves Horseback Riding," by Nancy Osgood.

June 18, 1956, *Reno Gazette-Journal*, "Perle Mesta Nephew Gets Reno Divorce, Remarries."

June 27, 1956, *Los Angeles Times*, "Perle Mesta Works Hard to Help Students."

July 10, 1956, *Los Angeles Times*, "Two Firms Negotiate for Perle Mesta Story," by Hedda Hopper.

July 19, 1956, *Washington Post*, "Suit Claims Perle Mesta, Two Others Unlawfully Took Antique Furnishings."

July 23, 1956, *Washington Evening Star*, "Exclusively Yours," by Betty Beale.

CHAPTER 22: WINDY CITY BLUES: THE PARTY MUST GO ON

Books

Robert A. Caro, *The Years of Lyndon Johnson: Master of the Senate* (Alfred A. Knopf, 2002).

Frederick Logevall, *JFK: Coming of Age in the American Century, 1917–1956* (Random House, 2020).

Perle Mesta with Robert Cahn, *Perle: My Story* (McGraw Hill, 1960).

Sylvia Jukes Morris, *Price of Fame: The Honorable Clare Boothe Luce* (Random House, 1998).

David A. Nichols, *Eisenhower 1956: The President's Year of Crisis* (Simon & Schuster, 2011).

Archives and Documents

Dwight D. Eisenhower Presidential Library: Mamie Eisenhower correspondence with Perle Mesta.

Library of Congress: Clare Boothe Luce papers.

New-York Historical Society. Courtesy of the New-York Historical Society and Time USA LLC. © 1949 TIME USA, LLC. All rights reserved. Used under license.

New York Public Library: *McCall's* magazine collection.

Articles

Aug. 6, 1956, *Time*, "Democrats: Who for Vice President?"

Aug. 8, 1956, *New York Post*, "It Happened Last Night," by Earl Wilson.

Aug. 8, 1956, *Washington Evening Star*, "Exclusively Yours," by Betty Beale.

Aug. 9, 1956, *Philadelphia Inquirer*, "Harry Bustles in, Humdrum Show Starts Humming" (AP).

Aug. 9, 1956, *Chicago Tribune*, "Perle Mesta Is Arranging Lavish Party," by Judith Cass.

Aug. 9, 1956, *Los Angeles Times*, "Perle Mesta Plans Party for Democrats."

Aug. 10, 1956, *Boston Globe*, "Adlai, Ave? Truman Isn't Saying," by John Harris.

Aug. 10, 1956, *Christian Science Monitor*, "Democrats Wait Truman Nod for Stevenson: Kennedy, Shift to Stevenson?"

Aug. 10, 1956, *Omaha World-Herald*, Bob Considine column.

Aug. 12, 1956, *Boston Globe*, "Best Candidate at the Moment Is Lyndon Johnson."

Aug. 12, 1956, *Los Angeles Times*, "Truman Strongly Backs Harriman's Nomination."

Aug. 12, 1956, *Washington Evening Star*, "Exclusively Yours," by Betty Beale.

Aug. 13, 1956, *Abilene Reporter News*, "Partying Perle Mesta for Johnson, Clement," by Elizabeth Carpenter.

Aug. 13, 1956, *New York Times*, "Mrs. Mesta's Life to Become Movie. Rosalind Russell," by Thomas M. Pryor.

Aug. 13, 1956, *Wall Street Journal*, "Truman's Harriman Souffle Goes Awry as Convention Opens: Few Northern Delegates Are Turned from Stevenson; Southerners Rage Anew. Heat from Texas' Johnson."

Aug. 13, 1956, *Washington Post*, "Nancy Stevenson Shares Spotlight: Perle Solves Problem," by Mary V. R. Thayer.

Aug. 14, 1956, *Washington Post*, "Perle Party Promise to Be Pink."

Aug. 15, 1956, *Austin Statesman*, "Demo's Elevator Just Short of Genius," by Inez Robb.

Aug. 15, 1956, *Washington Evening Star*, "Exclusively Yours," by Betty Beale.

Aug. 16, 1956, *Albany Times-Union*, "Party's Donkey Has Plenty of Kick. Leading Democrats Throng to Perle Mesta's Reception" (INS).

Aug. 16, 1956, *Boston Globe*, "Frisked at the Door . . . Perle's Shindig," by John Steinbeck.

Aug. 16, 1956, *Philadelphia Inquirer*, "Not-So-Poor Democrats Have a Party."

Aug. 16, 1956, *Washington Post*, "'400 Plus' Kept Perle in One of Her Biggest Whirls."

Aug. 17, 1956, *Reno Evening Gazette*, "A Postcard from Stan Delaplane."

Aug. 17, 1956, *Washington Post*, "Washington Scene," by George Dixon.

Aug. 18, 1956, *New York Times*, "Platform Hailed."

Aug. 18, 1956, *Reno Evening Gazette*, "A Plebian Party."

Aug. 18, 1956, *Tulsa Tribune*, "Oklahoman on the Loose," by Westbrook Pegler.

Aug. 19, 1956, *New York Times*, "Again Stevenson," by George Tames.

Aug. 20, 1956, *Chicago Daily Defender*, "Perle's Donkey Party Pleases Politicos."

Oct. 1956, *Town & Country*, "Les Ormes," by Jerome Zerbe.

Oct. 1, 1956, *Washington Evening Star*, "Exclusively Yours," by Betty Beale.

Oct. 2, 1956, *Reno Evening Gazette*, "Perle Mesta Is Purchaser of Ranch in Carson County."

Oct. 13, 1956, *Troy Daily News*, "U.S Marshall, Armed with Summons, Waits in Ambush for Perle Mesta," by Douglas Larsen and Kenneth G. Gilmore, NEA.

Oct. 27, 1956, *Morning Call*, "The Lyons Den," by Leonard Lyons.

Oct. 30, 1956, *Des Moines Register*, "Perle Mesta Won't Guess on Election," by Nick Lamberto.

Oct. 31, 1956, *Des Moines Register*, "700 Banker's Wives Hear Mrs. Mesta."

Nov. 1, 1956, *Herald News*, "White Tie and Tiara Season. Capital Hostesses Fan Party Mood but Hold Off for White House Pronouncement," by Jane Eads (AP).

Nov. 7, 1956, *New York Daily News*, "Hollywood and NY," by Hedda Hopper.

Nov. 20, 1956, *New York Times*, "Mrs. Luce Resigns as Envoy," by Joseph A. Loftus.

Dec. 16, 1956, *Washington Post*, "Society Sets Sail for Holiday Exodus," by Marie McNair.

Dec. 26, 1956, *Pittsburgh Post-Gazette*, "The Gallup Poll: Mrs. FDR Most Admired. Clare Booth Luce Places Second. Mamie Eisenhower Third."

Jan. 1957, *Inside TV*, "Playhouse 90 Is Real Account of Perle Mesta," by Eve Starr.

Jan. 1, 1957, *Los Angeles Mirror*, "Culture Winning over Cocktails," by Douglas Larsen and Kenneth Gilmore (NEA).

Jan. 5, 1957, *Tampa Times*, "Perle Mesta Is a Lady of Many and Varied Interests," by Margaret McManus.

Jan. 7, 1957, *Jersey Journal*, "On Broadway," by Hal Eaton.

Jan. 15, 1957, *Arizona Republic*, "Ex-Envoys Resting Here."

Jan. 17, 1957, *Hartford Courant*, "Mrs. Luce Well Rested Going to Inauguration."

Jan. 21, 1957, *New York Times*, "Politics Is the Be-All and End-All in Washington Society," by Allen Drury.

Feb. 1, 1957, *Salt Lake Tribune*, Hedda Hopper column.

Feb. 3, 1957, *Oakland Tribune*, "When I Was Hostess the Mostes'," by Perle Mesta.

March 1957, *Good Housekeeping*, "On Our List," by Mary Ellin and Marvin Barrett.

March 1, 1957, *Daily Sentinel*, "Perle Master-Minds Plans for Party 3,000 Miles Away" (INS).

March 5, 1957, *Tulsa Tribune*. "Perle Has a Colossal Party to Assist Hungarian Relief," by Leslie Carpenter.

March 5, 1957, *Washington Evening Star*, "Gwen Shows Up at Perle's Party," by Betty Beale.

March 6, 1957, *Newsday*, "Capitol Punishment," by Hal Levy and Bonnie Angelo.

March 6, 1957, *Tampa Tribune*, "Perle Mesta's Latest Party Evokes Blue Ribbon Meows," by Ruth Montgomery.

March 7, 1957, *Washington Post*, "Washington Scene," by George Dixon.

March 10, 1957, *Boston Globe*, "Pearl Shakes Hand with No. 1 Party Competitor," by Marjorie Adams.

March 16, 1957, *Texas Monitor*, "Party-Giver Perle Mesta Ducking Summons to Appear in Court" (UP).

March 17, 1957, *Los Angeles Times*, "Shirley Booth Plays Perle Mesta Thursday," by Walter Ames.

March 17, 1957, *New York Daily News*, "Perle Mesta an Expert on Steel," by Ben Gross.

March 17, 1957, *Washington Post*, "Can 90 Minutes Make the Most of Mesta Saga?" by Marie McNair.

March 20, 1957, *Los Angeles Times*, "Perle Mesta Explains Her Formula for Party Success," by Lydia Lane.

March 21, 1957, *West Los Angeles Independent*, "Don't Call Her Madam! Perle Mesta's Title Is 'Feminist,'" by Charlotte Leigh-Taylor.

March 22, 1957, *Buffalo Evening News*, "Radio & TV News," by Sturgis Hedrick.

March 22, 1957, *New York Daily News*, "Shirley Booth Really the Mostes' as Perle," by Ben Gross.

March 22, 1957, *New York Times*, "TV: Cliché and Corn," by Jack Gould.

March 22, 1957, *Washington Evening Star*, "All of It Was True, Said Perle Mesta," by Betty Beale.

March 22, 1957, *Washington Post*, "Video Depicts Perle as Humorous and Gay," by Lawrence Laurent.

March 24, 1957, *Sunday New York Daily News*, "What It Takes to Be a Success as a Hostess in Society," by Ben Gross.

March 31, 1957, *Hartford Courant*, "Life Story of Perle Mesta Mere Waste of TV Time," by John Crosby.

March 31, 1957, *Lima News*, "Perle Mesta Wonders Why People Crash Parties," by Jane Eads (AP).

May 18, 1957, *Daily Oklahoman*, "Perle Becomes Tribal Envoy."

May 21, 1957, *Alton, Illinois Evening Telegraph*, "The Hostess Addresses Principia on Communism."

June 15, 1957, *Daily Oklahoman*, "Capitol Now More Lively."

June 16, 1957, *Washington Post*, "Will Mrs. Post Be Queening Top Tiara," by Marie McNair.

July 3, 1957, *Washington Post*, "Perle is Back 'At Home'—but Not to Stay Put," by Marie McNair.

July 9, 1957, *Washington Post*, "Mostes' Hostess Perle et al. Settle Out of Court with Idel."

July 11, 1957, *Daily Oklahoman*, "Letter from Washington," by Betty Beale.

Aug. 11, 1957, *Daily Oklahoman*, "Perle Visits Plush Retreat," by Ruth Montgomery.

Feb. 23, 1958, *Washington Post*, "Beauty Mecca Resembles Rare Jewel Set in Desert."

April 6, 1958, *San Francisco Examiner*, "A TV Producer Believes in Instinct—plus Some Odd Casting," by John Maynard.

CHAPTER 23: FLY ME TO THE MOON

Interviews

Ann Hand; Lloyd Hand; Linda Picasso; Elizabeth Christian; Bonnie
Buchanan Matheson; Selwa "Lucky" Roosevelt

Books

Robert A. Caro, *The Years of Lyndon Johnson: Master of the Senate* (Alfred A.
Knopf, 2002).

Allen Drury, *Advise and Consent* (Doubleday, 1959).

Betty Ellis, "Years Remembered" (unpublished family memoir).

Frederick Logevall, *JFK: Coming of Age in the American Century, 1917–1956*
(Random House, 2020).

Perle Mesta with Robert Cahn, *Perle: My Story* (McGraw Hill, 1960).

Drew Pearson, *Washington Merry-Go-Round: The Drew Pearson Diaries,
1960–1969* (Potomac Books, 2015).

Archives and Documents

Dwight D. Eisenhower Presidential Library: Mamie Eisenhower
correspondence with Perle Mesta.

LBJ Presidential Library: Lady Bird Johnson oral history, interviewed by
Harry Middletown, Nov. 5, 1994.

Library of Congress: Clare Boothe Luce papers.

New-York Historical Society. Courtesy of the New-York Historical Society
and Time USA LLC. © 1949 TIME USA, LLC. All rights reserved.
Used under license.

New York Public Library: *McCall's* magazine collection.

Articles

Aug. 28, 1957, *Washington Post*, "Eyes of Texas Turn on Lyndon," by Frances
Rowan.

Sept. 1957, *Ladies' Home Journal*, "America's 10 Richest Women—Who are
they?" by Laura Date Riley.

Sept. 11, 1957, *Washington Post*, "Gwen Reveals Some Secrets," by Jack
Anderson.

Sept. 13, 1957, *Washington Post*, "Judy Opens Perle's Season," by Marie
McNair.

Sept. 17, 1957, *Washington Evening Star*, "Gates at Les Ormes Are Open
Again."

Sept. 17, 1957, *Washington Post*, "Perle's 'Opener,'" by Marie McNair.

Sept. 19, 1957, *Ottawa Citizen*, "Society Is Here to Stay," by J.R. Walker,
Southam News Service.

Sept. 30, 1957, *Minneapolis Star*, "The Lyons Den," by Leonard Lyons.

Oct. 9, 1957, *Washington Post*, "ONLY 100 of Capital's 400 Got Invitations,"
by William McGaffin.

Oct. 14, 1957, *Chicago Defender*, "Housewives Launch Private Investigation."

Oct. 17, 1957, *Washington Post*, "White House Bound, Perle Minus 26
Pounds," Dorothy McCardle.

Oct. 18, 1957, *Philadelphia Inquirer*, "U.S. Elite Honor Queen at Glittering State Dinner" (INS).

Oct. 18, 1957, *Tampa Tribune*, "Perle Mesta Dines with Queen as Rival Frets."

Oct. 22, 1957, *Buffalo News*, "Letter from Washington," by Betty Beale.

Nov. 1957, *Town & Country*, "Poodles and People," by Rheems Russell.

Nov. 12, 1957, *New Rochelle Standard-Star*, "Party Game Again Gets Perle Mesta," by Jane Eads.

Dec. 3, 1957, *Buffalo News*, "Perle Mesta Out-Staminas New Yorkers in Gay Visit," by Betty Beale.

Dec. 18, 1957, *Newsday*, "Capitol Punishment," by Hal Levy and Bonnie Angelo.

Dec. 22, 1957, *Daily Press*, "Capital Capers," by Betty Beale.

Dec. 30, 1957, *Washington Post*, "A Good Time in Anybody's Language. Perle Does It Again," by Muriel Bowen.

Jan. 3, 1958, *Washington Star*, "Exclusively Yours," by Betty Beale.

Jan. 6, 1958, *Buffalo News*, "Luminaries in Washington Suggest Changes in Capital," by Betty Beale.

Jan. 15, 1958, *Montana Standard*, "Washington Scene," George Dixon.

Jan. 20, 1958, *Washington Post*, "Perle Captures Curtain Coterie."

Jan. 23, 1958, *Washington Post*, "Dragon Calls on Quiet Man," by Marie McNair.

Jan. 23, 1958, *Washington Star*, "Dragon Aids Movie Premiere Benefit."

Jan. 26, 1958, *Indianapolis Star*, "Letter from Washington," by Betty Beale.

Jan. 29, 1958, *Variety*, "Movie Premiere," by Florence S. Lowe.

Feb. 3, 1958, *Washington Evening Star*, "Mrs. Mesta Honors Senator Green."

Feb. 6, 1958, *Nottingham Evening News*, "'They've Killed All the Good Looking Ones,' Says Perle Mesta."

Feb. 11, 1958, *Manchester Guardian*, "The Best Intentions."

Feb. 12, 1958, *Washington Evening Star*, "Eisenhowers Honor Diplomatic Envoys."

Feb. 23, 1958, *Philadelphia Inquirer*, "When Perle Gives a Party, Bigwigs Flock to Her Door."

Feb. 25, 1958, *Washington Post*, "Even Perle is Present. It's Social Coup at Soviet Soiree," by Muriel Bowen.

Feb. 26, 1958, *Washington Evening Star*, "Who's Who Empties Pages into Capital for Conference," by Betty Beale.

Feb. 26, 1958, *New York Herald Tribune*, "Nixon Leads Forum Backing Mutual Aid," by Robert J. Donovan.

March 3, 1958, *Washington Star*, "Senator is Against Changing Capitol. So is Perle," by Betty Beale.

March 14, 1958, *Washington Evening Star*, "Wernher Von Braun Honored by Perle Mesta."

March 19, 1958, *Nottingham Evening Post*, "Russian Envoy's Wife is 'Warm War' Victor," by Anne Sharpley.

March 27, 1958, *Washington Post*, "There's Magic in Their Names," by Marie McNair.

March 30, 1958, *Washington Post*, "Queen Mother Takes Stitch in Time for Kneeler," by Mary V. R. Thayer.

April 9, 1958, *Asheville Times*, "Social Fuel for Washington's Parties Comes from Perle Mesta, Menshikov," by Douglas Larsen (NEA).

April 12, 1958, *Carroll Daily Times Herald*, "Perle Mesta Doesn't Tie Strings to Her Donations."

April 18, 1958, *Washington Post*, "World Will Carry Press Card in 1960," by Winzola McClendon.

April 22, 1958, *Washington Post*, "2000 Democrats Whoop It Up," by Eileen Summers.

April 24, 1958, *Washington Post*, "Foggy Bottom Favored over Mall; Senators Argue Rival Proposals," by Elsie Carper.

April 24, 1958, *Atlanta Journal*, "Perle Mesta Spotlights Capital Culture Lag."

May 1958, *Cosmopolitan*, "Social Leadership in Washington," by E. M. D. Watson.

May 4, 1958, *Washington Post*, "Men, Perle Says Be Natty—Nicely," by Perle Mesta.

May 6, 1958, *Reno Gazette-Journal*, "Competing Creamery Firms Take Fight to Court Here."

May 28, 1958, *Newport Daily News*, "Burnham-by-the-Sea Owner to Purchase Perle Mesta's Estate."

June 22, 1958, *Washington Post*, "Perle Mesta Has Fun at a Party."

July 29, 1958, *Albany Times Union*, "Washington's Prize Parties: Perle Mesta's Soirees Sumptuous," by Ruth Montgomery.

Aug. 25, 1958, *Washington Evening Star*, "Washington Women Happy over New Cultural Center," by Mary L. Vaughn.

Sept. 11, 1958, *Newport News*, "Mrs. Mesta Hints Return to Politics."

Sept. 11, 1958, *Washington Post*, "Perle's Fair-ing, Meg Next," Reuters.

Sept. 11, 1958, *Reno Gazette-Journal*, "Brussel's Worlds Fair to Show Nevada Product."

Oct. 15, 1958, *Albuquerque Tribune*, "Mrs. Cafritz Took Her Ribbing Like a Lady; So He Likes Her."

Nov. 12, 1958, *Reno Gazette-Journal*, "Red Envoy Adopts Jovial Air at Races."

Nov. 28, 1958, *Washington Evening Star*, "Gay Thanksgiving Dinner Given by Perle Mesta at Chevy Chase Club," by Betty Beale.

Dec. 16, 1958, *Washington Post*, "Perle Toasts Italy," by Marie McNair.

Jan. 22, 1959, *Newsday*, "Capital Hostesses Have What It Takes," by Bonnie Angelo.

Feb. 1, 1959, *Boston Globe*, "Letter from Washington," by Betty Beale.

Feb. 4, 1959, *Variety*, "Songbirds of Different Feathers Flock Together with Mesta as the Mostest."

March 4, 1959, *Washington Post*, "Maxwell Maxim: Partygiver Rates Capital Hostesses," by Eileen Summers.

Aug. 9, 1964, *Philadelphia Inquirer*, "Shore Awaits Perle Mesta's Epic Parties."

Aug. 21, 1964, *Pittsburgh Press*, "Ready for Perle," by Inez Robb.

Aug. 23, 1964, *Daily Oklahoman*, "Roughing It with Perle," by Madelaine Wilson.

Aug. 23, 1964, *New York Times*, "Perle Mesta and Her Entourage Bring Party Spirit to Democrats," by Nan Robertson.

Aug. 24, 1964, *New York Post*, "Perle Mesta Finds a Host of Friends She Never Knew," by Lael Scott.

Aug. 24, 1964, *Philadelphia Inquirer*, "Hundreds Jam First of Perle's Party Series."

Aug. 25, 1964, *Los Angeles Times*, "Perle's Party Guests Avoid GOP Placard."

Aug. 25, 1964, *Miami Herald*, "Perle's Butler Keeps a Close Watch on Capers," by Vera Glaser.

Aug. 25, 1964, *Philadelphia Inquirer*, "Perle Even Feeds the Press."

Aug. 25, 1964, *Washington Post*, "Perle Puts Out the Party Plank," by Marie Smith.

Aug. 26, 1964, *Cherry Hill Courier-Post*, "Hostess Thinks the Johnsons Are the Mostes'," by Inez Robb.

Aug. 30, 1964, *Pittsburgh Press*, "Betty Beale's Carousel."

Sept. 1964, *McCall's*, "Memories of the First Family of Luxembourg," by Perle Mesta.

Sept. 2, 1964, *New York Times*, "Democratic State Convention Has National Flavor," by Martin Arnold.

Sept. 4, 1964, *Time*, "Nation: The Gay Life."

Sept. 27, 1964, *Morning Call*, "City Is Charmed by Perle Mesta," by Doris Leete.

Oct. 1964, *McCall's*, "Twigs Off the Branch: Sons and Daughters in Washington," by Perle Mesta.

Oct. 1964, *Town & Country*, "My Oklahoma," by Perle Mesta.

Nov. 1964, *Cosmopolitan*, "Space Age Hostess."

Nov. 1964, *McCall's*, "Parties for My Party," by Perle Mesta.

Dec. 1964, *McCall's*, "A 'Wishing Well' Christmas Party for Children," by Perle Mesta.

CHAPTER 27: BLAME IT ON THE FRUG

Interviews

Butch Fleischer; Luci Baines Johnson; Lynda Johnson Robb; Kandie Stroud; Marie Ridder; Elizabeth Picasso; Linda Christian; Patti Birge Spivey; Aaron Fodiman; Martha Bartlett

Books

Betty Ellis, "Years Remembered" (unpublished family memoir).

Leonore Hershey, *Between the Covers: The Lady's Own Journal* (Coward-McCann, 1983).

March 13, 1959, *Washington Star*, "For Perle and Gwen It's Sweetness and Spring," by Betty Beale.

April 16, 1959, *Hartford Courant*, "Mrs. Luce Harried by Sen. Morse in Hearing on Brazil Appointment," by Robert Byrnes.

April 28, 1959, *New York Times*, "6 in Senate Delay Vote on Mrs. Luce," by Allen Drury.

April 29, 1959, *Boston Globe*, "Foot in Mouth Epidemic in Washington" (UPI).

April 29, 1959, *New York Times*, "Mrs. Luce Wins in Senate, Husband Asks Her to Resign," by Russell Baker.

July 6, 1959, *Honolulu Star-Bulletin*, "The Social Whirl in Washington," by Virginia Kelly.

July 9, 1959, *Boston Globe*, "Skulduggery in the Capital."

July 9, 1959, *Washington Post*, "Perle Shows Hand for Equal Rights," by Eileen Summers.

July 9, 1959, *Long Beach Independent*, "Perle Mesta Life Story Being Told," by Virginia Kelly.

July 15, 1959, *New York Daily News*, "Capital Circus," by Robert Thompson.

July 17, 1953, *New York Times*, "Equal Rights Plan Adopted by Senate."

July 20, 1959, *Washington Evening Star*, "Perle Mesta Fetes Legislative Lights," by Betty Beale.

July 23, 1957, *New York Times*, "Still Burning Issue: Equal Rights Bill Divides Women's Groups, Congressmen," by Bess Furman.

July 23, 1959, *Sedalia Democrat*, "National Woman's Party Entertains Congressmen," by Esther Von Wagoner Tufty.

July 28, 1959, *Washington Post*, "Washington Merry-Go-Round: Dinner Parties Cause Tizzy Here," by Drew Pearson.

Aug. 9, 1959, *Washington Post*, "A Political Novel Close to Home," by Sen. Eugene McCarthy.

Aug. 16, 1959, *Detroit Free Press*, "Who'll Help Wine and Dine Mr. K?" by Betty Beale.

Aug. 16, 1959, *New York Times*, "Solons They Are, but Humans too," by Richard L. Neuberger.

Aug. 30, 1959, *News and Record*, "Music Gives Party Proper Pitch, Says Capital Hostess Perle Mesta," by Betty Beale.

Sept. 6, 1959, *New York Times*, "The Story That the Correspondent Told."

Sept. 16, 1959, *Washington Post*, "Soviet Boss Learns Two Party System," by Maxine Cheshire.

Sept. 16, 1959, *New York Times*, "Peace Is Theme of Toasts at White House Dinner," by Bess Furman.

Sept. 21, 1959, *Newsweek*, "The Book That Set Capital Tongues Wagging."

Sept. 25, 1959, *New York Herald Tribune*, "Khrushchev Tired? Not So You'd Notice."

Sept. 25, 1959, *Washington Post*, "Way Clear but Crowd Is Thick," by Bill McPherson.

Sept. 25, 1959, *Dayton Daily News*, "Nikita Bubbles in High Spirits" (AP).

Jan. 10, 1960, *Boston Globe*, "Caviar for Perle," by Betty Beale.

Jan. 1962, *McCall's*, "How Washington Society Goes to a Party," by Robert Gray.

1971, *Journal of Environmental Education* (vol. 2, no. 4), "Profile of Robert Cahn," by Saville Davis.

CHAPTER 24: ALL THE WAY (OR NOT AT ALL) WITH LBJ

Interviews

Luci Baines Johnson, Lynda Johnson Robb, Marie Ridder, Bonnie Buchanan Matheson.

Books

Cleveland Amory, *Who Killed Society?* (Harper & Brothers, 1960).

Robert A. Caro, *The Years of Lyndon Johnson: Path to Power* (Alfred A. Knopf, 1982).

Betty Ellis, "Years Remembered" (unpublished family memoir).

Frederick Logevall, *JFK: Coming of Age in the American Century 1917–1956* (Random House, 2020).

Perle Mesta with Robert Cahn, *Perle: My Story* (McGraw Hill, 1960).

Drew Pearson, *Washington Merry-Go-Round: The Drew Pearson Diaries, 1960–1969* (Potomac Books, 2015).

Archives and Documents

Dwight D. Eisenhower Presidential Library: Mamie Eisenhower correspondence with Perle Mesta.

Lyndon B. Johnson Presidential Library: Perle Mesta oral history, interviewed by Joe Frantz, Oct. 4, 1971; Luther Holcomb oral history, interviewed by T. H. Baker, June 24, 1969; Lady Bird Johnson oral history, interviewed by Harry Middletown, Nov. 5, 1994.

Articles and Documents

Nov. 24, 1958, *Time*, "Democratic Hopefuls."

Sept. 27, 1959, *Boston Globe*, "Party Rates Kennedy #1. Gallup Poll."

Oct. 14, 1959, *New York Herald Tribune*, "Joe Hyams in Hollywood."

Oct. 18, 1959, *New York Times*, "Rayburn Opens Bid for Johnson in '60."

Oct. 18, 1959, *Washington Post*, "Rayburn Opens Johnson Drive."

Oct. 19, 1959, *Bridgeport Post*, "Rayburn Rallies Texans to Put Johnson in Race" (AP).

Nov. 9, 1959, *Newsweek*, "The Dazzling Season Is On," by Ben Bradlee.

Nov. 28, 1959, *Buffalo Evening News*, "Washington Party-Givers Make Entertaining a Fine Art," by Elizabeth Carpenter.

Dec. 1959, *Town & Country*, "Parties! Parties! Parties!" by Igor Cassini.

Dec. 13, 1959, *Philadelphia Inquirer*, "Washington's Famed Hostess: How Perle Plans Parties."

Dec. 27, 1959, *Washington Post*, "Woman's Party to Meet Jan. 3–5 Just Prior to Reconvening of Congress."

Jan. 3, 1960, *Washington Post*, "Suffrage Is Not Enough," by Patricia Wiggins.

Jan. 6, 1960, *Washington Post*, "Equal Rights Victory Seen in New Session," by Marie Smith.

Jan. 11, 1960, *Washington Post*, "Perle Mesta Still Sets the Pace for Parties," by Marie McNair.

Jan. 16, 1960, *New Brunswick Daily Home News*, "The 1960 Primaries."

Jan. 28, 1960, *Los Angeles Times*, "She's Still Hostess with the Mostest."

Feb. 4, 1960, *Washington Evening Star*, "Perle Mesta Speaks Her Mind— From A to Z," by Isabelle Shelton.

Feb. 4, 1960, *Washington Post*, "Perle Is Corraled with LBJ Brand," by Marie Smith.

Feb. 9, 1960, *Chicago Tribune*, "Perle Mesta Breezes thru City to Coast," by Judith Cass.

Feb. 16, 1960, *Los Angeles Mirror*, "Perle's Tastes Are Really Quite Simple," by Dee Harris.

March 22, 1960, *Washington Post*, "Slumbering Gardens Stir," by Mary V. R. Thayer.

April 3, 1960, *Washington Evening Star*, "Perle Mesta Is Planning Peppy Convention Party," by Betty Beale.

April 10, 1960, *Washington Post*, "Just Call Her Perle," by Marie McNair.

April 16, 1960, *Time*, "They Call Me Madame."

April 17, 1960, *Atlanta Journal*, "Mesta's Three Careers Make Exciting Story," by Sam Lucchese.

April 19, 1960, *New York Times*, "Books of the Times," by Charles Poore.

April 20, 1960, *Boston Globe*, "Elsa Gets Brushoff at Perle's Party" (UPI).

April 20, 1960, *Washington Evening Star*, "Celebrities Toast Perle," by Betty Beale.

April 21, 1960, *Christian Science Monitor*, "Mrs. Mesta Tells Her Story in 'Perle,'" by Josephine Ripley.

April 24, 1960, *Los Angeles Times*, "Mostes Hostess Tells All on Guests," by Frances Ring.

April 24, 1960, *New York Herald Tribune*, "The Name Is Perle, the Life Is Lively," by Ellen Hart Smith.

April 26, 1960, *Washington Post*, "Partying Perle Is More Popular Than a Deb," by Marie McNair.

April 28, 1960, *Camden Courier-Post*, "Perle for Lyndon" (AP).

April 30, 1960, *Bergen Evening Record*, "Perle Mesta—Hostess with the Mostes," by Russell Thacher.

May 1960, *Town & Country*, "Life Is Her Party," by Herbert Saal.

May 5, 1960, *Passaic Herald News*, "No Insurance on Things in White House," by Merriman Smith (UPI).

May 6, 1960, *Newsday*, "Capital Starts Farewells for First Lady," by Bonnie Angelo.

May 11, 1960, *Washington Post*, "Georgetown's Chic—and Neighborly," by Marie McNair.

May 15, 1960, *New York Times*, "Political Party Girl," by Bess Furman.

May 29, 1960, *Clarion-Ledger* (Jackson, MS), "A Paradoxical Self-Portrait. Madame Mesta More Eager Kid Than Climber," by Jean Culbertson.

June 1, 1960, *New York Times*, "Ads Bid Johnson Avow Candidacy," by W. H. Lawrence.

June 1, 1960, *Wall Street Journal*, "Key Theme of Johnson Presidential Drive: Kennedy Can't Win."

June 15, 1960, *Washington Post*, "Perle Is in on Round-Up for LBJ," by Dorothy McCardle.

June 18, 1960, *Washington Evening Star*, "Mrs. Mesta Fetes Congress Wives for Johnson," by Daisy Cleland.

June 18, 1960, *Washington Post*, "LBJ Roll Reaches 84 at Party," by Winzola McLendon.

June 26, 1960, *Carlsbad Current-Argus*, "Perle Mesta Going to Coast Early to Battle for Johnson," by Ruth Montgomery.

June 30, 1960, *Philadelphia Inquirer*, "'Hostess with the Mostest' Likes Lyndon, Pats Nixon."

July 3, 1960, *Atlanta World*, "Former Pres Truman Charges Democratic Convention 'Fixed.'"

July 4, 1960, *Lubbock Avalanche-Journal*, "Kennedy Looks Like a Teenager" (UPI).

July 5, 1960, *Christian Science Monitor*, "Mrs. Mesta Backs Johnson Candidacy" (AP).

July 5, 1960, *New York Times*, "Johnson Enters Race Officially."

July 8, 1960, *Los Angeles Times*, "Democratic Parties Nominate Fun as Acclaimed Candidate," by Elizabeth Goodland.

July 8, 1960, *New Castle News*, "Emma Guffey Miller Again Calls for 'Equal Rights,'" UPI.

July 9, 1960, *Washington Post*, "Johnson 1st to Arrive in Los Angeles," by Edward Folliard.

July 10, 1960, *New York Times*, "Move to Kennedy Nears Stampede," by Russell Baker.

July 12, 1960, *Washington Post*, "Kennedy Victory Seen on First Ballot as Pennsylvanians Spark Stampede," by Edward Folliard.

July 13, 1960, *Boston Globe*, "Perle Retains Hostess Crown with Wingding."

July 13, 1960, *Buffalo News*, "Perle Mesta Gives a Brunch for 4,509," by Betty Beale.

July 13, 1960, *El Paso Herald-Post*, "2,500 Extra Guests Jam Perle Mesta Clambake," by Inez Robb.

July 13, 1960, *Newsday*, "Perle Mesta Forms Her Own Party."

July 13, 1960, *San Antonio Light*, "Lyndon at Perle's but Kennedy Left Out," by Emma Long.

July 13, 1960, *San Francisco Examiner*, "Perle's $10,000 Brunch for the Democrats," by Mildred Schroeder.

July 13, 1960, *Times-Union*, "Winning Party: Perle Mesta's."

July 15, 1960, *Miami Herald*, "Why Did Lyndon Suddenly Go with Kennedy," by Edwin Lahey.

July 16, 1960, *Lawrence Daily Journal World*, "The Lyons Den," by Leonard Lyons.

July 16, 1960, *San Francisco Examiner*, "Perle Wanted 'The Mostest' for LBJ," by Mildred Schroeder.

July 23, 1960, *New York Herald Tribune*, "Perle Mesta at Republican Convention," by Helen Thomas (UPI).

July 23, 1960, *Philadelphia Inquirer*, "Women in Politics Win Perle Mesta's Praises," by Victor Riesel.

July 23, 1960, *Washington Post*, "Perle's a Working Girl for GOP Convention."

July 26, 1960, *Christian Science Monitor*, "Famous Hostess Visits GOP 'Party,'" by Dorothea Kahn Jaffe.

July 29, 1960, *Morning Call*, "Convention Capers," by George Dixon.

July 29, 1960, *Tacoma News Tribune*, "Perle Mesta Miffed—Jackie Wears No Hose," by Pat Wells (AP).

Aug. 10, 1960, *Capital Times*, "Perle May Whirl," by Robert Allen and Paul Scott.

Aug. 14, 1960, *Honolulu Star-Bulletin*, "Johnson Booster Perle Mesta Is Mum on Voting," by Virginia Kelly.

Aug. 27, 1960, *Washington Post*, "Perle Cools towards LBJ," by Dorothy McCardle.

Aug. 28, 1960, *Washington Evening Star*, "Jovial Guests Toast Johnson on His Birthday."

Sept. 3, 1960, *Los Angeles Times*, "Nixon Endorses Equal Rights for Women."

Sept. 29, 1960, *San Francisco Examiner*, "Listening Is Her Punch Line: Esther Von Wagoner Tufty," by Mary Frazier.

Oct. 3, 1960, *The News*, "Hollywood Today with Sheilah Graham."

Oct. 9, 1960, *Tulsa World*, "Letter from Washington," by Betty Beale.

Oct. 19, 1960, *New York Herald Tribune*, "Perle Mesta Out for Nixon" (AP).

Oct. 19, 1960, *Washington Evening Star*, "Mrs Mesta—Nixon Best Qualified."

Oct. 23, 1960, *Washington Post*, "Busy Party Line."

Oct. 25, 1960, *Washington Post*, "Kennedy Backs Equal Rights for Women," by Marie Smith.

Oct. 28, 1960, *The Bellingham Herald*, Ray Tucker column.

Oct. 30, 1960, *Boston Globe*, "Perle Mesta Tosses Wing-Ding for Nixon," by Betty Beale.

Oct. 30, 1960, *New York Times*, "Final Round as Campaign Sharpens."

Oct. 31, 1960, *Newsweek*, "Out-of-Town Opening."

Nov. 2, 1960, *Palo Alto Times*, "Perle Mesta in Ladera. Joe Kennedy Can't Buy Presidency," by Mary Madison.

Nov. 3, 1960, *Sacramento Bee*, "Perle Mesta Calls JFK Nice But—" by Ann Colbrook.

Nov. 3, 1960, *Santa Barbara Independent*, "War with Kennedy. Warning by Famed Hostess," by William Jones.

Nov. 4, 1960, *Los Angeles Times*, "Democrat Perle Mesta Here to Boost Nixon."

Nov. 4, 1960, *Santa Barbara News-Press*, "Nixon Better Qualified: Mesta" (UPI).

Nov. 8, 1960, *New York Daily News*, "Why Democratic Women Vote for Nixon-Lodge," by Perle Mesta.

Nov. 9, 1960, *Salt Lake Tribune*, "Hours Pass, Margin Rises, Nixon Fans Grow Glum" (UP).

Nov. 9, 1960, *Washington Post*, "Women Weep as Nixon Admits Defeat," by Julius Duscha.

Nov. 11, 1960, *Washington Post*, "Brazil Is Sad Reality for Hosts," by Winzola McLendon.

Nov. 14, 1960, *Washington Post*, "The Washington Scene," by George Dixon.

Nov. 22, 1960, *San Francisco Examiner*, "Mesta Here, Spurs Vote Probe Push."

Jan. 1962, *McCall's*, "How Washington Society Goes to a Party," by Robert Gray.

1971, *Journal of Environmental Education* (vol. 2, no. 4), "Profile of Robert Cahn," by Saville Davis.

CHAPTER 25: A HOUSE IS NOT A HOME

Interviews

Luci Baines Johnson; Lynda Johnson Robb; Marie Ridder; Bonnie Buchanan Matheson; Linda Picasso; Elizabeth Christian; Elizabeth Skirvin Tyson; Patti Birge Spivey; Aaron Fodiman; Susan Eisenhower; Martha Bartlett; Sandra McElwaine

Books

Robert A. Caro, *The Years of Lyndon Johnson: Means of Ascent* (Alfred A. Knopf, 1991).

Betty Ellis, "Years Remembered" (unpublished family memoir).

Leonore Hershey, *Between the Covers: The Lady's Own Journal* (Coward-McCann, 1983).

Peter T. Higgins, *A History of the Westchester Cooperative and Its Neighbors* (Dog Ear Publishing, 2018).

Sylvia Jukes Morris, *Price of Fame: The Honorable Clare Boothe Luce* (Random House, 1998).

Julia Sweig, *Lady Bird Johnson: Hiding in Plain Sight* (Random House, 2021).

Archives and Documents

LBJ Presidential Library: Perle Mesta oral history, interviewed by Joe Frantz, Oct. 4, 1971; Luther Holcomb oral history, interviewed by T. H. Baker, June 24, 1969; Lady Bird Johnson oral history, interviewed by Harry Middletown, Nov. 5, 1994; Lady Bird Johnson White House Diary.

Library of Congress, Washington, DC: Clare Boothe Luce papers.

New York Public Library: *McCall's*.

Articles and Documents

Nov. 23, 1960, *Detroit Free Press*, "Her Man Lost but Perle's Staying," by David Kraslow.

Jan. 2, 1961, *Washington Evening Star*, "Exclusively Yours," by Betty Beale.

Jan. 13, 1961, *Buffalo Evening News*, "Perle Mesta Keeping Her Home in Capital," by Betty Beale.

Jan. 19, 1961, *New York Post*, "It Happened Last Night," by Earl Wilson.

Feb. 8, 1961, *Los Angeles Times*, Hedda Hopper column.

Feb. 13, 1961, *Los Angeles Times*, Hedda Hopper column.

Feb. 26, 1961, *Washington Post*, "Perle Is Bowing Back in April," by Judith Martin.

March 12, 1961, *Washington Post*, "LBJ Will Spin That Big Wheel," by Doree Lovell.

March 15, 1961, *Washington Evening Star*, "Exclusively Yours," by Betty Beale.

March 27, 1961, *Los Angeles Times*, "Who's IN and Who's OUT Along the New Frontier," by Betty Beale.

April 1, 1961, *Fairbanks Daily News-Miner*, "Mrs. Perle Mesta Is Storming the Washington Social Trail Again," by Robert Allen and Paul Scott.

April 13, 1961, *Honolulu Star-Bulletin*, "Perle Mesta Back in Grace," by Virginia Kelly.

April 20, 1961, *Free Lance Star*, "Washington Merry-Go-Round," by Drew Pearson.

May 14, 1961, *Tulsa Daily World*, "Washington Means Many Things to Many People," by Betty Beale.

May 20, 1961, *Washington Post*, "Johnsons Look Over Les Ormes."

May 21, 1961, *New York Herald Tribune*, "Johnsons Buy Perle Mesta Mansion."

May 22, 1961, *Amarillo Globe Times*, "Vice President's Family Buys Perle Mesta's Home," by Mary Ann Pardue.

May 26, 1961, *Washington Post*, "Perle Mesta Moving Up Now," by Ruth Wagner.

May 28, 1961, *New York Herald Tribune*, "Offbeat Washington."

June 6, 1961, *Miami Herald*, "World's No Oyster, Perle Mesta's View," by Roberta Applegate.

June 6, 1961, *Tampa Bay Times*, "Perle Mesta Not Only Likes People—She Loves Them All."

June 7, 1961, *Miami News*, "Some Gems from the One and Only Perle," by Rollene Saal.

June 8, 1961, *Reno Gazette*, "Over $400,000 Sought Action Filed in Reno."

June 8, 1961, *Tampa Tribune*, "Mrs. Mesta Offers Helpful Hints to Hostesses; Strong Words on Communism Evils."

June 24, 1961, *Minneapolis Star*, "Perle Mesta Is Honored for Her Work," by Willmar Thorkelson.

June 22, 1961, *Washington Post*, "Perle Mesta Wins Title."

June 25, 1961, *Family Weekly*, "Who's the Washington Hostess with the Mostest?" by Flora Rheta Schreiber.

July 31, 1961, *Tulsa World*, "Perle Seeks Permanent Vice President's Home."

July 3, 1961, *Newsweek*, "Nor Any Drop to Drink."

Aug. 4, 1961, *Reno Gazette*, "Over $1 Million. Tysons Face New Damage Action."

Aug. 30, 1961, *Johnson City Press*, "Broadway Gazette," by Leonard Lyons.

Sept. 10, 1961, *Washington Evening Star*, "Elizabeth Merchant Tyson Died Sept. 8."

Sept. 27, 1961, *Evening World-Herald*, "Perle Mesta Back with Diplomats" (AP).

Oct. 6, 1961, *Boston Globe*, "Sam Rayburn Has Cancer, End Is Near" (AP).

Oct. 23, 1961, *Morning Herald*, "Perle Mesta's Flying to Visit Old Friend Sam Rayburn," by Earl Wilson.

Oct. 25, 1961, *London Evening Standard*, "Mostest Hostess Plans a Comeback," by Jean Campbell.

Oct. 31, 1961, *Washington Post*, "Town Topics," by Marie McNair.

Nov. 6, 1961, *Battle Creek Enquirer*, "Letter from Washington," by Betty Beale.

Nov. 17, 1961, *Washington Post*, "Nation Mourns Death of Rayburn at 79," by Robert Albright.

Dec. 12, 1961, *News Herald*, "Perle Mesta Plotting a Big Comeback as Washington's Hostess with the Mostest," by Earl Wilson.

Dec. 20, 1961, *New York Daily News*, "Can Perle Do It Again? Chic-Chat," by Nancy Randolph.

Jan. 1962, *McCall's*, "How Washington Goes to a Party," by Robert Gray.

Feb. 3, 1962, *Washington Evening Star*, "Mrs. Mesta Returns to Capital Welcome."

Feb. 4, 1962, *Boston Globe*, "Perle Back in DC Setting," by Betty Beale.

Feb. 4, 1962, *Washington Post*, "New Setting for Perle Mesta," by Ruth Wagner.

Feb. 5, 1962, *Washington Evening Star*, "Perle Mesta's Parties, Chapters Two and Three," by Lee Walsh.

Feb. 9, 1962, *Washington Evening Star*, "Exclusively Yours," by Betty Beale.

Feb. 11, 1962, *Boston Globe*, "Perle, Gwen Patch Up," by Betty Beale.

Feb. 19, 1962, *Newsweek*, "Periscope."

March 9, 1962, *Washington Evening Star*, "Exclusively Yours," by Betty Beale.

March 28, 1962, *Washington Evening Star*, "Exclusively Yours," by Betty Beale.

April 1962, *McCall's*, "Perle Mesta's Party Notebook," by Perle Mesta.

April 2, 1962, *Newport News*, "Perle Again 'Hostess with Mostest,'" by Jean Sprain Wilson (AP).

April 15, 1962, *Family Weekly*, "People I Can't Forget: Perle Mesta," by Cornelius Vanderbilt Jr.

April 19, 1962, *Washington Evening Star*, "The Duke and Duchess of Windsor Are Honored at Cafritz Dance," by Lee Walsh.

April 20, 1962, *Washington Evening Star*, "Springtime Is the Star at Perle Mesta Party," by Lee Walsh.

April 26, 1962, *Chula Vista Star News*, "I Have Sinned, by Perle Mesta," by Art Hoppe.

May 1962, *McCall's*, "Back with a Bang," by Perle Mesta.

May 14, 1962, *Lubbock Avalanche-Journal*, "A New Claimant: Hostess with Mostest," by Ruth Montgomery.

May 18, 1962, *Time*, "New Frontier's New Order."

June 14, 1962, *Corsicana Daily Sun*, "Being Bachelor in Washington Could Be Almost Fulltime Job," by Joy Miller (AP).

July 1962, *McCall's*, "Perle Mesta's Party Notebook," by Perle Mesta.

July 1962, *Town & Country*, "High over Washington," by Gladys Freeman.

July 2, 1962, *Newsweek*, "The Zoo Story."

July 6, 1962, *Time*, "The Press: Social Snooping."

July 7, 1962, *Richmond News-Leader*, "Mostest Hostess Is Clubwoman Too," by Rose Bennett.

July 28, 1962, *Miami Herald*, "Perle Mesta Takes Vow: 'Do Things Differently,'" by Esther Wohl.

Aug. 1962, *McCall's*, "Perle Mesta's Party Notebook," by Perle Mesta.

Sept. 1962, *McCall's*, "Perle Mesta's Party Notebook," by Perle Mesta.

Oct. 1962, *McCall's*, "Perle Mesta's Party Notebook," by Perle Mesta.

Oct. 28, 1962, *Baltimore Sun*, "Ex-Envoys Crowding Capital," by Dorothy McCardle.

Nov. 1962, *McCall's*, "Perle Mesta's Party Notebook," by Perle Mesta.

Dec. 1962, *McCall's*, "Perle Mesta's Party Notebook," by Perle Mesta.

Jan. 1963, *McCall's*, "Merrie England's Christmas Customs. Perle Mesta's Party Notebook," by Perle Mesta.

CHAPTER 26: ALONE AGAIN

Interviews

Luci Baines Johnson; Elizabeth Christian; Linda Picasso; Elizabeth Skirvin Tyson; Patti Birge Spivey

Books

Robert A. Caro, *The Years of Lyndon Johnson: Means of Ascent* (Alfred A. Knopf, 1991).

Betty Ellis, "Years Remembered" (unpublished family memoir).

Tania Grossinger, *Memoir of an Independent Woman* (Skyhorse, 2013).

Leonore Hershey, *Between the Covers: The Lady's Own Journal* (Coward-McCann, 1983).

Peter T. Higgins, *A History of the Westchester Cooperative and Its Neighbors* (Dog Ear Publishing, 2018).

Perle Mesta with Robert Cahn, *Perle: My Story* (McGraw Hill, 1960).

Archives and Documents

LBJ Presidential Library: Perle Mesta oral history, interviewed by Joe Frantz, Oct. 4, 1971; Lady Bird Johnson oral history, interviewed by Harry Middletown, Nov. 5, 1994; Lady Bird Johnson White House Diary; Recording of Lady Bird's phone call to Perle Mesta, Nov. 3, 1964; Richard "Cactus" Pryor, interviewed by Paul Bolton, Sept. 10, 1968.

Library of Congress: Clare Boothe Luce papers.

Articles

Jan. 24, 1963, *Washington Evening Star*, "Mrs. Mesta's Birthday Fete for Lady Bird Is Texas Style," by Lee Walsh.

Feb. 1963, *McCall's*, "Give a Perfect Party," by Perle Mesta.

Feb. 13, 1963, *Washington Post*, "Perle Mesta Beams at Ceremonies Making Orphan She Aided a Citizen," by John Goshko.

Feb. 17, 1963, *Boston Globe*, "Letter from Washington," by Betty Beale.

Feb. 17, 1963, *Daily Oklahoman*, "Our Perle Hits the Comeback Trail," by Allan Cromley.

Feb. 19, 1963, *Los Angeles Times*, "By the Way," by Bill Henry.

Feb. 19, 1963, *Lubbock Avalanche-Journal*, "Washington's High Hostesses," by Marie Smith (Women's News Service; hereafter WNS).

March 1963, *McCall's*, "First Ladies I Have Known," by Perle Mesta.

March 1963, *Town & Country*, "Society U.S.A.," by Cleveland Amory.

March 4, 1963, *Washington Evening Star*, "Perle Introduces Hootenany Party."

March 5, 1963, *Washington Post*, "Perle's Hootennany Beards Collegians," by Ellen Key Blunt.

March 10, 1953, *Pittsburgh Press*, "Letter from Washington," by Betty Beale.

March 13, 1963, *Variety*, "High Society 'Sings Along with Perle' at Her Washington Hootenanny Fete."

March 26, 1963, *Reno Gazette*, "Marguerite Tyson, Former Resident, Dies in Capital."

March 26, 1963, *Washington Evening Star*, "Washington Loses a Beloved Figure," by Lee Walsh.

March 29, 1963, *Los Angeles Times*, Hedda Hopper column.

April 1963, *McCall's*, "Atlanta Adventures," by Perle Mesta.

April 3, 1963, *Washington Evening Star*, "Ranch Is Sold in Bankruptcy" (AP).

April 5, 1963, *Time*, "Died. Marguerite Skirvin Tyson, 58."

April 30, 1963, *Washington Evening Star*, "Cousin Oriole Does Talking, Vice President the Listening," by Lee Walsh.

May 1963, *McCall's*, "A Belated Birthday Luncheon for Lady Bird Johnson," by Perle Mesta.

May 4, 1963, *Lansing State Journal*, "Kennedy, Mesta Social Feud Erupts Over Grand Duchess," by Ruth Montgomery.

May 16, 1963, *Tri-City Herald*, "Kennedy's Snub Perle Mesta but Johnson's Entertain Her," by Sarah McLendon (WNS).

June 1963, *McCall's*, "Hootenanny for Young Leaders," by Perle Mesta.

June 1, 1963, *New York Daily News*, "DC Wash, Recent Visit of Grand Duchess," by Gwen Gibson.

July 1963, *McCall's*, "V.I.P's (Very Important Phrases) That Make a Party," by Perle Mesta.

July 7, 1963, *Washington Evening Star*, "Political Talk and Song Prevail at Perle's Party," by Betty Beale.

July 22, 1963, *Times-Herald*, "White House Watching for Civil Rights Support," by Esther Van Wagoner Tufty.

Sept. 1963, *McCall's*, "There Will Always Be a Newport," by Perle Mesta.

Sept. 5, 1963, *Washington Evening Star*, "Mrs. Mesta's In-Law George Tyson Dies at Age 94."

Oct. 1963, *McCall's*, "The Night I Met the Mets," by Perle Mesta.

Nov. 1963, *McCall's*, "San Francisco Saga," by Perle Mesta.

Dec. 1963, *McCall's*, "Perle Mesta's Party Notebook," by Perle Mesta.

Dec. 1, 1963, *Philadelphia Inquirer*, Suzy Knickerbocker column.

Dec. 1, 1963, *Pittsburgh Press*, "Who's Who among LBJ Friends," by Betty Beale.

Dec. 31, 1963, *Pittsburgh Press*, "Years of Exile Over. Perle Mesta Back in Action. White House Absence Ends When Johnsons Take Over," by Robert S. Boyd.

Jan. 1964, *McCall's*, "Perle Mesta's Party Notebook: Washington's Wonderful World of Diamonds," by Perle Mesta.

Jan. 15, 1964, *Atlanta Constitution*, "Perle Mesta Returns to White House" (UPI).

Jan. 18, 1964, *Washington Post*, "Perle Unfurled Hostess Ribbons," by Marie McNair.

Jan. 19, 1964, *New York Times*, "Foreign Policy Takes Front Seat," by Max Frankel.

Jan. 26, 1964, *Rochester Democrat and Chronicle*, "Johnsons State Dinner Is Full of Zip," by Betty Beale.

Jan. 31, 1964, *South Carolina Index-Journal*, "Perle Mesta Interested in Politics and People," by Margaret Byrd.

Feb. 1963, *McCall's*, "February: A Good Month to Look at Washington, the Man and the City," by Perle Mesta.

Feb. 16, 1964, *Daily Oklahoman*, "Oklahoma's Perle Mesta Is Back at White House," by Madelaine Wilson.

March 1, 1964, *Dayton Daily News*, "Letter from Washington," by Betty Beale.

April 1964, *McCall's*, "Perle Mesta's Party Notebook," by Perle Mesta.

April 4, 1964, *McLean's*, "The Return of the Old Frontier," by Ian Sclanders.

April 18, 1964, *Washington Post*, "Perle's the Mostes' Again as Her Party Pace Picks Up," by Marie McNair.

May 1964, *McCall's*, "A New Life for the Johnson Girls," by Perle Mesta.

May 21, 1964, *New York Post*, "Perle Mesta Will Be Life of the Party," by Lael Scott.

June 1964, *McCall's*, "Perle Mesta's Party Notebook," by Perle Mesta.

June 12, 1964, *New York Times*, "Morris Cafritz, Dead."

July 1964, *McCall's*, "Mamie Eisenhower's Longest Day," by Perle Mesta.

Aug. 1964, *McCall's*, "Convention Plans and Memories," by Perle Mesta.

Aug. 4, 1964, *Variety*, "Perle Mesta Dishing up 7 Fetes to Ease Dem's A/C."

Aug. 5, 1964, *Asbury Park Press*, "Perle Mesta Will Campaign for Texas Friend," by Vera Glaser (WNS).

Aug. 9, 1964, *Nevada State Journal*, "'Hostess with the Mostess' Perle Mesta has Convention Comeback All Planned," by Helen Thomas (UPI).

Sept. 14, 1973, *Washington Post*, "Hotel Lists VIP Discounts," by Judy Luce Mann.

Nov. 8, 1973, *WWD*, "Party Perle," by Kandy Stroud.

Jan. 1, 1974, *Washington Evening Star*, "Mostest Hostess Leaving Town," by Clare Crawford.

Feb. 7, 1974, *Washington Evening Star*, "Perle Leaves Town, Ends Era," by Betty Beale.

Feb. 8, 1974, *Washington Post*, "The Mostest Hostess Has Moved," by Donnie Radcliffe.

Feb. 10, 1974, *Detroit Free Press*, "Perle Leaves Washington. An Era Ends," by Ann Blackman (AP).

Feb. 14, 1974, *Journal News*, "Perle Mesta Plans a Party Back Home" (AP).

Feb. 18, 1974, *Newsweek*, "Transition. Withdrawing."

March 8, 1974, *Philadelphia Daily News*, "Perle Mesta Prepares for Coming-Out Party" (UPI).

March 27, 1974, *New Brunswick Home News*, "Memories Revived."

April 3, 1974, *Camden Courier-Post*, "Pearl Drops in on Her Friend Perle," by James Campbell (UPI).

April 4, 1974, *Hartford Courant*, "Pearl Bailey Sings for Ill Perle Mesta."

June 27, 1974, *Atlanta Constitution*, "Tea for Two" (AP).

June 27, 1974, *Washington Post*, "Personalities: A Career Continued."

Oct. 22, 1974, *Chicago Tribune*, "Guess Who's Planning for a Party?" by Dorothy Collins.

Oct. 27, 1974, *Los Angeles Times*, "Ins and Outs of the Green Book," by Marlene Cimons.

March 17, 1975, *New York Times*, "Reigned for 30 Years: Perle Mesta, Hostess to the Politically Famous, Is Dead," by Alden Whitman.

March 17, 1975, *Washington Post*, "Hostess Perle Mesta, 85, Dies," by Dorothy McCardle.

March 18, 1975, *Pittsburgh Post-Gazette*, "Perle Mesta as Pittsburghers Knew Her," by Zoa Unkovich.

March 22, 1975, *New York Times*, "Funeral for Perle Mesta Is Private in Pittsburgh."

March 22, 1975, *Pittsburgh Post-Gazette*, "Perle Mesta Buried in Private Ceremony," by Alvin Rosensweet.

June 7, 1975, *Daily Oklahoman*, "Mrs. Edna Camper Dies."

March 5, 1976, *Boston Globe*, "Pearl Mesta Left $466,000," by Maxine Cheshire.

April 22, 1976, *Daily Oklahoman*, "Value Not Told. Five to Share in Perle's Will."

June 1, 1976, *Tulsa World*, "Perle Mesta Park Planned."

Aug. 24, 1986, *Tulsa World*, "Perle Mesta Stamp Turned Down Again," by Malvina Stephenson.

March 1, 1987, *Washington Post*, "For Perle Mesta, Postage Is Overdue," by Sarah Booth Conroy.

Peter T. Higgins, *A History of the Westchester Cooperative and Its Neighbors* (Dog Ear Publishing, 2018).

Sylvia Jukes Morris, *Price of Fame: The Honorable Clare Boothe Luce* (Random House, 1998).

Julia Sweig, *Lady Bird Johnson: Hiding in Plain Sight* (Random House, 2021).

Archives and Documents

LBJ Presidential Library: Perle Mesta oral history, interviewed by Joe Frantz, Oct. 4, 1971.

Oklahoma Historical Society: Perle Mesta papers.

Sophia Fleischer date books, courtesy of Butch Fleischer.

Articles

Jan. 1965, *McCall's*, "Perle Mesta's Party Notebook," by Perle Mesta.

Jan. 12, 1965, *Hartford Courant*, "Ask Policemen What to Wear to the Ball," by Eugenia Sheppard.

Jan. 18, 1965, *Reporter Dispatch*, "Mesta Party Kicks Off Capital Swirl," by Saul Pett, AP.

Jan. 18, 1965, *Washington Evening Star*, "Perle Entertains 'House Guests,'" by Betty Beale.

Jan. 19, 1965, *New York Times*, "The Great Society Enjoys Pre-Inaugural Fetes," by Marylin Bender.

Feb. 1965, *McCall's*, "Perle Mesta's Party Notebook," by Perle Mesta.

March 3, 1965, *Austin American Statesman*, "Story Shows Sponsor Control," by Leslie Carpenter.

April 1965, *McCall's*, "The Heiresses of Susan B. Anthony," by Perle Mesta.

April 4, 1965, *Fort Worth Star Telegram*, "Singer, Noted Hostess Get Ovations."

April 15, 1965, *Washington Evening Star*, "Mrs. Mesta's Gala Dinner Fetes Humphreys."

April 26, 1965, *Los Angeles Times*, Hedda Hopper column.

May 1965, *McCall's*, "Perle Mesta's Party Notebook," by Perle Mesta.

May 10, 1965, *New York Daily News*, "Lots of Drinks Go Down the Drain in Washington," by Ben Gross.

June 9, 1965, *Lansing State Journal*, "Who Won—the Kennedys or Perle Mesta?" by Bob Harton (AP).

June 10, 1965, *International Herald Tribune*, "Party Politics," by Art Buchwald.

June 13, 1965, *Washington Evening Star*, "The Mostest Hostess Returns," by Frances Spatz Leighton.

June 16, 1965, *Philadelphia Inquirer*, "New Frontier vs Great Society: Kennedys Outdraw Mesta Fiesta," by Maxine Cheshire.

June 18, 1965, *International Herald Tribune*, "Quotesmanship."

June 21, 1965, *Washington Evening Star*, "New White House Social Whirl—II. Their Fetes Different," by Isabelle Shelton.

June 23, 1965, *International Herald Tribune*, "Mrs. Patricia Harris, Symbol for Negroes," by Judith Stahl.

June 26, 1965, *Newport News*, "Ted Takes on Perle to Attract Senators" (AP).

June 26, 1965, *Washington Evening Star*, "Perle Day Late for a Reason," by Betty Beale.

June 27, 1965, *Boston Globe*, "Kennedy Fiesta Bests Perle Mesta," by Gwen Gibson.

July 3, 1965, *Newsday*, "The Party Hierarchy," by Mike McGrady.

July 5, 1965, *Newsweek*, "Whither Mostest?"

July 8, 1965, *Abilene Reporter News*, "The Kennedy-Mesta Crisis," by Art Buchwald.

Aug. 25, 1964, *Philadelphia Inquirer*, "Perle Even Feeds the Press."

Sept. 5, 1965, *Washington Evening Star*, "Exclusively Yours," by Betty Beale.

Sept. 22, 1965, *Variety*, "Perle's TV Party."

Sept. 24, 1965, *Wilmington Delaware Evening Journal*, "Perle Mesta Will Tape TV Interview Show," by Helen Thomas (UPI).

Sept. 27, 1965, *Broadcasting*, "Mesta's Washington."

Oct. 3, 1965, *Daily Oklahoman*, "Birge-Tyson Betrothal announced."

Oct. 16, 1965, *New York Times*, "ABC, 3rd in Ratings, to Revamp Schedule," by George Gent.

Oct. 24, 1965, *New York Times*, "Miss Patti Birge Is Wed in Capital to W. S. Tyson."

Oct. 24, 1965, *Tulsa World*, "Perle Mesta Begins New Career," by Malvina Stephenson.

Nov. 3, 1965, *New York Times*, "I Don't Know Why I'm Here," by Frances Lanahan.

Nov. 8, 1965, *Broadcasting*, "Perle's Wedding Reception."

Dec. 21, 1965, *Washington Evening Star*, "Mesta Party Honors Debutante," by Ann Wood.

Jan. 20, 1966, *Washington Evening Star*, "Hostess with TV Mike," by Barbara Kobe.

Spring 1966, *Oklahoma Today*, "Madame Mesta," by Madelaine Wilson.

April 6, 1966, *Corpus Christie Times*, "Perle Mesta Aids Youths," by Vivian Brown.

May 2, 1966, *Pittsburgh Post-Gazette*, "Mike Connolly in Hollywood."

May 15, 1966, *Los Angeles Times*, "Queen of Washington," by Paul Coates.

May 16, 1966, *Los Angeles Times*, "Perle Sad Over Frug," by Paul Coates.

May 20, 1966, *Philadelphia Inquirer*, "White House Cuts Pre-nuptial Parties for Luci," by Francine Lewine (AP).

June 2, 1966, *Washington Evening Star*, "Garner Camper, Mesta Butler."

June 2, 1966, *Washington Post*, "Sad Note," by Maxine Cheshire.

June 19, 1966, *Tulsa World*, "No Sign of Summer Slump," by Malvina Stephenson.

July 24, 1966, *Oakland Tribune*, "Pearl Bailey, Lady at Work," by Allan Ward.

July 29, 1966, *Life Magazine*, "Here Comes, There Goes Barbara. Close-Up: A Swinger Frugs Gaily."

Aug. 1, 1966, *San Mateo Times*, "The Marque," by Barbara Bladen.

Aug. 7, 1966, *New York Times*, "Luci Johnson Wed to Patrick Nugent in Catholic Shrine," by Nan Robertson.

Aug. 15, 1966, *Washington Evening Star*, "Your Date with Ymelda Dixon."

Aug. 21, 1966, *Asbury Park Press*, "Washington Scene," by Jack Anderson.

Aug. 29, 1966, *Washington Evening Star*, "Your Date with Ymelda Dixon."

Sept. 8, 1966, *Washington Post*, "Auntie Mame Meets Mesta," by Maxine Cheshire.

Sept. 9, 1966, *Washington Evening Star*, "Mesta and Mame Shine," by Ymelda Dixon.

Nov. 2, 1966, *Saint Joseph News-Press*, "Perle Mesta Chatty, Folksy, Reveals No Secrets," by Robert Slater.

Nov. 3, 1966, *Saint Joseph News-Press*, "Top Hostess Talks," by Letty Morton.

Nov. 9, 1966, *Corpus Christi Caller-Times*, "Asleep to Style, Capital Avoids Evening Pajamas," by Myra McPherson.

Nov. 16, 1966, *Boston Globe*, "With Perle Mesta."

Nov. 20, 1966, *Austin American Statesman*, "Tea at the White House and Luncheon with Perle Mesta," by Lois Hale Galvin.

Dec. 25, 1966, *Parade*, "Barbara Howar."

Jan. 1, 1967, *Detroit Free Press*, "Inside Washington: It Can Be Glamorous or Dullsville," by Betty Beale.

Jan. 1, 1967, *Portland Press Herald*, "Presidents Come and Go but Perle Mesta Stays Forever," by Kelly Smith (AP).

Feb. 5, 1967, *New York Daily News*, "Fun City on the Potomac."

March 7, 1967, *Richmond Times-Dispatch*, "Perle Mesta Offers Advice on Parties," by Betty Parker Ashton.

CHAPTER 28: TUMULTUOUS TIMES

Interviews

Luci Baines Johnson, Lynda Johnson Robb, Ann Blackman, Kandie Stroud, Marie Ridder, Peter Duchin, Elizabeth Picasso, Linda Christian, Patti Birge Spivey, Aaron Fodiman

Books

Betty Ellis, "Years Remembered" (unpublished family memoir).

John A. Farrell, *Richard Nixon: The Life* (Vintage Books, 2017).

Catherine Forslund, *Anna Chennault: Informal Diplomacy and Asian Relations* (Scholarly Resources, 2002).

Peter T. Higgins, *A History of the Westchester Cooperative and Its Neighbors* (Dog Ear Publishing, 2018).

Julia Sweig, *Lady Bird Johnson: Hiding in Plain Sight* (Random House, 2021).

Archives and Documents

LBJ Presidential Library: Perle Mesta oral history, interviewed by Joe Frantz, Oct. 4, 1971.

Oklahoma Historical Society: Perle Mesta papers.

Articles

March 9, 1967, *Boston Globe*, "Perle Mesta, a Free-Wheeler to the Core," by Maxine Cheshire.

March 12, 1967, *Elmira Star Gazette*, "Washington Hostess Perle Mesta."

March 16, 1967, *Asbury Park Press*, "Mrs. Perle Mesta May Be Evicted," by Sarah McClendon.

March 21, 1967, *WWD*, "The Washington Insiders."

April 9, 1967, *Pittsburgh Press*, "Washington's Ageless Wonders: Senior Citizens in Government Maintain a Busy, On-the-Go-Schedule," by Frances Spatz Leighton.

April 11, 1967, *Los Angeles Evening Citizen*, "Perle Mesta Comes to Town," by Mary Sue Westland.

April 12, 1967, *Cocoa Evening Tribune*, "She's Always on the Party Line."

April 12, 1967, *Miami News*, "Perle Wants to Entertain G.I.'s Again," by Susan Miller.

April 12, 1967, *Orlando Sentinel*, "Hostess with Mostess Makes Visit to Brevard," by Peggie Marquette.

April 14, 1967, *Baltimore Sun*, "A Capital Eviction," WNS.

April 14, 1967, *Miami News*, "Hostess with Mostes' to Host Us," by Joan Nielsen McHale.

April 27, 1967, *Washington Evening Star*, "Johnsons Honor Diplomats," by Isabelle Shelton.

May 1, 1967, *Nashville Tennessean*, "Perle Plots a Party," by Judy Thurman.

May 7, 1967, *Los Angeles Times*, "Rain Can't Hurt First Lady's Tour," by Eugenia Sheppard.

May 25, 1967, *New York Times*, "A Former Monarch Sees His Life Story Depicted in Film," by Charlotte Curtis.

May 29, 1967, *Washington Evening Star*, "Your Date with Ymelda."

May 31, 1967, *Washington Evening Star*, "Perle Urges a Party Ban," by Malvina Stephenson.

June 4, 1967, *Washington Post*, "Very Interesting People," by Maxine Cheshire.

June 7, 1967, *Washington Evening Star*, "War Having Effect on Social Scene."

July 11, 1967, *Wichita Falls Times*, "Smaller Place Beckons Hostess Perle Mesta," by Leslie Carpenter.

July 23, 1967, *Washington Evening Star*, "For Your Information," by Megan Milbanks.

Aug. 2, 1967, *Washington Evening Star*, "Exclusively Yours," by Betty Beale.

Aug. 8, 1967, *Memphis Commercial Appeal*, "Perle Mesta Moves to Simpler Life," by Virginia Weldon Kelly.

Aug. 12, 1967, *New York Daily News*, "DC Wash," by Judith Axler.

Nov. 2, 1967, *Washington Evening Star*, "Perle Is Pearl's Fan," by Ymelda Dixon.

Nov. 7, 1967, *Variety*, "Perle for Pearl—a Jewel of a Washington Party."

Nov. 12, 1967, *Rochester Democrat and Chronicle*, "Young Patrick Takes a Big Bow," by Betty Beale.

Nov. 16, 1967, *Charlotte News and Observer*, "New York Is Pearl's Oyster," by Earl Wilson.

Nov. 16, 1967, *Boston Globe*, "Rates McCarthy Serious: RFK Hedging on LBJ."

Nov. 18, 1967, *San Bernardino County Sun*, "Johnson Speech plus Hostess with Mostest Aids Assistance League Program," by Harvey Feit.

Dec. 4, 1967, *Boston Globe*, "Lynda, Robb Plan to Invite Old Flames to Wedding . . . and Famous Figures too," by Marie Smith.

Dec. 5, 1967, *Hartford Courant*, "Perle's a Johnson Girl," by Suzy.

Dec. 5, 1967, *Port Huron Times Herald*, "Society Is Not a Dirty Word," by Barbara Ann Beeler.

Dec. 10, 1967, *New York Times*, "East Room Crowded by 500 Guests," by Marjorie Hunter.

Jan. 6, 1968, *Rochester Democrat and Chronicle*, "A Pair of Pearls."

Jan. 10, 1968, *Washington Evening Star*, "It Happened Last Night," by Earl Wilson.

Feb. 1, 1968, *Cue Magazine*, "People Are Talking About."

Feb. 11, 1968, *Washington Evening Star*, "Exclusively Yours," by Betty Beale.

Feb. 19, 1968, *Washington Evening Star*, "Johnson Night."

Feb. 24, 1968, *New York Daily News*, "DC Wash," Judith Axler.

Feb. 25, 1968, *Pittsburgh Press*, "Celebrities Jam Capital Parties," by Betty Beale.

Feb. 25, 1968, *Washington Evening Star*, "Exclusively Yours," by Betty Beale.

March 1, 1968, *Palo Alto Times*, "Perle Mesta Speaks Out on Politics and Personalities," by Joyce Passetti.

March 1, 1968, *San Francisco Examiner*, "Perle Still Likes the Big Splash," by Albert Morch.

March 4, 1968, *Santa Maria Times*, "Perle Mesta Keeps Eye on Communist Activities."

March 14, 1968, *White Plains Reporter Dispatch*, "Perle Mesta Tours Wiltwyck," by Barbara Taylor.

March 25, 1968, *Los Angeles Times*, "President the Life of Perle Mesta's Party," by Mary Lou Loper.

March 31, 1968, *Oakland Tribune*, "Pearl Pauses and Prognosticates."

April 1968, *Ladies' Home Journal*, "Why LBJ Dropped Me," by Barbara Howar.

April 4, 1968, *Baltimore Sun*, "Jewish Women Hear Perle Mesta," by Maxyne Brill.

April 4, 1968, *Quad City Times*, "I'm a Politician: Perle Mesta," by Maddy Ocheltree.

April 4, 1968, *Quad City Times*, "Perle Tells of Travels," by Maddy Ocheltree.

Sept. 14, 1973, *Washington Post*, "Hotel Lists VIP Discounts," by Judy Luce Mann.

CHAPTER 29: A WORLD TURNED UPSIDE DOWN
Interview
Kandie Stroud
Books
Betty Ellis, "Years Remembered" (unpublished family memoir).

John A. Farrell, *Richard Nixon: The Life* (Vintage Books, 2017).
Catherine Forslund, *Anna Chennault: Informal Diplomacy and Asian Relations* (Scholarly Resources, 2002).

Archives and Documents

LBJ Presidential Library: Lady Bird Johnson Diaries; South Vietnam and U.S. policy, FBI logs, Anna Chennault; Johnson tapes, Nov. 1, 1968, Richard Russell and Everett Dirksen conversations.
Sophia Fleischer date books.

Articles

April 6, 1968, *Boston Globe*, "Riots Sweep Nation's Capital; 5 Die," by William Clopton.
April 8, 1968, *New York Times*, "Washington Turmoil Subsides," by Ben A. Franklin.
April 14, 1968, *New York Daily News*, "D.C. Wash," by Judith Axler.
April 17, 1968, *Des Moines Register*, "Mrs. Mesta Supports Humphrey," by Malvina Stephenson.
April 24, 1968, *Washington Evening Star*, "Diplomats Are Feted by Johnsons," by Betty Beale.
May 2, 1968, *Des Moines Register*, "Perle Tells Support of Humphrey," by Nick Lamberto.
June 10, 1968, *New York Times*, "Humphrey Sweep Appears Assured by Kennedy Votes," by Warren Weaver.
July 1, 1968, *Washington Evening Star*, "Your Date with Ymelda."
July 3, 1968, *Washington Post*, "Perle Plays Waiting Game," by Dorothy McCardle.
July 7, 1968, *Washington Post*, "You're Invited to Perle Mesta's Party."
July 14, 1968, *Washington Evening Star*, "Name of the Game—Pick a Winner," by Donnie Radcliffe.
July 15, 1968, *Washington Evening Star*, "Two Pearls Toss Gem of a Party," by Roberta Hornig.
July 15, 1968, *WWD*, "Eye: Perle's Whirl," by Kandy Stroud.
July 18, 1968, *Washington Evening Star*, "Your Date with Ymelda."
July 20, 1968, *Knickerbocker News*, "Crowd Scares Perle Mesta," by Betty Beale.
July 20, 1968, *Washington Post*, "Good Show."
Aug. 1, 1968, *Washington Evening Star*, "Sunday Perle Will Be a Spy," by Helen Thomas (UPI).
Aug. 8, 1968, *Miami Herald*, "GOP Official Answers Flurry of Criticism over Perle Mesta," by Maxine Cheshire.
Aug. 9, 1968, *Washington Post*, "Perle's for HHH But Parties Around."
Aug. 11, 1968, *Washington Evening Star*, "Perle Mesta on Nixon's Selection of Agnew."
Aug. 18, 1968, *Washington Evening Star*, "Will Perle Give Party?" by Betty Beale.
Aug. 23, 1968, *WWD*, "The Perle," by Kandy Shuman.

Aug. 25, 1968, *Washington Post*, "Very Important People," by Maxine Cheshire.

Aug. 26, 1968, *Chicago Tribune*, "Perle's Here; It's Party Time," by Stephanie Fuller.

Aug. 27, 1968, *Bristol Herald Courier*, "Perle's Ready to Party and So Are the Yippies," by Anne Worrell.

Aug. 28, 1968, *Long Beach Independent Press Telegram*, "Perle Mesta Plans Big Demo Shindig" (UPI).

Aug. 28, 1966, *Pittsburgh Press*, "Is Perle Mesta Going to Give a Big Shindig Tomorrow Night or Isn't She?" by Wauhillau LaHay.

Aug. 28, 1968, *Pittsburgh Press*, "Stink Bombs—and Gossip—Fill Chicago's Air," by Betty Beale.

Aug. 28, 1968, *WWD*, "The Anti-Convention," by Kandy Shuman.

Aug. 29, 1968, *New York Times*, "Guests Flock to Week-Long Party Given by Playboy's Publisher," by Charlotte Curtis.

Aug. 30, 1968, *New York Times*, "Perle Mesta Cancels Party in Protest over Brutality" (UPI).

Sept. 1, 1968, *Washington Evening Star*, "The Trouble with Democrats," by Leslie Carpenter.

Sept. 6, 1968, *New York Daily News*, "Chicago Story: Everyone Has an Opinion," by Ted Lewis.

Sept. 24, 1968, *Pittsburgh Post-Gazette*, "Perle Joins Pearl in Prelude Party."

Nov. 14, 1968, *Washington Evening Star*, "Perle Is In."

Nov. 17, 1968, *New York Daily News*, "Capitol Stuffy," by William Umstead.

Nov. 24, 1968, *Pittsburgh Press*, "No 1 Hostess Title Dims—the Big Bash Is Out?" by Wauhillau LaHay.

Dec. 1968, *Town & Country*, "Christmas Party Etiquette," by Perle Mesta.

Dec. 1, 1968, *Washington Evening Star*, "Women Could Get Anywhere in Politics If They Had More Guts," by Frances Spatz Leighton.

Dec. 6, 1968, *WWD*, "In Washington," by Kandy Shuman.

Dec. 14, 1968, *Boston Globe*, "Washington Is Jumping and It's Not Even January," by Betty Beale.

Dec. 18, 1968, *Washington Evening Star*, "Perle Mesta above Party Lines," by Donnie Radcliffe.

Dec. 20, 1968, *Hartford Courant*, "Suzy Says."

Dec. 31, 1968, *Long Island Star-Journal*, "Hostess with Mostes Is Back," by Robert S. Boyd.

Jan. 3, 1969, *St. Louis Post-Dispatch*, "Pre-Election Contacts of GOP and Saigon," by Thomas Ottenad.

Jan. 4, 1969, *St. Petersburg Times*, "Post-Dispatch Says Nixon Aide Urged S. Vietnam to Stall" (UPI).

Jan. 5, 1969, *Tampa Tribune*, "Betty Beale's Washington Letter," by Betty Beale.

Jan. 9, 1969, *St. Louis Post-Dispatch*, "China Lobby Echoes."

Jan. 12, 1969, *Washington Post*, "Next Perle Mesta?" by Maxine Cheshire.

CHAPTER 30: NEVER GIVE UP: A FEMINIST IN HER EIGHTIES

Interviews

Ann Blackman, Peter Edelman, Kandie Stroud, Linda Picasso, Elizabeth Christian, Peter Edelman, Susan Eisenhower

Book

Susan Eisenhower, *Mrs. Ike: Memories and Reflections on the Life of Mamie Eisenhower* (Farrar, Straus and Giroux, 1996).

Archives and Documents

Dwight D. Eisenhower Presidential Library: Mamie Eisenhower correspondence with Perle Mesta.

Library of Congress: Clare Boothe Luce papers.

Harry S. Truman Presidential Library: Harry Truman's correspondence with Perle Mesta.

Sophia Fleischer date books.

Articles

Jan. 27, 1969, *Newsweek*, "All Brides Aren't Beautiful."

Feb. 8, 1969, *Afro-American*, "Pearl Bailey Is Named USO 'Woman of the Year.'"

Feb. 24, 1969, *Washington Post*, "Perle Mesta's Revolving Door," by Mary Wiegers.

Feb. 25, 1969, *Asbury Park Evening Press*, "Mrs. Hitt Starts Tempest: Knows No Woman of Cabinet Quality," by Malvina Stephenson (WNS).

March 4, 1969, *Christian Science Monitor*, "Home to the Agnews: Round Trip from Manhattan," by Marilyn Hoffman.

March 31, 1969, *WWD*, "Eye: The Girl He Left Behind," by Kandie Stroud.

April 3, 1969, *WWD*, "Perle's in the Pink."

May 3, 1969, *Boston Globe*, "Letter from Washington," by Betty Beale.

May 21, 1969, *The New York Times*, "Democrats Easy Winners in Political Tennis Match," by Nan Robertson.

May 25, 1969, *Philadelphia Inquirer*, "Washington Letter," by Betty Beale.

June 1, 1969, *Philadelphia Inquirer*, "Washington Letter," by Betty Beale."

June 22, 1969, *Washington Evening Star*, "Thousands Use USO Every Month in Washington," by Joy Billington.

June 25, 1969, *Washington Evening Star*, "Gen. Westmoreland 'Roars' at Benefit," by Ruth Dean.

June 26, 1969, *Los Angeles Times*, "Perle Mesta—a Social Dynamo at 78," by Kelly Tunny (AP).

July 9, 1969, *WWD*, "Jackie at 40."

July 16, 1969, *WWD*, "Eye Super Perle."

July 18, 1969, *Philadelphia Daily News*, "Dr. Anthony Sindoni Jr. Dies."

July 20, 1969, *Binghamton Evening Press*, "Perle Blooms Again," by Jack Anderson.

Sept. 21, 1969, *Philadelphia Inquirer*, "VIP," by Maxine Cheshire.

Sept. 28, 1969, *Philadelphia Inquirer*, "Letter from Washington," by Betty Beale.

Oct. 15, 1969, *WWD*, "Vietnam Moratorium: A Day for Americans to Do Their Own Thing."

Oct. 20, 1969, *Chicago Tribune*, "Suzy Says."

Oct. 20, 1969, *Washington Evening Star*, "My Date with Ymelda."

Oct. 20, 1969, *Washington Post*, "Major Robb: The Marine Recruiter."

Nov. 3, 1969, *Newsweek*, "The White House Social Notes."

Nov. 7, 1969, *WWD*, "Cheshire Cat."

Dec. 30, 1969, *New York Times*, "62 Debutantes Make Bows in a World of Pink and Silver," by Charlotte Curtis.

Jan. 9, 1970, *WWD*, "Mesta's Masse."

Jan. 10, 1970, *Washington Post*, "Mesta, Merman Star," by Dorothy McCardle.

Jan. 11, 1970, *New York Times*, "Perle Mesta Is Now Down to a Size 10 Dress, but Her Party Style Is Still Ample."

Jan. 18, 1970, *New Brunswick News*, "Letter from Washington," by Betty Beale.

Jan. 18, 1970, *Washington Post*, "Very Important People," by Maxine Cheshire.

Jan. 26, 1970, *WWD*, "Pearl of Price."

Jan. 27, 1970, *Washington Post*, "BBC's Yak-In," by Alfred Friendly.

Jan. 29, 1970, *Newsday*, "Still the Mostest," by Winzola McLendon.

March 4, 1970, *Washington Post*, "In Step: Bradley, Patton," by Dorothy McCardle.

March 8, 1970, *New York Times*, "Society Isn't Exactly Swinging," by Thomas Meehan.

June 24, 1970, *Philadelphia Inquirer*, "Suzy Says."

July 1, 1970, *Tallahassee Democrat*, "Perle Makes Return" (AP).

July 29, 1970, *Washington Evening Star*, "Party Given for Perle by Hope Ridings Miller."

Aug. 12, 1970, *Washington Evening Star*, "Exclusively Yours," by Betty Beale.

Aug. 24, 1970, *Newsweek*, "Ladies Day."

Sept. 2, 1970, *WWD*, "Perle Fights for Women's Rights."

Sept. 4, 1970, *Binghamton Evening News*, "Perle Mesta Fights Senate Cop-Out on Women's Equal Rights Amendment" (AP).

Sept. 4, 1970, *Washington Post*, "Women Fight Senators on Rights" by Marie Smith.

Sept. 7, 1970, *Los Angeles Times*, "Senators Beware—'Scorned Women' Strategy."

Sept. 13, 1970, *Philadelphia Inquirer*, "Mesta Luncheon Spurs Women's Rights Drive," by Betty Beale.

CHAPTER 31: THE OCTOGENARIAN JETSETTER

Interviews

Ann Blackman, Kandie Stroud, Elizabeth Christian, Linda Picasso, Sally Quinn

Books

Susan Eisenhower, *Mrs. Ike: Memories and Reflections on the Life of Mamie Eisenhower* (Farrar, Straus and Giroux, 1996).

Winzola McLendon, *Martha: The Life of Martha Mitchell* (Random House, 1979).

Archives and Documents

Ann Blackman notes.

Harry S. Truman Presidential Library: Perle Mesta correspondence with Harry Truman.

LBJ Presidential Library: Perle Mesta oral history, interviewed by Joe Frantz, Oct. 4, 1971.

Richard M. Nixon Presidential Library: Tricia Nixon wedding files.

Sophia Fleischer date books.

Stanford University, Hoover Institute: Allen Drury correspondence with Perle Mesta.

Articles

Sept. 23, 1970, *Washington Post*, "Joan Steals the Scene (Again)," by Elizabeth Shelton.

Oct. 4, 1970, *Sunday Home News*, "Hope Ball Was Smashing Swinger," by Betty Beale.

Oct. 8, 1970, *Newsday*, "Nixon's Nighttime Washington Yawn," by Kay Bartlett (AP).

Oct. 11, 1970, *Iowa Press Citizen*, "Perle Mesta, Going Forward, Takes a Look Back," by Gwen Dixon.

Oct. 11, 1970, *Los Angeles Times*, "Womlib 'Nonsense,' Says U.S. Grant Kin," by Ann Blackman.

Oct. 15, 1970, *Los Angeles Times*, "Martha and Midi Are in with Perle."

Nov. 27, 1970, *WWD*, "Mesta Mix."

Nov. 30, 1970, *Time* magazine, "Martha Mitchell's View from the Top."

Dec. 1, 1970, *Chicago Tribune*, "Suzy Says."

Dec. 2, 1970, *WWD*, "Perle in NYC with Martha Mitchell."

Dec. 8, 1970, *Rochester Democrat and Chronicle*, "Birthday Fakes," by Maxine Cheshire.

Dec. 13, 1970, *Washington Post*, "The Subject Was Squirrels," by Dorothy McCardle.

Dec. 18, 1970, *Hartford Courant*, "Suzy Says."

Dec. 28, 1970, *New York Times*, "Party by Perle Mesta Brings Youth to Capital."

Dec. 30, 1970, *Courier-Post*, "Tricia Skips Deb's Ball."

Jan. 17, 1971, *Greensboro Daily News*, "President Throws the Ball a Curve," by Betty Beale.

Jan. 29, 1971, *Washington Post*, "Alliance for Culture," by Sally Quinn.

Feb. 13, 1971, *Philadelphia Inquirer*, "Perennial Perle Still Pursues the Parties," by Ann Blackman.

Feb. 24, 1971, *Los Angeles Times*, "Dinner for Hostess with Mostest," by Christy Fox.

March 8, 1971, *Washington Post*, "Perle, Politics, and Food," by Dorothy McCardle.

March 27, 1971, *Washington Post*, "Perle's Party: Texas Overtones," by Maxine Cheshire.

May 25, 1971, *WWD*, "Perley Party."

May 27, 1971, *Washington Post*, "One Pro Fetes Another."

May 28, 1971, *WWD*, "Perle Did It Again."

May 30, 1971, *Austin Statesman*, "There's Never a Dull Moment When Texans Get Together in Washington."

June 2, 1971, *Rochester Democrat and Chronicle*, "He'll Dance with the Bride."

June 6, 1971, *Sunday Home News*, "Capital Glitter," by Betty Beale.

June 13, 1971, *Boston Globe*, "On Capitol Hill, the Uninvited Are Feeling Left Out," by Dorothy McCardle.

June 28, 1971, *Chicago Tribune*, "Perle's Home Again," by Suzy.

Sept. 6, 1971, *Los Angeles Times*, "Kennedy's Cuing Up for Center Bow," by Marlene Cimons.

Sept. 8, 1971, *Los Angeles Times*, "Perle—Hostess, Catalyst," by Marlene Cimons.

Sept. 27, 1971, *Philadelphia Daily News*, "Mamie Eisenhower Works for Ike's Ideals," by Helen Thomas (UPI).

Sept. 30, 1971, *Congressional Record*, "Our Five Enduring Women," by Irene Corbally Kuhn.

Oct. 16, 1971, *Chicago Tribune*, "Paging Perle," by Eleanor Page.

Oct. 23, 1971, *Philadelphia Daily News*, "High Court Picks Ruin Perle's Party," by Earl Wilson.

Oct. 31, 1971, *Boston Globe*, "President Nixon and the Women," by Jack Anderson.

Nov. 22, 1971, *Washington Post*, "Perle Mesta's Heart of Gold."

Nov. 28, 1971, *New Brunswick Sunday Home News*, "Capital Glitter," by Betty Beale.

Jan. 6, 1972, *WWD*, "Social Washington Has Hit the Skids."

CHAPTER 32: "PERLE, YOU'RE AN EVENT IN THE LIFE OF AMERICA"

Interviews

Linda Picasso, Elizabeth Christian, Ann Blackman, Kandie Stroud, Butch Fleischer, Patti Birge Spivey, Sally Quinn

Book

Betty Ellis, "Years Remembered" (unpublished family memoir).

Archives and Documents

Sophia Fleischer date books.

Stanford University, Hoover Institute: Allen Drury correspondence with Perle Mesta.

Library of Congress: Hope Ridings Miller files.

Oklahoma Historical Society: Perle Mesta files.

Articles

Jan. 24, 1972, *Washington Evening Star*, "Perle People at Lunch," by Ymelda Dixon.

Jan. 29, 1972, *Rochester Democrat and Chronicle*, "A Toast to Martha."

Jan. 30, 1972, *Washington Evening Star*, "Power Party Circuit," by Betty Beale.

March 2, 1972, *Washington Evening Star*, "Nixon-Turk Salute to Truman."

March 5, 1972, *New Brunswick Sunday Home News*, "Capital Glitter," by Betty Beale.

March 19, 1972, *Boston Globe*, "Perle Mesta: Washington's Hostess with the Mostest," by Marian Christy.

March 27, 1972, *New York Times*, "Perle Mesta Party: Politics and Prophecy."

March 27, 1972, *Washington Evening Star*, "No Wonder Nixon Left Town," by Ymelda Dixon.

March 27, 1972, *Washington Post*, "Perle's Party: Texas Overtones," by Maxine Cheshire.

March 27, 1972, *WWD*, "Magic Mesta."

March 29, 1972, *Chicago Tribune*, "Perle's Latest Bash," by Suzy.

April 2, 1972, *New Brunswick Home News*, "Capital Glitter," by Betty Beale.

April 10, 1972, *Newsweek*, "Newsmakers: How to Describe Perle Mesta?"

April 30, 1972, *Washington Post*, "Green Book Lives," by Dorothy McCardle.

May 12, 1972, *WWD*, "Cultured Perle."

May 22, 1972, *Pittsburgh Press*, "Little Slowdown at 80: Perle Continues Her Party Thing," by Marion Burros.

May 29, 1972, *Washington Evening Star*, "Perle Gives a Party for Clare Luce."

June 25, 1972, *New Brunswick Home News*, "Capital Glitter," by Betty Beale.

June 29, 1974, *Baltimore Sun*, "Nixon Unit Called Donors 'Hot Air' Dangerous."

July 22, 1972, *Washington Evening Star*, "Hugh—'Not Larry'—Stars," by Judy Flander.

July 29, 1972, *Washington Evening Star*, "Perle Mesta's Hip Broken in Fall; Operation Today," by Betty Beale.

Aug. 1, 1972, *Los Angeles Times*, "Perle Mesta Will Help Campaign after Hip Heals."

Sept. 26, 1972, *Boston Globe*, "Bess Consoles Margaret about Move to Capital," by Maxine Cheshire.

Oct. 8, 1972, *Philadelphia Inquirer*, "How Is Perle Mesta?" by Betty Beale.

Nov. 12, 1972, *New Brunswick Home News*, "Capital Glitter," by Betty Beale.

Dec. 21, 1972, *Washington Post*, "Standing in for Santa," by Maxine Cheshire.

Jan. 28, 1973, *Washington Evening Star*, "Perle Thinks Kennedy Will Be Next President," by Clare Crawford.

Feb. 2, 1973, *Washington Evening Star*, "Ready for Action," by Ymelda Dixon.

Feb. 2, 1973, *WWD*, "Pearly Return."

Feb. 6, 1973, *Philadelphia Daily News*, "Perle Pained by Chic."

Feb. 12, 1973, *Cherry Hill Courier Post*, "Perle and Nixon," by Winzola McClendon.

July 10, 1973, *Christian Science Monitor*, "Perle Mesta Still Likes Action," by Inga Rundvold.

Bibliography

Ambrose, Stephen E. *Eisenhower: Soldier, General of the Army, President-Elect, 1890–1952.* Simon & Schuster, 1983.

Amory, Cleveland. *Who Killed Society?* Harper & Brothers, 1960.

Anthony, Carl Sferrazza. *First Ladies: The Saga of the Presidents' Wives and Their Power 1789–1961.* Quill William Morrow, 1990.

Baime, A. J. *Dewey Defeats Truman: The 1948 Election and the Battle for America's Soul.* Houghton Mifflin, 2020.

Barkley, Jane Rucker. *I Married the Veep.* Vanguard Press, 1958.

Barrett, Mary Ellin. *Irving Berlin: A Daughter's Memoir.* Simon & Schuster, 1994.

Beale, Betty. *Power at Play: A Memoir of Parties, Politicians, and the Presidents in My Bedroom.* Regnery Gateway, 1993.

Brinkley, David. *Washington Goes to War: The Extraordinary Story of the Transformation of a City and a Nation.* Knopf, 1988.

Burner, David. *Herbert Hoover: A Public Life.* Alfred A. Knopf, 1979.

Cahill, Bernadette. *Alice Paul, the National Woman's Party, and the Vote: The First Civil Rights Struggle of the 20th Century.* McFarland & Co., 2015.

Campbell, W. Joseph. *Lost in a Gallup: Polling Failure in U.S. Presidential Elections.* University of California Press, 2020.

Caro, Robert A. *The Years of Lyndon Johnson: Master of the Senate.* Alfred A. Knopf, 2002.

Caro, Robert A. *The Years of Lyndon Johnson: Means of Ascent.* Alfred A. Knopf, 1991.

Caro, Robert A. *The Years of Lyndon Johnson: Path to Power.* Alfred A. Knopf, 1982.

Clifford, Clark, and Richard Holbrooke. *Counsel to the President: A Memoir.* Random House, 1991.

Culver, John C., and John Hyde. *American Dreamer: A Life of Henry A. Wallace.* W. W. Norton & Co., 2000.

Dalton, Joseph. *Washington's Golden Age: Hope Ridings Miller, the Society Beat, and the Rise of Women Journalists.* Rowman & Littlefield, 2018.

Daniel, Margaret Truman. *Bess W. Truman.* Macmillan, 1986.

Davis, Deborah. *Gilded: How Newport Became America's Richest Resort.* John Wiley & Sons, 2009.

Drury, Allen. *Advise and Consent.* Doubleday, 1959.

Edwards, India. *Pulling No Punches: Memoirs of a Woman in Politics.* Putnam, 1977.

Eisenhower, Dwight David. *The Papers of Dwight David Eisenhower.* Johns Hopkins University Press, 1970.

Eisenhower, Susan. *Mrs. Ike: Memories and Reflections on the Life of Mamie Eisenhower.* Farrar, Straus and Giroux, 1996.

Ellis, Betty. "Years Remembered." Unpublished memoir.

Farley, James A. *Jim Farley's Story: The Roosevelt Years.* Whittlesey House, McGraw Hill, 1948.

Farrell, John A. *Richard Nixon: The Life.* Vintage Books, 2017.

Fite, Gilbert C. *Richard B. Russell Jr., Senator from Georgia.* University of North Carolina Press, 1991.

Forslund, Catherine. *Anna Chennault: Informal Diplomacy and Asian Relations.* Scholarly Resources, 2002.

Frank, Jeffrey. *The Trials of Harry S. Truman: The Extraordinary Presidency of an Ordinary Man, 1945–1953.* Simon & Schuster, 2022.

Gadis, John Lewis. *The Cold War: A New History.* Penguin Press, 2005.

Garraty, John A., and Mark C. Carnes, eds. *American National Biography.* Oxford University Press, 1999. Vol. 2, "Theodore Bilbo" by J. William Harris; Vol. 6, "Thomas Dewey" by Nicol C. Rae; Vol. 7, "James Farley" by Eliot A. Rosen; Vol. 20, "James Sparkman" by Randy Finley; Vol. 21, "Robert Taft" by Nicol C. Rae; Vol. 22, "Henry Wallace" by Richard Kirkendale; Vol. 23, "Wendell Willkie" by James Madison.

Graham, Katharine. *Katharine Graham's Washington.* Alfred A. Knopf, 2002.

Grossinger, Tania. *Memoir of an Independent Woman: An Unconventional Life Well Lived.* Skyhorse, 2013.

Healy, Paul F. *Cissy: The Biography of Eleanor M. "Cissy" Patterson.* Doubleday & Co., 1966.

Hershey, Lenore. *Between the Covers: The Lady's Own Journal.* Coward-McCann, 1983.

Higgins, Peter T. *A History of the Westchester Cooperative and Its Neighbors.* Dog Ear Publishing, 2018.

Hoge, Alice Albright. *Cissy Patterson: The Life of Eleanor Medill Patterson, Publisher and Editor of the Washington Times-Herald.* Random House, 1966.

Holt, Marilyn Irvin. *The General's First Lady: Mamie Doud Eisenhower.* University Press of Kansas, 2007.

Karnow, Stanley. *Vietnam: A History*. Penguin Books, 1983.

Kirchick, James. *Secret City: The Hidden History of Gay Washington*. Henry Holt, 2022.

Kocher, Eric. *Foreign Intrigue: The Making and Unmaking of a Foreign Service Officer*. New Horizons Press, 1990.

Kroeger, Brooke. *Undaunted: How Women Changed American Journalism*. Knopf, 2023.

Lesch, Paul. *Playing Her Part: Perle Mesta in Luxembourg*. American Chamber of Commerce, 2001.

Leuchtenburg, William. *In the Shadow of FDR: From Harry Truman to Barack Obama*. Cornell University Press, 2011.

Lewis, David Levering. *The Improbable Wendell Willkie: The Businessman Who Saved the Republican Party*. Liveright, 2018.

Linsley, Judith Walker, Ellen Walker Rienstra, and Jo Ann Stiles. *Giant under the Hill: A History of the Spindletop Oil Discovery*. Texas Historical Association, 2002.

Logevall, Fredrik. *JFK: Coming of Age in the American Century, 1917–1956*. Random House, 2020.

Martin, Ralph G. *Cissy: The Extraordinary Life of Eleanor Medill Patterson*. Simon & Schuster, 1979.

Mason, Herbert Molloy, Jr. *Death from the Sea: The Galveston Hurricane of 1900*. Dial Press, 1972.

McCullough, David. *Truman*. Simon & Schuster, 1992.

McLendon, Winzola. *Martha: The Life of Martha Mitchell*. Random House, 1979.

McLendon, Winzola, and Scottie Smith. *Don't Quote Me! Washington Newswomen and the Power Society*. E. P. Dutton & Co., 1970.

Merman, Ethel, with George Eells. *Merman: An Autobiography*. Simon & Schuster, 1978.

Mesta, Perle, with Robert Cahn. *Perle: My Story*. McGraw Hill, 1960.

Miller, Hope Ridings. *Embassy Row: The Lies and Times of Diplomatic Washington*. Holt, Rinehart and Winston, 1969.

Money, Jack, and Steve Lackmeyer. *Skirvin*. Full Circle Press, 2009.

Morris, Sylvia Jukes. *Price of Fame: The Honorable Clare Boothe Luce*. Random House, 1998.

Morris, Sylvia Jukes. *Rage for Fame: The Ascent of Clare Boothe Luce*. Random House, 1997.

Murphy, George. *Diplomat among Warriors: The Unique World of a Foreign Service Expert*. Doubleday, 1964.

Nash, Philip. *Breaking Protocol: America's First Female Ambassadors, 1933–1964.* University Press of Kentucky, 2020.

Neal, Steve. *Eleanor and Harry: The Correspondence of Eleanor Roosevelt.* Citadel Press Books, 2004.

Nichols, David A. *Eisenhower 1956: The President's Year of Crisis.* Simon & Schuster, 2011.

Pearson, Drew. *Washington Merry-Go-Round: The Drew Pearson Diaries, 1960–1969.* Potomac Books, 2015.

Peters, Charlie. *Five Days in Philadelphia: The Amazing "We Want Willkie" Convention of 1940 and How It Freed FDR to Save the Western World.* Public Affairs, 2005.

Ritchie, Donald A. *The Columnist: Leaks, Lies, and Libel in Drew Pearson's Washington.* Oxford University Press, 2021.

Rubin, Nancy. *American Empress: The Life and Times of Marjorie Merriweather Post.* iUniverse, 2004.

Russell, Jan Jarboe. *Lady Bird: A Biography of Mrs. Johnson.* Scribner, 1999.

Scroop, Daniel Mark. *Mr. Democrat: Jim Farley, the New Deal, and the Making of Modern American Politics.* University of Michigan Press, 2009.

Sherwood, Robert. *Roosevelt and Hopkins: An Intimate History.* Harper & Brothers, 1948.

Smith, Amanda. *Newspaper Titan: The Infamous Life and Monumental Times of Cissy Patterson.* Alfred A. Knopf, 2004.

Solomon, Burt. *The Washington Century: Three Families and the Shaping of the Nation's Capital.* Harper Perennial, 2004.

Sweig, Julia. *Lady Bird Johnson: Hiding in Plain Sight.* Random House, 2021.

Thomas, Jean Hurt. *Settlements on the Prairie: A History of the Alta Loma, Santa Fe, and Algoa Communities, 1830–1985.* Gary Thomas, 1998.

Truman, Margaret. *Souvenir: Margaret Truman's Own Story.* McGraw Hill, 1956.

Williams, Marjorie. *The Woman at the Washington Zoo: Writings on Politics, Family, and Fate.* Public Affairs, 2006.

Woloch, Nancy. *A Class by Herself: Protective Laws for Women Workers, 1890s–1990s.* Princeton University Press, 2015.

Zahniser, J. D., and Amelia R. Fry. *Alice Paul: Claiming Power.* Oxford University Press, 2014.

Index

About the Author

MERYL GORDON is the *New York Times* best-selling author of *Mrs. Astor Regrets: The Hidden Betrayals of a Family Beyond Reproach*; *Bunny Mellon: The Life of an American Style Legend*; and *The Phantom of Fifth Avenue*. An award-winning journalist, she is a tenured journalism professor at New York University. Her work has appeared in *Vanity Fair*, *New York Magazine*, and the *New York Times*.